PHOTO JOURNALISM

THE PROFESSIONALS' APPROACH

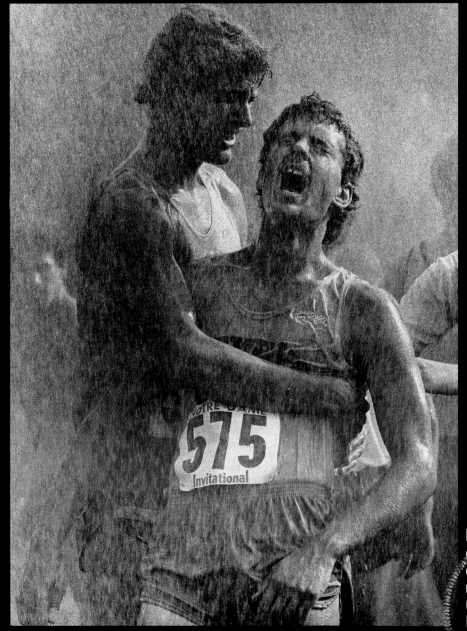

Firehoses cool exhausted runners. (Photo by Ed Ballots.)

PHOTO JOURNALISM

THE PROFESSIONALS' APPROACH

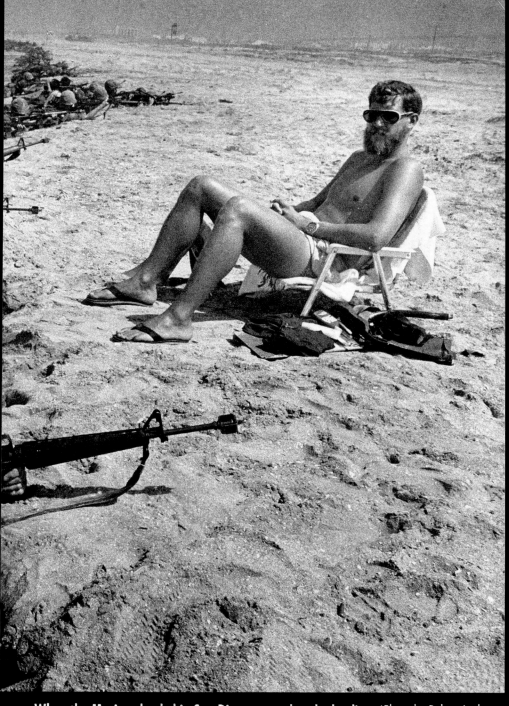

When the Marines landed in San Diego, the sunbather was unfazed because he was a demolitions expert who helped **plan the landing.** (Photo by Robert Lachman, *Los Angeles Times.*)

KENNETH KOBRE

EDITING & DESIGN BY BETSY BRILL

FOCAL PRESS
Boston London

Focal Press is an imprint of Butterworth–Heinemann.

Recognizing the importance of preserving what has been written, it is the policy of Butterworth–Heinemann to have the books it publishes printed on acid-free paper, and we exert our best efforts to that end.

Cover design and interior design:
Betsy Brill, Creative Connections, San Francisco

Cover photograph: C. J. Walker, *The Palm Beach Post*
(A Florida state trooper illegally tried to block the cameras of two *Palm Beach Post* photographers who were covering the arrest of an armed robbery suspect. The incident resulted in an apology from the highway patrol and a police-press relations document confirming the rights of photojournalists to cover the news.)

Library of Congress Cataloging in Publication Data

Kobré, Kenneth 1946–
 Photojournalism: the professionals' approach, Kenneth Kobré; editing and design by Betsy Brill — 2nd ed.

 p. cm.
 Includes bibliographical references and index.
 ISBN 0–240–80061–3 (paperback)
 1. Photojournalism. I. Brill, Betsy II. Title.
TR820.K75 1991
070.4´9 90-85279
 CIP

Butterworth–Heinemann
80 Montvale Avenue
Stoneham, MA 02180

10 9 8 7 6 5 4 3 2 1

Printed in the United States of America

Dedication

This book is dedicated to my parents, Sidney and Reva Kobre.

Photo by Allan Detrich, *Toledo* (Ohio) *Blade.*

Contents

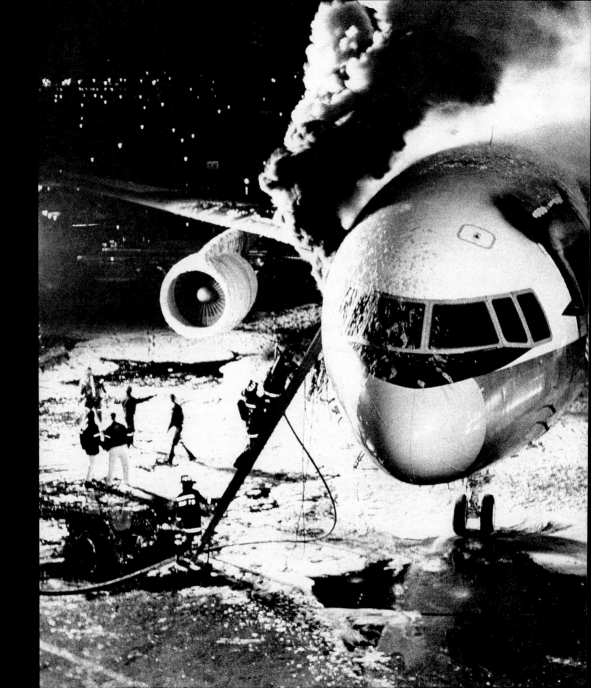

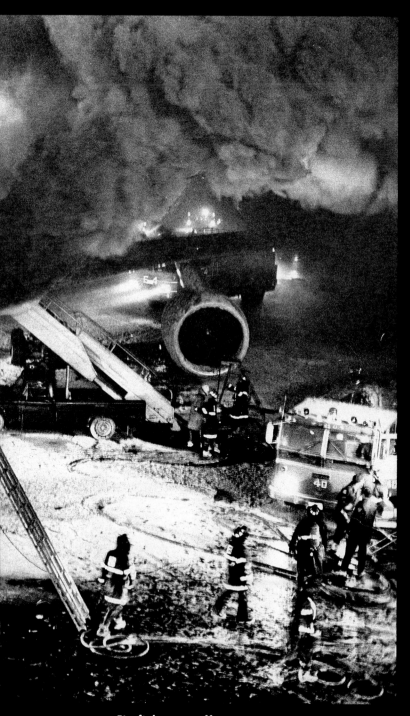

Firefighters snuff an electrical fire aboard an airplane parked on a Boston runway. (Photo by George Rizer, *The Boston Globe.*)

Photojournalists report with a camera. Their job is to search out the news and report it in a visual form. Today's news photographers must combine the skills of an investigative reporter and the determination of a beat reporter with the flair of a feature writer. In a visual age, photojournalists hold the key to communicating the news on the printed page. As the audience raised on television images begins buying newspapers and magazines, they will gravitate to more picture-oriented media.

That's why today's publications run more pictures than ever before. Weekly, *Time*, *Newsweek*, and *U.S. News and World Report* scour the world for the best news pictures, usually in color. Daily, the Associated Press, United Press International, Agence France-Presse and Reuters vie for the best images. Picture agencies like Sygma, Gamma, Picture Group, and Black Star grow despite competition from new, more specialized boutique agencies. Suburban dailies continue to expand as they compete with big-city newspapers.

Offset printing has improved the reproduction quality of newspapers. The reader particularly sees the effect of this new printing hardware in better looking pictures —

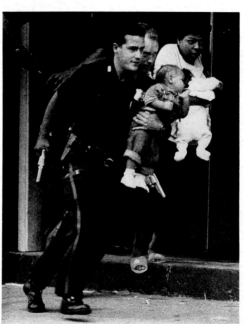

Hostage rescue. (Photo by Jim Mahoney, *The Boston Herald.*)

often in color. The result of this mushrooming growth in news pictures means more opportunities for employment of free-lance and staff photojournalists — photographers who can tell stories with their cameras.

Pictures today do not merely supplement the news stories of the day as tangential illustrations or serve as ornaments to break up the gray type on the page. Today's photos represent the best means available to report human events concisely and effectively.

Photojournalists are not an appendage of their writing colleagues. Rather, photojournalists find, interpret, and report the day's news, features, and sports. They watch for fires, accidents, and hold-ups as they cruise. Often, they are the first to respond to an emergency they hear on their scanner. They originate their own in-depth stories and essays about homelessness, AIDS, or child abuse. When photographing an individual, they form an opinion about the newsmaker that they then transfer onto film. And like other journalists in the field, they constantly face the ethical issue of when to interrupt a citizen's private moments of grief of joy. In the end, photojournalists are visual reporters who interpret the news with cameras rather than pens.

Acknowledgments

I would like to thank my parents, Dr. and Mrs. Sidney Kobré. Without their advice and guidance, I would never have written this book. My father, who has been a reporter, editor, and professor of journalism for many years, helped to give the book a clear journalistic focus. My mother, Reva, who is also a writer, suggested many ways to improve the prose style of the manuscript.

This revision would have never been completed nor obtained its look without the devotion and love of Betsy Brill. For nearly two years, through many alterations and changes, she has helped guide the project from initial concept to the final design of the printed page. Her experience as a professional photojournalist, editor, and designer helped bring my abstract ideas into reality on the page.

For some books, the author goes to the mountaintop and writes. That is not how the original book nor its revision was produced. This text is based on a number of interviews — both formal and informal — with working pros. I have mentioned their names in the text whenever possible. Without their information and time, this book would not be complete.

In addition, a veritable platoon of photographers, photo editors, editors, academics and lawyers have read parts of this revision. I greatly appreciate their time and effort: David Cole, Cole Group consultant in electronic technology; Henry Epstein, philosophy professor; Sharon Falter, assistant editor at Butterworth/ Focal Press; Barbara London, editor of the original photojournalism manuscript and co-author of *Photography* by Upton and Upton; Betty Medsger, chair of the journalism department, San Francisco State University (SFSU); Michele McCarthy, proofreader; Eric Risberg, Associated Press photographer; John Racanelli, California Appeals Court Justice; Rick Steadry, professor, Orange Coast College; Michael Sherer, associate professor of journalism, University of Nebraska at Omaha; Erna Smith, assistant professor of journalism, San Francisco State University; Mary Thorsby, free-lance writer/editor; Evangeline Tolleson, free-lance editor; David Weintraub, photographer and West Coast correspondent for *Photo District News*; Jim Wagstaff, media lawyer, Cooper, White and Cooper; Kirby Upjohn, assistant professor of communications at Boston University.

A second platoon helped with picture research and production. Without their aid, the book would not have its wide diversity of images. A special thanks to Hal Buell, Associated Press; Daria Brill, picture researcher; Randy Battles, lawyer; Joshua Chen, production assistant; John Faber, NPPA historian; Jim Gordon, *News Photographer* magazine; Carla Hotfedt, Silver Images photo agency; Jill Kelly, production assistant; Kevin Kuschel, AP librarian; Diana Smith, research assistant.

Almost all the photos in this book have been lent to me by photographers, some of whom I know and others I've not had the pleasure to meet; some former students and some present ones. I thank all of them for their generous contribution to this project. A book of this scope would be impossible without their generosity. One photographer who contributed a picture wrote that he had used the original book when he was a student. After a number of years in the profession, he had begun to teach part-time. Now he assigns the book to his students. His photo, in this edition, will help a third generation of future photojournalists.

This revision includes many more demonstration pictures and drawings than the original book. Ron Bingham, John Burgess, and Sybilla Herbrich went through numerous re-shoots to produce these clear and accurate demonstration photos. Ben Barbante prepared all the explanatory drawings and sketches. Lisa Griffin Bradrick of Kedie Orent and Paul Buxbaum of Color Imaging Systems produced the computer-manipulated examples.

Lucinda Covert-Vail, journalism librarian at San Francisco State University, undertook the extensive, computer-assisted bibliographical searches for the final bibliography.

My editor at Focal Press, Karen Speerstra, was the person who encouraged me to undertake this revision and who has chaperoned the project to its publication.

Like a chemist's research lab, my classes at SFSU have allowed me the opportunity to experiment on new approaches to photojournalism, particularly the picture story. I would like to thank my students for enduring the tribulations of trying new ways to tell stories photographically. The results of these experiments have been three extensive photo and writing projects: *Helpers in the War on AIDS; Teenagers: The Awkward Years,* and *Struggle for Life: Personal stories about birth and parenting.* Parts of these projects are included in the book.

Betty Medsger, chair of the journalism department at SFSU, allowed me the freedom to teach these unusual classes. In actions as well as words, she has supported the integration of writing and photography to produce the best reporting possible. She has created an environment in the department that fosters the highest principles of journalism.

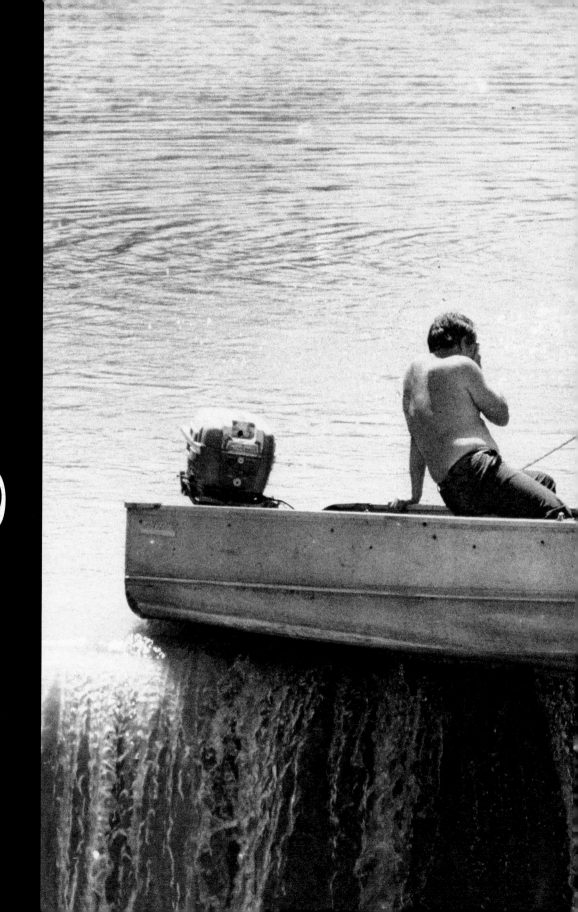

Assignment

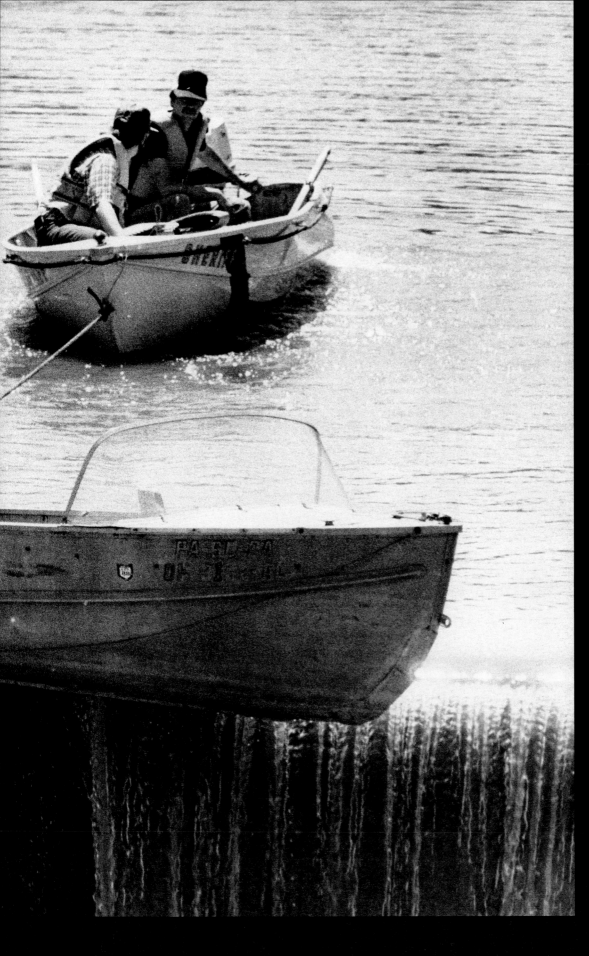

Protesting groups often tip news outlets about when and where they plan to demonstrate. Keep in touch with different organizations for your own leads. (Photo by John Burgess.)

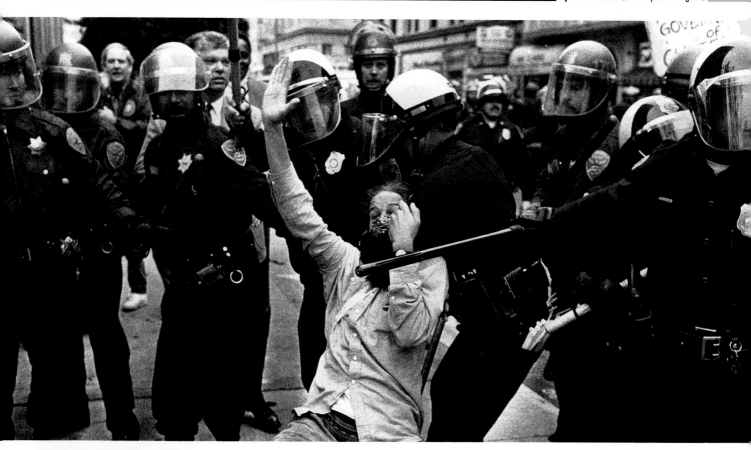

WHERE TO FIND NEWS

■ LOOKING FOR SCOOPS

LUCK

Allan Detrich of the *Toledo* (Ohio) *Blade* was driving across a bridge when he glanced down to discover a motorboat nearly going over a waterfall. After quickly pulling to the side of the road and then jumping out of the car with his camera, Detrich managed to snap a few frames as the sheriff's department rescue boat pulled the unfortunate boater from the edge of the falls (see previous page).

Luck can't be learned, but if luck is not accompanied by good technique and the sense of what to do with the exposed film once it's been shot, then the photographer won't be able to turn an accident into a front-page, news-making picture.

SCANNER RADIO SIGNALS FIRES AND ACCIDENTS

Only rarely will you stumble over a big breaking news story. "Anticipating spot news is like trying to predict where lightning will strike," says Robert Bowden of the *St. Petersburg* (Fla.) *Times.*

How does a news photographer know when a story is breaking? One way is to monitor the emergency-band radio frequencies for a tip-off on a major spot news break.

Most newspaper photographers monitor the police band because cops are usually the first ones called to a murder, robbery, or accident. Police use three bands: low (35-50), very high VHF (152-174), and ultra high UHF (450-70). You can find the exact frequency by asking your local police department or by obtaining from a local radio store a directory that lists all emergency frequencies in the region. To learn quickly about a major transportation disaster, monitor the international frequency for airplanes (121.5) or marine frequency (156.8) for distress calls at sea. Additional frequencies that enable you to get a jump on fast-breaking events include those of the state police, county sheriff, and fire department. Also consider monitoring the national weather alert and civil defense.

Normally, the police talk in codes. For instance, 10-42 means traffic accident at . . . 10-70 means fire at The codes are published, but sometimes the police

broadcast their calls through a scrambler, so you might have to purchase an unscrambler to understand what is being said.

NEWS RADIO GOOD IN PINCH

What else do photographers use to keep in touch with the news pulse of the city, especially when they can't afford a monitor? One alternative is an all-news radio station or a station that specializes in frequent news or updated news reports. A station with an all-news format interrupts any on-going programming immediately if an emergency arises. These stations monitor several scanner channels, including the fire and police departments, and will announce over the air any time a major fire alarm or multicar accident occurs. The all-news station also has its own reporters who cover breaking stories and give live updates. The radio's weather forecaster will predict a natural disaster such as a hurricane or tornado, and a reporter will describe the damage when the disaster hits. News radio does not provide as immediate information as the scanner, but the radio often will suffice.

TIPS HELP

Newspapers often get leads on top news stories when people call the city desk with tips. Some newspapers, in fact, offer monetary rewards for tips. The city desk sizes up the event. Then, if the decision is yes, the city editor or an assistant may send out a reporter and photographer.

Special interest groups call in tips to the newspapers if the members think publicity will do them some good. If minorities, welfare mothers, gays, or anti-nuclear groups, for example, are going to stage a protest for which they want coverage, they might telephone the newspaper with the time and place of their planned demonstration.

BEAT REPORTER KNOWS THE TERRITORY

Most newspapers assign reporters to cover a certain beat: city hall, hospitals, police headquarters. Beat reporters keep up with the news and events in their specialty; consequently, these reporters know when to expect a major story to break. The city hall beat reporter may call in to the city desk and say, "The mayor is greeting some astronauts today. It will be worth a good picture." The editor agrees and assigns a photographer.

Whether a photographer stumbles into an event in progress, finds out about it from a scanner radio, or gets a tip, he or she still must evaluate its news and picture worthiness, photograph the activity, and rush the picture to a media outlet in time for the next deadline.

MAKING CONTACTS

Michael Meinhardt of the *Daily Herald* in Wheaton, Ill., has developed his own system of finding out about spot news as it happens. Using a system of pagers, two-way radios, cellular phones, and a network of sources and contacts, he stays abreast of news as it breaks in the Chicago and suburban-Chicago area.

Firefighters, police officers, dispatchers, and even air traffic controllers at surrounding airports notify Meinhardt of news events via a voice message pager that he carries twenty-four hours a day. He has befriended these contacts at other news events, where he introduced himself, left a business card, and followed up by giving them photographs of themselves at work.

"You'd be surprised how many of them remember me when the news breaks," he says.

"Additionally," he explains, "I belong to a network of contacts led by a local radio news reporter who is considered the dean of spot news. . . . We all have two-way radios on our own frequency that we monitor around the clock. . . . Once the closest person arrives on the scene, I can usually ascertain whether it's worth traveling to shoot pictures. They can also let me know how urgently I need to get there before the scene clears up."

Not surprisingly, Meinhardt is considered a great source of information by his colleagues in the newsroom and by the newspaper's city desk.

PR OFFICE IS THERE TO AID YOU

The mayor will arrive at his office at 9 A.M. He leaves for the airport at 10:15 A.M. to dedicate a new runway. He will be at the Golden Age Senior Citizens home from 11:30 A.M. to 12:30 P.M. Then, during a 1 P.M. lunch at the Parker House, the mayor will meet with the Committee for City Beautification.

If you want to know the whereabouts of the mayor practically every minute of the day, just consult the schedule. The mayor's personal or press secretary arranges the itinerary weeks in advance. Mayors, Congressional representatives, senators, and the president of the United States have carefully planned schedules, available through their press officers.

Companies, schools, hospitals, prisons, and governmental departments also have press or public relations offices. These offices, sometimes called public affairs or public information departments, generate a steady stream of news releases announcing the opening of a new college campus, the invention of a long-lasting light bulb, or the start of a new special education teaching program. Many of these PR releases suggest good picture possibilities.

PAPER PRINTS SCHEDULES

Another source for upcoming news events comes daily to your doorstep rolled and held with a rubber band. The daily paper carries birth, wedding, and death announcements. The paper prints schedules of local theaters, sports events, parades, and festivals. When the circus arrives in your town, the paper will list the time and place of the Big Top Show.

TRADE MAGAZINES SUPPLY UNUSUAL LEADS

For more unusual activities, check special interest newspapers and magazines. Dog and cat lovers, cyclists,

plumbers, skateboarders, mental health professionals, and environmental groups all publish magazines and newsletters that announce special events.

To keep track of upcoming happenings with visual possibilities, newspapers and wire services maintain a log book listing the time, place, and date of each future activity. The notation in the book includes a telephone number for the sponsoring organization in case the photographer needs more information. The log book idea works well for free-lancers, also.

<div style="background:black;color:white;padding:1em">

WORKING WITH REPORTERS

</div>

■ WHEN CLICKERS MEET SCRIBBLERS

PHOTO REQUEST STARTS THE PROCESS

Most news publications have many more staff reporters than photographers. From their sources, these newshounds generate potential stories. When an editor approves a story proposal, the reporter makes out a photo request.

For the photographer, the key to great photo coverage depends on the information and arrangements on the photo request. Typical assignment requests include the name of the person or event to be photographed, the time, date, and place. Usually, the editor has assigned a slug, a one- or two-word designation for the story that serves as the story's name until the copy desk writes a final headline. Usually the assignment sheet includes a brief description of the proposed article as well as a telephone number with which to contact the key subject if anything needs to be changed.

PHOTOGRAPHER & REPORTER MEET AHEAD OF TIME

Under the best of circumstances, the reporter, photographer, and assigning editors meet at this point in the story's development to discuss the team's approach. The group tries to define the story's thrust and news. Here, the photojournalist can suggest visual ways to tell the story that correspond to the reporter's written approach. The photographer can recommend a candid approach, a portrait, or a photo illustration — and also can estimate the amount of time needed for the shoot, or identify props and necessary clearances.

On some publications, unfortunately, the photographer never meets with the reporter and assigning editor. Rather, the shooter receives the information from an intermediary editor or is briefed by notes on the assignment sheet. In these circumstances, the photographer plays a reduced role in determining the story's final outcome. Located at the end of the assigning chain, the

photographer has little say in determining the best approach to the story.

BEST TIME FOR AN ASSIGNMENT

On many newspapers and magazines, the reporter calls the subject and makes the shooting arrangements for the photographer. Sometimes this saves the photographer time. In most cases, though, the reporter can inadvertently eliminate great picture opportunities. The reporter, for example, may decide to do a story about the new principal at Lincoln High. The writer phones to ask when the principal is free for an interview and pictures. The principal responds: "Well, I'm busy all day. I greet the kids as they get off the bus. Then I meet with parents and teachers. Next I observe classes and eat lunch with the kids. Then I usually work with student discipline problems in the afternoon. All the teachers and students are gone by four. How about meeting me in my office after four?"

From the reporter's point of view, four o'clock would be fine. The principal is free to answer questions and chat in a quiet environment in her office. From the photojournalist's perspective, four o'clock would be okay if formal portraits or head shots are all that are sought. But four o'clock would be a disaster if the photojournalist wants to shoot honest, revealing candids.

The shooter should be at school at 7:30 A.M. as the principal greets the kids, again at noon when she eats with her teachers and students. Hopefully, the photographer could get access later to observe the principal's work with disciplinary problems. These pictures would show whether the principal is stern or kind, friendly or tough, or a little of each. Were the photographer to shoot when the writer originally planned, the resulting pictures would probably be of the subject standing in front of the building, in a hallway, or inside a classroom. The environmental portrait would show what the principal looked like but would hardly reveal her character.

PHOTOGRAPHERS MAKE THEIR OWN ARRANGEMENTS

When reporters and editors fill out assignment sheets, they do not always take into account the special needs of photographers. While reporters can hold a telephone interview or call back later for more facts, the photographer needs to be present when the subject is engaged in work. Photographers and photo editors need to educate those on newspapers' word side because an unimaginative assignment leads all too predictably to a routine picture.

Often, photographers find that because they know the kinds of pictures they are looking for, they can make arrangements better than the beat reporter or supervising editor. On some publications, photographers get names and phone numbers and then initiate the appointment or decide what other pictures might go with the story. While the reporters might tape the interview at four o'clock, the photographer might shoot the subject from dawn until dusk on a different day.

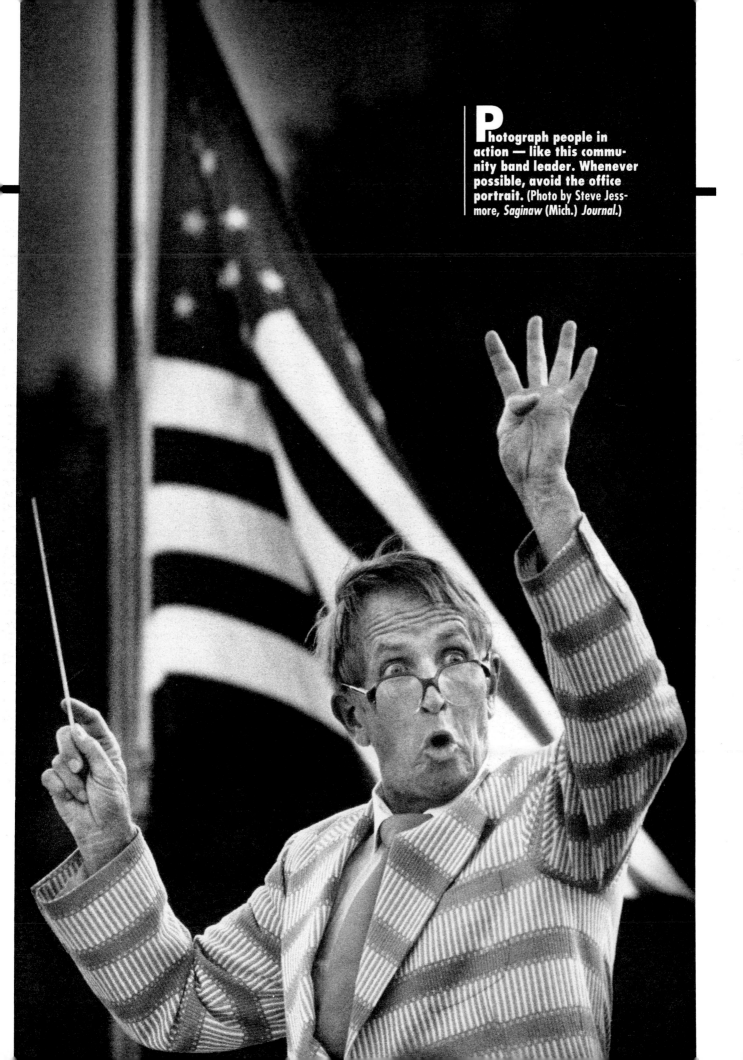

Photograph people in action — like this community band leader. Whenever possible, avoid the office portrait. (Photo by Steve Jessmore, *Saginaw* (Mich.) *Journal.*)

When arranging the shooting schedule with a subject, a good question for photographers to ask is "What is your typical day like?" As the subject goes through a normal day's activities, the photographer keeps in mind which hours the person is just sitting behind a desk talking and which hours he or she is doing something active and therefore photogenic. The photographer also should find out if anything unusual is coming up that would lend itself to revealing photos.

ON THE SCENE: WORKING IN TANDEM

For some types of news, the photographer and reporter must cover the event together. Sometimes the reporter knows the important players. Sometimes the photographer needs a second set of eyes to help provide protection, such as at a violent street protest. However, even at these kinds of news events, the photographer and reporter should not become wedded at the hip. Each has different needs. One is following the action as it flows down a street, while the other is checking a quote and making sure the name is spelled correctly.

Even so, while both the photographer and reporter need independence, the two also need to regroup every once in awhile to confirm they are developing the story in parallel ways.

Although the photographer and writer don't shoot and interview at the same moment, they should coordinate the message of their words and pictures. Photographers should pass on their observations about the subject or event to the writers. Writers can explain to photographers the gist of their leads.

In the end, the reader will be looking at both the picture on the page and the accompanying story. If the writer describes the subject as drab, yet the picture shows a smiling person wearing a peacock-colored shirt, the reader is left trying to resolve the conflict. Writers and photographers should resolve any conflict between words and pictures before the story goes to press.

■ PICTURE POLITICS

Ideally, media management avoids poor use of photo resources with good planning. However, many newspapers and magazines continue to operate in a traditional structure long unfriendly to effective use of photography.

Traditionally, management organized newsrooms to handle assignments proposed by either reporters or editors. In these newsrooms, photographers rarely originated story ideas. And even if they did, the photoreporters received little in the way of picture play for their efforts.

The old-style process (still widely used today) works this way: once the reporter gets the green light, research begins. The reporter might interview subjects, check the newspaper's morgue for related articles, call authorities on the issue and finally write the copy over a

period of days or even weeks. Only when the story is nearly completed and ready for publication does the reporter fill out a photo request. Finally, the photo department becomes aware of the issue.

With the story written and the publication date set, the photographer has little room to maneuver. While the reporter took days and weeks to develop the story, the photographer might have just hours to produce accompanying photos. The photographer might have to squeeze the assignment in with three or four others that day. The photojournalist might have no choice about when to shoot for the best light. The deadline might not allow enough time to hang around for a candid look at the subject.

On most publications, the managing editor, at a daily, weekly, or monthly story conference often referred to as a budget meeting, decides how much space to allocate for a story and where that story will play.

Representing each section of the publication, the different editors gather around a conference table to pitch their best stories to the managing editor, who ultimately decides which stories get front page display and which are buried inside. While the photo editor speaks up for pictures at this meeting, the word editors always outnumber the lonely representative from the photography department.

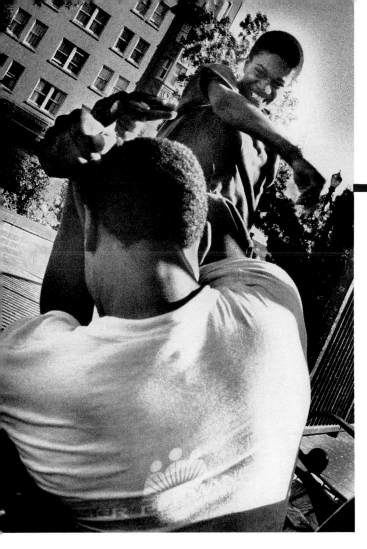

ducing yourself to one reporter. Ask what the writer is working on. If the story sounds interesting, talk about picture possibilities. If you know that an event is coming up that would help explain the story, suggest to your photo editor or managing editor an assignment that will help illustrate the story. On your own, start reading about the issue. If you notice a picture that might support the story, shoot it. Look for as many ways as you can to photograph the writer's story even before the wordsmith has finished the masterpiece.

When the story results in a formal photo request, your editor will likely assign the job to you because you have already started on the photos. By now you have a clear idea of the possible pictures that would help the story. Also, you know that because the story was written by a top writer, it will probably get prominent display.

If you continue to cruise the newsroom looking for good writers, anticipating photo requests, and building alliances with the word side, you will probably find writers agreeable to listening to your story ideas. A writing/photography partnership will probably garner more newsprint than your proposal alone.

■ SELF-GENERATED ASSIGNMENTS

Sometimes a photographer pulls over next to an over-turned car, jumps out, and shoots. No written assignment needed here. Most often, a photographer receives a verbal or written assignment from an editor. But many photographers report that their best assignments are those they proposed themselves. Self-generated assignments allow the photographer to pick exciting topics that lend themselves to visuals. When a photographer has researched a good story, the next step is to request a reporter to provide the needed text. The more stories photographers propose, the more control they will have over their work.

Fred Larson of the *San Francisco Chronicle* assigned himself to photograph a city neighborhood called the Tenderloin. The area got its nickname because in the old days, a cop on the beat was assured enough under-the-table money to guarantee beef tenderloin chops on his dinner table every night. To this day, the Tenderloin is still crime-laden.

Because of the very real danger of being attacked in this part of town, Larson shot many pictures for his story from his car window. He also replaced the speaker in a portable stereo with a camera. This sub-terfuge provided cover so that Larson could shoot easily and unobtrusively with the hidden camera.

After four months of street shooting, Larson had enough revealing pictures to show a reporter how the story could develop. Only at this stage did the reporter come aboard the project and begin interviewing and writing.

Hal Wells was working for the *Lewisville Daily Leader* in Texas when he shot photos of illegal aliens

Here, each editor represents a part of the paper or magazine. Individual editors defend their turf. On a large newspaper, the sports editor, fashion editor, city editor, and foreign desk editor might each have their own section fronts and inside pages. On a weekly news magazine, the national editor, political editor, and music editor each might have a minimum number of pages to cover the most important topics in a specific area. Too often, the photo editor has no designated turf: no space assigned solely to photo stories. While the photo editor might sit at the table with other decision makers, he or she has no formally reserved space in the publication.

Furthermore, the picture editor is up against colleagues who think their sections cover the most important news, contain the best writers, and ought to have the most space. And because more and bigger photos mean fewer words, few section editors see the advantages of story-telling pictures eclipsing longer stories. Furthermore, managing editors, most of whom graduate from the writing rather than the visual side of the publication, make the final decisions about the use of space.

The upshot at most publications: even a strong photo editor can rarely counterbalance these inherent structural biases toward words.

TAKE A REPORTER TO LUNCH

To avoid the trap of being the last one to know about important stories — and having your pictures played poorly, try this: if you are new on a paper, ask the managing editor which reporter stands out in the newsroom. If you have worked at a paper for a while, you probably already know the names of the best writers. Start by intro-

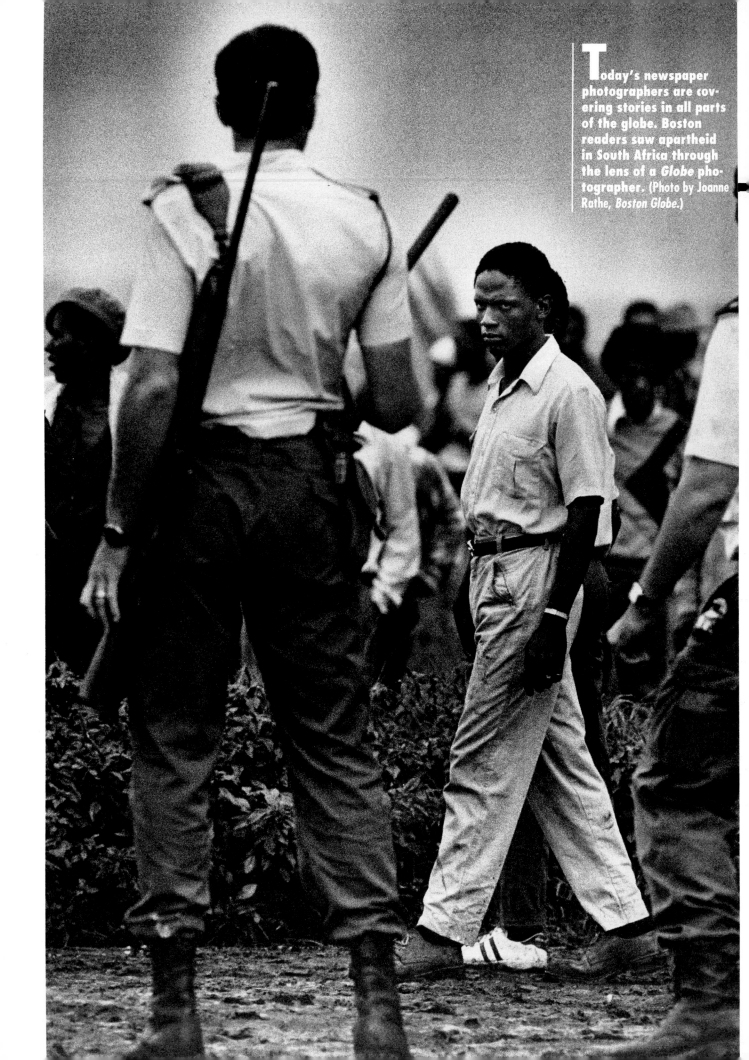

Today's newspaper photographers are covering stories in all parts of the globe. Boston readers saw apartheid in South Africa through the lens of a *Globe* photographer. (Photo by Joanne Rathe, *Boston Globe.*)

crossing the Mexico/U.S. border. Later, he arranged with a reporter to provide a local angle showing the influx of laborers into the Lewisville area. The final story and pictures were a result of Wells' initiative.

When, a number of years after the war ended, Vietnam began allowing Americans into the country, the *Hartford Courant's* Michael Kodas wanted to follow a veteran returning to the old battlefields. Kodas researched the story and even made the arrangements before proposing the idea to his editors. Not only did the editors agree to the story and underwrite the trip, but they assigned one of the paper's top reporters to accompany Kodas on the assignment.

In each of these instances, the photographer originated the story, researched it, and then connected with a reporter. Because the photographer in each situation had selected the story topic, the subject lent itself to pictures. Working with a reporter helped assure that the stories received careful attention in the newsroom. (See "Developing a feature beat" in Chapter 4.)

(See "Developing a feature beat" in Chapter 4.)

INTERNATIONAL ASSIGNMENTS

Many of today's newspapers have expanded their beats to include the world. From covering earthquakes in Mexico to revolutions in the Philippines, newspaper photographers are literally on the move. Photographers who covered high school football on Friday night may find themselves boarding a plane for South Africa on Sunday morning. Never has the mastery of foreign languages or knowledge of international affairs been more important to photojournalists.

Kodas of the *Hartford Courant*, who initiated his own international assignment, reads voraciously: the *Wall Street Journal,* the *Christian Science Monitor*, and the *New York Times*, among others.

National Public Radio is also a good source of international news for car-bound photographers. And if an intensive language course is out of your budget, try substituting language tapes for your favorite rock 'n roll groups when you're stuck in traffic.

Finally, photographers can follow the most basic preparations recommended by free-lancer Keith Philpott: pack an up-to-date passport in your camera bag at all times. And make sure your inoculations are current for travel in Third World countries. (See page 213, "Inside a photographer's camera bag.")

Pack light for international assignments, says Carol Guzy, who covered the Ethiopian famine for the *Miami Herald* and the tumbling of the Berlin Wall for the

Washington Post. She carries as little photo gear as she feels she can get away with but does bring an extra camera body, she says, and film — lots of film.

ASSURING VISUAL VARIETY

■ OVERALL SHOT SETS THE SCENE

If newspaper readers came to a news event, they would stand in the crowd and move their eyes from side to side to survey the entire panorama. The overall photo gives viewers at home this same kind of perspective. The overall allows viewers to orient themselves to the scene.

For some stories, an overall might include just a long shot of a room. For others, the overall might cover a city block, a neighborhood, or even a whole town. The scope of the shot depends on the size of the event. The overall shows where the event took place: inside, outside, country, city, land, sea, day, night, and so on. The shot defines the relative position of the participants. In a confrontation, for example, the overall angle would show whether the demonstrators and police were a block apart, or across the street from one another. The overall shot also allows the reader, by judging crowd size, to evaluate the magnitude of the event.

Margaret Bourke-White, a member of the original *Life* magazine staff, always shot overalls on each assignment, even if she didn't think these shots would be published. She explained that she wanted her New York editor to see the shooting location so that he could interpret the rest of the pictures she had taken.

Generally, the overall requires a high angle. Rick Ferro knew this when he was flown in by the *St. Petersburg* (Fla.) *Times* to cover the earthquake of '89 in the San Francisco Bay Area. After renting a car, his first stop was at a large hardware store, where he purchased a thirty-foot ladder in anticipation of photographing an overall of the collapsed I-880 freeway in Oakland. The ladder came in handy, as Ferro was able to climb up it and shoot photos of the ongoing rescue.

When you arrive at a news event, quickly survey the scene to determine what is happening. Then search for a way to elevate yourself above the crowd. In a room, a chair will suffice. But outside, a telephone pole, a leafless tree, or a nearby building will give you the high vantage point you need for an effective overall. When caught in a flat area, even the roof of your car will add some height to your view.

The wider-angle lens you have, obviously, the less distance from the scene you will need. However, on

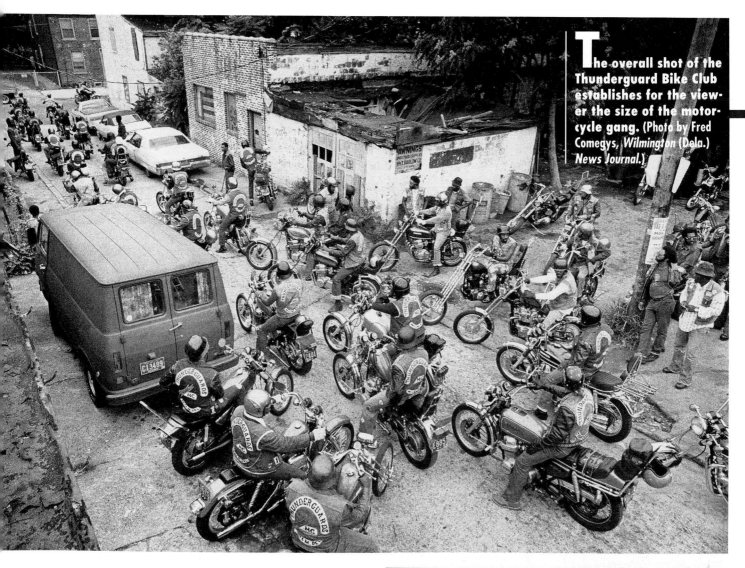

a major news story that encompasses a vast area, such as a flood, hurricane, or conflagration, you may need to rent a helicopter or small airplane to get high enough to capture the dimensions of the destruction.

■ MEDIUM SHOT TELLS THE STORY

The medium shot should "tell the story" in one photograph. Shoot the picture close enough to see the action of the participants, yet far enough away to show their relationship to one another and to the environment. The medium shot contains all the story-telling elements of the scene. Like a lead in a news story, the photo must tell the whole story quickly by compressing the important elements into one image. The medium shot is the story's summary.

An accident photo might show the victims in the foreground, with the wrecked car in the background. Without the wrecked car, the photo would omit an essential detail of the

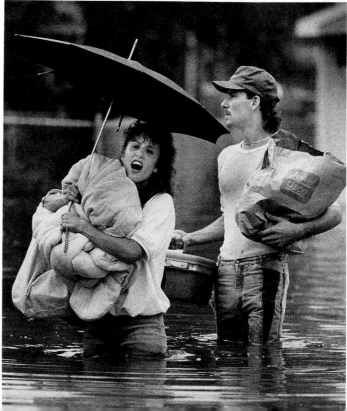

When published alone, a medium shot must tell a complete story. Had this couple not been carrying their belongings, readers wouldn't have known the two had been displaced by a flood. (Photo by Dan White, *Pioneer Press.*)

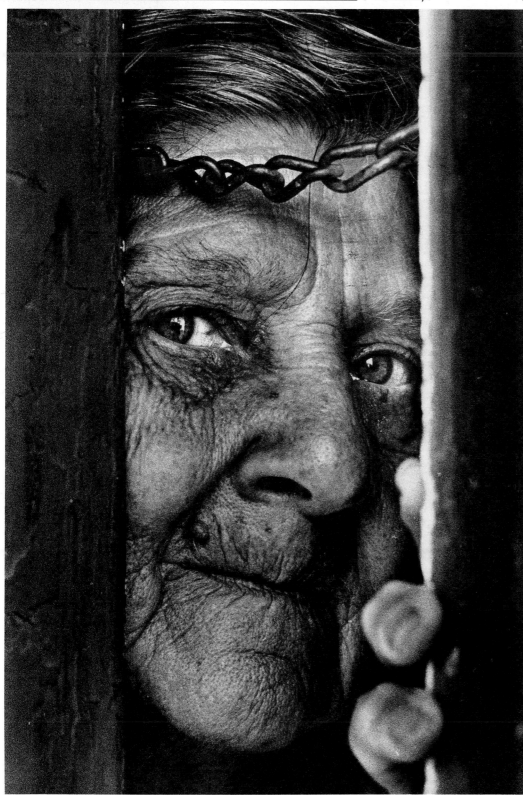

Nothing beats a close-up for drama. With the chain across her door, this woman's fear of outsiders is clear to the reader. (Photo by Bruce Gilbert, *New York Newsday*.)

story — the cause of the victim's injuries. With only the crumpled car, the reader would wonder if anyone had been hurt in the accident. The combination of the elements — car plus victim — briefly tells the basic story.

A medium shot gains dramatic impact when the photograph captures action. Although the camera can catch fast action on film, you may still have difficulty: action often happens so quickly that you have no time to prepare. Shooting news action is like shooting sports action (see Chapter 6, "Sports"). In both situations, you must anticipate when and where the action will take place. If a man starts a heated argument with a police officer, you might predict that fists will fly and an arrest follow. You must aim your camera when the argument starts and not wait until a punch is thrown. If you hesitate, the quarrel might end while you're still fiddling with your equipment.

For the medium shot, a wide-angle lens, such as a 24mm or 28mm works well, although a normal 50mm will do.

Walter Green, a top photographer who worked for the Associated Press for many years, notes that he takes most medium shots with his 24mm lens. With this lens, Green gets extremely close to the subject and fills the entire negative area. The resulting pictures, says Green, tend to project a more intimate feeling between the subject and the viewer.

Because Green works close to the subject, few distracting elements

intervene in front of his camera. Also, at this close distance, Green can emphasize the subject. Finally, Green's wide-angle takes in a large area of the background, thus establishing the relationship of the subject to his surroundings.

WIDE-ANGLE DISTORTION

Buying a wide-angle lens, however, is not a photographer's panacea. The wider the angle of the lens, the greater the chance for apparent distortion. This is because you can focus very close to a subject with a wide-angle lens. And the closer any part of a subject is to the lens, the bigger it will appear in the picture. For example, if you stand relatively close to and above a person, and tilt the camera down to include the subject's full length, head to feet, the subject's head will appear to be the size of a basketball, while the feet will seem small enough to fit into baby shoes.

If you stand at the base of a building and point your wide-angle lens up to include the structure's whole height, the resulting pictures will look as if the building is falling over backwards. This happens with any lens, but particularly with a wide-angle lens used close to the building.

To avoid distortion with the wide-angle lens, you must keep the back of the camera parallel to the subject. When shooting a building, you must either get far enough away or high enough that the back of your camera is perpendicular to the ground and therefore parallel to the structure.

■ CLOSE-UP ADDS DRAMA

Nothing beats a close-up for drama. The close-up slams the reader into eyeball-to-eyeball contact with the subject. At this intimate distance, a subject's face, contorted in pain or beaming in happiness, elicits empathy in the reader.

How close is close? A close-up should isolate one element and emphasize it. All close-ups don't have to include a person's face. Sometimes objects can tell the story even when the story involves human tragedy. A close-up of a child's doll covered by mud might tell the story of a flood better than an aerial picture of the entire disaster.

Longer lenses enable the photographer to be less conspicuous when shooting close-ups. With a 200mm lens, a photographer standing ten feet away can still get a tight facial close-up. The telephoto lens decreases the depth-of-field, blurring the foreground and background, thereby isolating the subject from unwanted distractions.

Rather than a telephoto for close-up work, the photographer can employ a macro lens or a standard lens with an extension tube. With either of these lenses, the camera can take a picture of a small object such as a contact lens and enlarge it until it is easily seen.

■ HIGH/LOW ANGLES BRING NEW PERSPECTIVE

Since most people see the world from a sitting or standing vantage point, a photojournalist can add instant interest to a set of pictures simply by shooting from a unique elevation. Shoot down from a thirty-story building or up from a manhole cover. Either way, the viewer will get a new, sometimes jarring, but almost always refreshing look at a subject. Even when covering a meeting in a standard-sized room, just shooting from the height of a chair or taking pictures while sitting on the floor can add variety to your contacts.

Avoid the 5'7" syndrome. On every assignment, avoid taking all your pictures at eye level. When you start shooting, look around for ways to take the high ground. Whether going out on a catwalk or shooting from the balcony, find some way to look down on the scene you are shooting. For a low perspective, some 35mm cameras allow the photographer to remove their pentaprism housings, which allows the photographer to shoot — literally — from ground zero.

■ SATURATION METHOD INCREASES THE CHANCES

When on assignment, take several frames from each vantage point. Milton Feinberg, the author of ***Techniques of Photojournalism***, calls this approach the saturation method. He recommends taking at least six shots from each position. Then move over a few feet and shoot more frames. A slight change in perspective can bring important elements in the scene together to make the picture more visual. Keep shooting, Feinberg counsels. A minor change in a person's facial expression or body language can turn a routine picture into an eye-stopper. Don Robinson, who worked for United Press International wire service, describes his shooting approach this way, "I shoot one frame, then another and another. I am trying to improve each picture. I may be looking for a certain expression or gesture, or watching for something to happen. I may get something that is unusual, but in the next frame, I might get something much better."

Photographers stay on location until they get the best picture possible within their time limits. Amateurs take a few snapshots and hope for the best. Professionals, by contrast, search for the decisive moment and know when they get it. The pro might have to take a hundred or even a thousand frames to get the perfect moment, but, luckily, 35mm film is cheap. Even a newspaper publisher knows that film is the least expensive budget item.

Says George Tames, a former *New York Times* photographer, "If you see a picture, you should take it — period. It is difficult, if not impossible, to re-create a picture, so do not wait for it to improve. Sometimes it's better, and you will take that picture also, but if you hesitate and don't click the shutter, you've lost the moment, and you can't go back."

■ SAVE THE LAST FRAME

Many photographers stop shooting before the end of the roll. They have been caught with only one frame left just as something spectacular takes place — such as a person leaping out of a building. They raised their cameras and ran out of film. By changing film without waiting for the last frame, photographers build in some insurance. Having blank film at the end of the roll is like having money in the bank. You might not ever need it, but it might save you in an emergency. Leaving film at the end of the roll will also reduce your own anxiety.

CATCHING CANDIDS

What sets photojournalistic pictures apart from other types of photography? The photojournalistic style depends on catching candids. The good photojournalist has developed the instinct to be at the right place, at the right time, with the right lens and camera. Often, the photojournalist can steal images like a pickpocket, without anyone realizing the sleight-of-hand photographer even grabbed the shot.

The photojournalist must catch the subject as unaware as possible to record real emotions. Rather than stage-manage pictures, the news photographer records the event as if it were an unfolding play. The photogra-

pher observes but does not direct. The results depend on the photojournalist's ability to capture these moments without interrupting.

With good candid pictures, subjects never stare at the camera. Eye contact would tip off the reader that the picture is not candid and suggests that the subject was at least aware of the photographer and might even be performing for the lens.

■ THREE APPROACHES TO CANDIDS
BIG GAME HUNTER

Like a hunter stalking prey, the photojournalist studies the subject. Siting through a rifle-like telephoto lens 100mm to 300mm long, the photojournalist stands across the room or across the street. The photographer watches, waits, and tries to anticipate what might happen next.

Patience. Patience. Patience.

At a Deep Sea Roundup in Port Aransas, Texas, patience paid off for Pete Silva, a staffer on the *Corpus Christi Caller-Times*. He noticed an elderly woman peering through her World War I vintage box camera. He kept his telephoto trained on the petite woman as a strapping, 6'3", bearded TV cameraman strode alongside her. Creating an ideal contrast, the two shooters, one holding an ancient box camera and the other shouldering the latest in electronic image recording devices, stood side by side photographing the prize-winning catch hanging by the dock. Focusing on this Mutt-and-Jeff pair, Silva waited for the moment of interaction. He knew that at some point, the huge cameraman or the tennis-shoed grandmother would notice one another.

The photographer snapped this candid by moving in quickly with a wide-angle lens. (Photo by Norm Shafer, *Fredericksburg (Va.) Free Lance-Star.*)

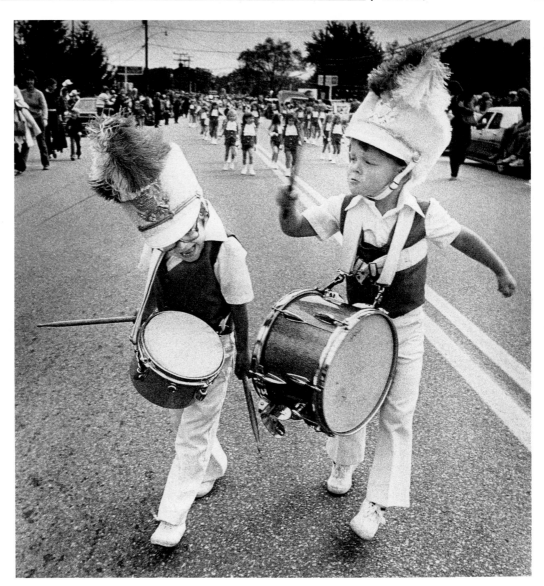

It happened. Just as the TV photographer glanced down, Silva snapped off four frames. Neither subject realized that Silva had photographed them until he later interviewed them for caption information.

HIT AND RUN

Rather than trying to operate unobserved, some photographers use the hit-and-run approach. They catch candids by walking past the subject, shooting quickly with a wide-angle lens and then moving on. Observers have described Henri Cartier-Bresson's technique that way. The outstanding French candid-catcher pauses in front of his subject and with one fluid motion raises his Leica, focuses and clicks several frames. By the time the subject turns toward the photographer, Cartier-Bresson has already gone his way. This type of hit-and-run photography leaves subjects unaware they have been photographed.

Norm Shafer of the *Fredericksburg (Va.) Free-Lance Star* was shooting the King George Fall Festival parade when he noticed two young drummers getting bored with the marching. Realizing that he might have a potential feature, Shafer got in step with the young marchers. One drummer started to tease the other with his stick. Shafer moved in, shooting with his 24mm wide-angle lens focused at about ten feet. Just as one drummer selected the other fellow's head for a practice timpani, Shafer began to shoot. Engrossed in their own rhythms, the two drummer boys never noticed Shafer and his camera. As the embarrassed mother of one of the misbehaving boys pulled her son out of the parade, Shafer contin-

ued to record the incident because, as he explained later, "you never know till you see the film if you have the exact moment."

Shafer had caught the moment.

OUT-IN-THE-OPEN

Sometimes the photojournalist doesn't have to use any subterfuge to catch a candid. The out-in-the-open approach works when the subject, engaged in an activity that is so engrossing, forgets for a moment the photographer's presence. For example, Ted Ancher of the *Boston Herald* was surely a presence in the room while a barber trimmed a young man's voluminous locks. The trimming session was obviously the young man's first in some time. Ancher hung back and watched for the reaction of the man in the chair as the barber's trimmers cut more and

The haircut was so engross-ing that the subject forgot for a moment that the photographer was present. (Photo by Ted Ancher, Boston Herald.)

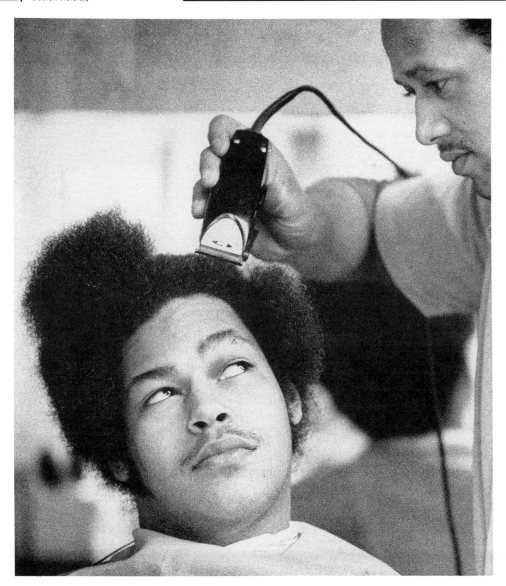

and stop just long enough to focus. As an alternative, you might focus on an object exactly the same distance away as your subject. The telephoto requires critical focusing. For that reason, some photographers prefer the wide-angle lens for candids, even though they must come closer to the subject. Prefo-cused at ten feet with a small aperture of f/16, a photographer with a 28mm lens can snap away happily without ever touching the focusing ring.

Now, watch your subject. The camera is set, hence all you must do is concentrate on the subject's expres-sion, and when it's right, swing up the lens, frame, and snap away.

■ ANTICIPATION AND TIMING

Catching candids requires the photog-rapher to have the skills of a weather forecaster. The photographer must guess what is going to happen based on how he or she sees the situation developing. If two kids in the street have their fists up, they are likely to fight. A couple holding hands might kiss. Sometimes the photographer, like the meteorologist, judges the evidence correctly and is prepared with the right lens, film, shutter speed, and f/stop. At other times, like the weatherperson, the photographer misreads the data.

As important as anticipation is the photographer's timing to release the shutter at the optimum moment. Even with motor drives, this skill requires photographers to "get into the flow of the action."

more deeply into the 'do. More concerned about the clip-pers than the camera, the young man glanced up — and Ancher snapped a lively picture.

■ PRESET YOUR CAMERA

Unless your camera is automatic, set its aperture and shutter speed before you point the camera. If you're fid-dling with the camera's dials, you might catch the sub-ject's attention and lose the candid moment. To take your light meter reading without the subject being aware, point your camera toward an area that is receiving the same amount of light as the subject, then adjust your f-stop/ shutter speed combination accordingly.

Select the appropriate lens before you bring the camera to your eye. Swing the lens once by the subject

Most action builds to a peak and then settles down again. And almost every event has a crucial moment.

George Rizer of the *Boston Globe* was covering a Harvard University football game when one of the players committed a foul. Rizer had been following the action through his telephoto lens. When the referee singled out the misbehaving player, Rizer was ready. He snapped just as the ref pointed his finger at the kneeling athlete. A sec-ond before or after and Rizer would have missed the telling moment. Anticipation and perfect timing resulted in the ideal picture of the funny moment.

■ CANDIDS WHEN THEY KNOW YOU'RE THERE

The photographer often faces the problem of taking a subject's picture, even though the subject is aware of the

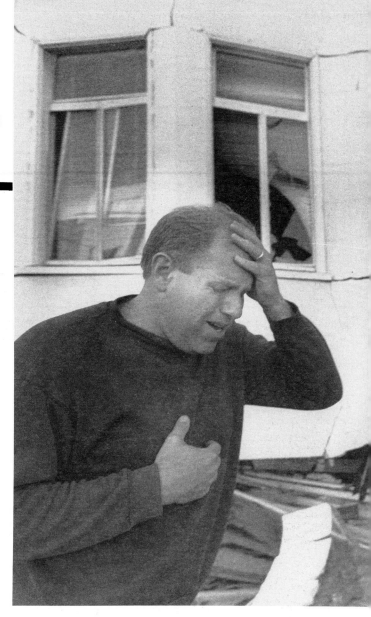

photographer's presence. "In most of the photo stories in *People* magazine, the subject knows ahead of time when we're coming, so the portraits are not truly candid," says John Dominis, who was the magazine's first picture editor. "If the subject has a trade like a blacksmith or fisherman, *People* photographers try to coax the subject to do what he normally does. When the worker goes back to his daily routine, he tends to get lost in his work, and the photographer can produce story-telling candids."

WHEN & WHERE TO SELL NEWS PHOTOS

■ STAFF PHOTOGRAPHER VS. FREE-LANCER

What should you do when you've snapped a good spot news picture?

The answer depends on whether you are a staffer or a free-lancer. If you are a staff photographer for a paper and you've stumbled on a major train disaster, you should shoot your pictures, then get to the nearest phone and call your editor. Provide a brief description of the accident and your photos. Your editor will weigh the importance of the train wreck story against other news of the day, and will decide whether you should remain at the scene and send in your film by messenger or return to the office to process and print your photos before deadline. If you are a free-lance photographer and you have a good spot news photo, you have, under the same circumstances, many more options for your pictures.

■ MARKETING SPOT NEWS: A CASE STUDY

After the earthquake that rocked San Francisco in October 1989, journalism student Kaia Means was one of thousands who initially thought the shaker was "just another" earthquake. Visiting friends atop Russian Hill, however, the San Francisco State University student noted moments after the quake a huge cloud of dust rising above the Marina District. She said her good-byes and left for a 5:30 P.M. meeting — thinking she'd drive by the Marina first to see what the dust was all about.

"I knew I had to turn in a spot news assignment sometime during the semester," recalls Means, a news-editorial major taking her second semester of photography. "So I thought I'd drive by to see if there was anything to take a picture of."

What Means found in the Marina was more than fallen bricks and broken glass. The first photographer on the scene, the 22-year-old student from Norway was there to photograph a distraught father awaiting the rescue of his wife and baby. Standing beside the father in the crowd, she photographed firefighters carrying the baby from the building, the father grieving in the foreground. Later, herself crying upon the realization that the baby was dead, Means photographed the mother's rescue and reunion with her husband.

Although she was "shaking all over" by the time she finished shooting the tragedy in the Marina, Means' real-life mid-term exam was just beginning.

DETERMINING POSSIBLE OUTLETS

The photo student's pictures certainly had wide local and national interest. And Means was in a good bargaining position because she had exclusive images. However, the earthquake had shaken local news outlets as well as buildings and bridges.

Means took the film to the *San Francisco Examiner*, which had lost all electricity and phone capabilities and was conducting its photo operation out of a van in the paper's parking lot. Having told the photo chief about the pictures, she helped out for a while and then left the film, marked "DEAD BABY" on the canister.

In less chaotic circumstances, Means could have bargained for the sale of the pictures. Having gotten a bid from the *Examiner*, she could have contacted local TV stations to see how much they would offer for rights to the photos. With the story's national impact, she could have offered the film to the wire services, either the Associated

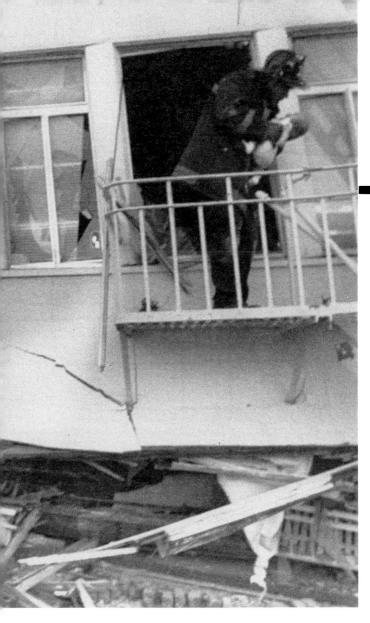

Press (AP), United Press International (UPI), Agence France-Presse (AFP), or Reuters — all of which depend a great deal on stringers and free-lancers. None of the services maintains a large enough photo staff to cover the country — or the world — thoroughly. Many photos appearing in print and carrying the AP, UPI, AFP, or Reuters credit line are taken by independent photographers.

Alternatively, on a big disaster like this earthquake or perhaps a tornado, Means could have called other large dailies around the country. Today, newspapers want their own photos of a major story to augment those supplied by the wires, and many send staff photographers. However, none would have had this series of pictures.

But with phone lines down and chaos around her, Means left the film with the *Examiner*. Naturally, she was surprised when she opened the paper the following day and did not see the dramatic pictures. She called to see what had happened and learned that in the confusion, the film had never been processed.

Following more confusion at the *Examiner*, the young photojournalist finally got her film back — still unprocessed two days after the event.

Under normal circumstances, this series of faux pas would have spelled photographic disaster for the fledgling photojournalist. The pictures' timeliness would have dissipated long before.

However, once the film was processed, it was easy to see that these were no ordinary pictures. It was time to seek a national market. The news magazines were already closing by the time the film had finally been processed. And besides, they rarely buy anything but color these days.

I gave the student the number of Peter Howe at *Life* magazine, and she took over from there. Howe was out of town, but editors at *Life* wanted to see the prints.

After viewing the pictures, *Life* editors not only purchased first North American rights for six months but also sent a reporter to San Francisco to interview Means and the parents she had photographed. When an order for a follow-up story came in, the second-semester photo student received the five-day *Life* assignment. In the 1989 year-end issue of *Life* magazine, Means' photo of the distraught father ran as a double-truck in addition to two of the follow-up pictures she shot on assignment.

TIME ELEMENT IS CRUCIAL

Don't underestimate the value of your pictures, and don't wait too long to find a buyer for them.

A student, Means could have assumed that professional photographers would have had more dramatic pictures than hers. However, while the *Examiner* missed its chance with the pictures, Means' photos turned out to be some of the most moving images to come out of the disaster.

In any news event, even if other photographers are present at the scene of an accident or fire, their equipment might fail, or you might have a shot from a better angle. For the price of a telephone call, you can find out if an editor is interested and would like to see your film.

Because of the time element, the best market for spot news is a newspaper or wire service. Means' instincts in taking the film to one of the city's major dailies was right on. However, it was the national interest in the quake that gave the photos an unusual second chance with *Life*. Editors have called the earthquake of '89 the top news story of the decade. Certainly, *Life* magazine recognized its importance in 1989 by including Means' coverage in its wrap-up issue that year.

If you have a timely fire, accident, or crime picture, the curious editor will usually ask you to bring the raw film to the newspaper or have it picked up by cab. A lab technician will develop the film, and an editor will quickly scan the negatives to determine if the photo has news value. If the story has significant national appeal, a news magazine like *Time*, *Newsweek*, or *U.S. News & World Report* might buy the photo if it's in color. These magazines maintain very small full-time photo staffs, so they also buy outside photos. Good editors don't mind a quick telephone call on a spot news story because they can't afford to ignore you and possibly miss the chance of publishing a Pulitzer prizewinning picture.

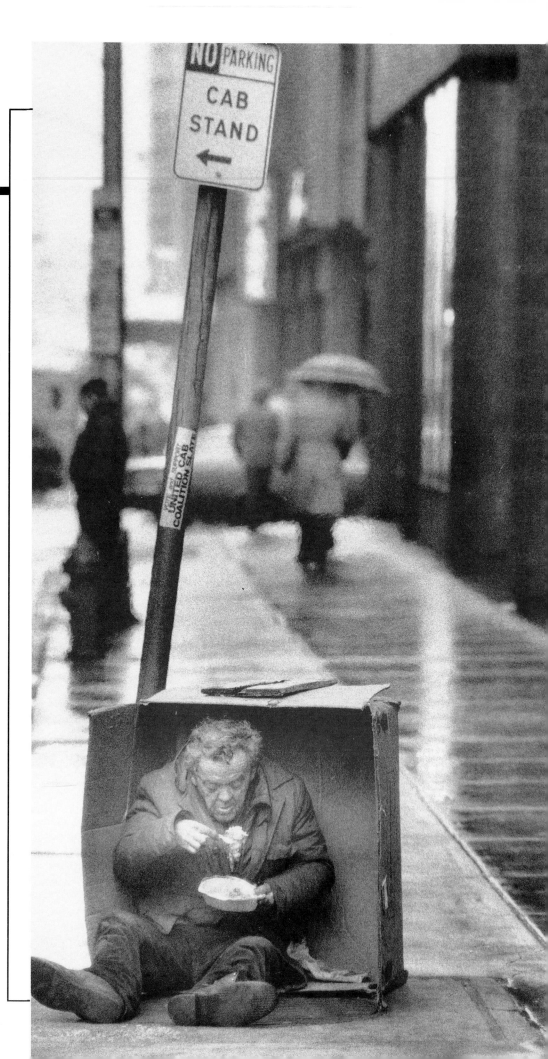

What newspapers, magazines, or wire services pay for a picture depends on the value of the photo at the time of publication. *Life* magazine paid Abraham Zapruder between $25,000 and $40,000, according to the *New York Times*, for his 8mm movie film of President John F. Kennedy's assassination. In contrast, AP and UPI pay a standard rate of less than $100 for most pictures they buy from freelancers. Still, each photo is unique, and its value must be dealt with on a case-by-case basis. If the story has national significance, you might call a picture agency like Picture Group or Black Star. If you turn your pictures over to a photo agency, its representatives will handle the negotiations with domestic and foreign magazines but will usually split the profit with you. ■

MAKING THE MOST
OF AN ASSIGNMENT

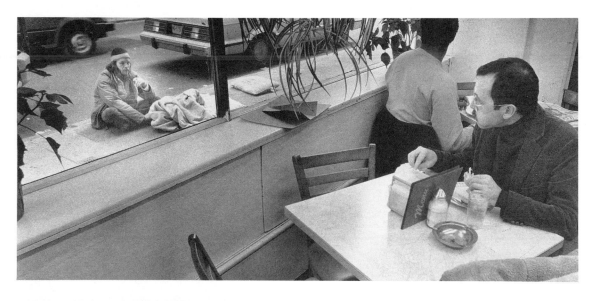

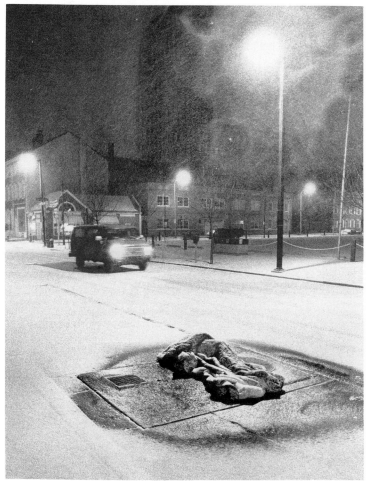

PHILADELPHIA'S HOMELESS:
HOW THEY SURVIVE

Tom Gralish of the *Philadelphia Inquirer* recalls that when he received an assignment to photograph the homeless, editors suggested he "might do portraits of the street people, each standing in front of their grates or cardboard boxes or whatever else they called home. At that point, I wasn't sure what I would do, but I decided then and there that whatever it was, it would be the most honest photography I'd ever done. I was determined to do something as true as possible to the traditional ideals of documentary photojournalism."

Consequently, Gralish did not set up portraits. Instead, he followed street people with names like Hammerman, Spoon, and Redbeard through the ups and downs of their barren, subsistence lives. He photographed them staying warm atop steam grates on a frozen street, drinking wine, and panhandling. He showed them sleeping in boxes. Rather than a series of formulated, posed portraits, Gralish photographed the nitty gritty of these men's lives. For his efforts, he won the Pulitzer and the Robert F. Kennedy Memorial prizes.

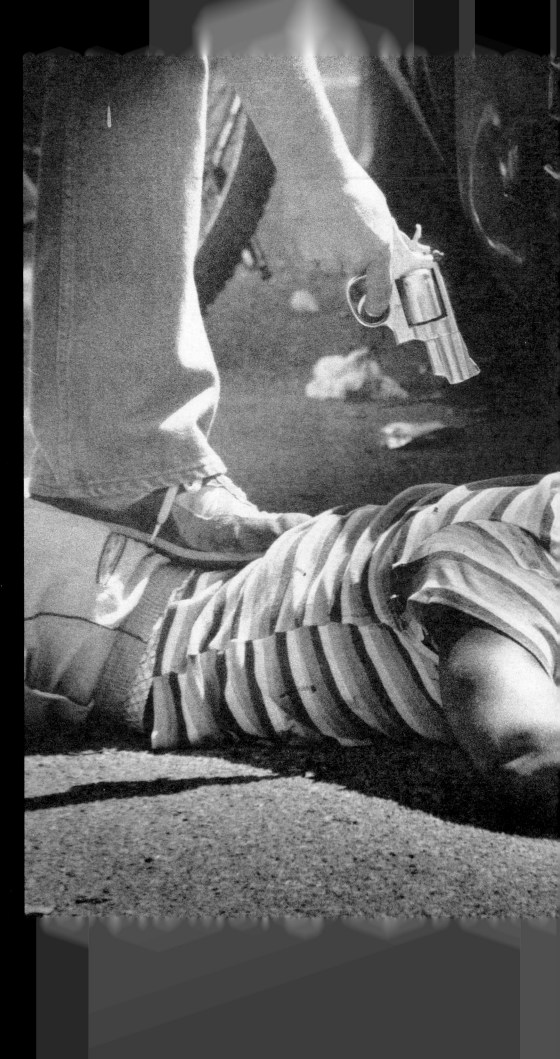

Spot News

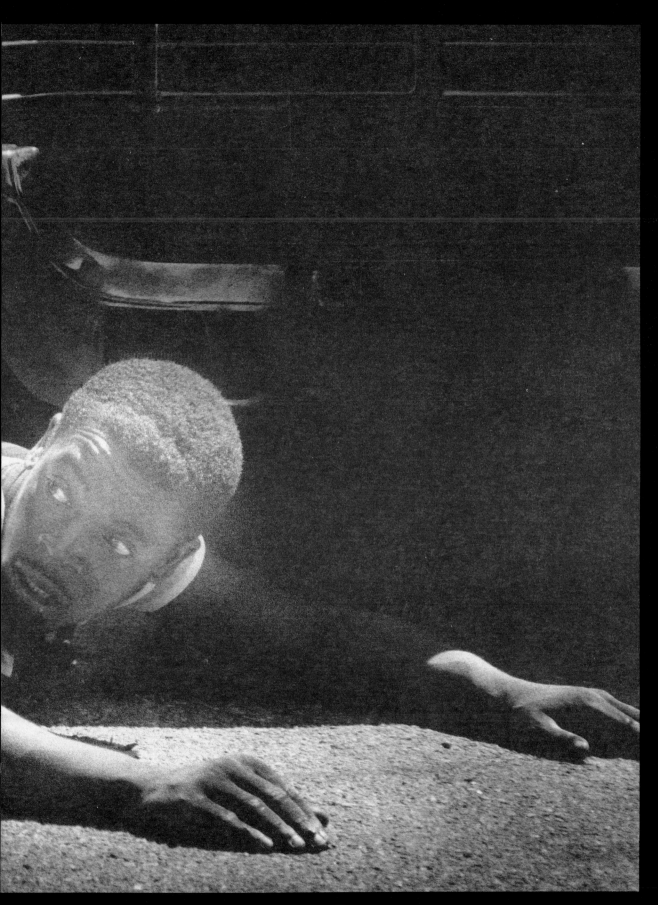

The key to getting great news photos is the ability to get to the scene on time. Here, the photographer arrived in time to photograph this drug bust. (Photo by Manny Crisostomo, *Detroit Free Press.*)

HOSTAGE SITUATION: A CASE STUDY

From daylight 'til dark, Joyce Marshall waited seven hours while the tense hostage situation played itself out. The stand-off finally ended when the man took his own life. His wife, whom he had been holding captive, escaped. (Photos by Joyce Marshall, Fort Worth Star-Telegram.)

At home early one morning, *Fort Worth Star-Telegram* staffer Joyce Marshall received a call from her paper's city desk. Her editor said that a man was holding his wife hostage at a 7–11 convenience store in nearby Arlington, Texas. Joyce threw on her clothes, and without brushing her teeth or combing her hair, jumped into her car thinking, "This is probably a false alarm. Most of them are."

With her cameras already in the trunk, she sped the five miles to the store in her two-door Subaru. As soon as she pulled to a stop, she got out of her car, grabbed her gear, and checked with the police officer in charge for an update on the situation. After determining that this stand-off was no false alarm, she called her office for backup equipment, including a 600mm lens and a two-way portable radio.

She knew that already the man had shot and possibly killed someone in the store. Later, she found out that the gunman's name was Thomas Stephens. His wife had left him because of his continued physical abuse during their seventeen-year marriage. When the divorce papers had finally come through the day before, he snapped. He left the drug treatment center he was in and tracked down his wife, who was working at the store. In the process of taking her hostage, he killed several of her co-workers.

Knowing there had already been gunfire at the store, Marshall used a car in a nearby driveway as protection. She had a clear view of the store window. Her telephoto lens and radio arrived via another staffer who took up a position behind the store.

"I was inside the police barrier," Marshall recalls.

"The area was cordoned off. The time dragged on interminably. I had not eaten, I could not get a drink of water. I had not brushed my teeth or my hair, and there was no bathroom available."

Marshall knew, however, that if she left she would not be able to get across the police barrier again. "I had to stay," she recalls.

As the sun was setting directly into Marshall's camera, police went in to take out the wounded. With some cardboard she found nearby and tape she kept wrapped around the leg of her tripod, Marshall constructed a homemade sunshade on her lens barrel.

When police took the bodies out of the store, the officers left the front door open. With her eye glued to her viewfinder, Marshall noticed Stephens coming to the front of the store while holding a gun to his wife's head. Marshall snapped off several frames.

By this time, a crowd had gathered behind the police lines. The neighborhood audience drank pop and beer and watched the situation in the 7-11 unfold in front of them like a movie playing in a theater. When the SWAT team arrived, the crowd started to yell, "Shoot them, shoot them. Hurry up and get this thing over with."

As the sun dropped in the late afternoon sky,

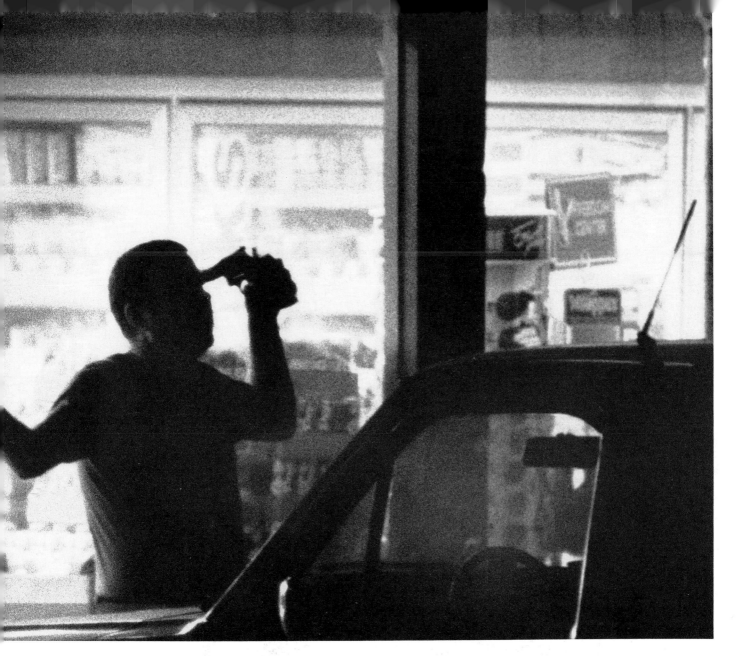

Marshall began switching to more sensitive film. She went from color print film rated at ISO 200 to 400 then to 800. When Marshall could see no color at all in the scene, she threaded in a roll of ISO 400 black-and-white, which she rated at 1600.

Soon after the photographer loaded her camera with black-and-white film, the sun dropped behind the horizon, leaving only the lights in the store for illumination.

Just then, Marshall could make out some movement at the front of the store — a shadowy figure so low she could not photograph it. The figure turned out to be Stephens' wife. Marshall learned later that when the gunman allowed his wife to go to the bathroom, she slipped out of the store.

Within a few minutes, Stephens, holding a gun to his head, walked out of the store. He told police he would shoot himself at the count of thirty.

Marshall thought to herself, "Surely they will do something about it."

In the silhouette against the store's window she could see that the gun's hammer was pulled back, ready to fire. When he got to thirty, Stephens paused a few seconds. Marshall quickly took a few frames in black-and-

white and in color.

Then the gunman fired a bullet into his own head. He slumped to the ground. The crowd rushed in to see what had happened.

"I'm not sure I shot a photo of the body," Marshall says now. "My mind was on getting the film back to the paper."

After racing back to the paper's darkroom and processing the film, Marshall quickly printed the frame of Stephens pointing the gun to his own head. She found the negative of Stephens holding his wife hostage a difficult one to print because of the sun's flare. Also, because the subjects occupied only a small part of the negative, she had to enlarge the image extensively.

The paper's editors felt the suicide picture was too graphic for the front page of the *Fort Worth Star-Telegram* and ran it inside, but they played the hostage photo as the lead picture on page one for the following day.

■ CRIMES MAKE HEADLINES

Crime, whether it's a hostage situation in Arlington or a riot in Boston, is costly to society. It can be a deep human tragedy for criminals and their families as well as for victims and theirs.

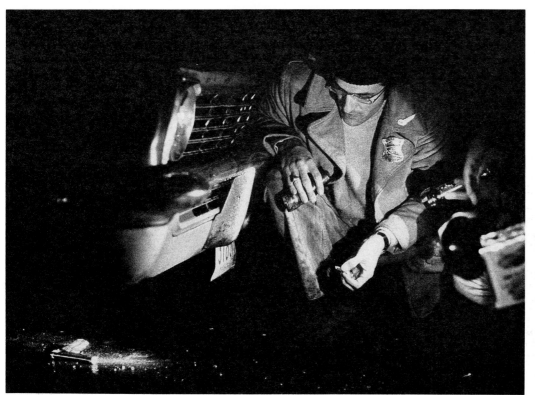

The news photo emphasizes the point that crime remains a major local problem. When readers recognize the street where a man was shot yesterday as the one they work on, when they realize the bank in the holdup is the one where they make deposits, then abstract crime figures — 19,120 murders, 404,850 robberies in one year — take on a personal meaning.

The public's insatiable curiosity about crime photos accounts also for editors' continued use of such photos. Few readers can resist inspecting a picture of a mugging in progress or a grocery store hold-up.

Perhaps readers' curiosity for crime pictures lies in a deep-seated belief that criminals look different from regular people. Although psychologists have disproved the notion of "the criminal face," the reader checks to see if the convict has close-set eyes or a lowered brow — just as the reader suspected. But to the unending surprise of the newspaper reader, criminals usually appear quite normal. Pictures of murder and mayhem not only excite readers' interest and satisfy their curiosity but provide information hard to visualize from a written description. Photographs of a drug bust show the actual size of ten tons of marijuana. Photos of an ambush explain how near the sniper actually was to the victims. A portrait shows how frail-looking was the grandmother who murdered five people. A newswriter would have to search long and hard for words that describe a crime scene with the clarity of a simple spot news photo.

Almost any kind of crime makes a printable story in newsrooms across the country. The cub reporter soon learns that whether it's an atrocious murder or a $100 hold-up of a gas station, the event is considered news in city rooms from coast to coast. Depending upon the crime's violence, the amount of money involved, the prominence of the people involved, or the crime's humorous or unusual aspects, the news is featured with varying amounts of emphasis.

CRIME: A NATIONAL PROBLEM

■ BRINGING THE CRISIS HOME

Crime pictures rivet readers' attention. The success of TV cop shows, dating back to "Highway Patrol" and followed by such shows as "Ironside," "Kojak," "The F.B.I.," and "Columbo," proves the solid, unflagging public interest in crime. Actual news photos take viewers from the fantasy of television to actual crisis in the streets. Newspaper crime photos are rare reminders that felonies don't stop at 11 P.M.; they can't be switched to another channel or turned off at bedtime.

■ PHOTOGRAPHING A CRIME IN PROGRESS

Joyce Marshall's photos are rare. Unlike reporters who can reconstruct the details of a mugging from police reports and eye-witness accounts, the photographer must be at the crime scene to get action pictures. Robbers, kidnappers, rapists, and murderers tend to shy away from the harsh glare of public exposure.

A photographer with a good news sense, however, can learn to predict some situations that might erupt into violence. For instance, a group called ROAR, Restore Our Alienated Rights, began organizing opposition to court-ordered busing the summer before South Boston's

You can predict some crime news. Violence was likely on the first day of busing at South Boston High School. As school opened, mounted police used billy clubs to disperse rock-throwing, anti-busing demonstrators. (Photo by Ken Kobré, for *The Boston Phoenix*.)

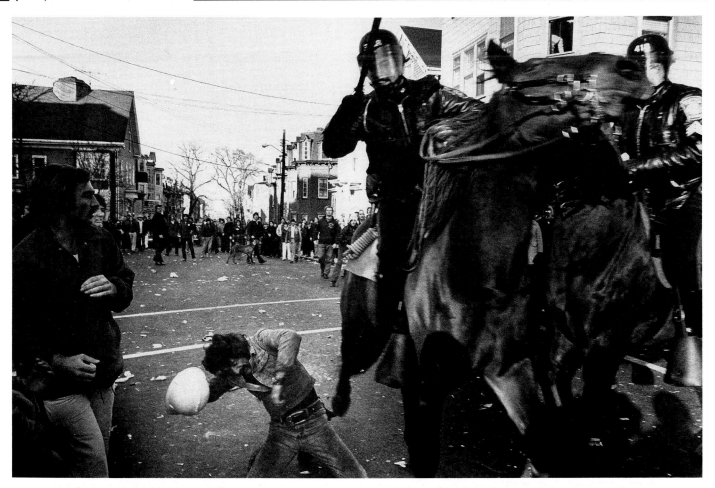

all-white high school was scheduled for desegregation. The press, tracking the growing size of the protest, evaluated the intensity of the local residents' feelings and predicted chaos, perhaps even violence, on the first day of classes. Photographers and reporters representing both local and national media gathered early in the morning in front of the school. Hundreds of police, assigned to escort the blacks from bus to building, stood across the street from taunting white teen-agers and their parents. When buses carrying the blacks arrived, the crowd broke through the police lines. A full-scale riot started. Mounted police scattered the rock-throwing demonstrators.

During the ensuing violence, the crowd hurled rocks and bottles at newspaper and TV photographers. The police provided no security for the working press; officers even tripped and pushed the photographers. Many demonstrators were arrested. Fortunately, no photographers were seriously injured. Caught between the police and the demonstrators, the media were hated by both. White residents of South Boston thought the press too liberal in its support of integration; the police believed the press had unfairly criticized them.

EVALUATING NEWS APPEAL

Sometimes crime photos take on an importance beyond the news value of the story they report. Because photographers rarely record a crime in progress or an actual arrest, editors usually play these rare photos on the front page regardless of the incident's significance. The photo's value depends not only on the importance of the crime but on the immediacy and freshness of the pictures.

Besides action, the photo editor evaluates a crime picture on the basis of the incident's severity. Were people injured or killed? Few papers failed to run pictures of the mass suicide of members of a religious group in Guyana. Color photos appeared on the covers of both *Time* and *Newsweek*. An editor also evaluates a crime photo based on the size of the property involved. Was a large amount of money stolen? A $2.8 million Brinks robbery produced banner headlines across the front pages of American newspapers.

■ WORKING WITH UNCOOPERATIVE SUBJECTS

George Reidy, a photographer for the old *Boston Herald*, once said, "The true test of a news photographer is get-

Beyond the standard news values such as the fire size and damage, this picture deserves large play because of the photo's eerie feel as the cross glows above the working firefighters. (Photo by Timothy J. Gonzales.)

ting pictures of criminals entering or leaving police headquarters. The prisoner is moving quickly and trying to hide his face. The photographer has to follow the prisoner, sometimes moving backwards, focusing all the way and always trying to get a shot of the prisoner's face. If the cameraman succeeds at this we can call him a news photographer." To avoid taking the time to refocus, the photographer can walk backwards, keeping a constant distance between the camera and the subject. (See the section on zone focusing in Chapter 6, "Sports.")

As Reidy points out, "It's hard enough to take a picture of a suspect if you know who he is, but how about the situation where you've never seen the suspect before?"

When AP's Walter Green has to photograph an unfamiliar suspect at a trial, he will peer into the courtroom and carefully identify what the defendant is wearing. "You want to see how the person is dressed and figure out what door he might come out of," Green says. By asking the sheriff which exit door will be used, the photographer can be positioned there ahead of time.

If defendants don't want to be photographed, they may hide their faces behind their hands. Green recalls the time that Raymond Patriarca, reputed Mafia boss of New England, was on trial. Speaking to Patriarca's lawyer after the first day of the trial, Green said, "We have

great stuff of your client going into the courthouse. With his hands covering his face, your client looks like a real hardbitten criminal. Why don't you do your client a favor and bring him downstairs, pose him outside? Then the photographers will leave him alone."

Patriarca's lawyer consented and persuaded his client to hold still for a picture. "Sure, Patriarca looked more like a criminal in my first set of pictures, but I made the second set because I thought the public wanted to see the Mafia boss's face," says Green. "I also knew that a picture of him covering up his face would not make the wires anyhow."

Sometimes photographers take surveillance pictures at night. Using ISO 3200 film, you can push the film with extended development to at least 6400. You get good detail in flat lighting situations. And you can record at least some of the scene even in contrasty lighting common at night when there is a great difference between brightly lit and dark, shadowed areas. Producing grainy but recognizable pictures, you can shoot the action of the

The attacker was part of an anti-busing group that had just given the pledge of allegiance during a demonstration at city hall. The unfortunate black man just happened to be walking by. (Photo by Stanley Forman.)

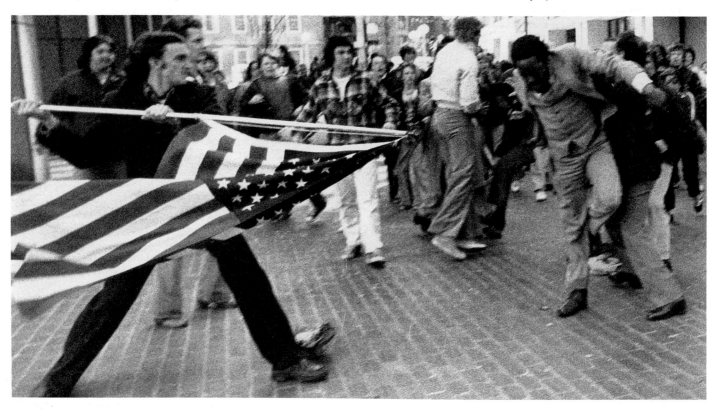

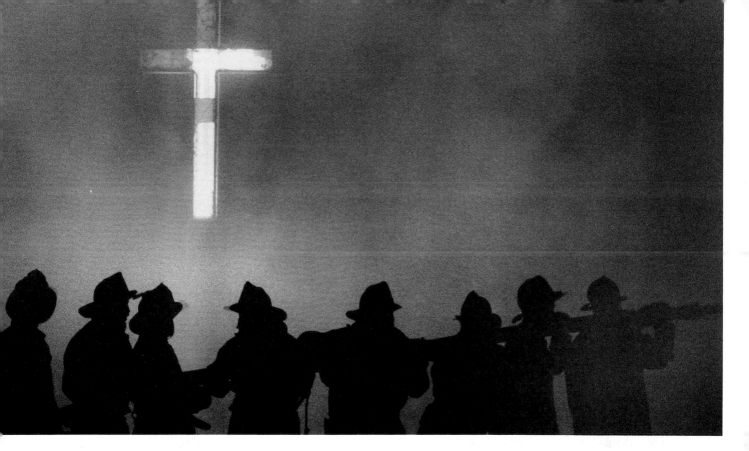

sleaziest underworld character handing over the payoff money or receiving the dope — even at night under poor lighting conditions.

<div style="background:black;color:white">

FIRES: CATCHING FLAMES WITHOUT MISSING PEOPLE

</div>

■ WHY SHOOT FIRES?

Reporting fires is an important job of the photojournalist. Each year more than 500,000 homes catch fire. Fires also destroy apartment houses, stores, office buildings, and factories. Fires sweep through schools where children are having classes. Autos and trucks burn up, and fires devastate forests in all parts of the country. Altogether, 3.5 million fires are reported annually, costing more than $6 billion in property damage. Still more serious than monetary loss, thousands of people die in fires each year.

A photo can show not only the emotion of the participants but also the size of the fire better than words can describe it. If a fire breaks out on the twenty-third story of a building from which an occupant might jump, a photo can indicate just how high twenty-three stories really is. The reader can quickly grasp the danger of jumping. If a wooden warehouse catches fire, requiring four companies to halt the spread of the flames, a photo can give the reader an idea about the vastness of the blaze. After the fire has been extinguished, a photo of the charred remains carries impact beyond a mere statistical description of the loss. A photo of a house burning or an office worker trapped in a building initiates an empathetic reaction in the viewer, who thinks, "that could be my house . . . that could be me in that building."

■ COVERING A FIRE

Scanner radios are standard gear for spot news photogra-

phers. These portable devices, no bigger than transistor radios, fit easily into pockets and can have at least four crystal channels tuned to the fire emergency frequency. The beeper going off on a scanner indicates that someone has pulled the alarm on a fire box. Every fire box in a city has a code so that firefighters know its location. As soon as the alarm sounds, firefighters in the nearest station drop whatever they are doing and head for the pole. They slide down, jump into their boots and roar off in their trucks in the direction of the fire box. The trucks usually arrive within one to two minutes after the alarm begins to ring. The firefighters first determine whether there is a fire or a false alarm. If they discover a fire in progress, they immediately radio back the size and extent of the hazard.

GET THERE ON TIME

This first on-scene report is critical for new photographers. Is the fire big enough and therefore long-lasting enough to get there in time? Most fires would be out by the time the photographer arrives. If the radio report indicates a false alarm or one alarm, pass it up. A scanner report of "working fire," however, indicates a substantial blaze — rated as one-half a second alarm.

A working fire means the fire is literally working its way through a building — usually giving a photographer plenty of time to arrive.

With two alarms, additional fire companies with their added trucks, ladders, pumps, and hoses arrive and spread out down the street. A two-alarm fire ties up several companies for some time. Five alarms mean a major conflagration is under way.

The key to outstanding photographic fire coverage is getting to the fire on time. "If you can't arrive at a fire within a few minutes of the time the first alarm sounds, you might as well stay home," cautions George Rizer, *Boston Globe* photographer.

PLAN FOR TRAFFIC

Check your map to determine the best short-cut route. To avoid the possibility of colliding with fire trucks, shut off

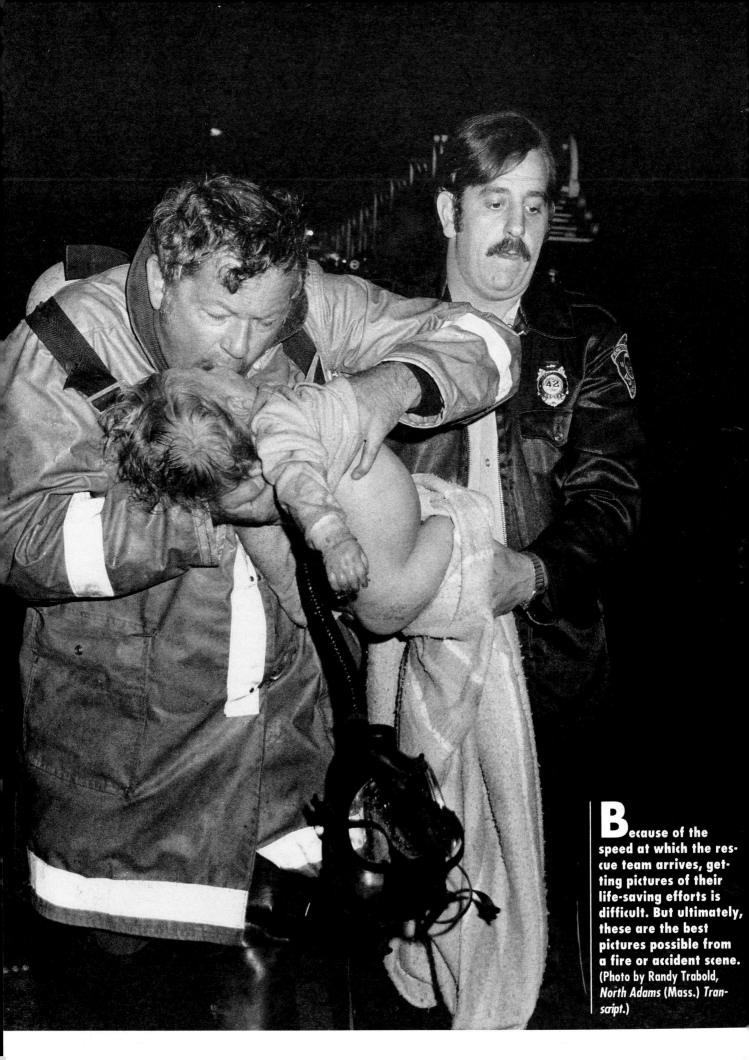

Because of the speed at which the rescue team arrives, getting pictures of their life-saving efforts is difficult. But ultimately, these are the best pictures possible from a fire or accident scene. (Photo by Randy Trabold, *North Adams* (Mass.) *Transcript.*)

FIRES: CATCHING FLAMES WITHOUT MISSING PEOPLE

your radio, open your windows, and listen for fire engine sirens. When you arrive, find a parking spot that doesn't block fire hydrants — and plan for your escape. "You might be ready to get your film back to the office before the firemen are prepared to leave," explains the *Globe's* Rizer. "If they're parked in back of you, you'll be stuck until the fire is over and all the men have packed up their equipment. You'll miss your deadline."

OVERALL SHOT SETS THE SCENE

When you first see a fire, you should take a record shot since you don't know if the fire will flare up or die down. Later, to establish the size of the blaze, the location of the trucks, and the type of building that is burning, you might look for a high vantage point from which you can shoot an overall photo.

WATCH FOR THE HUMAN SIDE

Once you have your overall, look for the human side of the tragedy. Are people trapped in the building? Will the firefighter bring up ladders to rescue the occupants or have they already escaped? Do the firefighters have to administer mouth-to-mouth resuscitation or other kinds of first aid?

Meanwhile, don't overlook the efforts of the firefighters to put out the blaze. Without interfering with their work, shoot the ladder and pump companies as they spray water on the flames. Keep an eye out for people overcome by smoke or exhaustion.

Fires inevitably attract people. Whether in a big city or a rural town, a fire brings out an audience — whether neighbors or just passersby. The crowd stares with wide eyes and open mouths, seemingly transfixed. Try to capture on film this psychological attraction.

LOOK FOR THE ECONOMIC ANGLE

Show the dimensions of the incident so that the reader learns whether the fire was a minor one or a major conflagration. Take a picture that indicates the kind of structure burned — single-family home, apartment house, business, or factory. Show how near the burned building was to other threatened structures in the neighborhood.

As the fire subsides, seek out a location where you can shoot a summary photo showing the extent of the damage. If you can accompany the fire inspector into a building, you might be able to photograph the actual cause of the blaze. When the fire marshal suspects arson, detectives will be called in to investigate. Investigators at work supply additional photo opportunities.

A photographer can return to the scene of the fire the following day to photograph the remains of the charred building. Often, residents return to salvage their property. The next day's photo of the woman carrying out her water-soaked coat might communicate more pathos than the pictures of flames and smoke of the night before. You also can follow up a fire story by checking to see whether there has been a series of fires in the same

area over the past year. If you find that certain blocks of houses or stores tend to have an unusually large number of fires, suggest that the editor run a group of fire pictures on one page, demonstrating the persistency of the fire hazard in that neighborhood.

FEATURES HIGHLIGHT THE SIDELIGHTS

Besides spot news, a photographer can find good material for feature photos at fires. A picture story about the Red Cross worker who attends every fire might provide a sensitive sidebar story. A small town may have an all-volunteer company, including a dentist who drills teeth and a mechanic who repairs cars when not battling flames. Capturing this split life in pictures offers a unique photo feature story to your readers.

GET THE FACTS

Always try to get factual data such as the firefighters' names and companies. Interview both the fire and police chiefs for cutline information: the exact location of the fire, the number of alarms sounded, the companies that responded, an estimate about the extent of the damage, and the names of the injured and what hospitals they were taken to.

■ JUDGING A FIRE'S NEWS VALUE

Every newspaper reports local fires, but their relative significance depends not only on the size of the fire but also on the size of the newspaper. On a small-town paper, a photographer covers almost every fire because residents know their neighbors and are interested in their welfare. A metropolitan newspaper limits its fire coverage to a major conflagration of disastrous proportion, except when people are involved and extensive property damage results. National magazines and newspapers report fires only if they are extensive, engulfing a skyscraper or a whole city.

In addition to the size and the number of people involved in the fire, picture newsworthiness depends on the nature of the burned building. If an airplane erupts into flames on the airport's runway, local residents want to know how it happened. When a factory that employs two thousand of the city's residents goes up in flames, the public desires to learn every detail, even if no one died.

Sometimes a fire that carries little news value as a written story can result in an excellent photo story. For instance, a picture of a tough-looking fireman administering oxygen to a tiny dog grabs at the reader's heartstrings, even if the fire was minor and caused no damage.

■ NIGHT FIRES ARE DIFFICULT

Night fires tend to sneak up between midnight and 6 A.M. — a time when people are sleeping, and smoke goes unnoticed. Arsonists choose the nighttime for this reason. Because fires are not reported quickly at night, they tend to be larger and more frequent.

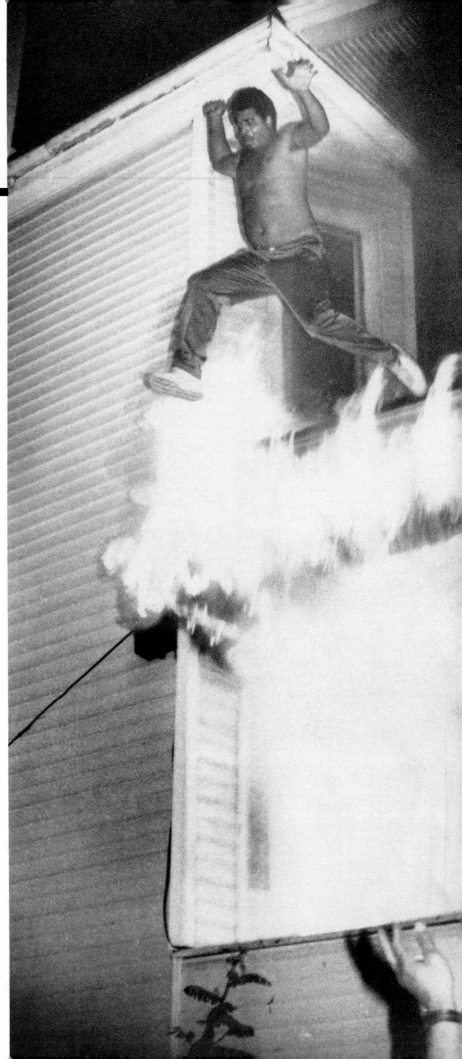

FIRES: CATCHING FLAMES WITHOUT MISSING PEOPLE

FORMAN COVERS A FIRE

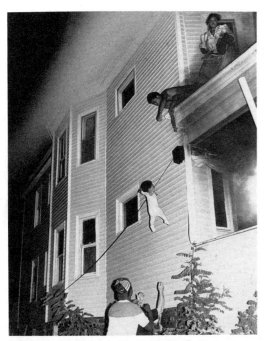

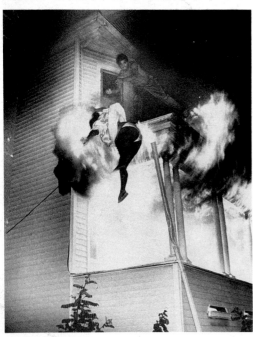

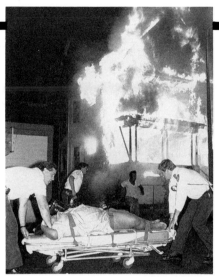

LEAP FOR LIFE:
A FIRE
IN BOSTON

Stanley Forman, three-time Pulitzer prizewinning photographer, knows his city like the back of his hand. In this instance, he was cruising when he actually smelled smoke and pulled up to the burning house along with police. Trapped on the roof, the man in the pictures first handed down the child. When the woman froze, the man pushed her off before he jumped. The woman suffered minor injuries, but everyone else was okay. Forman approached the fire as if shooting a picture story. He takes the reader through the danger to the trapped residents on the roof, follows up with pictures of the rescue, and comes in tight to end with a close-up of the officer holding the child.

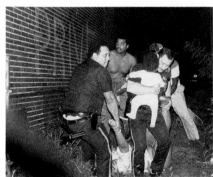

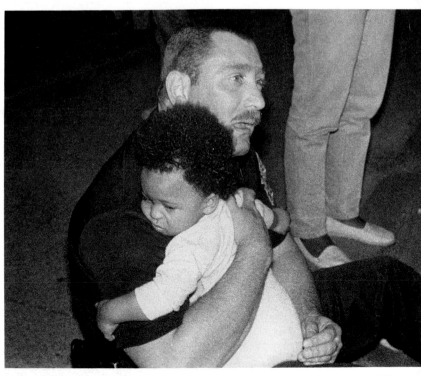

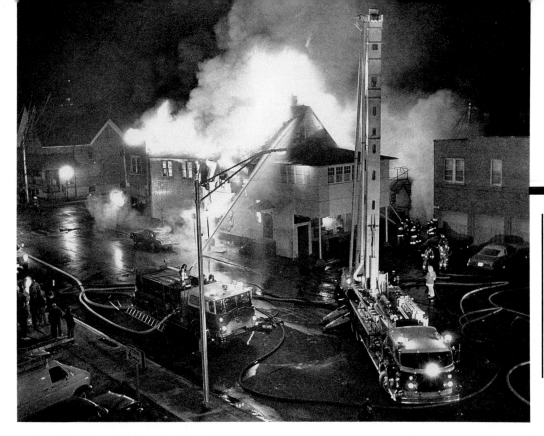

Don't let your light meter be thrown off by the bright flames at a night fire. While the flames engulfing the house will come out in the final picture, a longer exposure is needed to bring out the building and surrounding areas. (Photo by Michael Meinhardt, *The* (Chicago) *Daily Herald*.)

Photographically, night fires pose difficulties.

The *Globe's* Rizer, for example, does not take a light-meter reading at nighttime fires. "Why bother?" he asks. "It wouldn't do any good, anyway. A meter reading will be misled by the light from the flames and will not give you an accurate indication of the amount of light reflected off the sides of the building."

For night fires, Rizer uses a slow shutter speed and flash. At a faster shutter speed, the flames would still appear in the print, but the building would go completely black. Within fifty feet, the flash also helps to light up the building. With the slow shutter speed, however, the photographer must be careful to avoid any slight camera movement during the exposure.

Rizer recommends resting the camera on a car, a fire hydrant, or holding the camera tightly and leaning against a lamppost to cut down camera movement. And he puts away the strobe when flames start shooting out of every window in the building.

"It looks like a Christmas tree," he says, "you can shoot in available light, and you'll get great, action-packed fire pictures."

ACCIDENT & DISASTER: GRIM BUT NECESSARY

■ 100,000 DIE IN ACCIDENTS EACH YEAR

(*Dateline Baltimore*) One Dead, 21 Hurt in Bethlehem Steel Blast
(*Dateline Houston*) Fatal Accident on Southwest Freeway Kills Two

So read the daily headlines, as accidents take their toll of more than one hundred thousand lives and ten million injuries each year, according to the National Safety Council. Almost half the accidents in the United States involve motor vehicles. But people also die from falls, burns, drownings, gunshot wounds, poisonings, and work-related accidents.

Accidents make news. If one million Los Angeles residents drive home on the freeway safely on Friday night, that's not news. But if two people die in an auto crash at the Hollywood Boulevard on-ramp, then newspaper buyers want to read a story and see a picture of the accident.

■ ACCIDENT PICTURES SHOCK READERS INTO CAUTION

Why shoot accident pictures? First, accidents and disasters occur. Mines collapse. Hurricanes strike. Cars collide. Accidents happen. Accidents are facts of life. To record what goes on in a city and to keep readers informed about what's happening constitute two of the major roles of the press.

Second, readers are curious about accidents. Note how many people slow down and look as they pass a collision on the highway. Listen to what people talk about when they get home. Few people will fail to mention a major accident on the turnpike.

Third, people want to see what they read about. A thousand dollars worth of damage means little until the reader sees some visual evidence. Though a story may say that a car was totally wrecked, believability is established when readers see a picture of a Volkswagen mashed into the shape of a tin can.

Fourth, accident pictures grab readers' emotions. Accidents can happen to anyone. A mangled body, lifted from a wrecked car, reminds readers that but for chance they might have been in that car. The photo may shock readers into avoiding similar accidents. If cutlines indicate where an accident happened, readers may be more careful when approaching that intersection.

■ NOT ALL ACCIDENTS MERIT COVERAGE

"Two car pile-up at Main and Broadway, ambulance on the way," crackles a scanner radio in the photographer's car. The photojournalist must make a news judgment: Is the accident important enough to cover? Will a picture of

a multiple-car crash get play in the next day's paper?

Some factors that influence a decision about the newsworthiness of an accident might include:

• Were people rescued, hurt, or killed? If the driver died and the attending physician puts a passenger on the critical list, the accident will probably get coverage.

• Was the damage excessive? When an oil refinery blows up, putting people out of work for months, the economic impact of the accident merits strong play in the paper.

• Was the accident large? The size of the accident, even if no one was hurt, gives the incident importance, especially if the mishap involves buses, trains, or planes.

• Was a public official or celebrity involved? If the mayor accidentally shoots himself with a gun, the story gains interest beyond a routine firearm accident.

• Was the mishap unique in any way? Did

Five people were injured in this accident. All lived. As the rescue team removed the passengers, the mother asked for her baby. Using a low angle, the photographer created a powerful composition. (Photo by Dan Poush, *Statesman-Journal* Newspapers, Salem, Oreg.)

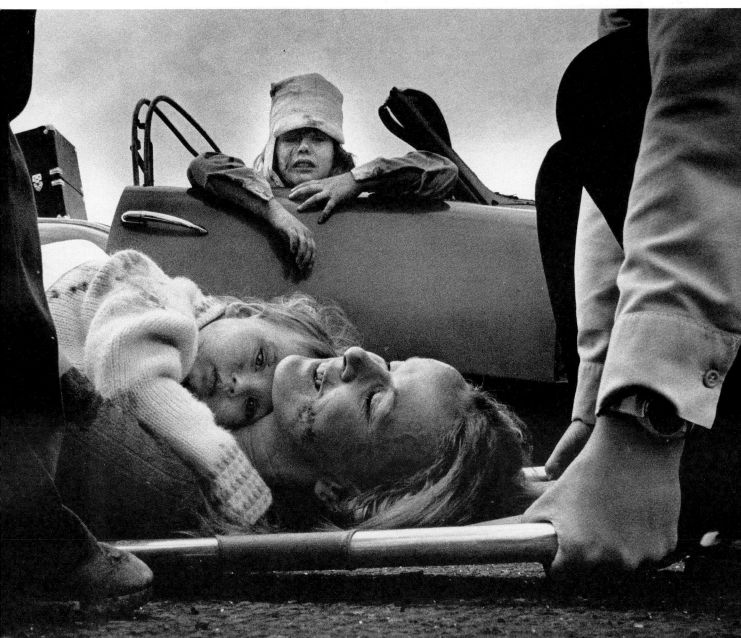

one of the cars, for instance, land in a swimming pool or imbed itself in a wall? Did a husband in one car and his wife in another run into one another?

An accident picture's news value sometimes depends on factors other than the nature of the collision. For example, a smalltown paper might feature an accident photo that would not even run in a major metro paper. Fender-benders happen so often in a big city that some dailies don't even bother to cover them.

Television's electronic news-gathering (ENG) equipment also has cut down on the amount of accident coverage in the newspaper. A major collision on the freeway at 5 P.M. rush hour can roll on the 6 P.M. local news broadcast. Coverage of the same accident in the next day's newspaper seems dated.

Policy at individual newspapers can also determine the play of an accident picture. Some editors think that because auto accidents happen every day they are no longer new, and therefore do not qualify as news.

By comparison, other editors view the alarming rate of injuries and deaths by motor vehicles as a trend — a trend their readers are talking about. These editors feature accident pictures to bring home the horror of reckless driving and perhaps to frighten their readers into better driving habits (see Chapter 14, "Photo Ethics").

■ PHOTO POSSIBILITIES: FROM TRAGIC TO BIZARRE

If 100 accidents take place daily in a typical city, no two will be identical. However, all accidents have certain points in common for the photographer.

CHECK HUMAN TRAGEDY FIRST

Concentrate on the human element of any tragedy. Readers relate to people pictures.

MAKE A RECORD OF THE ACCIDENT

Make a straightforward record of exactly what happened at the scene. The viewer, who doesn't know how the two cars hit or where they landed on the street, wants to see the cars' relationship to one another and to the highway.

SYMBOLIC PICTURES IMPLY RATHER THAN TELL

In some situations, the accident story is better told with a symbolic rather than a literal picture. A bent wagon lying in the street carries its own silent message. There is no need to show the body of the dead child.

PHOTOGRAPH THE CAUSE

In many news events such as riots or murders, there is no way of capturing on film the cause of the disturbance. At an accident, however, you can sometimes show clearly what caused the collision.

For instance, if a car failed to stop on a slippery street, you might show the wet pavement in the foreground and the damaged vehicle in the background. On a dry day, you might photograph the skid marks left by the car as it screeched to a halt. Perhaps the accident was caused by the poor visibility of street signs. In that situation, a picture that showed the confusing array of flashing

The news value of this accident was relatively minor, but the body language of the driver and the bizarre nature of the mishap give the picture its impact. (Photo by Stephen Reed, Alexandria (La.) Daily Town Talk.)

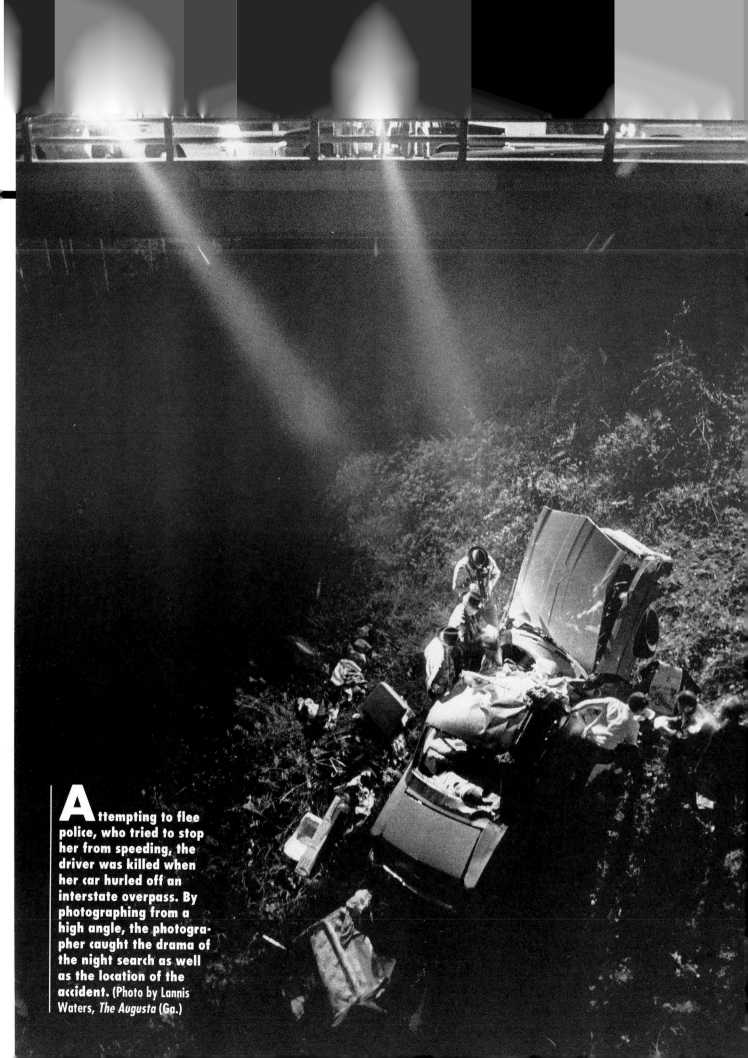

Attempting to flee police, who tried to stop her from speeding, the driver was killed when her car hurled off an interstate overpass. By photographing from a high angle, the photographer caught the drama of the night search as well as the location of the accident. (Photo by Lannis Waters, *The Augusta* (Ga.)

lights and day-glo billboards that distracted the driver would be effective.

SHOW THE IMPACT

Accidents affect more than the drivers of the involved vehicles. For example, look in both directions for long lines of blocked traffic and drivers slowing down to gaze as they pass the site.

FOLLOW UP

If accidents keep occurring at one particular intersection, you might follow up to see if the highway department does anything to correct the hazard. A time exposure of the intersection at night, showing the traffic congestion, might help to spur the highway department into action.

FEATURE ONE ASPECT

Notice how people adapt to their misfortune. Record the kinds of items people save from their wrecked vehicles. Note whether they act angry, sad, or frustrated. Catch the sorrow on the face of an owner of a new Corvette as she views for the first time her crumpled fender. See if an owner of a ten-year-old Volkswagen reacts the same way when he sees the damage inflicted on his "Bug."

However, don't become hardened to accidents. No matter what the size of the mishap, the accident usually is still a major tragedy, or at least a traumatic experience, to the people involved.

■ THE BIGGEST PROBLEM IS GETTING THERE

Taking pictures at the scene of a spot-news event requires a photographer with a cool head, someone who can work under pressure and adverse conditions. You need no unusual equipment or techniques — just steel nerves and an unruffled disposition.

However, before you arrive at the accident scene, you must be prepared. Load your camera and charge up your electronic flash so you will be ready to start clicking the minute you get out of your car.

In fact, getting to the accident in time is often the biggest challenge for the spot-news photographer. If you're stuck on the North Loop and two cars crash on the South Loop, you might find only a few glass shards from a broken windshield by the time you get to the scene. The ambulance has come and gone. Removed by the wrecker, even the smashed vehicles are on their way to the garage.

Consequently, a spot-news photographer's two most important pieces of equipment — after camera gear, of course — are a scanner radio and a city map. The radio provides the first report of the accident and the detailed map shows the quickest way to get to the scene of the collision. Stanley Forman, three-time Pulitzer Prize winner, attributes his success to the fact that he knows his city like the back of his hand. (See Forman's dramatic fire coverage on pages 32 and 33.)

A spot-news photographer finds that the hardest to cover is the story in which all forms of transportation are down. During a flood, hurricane, tornado, or blizzard, you often can't drive a car or ride public transportation.

Faced with a major natural disaster, you can sometimes get assistance from one of the public agencies such as the police department, fire department, Red Cross, civil defense headquarters, or the National Guard. In case of disasters at sea, you can telephone the Coast Guard.

Each of these agencies has a public information officer who handles problems and requests from the media. When a major disaster occurs, many of these agencies provide not only facts and figures but transportation for the photojournalist.

When the oil tanker *Argo Merchant* ran aground, cracked in half, sank off Nantucket Island, and leaked thousands of barrels of oil into the sea, I contacted the U.S. Coast Guard on Cape Cod in Massachusetts. The Coast Guard arranged for me to fly in one of its planes over the site to take pictures. In another instance, when all of New England was buried under four-foot snow drifts during a major blizzard, the National Guard provided photographers with a four-wheeled drive jeep and driver so they could shoot outlying areas hit by the storm.

As UPI's former New England photo bureau chief, Dave Wurzel, once said, "When a big storm breaks and everyone else heads for home, that's when the spot-news photographer goes to work." ■

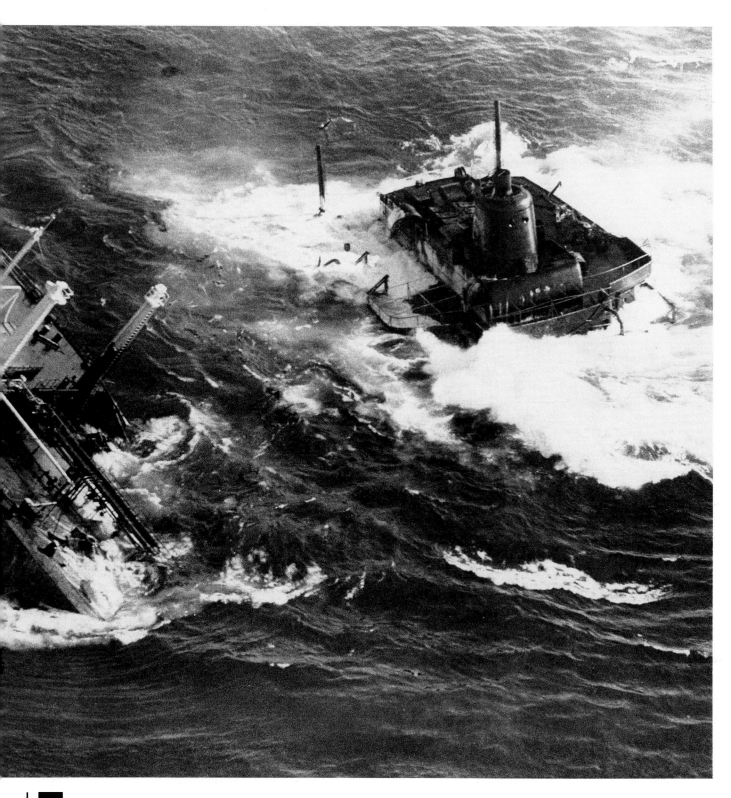

The oil tanker *Argo Merchant* went aground and broke up off the coast of Nantucket. Thousands of gallons of heavy fuel oil soiled the water. The Coast Guard provided journalists transportation by helicopter to the wreck site. (Photo by Ken Kobré, for *The Boston Phoenix*.)

You will find it hard to take a meeting picture that communicates as well as this photo of a fund-raising meeting for the Cincinnati Zoo — complete with cat-napping cheetah. (Photo by Patrick Reddy, *The Cincinnati Post.*)

Governmental and organizational news, including meet-
ings, elections, and awards, account for almost 80 percent
of the national news sections of *Time* and *Newsweek*,
according to **Deciding What's News**, by Herbert Gans.
The president alone receives 20 percent of all national
affairs coverage in these magazines. Local papers also
devote an enormous amount of space to appointed and
elected officials, and political campaigns. Therefore,
developing visually interesting techniques for reporting
these kinds of stories becomes mandatory for the profes-
sional photojournalist.

Jim Atherton has faced the problems of shooting
revealing political meeting pictures for more than thirty-
five years, first for Acme News Pictures, then for United
Press International (UPI), and most recently for the
Washington Post. Headquartered in Washington during
his years in the picture business, he has covered some of
the most momentous as well as some of the most trivial
political conferences in the country. Today, as the *Post's*
chief political photographer, Capitol Hill is his beat.

Says Atherton, "A committee meeting is like a
shooting gallery at the fair. You're there to shoot famous
heads. You do not have to hunt down the lions of politics;
they are captive on stage in front of you. You take careful
aim and shoot with your camera." Atherton's prize shots
are mounted on the front page of the *Washington Post*.

■ MEETINGS GENERATE NEWS

Similarly, in other large cities and small towns, photogra-
phers and reporters cover the news of governmental
meetings because the results of those meetings are
important to readers. Meetings possess the same news
value as do fires and accidents. Often, the results of a
governmental meeting — those involving changes in the
tax rate, for instance — directly bear on the reader's life

even more than yester-
day's fender-bender.

At each level
of power, every gov-
ernmental body —
from city council and
zoning board to state
legislature to the U.S.
House of Representa-
tives and the Senate —
forms public policy and takes action at meetings. The city
council votes to add a new school to the district. The
state legislature puts a ceiling on the mortgage rate. The
Senate committee reviews a bill on national health insur-
ance. All these meetings receive extensive coverage in
newspapers and magazines, with written stories as well
as with accompanying pictures.

Other groups besides governmental bodies plan,
decide, or announce decisions at meetings and awards
banquets. The United Fund presents a plaque for the per-
son donating the largest annual gift to the organization's
funding drive. The Committee for the Handicapped meets
to review the Transit Authority's planned transportation
facilities. The Chamber of Commerce announces a new
advertising campaign to bring business to the city. Editors
routinely assign photographers to cover these meetings,
awards, and press conferences.

Spot news challenges the photographer to get to
the breaking story in time. To cover planned news
events, the photographer has the advantage of knowing
the time and place of the action.

But meetings and press conferences carry a dif-
ferent challenge. They test the photographer's creativity.
Unfortunately, a critical meeting of the Senate Armed Ser-
vices Committee looks very much like an ordinary meet-
ing of the local zoning board. If the pictures remained
uncaptioned, readers could easily be confused. Press con-
ferences as well as awards ceremonies all look identical
after awhile.

A photographer's job, then, is to portray each
planned news event in a way that features the event's

The photographer was able to
summarize the city council debate
about access for the disabled by
photographing this man waiting out-
side council chambers, where the dis-
cussion was taking place. (Photo by Hal
Wells, *Long Beach Press-Telegram*.)

uniqueness. The picture must be related to the news — a difficult assignment because planned news often takes place in evenly lit rooms, produces little action, and the participants display few props that would add clarity to the picture. Infrequently, a panelist holds up a sign that tells the viewer clearly what the meeting is about. Few senators carry placards that read "I think we should reduce farm supports." Sometimes, however, you can catch a city council member yawning, or a participant from the audience yelling, thereby summarizing the tone of the meeting.

Also, through the creative application of framing techniques, catching the moment, and using long lenses and light, the photographer can help portray for the reader the excitement, the tension, the opposition, and the resolution of the meeting.

■ FACE AND HANDS REVEAL EMOTION

When Jim Atherton raises his 80-200mm zoom lens at a committee hearing or press conference, he looks for expressive faces. A wrinkled brow, a grin, or a curled lip can add life to a routine meeting picture. Hands, too, reveal a speaker's emotion, says Atherton. Readers understand the meaning of a clenched fist or a jabbing finger.

The *Washington Post*'s political photographer watched both faces and hands when he was assigned to cover Senator Sam Ervin's Senate Select Committee investigating the Watergate break-in. In session for several weeks, the Committee was receiving top play in the nation's papers. The outcome of the Committee's investigation could lead to the first impeachment of a president. The daily sessions turned into a running nightmare for the assigned photographers.

"There was nothing worse than to cover the same damn speakers, with the same panel of senators, sitting in front of the same green, felt-covered table, day after day," Atherton laments.

Excitement, however, peaked when John Dean, ex-counsel to President Richard Nixon, took the witness stand. Dean accused the president of the United States of breaking the law to cover up his involvement in Watergate. During the first day of his testimony, Dean read the lengthy text of his speech. The *Post*'s photographer needed a unique approach to dramatize the speaker. "I had to make something with a little pizzazz," recalls Atherton. On that first day Atherton tried overall shots and close-up head shots, but on the second day of Dean's testimony, the photojournalist concentrated on Dean's hands. Atherton produced a series of close-ups showing the ex-counsel's hands raised as he was sworn in, spread out as he listened to questions, drumming on the table as he read his text, and fidgeting with his pencil as he waited during

You can make anyone look foolish by selecting an awkward moment. Even Henry Kissinger looks bad when photographed eating. Beware of accidental photos that are misleading. (LEFT: Photo by Arthur Rothstein, the *Look* Collection, Library of Congress; RIGHT: Photo by Tom Kinder.)

a recess. Sometimes Atherton would miss a characteristic mannerism the first time it occurred. But, he notes, "I had patience; I knew Dean would repeat the quirk again; I just kept watching."

Isolating one revealing element, Dean's hands, helped tell the bigger story of a young man seemingly cool, but actually nervous underneath, who accused the president of the United States of lying. The poignant pictures were played on the front page in the next morning's *Washington Post*.

REVEALING VERSUS ACCIDENTAL PHOTOS

Atherton warns, however, that a speaker's facial expressions and hand gestures can be accidental and misleading. They might have nothing to do with the personality of the individual or the thrust of the message. Suppose that during a luncheon former Secretary of State Henry Kissinger is discussing detente. You take 100 to 200 frames. You might catch a shot while he is eating — showing him with his mouth screwed into a knot. This picture, although an actual shot, might not reflect anything about the nature of detente or even the speaker's character. The misleading picture, in fact, tends to distort the news rather than reveal it.

PERSONALITIES MAKE NEWS

For Jim Atherton, news means politicians. He describes himself as a head-hunter on "the hill." He shoots the faces of the famous. A Washington politician is news, whatever he does. He notes that "Washington is the only place in the country where you can take a simple snapshot of an elected official today and have it appear on the front page of every newspaper in the country tomorrow."

Translated into local coverage, this means that meetings, speeches, or press conferences in a town take on news value based on the personalities involved and on the importance of the subject debated.

The photographer must know or be able to recognize the players in the game without a score card. If you are not familiar with the participants in a meeting, ask someone for information about the speakers. What are their names? Which are elected officials? Who is best-known? With this information, you can zero in on the most newsworthy individuals.

PROPS ADD MEANING

Props can add meaning to a routine meeting picture. If the speaker or audience member holds up a prop, the reader will have an easier time understanding the point of the photo. If the speaker who denounces the lack of gun control laws brings to the meeting a few Saturday Night Specials, the photographer can photograph the person examining or displaying the guns.

Unfortunately, not all speakers have the camera-sophistication to bring along appropriate props when they speak at public meetings.

■ LET THE SUNSHINE IN

Besides props and facial expressions, the quality of light and the choice of lens can also add impact to a simple meeting picture. When you walk into a meeting room, notice the quantity and quality of light in that room. Is the light sufficient? Is the room lit by natural light from the windows or fluorescent light from the ceiling? Check to see whether the light comes from in front of or behind the speaker's table. Note whether television lights will be turned on in the room during the hearing. If, after "casing" the room, you find the level of light too low, you might ask if you can open the window shades. If there is enough natural light streaming through the windows, you could ask to turn off the overhead lights.

FLUORESCENT LIGHT IS BLAND

If natural light is a photographer's best friend, then fluorescent light is the shooter's most dastardly enemy. Fluorescent light is efficient, economical, cool, and saves energy. But for a photographer, fluorescent light is as exciting as white bread. Fluorescent bulbs emit light in all directions. The light bounces off ceiling and walls and even the floor. With enough fixtures, the light can illuminate every nook and cranny, leaving only dull highlights and faint shadows.

Some photographers, working in a room evenly lit by fluorescent light, will manipulate exposure and development to increase contrast. They underexpose their film, about 1/2 stop — rating, for example, Kodak's Tri-X 400 IS0 at 600. Then they overdevelop the negatives about 25 percent and increase the processing time with D76 (diluted 1:1), from 10 to 121/2 minutes at 68 degrees. This underexposure/overdevelopment technique increases the negative's contrast.

Television lights not only brighten the room but, if used correctly, can add contrast to the picture. The secret of using television light to add depth in a black-and-white picture lies in not shooting from the same position as the TV camera. If the main spotlight is located to the left of the TV camera, the still photographer benefits from cross-lighting by moving to the right of the TV equipment. The farther you move around the subject, and the greater the angle from the TV camera, the more the light crosses the subject's face. The side of the face nearest the lens is in the shadow. The contrast between the highlight on the far side and the shadow on the near side of the face brings out the texture of the subject's skin and adds roundness, which gives the whole picture an added sense of drama.

■ SEPARATE THE SUBJECT FROM THE BACKGROUND

A photographer must be conscious of not only ambient room light but also of the relationship between the tonal values of the subject and the background. How will the subject look on black-and-white film? A dark-suited sena-

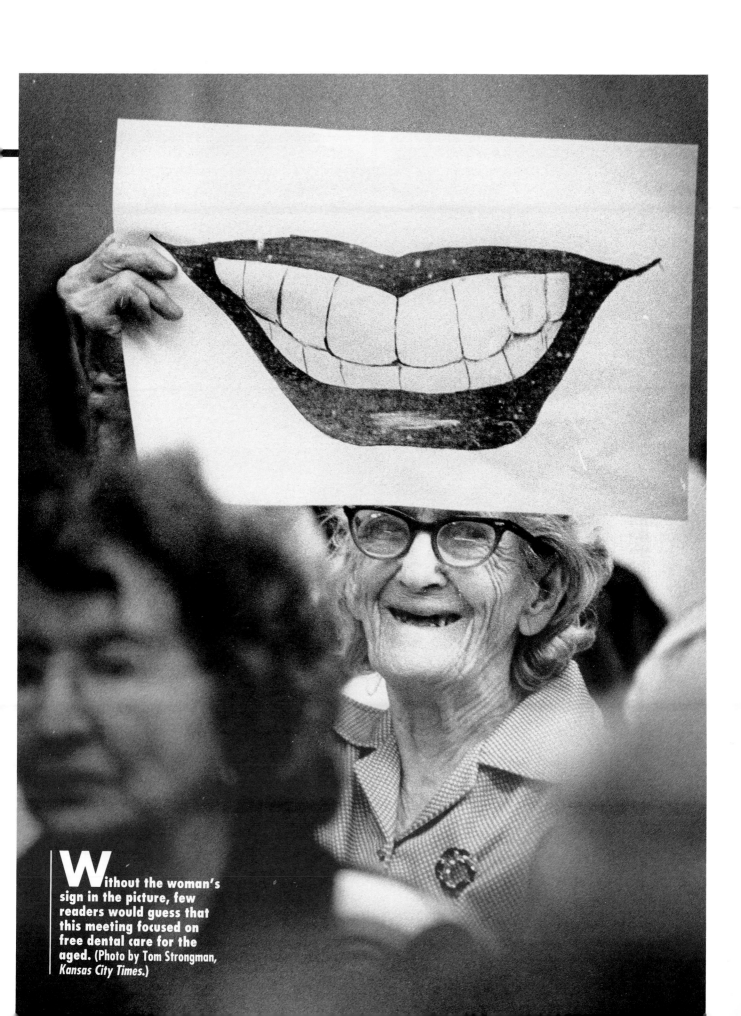

Without the woman's sign in the picture, few readers would guess that this meeting focused on free dental care for the aged. (Photo by Tom Strongman, *Kansas City Times.*)

Shooting perpendicular to the line of speakers results in a picture with large blank spaces between each person, and each face appears quite small. (Photo by Jan Ragland.)

Shooting these dignitaries from the side eliminated dead space between subjects. Photographing with a telephoto lens appears to bring the subjects closer together. (Photo by James K.W. Atherton, *Washington Post*.)

tor can appear to fade into an oak-paneled wall when photographed with black-and-white film.

The contrast between the tone of the subject and the tone of the background takes on added importance if the picture is reproduced in a newspaper. Newsprint grays out the blacks and muddies the whites. If the original difference in contrast between the Congressional representative and the wall were slight, the tonal separation would be completely lost when the picture was reproduced on newsprint.

If you had to take a picture of a dark-suited city council member speaking at a meeting, you might circle the official, and watch the background. You might look for a light-colored wall or door that could offset the subject. If you can't find the correct background, you could ask the speaker to move to a different location in the building after the speech is over.

Sometimes you still can't find a convenient background. Then you can shoot the pictures anyway and manipulate the tones of the background in the darkroom. In fact, some photographers claim that 50 percent of a picture's quality is created or destroyed in the darkroom. Burning and dodging can help sepa-

rate the subject from the background, but the technique can produce a light halo around the subject's head if the photographer is not careful.

Few politicians deserve a halo.

■ BLOW-UP OR COMPRESSION

When Jim Atherton covers an important committee meeting on Capitol Hill for the *Washington Post*, he carries three camera bodies: two Leicas, one with a 50mm and the other with a 35mm lens, and a Nikon with either a 24mm wide-angle or 80-200mm zoom. He bayonets the 24mm on the Nikon for "overalls" of the conference room but saves the zoom for close-up portraits. The close-up, he notes, brings the viewer and the subject nearer than they normally would meet in public.

Says Atherton, "A zoom is difficult to use because everything moves — the focus, the focal length, and the f/stops. Also, the telephoto magnifies my hand movements. I'll lean on any sturdy object available — tabletop, chair, or doorpost — to steady my aim." Atherton hand-holds the zoom lens for maximum flexibility and mobility. He often sets the shutter speed fairly slow (about 1/60 sec.) for this length lens in order to use a smaller aperture and get more depth of field. Atherton estimates that because he hand-holds the lens and shoots at a slow shutter speed, he loses 60 percent to 70 percent of his frames because of image blur. But, Atherton notes, 30 to 40 percent come out sharp. These more rare but striking pictures represent some of the photos that distinguish Atherton from the rest of the photo corps.

To avoid camera movement and to increase the percentage of sharp pictures, some photographers use extremely fast lenses and rate their film at higher than normal film speeds. With a fast lens that has a wide aperture, you can use faster shutter speeds to avoid the effects of camera-shake. The same result is produced when you push your film — rating it at a higher-than-normal ISO. When you rate 400 ISO film at 1600, for example, don't forget to use special development, such as processing in a high-energy developer. (See page 215.)

Besides creating close-up portraits, the telephoto lens offers another advantage when you cover a meeting or press conference. Often, the important figures at a conference stretch out in a line down one side of a table or sit on a platform at the edge of a stage. If you stand in front of the panelists to take a picture, each participant's head will appear quite small on the final print. Gaping holes of unnecessary space will lie between each speaker. If you move to one side or the other and shoot down the line of dignitaries, the panelists will appear in the picture to be quite close together, with little space between them. The compression effect becomes more noticeable as you use longer telephoto lenses and move farther from the subjects. However, depth of field decreases as the

lens length increases, so you may find it almost impossible to keep a long line of panelists in sharp focus when you shoot with an extreme telephoto. To achieve maximum depth of field, focus one-third the way down the row of dignitaries. You can put the camera on a tripod if you find you can't hand-hold the telephoto at slow speeds. With the aperture on a relatively small f/stop, all the subjects will appear sharp. Also, the panelists will look like they are sitting shoulder to shoulder without any dead space between them.

POLITICIANS & ELECTIONS

Politicians seek interviews and photographs. Press aides dream up news events and organize news conferences to attract coverage. Astute politicians know that re-election depends on good media coverage. The monetary worth of a page-one photo is inestimable — most newspapers will not even sell front-page space for advertising.

A politician plans media events that attract the camera, even if the events themselves have little news value. Called "photo opportunities," these nonevents have been designed for the camera journalist. One such event was held at the White House during Jimmy Carter's presidency and reported by Anthony Lewis in the *New York Times Magazine*: "11 A.M. Photo Opportunity White House Tree House. At 10:55 that morning 34 reporters and photographers lined up at the door of the White House press room. Then, led by Mary Hoyt (Mrs. Carter's press secretary), the group trooped across the broad green sweep of the south lawn toward a gigantic atlas cedar tree and the White House Tree House nestled in its lower branches. Squatting in the White House Tree House (WHTH) was the president's 9-year-old daughter, Amy, and his 3-month-old grandson, Jason. The cameras clicked, the mini-cams whirled and reporters fired questions at the two children huddled on the platform."

Ed Bradley, a White House correspondent for CBS, ruminated, "The White House grinds it out, and we eat it up." Don't assume that President Carter invented the photo opportunity. John F. Kennedy rarely missed a chance for full coverage. He knew that if he brought John-John, his young son, with him, the press was sure to be close behind.

Ted Dully, a photographer with the *Boston Globe*, points out that if the president puts on a stupid hat for a photo, an editor can't resist using the picture. As Dully says, "Politicians manipulate photographers and photographers manipulate politicians, both to their mutu-

To avoid routine political pictures, follow a candidate behind the campaign scenes. (Photos by Victoria Sheridan.)

al benefit. Politicians look for free publicity and photographers want visual events. Editors think readers want to see politicians in costume.

"The picture of the yarmulke-wearing senator is not wrong," he adds, "it's just not good journalism."

■ THE CAMPAIGN TRAIL

Politicians come alive at election time. The old "pal" gets out from behind the desk in his plush office and starts pressing the flesh at ward meetings, ethnic parades, and organizations for the elderly. The young challenger, by contrast, walks the streets of the ghetto with her suit jacket thrown over her shoulder. Both candidates plaster stickers on cars, erect billboards, appear in "I Promise" TV ads, and attend massive rallies. A photographer can take two sets of cam-

paign pictures: one set shows the candidate's public life — shaking hands, giving speeches, and greeting party workers. The other set shows the candidate's private life — grabbing a few minutes alone with his or her family, planning strategy behind closed doors, raising money, pepping up the staff, and collapsing at the end of a fourteen-hour day.

All too often, newspapers present their readers with a one-sided visual portrait of the candidate — the public side planned and orchestrated by the candidate's campaign directors. The papers print only upbeat, never downbeat, pictures; only happy, never sad, moments. Photographers continue to churn out photos of the candidate shaking hands and smiling — photos that reveal little about the person who is going to run the city, state, or federal government.

GO BEHIND THE SCENES

Political scientists claim that the American public votes for a candidate based on personality. If that is so, the responsibility of the photo editor should be to present a com-

plete picture of the candidate. The in-depth portrait must include the private as well as the public side. The public might vote its politician in or out of office on the basis of a pleasant smile but in the long run, progress in America depends on issues, not personalities. What has the incumbent mayor accomplished in office?

PHOTOGRAPH THE ISSUES

Almost all of a campaign's political issues can be translated into pictures. If the mayoral

Access is difficult even for the president's own photographer. To photograph the president while he was greeting onlookers from his car, Peter Souza attached a camera inside President Reagan's limousine. Souza ran a remote cord to the front seat, where the Secret Service agent tripped the shutter whenever he heard the president yell to the crowd. (Photo by Peter Souza, The White House.)

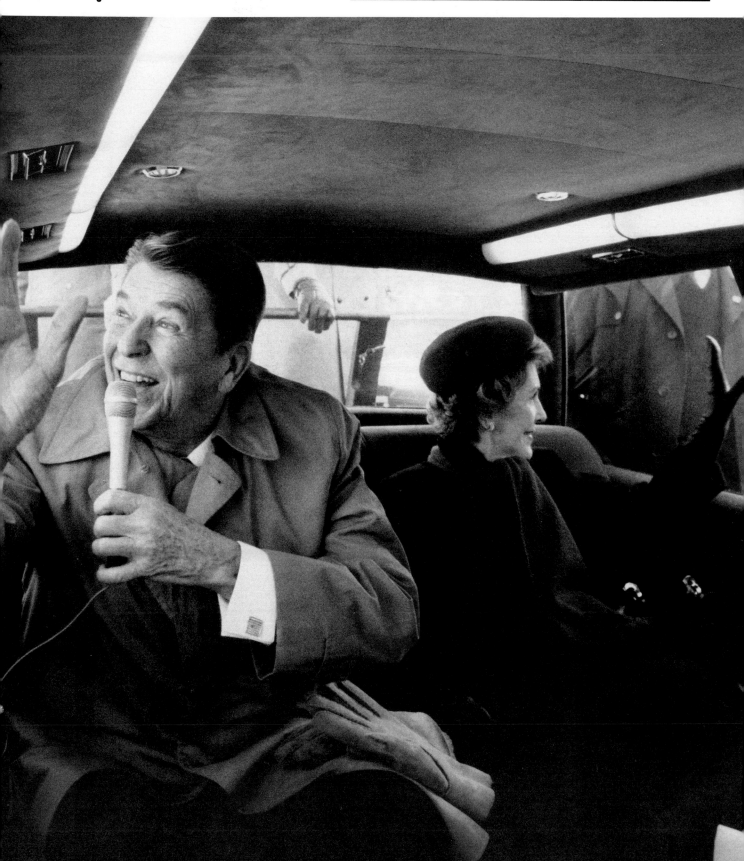

Watching for just the right gesture transformed what could have been an ordinary podium picture into a unique shot of Edward Kennedy. (Photo by Sandra Shriver.)

Enterprising photographers can avoid standard speaker pictures by moving away from the pack and looking for an interesting way to combine story-telling elements in one picture, such as the one below of Sen. Lloyd Bentsen. (Photos by Kathy Strauss.)

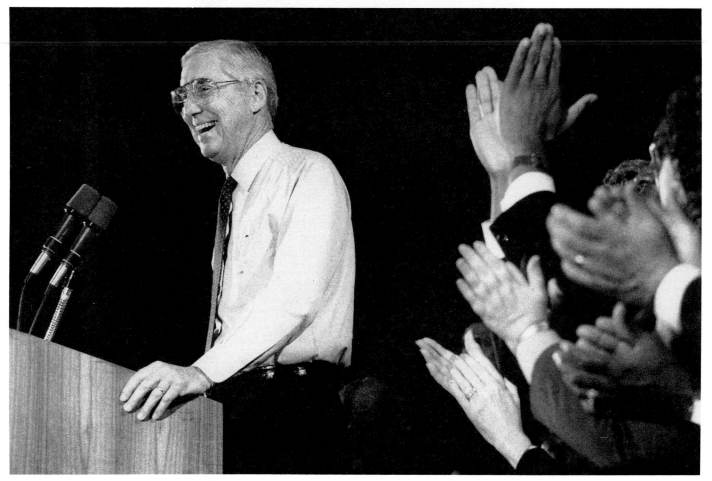

candidate says city education is poor and should be improved, the photographer must search for supporting evidence of the claim. Are schools overcrowded? Do students hang around in the halls with nothing to do after class? If racial tension exists between black and white students, can the journalist photograph the hostility? A set of realistic photos will transform the rhetoric of a campaign into observable issues. Photographers spend too much time shooting political mug shots and too little time digging up visuals that either confirm or deny the claims of these politicians.

When covering a campaign, election, or any other contested issue, the photographer has the same responsibilities to objectivity as does the reporter. Like a reporter, a photographer can directly distort a scene. A super wide-angle lens can make a small room look large. Strong lighting and harsh shadows can transform, in Jekyll-and-Hyde fashion, a mild-mannered speaker into a tyrannical orator. Even more damaging, the photographer, like the writer, can report one side of an issue and, intentionally or not, leave the other side uncovered. Because

papers often run only one or two pictures, such biased photo reporting creeps into the paper easily. The honest photographer, however, tries to select the lens, light, and camera angle as well as a representative moment or scene to present a fair view of a complicated topic.

Unfortunately, few staff photographers receive adequate time for investigative political photography. An editor finds it easy to send a staffer to cover a press conference. The editor knows the time and place of the gathering and can guarantee that some usable "art" will result. But readers don't want to see another "mayor talking" picture. They already know what the mayor looks like. They want to determine if the mayor is telling the truth about the school system. Pictures can supply part of the evidence for the mayor's assertions or negate his allegations.

STEER CLEAR OF THE PACK

Even if you're out conducting photographic political investigations, your editor in all likelihood will continue to assign you to rallies, speeches, and "photo opportunities." Cover these events if you must, but resist the PR-packaged photos politicians hope to see in tomorrow's

paper. At the most, look where the packaging has peeled away — but don't be surprised if you can't find it. At the least, turn your camera toward the crowd to find unusual political boosters. And, photographically, struggle to avoid the cliché of simply recording the routine picture, the stock shot.

Without doubt, every political rally starts to look alike. But by angling for a new view, like the ones of Lloyd Bentsen or Edward Kennedy (see previous two pages), perhaps you can at least bring back a photo you and your readers haven't seen thousands of times before.

AWARDS: AVOIDING THE GRIP & GRIN

After politicians' press conferences and meetings, the awards ceremony ranks as the planned news event most commonly photographed.

"I would like to present this check for $5,000 to your organization," says the president of the local bank as he passes a check to the head of a service organization. Cameras click. Strobes flash. These awards pictures, all identical, give the reader no new insight into the individuals involved in the ceremony. Who are they? Why did the group give the money? Who will benefit? The "grip-and-grin" photo, as its commonly known, doesn't answer

these questions. The picture simply records that two people held a trophy or a check, or just shook hands.

The Boston Globe's Dully says that awards pictures should not be run in a newspaper. "They pander to the desires of people to feel important and they perform no newsworthy function." Many papers, however, especially in smaller communities, continue to publish such photos, perhaps for public relations reasons.

Russ Hamilton, Cornell University's photographer, must take awards pictures almost every day. His attempts to give impact to these pictures, to make them different, have earned him a national reputation.

Yet here is how he describes his work:

"I have never seen or ever taken an excellent awards ceremony or presentation picture. In the line of duty, I have tried my best, using every trick of the trade — wide-angle lenses, high-angle shots, massive foreground — and never have I been able to obscure the artificial, ridiculous atmosphere of an awards presentation. Let us not overlook the fact that an awards presentation is a 'kiss-on-the-ass' to someone for doing something. In any case, many publications have dropped awards photos in favor of using the space for better purposes."

If you polled professional photojournalists, they would probably share the sentiments of Dully and Hamilton by voting overwhelmingly to eliminate awards pictures from newspapers. Some newspapers, in fact, have policies forbidding awards photos except for special circumstances. *The Boston Globe*, for example prints just one awards picture a year — of the winner of the *Globe* Santa

Contest, which the newspaper sponsors.

Most editors, nevertheless, continue to assign hand-shaking, check-passing pictures. Sometimes the events deserve coverage. When a small-town citizen wins a million dollar lottery, that is clearly worth a picture. Sometimes the event is so close to home that a photographer had better not miss it: when your publisher wins the community person-of-the-year award, you will probably take several shots of his receiving the plaque.

THE STORY BEHIND THE AWARD

As with meeting pictures and political pictures, the real secret to an awards photo lies in searching out the reason for the ceremony and bringing out this fact in the picture. Sometimes the photographer only has to add a prop to the picture to point out the meaning of the event. If a man wins an award for best marksman, his gun included in the picture cues the reader to the nature of the award.

At other times, the photographer must arrange the picture to clarify the point of the award. If an employee gets a bonus for stitching more shirts than anyone else in the shirt factory, then the photographer needs to find a time to photograph the worker standing next to her tall stack of finished clothing.

In some cases, an award might even be a peg for a picture story.

For example, the ceremony at which Annemarie Madison received an award for her work with people dying from AIDS was, as most of these stiff ceremonies are, a visual zero. However, her dedication and compassion became the subject of a moving photo story that was part of an award-winning photo project called "Helpers in the War on AIDS." (See "Developing a Fea-

The government emptied many mental hospitals but failed to provide halfway houses for the mentally ill people who had lived in the hospitals. Rather than photograph another press conference on the subject, the photographer documented the living conditions of the people who had nowhere to live but the streets. (Photo by Ken Kobré, for the *Boston Phoenix*.)

IN-DEPTH PHOTOJOURNALISM

■ PHOTOGRAPH THE SUBJECT OF THE TALK, NOT THE TALKER

Even with the best lens technique and a keen sensitivity to light, photographers still have trouble distinguishing for readers the difference between a city council meeting called to increase taxes and a meeting convened to decrease the number of district schools. The difference between these meetings lies in what the council members said verbally, not what they did visually. The photojournalist must translate speakers' words into pictures that portray the underlying controversy.

Arthur Perfal, a former associate editor of *Newsday*, gave his view of the problem at a conference of editors conducted by Chuck Scott, director of the Visual Communications program at Ohio State University.

"Remember that people talking often supply material for good stories," Perfal said, "but they seldom supply material for good pictures. Particularly when the same officials or the same chairmen are doing the talking. Let the photographer go where the action is — shoot what they're talking about."

If the Board of Education is having a hearing on a budget crisis, the reporter should cover the meeting.

The photos that appear on this and the following two pages were part of a four-part series that resulted in an investigation of neglect in California's nursing homes and the state's system for policing them. (Photos by Judy Griesedieck, *San Jose Mercury News*.)

Then, if the crisis involves dropping the hot lunch program, the photographer should go into the school cafeteria and shoot pictures that will indicate what effects the budget cut will have. If the Board is contemplating eliminating school athletics, the photographer should go to the gym and the playing field, where a photograph can capture what the athletic program means to students. The photographer should go where the action is.

■ NURSING HOMES: A CASE STUDY
TRANSLATING NUMBERS INTO PEOPLE

In California, investigators determined that over a three-year period, poor care in state nursing homes was a factor in 126 deaths. The *San Jose Mercury-News* decided to investigate the findings.

Mercury-News reporters discovered that "An aide shook a 74-year-old man in Long Beach so violently, an investigator said, that his brain was slammed against his skull 'like a clapper in a bell.'" Nurses diligently charted the progression of bedsores on an 81-year-old woman in Los Gatos until there was "black stuff oozing from her body" — but failed to save her life.

PHOTOGRAPHING STATISTICS

The paper's graphics editor assigned Judy Griesedieck to illustrate the series.

Problem one: the subjects of the story, the abused elderly, were dead and buried.

The solution: photograph current treatment of the elderly in nursing homes.

Problem two: aware of stories the paper already had written, nursing home owners and managers did not want a *San Jose Mercury-News* photographer anywhere near their nursing homes.

Solution: Griesedieck started the assignment by calling twenty nursing homes. Only two said she could come in and look around. Then Griesedieck talked to the paper's lawyer, Ed Davis, who pointed out that while nursing homes were private property, Griesedieck could enter and photograph if she was invited into the home by one of the residents. She could photograph the person

In one home, a daughter brought Griesedieck in to see her mother. The older woman had bed sores because of neglect. In another home, a patient would be in bed at 9 A.M. and still lie there — undressed, unattended, and with no outside stimulation — when the photographer left at 5 P.M.

Besides neglect, Griesedieck also found evidence of love and compassion at the nursing homes. The *Mercury-News* photographer watched a man who visited his wife daily, bringing his spouse a rose on each visit. The man spoon-fed his wife lunch each day. The husband said to Griesedieck, "I don't think she knows who I am." He started crying.

Griesedieck also obtained entrance to the nursing homes by accompanying a doctor who treated Alzheimer's disease, which makes people forgetful. Here again, she had to get permission ahead of time from every patient or guardian.

The photographer also made arrangements with the California Department of Health Services, which carries out unannounced inspections of nursing homes. The inspectors called Griesedieck the morning of the surprise nursing home visit, and when possible, she followed the health service employees on their investigative raids.

RESULTS

The four-part series in the *Mercury-News* ran with Griesedieck's powerful pictures illustrating each day's stories. Under the headline "A requiem of neglect," reporters described the lack of care that caused each of the 126 deaths that had occurred over the previous three years. The series caused the state commission to relaunch an investigation of California's nursing homes and its system for policing them. The series was a runner-up for the Pictures of the Year Canon Photo Essayist Award.

Griesedieck, however, continued to have nightmares about what she saw. Until leaving California, she continued to visit the old people in several of the homes. "What I saw made me sad," she says. "I might be here some day. People in these homes had great careers — doctors, models — and now. . . ."

And now, at least, people do know about the situation in these homes and can take action because of solid investigative reporting and photography by Griesedieck and her fellow staff members.

■ INGREDIENTS FOR IN-DEPTH COVERAGE
IMPORTANT ISSUES

Griesedieck started with an important issue. Her paper had published a number of spot news stories about deaths due to neglect in nursing homes and about official investigations. The paper had given each of the stories only inside play. In seeing the pattern generated by the numbers — noting the repetition of deaths due to neglect — the paper went beyond the individual news story. The

who invited her without being evicted by the management of the nursing home.

GAINING ACCESS

To meet people in the homes, Griesedieck attended meetings of Bay Area Advocates of Nursing Home Reform. Relatives of people in nursing homes, the group members were happy to introduce the *Mercury-News* photographer to their mothers, fathers, wives, and husbands who were living with inadequate nursing home care. With an invitation from nursing home patients she met through the advocates organization, Griesedieck began to shoot the story.

BACKGROUNDING THE NEWS

CALIFORNIA'S NURSING HOMES: **NO PLACE TO DIE**

Judy Griesedieck bypassed nursing home officials to develop relationships with families and doctors who allowed her to photograph the conditions of neglect in the nursing homes. (Photos by Judy Griesedieck, *San Jose Mercury-News*.)

(ABOVE) Griesedieck balanced her hard-hitting pictures of neglect with pictures showing love and care by staffers as well as by family. H.A. Himmelsbach visits his wife, Miriam, daily to feed her lunch.

pictures and story attempted not only to document the phenomenon of needless death but also to show the cause of the problem — neglect.

Over the year-long project, Griesedieck tried to bring the statistics — 126 deaths in state nursing homes caused by neglect — to light. She zeroed in on individual stories that provided examples of the larger trend. She showed Carrie Chelucci being checked for bed sores. She showed Lucille Dennison, who has Alzheimer's disease, asleep in her wheelchair in the hall of a locked wing in the home.

Just as important, Griesedieck balanced these hard-hitting pictures with those showing love and care by some attendants and doctors.

TIME

Like most investigative stories, Griesedieck's took time. The paper made a commitment of resources — a commitment of one photographer's time. Of course, Griesedieck did not spend full time shooting this story.

But the paper gave her sufficient time from her daily shift to research the issue, make contacts, telephone possible subjects, and wait for their responses. Many newspapers think nothing of assigning a reporter for weeks or even months on an investigative story. Unfortu-

nately, most papers fail to provide sufficient time for good visual reportage.

DISPLAY

Obviously, the photographer needed to make powerful images for the article, and Griesedieck's pictures were superb. Equally important, however, the images needed a showcase. The *Mercury-News* featured a large lead picture on page one each day the series ran. Its editors also used photos extensively inside.

■ BACKGROUNDING THE NEWS

"No Place to Die: California's Nursing Homes" is an outstanding example of backgrounding the news, a term Sidney Kobré, my father, coined in a book by that name written in 1939. Backgrounding means explaining the cause of a news story. Backgrounding means applying psychology, sociology, and economics to a news event to put it into perspective. While photography is an excellent medium for recording the immediate — the fire, the accident — you can also use photos to explain. In the future, with television's instant reportage of breaking news, still photography will find an increasingly important role in providing in-depth coverage that identifies patterns and explains causes. ■

A San Jose nursing home resident watches as the world goes by.

Awilda Olmoa, a nurse's aide, combs the hair of 100-year-old Gregoria Santos.

Chapter 3, General News — **57**

Features

For feature photos, look for the incongruous — like this sunbather in a cemetery on Block Island. (Photo by Chip Gamertsfelder, *Kettering/Oakwood* (Ohio) Times.) *Times.*)

WHAT ARE FEATURES?

"When I first entered the news-picture business in the '30s, papers would run a lot of gruesome, sensational photos of murders and accidents on their front pages. Today, editors print features," recalled Dave Wurzel, then-editor of UPI's New England Photo Bureau, during an interview. As we spoke in his office about feature pictures, the sound of teletypes and scanner radios in the adjoining room nearly drowned out his voice. The place was alive with action, as photographers rushed in to process film for their wire service deadlines.

"Many editors argue that since readers receive so much depressing news in the paper's gray columns of type, subscribers deserve a break when they look at pictures," Wurzel explained. "For this reason, these editors tend to publish light feature pictures more often than straight news pictures."

Feature photos provide a visual dessert to subscribers who digest a daily diet of accident, fire, political, and economic news.

■ HOW FEATURES AND NEWS DIFFER

TIMELESSNESS

Feature photos differ from news photos in several respects. A news picture portrays something new. News is timely. Therefore, news pictures get stale quickly. By comparison, feature photos published tomorrow, or a week after tomorrow, still maintain their interest value. Many feature pictures are timeless. Feature pictures don't improve with time, as good wine does, but neither do they turn sour. Some newspapers, in fact, refer to features as evergreens. Like evergreen trees, feature photos never turn brown. Wire service photos showing Nixon giving his inaugural speech carry little interest today. Yet pictures like those of the playful friends below will long retain their holding power. Gordon Converse, who worked for the *Christian Science Monitor* for more than twenty years, described feature photography as the "search for moments in time that are worth preserving forever."

SLICE OF LIFE

A news picture accrues value when (1) its subject is famous, (2) the event is of large magnitude, or (3) the outcome is tragic. A feature picture, by contrast, records the commonplace, the everyday, the slice of life. The feature photograph tells an old story in a new way, with a new slant. Two children playing games at a day care cen-

Unlike news, feature pictures are less timely. Their visual value holds up long after the action is over. (Photo by Stephanie Martin.)

The tough-looking fireman (RIGHT), with a cigarette dangling from his mouth, administers oxygen to a tiny dog. This scene, which adds human interest to a news event, is an example of featurizing the news. (Photo by Bruce Gilbert, *Long Island Newsday.*)

ter will not change the state of world politics, but the photo might provide the basis for a funny feature picture.

Some moments evoke universal understanding. Few people would fail to react warmly to the sight of the wind-blown walker. (Photo by Rob Weisman, *Middlesex (Mass.) News.*)

With hard news, the event controls the photographer. Photojournalists jump into action when their editor assigns them to cover a plane crash or a train wreck. When they reach the scene, they limit their involvement to recording the tragedy.

As a feature photographer, on the other hand, you often can generate your own feature assignments. In fact, many newspapers call features "enterprise pictures." You might arrange to spend the day shooting photos of a man who makes artificial arms and legs. Or you might head for the city park, looking for a child playing ball with her parents.

FEATURIZING THE NEWS

News does not stop with fires and accidents — features don't begin with parks and kids. The division between these two types of pictures is not that clear-cut. The sensitive photographer, for instance, could uncover features even at a major catastrophe. This is called "featurizing the news." The main story might describe a fire's damage to an apartment house, and give a list of the injured and dead. The news photo might show the firefighter rescuing the victims with the building burning in the background. For a news feature, the photographer might take a photo of a tough-looking firefighter gently administering oxygen to a frightened little dog. This picture, along with a caption about the canine rescue, might be printed as a sidebar alongside the main story and photos, which would concentrate on the residents' injuries and the general damage to the building.

UNIVERSAL EMOTIONS

Great feature pictures, and there are few, evoke a reaction in the viewer. When viewers look at a powerful feature photo they might laugh, cry, stand back in amazement, or peer more closely for another inspection. The photo has succeeded.

Some features are even universal in their appeal. They will get a response no matter in what country they are shown. When individuals in Russia, China, Africa, or the United States respond to the same photo, then the photographer has tapped into the universally understood language of feature pictures.

The term feature picture tends to serve as a catch-all category. In fact, some writers define features as "anything that's not news." Yet many pictures fit into neither the news nor the feature category. Snapshots from a family album, for example, don't really belong in either pigeon hole. How can you learn to recognize a scene

with good feature potential? By looking at feature pictures in newspapers, magazines, and books, you will begin to notice a consistent attribute that all features possess.

GOOD
FEATURE
SUBJECTS

A few years back, each time a new photographer was hired by Florida's *St. Petersburg Times and Independent*, a veteran staffer would draw the newcomer aside to explain the secret ingredients of the feature picture. "Friend," he said, "if you need a feature picture for today's edition, you can't go wrong by taking photos of kids, animals, or nuns wearing habits." These were not bad words of advice because a large percentage of pub-

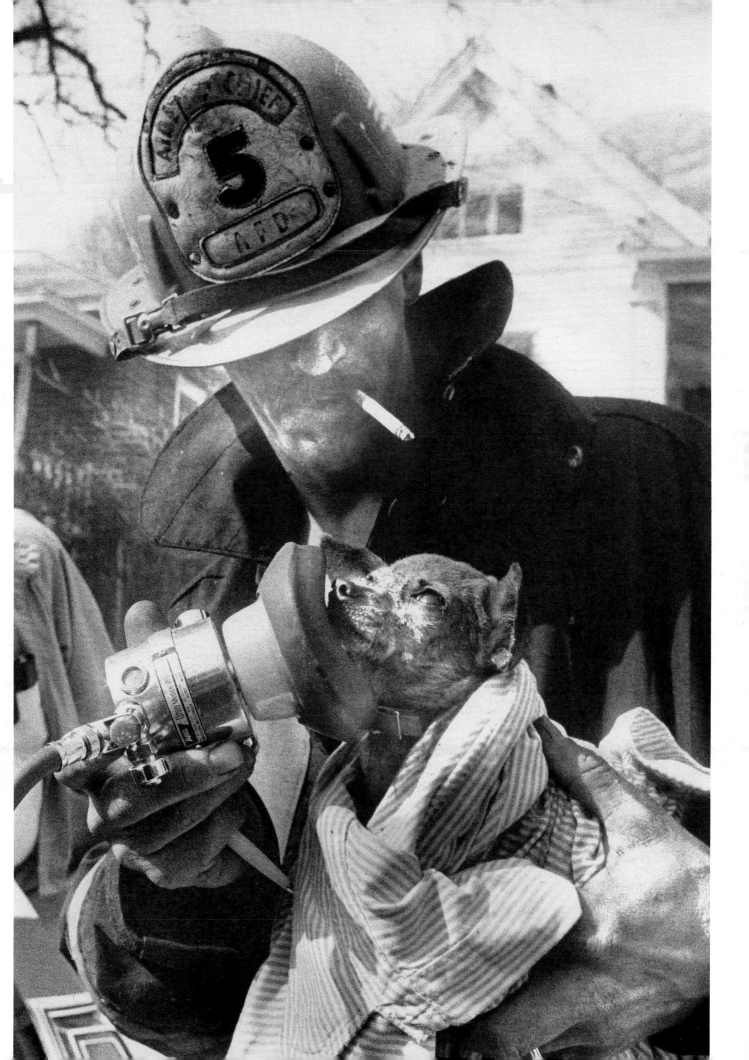

When children imitate adults, the youngsters prove to be appealing feature subjects. (Photo by Ted Ancher, *Boston Herald*.)

lished feature pictures includes kids, animals, and sometimes even nuns.

KIDS IMITATING ADULTS

Photographers find children relatively easy and willing subjects because they act in natural ways, play spontaneously, and look cute. Without any encouragement, children do silly things. To grown-ups, children seem particularly funny when they imitate adult behavior. The child often acts as a mirror, showing the adult how grown-up behavior appears to the younger generation.

A specialist in photographing children when she worked for the *Boston Globe*, Ulrike Welsch always asked permission of parents before photographing youngsters. "That way the parent does not become suspicious and does not interrupt the shooting," Welsch explains. If the parent is not around, Welsch asked the child to lead the way to the adult, giving Welsch the opportunity to secure the permission. Although asking permission interrupts the

People respond to pictures in which animals appear to have human-like emotions. (Photo by Chrissy Walker for the *Russian River News.*)

Anun with a gun seems incongruous and therefore provides the subject for a good feature. The guns were actually donated to the camp the sisters administered. *(Wide World Photos.)*

child's activity, Welsch notes that as soon as the parent gives the go-ahead, the child always quickly resumes his or her natural play.

ANIMALS ACTING LIKE PEOPLE

People commonly attribute human characteristics to animals. People respond to pictures in which pigs seem to

smile or chimps look bored. Pet lovers often believe their animals exhibit human emotions, and treat their animals as if they were little human beings. Dog fanciers feed their pooches at the dinner table, dress them in sweaters for walks, and at night tuck them in velvet beds. One owner even taught her pet bird how to smoke; another fed her turtle ice cream. Such idiosyncrasies supply the material for good features.

THE INCONGRUOUS

A photo of nuns holding guns looks odd because nuns and guns don't seem to go together. A revolutionary soldier carrying a 35mm SLR would

People like people. And who can help but like these two grandmotherly women as they play a grown-up version of dress up? (Photo by Chas Metivier, *The Gilroy* (Calif.) *Dispatch.*)

appear equally mismatched. And an elephant in a subway is certainly incongruous, as well. Such photos provide eye-catching features.

PEOPLE LIKE PEOPLE

Clearly, the feature does not restrict the photographer to picturing only kids, animals, and nuns, although whenever you can include these elements in a picture, the photo has a greater chance for publication. People of any age prove fascinating when they labor or learn, play or pray. Bob Kerns, a professor of photojournalism at the University of South Florida and a seasoned feature photographer, estimates that 90 percent of the feature pictures in papers across the country center on people.

DISCOVERING FEATURES

I asked several well-known feature photographers where they look for people features.

Ted Dully, who worked for the *Boston Globe,* says that when he has time he heads for the park or the zoo. "If you go where people collect, where things are happening, you have the deck loaded in your favor," he says.

Author of ***The World I Love To See***, a book of feature photos, Ulrike Welsch explains that her best

human interest pictures are shot outdoors. "Taking features outside is easier than my having to go into a shop, introduce myself, and obtain permission from the owner," Welsch says.

■ KEEP A FRESH EYE

To keep a fresh eye for features, Welsch gets in her car and drives to an area she's never seen before. The experience is similar to traveling to a new country, even though the place might be only a few miles away. Whenever you live for a stretch of time in the same place and see the same things daily, you grow accustomed to your surroundings. Psychologists call this phenomenon "habituation." Feature photographers face this same problem. They come to accept as commonplace the unique aspects of the area they cover.

"Whenever I go to a new place, even if it's just a little way down the road, everything is novel," Welsch points out. She notices and photographs the differences between the new environment and her familiar territory. When she first arrives, her eye is sharpest. Those first impressions usually lead to her best photos. "I take pictures I might have overlooked if the subjects were in my back yard," she says.

Even the most blasé New Yorkers would hardly expect to find an elephant riding in the subway. Halloween, when this picture was taken, creates vast opportunities for photographing characters out of place. (Photo by Frank D. Jacobs III.)

When the *Christian Science Monitor*'s Gordon Converse looks for feature photo possibilities, he shuns the car altogether. Even if he is on his way to an assignment, he prefers to walk if he has the time. "If you are in a car whizzing through a neighborhood, you miss seeing how the residents respond to one another. This interchange provides the basis for good features."

■ TAKE A CANDID

Constantine Manos, an outstanding freelance feature photographer for Magnum picture agency, looked for candid features during the year he spent shooting 500 rolls of black-and-white and color for a forty-projector slide show called "Where's Boston?" He says that he never posed or arranged any of the pictures contained in the show. Manos says he explored each area of the city on foot, introducing himself to the residents. "If you sneak up on people," he explains, "they have a right to resent

Candid moments remain the key to successful feature pictures. (Photo by Skip Peterson, Dayton (Ohio) *Daily News*.)

Taking a camera underwater can provide readers an unusual view of an otherwise familiar swimming pool. (Photo by John Zich, *Boca Raton* (Fla.) *News.*)

you. Instead, if you say 'Hello,' and talk a bit about what you are doing, people will let you continue with your work. All my subjects are aware of me."

Yet Manos caught remarkably candid and uninhibited moments in these people's lives. One of Manos' photos shows the bassoon player in a small chamber quintet leading the group with complete abandon. Another photo shows a janitor nonchalantly erasing a blackboard containing a word so long and obscure that few Harvard professors would understand it.

Manos points out that photographers have the responsibility not to offend by their presence. "That is why appropriate clothing is important, and it is also the reason I seldom work with more than one camera at a time. It is especially bad when the second camera body has a big impressive, fierce-looking telephoto lens." While out shooting, Manos once saw an old woman fleeing from a bearded youth with a big telephoto lens on a menacing SLR. "Why shouldn't she have felt intimidated?" Manos asks.

■ MAKE A PICTURE

Converse of the *Monitor* says that while he is happiest when he can capture a candid, doing so is not always possible. "Sometimes you can just take a picture but other times you have to make a picture," he said.

"When there is nothing happening, I will create a situation to make something happen. For instance, while sitting in the office one slow day, I decided to do a story about the window washer at the new all-glass John Hancock skyscraper. After I obtained permission I crawled out on the window washer's platform sixty stories above the city. . . . I gingerly stood on top of the protective scaffolding. A security guard held onto my legs for my protection. As I put my camera to my eye, I could see the window washer in one corner of the frame with the beautiful reflecting surface of the skyscraper sweeping down below. This was the picture I wanted."

Going underwater at a local swimming pool is another way to "make" a picture. Here, the photographer went with a camera where his readers couldn't — and in

The father-son portrait of "Bones" Kah and his young offspring "Harley Davidson" resulted from a series of self-assignments created by the photographer. This personal assignment was to illustrate the word "contrast." (Photo by Rob Goebel, *Indianapolis Star*.)

the process captured on film the unusual shot of divers plunging through the water.

■ THINK OF A WORD

Rob Goebel's funny photo of a burly biker holding his tiny infant son could be either a portrait or a feature. This striking photograph did not originate from an assignment desk, nor was it associated with any writer's story.

Instead, the photographer had given himself a set of self-assignments: illustrate different words photographically. Looking for ways to photograph the word "contrast," the photographer arranged a formal portrait of a biker and his young son, Harley. While it could accompany a story about the biker quite well, the picture stands on its own as a feature picture "made" by the photographer.

■ AVOID THE TRITE

The bread-and-butter feature in today's newspaper is still the pretty child playing in the park or the chimp clowning at the zoo. Photographers take pictures of kids and animals so often that these topics have become trite.

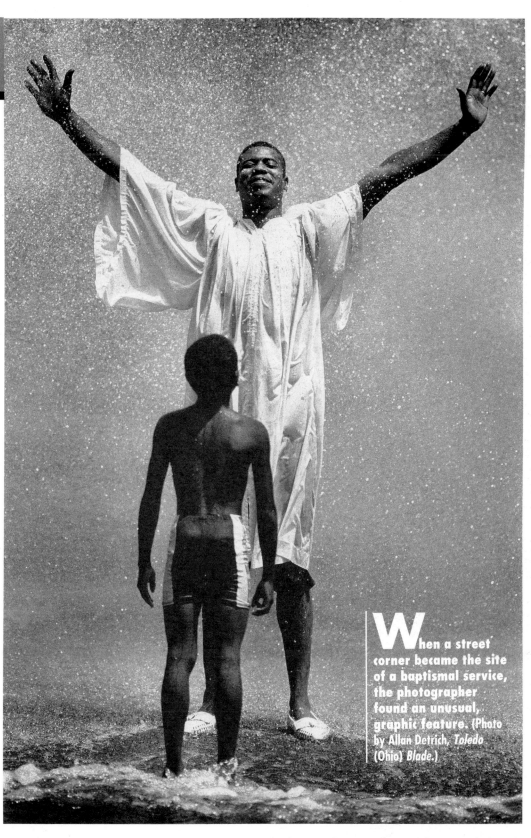

When a street corner became the site of a baptismal service, the photographer found an unusual, graphic feature. (Photo by Allan Detrich, *Toledo* (Ohio) *Blade.*)

Robert Garvin, in an article for *Journalism Quarterly,* explains the genesis of the unsubstantial feature picture. "I have known picture editors (including myself up until ten years ago) who, on a dull afternoon, assign a photographer to walk around town and photograph anything he sees. What does he see? On an August day, he sees a small boy in the spray of a fire hydrant, or a group of tenement dwellers sitting on a fire escape. These are so obvious that every passer-by has seen them

When a group of photojournalists collaborated on a beat focusing on helpers in the war on AIDS, a host of stories unfurled, including one about volunteers who bring food to people too sick to cook. (Photo by Mary Calvert, *The Hayward (Calif.) Daily Review.*)

in the newspaper for the last forty years. If there is no thought and preparation, one cannot expect striking pictures with more lasting merit."

When Arthur Goldsmith, an editor for *Popular Photography* magazine, judged the Pictures of the Year Contest, he concluded that pictures in the feature category tended to be hackneyed. He wrote, "Feature pictures often mean space fillers for a slow news day. Here are the visual puns, the cornball, the humorous, the sentimental, the offbeat. (Greased pigs and belly dancers were especially big during this year's competition.)"

Goldsmith said editors divide the photo world into two camps. "Either an event is hard news, which usually means violence, death, horror, confrontation, etc., or the event is a 'feature,' meaning something that appeals to our warm, furry sentimentality. But between the two extremes, the agony of the spot-news disaster and the ecstasy of the feature picture, lies that great amorphous zone that is most of our life."

DEVELOPING A FEATURE BEAT

HELPERS in the WAR on AIDS

A community responds to an epidemic

How can the photographer tackle that great amorphous zone outlined by Goldsmith? If photographers hope to produce meaningful features, the answer lies in developing their own specialty area — their own beat.

For years, writers have pried loose the city's news by covering a beat. Typical beats include police, hospital, and courts. Reporters on police beats check the precinct headquarters each day to see what is going on. They look over the police blotter and talk to the sergeant to find out if anyone reported a major or unusual crime during the night. Getting the inside track on current investigations, reporters find out about possible suspects. They know when the police plan to carry out a gambling raid or drug bust. They also get to know the personalities in the department — the seasoned police officer as well as the new rookie fresh from the police academy. From these contacts and observations, beat reporters don't just react to the news; instead they can interpret and predict it. If the police go on strike, they can explain why. If a cop dies in the line of duty, they can write a story based on personal knowledge of the officer.

Feature photographers can also cover a beat, but rather than choosing the police, hospital, or courts, they might select education, science, medicine, or religion.

■ GETTING THE IDEA

Sometimes a beat can grow out of one story. While walking in the Castro section of San Francisco in 1987, I noticed that inside a storefront, people were sewing large colorful quilts. I walked in and asked what was going on. The scene looked like a cross between an old-time sewing bee and a sweatshop factory. One of the volunteers explained that each quilt contained the name of someone who had died from AIDS. Volunteers were sewing quilts to remember famous people like Liberace and Rock Hudson, as well as personal friends, lovers, and relatives who had died from this dread disease. My guide said that eventually the volunteers would assemble all the individual quilts together, forming a massive mosaic that would be displayed in Washington, D.C. The quilts would provide a memorial to those who had died from AIDS. The final piece, which eventually measured more than two football fields in size, would bring home the enormity of the epidemic that some have called a modern-day plague.

According to my volunteer guide, neither the individual quilts nor the mosaic had ever been exhibited at that time. Nor had stories appeared in the national press about this effort called "The Names Project." I called M.C. Marden, the photo editor at *People* magazine, to see if she would be interested in a story. Eventually, I received an assignment to photograph Cleve Jones, the founder of the project, as well as to photograph several of the individual memorial quilts.

After the quilt story appeared in *People*, the magazine assigned me to another "AIDS story." Rita Rockett, as she is known in San Francisco, throws a fancy catered brunch every other Sunday for AIDS patients on Ward 5A of San Francisco General Hospital. She brings a breath of sophistication and fun into the hospital's AIDS Ward every other weekend.

The Names Project and Rita Rockett sparked my interest in the San Francisco community that had developed

Knowing how much people love their pets, volunteers for PAWS (Pets Are Wonderful Support) care for pets when their owners are in the hospital and then help find new homes if necessary when the owners die. (Photo by Mary Calvert, *Hayward* (Calif.) *Review.*)

to support people with AIDS. In the face of no known cure for AIDS, this diverse set of groups had sprung up to help the growing number of people with the deadly disease.

PAST STORIES ON THE TOPIC

Over the previous few years, I had seen several excellent stories about AIDS. The earliest I remembered was by Steve Ringman of the *San Francisco Chronicle*. I had also seen memorable stories photographed by Cheryl Nuss of the *San Jose Mercury-News* and Alon Reininger of Contact Press Images. All these stories were moving. All concentrated on the patients, showing their battles against the agonizing deaths they were facing.

I was interested in developing a new angle on the story — a series of vignettes about people who help people with AIDS. The focus would be on the outpouring of support that had cropped up in the Bay Area to provide emotional, physical, and economic help to people with the incurable disease. The project was eventually called "Helpers in the War on AIDS."

While the original identification and later unraveling of the cause of AIDS provided the basis of important news stories, approaching the issue from the viewpoint of the helpers gave the story a new twist. Readers will look at only so many stories on a topic about dying and death, but they will look at and read stories of people who are willing to put themselves on the line to help others. By emphasizing the life-affirming angle and by giving the story a feature slant rather than a news slant, I hoped readers would be drawn into a story that could be otherwise very depressing.

ORGANIZATION

One photographer could photograph the AIDS beat. However, in this instance, "Helpers in the War on AIDS" became a group project at the journalism department of San Francisco State University. Each photographer researched, developed, and photographed three stories over a fourteen-week period. In addition to taking pictures, all group members either worked with writers or provided the text for the story themselves.

RESEARCH

Before photography began on the project, the group brought in a number of experts in order to get story leads. Specialists ranged from the city's health department AIDS expert to journalists who had tracked the story over a long period of time. In addition, group members read Randy Shilts' book, **And The Band Played On**, which analyzes the government's delayed and inadequate response to the growing epidemic. Other leads came from the classified listings in local gay newspapers. A writer in the group, who actually had the virus, provided a key link to the gay community.

Having a beat gives a focus to research. Research, in turn, allows you to go beyond the surface facets of an issue to investigate causes of a problem, solutions, and, usually, stories that other journalists have not already photographed or written about extensively.

■ INITIAL STORIES

To get a handle on such a large subject, the photographers divided the topic into sections including medicine, religion, alternative healing approaches, minorities, physi-

cal support, emotional support, etc. Once the photographers selected subject areas, they began making telephone calls — and telephone calls — and telephone calls. Then the photojournalists arranged for meetings with the subjects. Often these meetings involved no photography at all. In fact, for one story, photographer Anne Wells started by volunteering at the first private nursing home for AIDS patients on the West Coast.

Another of Wells' stories was called "The Godfather," about a man who raised money and then made wishes come true for hospital-bound AIDS patients. If a patient needed a TV, The Godfather would provide it. If a patient needed a bathrobe, The Godfather would bring one. Another photographer, Kim Gerbich, worked on a story eventually called "Mamacita of the AIDS World," which centered on a female social worker who cared for homeless AIDS patients living in a run-down, inner-city transient's hotel. A third member of the team, Mary Calvert, photographed a woman who cared for the pets of people with AIDS. Her organization, called PAWS (Pets Are Wonderful Support) supplied food for pets of people with AIDS and took the animals to visit the sick people in the hospital. Calvert also followed the work of volunteers for "Project Open Hand," an organization that provides meals for shut-in people with AIDS. (See previous spread.)

In the AIDS Ward itself, a nurse allowed herself to be the subject of a story. Photographer Yvonne Soy tried to depict how a nurse works with people day after day knowing they will not live much longer. The project's story list included a makeup artist who helped camouflage the ugly purple scars of Kaposi Sarcoma that sometimes afflict people with AIDS. The list also included a story about a faith healer and her work with the sick.

The story list grew as the photographers dug

into the subject. Everyone knew someone who was helping out in the AIDS community. Soon the photographers started to uncover stories about people

One story focused on a nurse who volunteered to work in the AIDS Ward of San Francisco General. (Photo by Yvonne Soy.)

who helped prisoners with AIDS and workers who helped teen-age prostitutes avoid AIDS.

START-UP PROBLEMS

After the photographers uncovered the initial leads for their stories, problems started to crop up. While many of the helpers were happy to have their pictures taken, sometimes their friends with AIDS did not want photos of themselves published. Some didn't want out-of-town friends to see them scarred by Kaposi Sarcoma. Others didn't want people to know they were gay. Sometimes, the photographer would start on a topic, begin photographing the relationship between a helper and a patient and then, suddenly, the patient would die. The story would end before it began. In addition, hospitals worried about lawsuits if the photos were published — even though the photographers got photo release forms from every subject. Altogether, "Helpers in the War on AIDS" was a difficult story to photograph.

ONE STORY LEADS TO ANOTHER

For good beat coverage, besides reading daily papers like the *San Francisco Chronicle* and *Examiner* and the special-interest gay papers like the *Bay Area Reporter* and *The Sentinel*, the photographers returned to their primary sources week after week for new leads. Sources such as research experts, specialized doctors, hotline workers, counselors, and friends with AIDS supplied suggestions for new stories.

SELECTS FROM A FEATURE BEAT

ERNIE'S FINAL MOMENTS

Annemarie, a volunteer hospice worker, comforts Ernie during his dying moments. After his last breath, Annemarie provides emotional support for his friends and relatives. These pictures are part of a story that was the product of a photographer's beat. (Photos by Sibylla Herbrich.)

One Monday, the photographer accompanied Annemarie to the hospital to see Ernie, the man who had told Herbrich about Annemarie in the first place. On Wednesday, when Herbrich returned with the hospice worker, Ernie looked much worse. His friends were in the hospital room. Herbrich later wrote about that day:

"On the afternoon of June 9, for the first time I saw someone die. Ernie Smith died of AIDS at the age of 56. I photographed the hours of his dying and for two days I could not process the film. I stared at the one little roll that contained him in life and also in death. He died in the moment of the 'black space' between two frames. . . . I didn't sleep for a long time."

Herbrich's story along with others in the project were published as a 76-page magazine named *Helpers in the War on AIDS*. The project won the Sigma Delta Chi award for feature photography and tied for first place in the college division of the Robert F. Kennedy Awards for Coverage of the Disadvantaged.

INFORMATIVE FEATURES REQUIRE RESEARCH

For more informative features, such as those taken by group members of the "Helpers Project," you will need to perfect your skills as a reporter: (1) pick an area of specialization; (2) make contacts with experts in the field; and (3) become familiar with the issues and new trends on the subject. Once you hear about a story that sounds interesting, make arrangements to photograph it. Often you will need to return several times to secure complete coverage. After shooting the pictures, you can write the captions and submit the feature series. You might suggest to your editor that a more detailed story by a reporter would amplify your series of pictures. To assure more stories on the subject in the future, keep up your contact with your sources of information. These contacts will tell you when something new happens that might make striking pictures.

Few newspapers will release photographers to work full time on their beats. Therefore, the photographer must fit his or her special beat around routine assignments. Developing a feature area rarely produces great pictures on the first day. The photographer needs time for research. In the long run, though, a photographer's beat will generate meaningful feature pictures that will remain permanently in the viewer's memory. ∎

Sometimes when working on a beat, the first story doesn't pan out. But it may lead to another, even better opportunity — an opportunity you might not have had without developing contacts in the field.

For example, while researching one story for the project, photographer Sibylla Herbrich spoke at length with Ernie, who had AIDS. She asked him if he knew anyone doing extraordinary work with people who had AIDS. He told the photographer that she must meet Annemarie.

After meeting and getting to know Herbrich, Annemarie Madison, a striking woman with long silver hair and a Mother Teresa smile, took the photographer with her as she went day after day to see her "boys." Annemarie's boys were men who, a few months earlier, had been in the prime of their lives. Now they were near death. As a volunteer with the San Francisco Home and Health Care Hospice, Annemarie changed the men's beds, listened to their complaints and fears, and wiped saliva from their mouths. Whatever they needed, she provided. She was a substitute mother and a father confessor. She was there to ease their pain and provide dignity to their deaths.

No pictures at first. In the beginning, Herbrich came to know Annemarie and her "boys" before she brought out her camera. Then the photographer obtained permission from each person. Soon Herbrich was photographing everything.

Portraits

Beyond a record of the pianist's face, the picture echoes the mood of her jazz. Notice the hearing aid on the musician, who is partially deaf. (Photo by Karen Mitchell, *Gannett (Rochester) Newspapers.*)

THE STUDIO VERSUS NEWS PORTRAIT

Dr. Kenneth Edelin, obstetrician at Boston City Hospital, had just gone to a fancy downtown studio for a formal self-portrait to give to his wife on their wedding anniversary. A few days later, I photographed Dr. Edelin for a completely different reason. The district attorney of Suffolk County had charged Dr. Edelin with manslaughter for performing an illegal abortion. My paper wanted a front-page picture of the physician.

Both Dr. Edelin's studio portrait and my photojournalistic portrait contained a record of the doctor's features. The same face appeared in both pictures, but there the similarities stopped. First, Dr. Edelin chose to have his portrait made. Therefore, the studio photographer had to please one person — Edelin, the customer. I, however, went to Edelin's office to get a picture because he was in the news. I was imposing on the doctor's time and taking a picture that he certainly did not ask for and might even want to avoid. By telephone, I had persuaded Edelin to let me come and take up fifteen minutes of his day to shoot the news picture.

The studio portraitist took his time during the shooting session. He arranged the lights to flatter the subject, adjusting the main light to de-emphasize a double chin, moving the fill light lower to strengthen the line of the cheekbone. The studio photographer tried to subdue any blemishes to idealize or even glamorize his subject. After all, the studio picture was designed to last Dr. Edelin for years. My photojournalist's portrait had a much shorter life expectancy — a few days at most.

The job of the news picture was not to glamorize Edelin but to show why he was in the news. Although I couldn't record Edelin performing an abortion, legal or otherwise, I could at least use enough elements to indicate to the reader the doctor's profession. When I arrived at his office, Edelin was wearing a business suit. With the exception of his diplomas on the walls, the office gave little indication that it belonged to a doctor rather than to a lawyer or to an accountant. I noticed, hanging on the back of the door, a white lab coat. I asked Edelin if he ever wore the coat in the office and he replied that he had just taken it off before I came in. I asked the doctor to put on his lab coat, and after exposing a few frames in

his office, I suggested we go into his research lab. There I made additional pictures of him surrounded by microscopes and other paraphernalia of his profession. With the right background, dress, and equipment appearing in the photo, I hoped my editor and, ultimately, our 100,000 readers could immediately tell Edelin's type of work.

The studio photographer, on the other hand, had no interest in white lab coats and microscopes. His final portrait, with Edelin in front of a seamless roll of paper, would be seen only by Edelin's wife and their personal friends, who needed little reminder of the physician's profession.

Which photo truly captured Edelin's personality — the studio portrait or the photojournalistic portrait? The studio photographer tried to elicit a pleasing look from Edelin that seemed characteristic of the man. The photographer exposed six 4"x5" sheets of film. By comparison, I took many more shots with my 35mm camera as I discussed with Edelin the political implications of the charges against him. As he became engrossed in his story, explaining to me the details of the grand jury investigation, I made exposure after exposure.

When Edelin paid for his studio portrait, it was printed on matted stock, handsomely mounted and framed. When he bought his photojournalistic portrait, it appeared on newsprint, on the cover of the *Boston Phoenix*, and later it was printed smaller but on glossier paper in *Newsweek*.

■ EVEN A "MUG SHOT" REVEALS CHARACTER

In the trade, newspeople call a single picture of a person's face "a mug shot" or "a head shot" or "a head and shoulders." The casual, slightly derogatory terms indicate that the photo usually runs only about two inches square — one-column wide — in the newspaper. The photo is not meant to be a revealing study but merely to identify the subject.

You might ask why editors print these little postage-stamp sized pictures. Newspaper and magazine editors respond that their readers want to see what people in the news look like. Whereas a one-column photo won't stand alone in the paper, with a caption the photo will tell the reader about the subject's sex, age, and race. The mug shot also gives the reader an idea of the subject's personal characteristics, such as hair style, physical build, and general appearance.

T. Clayton Scott

TIGHT AND SIMPLE

The purpose of the often-used mug shot is to provide a clear, well-lit record of a subject's face. Photographers find this type of portrait easy to take. With a 105mm lens on a 35mm camera, the photographer needs to get only about four or five feet away to fill the subject's face in the camera's viewfinder. A 200mm telephoto lens proves handy if the photographer's movements are restricted, and the photojournalist is relatively far from the subject as often happens at a speech or press conference. Most photographers avoid wide-angle lenses for mug shots, unless they want to exaggerate purposely a person's nose or forehead.

VARIETY

George Tames, a retired Washington photographer for the *New York Times*, would shoot his subjects looking both left and right. "You never know on which side of

Even a "mug shot" can take on character when the photographer watches for the best moment. Michael Maher waited for this 80-year-old retired police officer to take a puff on his cigar. (Photo by Michael Maher, *Lowell (Mass.) Sun.*)

the newspaper page the editor will place the head shot, and editors like to have the subject facing into the page." In addition to a left and right shot, Tames provided his editors with a selection of photos showing different facial expressions. If the news story runs several days, such as in a murder trial, the editor will want to print for each issue slightly different head shots of the persons involved. Of course, if the outcome of the event is tragic, the picture editor will not want a smiling mug shot to go with the final day's story.

When shooting the mug shot, the photographer runs into the danger of sloppy technique and composition. The photographer takes a few quick shots, figuring that the photo will be small and mistakes won't be noticed. Too often, however, the head shot assignment winds up being played as large as a half page because no other picture is available. So keep in mind that the mug shot of today might appear on a newspaper's front page tomorrow or become next week's magazine cover.

ENVIRONMENTAL DETAILS TELL A STORY

From a mug shot alone, the viewer can't tell a banker from a bandit, a president from a prisoner. The wrinkles of a brow or the set of the eyes reveal little about a subject's past, profession, or newsworthiness. An environmental portrait, however, supplies enough details with props and choice of background to let the reader know something about the lifestyle of the sitter. In an environmental portrait, the subject is photographed at home, at the office, or on location, whichever place best reflects the story's theme. As in a traditional studio portrait, the environmental photo generally has the subject look directly into the camera. But rather than sitting the subject before a plain seamless paper background as in a studio portrait, an environmental portrait positions the person amid the everyday objects of his or her life. For instance, you might shoot a butcher holding a side of beef inside his walk-in freezer. I shoot environmental pictures whenever a portrait is needed, knowing the photo will probably play two columns or wider in the publication.

■ ARNOLD NEWMAN: SYMBOLS REINFORCE THEME

Arnold Newman, a master of the environmental portrait who has taken the official photographs of U.S. presidents, outstanding artists, and corporate executives, often arranges his portraits so the background dominates. The subject in the foreground is relatively small. In fact, one famous portrait of Professor Walter Rosenblith of the Massachusetts Institute of Technology shows him wear-

The portrait of Piet Mondrian, with its strong lines and rectangles, reflects the painting style perfected by the artist. (© Arnold Newman; ABOVE: Piet Mondrian, composition #33, courtesy The Museum of Modern Art.)

ing headphones with an oscilloscope in the foreground and a maze-like baffle system in the background. His face takes up a small percentage of the picture with the lines of the experimental chamber occupying the rest of the area.

Newman says that the image of the subject is important, "but alone it is not enough. We must also show the subject's relationship to the world." Newman goes on to say that "twentieth-century man must be thought of in terms of the houses he lives in, and places he works, in terms of the kind of light the windows in these places let through and by which we see him every day."

The power of Newman's photos lies in his choice of symbolic environmental details that

not only show the sitter's profession but the style of the sitter's work. For example, Newman photographed the modern artist Piet Mondrian at his easel. The artist is known for his exploration of pure shape and color (see opposite page). By creating a composition with the vertical bar of the easel juxtaposed against rectangular shapes on the wall, Newman's portrait of Mondrian suggested the artist's own style.

In the daring and stylistically original portrait of the Beatles' John Lennon and his wife Yoko Ono, the photographer explored the couple's intense psychological relationship. (Photo by Annie Leibovitz, *Rolling Stone*.)

For a portrait of Dr. Kurt Gödel of the Institute for Advanced Study, Newman arranged the sitter in front of an empty blackboard. The blackboard says to the reader, "Gödel — the academician"; the empty board says, "Gödel — the high-level thinker."

Although Newman might not think of himself as a photojournalist, his approach to the portrait is reportorial. He goes beyond the lines in the subject's face to tell his audience something about the person's work and life.

Technically, the environmental portrait does not differ from any other portrait. The photographer can use a normal or, if necessary, a wide-angle lens. Because the photographer wants to record the environmental background sharply, maximum depth of field is needed. You can increase the depth of field by stopping down the aperture to a smaller opening. This, however, requires a longer shutter speed. The camera on a tripod gives the photographer freedom to use longer exposures if the subject can hold still.

PSYCHOLOGICAL PORTRAITS

■ ANNIE LEIBOVITZ: BUILDING A PORTRAIT

For portraits of personalities like Mick Jagger or Paul Newman, the viewer has a frame of reference — the viewer knows the face, has seen the personality on television, in the movies, and on magazine covers. By the time Annie Leibovitz, who has shot many covers for *Rolling Stone* and *Vanity Fair*, photographs the celebrity, the viewer probably has read about the person in gossip columns or heard interviews on talk shows.

Leibovitz tries to go past a visual topographic map of the face. Her pictures ask the question: What makes this person famous? What is the psychological factor that separates this individual from others in the field?

Leibovitz is not interested in showing the viewer details of the subject's life or lifestyle. She does not depend on found items in a celebrity's house or office on which to build the picture á la Arnold Newman. She is not waiting and watching for a candid moment in the style of Cartier-Bresson. Rather she imagines what the picture *ought* to look like. Then she creates that look.

Portraits don't always have to be an individual picture. In this case, this person's transformation from man to woman provides a more telling psychological portrait than any single picture could. (Photos by Sibylla Herbrich.)

For instance, Leibovitz photographed Dennis Connor, captain of the winning America's Cup racing team, wearing a red, white, and blue shirt, wading in a pond, sailing a toy boat. Although the America's Cup challenge represents millions of dollars in investments and winnings, the picture caught Connor's little-boy spirit. Leibovitz did not happen upon Connor wading one afternoon in the pond. She and her stylist bought the props, dictated the clothes, and located the perfect pond.

Leibovitz builds a picture rather than takes a picture. In conjunction with the subject, she dreams up a visually startling way to portray that individual. Leibovitz, for example, photographed the black actress Whoopi Goldberg in a white bathtub filled with milk.

The *Vanity Fair* photographer has a remarkable ability to coax celebrities to cooperate. She persuaded John Lennon to lie, nude, curled in a fetal position around his wife, Yoko Ono. She cajoled Meryl Streep, the multifaceted actress, to wear white face paint while pulling out the skin of her cheek as if it were a rubber mask.

Leibovitz's pictures lie somewhere between psychological portraits and photo illustrations. Her mannered, stylized approach has influenced many other magazine and newspaper photographers.

PORTRAIT ELEMENTS

By means of pictures, the photojournalist tells a story about a subject. The portrait of a scientist shouldn't look like that of a steel worker. An aggressive personality deserves a different portrait from a shy and retiring type.

Three elements add to the story-telling nature of a portrait. First, a subject's face, hands, and body position reflect the psychological state of the sitter. Is the subject smiling or showing a grim face? Are his hands pulling at his beard or resting at his side? Is he standing awkwardly or comfortably?

Second, the location of the picture and props held by the subject tell the viewer something about the profession, hobbies, and interests of the subject. A portrait taken in a dark factory, with the worker holding a wrench, says something different about the sitter than a portrait taken in a pristine office with the accountant seated at a computer.

Third, an equally powerful message carried by the photo depends on the light and composition of the picture. A heavily shadowed portrait, for instance, might look foreboding. An off-balanced composition could add tension to the picture.

■ CLUES TO THE "INNER PERSON"
FACE

Of all the elements in a photo, the face still carries a disproportionate amount of psychological weight. Studies show that children, almost from birth, recognize the basic elements of a face, including the eyes, nose, and mouth.

Most people assume they can read something about a person's personality from his or her face. How often have you thought, "That man looks sneaky, I wouldn't trust him"? Or, "That person looks friendly, I'd like to meet her" — all reactions based on a glance at the person's face.

Whether true or not, people assume that the face is the "mirror of the soul." If the face is the soul's reflection, then the soul is multidimensional. Even the most sedate face reflects a surprising number of variations. Take a thirty-six exposure roll of film of one person's face as she talks about her favorite topic. Note the number of distinctly different expressions the person exhibits. Is one frame of those thirty-six pictures true to the nature of the person? Have the others missed the essence of the underlying character of the subject? Arnold Newman says in his book ***One Mind's Eye***, "I'm convinced that any photographic attempt to show the complete man is nonsense. We can only show what the man reveals."

The photojournalist usually selects an image of the subject talking, laughing, or frowning, an action coinciding with the thrust of the news story. When a recently appointed city manager expressed fear about his new job, the photo showed him with his hand massaging his wrinkled brow. A year later, a story in which the city manager

Eyes looking straight at the camera establish a strong bond between the reader and the artist in this picture. Also, this direct eye contact tells the reader that the picture is a portrait, not a candid. (Photo by Ken Kobré for *The Boston Phoenix*.)

talks about his accomplishments might require a picture of him talking and smiling. The photojournalist's portrait doesn't reveal a person's "true inner nature" as much as it reflects the subject's immediate response to his or her present success or predicament.

EYES

Where should the subject look? Early journalism portraits taken around the turn of the century showed the sitter staring into the camera's lens during the prolonged time exposures. During the Depression, Farm Security Administration subjects seemed always to stare off into space. Portraits taken during the '60s and '70s often showed the subjects looking as if they were in action, never noticing the camera's presence. More recent portraits have tended to return to the turn-of-the-century stare. Photographers today point out that the viewer gets most involved with the subject of the portrait when the two make eye contact.

WATCH FOR GESTURES

The hands of Massachusetts' former Secretary of Human Services, Jerald Stevens reveal the pressures and pleasure, tension, and relaxation of this powerful state official. (Photos by Bill Collins.)

In the photo, a handwritten sign reads:

ARTHUR B. CHERRY
RETIRING AT AGE 92
EVERYTHING TO BE SOLD
AT DISCOUNT

Besides, photographers argue, direct eye contact is honest. When the subject looks straight into the camera's lens, the reader knows that the subject was aware of the photographer. This technique removes any hypocrisy or illusion that the photographer took the photo in a candid manner. This convention — subject looking directly into the lens — like many others, will change over time.

HANDS

Hands help tell the news in a nonverbal way. A news photographer covering a speech won't even bother to click the shutter until the lecturer raises a hand to make a point. When shooting a portrait, watch the individual's hands as she toys with her hair, holds her chin, or pushes up her cheek. A person chewing her fingernails reveals a certain amount of tension about the situation in which she finds herself.

BODY LANGUAGE

Desmond Morris wrote an excellent book, ***Manwatching, A Field Guide to Human Behavior***, for those interested in improving their observational skills. Morris documented various types of gestures and signals that people use to express inner feelings. The way an individual stands, whether as straight as a West Point cadet or as bow-legged as a cowboy, might clue the reader about the subject's upbringing. Studying ways people communicate nonverbally can sensitize the photographer to good picture possibilities.

Photographing the retired dentist among the tools of his long career adds much information to this environmental portrait. (Photo by Michael Grecco, Picture Group.)

When body language speaks clearly, the photographer grabs the shot.

■ COMPOSITIONAL ELEMENTS ADD IMPACT

BACKGROUND

As with the selection of props, choice of background can transform an ordinary snapshot into a revealing portrait. Sometimes the subject knows just the right spot for a portrait. Other times the photographer must scout out the location. Tames of the *New York Times* recalls using his reading of the day's news and the particular assignment to enter the senator's or representative's office with a "battle plan." By knowing his subject ahead of time, he said, "I can take control of the situation." Eisenstaedt, of *Life*, wrote, "By now I've learned that the most important

thing to do when you photograph somebody in a room or outside is not look at the subject but at the background."

Tames and Eisenstaedt concentrate on the background behind the subject for two reasons. One, the background details help report the story. The rundown shack of the sharecropper tells us about the farmer's problems. The plush office of a new corporate executive indicates one of the job's advantages. Two, the background affects the "readability" of a photo. Readability means that the subject must not get lost in the details of the environment. In a black-and-white photo, a dark subject can blend into a dark background, never to be seen again. You are about to photograph a white-haired man standing in front of a light wall. When you shoot the picture, the man's hair seems to disappear into the wall. To avoid this problem, place the man in front of a dark wall, and his hair will not disappear.

Because the world is colorful, the photographer might not remember that a red-shirted Santa Claus standing in front of a green Christmas tree background might blend together when photographed with black-and-white film. The reason for this is that red and green are different hues but can be of equal brightness; therefore, the film records them as nearly matching shades of gray. Santa Claus might look as if he were growing out of the tree in the black-and-white print. The photographer can improve readability by choosing a background setting with a tone that contrasts with the subject. You could place Santa Claus in front of a light-toned wall, for instance.

Light as well as background tone helps define the subject. If the person you are shooting has dark hair, the light hitting the back of the subject's head will create a highlight, thereby helping the subject stand out. If you could direct some light toward the back of Santa's head, the resulting hair light will help to separate Santa from the background.

A busy, multitoned background can clutter up any picture, distracting the viewer's attention from the main event. Keep in mind that a further complicating fac-tor is that the subject-background tonal difference decreases when the photo is reproduced on coarse newsprint.

LIGHTING

Light can set the mood of a picture. When photographers shoot a picture that is lit brightly but has only a few shadows, the photo is called "high-key." In pictures of brides, photographers often employ high-key lighting because they want to give an upbeat mood to the photo.

When a somber effect is desired, however, the photographer chooses lighting that will leave large areas of the picture in shadow. The photo's dominant tones are dark gray and black. At night, a tough police chief involved in a crime clean-up story might be photographed with the available light of a street corner. The lighting's moody character coincides with the story's thrust.

To add depth to a subject's face, arrange the person so that the main light, whether it is flood, flash, or window, falls toward the side of his or her face. Side light, as compared to direct frontal light, adds a roundness and three-dimensional quality to the mini-portrait. Side light also emphasizes the textural details of the face — a technique especially suited for bringing out the character lines in a person's features.

Alternatively, Hollywood photographers light starlets with a large flat light located near the camera's lens to eliminate any shadows. Shadowless light, sometimes called "butterfly" lighting, tends to eliminate wrinkles, giving a youthful look to the subject in the photo. (See more on lighting in Chapter 11, "Strobe.")

COMPOSITION

Suppose your editor assigns you to photograph a banker. You size up the situation and decide to show the banker as a stable person in the community. You might want to position the person in the middle of the frame, lending balance and therefore dignity to the picture. You have used composition to help tell your picture story, convey-

For a portrait of the owner of an audio-visual company, the photographer incorporated this light pattern into the picture. (Photo by Yoshi Shimizu.)

In black-and-white, the subject will appear to blend or pop out depending on which background the photographer chooses.

PORTRAIT ELEMENTS

Using a macro lens allowed the camera to come in unusually close for this portrait of a poet. A strobe inside a soft box provided light for the photo. (Photo by Ken Kobré for the San Francisco State Annual Report.)

ing to the reader the point you wish to make about the banker.

Suppose, on another day, you are assigned to photograph the director of the Little Theater, an off-beat dramatic group. You want your picture of the director to be as exciting and tension-producing as a good Hitchcock thriller. By placing the director of the theater on the edge of your viewfinder and leaving the remaining area black, you can produce an off-balanced picture that gives added visual suspense to a photo.

The effect of the final picture changes, depending on whether the photographer fills the frame with the sitter's face or stands back for a full-length portrait. An extreme close-up, for instance, appears to bring the subject so near that the viewer gets the feeling of unusual intimacy with the sitter.

When I photographed the director of a Poetry Center, I used a macro lens, which allowed me to bring my camera within a few inches of the

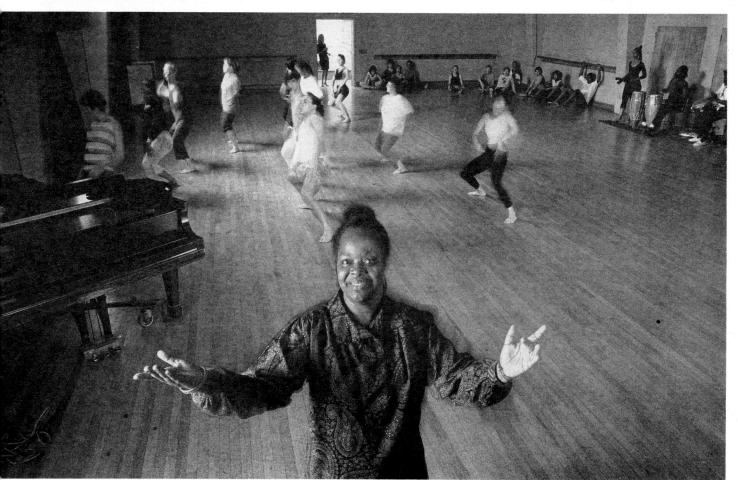

The director of the Ethnic Dance program was stiff and formal in her office. Once in the rehearsal hall, with the music playing in the background, she started to move to the music's beat. (Photo by Ken Kobré for the San Francisco State University Annual Report.)

man's face. The resulting portrait of the poet gained impact because I broke the unwritten but traditional space barrier, which is about three or four feet in normal conversation. With my camera, I had invaded the writer's natural "psychological space" to produce this personal portrait. The extreme close-up lent the portrait a unique perspective by concentrating the viewer's attention solely on the sitter's eyes and facial features.

Body language and choice of clothes can also reveal personality characteristics of the sitter. To capture these elements, the photographer must take a step backwards to include in the composition the full length of the subject. Sometimes an overall photo can reveal more than a close-up showing only the face.

■ PUTTING YOUR SUBJECT AT EASE

If a subject doesn't feel comfortable in front of the camera, the best photojournalistic techniques in the world won't produce a revealing portrait. When a photographer disappears behind the camera, even if it is a relatively small 35mm, the photographer loses eye contact with the subject. The subject is left alone to respond to a piece of coated glass and a black mechanical box, items not conducive to stimulating conversation. To loosen up and relax the subject, each photographer has developed his own technique. Keep in mind that an approach that works for one photographer might not work for you. Here are some choices to consider.

STIMULATING A REACTION

Chip Maury, who worked for the wire services and thus had little time to wait around for his photos, used the shock approach. When taking a head shot of a staid individual, he would ask the person to say his or her favorite four-letter word. The effect certainly works better than asking the person to say "cheese." For another approach, I ask the person to say the "ABCs" in a conversational tone. No subject thus far has reached "Z" without laughing.

CREATIVE BOREDOM

When you have time, the boredom technique works well; if you hang around long enough, often the subject gets tired of posing, and you can shoot natural-looking photos that result in casual, relaxed portraits.

Arthur Grace, a *Newsweek* magazine staffer, says that "once you put people in a location, you just wait and

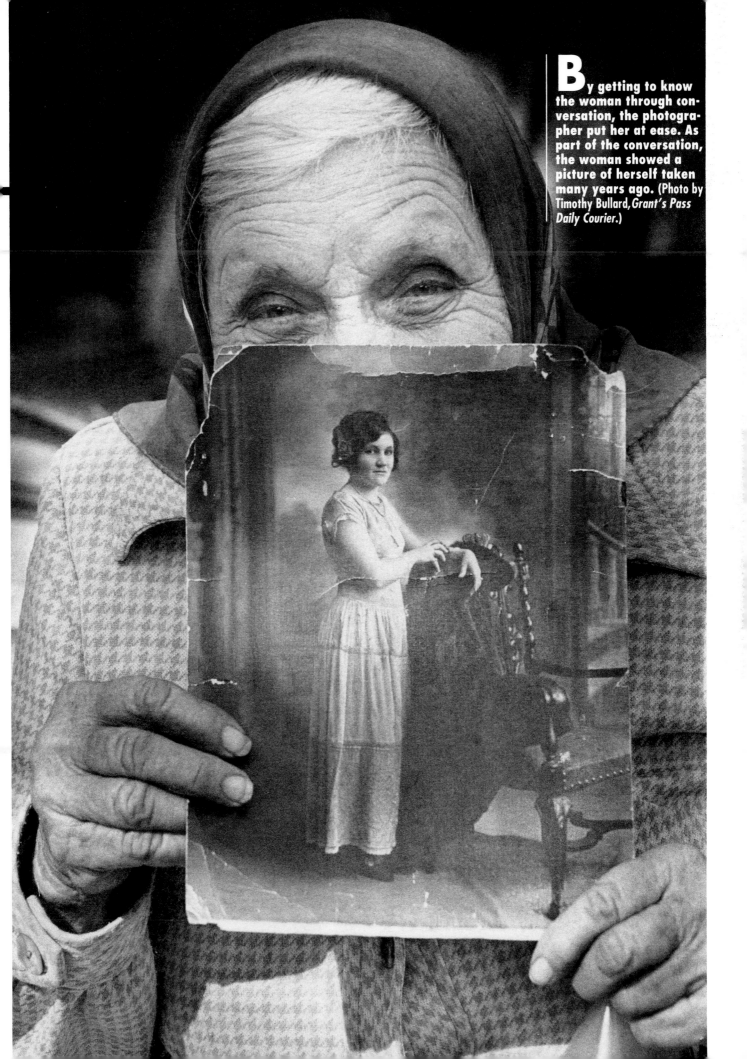

they will get lost in their own thoughts." Grace just sits there. "Maybe I'll take one frame to make them think that I've started, but I haven't." Eventually, the subjects get so bored they forget they are having their picture taken and they relax. That's when Grace goes to work.

CONVERSATION

One of the most enjoyable aspects of photojournalism is meeting different kinds of people. Conversations with subjects often loosen them up. During a shooting session, the talk usually turns to why the person is in the news. When they become engrossed in explaining their involvement, they forget about the camera.

Sometimes photographers should research their subject. To photograph the newly arrived Jimmy Carter in 1976, Washington-based George Tames read Carter's book, **Why Not the Best.** Tames says he tried to know enough about his subject for a preconceived notion of "what I was going to get before I got there." Tames would calm his subject down with "strokes." He massaged their egos —

who can resist that? Tames put subjects at ease because they sensed he was their friend. "I have never deliberately made a bad picture of anyone," Tames says. His media-conscious subjects knew Tames' reputation for honesty. Tames never shot a roll to the end because he found that as soon as he put his camera down, the conversation would liven up. He used those last frames to catch the subject-uninhibited and animated.

The photographer took command of this situation by having a person dress up in the gorilla suit and pose between the owners of the costume shop. (Photo by Sandy Shriver.)

TAKE COMMAND

The difference between the veteran Tames and a shy young photographer is that the *New York Times'* camera-man took command of the situation rather than holding back. "You have to learn to influence politicians in a way that they will do what you want them to do," he explains.

ONE SUBJECT: MANY INTERPRETATIONS

Photographers can find an infinite number of ways to photograph anyone. The only limitations are the photographer's creativity and the subject's time and patience. Each picture highlights a different aspect of this subject's personality, physical characteristics, or profession.

 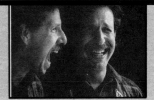

 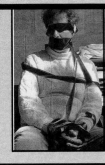 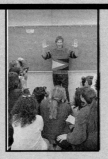

(FROM LEFT TO RIGHT, PHOTOS BY:
FIRST ROW: Naomi Malig, Stephanie Martin, Sandie Witbeck, Kaia Means.
SECOND ROW: Angela Hayes, Eric Slomanson, John Burgess, Monica Davey,
THIRD ROW: Herman Segovia, Eugene Kettner, Jeff Vendsel, Ward J. Austin.
FOURTH ROW: Stephanie Martin, Eric Slomanson, Kaia Means, Eric Slomanson. FIFTH ROW: Chiaki Kawajori, Chiaki Kawajori, Nelson Carrera.)

In a group portrait, try to stagger the placement of heads to allow each to occupy a different level. This arrangement maximizes the size of each face. (Photo by Vincent S. D'Addario, Springfield (Mass.) Newspapers.)

ANOTHER INTERVIEWER

Because it's often difficult to work the camera and carry on a meaningful conversation simultaneously, I have found it valuable to shoot pictures while the subject is being interviewed by a reporter. I took lively pictures of Marcel Marceau, the French mime, as he was busy talking to a reporter from my paper. The Frenchman was far too engrossed in the conversation to care about me or my camera. Before the interview started, I carefully placed Marceau so that he would be side-lit. Then when I sat side by side with the reporter, I could take unobstructed candid portraits. Also, without disturbing the interview, I changed lenses and moved around the room to capture Marceau from a variety of positions and angles.

If an interviewer does not accompany me on a story, I often will take a friend along on the assignment. When no outsider is available, I will look for someone on location, like the subject's colleague, to whom the subject might enjoy talking. As the subject becomes involved in conversation, he unfreezes and his face becomes animated, producing a better picture.

He was frank with them. He would tell a senator, "Look, this is only going to run one column, I need you to stand by the window and smoke your pipe." The senator responded because Tames exuded professionalism. Tames says, "Anytime I could control the situation I did. I shot candids only when I had to." But Tames also knew when not to push his subjects too far. "I could tell immediately when enough is enough," he says.

USE A TRIPOD

One of *Life*'s original staff photographers, Alfred Eisenstaedt emphasizes the psychological side of the portraitist. "You have to be able to sense very quickly when you meet someone whether you can back-slap him and call him by his first name right away, or whether you must be reserved and formal on your first meeting." Sensitive to his subject, Eisenstaedt avoids the disruption of picking up and putting down the camera by using the tripod and cable release technique. He puts his camera on a tripod and focuses, which frees him to talk directly and keeping eye contact with his subject while snapping pictures. "For me," he says, "this method often gives the most relaxed pictures."

GROUP PORTRAITS

■ SHOW ALL THE FACES

A prime requirement of a formal group picture is that it shows, as clearly as possible, each person's face. This takes careful planning. Arranging people shoulder to shoulder might work, but if the group grows to more than a few people, the line will be excessively long and each person's face will appear quite small in the final print. Instead, you could arrange the people in rows, one row behind the other. Typically, you want to have the short people in the front and the taller ones in back. With

an extremely large group like a band or a football team, you have little choice but to arrange the members, military style, at different levels but in a fixed formation.

SOFT LIGHT IS BEST

For group portraits, soft light that creates the minimum of shadows is usually the most effective. If you can, avoid lighting that creates strong, well-defined shadows typical of a bright, sunny day. When you must take a large group portrait on a perfectly clear day, look for the open shade of a tree or large building to provide even lighting.

■ ADD ZEST TO SMALL-GROUP PORTRAITS

TRY DIFFERENT LEVELS

When the assembly is limited to between three and eight members, creativity is possible. Try to keep each person's head on a different level. With a combination of kneeling, sitting, and standing, you usually can arrange an attractive juxtaposition of heads so that each is spatially located on a different elevation. The closeness of the bodies holds the picture together as a unit; the staggered arrangement adds visual interest.

TRY COMMON CLOTHING

A group of clowns in costume could lighten up a graduation picture at the Ringling Brothers Clown School.

HAND 'EM PROPS

A cooking class holding spatulas and saucepans would serve up a picture of their activities.

WATCH THE BACKGROUND

Women welders in front of the foundry where they work would reinforce the viewer's understanding of this group's profession.

POSE CARRIES INFORMATION

A group of teen-agers slouching in front of a low-slung car tells a different story than the same group posed sitting in classroom chairs.

"JUST-ONE-MORE"

Finally, knowing the location of the door is just as important as knowing the location of the shutter. With a few frames left at the end of the roll, just in case, you should pack your gear before you wear out your welcome. Photographers have a bad reputation for asking for just one more picture. Leave in good standing with your subjects because you never know when they will be in the news again and you will need to make a new portrait. ■

Sports

Shooting sports requires the same concentration as playing the game. The photographer needs practice, fast reaction time, and stamina. (Photo by John Coley, *Palm Beach Post.*)

Thinking he had won, the biker on the left raised his hands just before the finish line. The biker on the right passed him at that moment. This sports news photo leaves no doubt in the viewer's mind which cyclist won the race. (Photo by Scott R. Linnett, *San Diego Union-Tribune*.)

SPORTS AS NEWS

■ PHOTOGRAPHER AS ATHLETE

Sports photographers are like athletes. They must have the aim of a football quarterback, the reflexes of a basketball guard, and the concentration of a tennis player.

Sports photographers talk about getting in slumps just as baseball players who are having trouble at the plate get into ruts.

"Sometimes I will go about twelve days without getting a good picture," says Frank O'Brien, long-time sports photographer with the *Boston Globe*, "then I will have a good streak and my stuff is fresh and exciting." O'Brien warns photographers not to get uptight when they're in a slump because the extra tension will make their eye-hand coordination even worse.

Just as players on the field cannot lose their concentration, so photographers on the sidelines must be aware of every subtle movement in the game. O'Brien says he doesn't even talk with his fellow photographers during a game because conversation breaks his concentration. Pam Schuyler, who photographed for the Associated Press and produced a book about the Celtics basketball team, commented that she won't even sit next to other photographers when she is shooting basketball pictures because the other photographers distract her too much.

Sports photographers strive to create an image on film that captures in a unique way the fast-paced action and drama of competition.

■ TIMELY PHOTOS PARAMOUNT

A good sports photo and a well-written news story have similar characteristics: both are timely and both have high reader interest.

Timeliness in a sports picture is essential. Nobody cares about a week-old game score, but millions of viewers stay up to see scores on the eleven o'clock newscast. Interest is so high in sports that millions of people watch the World Series on television, and even more see the summer and winter Olympics.

Sports is big business, and the financial side of football or baseball rates as much attention as any other business story. Players are bought, sold, and traded for thousands of dollars: clubs approach the bidding block, ready to spend millions for promising superstars. Readers want to see pictures of these superstars sinking a basket, knocking a home run, or winning a marathon. Editors are aware of this star-gazing. During my interview with George Riley, who used to shoot for UPI, he commented that "a paper is more likely to run a picture of a top star hitting a home run than a lesser player doing the same thing, even if the pictures are equally good."

So sports photographers have to become sports fans; they must read regularly the sports section of the paper to learn who the top stars are, and what newsy things have happened to them lately. O'Brien says he combs the sports pages every day to pick up information on a player he might have to cover. He looks for stories about injured players and major trades, about fights and feuds among players and between players and coaches, about impending records, and about disputes over money. O'Brien also checks the paper to see if a player is having a hot streak that week. This news angle adds an extra dimension to a sports photo. If a player has made news on the sidelines, readers will want to see what that player will do on the court or the field.

When Hank Aaron hit his 715th home run to break Babe Ruth's career record, every camera in the stands clicked because the event was big news. A broken record is history in the making. As sportswriter George Sullivan told me, "One job of the newspaper is to record history." In baseball, especially, there seems to be an almost endless array of records to break. Surely, the record book has listed the left hander who had the most hits during an out-of-town night game pitched by a southpaw.

Photographers can't memorize the record book, so they should check with the statistician before every game to see if any new records are likely to be broken. A record-breaking homerun or free-throw might be the most newsworthy moment of the game, and an editor will want to see a picture of the event.

■ SUMMARIZING THE GAME IN ONE PHOTO

A sports story's lead usually contains the names of both teams or players and the outcome of the game. It also describes the game's highlights — the turning point or winning goal, the star of the game, and injuries to important players. Knowledgeable sports photographers follow the game closely enough that their pictures complement the story's lead.

"I always try to develop the lead picture that will parallel the thrust of our wire story," explains Riley. "UPI will often play up the top scorer in the game, so I will need a picture of him in action." If a particular play changes the course of the game, the photographer should have a shot of this play on film.

A good sports photographer watches all the action but doesn't stop when the final gun goes off. Sometimes the expression on the athletes' faces after a tense meet tells the story better than an "action" shot.

The *Globe*'s O'Brien says that at the end of a game, he looks for the crowd's elation or anything else that will characterize the game's emotional flavor. "Sometimes," he says, "these postgame photos are more reveal-

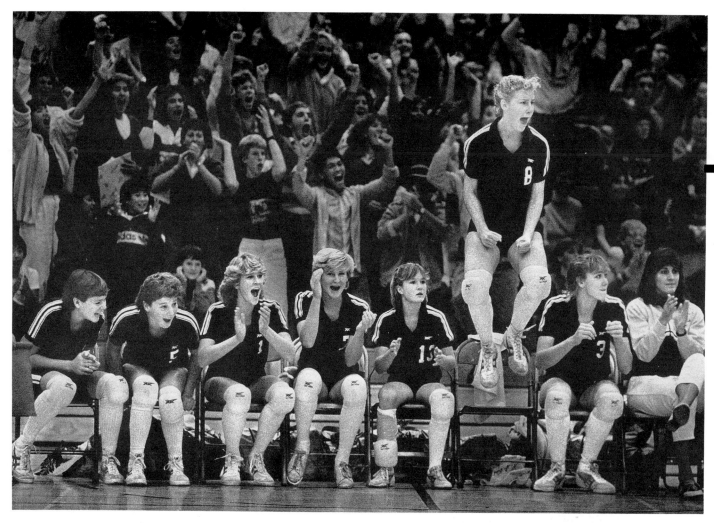

ing and have more story-telling value than a crisply focused action photograph of the critical play."

■ CATCHING REACTIONS ON AND OFF THE FIELD

The sports photographer looks for the interesting, the unusual, the emotional, the unexpected, both on and off the field. What's happening on the bench can be as interesting as what's happening on the field. "Whenever I shoot sports, I simultaneously watch the field and the sidelines," says the *Globe*'s O'Brien. "I lose some action plays sometimes, but I get great emotional, story-telling pictures this way."

 Coaches are under tremendous pressure because their jobs are on the line every time the team takes the field. A picture of a coach pacing the sidelines, yelling at the referees, or jamming his finger at other coaches can reveal his underlying tension. Players feel that same pressure. The clenched jaw of a player sitting on the sidelines or the wince of an athlete wearing a cast could also tell the evening's story.

■ CAPTIONS NEEDED

Whether the picture shows critical action on the field or reactions off, the photographer must have complete caption information. The caption, as it is called in a magazine, or cutline, as it is known in a newspaper, is the explanatory line of type usually below the printed photograph.

 If it is not obvious from the picture, a caption should answer the five Ws plus the H: Who? What? When? Where? Why? and How? Readers will know that the photo depicts a basketball game if a basketball is in the picture. But they might not know whether the picture was taken in the first or last quarter of the game, or the identity of the players, or the significance of the play.

Good sports photographers keep an eye on the bench as well as on the action. (Photo by Lui Kit Wong, *Virginian-Pilot*.)

 A photographer's nightmare is to bring back 200 shots of a game, develop the negatives, select one frame with excellent action, and then not know the names of the players, what happened, or when the action took place. Fortunately, players wear large numbers on their uniforms. If the numbers are visible in the print, the player can be identified by matching the number against the roster list in the program. To determine when the play occurred, one old trick is to take a picture of the scoreboard after each major play or at the end of each quarter. By working backwards on the roll from the scoreboard frame, the photographer can determine when each shot was taken and which play led to which scores.

 Play-by-play statistics sheets, available from officials after the game, also help photographers write accurate captions. Besides shooting frames of the scoreboard, sophisticated sports photographers usually take notes during the game. In baseball, there is time to record each play if you use a shorthand notation (for example FB = first base, HR = home run). In football, jot down a short description after each play. Riley comments, "Keeping track of the plays can get tricky at times. This is where newcomers usually have the most trouble in sports pho-

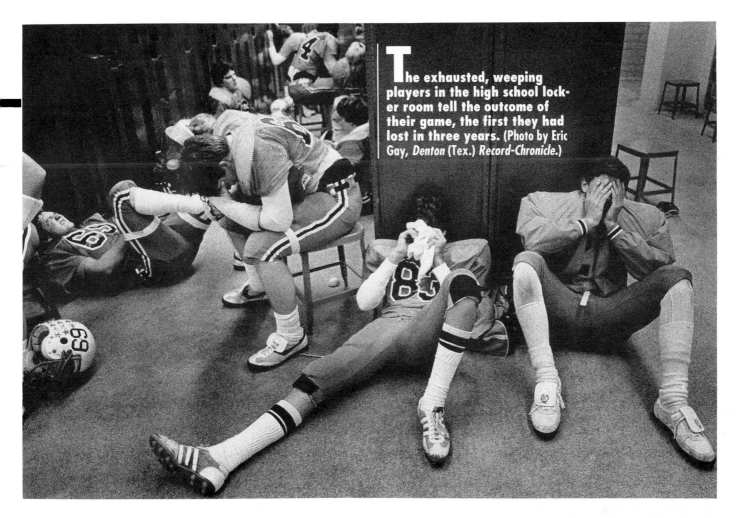

The exhausted, weeping players in the high school locker room tell the outcome of their game, the first they had lost in three years. (Photo by Eric Gay, *Denton* (Tex.) *Record-Chronicle*.)

tography." (See Chapter 9, "Photo Editing," for more on caption writing.)

SPORTS
AS FEATURES

Sports might be as timely and may command as much reader interest as any story in the newspaper. But sports events aren't hard news — they're entertainment. A football game, no matter who wins or loses, is still a game. You might have a side bet resting on the World Series, but the outcome of the game will not affect your life beyond giving a moment's elation or depression (unless, of course, you've staked your savings on your favorite team).

When looking for features, draw your lens away from the field action to view the fans in the stands. Diehard fans go to great lengths to show their support for the home-town team. From funny signs to outrageous outfits, fans come prepared to root or rout the players of their choice.

Players themselves can also provide grist for funny pictures. For many athletes, the pleasure of playing has never been lost. During the game, keep your eye on the dugout or the bench.

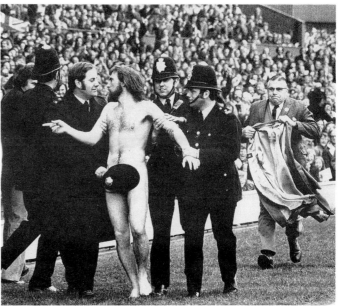

This feature of an accountant streaking across a rugby field proved far more interesting than any action photo of that day's match. (Photo by Ian Bradshaw, *London Sunday Mirror*.)

Sports is entertainment and therefore provides good, sometimes unpredictable feature material, such as this unsuccessful attempt to catch a stray parakeet by Ranger catcher Jim Sunberg. (Photo by Gerald R. Schumann, free-lance.)

Try to get into the locker room after the contest is over.

The news approach to sports usually involves getting sharp, freeze-frame action shots of players hanging suspended in midair, grasping for the ball. Sometimes this literal approach robs the sports photo of its most vital element — the illusion of motion. A more impressionistic feature approach can add drama and reinforce motion in a still photograph. Certain camera techniques can heighten the effect. A sports photographer might pan a cyclist's action by setting the camera on a slow shutter speed and following the subject with the lens, intentionally blurring the background while keeping the subject sharp. (See page 105.) Such a picture can have more impact than would a traditional news photo of the winner of the bicycle race, in razor-sharp detail, crossing the finish line.

In a sports feature photo, the photographer ignores the critical winning moment in favor of capturing the atmosphere of the event. Impressionistic pictures of

this kind transcend the actual event and become a universal statement about the sport. A bone-crushing tackle made by a football player may resemble a delicate pirouette when captured by a skilled photographer. In **Man and Sports**, a photo exhibit and catalogue produced by the Baltimore Art Museum, the outstanding sports photographer Horst Baumann said that there is an increasing appreciation for the impressionistic, nonfactual but visually elegant portrayal of sports.

TECHNIQUES OF THE SPORTS PHOTOGRAPHER

■ FREEZING ACTION

Sports photography requires specialized technical skills because of the speed at which the athletes move and because of the limitations of position imposed on the photographer. To stop motion in action sports like baseball, football, and basketball, photographers try to shoot with a shutter speed of at least 1/500 sec. Says Eric Risberg, a top sports shooter for the Associated Press, "The slowest I ever shoot is at 1/500 sec. At a 1/1000 sec. things get a lot sharper."

Four factors affect the apparent speed of a subject and therefore determine the shutter speed:
1) the actual speed of the subject;
2) the apparent distance between subject and camera;
3) the focal length of the lens;
4) the angle of movement relative to the camera's axis.

SPEED

You will need a faster shutter speed to stop or freeze the action of a track star running a 100-yard dash than you will to stop the action of a Sunday afternoon jogger. To freeze a sprinter, the shutter must open and close before the image of the runner perceptibly changes position on the film. Therefore, the faster the subject runs, the faster shutter speeds you must use to stop the action and avoid a blur on the film.

DISTANCE

A second factor affecting the image on the film is the camera-to-subject distance. If you stand by the highway watching speeding cars go by, you may observe them zoom rapidly past you; but when you move back from the edge of the highway 100 feet or so, the apparent speed of the cars is considerably less. Speeding cars on the horizon may appear to be almost motionless. Translated into shutter settings, a general guideline for this effect is that *the closer the camera is to the moving subject, the faster the shutter setting needed to stop or freeze its movement.*

	Type of motion		Camera-to-Subject Distance		
			25 feet	50 feet	100 feet
SHUTTER SPEEDS FOR ACTION PARALLEL TO FILM PLANE	Very fast walker	(5 mph)	1/125	1/60	1/30
	Children running	(10 mph)	1/250	1/125	1/60
	Good sprinter	(20 mph)	1/500	1/250	1/125
	Speeding cars	(50 mph)	1/1000	1/500	1/250
	Airplanes		———	———	1/500

LENS LENGTH

Whether you get the camera closer by physically moving it toward the subject or remaining stationary and attaching a telephoto lens, thereby bringing the subject apparently closer, you must increase your shutter setting to freeze the action. Suppose you are 50 feet away from the track with a 55mm lens. A shutter speed of 1/500 sec. would be adequate to get a sharp picture of a car speeding at 50 mph. However, if you keep the same lens but move forward to within 25 feet of the railing, you must set the shutter at 1/1000 sec. to freeze the car's movement. If you change from a 55mm to a 105mm lens but still remain at the 50-foot distance, you would still have to use 1/1000 sec. shutter speed (see diagrams on this page). The rule is this: *when you halve the apparent camera-to-subject distance, you need to double the shutter speed to get the same representation of motion.*

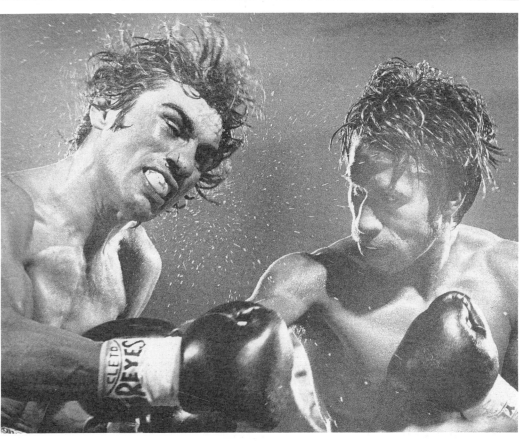

With an 85mm lens, the photographer needed a shutter speed of at least 1/500 sec. to stop the sweat flying off these fighters' faces. (Photo by Jim McNay.)

SHUTTER SPEEDS REQUIRED TO FREEZE ACTION

SPEED OF CAR (MPH)	SPEED OF CAR			DISTANCE TO CAR			DIRECTION OF CAR			LENS FOCAL LENGTH		
	25 MPH	50 MPH	100 MPH	50 MPH	50 MPH	50 MPH	50 MPH	50 MPH	50 MPH	50 MPH	50 MPH	50 MPH
100'				car								
DISTANCE FROM CAR TO CAMERA — 50'	car	car	car		car		car	car	car	car	car	car
25'						car						
										WIDE	NORMAL	TELE
SHUTTER SPEED	1/250	1/500	1/1000	1/250	1/500	1/1000	1/500	1/250	1/125	1/250	1/500	1/1000

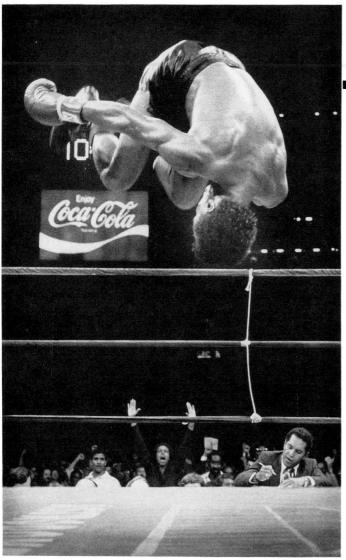

motion is over. He can't go any higher, and, for a split second, his vertical motion will cease before gravity pulls him back to earth. A basketball player shooting a jump shot follows the same pattern: he leaps into the air, reaches his peak, hesitates, and then shoots the ball before he begins dropping back to the floor. A pole vaulter's leap is another example of this type of motion. A sports photographer can use a slower shutter speed to stop action at the peak of the vault by anticipating where the peak will occur and wait for the athlete to reach the apex of the arc.

PANNING

While a fast shutter speed allows the photographer to catch the action of the play, the resulting frozen figure may not capture the essence of the sport. Freezing a player in mid-air can rob the photo of any illusion of movement. To solve this problem, you can use a technique known as panning: use a slow shutter speed and follow the subject during the exposure. This technique produces a picture with a relatively sharp subject but a blurred and streaked background. A pan shot is dramatic and can make even the proverbial "Old Gray Mare" look like a triple-crown winner running at breakneck speed.

On sports assignments for *Life* magazine and *Sports Illustrated*, Mark Kauffman has tried the panning technique on several different events. In ***Photographing Sports***, a book about his work, Kauffman said, "Panning is something like shooting in the dark. It's practically impossible to predict the final result. Background colors will move and blend together giving shades and tones and creating hues which we cannot predict."

If the photographer doesn't follow the subject smoothly, the image won't be sharp enough. Many photographers can't afford to risk a pan shot because the editor counts on having at least one tack-sharp photo of the principals in the event. Therefore, the photographer never gambles solely on a pan shot for an important news assignment. "When on assignment," Kauffman cautions, "get the picture the editor needs first — then, if you have time, experiment with a pan."

The choice of lens is critical in panning. A long lens allows the photographer to back off from the subject. The farther the camera is from the subject, the slower the photographer can pan — thus achieving more control. The lens, however, must allow a field of view that is wide enough to accommodate the anticipated action.

In panning, use your eye-level viewfinder to spot the subject as it moves into view. Pivot your head and shoulders so that you keep the subject in the viewfinder at all times. When your subject is in view, release the shutter without interrupting your pivot. Be sure to follow through after you snap the shutter. The trick is to have the camera moving at the same speed and in the same direction as the subject.

ANGLE

The angle of the subject's movement relative to the axis of the camera also affects choice of shutter speed. A car moving directly toward you may appear to be nearly stopped because its image moves very little on the film. Yet the same car moving at the same speed, but this time moving across your line of vision, may appear to be traveling quite rapidly. This phenomenon means that if you position yourself to photograph a car 50 feet away going 50 mph moving directly toward you, you would need only 1/125 sec. shutter speed to stop the action. From the same distance, the same car moving across your line of vision would require 1/500 sec. to stop the motion.

PEAK ACTION

With some movements, it is possible to stop the action at a relatively slow shutter speed by timing the shot to coincide with a momentary pause in the motion of the subject. Athletes come to almost a complete stop at the peak of their action. Consequently, the photographer can use a relatively slow shutter speed and still get a sharp picture. In track, for example, when a high jumper reaches the apex of his leap directly above the bar, his vertical

To retain a sense of movement in this still photo of an antique tricycle, the photographer panned the camera and exposed the film for 1/15 sec. as the cyclist peddled by. (Photo by Ken Kobré, for *The Boston Phoenix*.)

■ FOCUSING: TWO WAYS TO ACHIEVE SHARP IMAGES

FOLLOW FOCUSING

Whether you use a slow shutter speed to pan or a fast shutter speed to freeze the action, the subject will not be sharp unless the lens is critically focused. Focusing a lens on a rapidly moving subject takes considerable practice.

Follow focusing requires eye/hand coordination. As the runner moves down the field, you must move the lens' focusing ring to maintain a sharp image on the ground glass. When the runner is near, you must completely rotate the focus ring to keep the subject sharp. When the runner speeds into the distance, a little twist of the ring suffices to pop the runner in or out of focus.

To follow focus, use the ground glass on the edges of your viewfinder, not the split image or micro screen in the center. For most shooters, these focusing aids are too slow for the continuous movement of sports action.

The photographer must adapt eye/hand coordination to each lens length and camera brand. Each lens requires a different amount of movement to achieve sharpness. Like a musician playing the same note on a base fiddle, cello, and violin, the photographer must learn different eye/hand motor skills depending on whether he or she is using a 100mm, 400mm, or 600mm lens. Even more confusing is the difficulty of switching among brands of cameras. Some focus clockwise; others focus counterclockwise. Whenever possible, try to stick to one camera brand to avoid this confusion.

Bill Thompson, a former staffer at the *Houston Post*, recommended to new photographers that they stand beside the highway to practice follow focusing on cars. Select a car, he said, and try to keep its license plate in focus as it moves down the road. Track car after car, and soon, without thinking about it, your hand will move the lens barrel the exact amount necessary to hold focus as the speeding car passes in front of you, zooms down the highway, and recedes from view.

Don't be discouraged if every negative of your sports action is not tack sharp. Few sports photographers bring back 36 perfectly focused exposures. However, with practice, the number of razor-sharp frames will increase.

For many assignments, sports photographers shoot with lenses in the 200mm to 600mm range. From the perspective of sharpness, the bad news is that long lenses have narrow depth of field even at small apertures. This means that unless the lenses are exactly focused, the pictures will look blurry. Shallow depth of field means that the lens is intolerant of any focusing inaccuracy. The good news is that when you site through long lenses, the image pops in and out of focus very cleanly and dramatically on the viewfinder's ground glass. Critically focusing a long lens is actually easier than focusing a wide-angle lens. (See Chapter 10, "Cameras and Film.")

ZONE FOCUSING

In sports like auto racing or track and field, when the photographer can predict exactly where the subject will be — at a finish line or a specific hurdle — photogra-

By zone focusing on the finish line, you are guaranteed a sharp photo of the winning runner. A check of your depth-of-field scale will tell you how far the range of sharpness in the picture extends. (Photo by Patrick Downs, *Los Angeles Times*.)

phers use a method called zone focusing. To zone focus, prefocus the lens for the point at which you expect the action to take place, and let your lens' depth of field do the rest. As the subject crosses the predetermined mark, frame and shoot your picture. Your picture will be sharp not only at the point at which you have focused but for several feet in front of and behind that point — depending on the depth of field of your lens, aperture, and distance from the subject.

Once you have prefocused and determined your depth of field, you know the zone in which you can shoot without refocusing. When the subject speeds into the framed area, you can take several shots as long as the subject is within that zone. At an equestrian event, for example, the sports photographer can prefocus on the hurdle and wait for the horse and rider to jump.

In baseball, the action occurs in definite places — on the bases and at home plate. Baseball is ideal for zone focusing, and some baseball photographers even label the base positions on their lenses. First, they sit in a fixed position between home plate and first base. Then, they put a strip of white tape around the lens barrel next to the footage scale. They focus on each base, home plate, the pitcher's mound, and the dugout, and mark on the tape labeling each point. When a runner breaks to steal second, the photographer can quickly rotate the lens to the "2" position, and the lens will be in sharp focus to catch the player sliding into second base. If the action suddenly switches to third base, a short twist of the lens to position "3" and the photographer is ready for the new action. Some long lenses provide adjustable click points for this purpose. With the click stops, the photographer does not have to peer through the lens, spending time to find the optimum focus.

THE SPORTS PHOTOGRAPHER'S BAG OF SOLUTIONS

■ FIXED FOCAL LENGTH TELEPHOTOS

A sports photographer can't just run onto the playing field with a wide-angle 20mm lens and snap a picture of the action. To get an image large enough to print, the sports specialist usually must use long telephoto lenses. The telephoto adds drama to the drama, and heightens the impact. With these long lenses, you magnify what you want to show by eliminating all other distractions. In addition, using these lenses helps to pop the key player out of the pack, leaving a distracting background lost in an out-of-focus blur. In fact, some photographers always use the widest lens aperture to achieve minimum depth

of field, therefore knocking out, as much as possible, the distracting background. Long lenses also can be a creative tool because they pull things together in a way the human eye never sees. Because a telephoto lens appears to compress space, objects appear much closer together in depth than they really are.

Unfortunately, telephoto lenses are not the sports photographer's panacea. The telephoto lens itself has inherent problems. For instance, the longer the lens, the less depth of field; therefore, focusing becomes even more critical. With extreme telephoto lenses like the 500 mm f/4, 600mm f/4 and f/5.6, and the 800 f/5.6, there is no margin of error. The focus must be perfect or the shot is lost.

Critical focusing is just one challenge when you use a telephoto lens. Another is the exaggerated effect of camera movement on the picture's sharpness. The lens length exaggerates any camera movement and thus can result in camera shake that blurs the final image. A 200mm telephoto, compared to a normal 50mm lens, magnifies the image four times, but it also magnifies camera-shake by the same amount. With any very long lens, it is sometimes necessary to use a monopod, a one-legged support.

Additionally, if your eye is not perfectly aligned with the optics of the lens, one-half of the split-image focusing circle will tend to go dark when you use a long telephoto lens. If possible, use a focusing screen without a split-image circle on the ground glass.

Even though telephoto lenses are difficult to use, they do put the viewer right in the middle of the action. Many newspapers as well as individual photographers carry the 300mm f/2.8 as regular equipment.

■ ZOOM LENS

Rather than carry a satchel of different lenses, some sports photographers prefer to use zoom lenses. With the zoom, you can continually change the focal length of the lens, so that one lens is doing the work of several. Because you can zoom to any millimeter within the range of the lens, your framing can be exact. Sports photographers also like the zoom because it lets them follow the action as a player is running toward the camera and keep the player's image size constant in the viewfinder. Another advantage of the zoom is that you can get several shots from a single vantage point without moving. For instance, you can zoom back and catch all the horses at the starting line of a race; then, after the horses leave the gate, you can zoom in to isolate the leader of the pack — all this by just a twist or push of the lens barrel.

But even this versatile lens has some drawbacks. A zoom is usually heavier than a single-length telephoto lens. You can balance this increased weight, however, against not having to carry as many lenses to get the

same effect. Second, the zoom lens' widest apertures are usually smaller than the maximum aperture on a fixed focal length lens, so the zoom is less useful in low-light situations such as indoor arenas or night games. Manufacturers, on the other hand, have introduced mid-range (80-200mm), relatively fast (f/2.8) telephotos. Third, focusing and zooming simultaneously as the subject moves can be difficult to coordinate. You can develop this skill with practice, of course, but it does take time. The AP's Risberg concludes that zooms are "one of the best tools for sports photography."

■ THE MOTORIZED CAMERA

Either attached to your camera or built into the body, a motor drive allows you to fire a series of frames without manually advancing the film between each shot. Every sports photographer interviewed for this book used a motor-drive, but several mentioned that in some instances a motor-drive caused them to miss the peak action of the play.

Sports photographer George Riley says that "motors can throw your timing off, and sometimes the best pictures come between the frames." However, Riley quickly points out that on a controversial play, the photographer needs the motor-drive to fire off a sequence and show how the play developed.

Pressing the motor-drive trips the shutter,

advances the film, and cocks the shutter again for the next picture faster than you can blink an eye. If you use the motor drive semi-automatically — one frame at a time — you need not remove the camera from your eye to advance the film. Or you can shoot rapid-sequence pictures, depending on the make of the camera, at a rate of two to five frames per second or even faster with some cameras, without taking your finger off the shutter. This rapid-fire pace increases your chances of capturing peak action.

As in working with all photographic equipment, you must learn the technique of using a motor-drive. You should begin shooting before the action starts and continue holding down the shutter release until after the action stops. This will expose a series of frames that encompasses the complete play. From the sequence, you can choose the best frame, one you might have missed had you advanced the film manually.

Because no sane photographer wants to be subjected to a barrage of speeding hockey pucks or powerful slam dunks, a motor-driven camera may also be placed in a remote location such as inside a hockey goal or behind the plastic of a backboard. The camera can be activated either by an electrical wire or by a radio control. Firing the camera remotely can give the photographer a unique vantage point, right in the middle of the melee.

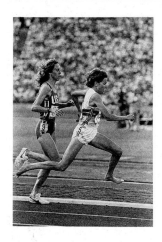
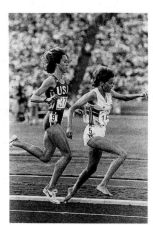
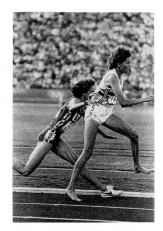
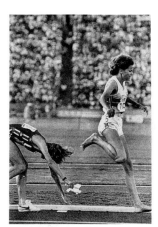

MOTORING CATCHES THE FALL

Only a motor drive would have caught this sequence of Mary Decker tripping during the Los Angeles Olympics in 1984. (Photos by Bruce Chambers, *Long Beach (Calif.) Press-Telegram*.)

■ DEVELOPING THE FILM FOR DIMLY LIT SPORTS

Outdoor sporting events present few lighting difficulties, but indoor and night sports can be tricky to shoot because of low light. First, poor light means that you must set your lens on its widest aperture. Unfortunately, this narrows the depth of field and reduces the chances for a sharp picture. You also might have to turn your shutter dial to a slower speed to compensate for the low light conditions, but this, too, may blur the image in the final picture.

Sports photographers shooting in poorly lit gyms, dark hockey arenas, or unevenly lit outdoor stadiums at night select the fastest film available. The introduction of 1600 ISO color and 3200 ISO black-and-white film has saved the day for many sports shooters.

But sometimes even these fast films are not sensitive enough for shooting high school football where half the stadium's light bulbs are burned out, or in dungeon-like basketball gyms. In these situations, photographers overrate their film, effectively underexposing it, and then partially compensate for the lack of exposure by increasing development. (See Chapter 10, "Cameras and Film.")

■ DON'T HOCK YOUR STROBE YET!

A few sports situations demand electronic flash, whereas others merely benefit from the use of this lighting source. The electronic flash from a strobe begins and ends so fast that the flash will stop just about any action you might encounter. Although the lighting effect from a single strobe looks harsh and unnatural, the resulting print will be sharper than a blurred shot taken with available light at a shutter speed too slow to stop motion.

Sometimes, flash even enhances a sports picture. David Eulitt was shooting a bicycle race for the *Indianapolis News* when he combined strobe and available light in one exposure. (See following page.) The strobe stopped the racers' motion and produced a sharp image. The slow shutter speed, which let in the available light, added a ghosting effect that gave the photo a feeling of motion.

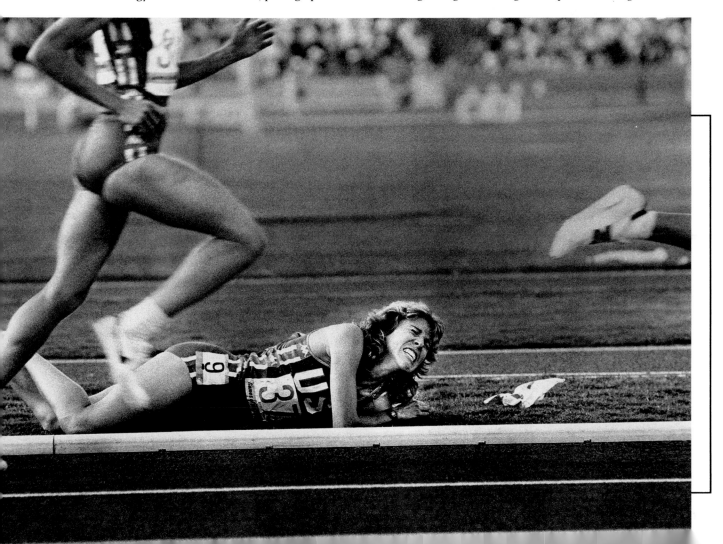

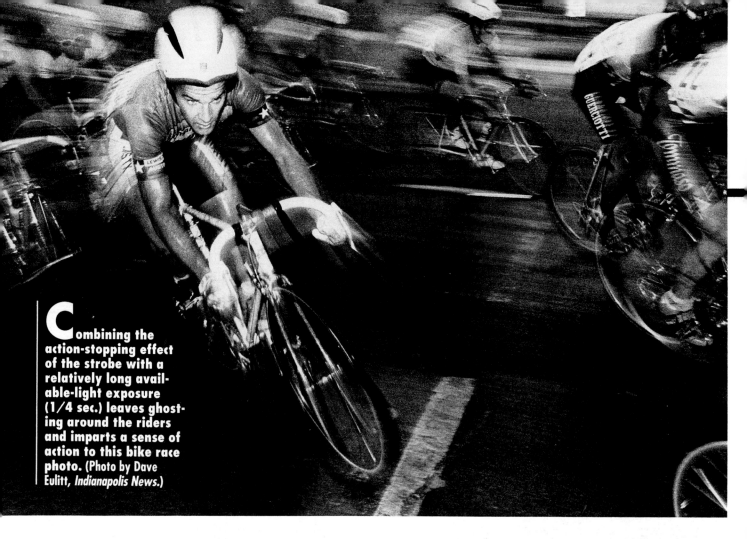

Combining the action-stopping effect of the strobe with a relatively long available-light exposure (1/4 sec.) leaves ghosting around the riders and imparts a sense of action to this bike race photo. (Photo by Dave Eulitt, *Indianapolis News*.)

Some photographers like to set up strobes for a spectacular multilight photo at indoor and night sports events. Two lights can be synchronized with a connecting wire or photoelectric slave cell that fires both units at the same time.

Some large newspapers and several major magazines such as *Sports Illustrated* light entire sports arenas with a battery of huge strobes. Photographers connected to these systems can shoot with slow, fine-grain color film and still get outstanding results. The elaborate multilight installations require a great deal of money and time but provide the photographer great flexibility and increase quality images. (See Chapter 11, "Strobe.")

ANTICIPATION

■ KNOWING WHERE THE BALL WILL BE BEFORE IT GETS THERE

At one time, photographers were allowed to work on the field of major league baseball games, but this freedom was curtailed because of the antics of photographers like Hy Peskin. An outstanding photographer, Peskin was covering a close game between the Giants and the Dodgers from a spot behind first base when he saw a ball hit into right field. He realized there would be a close play at third base. With the volatile Leo Durocher coaching at third, Peskin knew there would be a scene. As the right-

fielder chased down the ball, Peskin took the shortest route to third base — over the pitcher's mound and across the infield. Peskin, the runner, and the ball all arrived at third base at the same moment. Peskin got his pictures, but after similar incidents photographers were barred from the playing field of major league games.

If Peskin had anticipated third-base action before the play began, he could have positioned himself near that baseline, or he could have focused with a long lens on the bag at third.

The key to getting great sports photographs is anticipation. Anticipation means predicting not only what's going to happen but where it's going to happen. You must base these predictions on knowledge of the game, the players, and the coaches.

Anticipation in football, for example, means that you must know the kind of play to expect — run, pass, or kick. Then you must predict who will be involved in the play — quarterback, running back, or pass-receiver. And finally, you must guess where the play will take place — at the line of scrimmage, behind the line, or downfield. Basing your position on these predictions, you would station yourself along the sidelines, usually at the point nearest the expected action. Choose the appropriate lens and follow focus the player you expect to get the ball. Then wait and hope the action will follow the course you have predicted.

■ COUNTERACTING REACTION TIME

Besides anticipating the action of key players, you must also press the shutter before the action reaches its peak. In baseball, for instance, if you hit the trigger of your cam-

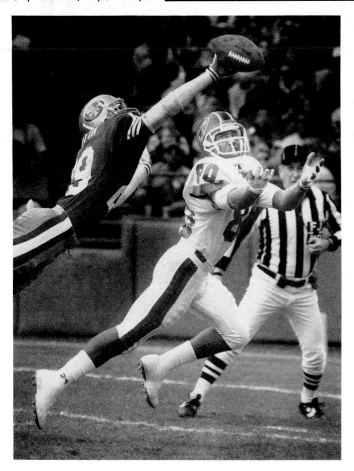

era when you hear the crack of the bat against the ball, your final picture will show the ball already headed for left field. You would swear that you squeezed the shutter at the same instant the bat met the ball, yet the picture clearly demonstrates the shutter was delayed. Why?

A lag-time occurred between the moment you heard the crack of the bat and the moment you pressed the shutter. Psychologists have termed this lag period "reaction time," and they are able to measure precisely its duration. The delayed reaction is caused by the amount of time it takes you first, to recognize that an important play is in progress; second, to decide if a picture should be taken; third, to send a positive signal to the muscle group needed for the movement, in this case the index finger; and fourth, to contract the muscles in the forefinger and thereby release the camera's shutter. Even after the shutter trigger is depressed, there's another delay while the camera itself responds. Even the most sensitive shutter still takes time to function. This shutter reaction time is the fifth step. All five steps added together account for the reaction time between seeing the action and taking the picture. You run through these same steps every time you take any picture, but the cumulative

length of reaction time becomes critical when the subject is a baseball moving at 90 mph.

BASEBALL

■ WAITING 'TIL "ALL HELL BREAKS LOOSE"

Pam Schuyler describes baseball as a "Zen sport" that requires infinite patience to photograph because the action erupts in spurts, and instant response is needed. "You wait and wait, and nothing happens. Then, all of a sudden, all hell breaks loose," says Schuyler. "I get bored easily at a baseball game and then I lose my concentration. That's when the big action always seems to occur!"

It does appear sometimes that nothing ever happens in baseball, and, in fact, the perfect game from the standpoint of a baseball aficionado is a "no-hitter." Sports writers still refer to the "great" game in the 1956 World Series when Don Larsen of the Yankees pitched a no-hit-

ter. Not only were there no hits but also no walks and no errors, either. Twenty-seven Dodgers went from the dugout to the plate and back again without reaching first base. Unfortunately, there was no action for the photographer to shoot in this perfect baseball

When you suspect the play is going to take place at home plate, prefocus on this base and wait for the slide. Capturing catcher, runner, and umpire at the base, this photo contains all the needed story-telling elements of a good sports photo. (Photo by Dale Guldan, *Milwaukee Journal*.)

game. The picture that is remembered shows Larsen pitching his last ball, with a row of Dodger zeroes on the scoreboard in the background.

■ SLIDING SECOND

Luckily for the photographer, a no-hitter is rare. Most games have at least some action at the bases, and baseball, like all sports, has its standard action shot. In baseball, the standard photo is the second-base slide.

When the play is going to take place at second base, train your telephoto lens on the base, focus, and wait for the action. With a motordrive, the timing does not have to be so exact because the camera fires several frames per second. If you press the release as the slide

By anticipating the next play, the photographer can use one camera to pick up outfield action and cover the bases with a second, prefocused camera. (Photo by Tim Bullard, *Grants Pass Daily Courier*.)

with an extremely long telephoto lens. He also points out that during slow games, the shooter should watch the reactions of batters. For games without much action, he adds, the dugout provides good picture opportunities.

Photographers position themselves several yards back from the base path between home and first base, or home and third base, or in the press gallery. From these positions, especially when shooting high school, college, and professional baseball, sports photographers prefer a 300mm or 400mm lens to cover the infield and a 600–800mm to cover the outfield. A sandlot or Little League playing field measures a shorter distance, hence a 135mm lens covers the infield easily. A shutter speed of 1/500 sec. captures either the little leaguer or the professional and results in sharp pictures.

begins, and hold it until the umpire makes the call, one frame is likely to coincide with the peak of the action. Often a good series of pictures results. If any of the photos in the series show the intense expressions on the players' faces, these pictures will have added human interest.

■ STEALING BASE

When the key play is a second-base slide, the photographer simply zeroes in on the base and concentrates. A more difficult situation occurs when a notorious basestealer ventures into no-man's land between first and second. The pitcher could try to pick off the runner at first if he thinks the runner has too daring a lead-off, or the catcher could peg the runner if he breaks for second. Frank O'Brien covers this split action by prefocusing one camera on second base and setting this camera aside; then he focuses another camera on first base and keeps this camera to his eye. O'Brien can snap a picture of the pick-off on first, or, if the runner heads for second base, O'Brien has time to raise his other prefocused camera and catch the slide at second.

When a runner gets to second base and is officially "in scoring position," you should prefocus on home plate. On the next fair play, the runner might try to score.

■ RUNNER VS. THE BALL

One general rule is to follow the runner, not the ball, with your lens. A routine catch in the outfield makes a routine picture. "Except with a short fly, when either the infielder has to catch the ball in back of him, or the outfielder has to dive for it, I keep my camera focused on the base path runners," O'Brien says.

AP's Eric Risberg, on the other hand, says he has taken many exciting pictures of outfield play shooting

■ THE UNUSUAL

Baseball is a team sport played by individuals, each with his own strengths and his own repertoire of favorite stunts. One ballplayer might hold the season's record in stolen bases, while a pitcher might lead the league in pick-offs at first. With this combination, the smart photographer has the camera lens focused and aimed squarely at first. One batter might be a consistent bunter; another might consider a bunt below his dignity under any circumstance. The more you know about the idiosyncrasies of the players, the better your forecasts and your pictures will be.

Although the dust-swirling second-base slide is a sports photographer's guaranteed "bread-and-butter" shot, sometimes the shot can be overworked. "You can almost take the slide shot out of the files, the situation starts to look so similar," says Riley.

The antics of the team manager may provide a rich source of photographic material. When he strides onto the field, you can bet sparks will fly whether he harangues the umpire or yanks out the losing pitcher.

A photographer can shoot baseball without being a Zen master. Just remember that you will never go hungry if you consistently catch your bread-and-butter action picture, the second-base slide. But you are more likely to be eating steak and lobster if you cover all the important action on the field.

FINDING THE FOOTBALL

When you cover a football game, you face some of the same problems as does a 250-pound defensive tackle. Before each down, you and the football player have to predict which way the quarterback will move on the next play. After the center hikes the ball, you and the tackle must react quickly and make adjustments as the play unfolds. Will the quarterback hand off to a speedster for an end-run or to a powerful halfback for a bruising plunge through the center? Or will the quarterback throw a quick spike for short yardage or a long bomb to the end zone? As the defensive player considers the options, the sports photographer likewise anticipates the call and prepares for the play. You must be in the right place at the right time, with the right equipment, ready and waiting for the action: runs, passes, and punts.

■ WATCHING FOR THE RUN

On a run, track the football as it is snapped by the center and either carried by the quarterback or handed to another backfield player.

Most teams tend to run the ball on the first down because a run is generally considered a safer play than a pass, or, as former Ohio State coach Woody Hayes put it, "Only three things can happen when you pass, and two of them are bad." Therefore, cautious quarterbacks like to keep the ball on the ground on the first down. Caution

also dictates the use of a running play on a third down when the team is just one or two yards shy of a first down. Some teams, particularly the Big Ten power squads, with their strong running backs and blockers, carry the football not only on the first and third down, but are very likely to run on the second down, as well.

■ SHOOTING THE "BOMB"

The photographer can anticipate a pass on the first down instead of a run only if the team is behind on the scoreboard, needs long yardage on the play, or wants to stop the clock. A quarterback might go to the air on the second down if the team is just a few yards short of first down; he knows he still has two more downs to pick up the necessary ground. The photographer can bet with good odds on a third down pass if the team has lost ground or failed to advance the ball on the first two downs.

A photographer can predict the "Big Bomb" by noting the score and watching the body language of the quarterback. If the quarterback drops back far behind the line of scrimmage, firmly plants his feet, pumps the ball a few times, and then cocks his arm way back behind his head, the player is very likely winding up for a long throw.

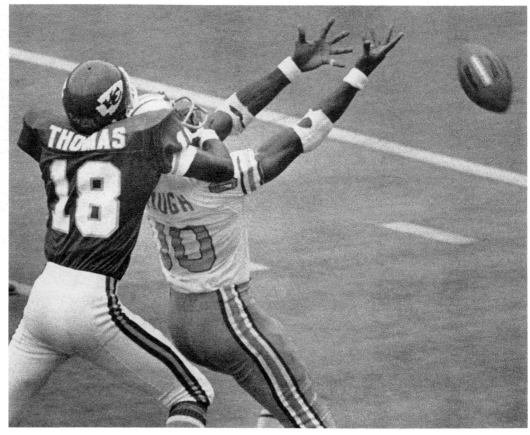

Photographs of players making mistakes like this pass interference are often more interesting than plays executed successfully. The photo was taken with a 600mm lens from the press box. (Photo by George Honeycutt, *The Houston Chronicle.*)

Once you read these cues and see a "bomb" in the making, you should immediately swing the barrel of your telephoto lens downfield, focus on the expected receiver, and follow his pass pattern. Do not try to track the ball as it flies through the air; you couldn't focus fast enough to keep the ball sharp. Observe the direction of the quarterback's gaze for a tip off on which downfield receiver will get the ball. Frank O'Brien points out that "even the best quarterback has to look where he's throwing the ball."

Knowing a team's idiosyncrasies will help the photographer predict when the team will call for an aerial play. O'Brien was once going to cover a home game between the New England Patriots, his local team, and the Baltimore Colts. He began watching the Colts' games on television, and noticed that 90 percent of the time when the Colts used a "split back" formation they went to a pass play. This bit of knowledge gave O'Brien an edge on his photographic competition when he covered the Colts-Patriots battle on the home field.

■ ADJUSTING YOUR POSITION

At each down, station yourself a few yards ahead of the scrimmage line. Then, when the play begins, wait for a clear, unobstructed view of the ball carrier before you press the shutter release. At most stadiums, photographers are permitted to roam freely from the end zone to about the 35-yard line on either side of the field. To avoid distracting the coaches and sidelined players, photographers are prohibited from moving in front of the benches at the center of the field. Photographers must stay behind the sideline boundary strip at all times and never get between the player on the field and the yardage marker poles. If you had to jump back quickly as the thundering pack of players heads toward the side-

lines, you could trip on the marking chain and get trampled — a high price to pay for even the most dramatic action shot.

All 50,000 pairs of eyes in the stadium are searching for the pigskin. The ball itself is the center of interest because everyone wants to know who has the ball and what's happening to it. Therefore, you have an obligation to get the brown leather ball in your picture as often as you can. The players, however, trained by their coaches to protect the ball at all times, will make your task difficult.

But not every picture must involve the ball carrier. After all, when one 250-pounder, with an indestructible frame and shoulder pads, meets another human impasse capped by an impact-resistant helmet, something has to give. The confrontation scene might be spectacular — even if it occurs ten yards away from the ball.

A 400mm lens will cover the action. If you try to cover midfield action with a shorter lens, the image size on the negative will be too small for a high-quality enlargement. With a versatile 80-200mm zoom, you can photograph from the end zone when the team is on the ten-yard line and goal to go. In addition to the 200mm and 400mm lenses, some photographers carry an extra body with a wide-angle attached for moments when the play runs toward them. Also, the wide-angle comes in handy when, at the end of the game, the team carries the coach on their shoulders or slumps off in defeat.

To ensure freezing the action of a football run or pass, set the shutter speed at 1/500 sec. or faster.

■ AVOIDING THE "STANDARD STUFF"

When Pam Schuyler covered football for the AP, she looked for dramatic catches, fumbles, collisions, and flagrant penalties such as face masking or illegal holdings.

She is always searching for the unusual football picture. "You get only a half-dozen super pictures a year if you are lucky," she says. "The remainder is standard stuff."

The ball travels so lightning-fast in basketball that following the ball is like keeping your eye on the pea in the old shell game. Unlike football with its discreet downs, and baseball with its clearly defined plays, the basketball game rolls on at full speed until a point has been scored, a foul called, or the ball goes out of bounds. The basketball might be bigger than a baseball or a football, but keeping track of it can be just as tough.

Risberg of the AP says that he concentrates on watching the ball and the players' arms. They tip him off when he is trying to anticipate action.

Pam Schuyler, who spent two intensive years covering the world-champion Boston Celtics for a picture book she photographed and wrote called *Through The Hoop: A Season With the Celtics*, formed some valuable theories about anticipating basketball action. Schuyler says that the key problem in photographing basketball is learning to read the "fake," the quick twisting and jerking movements that players use to "fake out" their opponents and get a clear shot at the basket. As Schuyler says, "They often fake out the photographer, as well."

Schuyler points out that a pro basketball player can fake not only with his hands and arms, but also with his legs and feet. Therefore, Schuyler has discovered that

watching the player's stomach muscles provides the best clue to the timing and direction of the player's movement. "A player cannot fake with his stomach, so where the stomach of the player goes, his arms, legs, and head will soon follow," Schuyler says. Basketball players wear tight, thin jerseys that cling to their ribs like surgeon's gloves. "You can easily see a basketball player's stomach muscles contract through his jersey, just before he breaks for the hoop."

Schuyler points out, however, that you can't constantly stare at the abdomens of all the players during the game because you have to spend most of your time and attention tracking the path of the basketball.

While you might not use a photo like this from every game, shooting from the rafters of the gymnasium offers a refreshing angle on the sport. (Photo by Michael Murphy, *Houston Chronicle*.)

■ SIDELINE POSITIONS

Many basketball photographers sit on small stools or kneel on the floor behind and a little to either side of the basket. Then they prefocus their 50mm or 85mm lens about 10 to 15 feet into the court and wait. Schuyler, however, prefers to gamble on more unusual shots. Instead of prefocusing and thereby snapping off sharp pictures only of action under the basket, she follow-focuses on the ball as it is tossed around the court. She rotates the lens barrel as fast as she can, trying to to keep the ball in sharp focus as it flies from one player to another. Follow-focusing the ball is tough. "You get more bad, out-of-focus shots when you follow-focus, but your good shots are usually worth it," Schuyler says.

After the first few minutes of the game, Schuyler identifies the key players and notes where they execute

Watch for fouls committed during the game, like this one between the Seattle Supersonics and the L.A. Lakers. This moment reveals the intensity of the game. (Photo by Larry Steagall, *The* (Bremerton, Wash.) *Sun.*)

most of their plays: under the backboard, to the right of the foul line, and so on. She then positions herself as near as possible to this focal spot. If the action spot changes as the game progresses, she shifts her sideline position.

With her two favorite basketball lenses, the 85mm and the 180mm, Schuyler covers the entire court. From a vantage point under the basket, she shoots with the 85mm; from mid-court, she works with the 180mm. She always sets the shutter speed at 1/500 sec. to freeze movement. "At slower speeds, I've found the players' hands move so fast they tend to blur." Many photographers include the 300 f/2.8 in their regular arsenal. This lens allows the shooter to cover the action at the far end of the court.

■ THE "ARM-PIT" SHOT

The standard bread-and-butter basketball photo, nicknamed the "arm-pit" shot, shows the lanky basketball player jumping off the floor with arms extended over his head, pumping the ball toward the basket. Pro players use the jump shot so often that the conscientious photographer actually has to work hard to avoid taking this standard photo.

■ SKIPPING THE CLICHÉ

Photographers who cover basketball regularly try to find alternatives for the armpit shot, figuring that readers will consider the shot a boring photographic cliché.

For unique basketball pictures, Schuyler is always on the lookout for loose basketballs on the court. "You can bet when a ball's free, there will be a scramble for it and then a fight to gain possession of it," notes Schuyler. "Players fouling one another always look funny on film and

these seem to be the pictures people remember longest. When a ball bounces loose on the court or a foul is committed, the rhythm of the game is broken. A mistake was made. The game gets interesting, and so do the pictures."

When you can't attend the practice sessions of a team or when you don't have time to learn the team's basic patterns, concentrate your coverage on the player with the star reputation. Stars tend to score the most points and snag the majority of rebounds. Also, stars don't just sink baskets like regular folk; they exhibit individual styles and almost choreographed moves. Michael Jordan, for example, seems to counteract gravity as he floats through the air, passes the basket, and as if it was an afterthought, changes direction in mid-flight to sink a hoop. A good sports photographer tries to capture on film the style of the star. ■

Picture Stories

TELLING STORIES WITH PICTURES

With the advent of high-speed presses that could quickly dry the ink on glossy coated paper, Henry Luce published the first issue of *Life* in 1936. Soon after *Life* began publication, other large picture-dominated magazines with names like *Look, Click, Scoop, Peek, Pix,* and *Picture* hit the stands. These magazines also ran pages of pictures on a single topic.

■ SCRIPTED STORIES PREVAIL

Click was typical. Its October 1939 issue featured a story titled "Dance of Death: Bali natives perform a weird ceremony outlawed by missionaries." Over three pages, the candid photos tracked the ceremony from its ritualistic beginning to its frenzied end. Other stories were considerably less candid. In fact, most were posed, with some stories even using hired models as subjects. One story, for example, documented a trend in home dressmaking. "Home sewing hits new high with 50,000,000 dresses in one year," read the headline. The story showed a woman going though each step in the dressmaking process, from attaching the dress pattern to the cloth to finally wearing the outfit. Each picture in the how-to series was posed. Like a Hollywood movie, a script obviously had been written before the photographer began to shoot. The end picture was ordained before the photographer took the opening shot.

Even after World War II, magazines continued to produce highly scripted picture stories. *Look* magazine, for example, published in its January 8, 1946, issue a story on quick-frozen, precooked, ready-to-serve meals (today known as TV dinners). The opening picture featured a "family" in their living room casually reading and playing records. The caption read: "2:00 P.M. 'How about dinner?' asks Mother." The following overly lit pictures show a woman taking frozen meals from the refrigerator, putting them in the oven, and then taking the food out after fifteen minutes. The final shot shows "family members" in their Sunday best, seated around the table, prepared to eat the new frozen cuisine. The photographer's shooting script, which specified opening and closing shots as well as a record of the preparatory steps in between, obviously left no room for real people or candid moments to interfere with the slick look of the pictures. The photos look like stills from an ad.

■ FOLLOWING THE FLOW

Toward the end of the '40s, photographers began experimenting with a freer form of picture story development.

W. Eugene Smith, working for *Life* magazine, broke with the typical prescripted story line. Smith's pictures of country doctor Ernest Ceriani of Kremmling, Colo., (pop. 1,000), actually documented the rural physician's life — without a New York editor predetermining the story's look and point of view (*Life*, September 20, 1948). By staying with the doctor long enough, six weeks in all, and by recording the doctor's everyday activities as well as the emergencies and traumas he handled, Smith built a realistic story about this dedicated health worker. While the story still had cohesion, it was based on Smith's observations, not the preconceived ideas of a New York editor who demanded an overall and a close-up for the script. By staying close to his subject long enough and by observing carefully enough, Smith fashioned a revealing story that explained the life of this rural doctor.

In the tradition of Smith, photographers today continue to photograph long-term projects. While Smith spent six weeks photographing the Colorado doctor for *Life*, few of today's magazines or newspapers will fund a project of this length. Consequently, many photographers shoot extended stories on their own time, or they turn to agencies outside the publishing industry for grants or foundation support to underwrite their projects. Whether personally financed, grant-supported or underwritten by a newspaper or magazine, the picture story provides the one place in photojournalism where the photographer can explore a topic in depth, present a point of view, or show with pictures the many sides of an issue.

DEVELOPING IDEAS

Talking with other people alerts you to good picture-story ideas. Someone's description of an 80-year-old man who plows the field every day, or a tip about a women's motorcycle gang called the "Fantastic Foxes" might provide the catalyst for a story. Perhaps an issue addressed in a topical book or movie might stimulate your interest to investigate the subject with your camera. The conversation might turn to a national trend like elder-care. This trend story can be localized for your area with a picture

Many magazine stories during the '30s and '40s were completely scripted. An editor decided what each of the pictures would look like before the photographer exposed the first frame. The stories had a beginning, middle, and end; but rather than document a real situation, they were completely stage managed. (© *Look*, January 8, 1946.)

Dinners in 22 Minutes

Quick-frozen, precooked, ready-to-serve meals aren't an idea for the future—they're here

Imagine a meal that can be fixed in minutes instead of hours and offers the cooking genius of a queen's chef, yet requires no skill to prepare. Furthermore, it allows everyone at the table the individual dish of his own selection; eliminates the food waste of spoilage and leftovers, and the drudgery of potato peeling, shelling and the other minutiae of food preparation. And, finally, it makes shopping quicker, cleaner, more compact; saves kitchen storage space; and even cuts out dishwashing!

Cease imagining, for Americans have eaten more than half a million of these culinary wonders in the past nine months, mainly on U. S. Army and Navy planes.

Producer William L. Maxson expects to sell 25,000,000 more meals this year in retail stores and shops from coast to coast. Prices may run about one-and-a-half times the cost of the raw food. Maxson's Queens Village (N. Y.) plant, working like an automobile assembly line under the supervision of a former chef of Queen Marie of Rumania, produces 50 different precooked, frozen meals, including those pictured on the opposite page.

Other companies are also making the frozen meal. Its sponsors believe it will be a boon to working wives, career women, bachelors, people in a hurry and homemakers who wish an occasional vacation from the kitchen.

The dishes shown on the opposite page were prepared and served in exactly 22 minutes

2:00 P.M. "How about dinner?" asks Mother. "I'll have a steak," says Dad, and the kids chime in with their choices. Mother goes to kitchen, clicks switch that starts oven's seven-minute warm up.

2:06 P.M. From freezer compartment, Mother takes four frozen meals which may be stored safely as long as a year.

2:07 P.M. Mother puts the meals in special six-tier Maxson oven. An ordinary oven will do, but requires more time.

2:10 P.M. While oven finishes cooking, begun weeks before in Maxson plant, Mother makes coffee, daughter sets table.

2:22 P.M. Bell rings 15 minutes after insertion of dishes. The meals emerge sizzling, and ready to be served at once.

The family served, Mother joins them with her own dish. The lacquered cardboard plates in which meals are heated and served, are water-, heat-, grease-resistant, are discarded at meal's end.

investigation of a nursing home in your town. (See pages 54–57.)

Like any good journalist, however, the photo reporter must rely on basic journalistic research skills, a highly sensitized nose for news, and a trained sense of whether what smells like news can be reported visually, as well.

■ VIEWERS RELATE TO PEOPLE STORIES

Maitland Edey, an editor on the staff of the old *Life* magazine, concluded that "Great photo essays have to do with people: with human dilemmas, with human challenges, with human suffering." People's lives, even if they are not in crisis situations, still provide the basis for most of the best photo stories.

Photo stories about people usually break down into three categories: the well-known, the little-known but interesting, and the little-known who serve as an example of a trend.

THE WELL-KNOWN

Photo stories about well-known personalities provide the primary content for several larger circulation magazines. The best-read section of *Time* magazine, called "People," gave Time, Inc., editors the idea for a picture magazine featuring personalities as the sole subject. Naturally, the editors called the magazine *People*. This popular weekly publishes a steady diet of photos showing the lives of the famous and the infamous.

THE LITTLE-KNOWN BUT INTERESTING

In addition to the famous, *People* magazine prints photo stories about little-known people who either do something interesting or exhibit eccentric characteristics. Hero or not, the person must do something to fascinate readers. George Willis, who climbed the outside of the World Trade Center, and Hap Paul, inventor of a robot that performs surgery, are examples of people with unusual accomplishments. The Hare Krishnas (see pages 123–125) and punkers (pages 228-229) live unusual lifestyles.

THE LITTLE-KNOWN WHO REPRESENT A TREND

Another type of personality story investigates the life of a little-known person who is an example of a new trend or developing style. Perhaps John Jones, a divorced single-parent father, represents a trend in men taking over traditional female roles. How Jones handles the combination of wage-earner, homemaker, baby-sitter, chauffeur and cook represents the way similar males are coping with the same problems. Jones thus typifies a larger group of single-parent fathers.

Traditionally, a pregnant woman who chose to give up her baby for adoption had little control over the selection of the child's new parents. A new trend called open adoption lets the birth mother select the adoptive parents. (See page 160.) A picture story about a pregnant woman and her child's prospective parents meeting, going through the pregnancy and delivery together, and then exchanging the baby would help to explain the trend.

At times, the photographer wants to explore an abstract topic. Personifying a topic helps readers relate. Zeroing in on one person affected by atomic radiation or focusing on one person living on the streets dramatizes the general problems of nuclear power or homelessness. Readers identify with the woes of a little-known individual much more than with the problems of a political group or a sociological class. For photographers, converting a topic into human terms provides a visual clothesline on which to hang the individual points of the picture story.

Both Tom Gralish and Stephen Shames produced stories about the lives of individuals as part of larger long-term photo projects addressing the issues of homelessness and poverty. Parts of those stories appear on pages 8–9 and pages 158–159.

■ SPOTTING TRENDS

Whereas a news story has a specific time peg, a trend story identifies a gradual but demonstrably real change in the public's buying preferences, lifestyles, or a technological shift in an industry. For example, a news story might read, "The First National Bank went bankrupt yesterday." By comparison, a trend story might say, "The number of two-income families increased dramatically during the past ten years." A trend doesn't start one day; it happens gradually over time.

Surprisingly enough, the *Wall Street Journal* is an excellent source for picture story ideas. Although the international business newspaper reproduces no photographs itself, the *Journal* does report on interesting trends in the business world: trends that the photographer can translate into highly visual photo stories. Not only are the *Journal* stories often first to spot a trend, but the stories are usually well-researched. For major trend stories, which appear on the left, middle, and right-hand columns of the front page, *Journal* staffers spend months researching and gathering data before they begin to write.

After reading the *Wall Street Journal's* story, the photographer should find visual verification of the trend. The camera reporter must transform the economic charts and abstract statistics from the *Journal's* article into subject matter for eye-catching pictures.

■ TEST YOUR THEME WITH A HEADLINE

How does a picture story differ from a collection of pictures on a topic? A story has a theme. Not only are the individual pictures in the story about one subject, but they help to support one central point. Here are some headlines for stories that have no theme: "All you ever want to know about..., " "A day in the life of...," "Aspects of...," "Scenes from..." Stories with these headlines might contain beautiful or even powerful pictures, but the pictures don't

add up to a story. They remain the photographer's observations without a story line or central message.

On the other hand, a theme story such as Neil McGahee's about the relationship of two bachelor brothers who had spent their lives farming together might have the headline "Friends for Life: Brothers on the Land." As McGahee followed the story, one brother died and the other had to carry on alone. This set of pictures does not portray everything you wanted to know about farming or even a survey of the old ways of farming. Instead, the pictures concentrate on the end of a 75-year relationship between the two men. (See pages 154–157.)

W. Eugene Smith's classic story for *Life* magazine, "Nurse Midwife Maude Callen eases pain of birth, life and death," was not all you want to know about how to be a midwife or even a complete picture of Maude Callen's life, but rather how Maude Callen helps her clients face pain. (See pages 132–143.)

Once you have decided on a story and started to shoot it, try writing a headline for it. Easily nailing down a headline indicates you have a clear focus for the story. Make sure your headline is specific to the story and differentiates your point of view from other stories on the same topic.

Headline completed, see if you can include or reject pictures on the basis of whether the photos fit the story's theme and headline. If the headline is so encompassing that all the photos fit, your theme is probably too broad.

You can devise many themes from a single situation. Even after you have finished shooting, you might find that by re-editing your pictures, you can produce a different story line. Each theme demands a different edit not only for the opening spread but also for all the pictures that follow. For an example of how changing headlines can change the how you edit the pictures, see the next three pages for the story on the Hare Krishnas.

■ FIND A NEWSPEG

Whether you are a publication's employee or a freelancer, an editor is more likely to use your picture story if it has a newspeg. A newspeg tells the reader why the story is being seen now instead of six months ago. If you can tie your picture story into a front-page news item, then your story will take on more immediacy.

Suppose your story revolves around the life of a family doctor. You might peg your pictures on a recent study showing that the number of general practitioners is decreasing nationally.

Or suppose your story concerns your town's emergency medical squad. If a squad member died last month while trying to save a child's life, your timeless story about the unit's general operations can be pegged to this recent news event.

Some magazines commission picture stories that the editors hold until a related news event breaks. The news sections of the daily newspaper, therefore, provide excellent sources for story ideas because the news leads are timely.

■ VISUAL CONSISTENCY

Regardless of their subject matter, pictures take on an additional quality when they appear on a printed page. In a successful layout, the photos interact with one another and form an eye-catching, compelling picture-story. When the layout is unsuccessful, the pictures remain separate units simply co-existing on the page.

What clues the reader that a group of pictures interacts as a story rather than functions independently as individual images, such as the ones you see on a gallery wall?

To link pictures together visually, photographers use pictorial devices. With a visually unified essay, the viewer sees in almost every picture either the same (1) person, (2) object, (3) mood, (4) theme, (5) perspective, or (6) camera technique.

SAME PERSON

The easiest way to tie pictures together into a photo story is to concentrate on one person. Restricting the scope to one individual helps to define the focus of the series. The person's identity, repeated in each photo, threads the story together and gives the layout continuity. (See "Nurse Midwife," pages 132–143; "Friends for Life," pages 154–157; "Julie: Lifestyle of a Punk," pages 220–221.)

With a picture story, the camera, like a microscope, magnifies the subject's daily routine. The results of the visual probe depend on the subject's accessibility and cooperativeness. The photographer shadows the subject as long as the person doesn't object, and as long as the paper or magazine will finance the effort. In the heyday of the big glossy picture magazines and their lavish photo budgets, photographers were given considerably longer time to shoot personality stories than they are today. When John Dominis was on the staff of *Life* magazine, he worked on his "day-in-the-life" of Frank Sinatra for four months before the story was finished. Later, as picture editor of *People* magazine, with its much smaller photo budget, Dominis assigned photographers to personality profiles and expected the job done in a half day.

In fact, following a "day in the life" of a person is one of the most simplistic approaches to story-telling. The headline might read "A Day with...." The pictures simply track the person's life from morning to evening. Or the pictures might follow someone at work. This approach gives the reader a glimpse of a person's lifestyle or work habits. These stories capture a "slice of life."

For a story about Julie, a midwestern punk who still lives at home, photographer Donna Terek wanted to

WRITE A
HEADLINE,
EDIT THE PIX

I began a picture essay on the International Society for Krishna Consciousness when the *Boston Phoenix* assigned me to cover the group. I had a vague idea that this transplanted Eastern religious sect would provide material for an interesting picture essay, but I didn't have a focus for the project yet.

Look at the pictures, and determine what theme you might select.

Depending on the selected theme, this story could be edited in several ways. One edit might emphasize the unusual lifestyle of the Hare Krishna. The story might be called "Strangers in their own land," with the lead photo showing saffron-robed Krishnas chanting on the Boston Common. Another story might emphasize their religious fervor. The headline might read, "Ecstasy on Earth." For this story, the lead photo might be the women dancing with their fiery lamps.

I discovered that many members of the International Society led double lives. They began each day at 4 A.M. as saffron-robed religious devotees with shaved heads, chanting and praying. Then at about 9 A.M., several of the bald-headed monks disappeared into their rooms

[CONTINUED ON FOLLOWING PAGE]

Gandolf, a member of the International Society for Krishna Consciousness, chants in the Boston Common. He, like all members of the religion, repeats the words "Hare Krishna, Hare Rama" more than 20,000 times each day. Gandolf was an advertising executive in New York before joining the movement.

During the daily, four-hour morning prayer, members worship their Guru, the founder of the movement, His Divine Grace A.C. Bhaktivedanta Swami. His picture rests on the seat reserved for him.

Although they cleanly shave most of their heads, the Krishnas leave a pigtail, called a sikha, to distinguish themselves from Buddhists.

Members of the Krishna movement rise before 4 A.M. to begin praying. They feel that for prayer, certain hours are better than others. Their temple and living quarters are both located in this brownstone house.

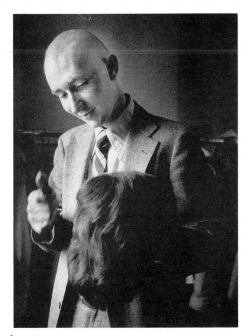

A Krishna member readies his wig for a day at work. His job is to solicit contributions at the airport.

On Sunday evening, the temple opens to guests who come to observe the ceremony and take prusada, a vegetarian feast. The members of the temple try to convert the newcomers to Krishna consciousness through intense discussions about the faith.

Each Krishna puts in about two hours of individual chanting, called Japa, every day. Some members pace around the room as they repeat the "Hare Krishna." They count the number of chants on beads carried in a small sack.

Wearing street clothes and a wig, a Krishna member solicits money at Logan Airport.

Judy Schimmel waves to her son, Govinda das.

A Krishna member holds the Ghee lamp during the evening worship. The structured life of the Krishnas, beginning at four o'clock each morning and ending at 10 o'clock each night, attracts members, but few can handle the discipline. The woman dancing on the right remained with the movement for only two months.

and emerged a few minutes later wearing modern tailored sports jackets, white shirts, Ivy League ties, and, most surprising of all, full heads of hair — from wigs.

The Krishnas, in jackets, ties, and hair, got into the temple's trucks for the drive to the city's main airport or a suburban shopping center. At these busy public places, the Krishnas hawked their religious books, magazines, and even gave out flowers in exchange for donations. Sometimes they approached potential donors with a simple question like, "Where are you from?" At other times, the street-clothed Krishnas tried straight-out flattery, such as, "You're the prettiest girl I've seen today."

The Krishnas themselves say that nationwide they collect more than $7 million from these solicitations. According to television reporter Chris Wallace, outside observers of the movement estimate the figure to be even higher — from $25 million to $50 million.

For a story that focused on the deception practiced by the group, the headline might read "The Double Life of the Hare Krishna."

Which picture would you lead with to illustrate this story? Photos by Ken Kobré, for *The Boston Phoenix*.

Kathrin Mathews is one of only six women in the Boston Temple.

With all his worldly possessions in the trunk at the head of his blanket, a Krishna member naps in the spartan sleeping area.

Richard, husband of Katherin Mathews, pictured in photo at left, holds their son Kancabla. The religion dictates that married men and women can have sex only once a month. Single men and women must remain celibate.

Richard Mathews, wearing a wig and hat, solicits contributions at Faneuil Hall, a downtown shopping center in Boston. He gives a flower and a compliment to each pretty woman who passes, and then he asks for a donation. If she doesn't give a contribution, he takes the flower back.

go beyond a series of pictures of weird-looking kids who sport outrageous hairdos.

The photojournalist tried to explain one young person's way of rebelling against her middle-class upbringing. The story shows Julie wearing a ring in her nose and a tattoo on the side of her shaved head. Other pictures catch Julie working, partying, kidding around with her boyfriend, and sitting stiffly on a couch next to her straight-looking younger sister and mother. To drive home the contrast between her old and new lifestyle, a final photo shows the orange-haired punk carrying her boombox and sporting a black leather jacket and spiked boots as she returns home to her parent's run-of-the-mill ranch-style suburban house. With this final picture, the reader has a surprisingly rounded picture of this young woman's life. (Part of this story is reproduced on pages 220–221.)

Before he became a photo editor at the *Philadelphia Inquirer,* Stephen Shames was a free-lance photographer in New York. He spent a year and a half photographing a 14-year-old boy who sells his body on the streets near Times Square. Like onion layers, each photo in the story comes closer to the core of this child's life.

The photos (see pages 144–149), eventually published in the German magazine *Stern,* first reveal Rudi Gomez's home life in the Bronx — his alcoholic father and nine bothers and sisters living on $308 a month from welfare. Other pictures explore his street life—hustling in Manhattan, stealing, picking up older men, and having sex with them. The photos try to explain how this young child survives in an adult world. Their power lies in the photographer's ability to take us someplace we have never gone — to visually verify the life of one child's misspent youth. Shocking but fascinating, the story draws us into the life of this young street hustler. The pictures put the child's life into perspective by showing his home environment. Finally, they do not hold back in showing what this child actually goes though to make a living. Few readers will be able to ignore the problem of child prostitution or forget 14-year-old Rudi Gomez.

SAME OBJECT OR PLACE
Sometimes the same object appears in all the pictures. In a story about rats, photographed by James Stanfield of the *National Geographic* (July 1977), for example, each photo featured a rat of some kind — a trained rat, rats as objects of worship, rats as lunch. These kinds of stories tend to document the most amazing or most photographic aspects of a subject. The story is not about the life of one rat. It does not detail a day in one rat's life. Nor does it show the impact of rats on one family or town. Rather, it tries to portray the interesting aspects of rats around the world.

Place stories often fall into this category. A travelogue that shows the most interesting stops on a visit to Paris would be held together by the visual consistency of

the city even if no other connecting device were used. The pictures for Jim Gensheimer's story on train commuters connect because in each photo you can see some aspect of the railroad. (See page 195 for part of this essay.)

SAME THEME/EDITORIAL POINT OF VIEW
Some photographers tackle social issues with their pictures. Such photo essays try to lay out society's problems. Stephen Shames' essay on child poverty in America, which won numerous awards, is a collection of pictures depicting the toll of poverty on American children. (See pages 158–159 for part of this essay.) All the pictures in the essay, coming from a common point of view, attempt to elicit a similar reaction in the viewer.

Other essays attempt to show how people are trying to change or solve a problem. *Helpers in the War on AIDS,* by students at San Francisco State University, was a project to document how a group of dedicated professionals and volunteers attempt to ease the life of people with AIDS (see pages 72–77).

In both essays, individual subjects were selected and final pictures chosen that reinforced the basic theme — poverty in the first set of pictures and helping in the second.

Sometimes a group of pictures attempts to compare and contrast an aspect of life. André Kertez compiled an entire book showing all the ways people read. He showed people reading on benches, lying down, and standing up. The pictures documented people reading in the library, in the park, and on rooftops. Each picture added an element to the central theme.

Similarly, the essay on "Seeing Sound" (pages 150–151), turns an auditory subject into a visual delight through a number of different photographic techniques.

Pictures alone might be interesting, but published together, photos allow the reader to compare two or more different approaches to the same problem. Compare-and-contrast photo essays have ranged from how people wait in line to how they cut their hair or wear the latest fashion statement.

CONSISTENT PERSPECTIVE, TECHNIQUE, OR COMMON VISUAL MOOD
A uniform camera perspective also can add a coherent atmosphere to a picture story. If, for example, the photojournalist takes all the pictures in the essay from a helicopter, the reader perceives a view of the world from a consistent vantage point. To capture a child's view of the world, a photographer might shoot the pictures from two feet above the ground. Again, the same perspective in each picture interlocks the images.

W. Eugene Smith once took an extended series of pictures from the window of his downtown New York loft. The pictures of the street below were connected not just by the fact that they were all taken in the same place, but also by the restricted view of the camera.

The photographer might choose a unique camera technique as another cementing device. To photograph the U.S. Olympic trials in 1960, George Silk used a "strip camera" with an extremely narrow slit for a shutter, which the film ran past. The camera was operated by a motor. Against a streaked background, the bodies of the athletes looked stretched out or compressed. The final layout, "The Spirit and Frenzy of Olympian Efforts" (*Life* July 18, 1960), was held together visually with this uniform graphic identity.

Holding a topic together by shooting a series of portraits also provides a consistent perspective, whether the people are the royalty of Europe or the homeless of America. Sometimes, the photographer uses a consistent background — perhaps just seamless paper or a portable piece of painted canvas. At other times, the photographer shoots each subject in his or her environment. Even with the environmental portrait, however, the photographer needs to use a consistent approach to lighting and subject placement for the photographs to provide a unified look on the printed page.

Light itself can provide a glue that holds pictures together. Pictures of a place all can be taken in the late afternoon or early morning. The consistent quality of light helps to tie pictures together visually. Winter pictures of Maine by Kosti Ruohomaa (*Life*, Feb. 26, 1951), all taken in the late afternoon or evening, add to the feeling of coldness and barrenness in this northern state. The photographer went beyond providing a sampler of scenes from around the state to express how it felt to live in that frigid climate in the winter.

THE NARRATIVE

Without structure, words alone don't form a sentence. Regardless of how beautiful or powerful each word is, taken as a group, they don't add up to a coherent thought without the underlying structure of grammar.

Pictures, likewise, remain individual images unless they are integrated into a cohesive narrative story.

All short stories have a common underlying structure, argues Pulitzer prizewinning author Jon Franklin, in his book ***Writing for Story.***

Franklin, who twice won the prestigious award for feature writing, says that stories revolve around a complication. He defines a complication as any problem a person encounters. Being threatened by a bully is a complication. Having a car stolen or being diagnosed with cancer is a complication.

Complications are not all bad, Franklin says. Falling in love is a complication because you may not know whether the other person is in love with you. Winning the lottery means you have to figure out how to spend the money — and pay the taxes.

Complications that lend themselves to journalism must tap into a problem basic enough and significant enough that most people can relate to it.

When a mosquito bites you, you have a complication but one that reflects neither a basic human dilemma nor a significant problem. Discovering you have cancer and might die, on the other hand, is a basic problem significant to most readers.

The second part of a good story involves a resolution, which Franklin says "is any change in the character or situation that resolves the complication."

Whether you are cured of cancer or die from the disease, the complication is resolved.

Franklin points out that most daily problems don't have resolutions and therefore don't lend themselves to good stories.

Journalists often cover a story's resolution without ever showing the complication. "Endings without beginnings attached," Franklin calls these kinds of articles.

Applying Franklin's analysis of story development to photojournalism reveals that photographers shoot racial confrontations or political victories without putting the situations into context. Here, photographers are shooting the story's resolution without showing the problem or complication.

Alternatively, photojournalists sometimes concentrate on the complication but never present a resolution. While they document a social ill like poverty or drug addiction, their documentaries don't turn into narrative stories. These photographers legitimately document the complication of having no money or of craving for narcotics or alcohol, but the photos don't show how someone finally earns money to survive or kicks the habit: how someone resolves the problem.

While complications often don't have resolutions, resolutions almost always have complications. When John Doe wins the Olympic high jump award, you know that he faced many hurdles to get there. The story comes to life only when you show both the challenges on the way to the top (the complication) as well as the final victory (the resolution).

A compelling photo story requires action. The complication must be visual and not just internal. The subject must try to resolve the complication by doing something.

A woman sitting in a wheelchair presents a complication. The reader can see that the woman is faced with a problem. However, her sitting there alone doesn't provide the subject matter for a story. If the wheelchair-

bound woman wants to walk, then the photographer has a potential narrative photo story. Showing the woman struggling to get out of the chair and finally learning to stand and walk would provide a possible resolution to the story. After many attempts, photos of her walking alone would complete the story. The story is not a description of her handicap but a tale of her efforts to overcome her limitations.

Rather than being "a story about someone who is disabled," the story's outline might read:

At first, after the accident, the subject is confined to her wheelchair.

Then she **exercises** and **swims** for therapy.

Next, she **takes a few halting steps**.

Finally, the subject **walks** alone.

Jim Mahoney of the *Boston Herald* photographed a narrative story about a mounted police officer whose horse was injured by a passing car (see pages 152–153). The officer faced the complication of dealing with his horse in pain. The short story was resolved when the veterinarian put the horse out of his misery. The drama lasted only a few minutes, but the sequence of pictures showed the reader what the officer had to go through and how the problem was resolved.

Stanley Forman, three-time Pulitzer winner, produced a complete story with a complication and resolution built in when he covered a fire in the Boston neighborhood of Dorchester. (See pages 32–33.)

Forman was cruising the city with his scanner radio turned on, looking for spot news, when he actually smelled smoke. He pulled up next to a house as flames were billowing out of the first floor. As he arrived, police cars came screeching to a halt with their sirens blasting and lights rotating.

Stranded on the roof of a burning porch, a man and a woman clutching a small child looked for help. Flames curled up from the porch below. The family was trapped (complication). Fireman had not arrived with a ladder. The father bent over the roof and delicately dropped his child into the arms of a waiting policeman, who safely caught the child.

Then the mother panicked. Afraid to jump, she froze. The man literally pushed her off the roof to save her life. She fell to the ground, slightly injuring her leg. Then the man himself leaped to safety.

To complete the narrative news story, Forman photographed the medics carrying the mother away on a stretcher as the building blazed in the background and also caught a picture of the policeman hugging the child he had saved (resolution).

■ A STORY IN THREE ACTS

Sometimes a story involves several complications and resolutions. Each complication/resolution is like an act in a

play requiring one or more two-page spreads to tell an aspect of the plot. You could treat as a three-act play, for example, the classic *Life* essay "Nurse Midwife," by W. Eugene Smith, reproduced on pages 132–143.

Jim Hughes, one of Smith's biographers, says in his book **W. Eugene Smith: Shadow and Substance,** "Gene began to approach his story about Maude Callen as he thought a playwright might." Smith himself said, "I think this (analogy to drama) comes closer to being what a picture story is . . . "

In the first act, Maude, the nurse midwife, has been brought in to oversee a difficult birth (complication). In the photo, Maude sits watchfully by as the expectant mother rests. The resolution for the first act is found in the following spread, when Maude delivers a healthy baby.

The second act, called "Maude's 16-hour day," leads with a picture showing a child on crutches walking toward Maude. The caption explains that last summer Maude arranged for the girl to attend a camp for special children. The camp had strict entrance requirements — each child had to have two dresses and one pair of pajamas. Maude supplied the clothes so the child could go to camp. While the picture sets up the complication (girl on crutches approaches Maude), the caption suggests the resolution — Maude had provided the clothes for camp. The real visual resolution for the second act, however, does not come until the following page. This page shows a different little girl showing off a new dresses provided by Maude.

Life called the final act in the layout "Maude and M.D." The complication shows Maude bringing a dying child to the doctor. While the layout's next picture shows the child, just before death, in the doctor's care, the third act's (in fact, the whole story's) real resolution is contained in the last picture. In the drama's final photo, Maude teaches a class in midwifery. She holds up a healthy baby while lecturing to a roomful of eager students. Maude passes on her knowledge of modern medicine's life-saving techniques that will save the lives of mothers and babies in the future (resolution).

Smith's story, by the way, did not just include pictures showing the story's complications and resolutions. The narrative contained photos used by Smith to make a particular point or to flesh out aspects of a character not captured in the leading pictures. In the opening spread, for example, Smith included a picture of Maude washing her hands. He was making the point that she performed her deliveries under antiseptic conditions. In the third spread, a quiet portrait of Maude holding a flower portrays yet another side of the woman's personality.

While point pictures provide development and explanation to a story, used alone they don't move along the narrative. Point pictures provide expository breaks to

fill in the story's gaps. Those that show the complication and resolution are the ones that thrust the story forward.

■ YOU DON'T HAVE A LIFETIME TO SHOOT THE STORY?

Writers can reconstruct past events just by interviewing someone. For the photographer, the biggest problem with shooting narrative stories is that many complications faced by potential subjects simply don't take place in the relatively short time span allotted for most assignments. Sometimes, months or even years go by before a person resolves a complication. Editors often allot today's newspaper and magazine photographers only a few days to work on most stories. Here are a few ways you might compress time in a narrative story.

RESOLUTION NEAR AT HAND

Pick a story in which the resolution is near at hand. If you want to shoot a story about a political newcomer running for mayor, zero in on the subject a few weeks before the primaries or before the actual election. At this time, you will be able to show how the candidate grapples with the complication of getting into office: gladhanding, strategizing, chain-smoking, late-night meetings, and preparations for television interviews. The narrative story will resolve itself on election eve or perhaps the mayor's first day in office. Starting the story too early or late, however, means you may miss the complication or resolution.

In February, Ron Bingham set out to shoot a story on open adoption, an arrangement in which a pregnant woman planning to give up her newborn selects the parents who will adopt the child. Bingham did not want to take pictures of couples playing with their recently adopted child or shoot a series of portraits of mothers who had given up their children at birth. He wanted to shoot a narrative story in which he was present at all the important emotional moments that a birth mother and adoptive parents go through.

He wanted to show the relationship developing between the biological mother and the adoptive parents. To pull off the story within the allotted time slot — by the middle of May — he knew he had to pick a woman who was near term. If he started with a woman who was too early in her pregnancy, he would not be able to shoot the birth and adoption sequence. If he started too late, he would miss the interaction between the biological mother and the new dad and mom. Picking the right time in the subject's life proved ideal for the story.

Bingham photographed the biological mother going to Lamaze class with her boyfriend and prospective adoptive parents. Bingham photographed the adoptive mother taking the biological mother in for a obstetrician's exam. He took pictures at the baby shower given by friends of the soon-to-be adoptive mother. Finally, he

was there when everyone in the story went to the hospital for the delivery.

Like a short story written by the American writer O. Henry, this story had a surprise ending.

Unlike prescripted Hollywood stories, real-life stories don't always end as you expect. After following the relationship between the mother and prospective adoptive parents for three months, a dramatic change occurred. Following labor and delivery, the adoptive parents first held the child. Then the birth mother held her... and did not want to let her go. The adoptive parents left the hospital empty-handed. (See page 160 for pictures from this story.)

SMALL RESOLUTION WILL DO

Within a story, you might zero in on a small resolution rather than the ultimate resolution to the complication. You might follow a person with cancer through a bone marrow transplant and photograph some of his or her recovery. You might end the story with dismissal from the hospital even though this juncture might be only the first step in an eventual cure. Although your camera has not recorded the ultimate victory over death, you have told a unified story.

EXISTING PICTURES

Investigate photo albums or archives to show what your subject or location used to look like. If your story is about a successful banker who has overcome a poverty-stricken past, can you show the complication with photos of the person as a youngster living in a cold-water flat or a run-down shack?

Without these pictures, the banker's success would seem unearned. If your story is about a neighborhood, can you find old pictures from the historical society or your paper's morgue that would indicate whether the neighborhood used to be wealthy or poor or even farm land or trees.

SEPARATE PATHS

For some narrative stories, you might find two people who have taken separate roads in life. Suppose you want to tell the story of an escapee from the ghetto. To document the story in real time would take years, following someone from childhood through adolescence to success or degradation as an adult. Rather than document one person's entire life, you might find brothers or sisters raised in the same conditions. One took to the streets and now sells crack cocaine. The other stayed in school and now teaches at a university.

A picture story of the crack-selling sibling would show the complication but not the resolution. A story of the scholar would reveal a resolution but miss the problem. Photographing both lives, perhaps, could lead to an imaginative narrative story.

THE NARRATIVE

■ DOCUMENTARY VS. NARRATIVE

The great photographers of the Farm Security Administration (FSA) set out to document the severe poverty resulting from the 1929 depression and dust bowl. These photographers also documented government aid in the form of work programs and housing provided by Franklin Delano Roosevelt's Works Progress Administration (WPA). While the landmark photo project set out to show both complications and resolutions, its organizer, Roy Stryker, never intended to tell a narrative story. FSA photographers did not follow one family or even a set of families through their trials and tribulations on the way to economic self-sufficiency. Rather, the photographers documented a problem in one part of the country and a solution in another. Stryker's photographic corps provided not a story but an important historical record (document) of the times.

Similarly, when the *National Geographic* assigns a "place story" — a story on Kansas, for example — the magazine makes no attempt at producing a narrative. The opening picture of wheat fields does not set up tension that will be resolved by the following images of dairy farms and women baking pies. There is no need for relief in the concluding spread that shows a rural school teacher waving goodbye to her students. Even point pictures that show a modern city skyline and pulsing factories don't form the material into a narrative. While each individual picture might be strong, no storyline holds the images together. The viewer can stop anywhere in the section without losing the flow of the layouts. Instead, each picture makes a point that the editors hope will document and explain to the reader some aspect of the area.

■ NATURAL NARRATIVES

Some stories lend themselves to the narrative approach. Consider stories about an athlete preparing for the big match. Here the complication is the athlete's desire to win. The story follows the athlete through the rugged, sweaty, muscle-torturing training regime. Finally, the athlete wins or loses the big contest.

Many adventure stories have a built-in complication as well as a resolution. Bob Gilka, director of photography at the *National Geographic* at the time, assigned Keith Philpott to photograph an exploratory raft trip down Africa's Omo River. (See page 161.)

Starting in the Omo's headwaters, near Ethiopia's capital city of Addis Ababba, the trip ended 600 miles later at the river's final destination, Lake Turkana. The built-in complication involved overcoming the river's perils, including fighting off wild hippos. The rafters also experienced adventures along the way and witnessed the primitive lives of natives living near the river. The story's natural resolution showed the rafters successfully paddling into Lake Turkana.

■ CONCLUSION

Shooting narrative stories takes research, scheduling, and time. Narrative stories often require the patience of Job and the planning of an air traffic controller. Sometimes the end is not predictable when you start. However, all the difficulties are worth it. Rather than seeing an interesting collection of pictures that holds readers for a few minutes, the narrative story sucks the viewer into the subject's predicament.

With a narrative story, readers start to care about the subject and want to know how the person is going to solve the dilemma. What is going to happen to the person? When picture stories are done well, readers remain on the edge of their chairs, waiting to see the last picture that reveals the story's outcome.

The story has a plot line — not an invented, preplanned script typical of '30s and '40s magazines — but a real story line in which people face problems and overcome them in some way.

Most important, the reader comes to care about the hero or heroine of the story. Whether you are showing a story about a family jumping off a roof in Boston or about adventurers river-rafting in Africa, the subject is not shown just once, but is repeated in picture after picture. The reader gets involved in the subject's life. Will the family survive the fire? Will the adventurers be killed by dangerous hippos? And, perhaps, if the story has merit and is well-photographed, the reader won't just give a passing glance to the pictures and move on. Instead, the magazine or newspaper subscriber will remember the story, repeat the story, and perhaps show it to others. ■

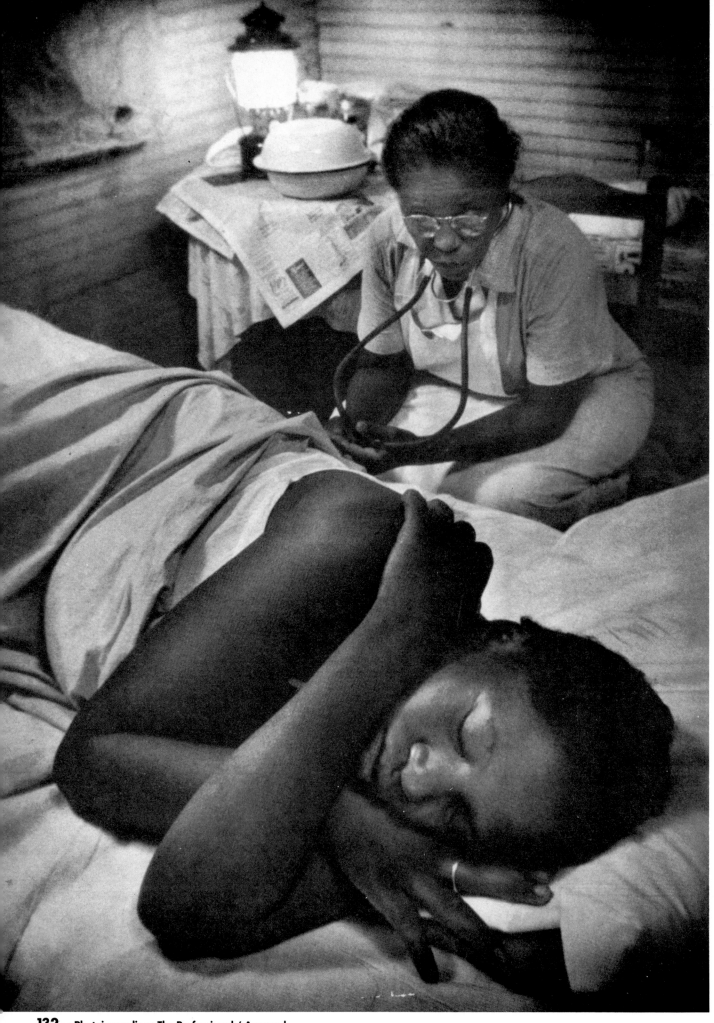

WAITING, the young mother leans forlornly against the window, ignoring sympathy and looking for Maude's car.

Nurse Midwife

MAUDE CALLEN EASES PAIN OF BIRTH, LIFE AND DEATH

PHOTOGRAPHED FOR LIFE BY W. EUGENE SMITH

Some weeks ago in the South Carolina village of Pineville, in Berkeley County on the edge of Hell Hole Swamp, the time arrived for Alice Cooper to have a baby and she sent for the midwife. At first it seemed that everything was all right, but soon the midwife noticed signs of trouble. Hastily she sent for a woman named Maude Callen to come and take over.

After Maude Callen arrived at 6 p.m., Alice Cooper's labor grew more severe. It lasted through the night until dawn. But at the end (*next page*) she was safely delivered of a healthy son. The new midwife had succeeded in a situation where the fast-disappearing "granny" midwife of the South, armed with superstition and a pair of rusty scissors, might have killed both mother and child.

Maude Callen is a member of a unique group, the nurse midwife. Although there are perhaps 20,000 common midwives practicing, trained nurse midwives are rare. There are only nine in South Carolina, 300 in the nation. Their education includes the full course required of all registered nurses, training in public health and at least six months' classes in obstetrics. As professionals they are far ahead of the common midwife, and as far removed from the granny as aureomycin is from asafetida.

Maude Callen has delivered countless babies in her career, but obstetrics is only part of her work. To 10,000 people in a thickly populated rural area of some 400 square miles veined with muddy roads, she must try to be "doctor," dietician, psychologist, bail-goer and friend (*pp. 140, 141*). To those who think that a middle-aged Negro without a medical degree has no business meddling in affairs such as these, Dr. William Fishburne, director of the Berkeley County health department, has a ready answer. When he was asked whether he thought Maude Callen could be spared to do some teaching for the state board of health, he replied, "If you have to take her, I can only ask you to join me in prayer for the people left here."

◄ **WEARY BUT WATCHFUL, MAUDE SITS BY AS MOTHER DOZES**

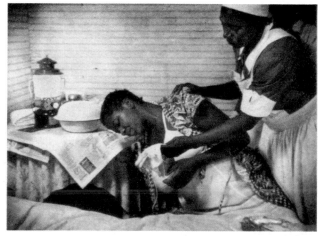

FRIGHTENED AND SICK, the nervous mother is helped by Phoebe Gadsden, the first midwife she called. Mrs. Gadsden, a practicing midwife who attended Maude's classes (*pp. 144, 145*), has helped at several deliveries but felt that this one needed special attention and so decided to ask Maude to come and supervise.

MAUDE GETS READY in the kitchen by lamplight. In addition to the stethoscope and gloves, her equipment consists of about $5 worth of such items as clean cloths, bits of cotton, scissors, cord ties, Lysol, surgical gown and mask and a blood-pressure gauge. Her deliveries are always made under aseptic conditions.

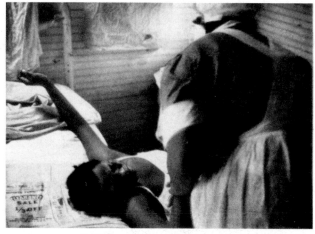

IN DEEP PAIN, the 17-year-old mother writhes, mumbling prayers while Mrs. Gadsden holds her hand. She could do little to relieve pain because she is not permitted to administer any drugs. The mother was worn out and weak even at the beginning of her ordeal, having previously gone through a period of false labor.

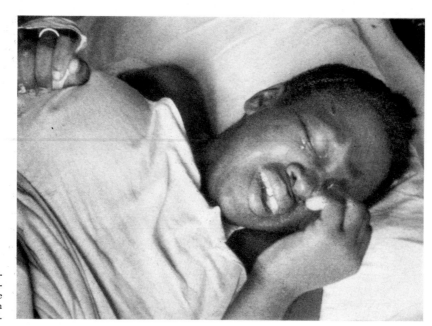

4 A.M. As hard labor begins, the face of Alice Cooper seems to sum up all the suffering of every woman who has ever borne a child.

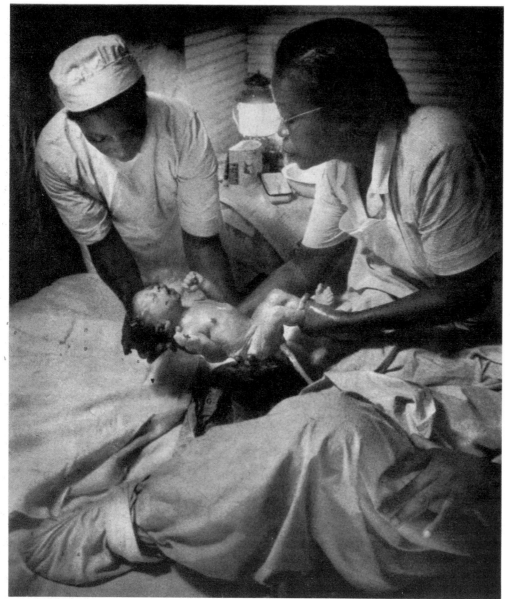

5:30 A.M. A few seconds after the normal delivery, Maude Callen holds the healthy child as he fills his lungs and begins to cry.

5:45 A.M. The mother's aunt, Catherine Prileau, tries to soothe her so that she will go to sleep and begin to forget her misery.

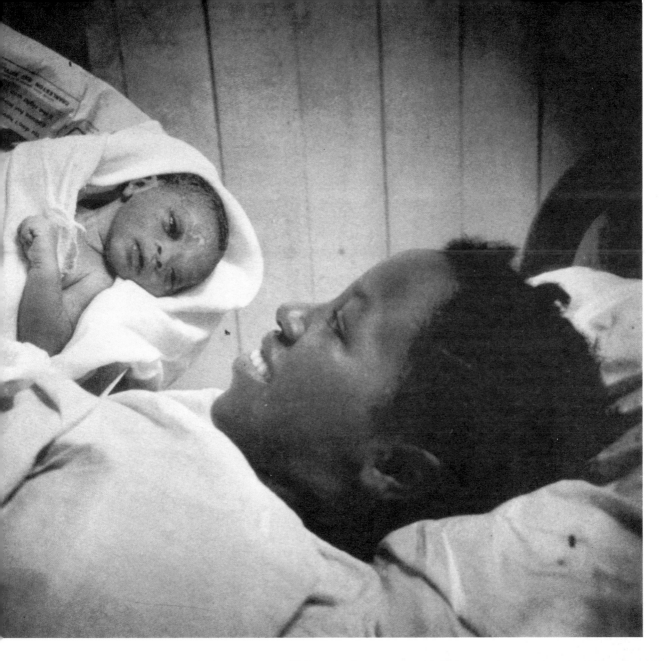

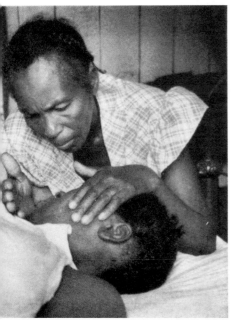

5:40 A.M. The long-suffering over, the mother first sees her son. She had no name for him, but a week later she chose Harris Lee.

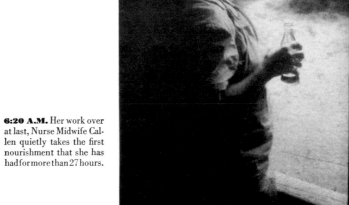

6:20 A.M. Her work over at last, Nurse Midwife Callen quietly takes the first nourishment that she has had for more than 27 hours.

MAUDE AT 51 has a thoughtful, weary face that reflects the fury of her life. Orphaned at 7, she was brought up by an uncle in Florida, studied at Georgia Infirmary in Savannah, became a nurse at 21.

HEALTHY TWINS, who were delivered a day apart last year by Maude, get a quick once-over when she stops in to see them and to pump herself a drink of water. Only about 2% of her patients are white.

MAUDE'S 16-HOUR DAY

Maude's duties as midwife are no more important than those as nurse. On her daily rounds she sees dozens of patients suffering from countless diseases and injuries. She visits the nine schools in her district to check vaccinations, eyes and teeth. She tries to keep birth records straight, patiently coping with parents who say, "We name him John Herbert but we gonna call him Louie." She tries to keep diseases isolated and when she locates a case of contagious illness like tuberculosis she must comb through her territory like a detective, tracking down all the people with whom the patient may have been in contact. She arranges for seriously ill men like Leon Snipe (right) to go to state hospitals, and she keeps an eye on currently healthy babies to see that they remain that way. Whenever she is home—she is childless and her husband, a retired custom-house employe, sees her only at odd hours—she throws open a clinic in her house to take care of anyone who wanders in. And sometimes patients like Annabelle Mc-Cray Fuller (below, right) will travel all the way from Charleston, 50 miles away.

Maude drives 36,000 miles within the county each year, is reimbursed for part of this by the state and must buy her own cars, which last her 18 months. Her work day is often as long as 16 hours, her salary $225 a month. She has taken only two vacations and has now become so vital to the people of the community that it is almost impossible for her to take another.

TUBERCULOSIS CASE, 33-year-old Leon Snipe, sits morosely on bed while Maude arranges with his sister for him to go to state sanatorium. Maude had met him on road, noticed he was thin, wan and sickly.

AFTER ANOTHER DELIVERY Maude departs at 4:30 a.m., leaving the case in charge of another midwife. Since she is already up, she is likely not to go to bed but to continue through rest of morning.

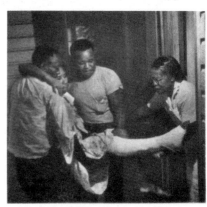

ACCIDENT CASE is brought to Maude's door one night. Annabelle Fuller was seriously cut in an auto accident and Maude had given her first aid. Now the girl returns to have her dressings changed.

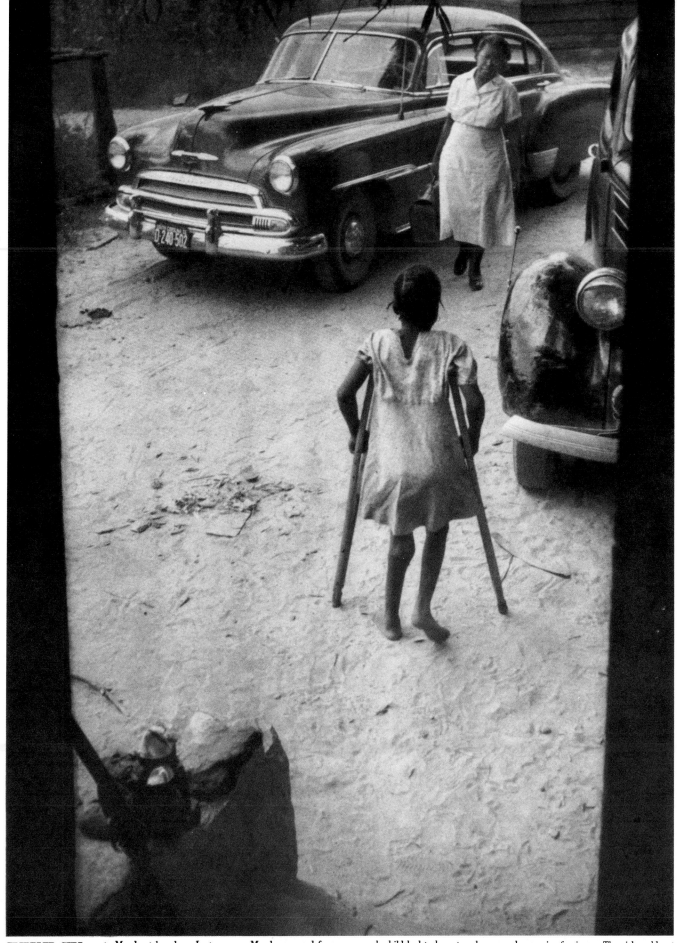

CRIPPLED GIRL greets Maude at her door. Last summer Maude arranged for her to go to a state camp for crippled children which had strict entrance requirements —each child had to have two dresses and one pair of pajamas. The girl could not meet these, but after Maude got her one dress and one pair of pajamas, she could.

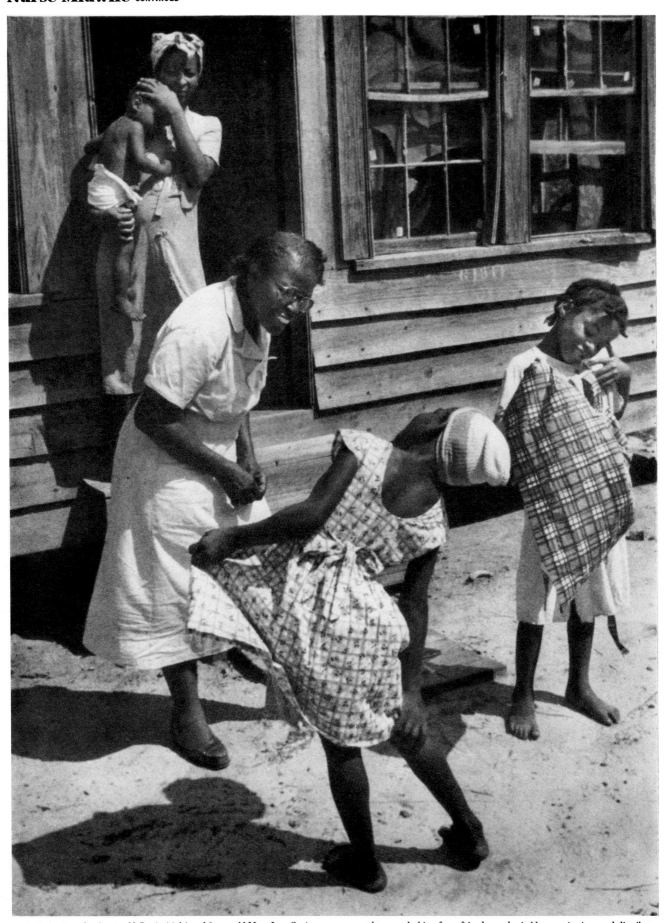

NEW DRESSES for 9-year-old Carrie (*right*) and 8-year-old Mary Jane Coving-ton were dropped off by Maude on her way to a patient. Occasionally, as in this case, she gets clothing from friends or charitable organizations and distributes it where she thinks it is most needed. But sometimes she buys the clothes herself.

SIMPLE KINDNESS overwhelms an old man. Frank McCray had a headache one day in 1927, soon was paralyzed, and has been in this chair ever since. He broke down and wept when Maude stopped in.

EXTRA DUTY assumed by Maude includes cashing of relief checks and dealing with storekeepers for several people who are mentally incompetent or, like this man, blind. She paid his bills for him and counted out change so he could buy some tobacco.

STORE-BOUGHT FOOD donated by Maude fascinates youngsters outside log cabin. She frequently finds families with only two or three items on their diet, recently found this one living entirely on corn.

AFTER A CALL she wades back to her car. Roads like this are not unusual. At the end of some of them in the '20s, she "found people who did not know the use of forks and spoons."

DR. W. K. FISHBURNE, head of the Berkeley County health department, examines a patient brought to hospital by Maude.

MAUDE AND M.D.

When she is not visiting her patients in their homes, Maude holds clinics in churches, school buildings and backwoods shanties throughout her district. Some are for a single purpose—inoculations, classes for midwives or expectant mothers, examinations for venereal disease. Others are open to all comers with all ills. All are part of the activities of the South Carolina State Board of Health, Maude's ultimate employer, which has perhaps the best state midwife-education program in the U.S., although a recent budget cut seriously threatens it.

At her clinics Maude does not compete with doctors. There are not enough M.D.s in any case to cover the territory, and whenever her patients are in need of treatment that Maude is incompetent or unauthorized to give, she takes them to the health department clinic or the county hospital. There she works under the direction of Dr. William K. Fishburne (*above*), from whose shoulders she has taken an enormous amount of work.

DYING BABY who is suffering from acute enteritis is rushed to hospital. Mother brought her to Maude, who took her temperature (105°) and raced 27 miles in hope of saving her life.

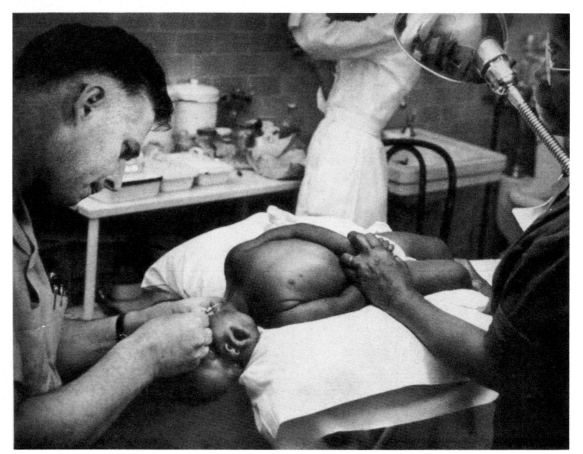

TRANSFUSION was almost impossible because fever's dehydration had affected arm veins and doctor had to try one in neck. Baby died before he could get blood flowing.

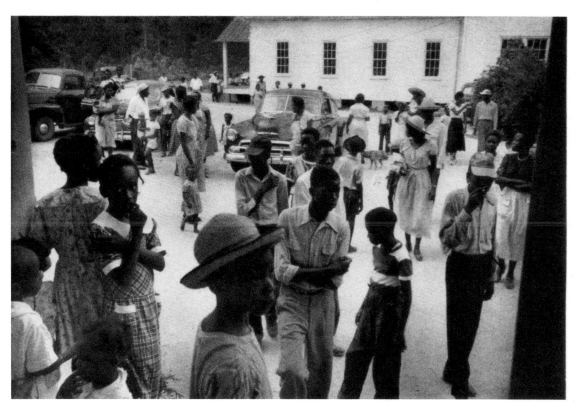

OUTSIDE A CLINIC
held in school, crowd waits
to see Maude. On one afternoon, with one assistant, she gave 810 typhoid
shots, later went out and
delivered another baby.

INSIDE A CHURCH,
Maude inspects a patient
behind a bedsheet screen.
She dreams of having a
well-supplied clinic but
has small hope of getting
the $7,000 it might cost.

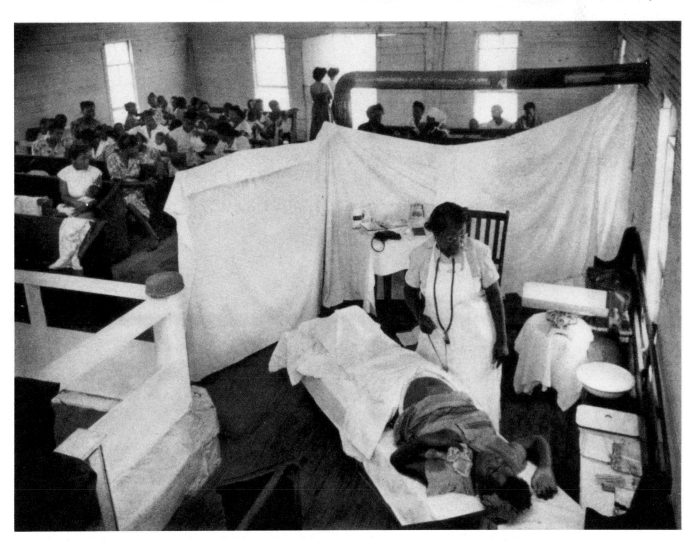

MAKING A DELIVERY PAD in patient's home according to classroom method, Maude crimps together the edges of several pieces of newspaper. Her materials must be makeshift; even paper is scarce.

INCUBATOR is made of box and whisky bottles full of warm water. The bottles are placed at foot and sides of box, then covered with layers of cloth. This will sometimes work for as long as two or three hours.

CRIB is made of an old fruit crate propped near a cold stove. Maude must demonstrate even this simple idea—she has seen newborn babies thrown into bed with older children where they might suffocate.

TEACHING A MIDWIFE CLASS, Maude shows how to examine a baby for abnormalities. She conducts some 84 classes, helps coach about 12 new midwives each year. These midwives, who are already

practicing, return to Maude for monthly refresher courses which open and close with a hymn. Few have more than fourth-grade education but are trained for two weeks at the state midwife institute and are very proud of their calling. Unlike Maude, they get fees for deliveries, set at $25 but often paid in produce.

RUDI GOMEZ: CHILD PROSTITUTE

ON THE STREETS OF NEW YORK

Rudi Gomez, age 14, hustles. He doesn't steal or deal drugs. He sells his body to older men.

Stephen Shames' story reveals the life of this child who uses prostitution as a way to survive in an adult world.

For the story about child prostitution, the photographer could have just taken pictures of young boys hanging out in Times Square, where Rudi makes his meager living.

However, this story goes far beyond simple surface images.

Zeroing in on one boy who prowls the area, the story digs deep into the life of Rudi Gomez. The photos help the reader understand the life of the child from the South Bronx. A drunk, unemployed and abusive father. Parents and eight siblings all living on $308 a month from welfare.

The story shows the child's entertainment as he does gymnastics on a subway car's strap hangers and as he badmouths people at the pinball parlor.

Then the story discloses how Rudi makes a living. The pictures show an older man picking up Rudi. The story's crucial and unforgettable final photo takes the reader inside a barren room. Here Rudi, in his underwear, lies on a mattress, awaiting an older man wearing a sleeveless T-shirt, who looms over the youngster.

This story does not just give a slice-of-life of this street hustler. Rather, it carries the reader through the child's life trying to explain how a 14-year-old could wind up in this condition. (Photos by Stephen Shames, Visions/*Philadelphia Inquirer.*)

A policeman and a security guard lecture Rudi after he's been thrown out of a pinball arcade for badmouthing and other poor behavior.

[continued]

Rudi can't take being at home too long. He returns only to shower or change clothes. His real life is on the street. He sleeps in subway cars, bus depots, and trucks, under staircases in houses and, in the summer, in parks.

(LEFT) Rudi does gymnastics on the strap handles as he rides the subway from the South Bronx to hustle on Times Square. Fifteen or twenty other boys from his block make the same trip for the same purpose every day.

RUDI GOMEZ: CHILD PROSTITUTE

HOME IN THE SOUTH BRONX

In a moment of anger, Rudi picks up a broom and strikes his brother.

Rudi Gomez lives in a run-down, burned-out, boarded-up section of the South Bronx in New York.

Rudi is one of Efigenia Gomez's nine children. She speaks English poorly and does not exactly know how Rudi makes his living when he goes to Times Square. His father, unemployed, remains constantly drunk and beats up his son.

[continued]

Rudi calls one of his customers on the phone.

Rudi feigns a smile at a man just before being picked up by him in the subway's pinball arcade.

The man with Rudi keeps this apartment near Times Square for the purpose of bringing boys to it for sex. The man, in his 60s, lives with his mother. Rudi does not consider himself a prostitute or a homosexual. He simply sells what he has. His body.

SEEING
SOUND

Each picture individually shows one way of depicting sound. Together, the photos take on an added dimension. An essay is usually produced by a single photographer, but it can also comprise the work of several photojournalists. Here, the essay emphasizes camera technique as a way of turning a non-visual subject into something you can see on the printed page.

(BELOW) A straightforward photo of a child listening to music through earphones. (Photo by Greg Schneider, *San Bernardino* (Calif.) *Sun Telegram.*)

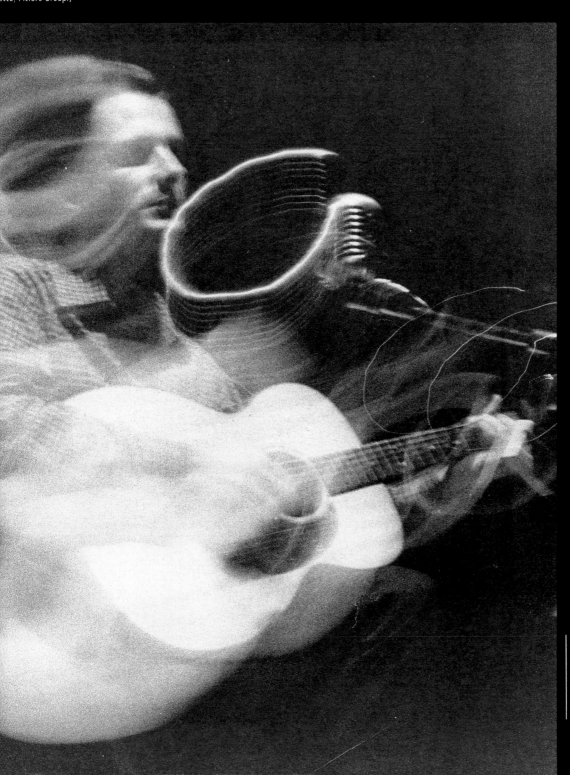

(FAR LEFT) Double exposure of Bruce
..kerson, bass player of the "Atlantics."
..hoto by Pamela E. Chipman.)

(.AR LEFT) The saxophonist, Anthony
..axton, swayed during a long exposure,
..ating this blur effect. Notice the micro-
..one is still sharp. (Photo by Michael
..ecco, Picture Group.)

For this photo of a folk singer, the
photographer held the camera steady
for 1/2 sec. and then moved the cam-
era in an arc before closing the shut-
ter. (Photo by Ken Kobré for Photo
Associates, Denver.)

DEATH OF
A PARTNER

A police sergeant leads officer Alan Keith away from the horse once the veterinarian arrives.

Officer Alan Keith tries to calm and comfort his horse, Tivoli, after the horse's leg was broken by a passing drunk driver. A fireman puts an icepack on the officer's head.

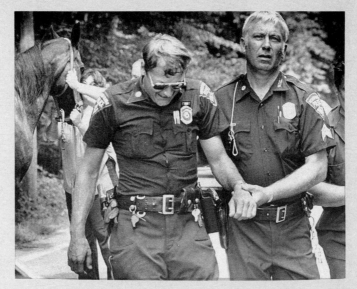

Police officer Alan Keith was writing a traffic ticket near the Blue Hills Reservation in Milton, Mass., when a speeding car clipped Keith's horse, Tivoli.

The impact threw the policeman and fatally injured his four-legged companion of three years.

Keith embraced this injured friend, then was helped away by fellow officers as Tivoli was put down.

Within the space of a few minutes, an entire drama unfolded in front of Jim Mahoney's camera. In this sequence of pictures, Mahoney concentrated on telling the story of the policeman and his reactions to the loss of his equine partner.

The original edit that appeared in the *Boston Herald* overlooked the photo of the officer with his arm around the horse. The photo was later run in *Life* magazine. The newspaper also omitted the photo of the veterinarian putting down the horse. Editors considered the photo too graphic.

These pictures show the emotional side of a police officer, a sight rarely revealed on film. Mahoney notes that most officers are seen as "John Wayne" types, never expressing fear or sadness. He says that perhaps the unusual combination of the tragedy for this animal combined with the clear grief of the officer accounts for the reason the pictures not only received good play in the paper and on both AP and UPI wire services but also generated so many sympathetic letters and phone calls. (Photos by Jim Mahoney, *Boston Herald*.)

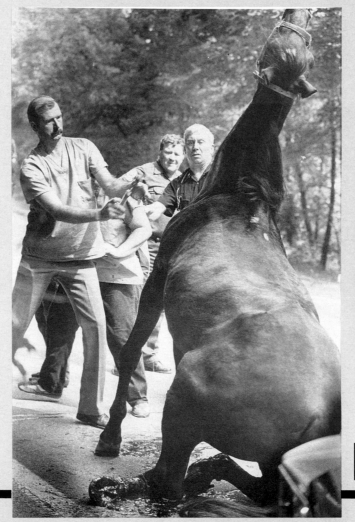

(LEFT) A veterinarian readies a shot that will quickly and painlessly kill the horse, whose leg was severely broken.

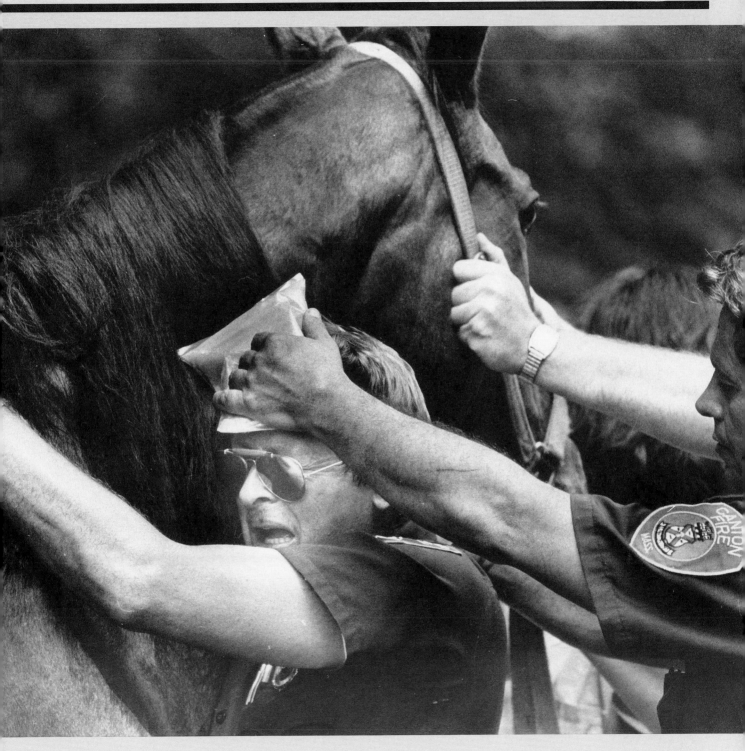

Finally, officer Keith is led to a waiting ambulance for a trip to the hospital. He returned to the mounted police force soon after the accident.

FRIENDS FOR LIFE
BROTHERS ON THE LAND

TOILING TOGETHER

Charley and Wilhelm Eilers used only horse-drawn equipment to farm their land. The Minnesota bachelors were born in the same house they still lived in.

Charley and Wilhelm Eilers, two elderly bachelor brothers, clung to farming methods of the 1920s. The Eilers were born in the same house in which they continued to live for seventy-five years. Neither ever married. They chose to work the land by the time-honored method of horse-drawn machines.

Together, they worked the rich soil, growing corn, oats, and beans. Through the years, they worked as a team, alternating the heavy labor and carrying out their individual chores. Although mechanized equipment began making farm work easier, the Eilers chose to stick with the methods they knew best.

Without warning, Charley had a stroke and died, leaving Wilhelm to continue by himself.

While the story, at first, seems to be about old-fashioned farming methods, photographer Neil McGahee recognized that what he was observing had a deeper meaning. The photographer saw that the real theme of the story was the relationship between the brothers. His story established that relationship. Then the story takes a turn. In the course of McGahee's project, one brother has a heart attack. By returning and photographing afterward, McGahee shows the effects of the death on the remaining brother.

What will happen to the surviving brother? The photo of Wilhelm, quietly grieving, with his hand covering his eyes, reveals the emotional side of this man. The ending shot — Wilhelm plowing the field alone — resolves the complication. Wilhelm is going to continue. **Alone.** (Photos by Neil B. McGahee)

The brothers, after living on the land together for 75 years, worked as a team so often that they seldom needed to talk about what to do.

Side by side, like the brothers themselves, their work clothes wait for another day on the farm.

[continued]

FRIENDS FOR LIFE:
BROTHERS ON THE LAND

ONE BROTHER ALONE

Wilhelm could only stand by stoically as Charley lay in a hospital bed after his stroke.

(BELOW) Wilhelm quietly grieves the loss of his brother. Clutching a kitten that had wandered onto the farm, he weeps.

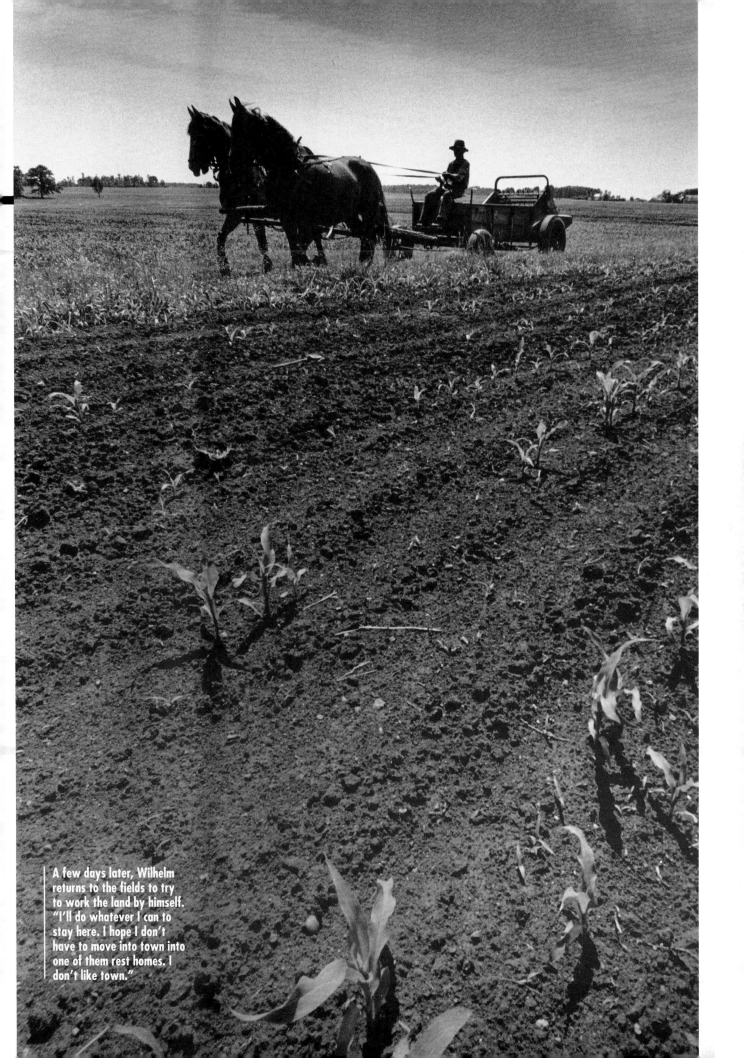

A few days later, Wilhelm returns to the fields to try to work the land by himself. "I'll do whatever I can to stay here. I hope I don't have to move into town into one of them rest homes. I don't like town."

CHILDREN OF POVERTY

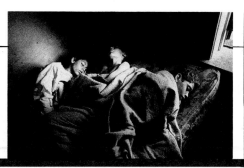

Lafayette Walton, a soft-spoken, shy ten-year-old, watched as a 30-year-old neighbor was gunned down by rival gang members. On a tour of his building, he points out where a gang member was beaten to death the previous year. Bullet holes scar the thick metal doors to his building. Recently he watched as a young girl was shot in the leg by gang crossfire as she jumped rope. "I'm scared to sleep by myself," he said.

Lafayette Walton is a part of the growing number of Americans under the age of 18 who live in poverty. Between 1973 and 1983, their ranks increased 50 percent, according to a Congressional report. One out of five children, or 13.8 million, are poor. The Children's Defense Fund says that the problem is worsening. Nearly half of all poor people in America are children.

Photographer Stephen Shames received a grant from the Alicia Patterson Foundation to document child poverty across the nation. The pictures are not a neutral document nor a narrative photo story. Rather, Shames' photos are a strong emotional editorial. Each picture in the essay builds on the previous photos like drum beats, inevitably leading to only one conclusion: a searing condemnation of how one of the richest countries in the world, the United States of America, takes care of its young. Shames' pictures are in the photo muckraking tradition of Jacob Riis, who exposed slum conditions in New York, and Lewis Hine, who revealed intolerable work conditions for children, at the turn of the century. (See Chapter 15 "History.") (Photos by Stephen Shames, Visions/*Philadelphia Inquirer*.)

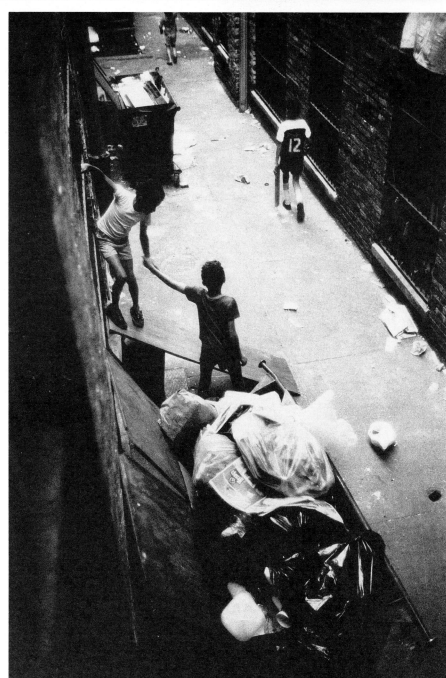

(ABOVE) An alley is their playground and a dumpster is their jungle gym.

(RIGHT) Amid the family's laundry, Coleta Coleman bathes her son, Michael. She and her seven children live in a two-bedroom apartment.

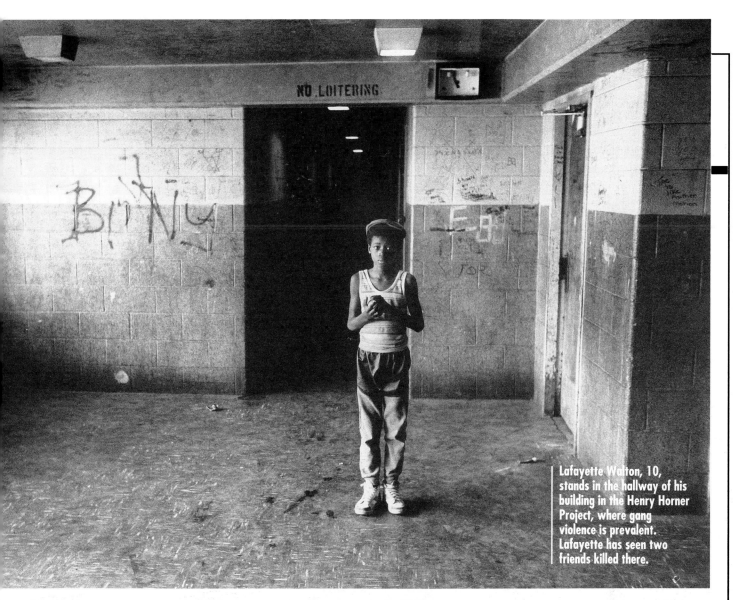

Lafayette Walton, 10, stands in the hallway of his building in the Henry Horner Project, where gang violence is prevalent. Lafayette has seen two friends killed there.

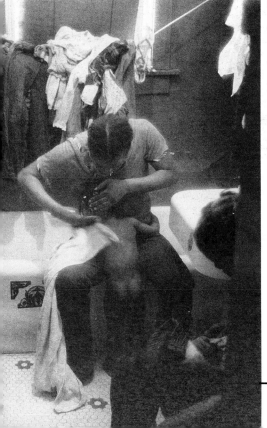

Iris Burgos walks in on a fight between two of her sons. She has twelve children in all, and they all live in the same apartment. Two of the children have already dropped out of high school because of gang threats.

OPEN ADOPTION

At Lamaze class, the biological mother practices breathing with the help of her boyfriend (on the right) and the couple she has selected to adopt her child.

(ABOVE) During labor, the adoptive parents, standing on either side of the bed, provide support and encouragement to the mother.

After the birth, the adoptive parents proudly hold the newborn they expected to be theirs.

In an open adoption, a pregnant woman planning to give up her newborn selects the parents who will adopt the child. This story set out to show how the relationship developed between the woman and the couple she selected. Ron Bingham started the story near the woman's due date so that he could complete it by deadline. By selecting the right subject, a story that might have taken months to shoot could be completed in a relatively short period of time.

The story proceeded as expected until immediately after the birth. The proud adoptive parents held the child for a picture. Then the mother held the child. Only she didn't want to give it up. After all the months of preparation and anticipation, the adoptive parents left the hospital empty-handed. With real stories, you never know how they will turn out. (Photos by Ron Bingham for the *Struggle for Life* project.)

After holding her baby for the first time, the mother decided not to give the child up for adoption, but instead to keep it herself.

DOWN ETHIOPIA'S OMO RIVER

Starting out at the headwaters of the Omo near Ethiopia's capital city of Addis Ababba, the explorers could see the river in the distance.

To impress the outsiders, this villager sticks her tongue through a hole in her chin.

A group of explorers and naturalists paddled down the Ethiopia's Omo River on inflatable rafts. The adventurers faced heat, unsanitary water, friendly and unfriendly natives, and hostile hippos along the way. Alive and well at the end, they finally reached the mouth of the river as it fed into Lake Turkana.

Trip stories, like this one that Keith Philpott shot for the *National Geographic*, have a natural narrative with complication (overcoming the problems of getting down the river) and resolution (arriving at the destination) built in. (Photos by Keith Philpott for the *National Geographic*.)

Traveling in inflatable rafts, the group carried enough food for half the trip. They restocked midway, where the river intersected a road.

After 600 grueling miles, the adventurers successfully reach the end of their journey at Lake Turkana.

Illustrations

This illustration was for a story about cryonics, freezing dead people in hopes of a future cure.
(Photo by Susan Gardner, *Fort Lauderdale* (Fla.) *News-Sun/Sentinel.*)

ONIONS:
ATTACKING
BACK

A product illustration, like the one above, is often an attractive still life that simply shows what an object looks like. An editorial illustration, like the one at right, depicts a concept. Here, the concept is how to protect yourself against the odoriferous onion. (Photo illustrations by Joseph Rodriquez, *Greensboro* (N.C.) *News & Record.*)

Today's photojournalists are borrowing the techniques of the advertising photographer to illustrate stories based on abstract ideas. This blend of advertising technique and photojournalism — the photo illustration — has come about as newspapers have shifted from the "simple account of what happened yesterday" to analysis of what happened over a period of time and to evaluations of what may happen in the future. This change in journalistic emphasis from immediate reaction to longer-term interpretation of the news has led to stories about more abstract — and non-visual — issues, such as those dealing with economy, psychology, and science. Stories might include causes for a bull or bear market, cures for manic depression or potential results of gene splicing. To satisfy an increasingly visually sophisticated readership, editors who understand the appeal of photography often assign illustration photos rather than call on artists for pen-and-ink drawings to accompany these difficult-to-visualize stories.

For example, for a story about cryonics, freezing dead people for possible resuscitation in the future as medical science improves, Susan Gardner of the *Fort Lauderdale* (Fla.) *News-Sun Sentinel* produced a shocking but dramatic picture of an old woman with her head in a block of ice (see previous page). A visual interpretation of this new concept, the picture is clearly not a documentary photograph.

To create illustrations, photographers might cut photos apart and reassemble them to form a collage, sandwich negatives together, or use a variety of studio techniques to produce the final image.

According to a survey conducted by Betsy Brill for a master's thesis, more than three-fourths of the news-

papers in the United States use photo illustrations. In fact, the rise of the photo illustration may be the most significant change in the history of photojournalism since the 35mm camera introduced the era of candid photography half a century ago. Today's photojournalists are creating pictures from whole cloth. Subjects are actors, backgrounds are sets, the lighting is artificial. Only the film is real. Yet these pictures run on the same newsprint and often on the same page as documentary photographs, in which the photographer has traditionally remained only an observer, not a participant.

This chapter reviews different kinds of photo illustrations and offers tips on creative processes, as well as suggestions for avoiding potential abuses.

■ DIFFERENT KINDS OF PHOTO ILLUSTRATIONS
PRODUCT PHOTOS

The product photo is a photograph of a real object, usually involving food or fashion. For example, the food editor might assign a photo to accompany a story about the lowly onion. To show how onions differ, the photographer might artfully arrange a number of different onions, ranging from white to red.

Illustration fashion photos, too, are product photos that simply record what an outfit looks like. Some newspapers run fashion photographs of average people on the street — candids that accompany a story about new trends in hemlines or the new look in pleats. These types of photos are not illustrations. Instead, they are like other candid features a photographer might take. While the setting of a fashion show is staged, the photos document a real event.

A fashion illustration, on the other hand, might show off a new clothing line. Almost all the pictures in fashion magazines result from photographers working with hired models to create idealized photographs of new clothing trends. The setting might be a seamless background or an empty beach, but the pictures never look real. Stylists prop the pictures in such a way that the situations look

The Art of Being Beautiful at Any Age

Bedford Shelmire, Jr. M.D.

An essential guide to beauty care with the revolutionary Personal Skin Index
by the best-selling author of **The Art of Looking Younger**

Carl Fischer

like Alice, into a surreal Wonderland of ideas. No reader would mistake Wonderland for reality. Carl Fischer's startling photo illustration of aging, for example, combines photographs to create an image of a woman's face — half-young, half-old.

To illustrate a story about latchkey children (youngsters who come home to an empty house while their parents work), Jeff Breland created a collage for the *Columbia Missourian* that conveyed the concept of children — perhaps perilously — alone. In Breland's cut-and-paste image, a little boy dangles from a huge key ring in the lock to a gigantic door. (See page 177.)

The subject of an editorial photo illustration may be about aging, latchkey children, or it might involve politics or food. But if you create an editorial illustration about onions, you won't produce a photo of the onion itself. Rather you may try to show how people defend themselves against the vegetable's vapors. A photo of a chef wearing a gas mask while cutting onions would illustrate the concept of protection against

better than real life. The photographer is not trying to illustrate an abstract editorial concept or imitate reality.

Whether the photograph is of an onion in soup or a swimsuit on a woman, the photographer tries to accurately and attractively record the object. The photographer is not trying to create a concept nor dupe the reader into thinking the picture is really a candid.

EDITORIAL CONCEPT ILLUSTRATIONS

As the visualization of an idea, the editorial concept illustration may employ actors or models to create the photographic image, but the total effect is that the viewer instantly recognizes fantasy, not reality. By using sandwiched negatives, subjects out of proportion with other props, backgrounds apparently reaching into infinity and other tromp de l'oeil, the concept photo lures the reader,

the odoriferous onion.

DOCU-DRAMA

The docu-drama photo illustration, by contrast, actually appears to be real. Here, the photo looks just like a candid but is really a complete creation or re-creation. Rather than abstracting or idealizing, like the product photo or the concept illustration, the docu-drama photo imitates reality; intentionally or not, it fools the reader.

Avoid this approach at all costs. The docu-drama approach is a tempting one to photographers with little time to establish contacts for a documentary story or to conceive and prop a concept photo. To set up a real-looking photograph may not seem so far from what an artist does to "illustrate" a story, but such photographs threaten to undermine a newspaper's credibility.

To illustrate an article about artist Andy Warhol, who turned ordinary objects — including soup cans — into art, Carl Fischer portrayed the artist as being consumed by his own art. (© Photo illustration by Carl Fischer.)

The final decline and total collapse of the American avant-garde. See page 142

When another newspaper ran a story about latchkey children, the accompanying "photo illustration" showed a lonely-looking child sitting on a doorstep. While this young model surely was not really alone or lonely, the reader's only clue was the tiny tag "photo illustration." Do readers understand what that line means?

And equally important, do latchkey children really look lonely? The one thing we know is that they do in the imagination of the docu-drama photographer. (See page 177.)

HOW TO PRODUCE EDITORIAL ILLUSTRATIONS

Often, after a paper runs a photo illustration, you can hear the following conversation in the newsroom.

The writer whines, "This stupid headline does not go with the gist of my insightful story."

The copy editor replies, "When I wrote that head, the story wasn't ready, and I never saw the picture."

From the darkroom comes the photographer's voice: "The ugly headline type runs across the model's face. How can I create great art surrounded by insensitive people?"

And from the page designer's corner of the room: "The inept photographer didn't leave room for type on the picture. And anyhow, the vertical picture didn't fit into the horizontal hole on the page left me by the copy desk."

Avoid this scenario.

When producing an editorial photo illustration, get all the players together from the beginning. The advertising world calls a group like this a creative team. Japanese business calls it a quality circle. Regardless what you call it, get everyone together who will participate in the creation and execution of the photo illustration. By communicating, not only will all team members perform their own creative tasks better, but knowing what others are doing will help dissolve territorial battles. Sometimes photographers will contribute catchy headlines while writers will propose bold typographic solutions to problems. At the least, coordination never hurt a project.

BRAINSTORM THE CONCEPTS

Alex Osborn, a partner in Batten, Barton, Durstine & Osborn (BBD&O), a large New York advertising firm, formulated one method for bringing workable, productive ideas to the surface. He called his method brainstorming. He recommends getting a group of people in a small room where everyone can voice his or her ideas, no matter how foolish-sounding the suggestions. Each suggestion stimulates and generates the birth of another sugges-

tion. A brainstorming session can produce more than a thousand ideas, Osborn claims. Brainstorming works even if you just talk over your ideas with another person.

In his book **Halsman On the Creation of Photographic Ideas,** Philippe Halsman, who produced more than one hundred *Life* covers, explains why he uses the brainstorming technique. "You are not alone, you face someone who serves you as a sounding board, who prods you and who expects you to answer. . . . Your system is stimulated by the challenge of the discussion. There is more adrenaline in your blood, more blood flows through your brain and, like an engine that gets more gas, your brain becomes more productive."

One cardinal rule prevails when working in a brainstorming session: never put down anyone else's ideas. Like turning on the lights at a high school dance, a negative comment will be inhibiting. By the end of the brainstorming session, surprisingly, good ideas will float to the surface and poor suggestions will sink out of sight from their own weight.

WRITE A HEADLINE

After each member of the group has read the story or heard a presentation of the central theme, everyone should try to write a headline for the copy. Compared to writing headlines for a news story and documentary picture, writing headlines for a photo illustration requires the writer to take a different approach.

In a traditional news headline, the desk editor tries to summarize the story in a few words. The words of the headline usually include an active verb: "The president proposed new legislation today."

A photo illustration headline might have no verb. In fact, the headline could consist only of a phrase or sentence fragment. The headline might be a play on words like a pun, or it might work off a movie play or song title. Or the words might raise a question.

• "Is there a hare in your soup?" for a story about rabbit stew.

ALL-AMERICAN VEGETABLE

MADE IN THE USA

Old Glory is an unmistakable symbol for concepts involving the U.S.A. — whether the story involves **All-American corn** (photo illustration by Brad Graverson, (Torrance, Calif.) *Daily Breeze*) or fortune cookies made in the United States and exported to **China.** (Photo illustration by Stephen Reed, *Alexandria* (La.) *Daily Town Talk.*)

• "M-M-M Mail order" for a story about buying food through the mails.
• "Making the first move" for a story about women asking men on dates.

Once all group members have read the story, each must try to write a headline, as fast and as many as possible. Don't stop to analyze each attempt. Never reject any idea at this stage of the process. Let your thoughts flow. Then read over each one to see if the idea lends itself to a photo. Almost always, the best idea pops out.

■ TRANSLATE WORDS INTO IMAGES
SYMBOLS

Once you have the headline you must translate the words into pictures. When you translate to picture language, you speak with symbols, analogies, and metaphors. You are trying to find visual ways to express amorphous, sometimes theoretical ideas and concepts.

For photography, however, concepts must become something concrete.

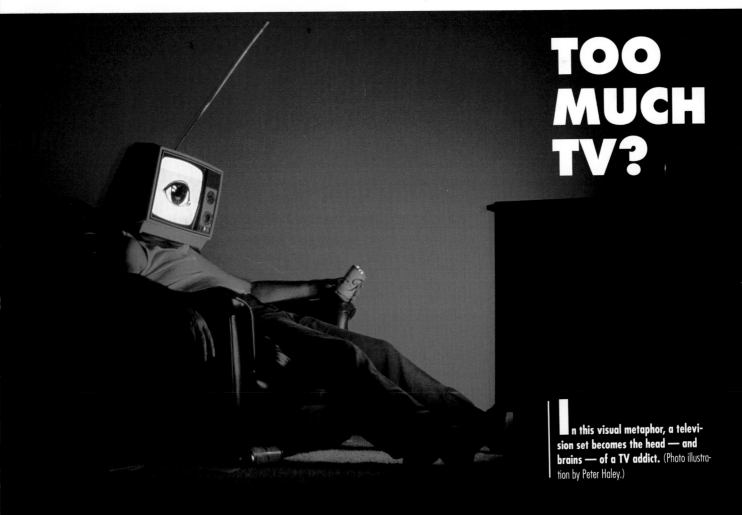

TOO MUCH TV?

In this visual metaphor, a television set becomes the head — and brains — of a TV addict. (Photo illustration by Peter Haley.)

TURNING INTO A BOOKWORM?

The propping/set-building for this picture was meticulous and exquisite in its attention to detail. (Photo illustration by Doug Kapustin, Patuxent Publishing Co.)

For example, how do you say America or American without words? You might use a generally accepted visual representation of an idea — a symbol like the Stars and Stripes. (See previous page.) You could use an actual flag or turn something else into a flag. You might decorate a cake in red, white, and blue to symbolize America's birthday. The Statue of Liberty also serves as a symbol of the United States, as does the "Uncle Sam Wants You" recruiting poster in World War I. Grant Woods' painting, "American Gothic," which shows a farmer and his wife looking stoically out at you, also has become a symbol of the United States.

Photographs themselves can become symbols. Joe Rosenthal's photograph of the flag-raising at Iwo Jima has been reproduced and transformed so many times it has become a symbol of American patriotism.

If, on the other hand, you were trying to illustrate a story about France, you might use an Eiffel Tower, a baguette, or a bottle of wine.

Balanced scales suggest justice; a dove represents peace; a gun symbolizes war. A light bulb often stands in for abstract concepts like thinking or ideas.

Carl Fischer, who produced many famous *Esquire* magazine illustration covers in the 1960s, says that some symbols exist in our subconscious, like those described by the psychoanalyst Jung with his archetypes. These are images that seem to occur in every culture. The multiarmed-armed Indian god, Shiva, crops up over and over as a symbol for handling multiple tasks.

Literature, too, can provide visual symbols. The nose of Pinocchio, which grew longer with each lie he told, turns the act of lying into a concrete object. Symbols can be reinterpreted or newly invented. As pointed out by Steven Heller and Seymour Chwast in **The Source-**

book of Visual Ideas, smokestacks were used at one time to symbolize progress. Today, they represent pollution. At the turn of the century, the caricature of the fat, diamond-studded, tuxedo-clad gentleman represented capitalist greed; today, yuppie-pinstripes and pastel ties are the symbols of preference. Still, the skull and crossbones, an ancient symbol, continues to evoke the message, "hazardous to your health."

METAPHOR

When you use a metaphor or simile, you replace one image with another to suggest a likeness of some characteristic. For instance, you might substitute an hourglass for an old person to suggest aging. In this situation, the hourglass becomes the passing of time. The sand at the bottom of the hourglass represents age. Sand can also become power. Sand sifting through hands could become a metaphor for disappearing power.

Similarly, the word "love" often is replaced visually with something heart-shaped or with, perhaps, a rose.

The university becomes an octopus wrapping its tentacles around a checkbook. A TV screen becomes the head of a television addict. (See previous page.) A woman swings at a golf ball with a giant feather for a story about light golf clubs. If the visual play on words is funny, you have produced a visual pun — like the one accompanying the food story on how to "dress" a turkey for a holiday dinner.

■ SELECT THE MOST WORKABLE IDEA

Simplicity and practicality come into play when you are pondering a list of headlines to illustrate. The least number of props, models, backgrounds, and special effects give the best chance of producing a successful photo illustration. For instance, suppose you have selected the following headline: "The nuclear family crumbles." You could illustrate this idea by breaking apart clay figures in the form of a family.

Great idea, but You don't know how to work in clay, so you call a sculpture friend.

She says, "Great idea, but I'll need five days and $500."

Your editor says, "Great idea, but. . . I need the illustration in three days, and we have a $20 prop limit."

It's time to either rethink the visual for the headline or to continue down the list to find a different head-

Visual puns such as this one, where a well-dressed turkey makes a holiday appearance, can lighten up traditional food illustrations. (Photo by Stuart Wagner.)

HOW TO DRESS A TURKEY

line that can be illustrated more easily. Remember, the nuclear family can unravel just as easily as it can crumble, and knitting a family portrait just might be easier than sculpting it.

■ PRODUCE THE PICTURE

Once you have selected a headline to accompany a visual and have drawn a sketch, you need to plan the location, props, and models. On a big-budget ad shoot for a New York client, you might hire a stylist to find the props, call a casting director to locate the models, and ask a location specialist to scout the best backgrounds. On a low-budget shoot, you probably will play all the roles.

PROPS

Remember that precise propping can perfect the picture, whereas inappropriate props can destroy the desired illusion. For example, a photographer was

Business suits and cash symbolize the race for financial success in this low-cost illustration about financial planner. Props were borrowed from a pop-culture museum. (Photo by Ken Kobré for *San Francisco Business*.)

FINANCIAL PLANNERS
STAYING AHEAD OF THE PACK

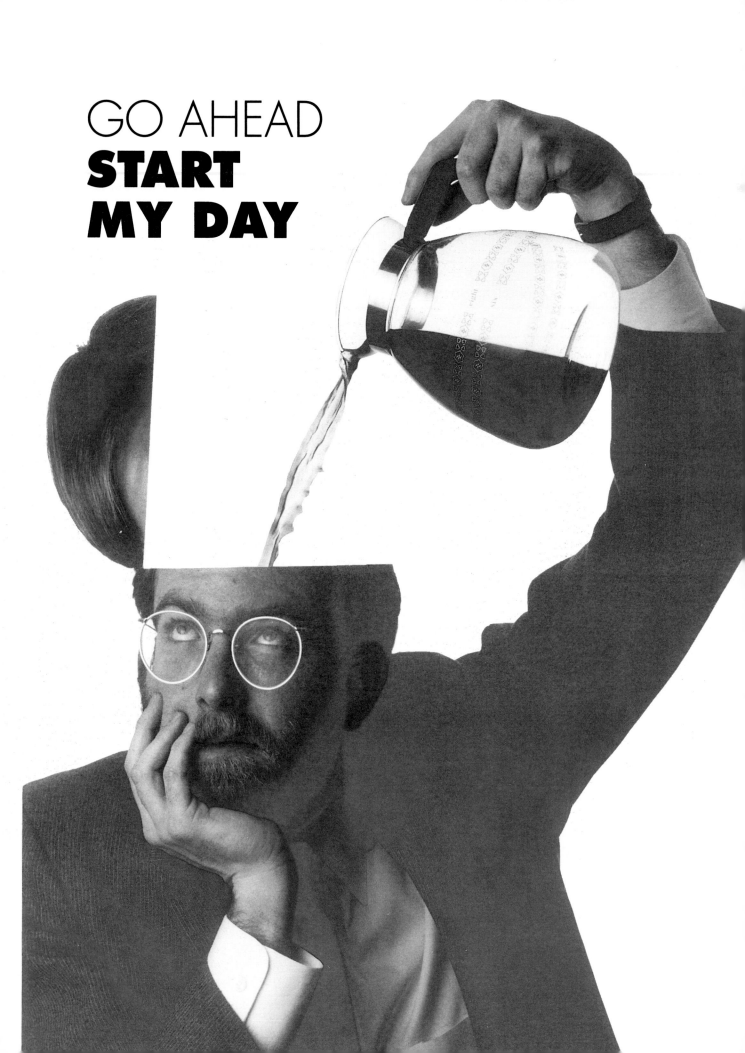

This illustration was created by cutting apart and then pasting together individual photos. For each separate shot, the lighting was kept constant. (Photo illustration by Ken Kobré for *San Francisco Business.*)

assigned to illustrate a story about an English butler serving tea. The sketch called for the butler to wear a bowler hat. The photographer returned from the local theatrical prop shop with a hat that was black like a bowler but round on top like a hat worn by the Amish. No self-respecting English butler would be seen serving tea (or much else) in such a piece of headgear. While viewers of the picture might not spot the exact error, they would sense something was wrong about the high tea scene.

On a low budget? Here are some ways to find props for a limited outlay of cash: you can find period props in antique and second-hand stores. For a story on financial planners, I borrowed plastic human figures from a pop-culture museum. Stores with guaranteed return policies will come in handy at times like this. High schools and colleges maintain costumes for their theater departments. They, too, will often lend out period clothing for photo shoots.

MODELS

You don't need a trained Shakespearean actor to model in your photo illustration. Most photo illustrations don't depend on facial expressions or acting. They do, however, depend on stereotypes. You need a person who fits the part. For an editorial photo illustration about runners hitting "the wall" at fifteen miles, you may not need a world-class marathon runner, but don't pick a couch potato, either. Save your couch potato friend for the story on the dangers of being sedentary.

BACKGROUNDS

When it comes to backgrounds for photo illustrations, try to pick an abstract setting. If your background looks too realistic, the viewer may think the scene is real and mistake your concept photo for an actual candid. Remember, don't confuse the reader. Here is where you can slip over the line from editorial photo illustration to docu-drama. To avoid the confusion between true and manufactured pictures, photographers shoot a great many photo illustrations against a seamless paper background. The seamless paper adds an abstract quality to the photo.

TIME

Allow time — lots of time — to conceptualize, prop, and photograph an editorial photo illustration. Editors are accustomed to asking the photo department to run down to Castro and 14th streets to take a quick shot before the 5 P.M. deadline. Unfortunately, editors often maintain the same mind-set when they request editorial photo illustrations. According to the Brill survey, in fact, the majority of newspaper editors allot only two hours for shooting photo illustrations.

Most photo illustrations, however, require much longer than two hours. Photo illustrations can take hours that stretch into days. Dreaming up concepts takes time. Rarely do the first headline and visual that come to mind result in the final photo. Propping takes shopping. Without

the right props, the picture will look amateurish. Finding the perfect model can be as difficult as finding the perfect spouse. Then comes shooting. With the patience of Job, the meticulousness of a watchmaker and the flair of a set designer, you will build the picture. The clock ticks by as you move the main prop from left to right. Each change requires an adjustment of the lights. After you've taken many Polaroids to check each detail, the time finally comes to expose the film. The moment is almost anti-climactic. Like sex, everything is in the foreplay.

When the editor at the *News/Sun-Sentinel* in Fort Lauderdale, Florida, assigned Susan Gardner to illustrate an article on cryonics, the photographer knew to allow time for the whole production. (See opening spread for this chapter, pages 162–163.)

First Gardner commissioned a fake block of ice from Plexiglass, four sides and a top. She sprayed this with fake snow, lit it with blue gels and created a mist with dry ice. A hole in the bottom of a table allowed the model to slip her head inside the cube. The first model, however, took one look at the set and backed out, saying it would be "detrimental" to her career. Her replacement, an elderly woman, was touched up with some white and blue makeup. The time elapsed from the original concept to the final exposed 21/4 chrome on Fujichrome 50D ran one month.

SPECIAL PHOTOGRAPHIC TECHNIQUES

■ CUT AND PASTE

To create a surreal effect, you might want the picture's subjects to appear completely out of proportion. Perhaps you want the mayor of New York towering over the Empire State Building, or a sailor carrying the QE II under his arm. Before the advent of computers, you would photograph each subject alone or perhaps rephotograph an existing photo of each subject. In the darkroom, you would enlarge each image to the desired size, based on a predrawn sketch. After processing the prints, you would cut out all the photos and simply paste them together using wax, spray, or rubber cement. (See "Cruelest Cut," on following page.)

While this technique works well, it presents a few problems. If you used existing photos of a person, you'd probably find cutting precisely around the subject's head difficult. Hair, because it is so irregular, looks particularly funny when you try to cut around it. After a cutout, a person's head always looks like it is in the shape of a bubble.

CIRCUMCISION
**THE UNKINDEST
CUT OF ALL**

Before computers, you would have found joining photos easier if in the first place you had photographed each individual subject or model against a plain background. For a story about coffee addicts, I needed to show a man pouring coffee into his head. Against a white background, I photographed one shot of the man holding an empty coffee pot and pretending to pour. Against the same white background, I photographed the model standing to the side and actually pouring the coffee. I also photographed the background itself. When I got the prints back, I sliced apart the subject's head and pasted the bottom and top half on the print of the white background. Then I cut out the coffee pot with the pouring liquid and pasted that over the empty coffee pot in the man's hand. A little touch-up work with a pencil helped to blend together the pouring coffee and the original arm together. The final effect looked like the man's head was half open as he poured coffee directly into his brain. The headline read, "Go ahead, start my day."

Usually you want to keep the lighting identical for each shot that goes into the final illustration. For example, with the separate shots of the man and the coffee pouring, I kept the soft box light located in the same place for each photo.

If you can't photograph all the subjects and props at the same time in the same location, remember to keep the light consistent for each image you plan on combining later on. For example, if the light appears to be diffused and coming from the upper left side of the scene, keep the same effect on all subsequent photos. Then, when you put all the elements together, the final picture will look natural since the light will appear to be coming from only one source.

■ ELECTRONIC CUT AND PASTE

Computers have come along to make life simpler — at least at publications with hefty budgets. In today's high-tech age, each separate image can be scanned into a computer's memory. Then the images can be enlarged, contracted, and finally combined electronically without the need of any physical retouching. (See page 264.)

■ ADDITIONAL TECHNIQUES

In addition to cutting and pasting, the editorial photo illustrator draws on a number of specialized photographic and graphic arts techniques to produce the final product. They include:
- retouching the final photo;
- painting or drawing on the picture;
- filters and gels to change the natural color of the image;
- model-making;
- double exposure;
- combining available light and strobe to give a feeling of movement;
- projecting an image from a slide projector onto a surface.

**SOME WORK —
AND SOME DON'T**

Some editorial photo illustrations cause the reader to say, "Dear, you have to see this. It's just too funny." Others don't stop the reader at all, or, even worse, they cause the reader to ponder the strange picture, wondering why anyone would put it in the newspaper. Why do some editorial photo illustrations hit the reader like a sledgehammer and others leave no mark at all?

WEAK PHOTOS

Sometimes the photo is weak. Everyday readers see slick ads produced by high-priced New York ad agencies. Consequently, readers are accustomed to illustrations that appear flawless.

Poorly planned editorial photo illustrations look unprofessional. If the models look like they were grabbed right out of the newsroom, if the set looks like it was a corner of the darkroom, and if the whole production looks like it was thrown together between assignments, then the final photo will probably look amateurish.

For an illustration titled "Sitters can be a pet's best friend," the photographer had a subject pretend she was reading comics to two German shepherds. The scene, however, took place on a beat-up old couch. The run-down setting distracted from the picture's concept.

One newspaper ran a photo illustration showing a man's hand writing on a blackboard the words "American education stumbles." The foreground contained a few books sitting vertically on a desk. The strong headline in

Small-screen hypnotism

Tuning in on TV soaps, see pages 18-19

PEARS Homer sang the praises of this fruit of the gods

This headline and this picture leave the reader wondering just what the central theme of the story is — the headline, not the subhead, should tie the picture and the words together. A nicely executed photo loses its impact with a weak headline.

WHY DON'T THESE ILLUSTRATIONS WORK?

A good image in this example was matched with a weak headline. A better head might read "Picture Perfect Pears."

By Pam Bilger
Gazette Lifestyle Editor

Sunday, as any football fan knows, is Super Bowl Sunday. The Chicago Bears will battle the New England Patriots in New Orleans, beginning at 5 p.m. on NBC.

And what better reason to throw a party than the Super Bowl? After all, more than 110 million people watched last year's extravaganza, and you can bet that quite a few will watch this Sunday's contest.

Decorate your home with football memorabilia — streamers, pennants, items with the Bears' and Patriots' logos.

Make sure that your television set is in a central location and that chairs and floor pillows are situated so that all your guests have an unobstructed view.

Use colorful paper plates, cups and napkins. Station several wastebaskets in convenient areas. Make sure serving tables are within

sight of the TV so ardent fans won't miss a single play.

Be sure you have plenty of ice and beverages on hand — nobody wants to have to run to the store during the game.

If you plan to serve a half-time buffet, set up as much as you can before guests arrive. Serve simple-to-prepare items, such as sandwiches and chips. You might buy an assortment of deli meats and cheeses and a variety of bread and rolls.

Another idea is to fix a big batch of your favorite chili Sunday morning and let it simmer until serving time.

Following are recipes for Super Snacks you might like to serve:

Barbecue Wings
6 chicken wings (about 1 pound)
2 tbls. butter
1/4 cup chili sauce
1 tbls. lemon juice

Please see Snacks,
P. 3-E, Cols. 1-6

This illustration combines an unimaginative headline, "Super-bowl Snacks," with a picture that is too literal. Try thinking of some alternatives for both words and pictures.

this instance was not supported by an imaginative visual. The photographer failed to find a symbol for American education or to play off the idea of stumbling.

POOR HEADLINES

While editorial illustrations often fail because of poor photography, they also fail because of poor headlines. Rather than leaving 'em laughing, an unclear or confusing headline leaves readers scratching their heads.

Sometimes, even clear headlines are not enough for a memorable photo illustration — if the headline is clear but dull. Beware of headlines that start out "Everything you ever wanted know about pizza" or "The entire history of bicycles."

Sometimes the writer has provided a label headline like "Potatoes." A headline like this probably came from a story that had no theme or focus. When the headline and story lack a clear focus, the photographer winds up taking a generic picture of a potato rather than illustrating a concept about the potato. Suppose the story had

focused on the role of the potato in the Irish famine or had described the many nutrients contained in potatoes. Either article would lend itself to a possible editorial photo illustration. If the story has no focus, however, the photographer is left to photograph the potato itself, a vegetable all too familiar to most readers.

Sometimes headlines are too news-oriented. Photo illustrations work best with ideas, not events. Avoid headlines like "Stock Market Drops for Third Straight Day."

HEADLINE AND PICTURE DON'T MESH

Still, the headline might be great. The photo might be eye-popping. But if the two do not mesh, then the final package looks like an afterthought. Sometimes the reader gets the impression that the headline was written without the editor seeing the photo. Other times, the page looks like the photographer never read the headline or story before snapping the shutter.

A *Florida Times-Union* copy editor wrote this catchy headline: "When marriage seems like war." The

After you come up with a good headline like this one, try drawing a rough sketch of the final layout. (Photo illustration by Marilyn Glaser.)

photographer produced a strong photo showing a couple having a highly stylized argument. The man's tie is blowing out behind him. Both models look like they are talking with their hands. The problem: they don't look like they are at war. The couple appears to be arguing in the wind, not battling. The words and pictures, like the married pair in the story, just don't communicate.

THINKING CREATIVELY: A STRUCTURE

John Newcomb's *The book of graphic problem-solving: How to get visual ideas when you need them* is based on the premise that visual problem-solving starts with words. He suggests that the starting point is the editor's working title for the story.

For example, let's take a story about men who are losing their hair. The editor's working title: "Are you worried about balding?" Start by analyzing the nature of the subject.

■ LIST THE FACTS

What is balding? How would you describe balding to someone from another planet? What words might you use? Round, smooth, hairless. List some of the characteristics of the subject including:

SOURCE

What is the source of the problem or item you are illustrating? In this example, where does balding come from? What causes it? Balding in men is a hereditary trait that comes from their mothers, grandmothers, and great-grandmothers.

DELIVERY

If the topic is about a service or object, describe how it is delivered. If the story is about a new cure for balding, how would the patient get the cure? By pill, by surgery, or by a new diet?

SIZE

How large is the object or problem — both physically and emotionally? In the balding assignment, is the hair loss partial or complete? Does balding make men feel like jocks or like jackasses?

WEIGHT

Is the subject of the assignment physically or emotionally heavy or light? Is it a crushing burden, or is it a minor irritant? Do those with only a few wisps of hair left on their heads feel dragged down or light-headed?

WINNERS/LOSERS

Who gains and who loses with balding? Most stories requiring illustration have a winner and loser, a survivor,

and a victim in the plot. At first, you might not think anyone gains from balding. But charlatans with patent cures gain, as do pharmaceutical companies that develop cures for balding. Doctors who perform transplants gain. Wigmakers gain. Psychiatrists gain. Who loses? When hair falls out, not only do bald men lose hair, but sometimes they lose their wives and girlfriends, too.

■ FACTS BECOME PHRASES

As you have just seen, Newcomb's method requires you to identify the facts about your topic. Write each answer down without worrying about being creative. Just start listing information.

Next try sayings, phrases, proverbs, or any other bits of traditional wisdom. In the list of facts, we noted that the source of balding is genes inherited from the mother — not the father. Try the headline "Balding — Not Dad's Fault." To illustrate this idea, you could photograph a bald man holding a hairless baby.

Balding: Not Always Dad's Fault

BALDING, ANYONE?

BALDS HAVE MORE FUN!

In the fact list under weight, we noted that some bald men feel like jocks and others feel like jackasses. Think about twisting the emphasis. To express the idea that bald men are not burdened by their hair loss, twist the line "Blondes have more fun" to "Bald men have more fun." Now illustrate this line with a photo of a Telly Savalas-like character, bald and proud of it, sitting in a bar surrounded by women.

■ PLAY WORD GAMES

Now take the key words from each of the facts above and play word games with them. For instance, in describing the nature of a bald man's head, we listed the word

"smooth." Smooth as a balloon, as a billiard ball, as a bowling ball. Imagine a bowling ball looking like a bald man's head. The phrase "Balding, anyone?" could evolve into a photo of a bald man with his head in a rack of bowling balls.

From the editor's original working title, "Are you worried about being bald?" came first a set of facts about baldness. The facts led to plays on words and phrases. These sayings, puns, and double entendres produced many visual ideas that could easily illustrate the story.

The final photograph, by the way, of the man's head lined up next to bowling balls, has since been shown to hundreds of editors, photographers, and others. The photo has never failed to bring the house down with appreciative laughter.

Trapped

Agoraphobics suffer from irrational panic in normal situations

REAL OR CREATED?

Pictures like these docu-dramas are too real-looking to be effective photo illustrations. Unintentionally or not, they can mislead the reader. Of these three published pieces, only the photo to the left carried the tag line "photo illustration."

Now You See It . . .

Now You Don't

More Thieves Are Getting the Picture — and Keeping It

RAPE

Victim of the system
that provides justice

By BARBARA KUENY
Pantagraph staff

She talks about the attack in a calm, detached voice, as though it happened to someone else. But her bitterness is unmistakable.

A crime is an act of violence. But for many victims, the crime itself is only the beginning of a chain of events that continue to trouble their lives.

Susan O'Neal wound up feeling victimized by the very justice system she hoped would vindicate her.

Susan was raped by two men in 1980. She was then 22. One of the men served a two-year prison term for violating his bail bond. The rape charge against him was dropped.

The rape charge against the other man was reduced to battery in exchange for his testimony against his friend before the grand jury.

Some time had to elapse before Susan could talk

Interview with a man convicted of rape on page D6.

about what happened. But she is still angry at the way her case was handled. She believes the justice system failed her.

Susan met the two men who would eventually rape her at a neighborhood bar. The men were sitting at a table with some of her friends. She invited her friends to a party her roommate was giving that night, and the men also appeared.

They made sexual advances toward Susan all night and she kept telling them she was not interested in having sex with them, and expected them to take her at her word.

Later that night, Susan decided she wanted to go to her bedroom to sleep. One of the men followed her and told her he wanted to have a "meaningful relationship" with her. She told him to leave and started getting ready for bed.

The man left, but returned a short time later, raped her, and nearly strangled her.

During that incident, the second man entered the room and told the first man to leave. Then the second man started undressing and told Susan that she owed him sex because he saved her life. She was crying. The man raped her.

Afterward, the man offered Susan money as payment for the act, but she refused it.

WORDS OF CAUTION

■ DOCU-DRAMA CONFUSION

Like editorial photo illustrations, docu-dramas are created situations. However, as we've seen, docu-dramas look natural rather than surreal. By mimicking reality, docu-dramas cause confusion in readers' minds.

Look at the tearsheets on this spread. Did a photographer surreptitiously snap a picture of a crime in progress at the art gallery? What about the attack on the stairs? Isn't it conceivable that a photographer could have happened upon this attack and photographed it on the spot?

Even with the words "photo illustration" published beneath the picture — which not all of these had, by the way — photographers should avoid docu-dramas. Docu-dramas detract from a paper's credibility. The reader should never have to ask, "Did that picture really happen that way?"

The job of the photojournalist is to show the world as it is, not as the photographer imagines it is.

Editorial photo illustrations, by contrast, add to the reader's understanding and fun. A picture should either be real or so outrageous that no reader is fooled. Don't leave the reader in the twilight zone of the docu-drama.

■ PROBLEMS IN PLACEMENT & IDENTIFICATION

While most editorial photo illustrations are likely to appear on the lifestyle, food, and fashion pages of newspapers, the Brill survey found that a sizeable majority (nearly 67 percent) occasionally run on the front page. According to the survey, in fact, only about 23 percent of the responding newspapers "never" run editorial photo illustrations on page one.

Furthermore, nearly 78 percent of newspapers use editorial photo illustrations on the same pages as documentary-style photos — lending to possible confusion among readers as to what is real and what is not.

Further lending to a possible credibility gap, the survey found that almost half the newspapers *failed to identify* editorial (excluding food and fashion) photo illustrations as created images.

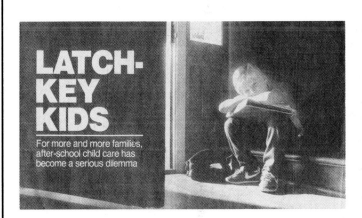

LATCH-KEY KIDS

For more and more families, after-school child care has become a serious dilemma

LATCH-KEY KIDS
DOCU-DRAMA VS. CONCEPT PHOTO

Avoid docu-dramas such as the one above. They fool the reader. Instead, create a concept photo like the one on the right, which is so abstract that no one will mistake it for real. (Photo illustration at right by B. Jeff Breland.)

They did not even label the pictures with a special phrase like "Photo illustration by..."

Imagine for a moment a newspaper that sprinkles its editorials and analysis — unidentified — throughout its pages, including the front page. How would a reader, accustomed to the straight news on page one, know where fact ends and interpretation begins?

Failing to identify created photographs is every bit as serious as failing to properly identify written editorial comment — and playing editorial photo illustrations on the front page or alongside documentary photographs is as questionable as mingling editorials with unbiased news stories. While newspapers prior to the Civil War did not hesitate to mix fact and opinion on the front page, most modern newspapers shy away from this practice and carefully limit opinions to a well-marked editorial page or clearly designated opinion column. The same stringent rules should be applied to editorial photo illustrations. Regardless of how unreal they may appear, they, too, should be labeled and segregated from straight photo reporting.

■ PRACTICAL AND ETHICAL GUIDELINES

The following are practical and ethical guidelines for using photo illustrations:
• Eliminate the docu-drama. Never set up a photograph to mimic reality, even if it is labeled a photo illustration.
• Create only abstractions with photo illustration. Studio techniques, for example, can help to make situations abstract — the use of a white or black backdrop, photo montage, or exaggerated lighting. Contrast in size and content, juxtaposition of headline and photo — all can give the reader visual clues that what appears on the page is obviously not the real thing.
• Always clearly label photo illustrations as such — regardless of how obvious you may think they are.
• Never play photo illustrations on news pages. Restrict them to feature pages or to section fronts. Display them in a way that is obviously distinct from straight news or feature pictures.
• If you haven't got the time to do a photo illustration right, don't do it. Suggest another solution. ■

Photo Editing

Creative cropping improved this picture by further emphasizing how high the basketball players jumped. (Photo by George Rizer, *Boston Globe*.)

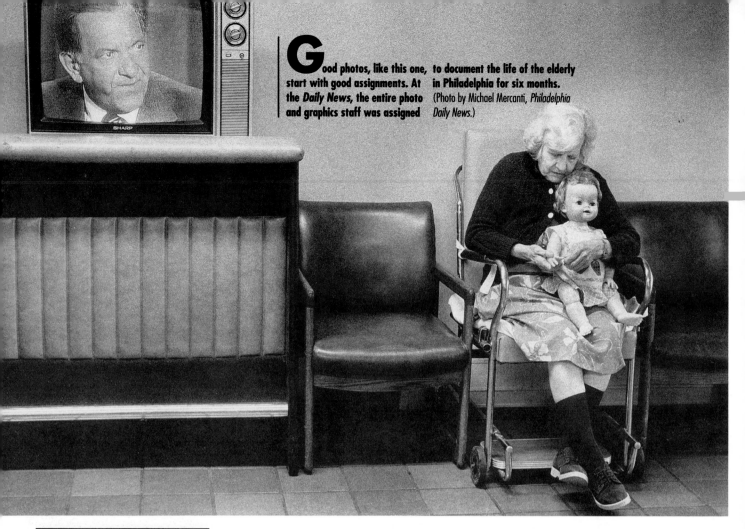

Good photos, like this one, start with good assignments. At the *Daily News*, the entire photo and graphics staff was assigned to document the life of the elderly in Philadelphia for six months. (Photo by Michael Mercanti, *Philadelphia Daily News*.)

ROLE OF THE PICTURE EDITOR

Photo editing takes strong eyes, a sharp grease pencil, and the psychological strength to reject thousands of pictures as you seek to find the one frame or part of a frame that tells the story and has visual impact. Technically poor negatives that are out of focus, underexposed or overexposed are easily rejected. After squinting through a magnifying glass at page after page of contacts, each containing up to thirty-six frames, the experienced editor only glances at static, routine, outdated, duplicate, or clichéd photos. But when a unique image catches the editor's eye, the picture is like a red traffic light signalling "STOP."

■ START WITH IMAGINATIVE ASSIGNMENTS

Striking pictures result from sound assignments. The picture editor runs down the list of news stories on the day's log to determine which lend themselves to pictorial reporting, which need an inked illustration or computer graphic, and which need no accompanying artwork at all. With limited staff and resources — and most newspapers and magazine fall into this category — the editor must choose to cover stories with a certain amount of intrinsic visual interest.

Bruce Baumann, assistant managing editor/graphics for the *Pittsburgh Press,* warns that the photo department should not become a "service station." He points out that a photographer's job is not just to pro-

vide the service of illustrating a writer's story.

Therefore, the enlightened photo editor not only assigns the listed news stories of the day but generates pictorial story ideas, as well. The photo editor might ask a photographer to cover the background or sidelights of a news story in addition to the breaking event itself.

For example, a news conference is called to announce a $4 million grant for retirement homes. Although a picture of the press conference may be necessary, it has little chance of producing exciting photos and less opportunity for providing readers with valuable information about aging or the crisis in care for the elderly. The story is concerned basically with statistics — the percentage increase in care costs — and with the number of dollars spent on nursing home facilities.

The photo editor might try to interpret these statistics visually by instructing the photographer to spend several days in a nursing home. These kinds of photos would help translate the dull, itemized costs of research into more human terms. The reader would see the conditions of the facility and the regressive effects of aging on the home's clientele. Finally, photos showing an aging patient holding a doll, sitting alone, can bring the dollars-and-cents issue home to the reader. (See Chapter 2, "General News.")

■ SELECT THE PHOTOGRAPHER

The sensitive, perceptive photo editor realizes the strengths and weaknesses of the available staff and freelance photographers. All photographers do not like sports; only a few take funny pictures. Some photographers notice subtle shadings of light and shade, whereas others have an eye for action. Matching the correct pho-

tographer with the appropriate assignment can be a complex task for the photo editor. In fact, the primary way a magazine editor controls the look of the publication is through the selection of photographers with different styles, says Peter Howe, who has been photo editor of the *New York Times Magazine* and director of photography at *Life* magazine.

The photo editor should provide the photographer with all the available information on an upcoming story. The more a photographer knows about an assignment, the better he or she will cover it. The editor should give the photojournalist clips of previous and related stories to fill in the background and put the story in context. The editor should suggest possible contacts who can provide further information.

And, of course, if the story is expected to run with a photo layout rather than a single picture, then the editor should forewarn the photographer about the number of pictures that will be needed.

Ideally, after the film has been shot and processed, the photo editor reviews the contacts with the photographer, selecting the frames that best fit the story.

■ FIGHT FOR SPACE

Next begins the behind-the-scenes job for the photo editor, who battles for adequate space for the photographer's pictures. The city editor, wire editor, feature editor, and sports editor each try to hoard sections of the paper for their stories; consequently, the photo editor must be just as aggressive as the other editors in fighting for picture space. Great pictures never seen by the readers are as worthless as great pictures never assigned or taken.

Some photographers shine at features, others at sports. In assigning, a good picture editor considers the strengths and weaknesses of each staffer. (Photo by Allan Detrich, *Toledo* (Ohio) *Blade.*)

■ CAMERA SKILLS NOT REQUIRED

Surprisingly, one skill that is not necessary to be an outstanding photo editor is the ability to take pictures. Many of the best-known photo editors never learned to use a camera; others, although they know the basic techniques, never practiced photojournalism.

Robert Wahls, a photo editor for the *New York Daily News,* says he was better off not knowing about the mechanics of a camera: "It just bogs you down," he says. "What you need to edit pictures is in you — not the camera."

John Durniak, formerly of *Time, Look,* and the *New York Times*, and Tom Smith, who was *National Geographic*'s illustrations editor, both have spent most of

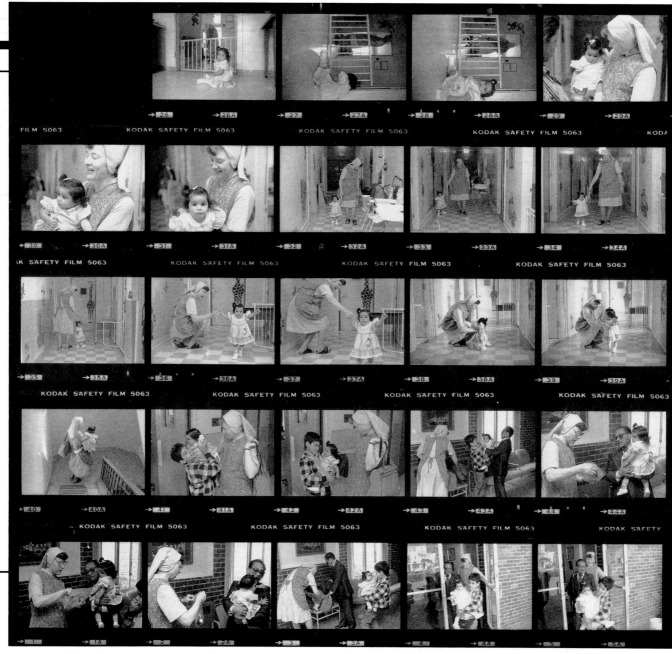

their lives handling pictures, not lenses. Bob Gilka, long-time director of photography for the *National Geographic*, was never a shooter. Roy Stryker of the Depression-era Farm Security Administration, who produced probably the most complete and lasting still-photo documentary of any era, never took pictures himself. The most famous example, however, is Wilson Hicks, an executive editor of *Life* magazine. He sent photographers to every point on the globe; he hired and fired the best photojournalists and set the direction of the field for years to come. Yet he never took a picture that was published in his own magazine. No one has proved that shooters don't make good photo editors, but camera knowledge is not a prerequisite for becoming a successful picture desk executive.

■ THE HAZARDS AND SATISFACTIONS OF DO-IT-YOURSELF PICTURE EDITING

Should photographers edit their own work? In the past, the old *Life* and *Look* magazines represented diametrically opposed positions in this controversy. Wilson Hicks, executive editor of *Life*, said that photographers are too emotionally involved when taking pictures to evaluate the pictures objectively during the editing process. Former *Look* art director Will Hopkins argued the opposite philosophy. At *Look*, the photographer and photo editor, as well as the writer and art director, operated as a closely knit group, each contributing to the final story, without letting job titles limit each participant's input.

Life staffers received assignments, covered the

The child had been removed from her parents and placed in this orphanage because her mother was a crack addict. Through the courts, the father is trying to win custody of the child. In this scene, the child prepares to leave for a visit with her father. Which frame would you have selected from this take? (Photos by Jeff Vendsel, from *The Struggle for Life* Project.)

a different basis from their editors. The photographer, who might have dangled from the top of a mountain in subzero weather to get a particularly evocative picture, attached more significance to the resulting image than did the editor, who evaluated the picture's merits impartially, without considering the trials and tribulations under which the photo was taken. The photographer's familiarity with the difficulties of the assignment might affect personal objectivity.

On many small newspapers, a photojournalist shoots an assignment, develops the film, scans the negatives, chooses the frames, prints the pictures, and delivers the finished glossies to the editor's desk; no one else inspects the original negatives. What this system gains in efficiency, it loses in objectivity. The editor or managing editor does not have to view the negatives; the photographer, however, should find someone who was not present at the news scene to offer an impartial opinion.

Photographers should try to avoid the "shoot-and-ship system," so often practiced at national magazines, in which the photojournalist shoots the pictures and ships them to the newspaper or magazine, along with a few sketchy cutline notes, never even catching a glimpse of the negatives before the pictures are published. The photographer, like the reporter, participated in the news event and therefore has a better idea of what actually occurred than does an editor in an executive office. Photojournalists should be involved, if possible, in the picture-editing process at all stages.

story, turned in the film, and waited until the magazine appeared to see which of their pictures had been selected and how they had been played. *Life* photographers had almost no control over stories after shooting them. Specialists in picture research, picture editing, caption writing, text block writing, and layout took the photographer's raw material and produced a finished photo essay.

By comparison, each photojournalist at *Look* magazine stayed with the story from conception through shooting to editing and paste-up. Tim Cohane, *Look*'s sports editor for twenty-one years, recalled that in the initial stages of each assignment, he sounded out the ideas of photographers and layout people. "If you can use their enthusiasm and combine your ideas with theirs, you will come up with imaginative picture stories," said Cohane. "The photographer voiced his opinions at each stage of the story's development."

Over at the Time-Life building, Hicks used to argue that photographers evaluated their own pictures on

■ THEORIES OF PICTURE SELECTION

Laura Vitray, John Millis, Jr., and Roscoe Ellard, in ***Pictorial Journalism***, an early book (1939) on news photography, tried to develop a mathematical formula for determining reader interest in pictures. The researchers assigned points for the degree of news value of the event, the notoriety of the subject, and the amount of action in the picture. But many newspaper editors did not adopt the formula because it did not define the word news, nor did it provide a yardstick for measuring the subject's notoriety or a system to quantify the degree of action in the picture. Also, editors felt limited when required to judge all pictures on only three scales.

Stanley Kalish and Clifton Edom, in their book ***Picture Editing***, added several new factors to consider when selecting pictures. They advised editors to look for

pictures that not only had news, notoriety, and action, but also eye-stopping appeal. By "eye-stoppers," the authors meant pictures that contained interesting patterns, had strong contrasts in tonal value, or could be uniquely cropped (like extra-wide horizontals or slim verticals). Then, after the readers' attention was engaged, the pictures should also hold interest. What galvanized readers' attention, they said, depended on the subject matter. A picture about love or war was more likely to maintain attention than was a picture about farming or economics. Some topics, the researchers concluded, are intrinsically more interesting than others, regardless of the quality of the photo.

■ RESEARCH INDICATES READERS' PREFERENCES
FIRES, DISASTERS, AND HUMAN INTEREST

Researchers have conducted several surveys over the years to determine subjects that have intrinsic interest to readers. The first study of any size was conducted by the Advertising Research Foundation, which surveyed readership of 130 daily newspapers varying in size, circulation, and locality. The Continuing Study of Newspaper Reading completed eleven years later was statistically analyzed by Charles Swanson to determine what categories of pictures were the most read. From the 3,353 photos in the study, Swanson reported in *Journalism Quarterly* that fire, disaster, and human interest were among the top-read categories. Least-read picture categories included sports, fine arts, and the family.

FEATURES PREFERRED

Joseph Ungaro, chairman of the Associated Press Managing Editors (APME) photo committee, with the assistance of Hal Buell, then AP's assistant general manager for news photos, polled 500 readers to find out what type of pictures they liked. The AP survey reported that readers liked human interest and feature pictures most. Readers found general news and sports least interesting. Out of the many photos presented in the AP picture survey, readers selected as their favorite a photo of a big fluffy Saint Bernard kissing a little child.

An innovative research technique called Eye-Trak Research systems, run by the Gallup Applied Science Partnership, Princeton, New Jersey, further supports the AP survey that readers prefer features to news. The Eye-Trak research uses two tiny television cameras mounted on the subject's head to record where, how long, and in which order a subject looks at photos in a newspaper or magazine. While older studies asked readers what they liked or remembered about pictures, this equipment actually records the amount of time a subject stares at a given photo.

Qualifying her statement by restricting her conclusions to "some newspapers and audiences," Sharon H. Polansky, vice president of the research organization, says that the majority of subjects reading newspapers gravitate more to features than news photos. She says feature photos have a higher "attention" factor.

WOMEN MORE PICTURE-MINDED

Surveys indicate that all readers do not have the same taste in pictures. Based on the data of the Continuing Study of Newspaper Reading, Swanson found that women are more picture-minded than men. He concluded that women have a greater interest in a larger number of picture categories than men do, and they also differed from men in their preference of specific categories. In a survey published in *Search* magazine, Randall Harrison

Studies show that readers prefer feature pictures like this accidental slip of the skirt during a rehearsal over sports and news pictures. (Photo by Scott Eklund, *Bellvue* (Wash.) *Journal American*.)

found that men tend to prefer photographs of events, whereas women prefer pictures of people. Both sexes looked more at pictures of women than at pictures of men.

One category on which men and women differ is sports. Although the overall statistics of the picture surveys indicate that sports is a low-preference category, this finding results from the fact that women look at baseball, basketball, and football pictures only half as much as men, according to Swanson's analysis.

CONCLUSIONS

With so few studies available, and the studies themselves differing in sampling and survey techniques, generalizations have to be limited. Several conclusions, however, do seem justified. Human interest pictures received high ratings from readers. Not surprisingly, the public liked to look at pictures of people engaged in funny or unusual activities. Sports appeared at the bottom of the surveys. In fact, a Lou Harris survey found that newspaper editors overestimated the general public's interest in sport stories.

However, sports pictures should not be eliminated from the newspaper. A newspaper's inherent advantage over its nearest competitor, television, is that newspapers can display an array of items simultaneously, letting individual readers pick the news articles they are interested in pursuing and disregard those that do not pique their curiosity. Women can look at people pictures while men can review sports photos. Television, by contrast, is linear. It can display only one item at a time. Therefore, it presents only items that have mass viewer appeal. Television selects its subjects based on what the station managers think will have the broadest common pulling power for all sexes and ages. Newspapers do not have to be edited this way. A newspaper can present a variety of items, each of which will appeal to a select group of interested readers.

■ CAN PROFESSIONAL EDITORS PREDICT READERS' PREFERENCES?

Who knows what kinds of pictures people like? Logically, you might assume that photo editors know their audi-

ences, but a study by Malcolm S. MacLean and Anne Li Kao reported in *Journalism Quarterly* suggested that editors are just guessing when they predict reader response to pictures. The researchers asked average newspaper readers to sort through pictures, and to arrange them in order from most favorite to least favorite photos. Then the researchers asked a group of experienced photo editors and a group of untrained students to sort through the same photos. The editors and students arranged the photos in the order they thought the readers had organized the photos. The editors and students based their predictions on statistical information they had about the readers. MacLean and Kao hypothesized that the more information such as age, sex, and occupation the editors and students had, the more accurately they could predict the likes and dislikes of readers.

Surprisingly, the researchers' hypothesis was wrong. Professional photo editors performed little better than even chance when given minimal or even detailed information about their readers. Furthermore, photo editors did no better at predicting than did the students. However, once the professionals had seen how their readers sorted one set of photos, the editors could anticipate how readers would sort a second set. These predictions were even better if the editors knew more about the reader, including the person's age, hobbies, and lifestyle.

Until the editors had seen the picture selections of the readers, however, they could not predict an individual reader's preferences. Clearly, more editors should find out what pictures their readers are actually looking at rather than base editorial decisions on their own biases.

THE BUS SURVEY

Robert Gilka, former director of photography for the *National Geographic*, tells a story about Charlie Haun, a picture editor in Detroit who used to make his own surveys: "Every couple of days, Haun would ride the bus in Detroit and look over the shoulders of bus riders who were reading the paper. He would note which picture their eyes stopped at, how long they dwelt on each photo, and see if they read captions." Gilka points out that although Haun's method was primitive, "Charlie probably knows more about pictures than most of us today." Haun, from his bus rides, came to the same conclusion that MacLean and Kao did from their research. Identifying what pictures people have picked in the past is the best determinant of what pictures they will choose in the future.

■ DO READERS AND EDITORS AGREE?

To discover if editors and readers agree on what constitutes interesting and newsworthy photos, the Associated Press Managing Editors photo survey, mentioned earlier, was designed to determine which kinds of pictures readers liked as well as which type editors preferred, and whether readers and editors shared the same taste. The results indicated a surprisingly close agreement between readers and editors. Both selected the same photos in the sports, general news, and feature categories. Editors' and readers' opinions, however, differed radically on the use of dramatic news pictures. By a two-to-one margin over readers, editors chose action-packed, often violent, and sometimes gruesome news pictures. A majority of the readers not only disliked such pictures, but thought that violent pictures should never be published. As the pictures became successively more gruesome, fewer readers voted for photos in this category.

As MacLean and Kao discovered, editors cannot predict an individual's photo preferences. Yet, as the AP survey indicated, except for spot news, editors' and readers' tastes are generally similar.

When it came to picking a favorite picture, however, the two groups, editors and readers, diverged. Readers chose the Saint Bernard-kissing-child picture. Editors, by comparison, chose as most interesting the photo of the lifeless body of a hanged Bangkok student being beaten by a right-wing opponent.

When I interviewed Hal Buell, he tried to draw some conclusions from his picture survey: newspapers have to be all things to a lot of different people. Editors must print what people want and also what the editors think is significant.

I guess a paper in the end has to publish some of both in order to present a complete picture of the world: pictures of dogs kissing kids as well as pictures of political violence.

Cropping this picture into a slim horizontal and running it across two pages gives it added impact. (Photo by Jim Clark, *Springfield* (Oreg.) *News.*)

CROPPING: CUTTING OUT THE FAT

Regardless of how good the original is, if a photo is butchered on the cropping table, buried in a back corner of the paper, or reduced to the size of a postage stamp, no one will see the picture. Newspapers commit all of the above sins. Says Roy Paul Nelson, author of ***Publication Design***, "The typical daily or weekly newspaper is not designed, really; its parts are merely fitted together to fill all the available space, sort of like a jigsaw puzzle." To save their photographs, more and more camera journalists are getting involved in layout. These photographers want a say in how their pictures are cropped and sized.

■ PERFECT FRAMING IS RARE

When you take a picture, you must decide what to include in the viewfinder and what to leave out. The impact of a picture often depends on this decision. By including too much in a picture, you run the risk of distracting the viewer from the main subject. By framing too tightly, on the other hand, you might leave out important storytelling elements. Photographers carry a variety of lenses to enable them to zoom in or draw back to include only the important pictorial elements.

Every photo cannot be perfectly framed in the camera, however. To save the shot, the photographer must enlarge the negative in the darkroom and crop the print with the adjustable borders of a printing easel. The final glossy often represents only a portion of the original negative. The *Boston Globe*'s George Rizer realized he had a good picture of two basketball players soaring into the air high above the referee. After printing the negative full frame, Rizer decided he had a much better shot if he cropped off the top of the players, leaving only their legs dangling in midair. The final photo, shown on the opening spread of this chapter, emphasized the floor-bound referee, leaving the players floating in the stratosphere.

If, however, the photographer does not crop the picture in the darkroom, then the layout editor provides a second line of defense. Looking at the 8"x10" print, with all its distractions, the layout editor can cut out the extraneous by putting crop marks on the white border of the picture. These marginal marks indicate to the printer the area that should be left in the final reproduced halftone. The editor can cut out as much of the picture as he or she wants from the top, sides, or bottom of the print by merely drawing a short line with a grease pencil where the new border of the picture should be.

Even with tight framing in the camera to eliminate distracting elements, every subject does not fit neatly into the format of a 35mm negative. For that matter, all subjects do not fit naturally into a 21/4" x21/4" square or a 4"x5" rectangle. Some subjects are low and wide, like a classroom blackboard, whereas other subjects are tall and skinny, like the Washington Monument. Consequently, no matter how carefully you compose the picture in a 35mm view-finder, the image from the real world may not completely fill the frame. In these situations, all you can do is shoot and then crop the negative in the darkroom or the picture on the layout table later.

CROP
THE
EXCESS. . .

Cropping from the top and bottom removed wasted areas from this photo. (Photo by Betsy Brill, for *The Houston Post*.)

Editors use arrows to indicate crop marks. Here, the editor cropped off distracting elements of this photo of Jack Ruby killing John Kennedy's accused assassin, Lee Harvey Oswald. (Photo by Bob Jackson, *Dallas Times Herald*.)

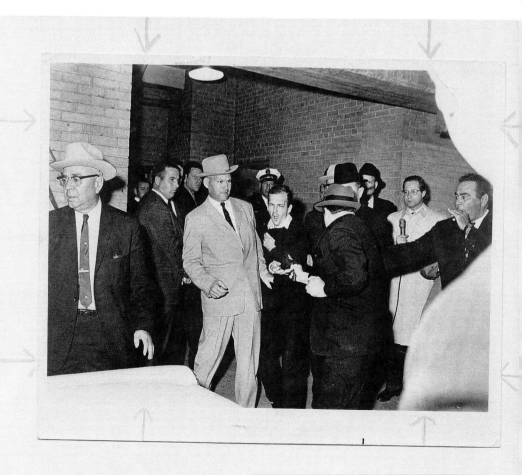

CROP THE EXCESS

Like a writer editing copy, the layout person should emphasize the significant elements in the picture by eliminating extraneous material that carries little meaning. If a person's expression gives the picture sparkle, zero in on the face and cut out the peripheral material.

Light, bright areas of the picture like windows and lights tend to attract the eye. If these windows and lights are extraneous to the

...BUT PRESERVE THE MOOD

Be careful when you crop not to cut out important elements in a picture — like the excited faces in this tenth inning, game-winning slide into home plate. (Photo by Kevin Reeves, *Cleveland* (Ohio) *Sun Newspapers*.)

main subject, they will pull the reader's attention away. Avoid a competing area that might distract a reader's interest from the photo's primary subject. Crop out these irritating sidelights from the picture. Bob Jackson of the *Dallas Times Herald* took a remarkable photo in the Dallas County jail of Jack Ruby gunning down Lee Harvey Oswald, the accused assassin of President John F. Kennedy. Jackson's strobe, used to take the photo, burned out the person standing near the camera. The unidentified person was bleached white on the print. Cropping out this distracting element in the foreground greatly improved the historic picture.

If the action occurs in one corner of the picture, focus on that area. The layout editor should have a reason for leaving in each area of the picture. No corner of the picture should remain just because it happened to be in the original negative. The rule is: save the meat of the photo by cutting out the fat.

CROP RUTHLESSLY

"Crop ruthlessly," advises Edmond Arnold, a pioneer of modern newspaper design. "Cut out anything that's not essential to the picture, so that the reader's attention won't be distracted or wasted. Ruthless cropping leads to stronger images."

Research supports the notion that eliminating extraneous details helps a picture. Gallup's Sharon Polansky, recording eye movement as subjects perused printed material, found that the simpler the picture's background, the more attention it received.

PRESERVE THE MOOD

The editor's red grease pencil can save a picture or destroy it. Cropping can improve a picture by eliminating

irritating details. But mindless cropping can ruin the intent of the picture by slicing off areas of the photo that give the image its mood. The sensitive editor preserves the ingredients that give a picture its arresting look by leaving the brooding gray sky in a scenic or including the messy bookshelves in a college professor's portrait.

Sometimes a blank area in the picture balances the action area. Leaving a little room on the print in front of a runner helps create the illusion that the athlete is moving across the picture. Similarly, some blank space in front of a profile portrait keeps the subject from looking as if he or she is peering off the edge of the print.

Besides mood, insensitive cropping can rip away parts of the picture that give it context. Sometimes it's important to know that a riot occurred in the ornate foyer of city hall or in a barren, dusty field. An editor's overzealous cropping could eliminate these informational, telling details.

■ REDUCED QUALITY: THE PRICE OF CROPPING

A perceptive editor can improve a photo's impact using thoughtful cropping but sometimes only at a price. Enlarging only a very small portion of the original negative or blowing up just a part of the final glossy magnifies any defect in the original picture. If the original negative lacked perfect sharpness, then the published picture will look soft and indistinct. Even if the original is sharp, enlarging a portion of the negative expands each grain of the film, thereby decreasing the photo's resolution. The more the image is enlarged, the more the grain is visible. Enlarged grain means the detail of the photo may be obscured to the point where the print takes on the tex-

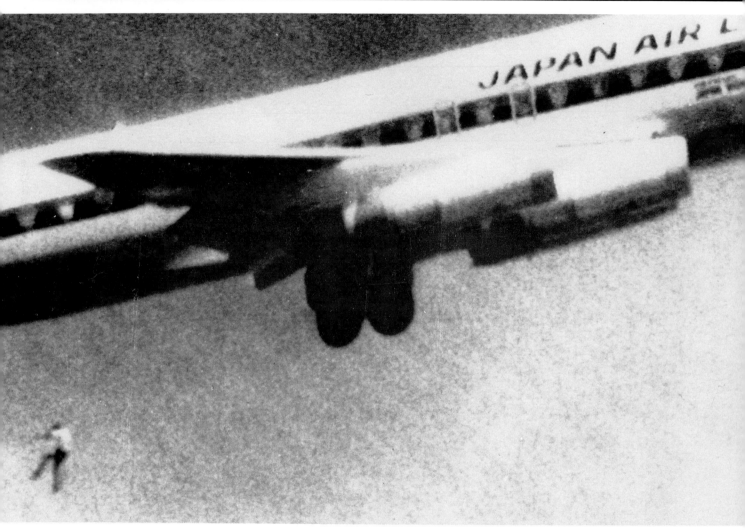

ture of rough sandpaper. The photographer faces a dilemma then. While the technical quality of the picture decreases when a photo is drastically cropped and enlarged, the visual impact of the photo often is improved. Cropping, therefore, involves a tradeoff between poorer quality but better composition. Taking a one-inch square segment of an 8"x10" photo and publishing it as a half-page spread in the newspaper might produce a perfectly composed picture that is too fuzzy for the viewer to appreciate.

Few situations merit an extreme blow-up from such a tiny portion of a picture. Generally, however, a good photo editor will opt for a dramatic image at the expense of some sharpness and grain. The editor reasons

The price of extreme enlargement is increased grain and decreased quality. Only for news as unusual as this airplane stowaway falling to his death should poor quality photos be enlarged to this extent. (Photo by John Gilpin, *Wide World Photos*.)

that it is better to catch the reader's attention with an exciting photo than lose the reader with a technically sharp but dull image.

SIZING UP FOR IMPACT

■ A BATTLE FOR SPACE

A battle rages in many newsrooms every day between wordsmiths and photographers. The outcome of the battle determines the size of the pictures in the next day's paper. The wordsmith, backed up by the copy and managing editors, fights for small pictures to leave room for plenty of type. Reinforced by the photo editor, the photographer demands that the pictures be printed large

CROPPING THE HUMAN BODY

The editor's most perceptive skills come into play when cropping a picture containing a person. The editor must be careful to operate not amputate. Parts of the body can be cropped off, but usually the crop mark should not fall on a joint like an elbow or knee. If the editor divides the head from the neck in a photo, some of the shoulder should be left so that the head will have a platform to sit on. The layout person can crop into the face of a person, but should not leave half an eye or just part of a mouth. Look at the pictures of the dancer and decide which crops seem natural and which crops seem arbitrary and absurd.

Some insensitive designers dream up pages before they even see photos for the spread. When they receive the glossies, they slice and dice them into the preplanned shapes of their layouts, regardless of the photos' content. If these designs call for thin verticals running down the right-hand side of the page, these graphic artists care not if they have to chop up a perfectly composed horizontal shot and leave in only one eye and the tip of a nose — as long as the picture fills the predetermined space. These thoughtless people crop pictures to fit their designs, not to tell stories with photography.

Much detail would be lost if this photo were run small. Here, a church member faints at the peak of a faith healer's sermon. (Photo by Sandra Shriver.)

enough so that readers will not miss them.

The camera contingent argues that the larger the picture, the more powerful its impact. Ample evidence supports this claim. In his article, "Reader Interest in Newspaper Pictures," published in *Journalism Quarterly*, Bert Woodburn concluded that as the size of a photo increases, the number of readers grows proportionately. For instance, 42 percent of all the readers looked at a one-column picture, but the audience grew to 55 percent when the photo ran across two columns. A four-column-wide picture caught the attention of about 70 percent of the readers. Seith Spaulding verified Woodburn's findings in another study, "Research on Pictorial Illustration," published in *Audio Visual Communication Review*

When all other factors were equal, not surprisingly, Sharon Polansky at Gallup Applied Science came to the same conclusion. She found that increasing size also increases attention to a picture. She found that one reason "mug shots" receive little attention is because editors play these portraits so small.

Even this axiom — bigger size gets more attention — has exceptions. The axiom's corollary might read: if the subject matter is exceptionally galvanizing, even small pictures will be noticed. Polansky, the Gallup researcher, noted during one of her studies that a tiny ad showing a female mud wrestler (with lots of torso showing) — played on the inside of a sports section — got much more attention than its size would have predicted. When it comes to sex, at least, picture size is not the only determinant for reader attention.

If the photo is striking, the photographer should fight for space. Bad photos, of course, should not appear in the paper, but if they must be printed, play them small. Oversizing a technically poor photo calls attention to its deficiencies. On the other hand, underplaying an exciting, technically sharp photo does a disservice to the photographer and to the reader, as well.

■ WHEN SIZE IS NEEDED
DRAMA

Armed with Woodburn's finding and Arnold's axioms, the photographer fights for larger photos so that the audience can easily see the textural detail that the original glossy contained. A one-column head shot is so small that it communicates almost nothing, and the person is barely recognizable. With a four-column head shot, the reader can examine the two-day-old whiskers on the mayor's face, or the size of a contact lens on a woman's finger.

DETAIL

A long shot, such as an overall of a church interior or a shot from an aerial from a plane, also demands newsprint space. Compressed into one column, all the details blend together and lose the bits of information that give the picture meaning. "Exquisite," remarks the reader who sees a larger-than-life, oversized photo. A common object, like a pencil or pen, a contact lens, or even a media-worn face, becomes fresh and exciting when magnified beyond its natural size.

ACHIEVING CONTRAST WITH SIZE

Good layout on a newspaper page or magazine spread usually involves playing pictures so that one image dominates the spread. Dominance is achieved through size. The dominant picture seems large especially when it is played alongside considerably smaller images. If the dominant and subordinate images are too close in size, they compete for the reader's attention. (The newspaper pages here were designed by Marilyn Glaser of the *Dallas Morning News* for the "Today" section. The magazine spreads were designed for *San Francisco Business* by (TOP) Betsy Brill and (BOTTOM) Ben Barbante.)

Shirley Ballas of Houston collects her thoughts just before the Texas Challenge. Her rhinestone in place, Patricia Slayle of Venice, Fla., awaits her turn in the spotlight.

RHYTHM & RHINESTONES

Jerry Anderson of Milwaukee and her instructor, Stephen Knight, show off the moves they've practiced together countless times before.

The Dallas Morning News: William Snyder

While couples do their best to stand out in the elegantly dressed crowd, judges on the sidelines rank the dancers' technique on score cards.

The belles of the ballroom rise to the Texas Challenge

By Maryln Schwartz
Staff Writer

HOUSTON — At the Adam's Mark Hotel, a young man in black tie and gold lamé tails is doing knee-bends in the glass elevator.

A 46-year-old woman wearing a plunging neckline and rhinestones in her platinum hair is practicing the rhumba in front of the lobby ladies' room.

Not far away, a 70-year-old woman is tangoing down the hall with her 28-year-old dance instructor. His silver and aqua tunic is perfectly coordinated with her silver and aqua-spangled gown. After a few steps, the instructor lifts his partner above his head as she gracefully extends her leg in an arabesque.

It's as if Patrick Swayze were doing an acrobatic routine with Bette Davis — only Miss Davis is costumed like Cher.

And these are just the warm-ups.

In less than an hour, the Texas Challenge ballroom dancing championships will get underway. Then the real excitement begins.

More than 400 ballroom dancers from all over North America take part in the four-day, noon-to-midnight competition held each spring. Most are women in the 35-65 age range who enter with their dance instructors as partners.

The youngest contestant this year is a 17-year-old from Florida; the oldest, a 75-year-old from Arizona.

For these women, dancing is no mere hobby. It is almost an Please see BALLROOM on Page 2F.

Business volunteers go
Back
to School

by Linda Gebroe ■ photos by Ken Kobre

San Francisco Business/March 1989 – 49

ANSWERING the CALL

Chaplain Holsey Hickman isn't looking for confessions. He's not out to save souls.

Instead, he listens. He comforts. He brings a little humanity to a cold, frightened world behind bars.

The Dallas Morning News/Bryan Caplage

The Rev. Holsey Hickman visits prisoners in Dallas County jails, where he does some of the talking and most of the listening.

By Leslie Barker
Staff Writer of The News

The Rev. Holsey Hickman's dream of his own congregation never included church suppers and choir rehearsals. Instead, he chooses to minister to people he may see only once or twice, those he may never physically touch, those he may inspire only briefly.

Hickman's congregation of 3,500 is divided into the five Dallas County jails. He is not there to condemn, condone or convert. His job may be chaplain, but he is not a preacher. He is just as likely to talk about bail as he is to talk about God. He treats prisoners as human beings, at a time in their lives when they feel like nothing.

"I'm here to help them get through the midnight of incarceration," says Hickman, director of jail ministry for the Greater Dallas Community of Churches. "I'm here because they're here."

He is there on a recent morning for a 17-year-old inmate at the Dallas County Courthouse jail. Hickman learned of the teen's incarceration by checking a computer printout that lists inmates' ages. He feels that the very young and the very old, in particular, need his visits. So he decides to leave his office at the Lew Sterrett Justice Center and meet the teen.

He rides the inmate-operated elevator to the sixth floor of the courthouse and kids around with a guard before asking to see the youth.

Hickman eases his lanky legs under the table of the visitor's booth, a set of bars separating him

from the prisoner. He asks the teen about school, about the position he plays on the football team. The teen answers with nods, shakes of the head or a voice that is soft and sad.

"Who's been to see you since you've been in jail?" Hickman asks.

"Nobody."

"What about your mom?"

"I asked her not to come."

"Why not?"

"I didn't want to see her behind bars."

When Hickman asks about football, the teen smiles slightly. He tells Hickman about his best game, when his team beat its opponent 55-6. He intercepted the ball six times, he adds, briefly letting his gaze meet Hickman's before he looks down at his hands.

He begins to open up and tells Hickman about $5 his uncle sent. He would like to buy peppermint sticks from the commissary cart, but his privileges have been suspended. Hickman asks why. The youth's voice is so quiet that Hickman has to lean forward to hear him.

"Someone called me things like — excuse me for saying them," he says, and tells Hickman a few racist names.

"What did you do?"

"Nothing," he says, almost whispering. "Then he spit on me. Then we started to fight."

Hickman only nods, as calmly as if the teen had said he ate a sandwich for lunch.

Please see CHAPLAIN on Page 2F.

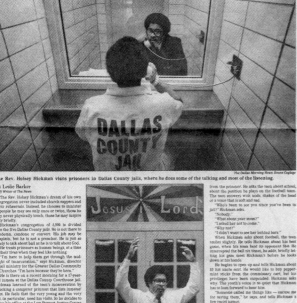

Hickman focuses on the person, not the crime.

Shopping the Haight

Daddy Would You Know Your Little Girl Now?

by Mary Thursby • Photos by Ken Kobre

BEFORE

AFTER

6—San Francisco Business/April 1989

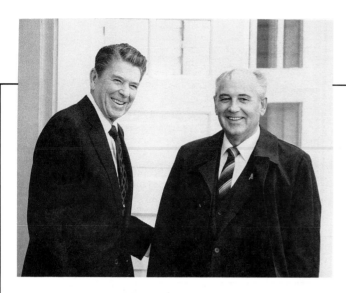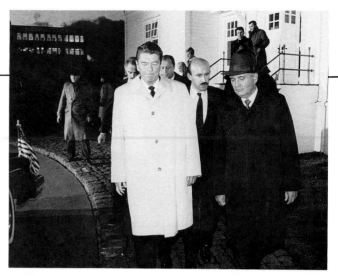

BEFORE & AFTER SEQUENCE

The contrast between the warm, friendly opening and the chilly closing moments of the Icelandic Summit between Soviet President Mikhail Gorbachev and then-U. S. President Ronald Reagan tell the story of the meeting's outcome. (Photos by Peter Souza, The White House.)

CONTRAST

Printing some pictures small and others big heightens the contrast between them, adding to the interest of the page. Publishing all pictures in a 3"x5" size produces a deadening effect. No individual photo dominates. It appears that the editor simply could not decide which pictures were the most important. Just as a reporter or copy editor emphasizes certain points of an article by putting them in the lead, the layout editor spotlights certain pictures by playing them larger than the other photos on the page.

The never-ending battle between the word and visual camps continues, but the photographer can gain space if he or she is willing to sacrifice a few weaker pictures so that stronger ones can be printed larger.

■ BIG PICTURES HELP STORY RECALL

The reporter also gains when a large picture accompanies a story. William Baxter, Rebecca Quarles, and Hermann Kosak, in a study presented to the Association for Education in Journalism and Mass Communication (AEJMC), found that while a small, two-column picture accompanying a story does not help the reader remember the details of that story, a large picture, six columns wide, measurably improves readers' recall of details in the associated article. Big pictures, therefore, attract readers' attention, lure them into the accompanying article, and help them remember the story's facts.

PAIRING PICTURES

Sometimes one picture can sum up an event. The flag-raising at Iwo Jima or the Hindenburg explosion needed only one photo to tell the story. Other situations require

several. Pairing photos, according to Wilson Hicks in his landmark book ***Words and Pictures***, causes a third effect. The reader looks at the two pictures separately and then mentally combines them. The effect is different than what any picture alone can produce.

■ PICTURE SEQUENCE/SERIES

Sometimes a story takes place over time. For example, Olympic competitor Mary Decker was tripped by another runner during the much-awaited race. The sequence of events — running, tripping, and falling — required a sequence of pictures to tell the whole story. The unfortunate accident, which Bruce Chambers of the *Long Beach Star-Telegram* recorded with his motor drive, needed a beginning, middle, and ending picture to tell the complete story. (See the series of photos on pages 108–109, in Chapter 6, "Sports.")

■ PACKAGING PICTURES

Some situations are multifaceted. One photo just won't explain all the diverse elements.

For example, Jim Gensheimer of the *San Jose Mercury-News* wanted to illustrate the variety of ways people entertain themselves while commuting on a train. A picture of the train alone wouldn't tell Gensheimer's story. Nor would a single picture of commuters. Instead, packaged together, pictures of the conductor inspecting the train, of passengers partying or relaxing while others run to catch the next coach, give a more complete vignette of the commuters' lifestyle.

Other times, two photos provide a contrast with one another. When Soviet President Mikhail Gorbachev met with U.S. President Ronald Reagan at a summit in Iceland, the two started off quite jovially. By the end of the summit, however, they were barely speaking. By showing before and after pictures, White House photographer Peter Souza captured the change in mood at this important meeting.

THE PICTURE PACKAGE

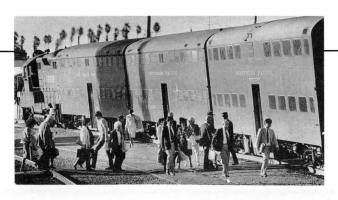

Several photographs packaged together best capture the commuter-train lifestyle in the San Francisco **Bay Area.** (Photos by Jim Gensheimer, *San Jose Mercury-News.*)

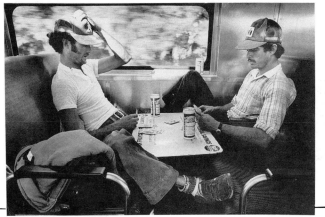

PICTURE
PAIRS

A beauty contest (LEFT) is paired with a photo of a risqué fashion show for women. Played together, the pictures deliver a stronger editorial message about the sexes than either could alone. (LEFT: Photo by Mike Smith, *Detroit Free Press*; ABOVE: Photo by Curt Johnson, *Long Beach Press-Telegram*.)

■ UNRELATED PICTURE PAIRING
DIFFERENT PICTURES — SIMILAR MEANINGS

In written language, different words can have similar meanings. With pictures, different images can carry the similar messages. Language experts call words with related meaning synonyms. A thesaurus is filled with examples of synonyms. Pictures with similar messages could be called visual synonyms.

Pairing pictures that were taken at different times and places but carry the same editorial statement allows the reader to see the common elements in the different images. The reader draws comparisons between the different photos. For example, you could publish side by side the picture of a man judging a beauty contest with that of women watching husbands and boyfriends stage a risqué fashion show. While the two pictures were photographed at widely different times and places, one in Texas and the other in California, and taken by two photographers, Mike Smith and Curt Johnson, pairing them makes an editorial statement about the sexes. Similar in editorial content and point of view, the two pictures might be considered visual synonyms. They look different, but their underlying meaning is similar.

VISUAL HOMONYMS

On the other hand, some words — like "to," "two," and "too" — sound the same but carry completely different meanings. These are called homonyms. Likewise, some pictures look superficially similar but carry dissimilar information. For example, a picture of an Egyptian pyramid and a photo of a pile of oranges might look similar — both are triangle-shaped. Some pairs may be entertaining, but because the pictures share no editorial relationship, a reader trying to find their common editorial thread may be confused. The pictures have no real journalistic commonality.

Be careful, then, of visual homonyms, photos unrelated except by looks. Pairing such pictures can lead to editorial abuse. Pairing pictures that are not intrinsically connected editorially can lead to silly or, in even worse situations, offensive results. Some readers would object to pairings that don't relate editorially. Others would vehemently disagree with the pairing.

I once saw a collection of unrelated pictures of overweight people — shot by different photographers for different purposes — published together on a page in a photo book. The editor must have thought it clever to assemble these editorially unrelated pictures together because they shared a common visual element: over-

weight people. I thought his decision was tasteless and insensitive. What was the message?

CAPTIONS: STEPCHILD OF THE BUSINESS

Some pictures — such as Norman Rockwell's cover illustrations for the *Saturday Evening Post* — need no words. The idea portrayed is so simple or its emotional content so powerful that the illustration tells the story clearly and immediately without any captions.

But most photos do need words. The old Chinese proverb relates that a picture is worth a thousand words, but the corollary to the proverb is that a picture without words is not worth much. A picture raises as many questions as it answers. Look at the pictures on these two pages and ask yourself if you know who is in each picture, what is happening, when the events took place, and why the action occurred. Pictures usually answer these questions only partially. A picture that can stand completely alone is rare. The point is not whether photographs can survive without words or words without pictures, but whether pictures and words can perform better when they are combined.

■ WORDS INFLUENCE PICTURE MEANING

When Jean Kerrick was assistant professor of journalism at the University of California, Berkeley, she conducted research to determine the influence that captions had on readers' interpretations of pictures. Captions, Kerrick found, can at least modify and sometimes change the meaning of a picture, especially when the picture itself is ambiguous. A caption can change from one extreme to another the viewer's interpretation of the same picture.

Kerrick presented a profile shot of a well-dressed man sitting on a park bench to two groups of subjects. She asked the groups to rate the picture on several subjective scales. The scales ranged from "good to bad," "happy to sad," "pleasant to unpleasant," and so forth. Then, the first group was shown the same picture with this caption: ***"A quiet minute alone is grabbed by Governor-elect Star. After a landslide victory, there is much work to be done before taking office."*** The second group was shown the same picture with a different caption: ***"Exiled communist recently deported by the U.S. broods in the Tuileries Garden alone in Paris on his way back to Yugoslavia."*** Both groups were again asked to rate the picture on the evaluative scales.

Kerrick found that after the first group read the positive caption, they rated the picture "happier," "better," and "more pleasant" than they had originally judged it. The second group of viewers, who read the caption about the exiled communist, changed their rating of the picture in the opposite direction — the photo now seemed "sad" and "unpleasant." In this example, the caption completely reversed the impression initially given by the picture alone.

Pictures serve as a primitive means of communication but carry out their task instantly. Words function as a sophisticated means of communication, but lack the impact of the visual message. Pictures transmit the message immediately, but words shape and give focus to that message.

■ PICTURES DRAW ATTENTION TO WORDS

Pictures need words, but words also need pictures. A picture serves a story as an exclamation point does a sentence. Regardless of its content, the photo says to the audience, "READ THIS STORY. IT'S IMPORTANT!" By adding a picture related to the news, an editor adds significance to the story. Functioning as a banner headline, the picture flags down the readers' attention to a given spot on the newsprint page.

A study by Bert Woodburn points out the advantages of pairing print with pictures. In analyzing the data from the Advertising Council's Continuing Readership study, Woodburn discovered that while only 10 percent of the audience read the average story, 33 percent looked at and remembered the average picture. One-third more of the public viewed the picture page than read any story on the front page. The conclusion from this data is that even the most important news profits by adding photography.

■ WRITING CLEAR CAPTIONS

The need for clear and concise caption-writing is obvious. Readers often determine whether they are going to read an entire article based on what they gleaned from a picture and caption. If you glance through some newspapers, however, you may get the impression that the first person to walk into the city room wrote the captions in the paper that day. Writers polish their story leads, and photographers polish their lenses, but no one shines up the captions. Writers claim that caption-writing is beneath them, while photographers often seem to find an important blazing fire to cover when the time comes to compose captions. The caption — the stepchild of the newspaper business — is the most read but least carefully written text in the paper.

Poor captions sometimes result when photographers fail to get adequate information at the time they take the pictures or forget to include the information when they write the captions.

Former *People* magazine photo editor John Dominis tells the story of holding up the magazine's production because a photographer did not send in one

Why is this boy crying? Without a complete caption, readers would not have known that the child was watching his home burn as a result of a gas leak caused by the 1989 San Francisco earthquake. (Photo by Ron Bingham, *The Golden Gater.*)

critical identification. Lights in the New York headquarters burned past midnight as the editors carried out a desperate search by telephone for the forgetful photographer. Editors, writers, layout artists, designers, and production staff all waited hour after hour for the missing caption, costing *People* magazine thousands of dollars in overtime.

■ PUTTING THE FIVE Ws IN A CAPTION

"A caption is a verbal finger pointing at the picture," wrote John Whiting in his book ***Photography Is a Language***. Captions, like fingers, come in many sizes and shapes. The opening words of a caption must capture the reader's attention just as do the lead words of a news story or feature. The caption writer starts off the sentence with the most newsworthy, interesting, or unusual facts. Copy desks have developed several varieties of captions, each emphasizing a different element of the story.

WHAT

The reader wants an explanation of what is happening in the picture; hence, the first words of the cutline should explain the action. Unless the situation in the picture is obvious, the cutline must describe what is going on. ***After two years of drought, it rained in the southern part of the state yesterday. . . .*** Further down in the cutline, the writer can fill in the other details of the story by giving the remaining four Ws.

WHO

The who may be emphasized in the caption when the person in the news is featured. ***President Bush said yesterday that he will spend the weekend at Camp David.*** In this situation, the newsworthy aspect of the picture is the person, President George Bush. The fact that the president was speaking outweighed what he had to say or where he said it.

A person's name should lead the caption only when that person is well-known to the readers of the magazine or newspaper. Do not start the caption, "John Doe said yesterday that the budget should be slashed." No one knows John Doe, so placing his name prominently in the cutline neither adds to the picture's interest nor explains its news value. However, if John Doe's face is recognizable in the photo, he should be mentioned somewhere in the caption. People's names are always included in the caption even if they are not famous. Someone — spouse, parents, friends — certainly will recognize them.

Also, readers can misidentify the person in the photo if the name is left out of the caption. Often you

This fascinating but complicated vignette becomes clearer when the caption explains that these were bored kids entertaining themselves while waiting in line for their turns to kick the ball at soccer practice. (Photo by Scott Eklund, *Bellvue* (Wash.) *Journal American*.)

CAPTIONS:
STEPCHILD
OF THE BUSINESS

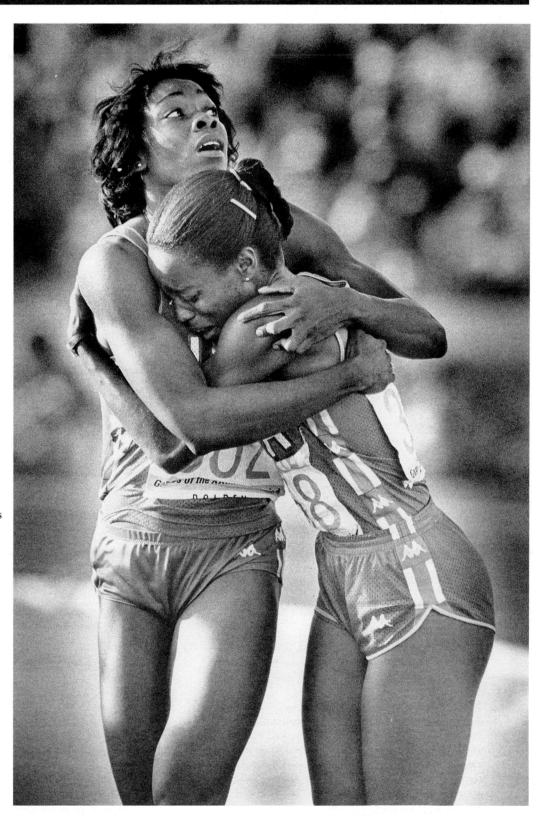

Sometimes pictures capture great emotion, but without captions, readers may be unable to determine just what emotion they are seeing. Are these women happy or sad? Did they win or lose the event? (Photo by Paul Chinn, *Los Angeles Herald Examiner.*)

may hear, "That woman in the picture in the paper today looks just like"

Many editors will not run a picture unless the photographer has included in the caption the names of all recognizable people. The wire services, whose pictures go around the world, write in the person's first and last name, regardless of the individual's national prominence.

If a child is pictured, the photographer should get the name and the age of the youngster. This information often adds additional human interest to the picture. *The collie pup would have drowned if the Selleck girls (left to right) Debbie, age 3, Heidi, age 5, and Becky, age 7, had not pulled their dog, Sam, from the stream in time.*

Note that readers are given clear directions about which girl is which with the phrase "left to right." Sometimes the words "top row," "wearing the tie," or

Telling the reader in the caption that the pole is greasy, a fact the picture alone could not convey, helps explain the contestants' predicament. (Photo by Jim McNay.)

other identifying features will help readers match the faces in the photo with the names in the cutlines.

WHEN/WHERE

Photos rarely tell the reader exactly when or where the pictures were taken. If this information helps the reader understand the picture, supply the location and the time of the news event. Use the day of the week, not the calendar date. ***José Canseco hit the home run yesterday that gave the A's their win over the Giants.*** (Not "Canseco hit the home run July 6.")

The writer should begin the cutline with time or place only when that fact is significant or unusual. ***At 3 A.M., Mayor Ted Stanton finally signed the zoning bill.*** Or: ***Standing in the sewer, the water commissioner, Edna Lee, explained the new drainage system.***

WHY

Some caption writers claim that explaining why the action occurred in a picture takes away the reason for reading the story and thus causes readers to skip the adjoining article. Other news photographers and editors argue that extensive captions pique reader interest for the main body of the story. ***Because of the transit strike, highways leading into the city were jammed at the early morning rush hour today.*** Without answering the "why," this photo and caption would not make sense.

■ FILLING OUT THE DETAIL

The caption is the place to tell readers if the subject in the picture was posed. If the photographer took the picture with a special lens, or manipulated the print in the darkroom, this fact should be noted. In fact, anything about the scene in the picture that differs significantly from the actual event and, therefore, might distort the facts should be explained in the caption.

SMALL DETAIL

Casually glancing at a photo, readers might miss an important but small detail. The cutlines can focus attention on various parts of the picture, emphasizing the elements the photographer thinks are important. The cutlines can supply details about the four senses — hearing, tasting, smelling, feeling — that the picture does not convey.

QUOTE

Sometimes this purpose can be accomplished by telling what the subject said with a catchy quote. ***"Some days I***

What had happened before this picture was taken lends great importance to what the reader is seeing now. Years ago, the Cambodian refugee in the car fled the Khmer Rhouge and came to the United States. The photographer accompanied the man on his first — and perhaps last — trip back to Cambodia. The people outside the car are his sole surviving relatives, and all realize this may be the last time they see him again. (Photo by Bruce Chambers, *Long Beach Press-Telegram.*)

wisb I had never left Kansas," said rock star *Dorothy Oz on the eve of her thirty-fourth record-breaking performance.*

TASTE, SMELL, AND TOUCH

How something tastes or feels might explain a subject's reaction in a picture. Without an explanatory phrase in the caption, the picture might not make sense. *David Krathwohl, 10, Jerry Lazar, 9, and Lou Madison, 11, struggle to climb an oil-covered plastic pole*

COLOR

Even though black-and-white photos record the world in almost infinite detail, one visual element is left out: color. When color is an important aspect of the scene, the cutline must supply this missing dimension. *The Franklin High Majorettes, dressed in bright pink uniforms and matching pink tennis shoes and carrying pink batons, marched and twirled in front of the Franklin County Courthouse yesterday.*

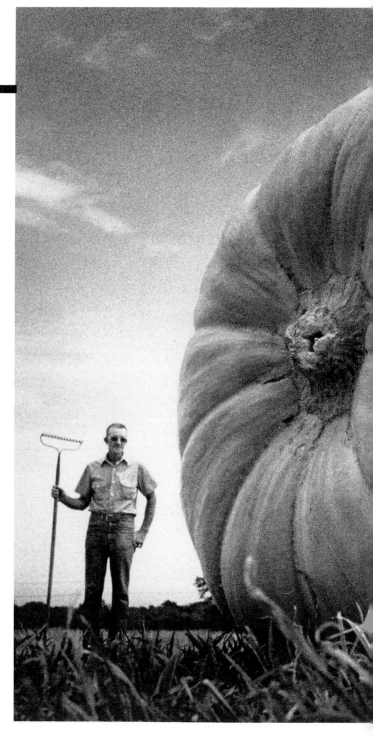

Special effects such as the close placement of the wide-angle lens (28mm) used in this picture should always be explained in a caption. (Photo by Marshall Spurrier, *Chanute* (Kans.) *Tribune*.

BEFORE AND AFTER

A camera shutter, open for 1/500 sec., results in a photo that accurately describes what happens in that brief span of time. But the photo does not inform the readers about what happened before or after that split second; the cause of the event and its effect are absent. Cutlines must supply the befores and afters.

SPECIAL CAMERA EFFECTS

Whenever your picture's overall look is the result of a special photographic effect, your caption should let the reader know how you accomplished this. When Marshall Spurrier was assigned to photograph the farmers who grew a large pumpkin, he placed the vegetable on the ground, attached an ultra-wide lens to the camera and positioned the man and his wife on either side of the frame, several feet back. The resulting picture made the vegetable look as if it were as big as a house. Spurrier used the picture's caption to explain how he achieved the effect.

Besides the distorting effects of the wide-angle lens, sometimes you might need to point out the compression effect of an extra-long telephoto or the color shifts produced when shooting in mixed lighting.

■ CAPTION-WRITING STYLES

Write short, declarative sentences with as few words as possible. Avoid complex sentences. Don't put unrelated facts in the same sentence. Keep facts separated with periods, not commas or other punctuation.

Hal Buell, The assistant to the president/Photostream, says, "Skip the adjectives and adverbs in a caption. Let the picture speak for itself."

Two schools of thought differ on the question of the tense of verbs in captions. The first group advises putting everything in the cutline in the present tense, because the words in the caption are describing a photo immediately in front of the reader. The present tense also involves the reader more than does the past tense. Says Karen Cater of the *Seattle Times*, "Present-tense captions give a sense of action, immediacy, and life to a photo."

The opposing view advocates using the past tense because all the action in the picture has already taken place. *John Brown tags (tagged) the runner to make the last out in yesterday's game.*

Avoid the obvious. Phrases like "firefighter fighting blaze" or "basketball player going for hoop" are unnecessary because readers can see that, in the first picture, the people are firefighters, and in the second, that the athlete is a basketball player. Phrases like "pictured above" also add no new information. Captions should avoid telling readers what they can find out for themselves by looking at the picture.

Avoid speculation about what the subject might be thinking. Such guessing can be inaccurate and give a

wrong impression. *Claire Katz smiles with happiness as she receives a check from the president.* For all we know, she is putting on an act. She might really think that the check was far too small for her efforts. The photographer has no way of looking into the subject's mind.

And, of course, no photographer can read an animal's mind. Don't fall into this trap: *"These pigs seem to be wondering if"*

Write simply. The best cutlines are written with no cute or pretentious prose, no clichés, no painful puns

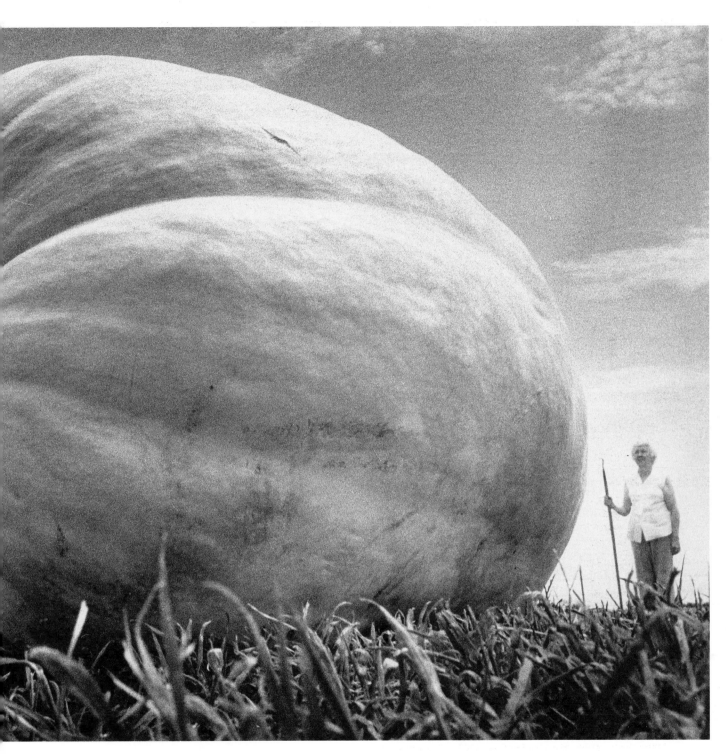

that take the enjoyment out of the photo. Remember, puns are the lowest form of caption writing.

Don't forget to identify old photos from the morgue as file photos. Otherwise, the reader thinks they were taken yesterday.

■ FINAL ADVICE

Caption writers — both neophytes and old hands — must always remember to start with the picture. If the writer looks at the picture, at least he or she will avoid the mistake that one caption writer made. The caption read, "Police seized a quantity of opium." But in the picture, there were no police and there was no opium.

Joseph Kastner, who was the head copy editor and caption writer for *Life* magazine, said that the discipline of caption writing is of an order that no other kind of journalism requires. "And when this discipline is exerted, it produces writing that is as taut, as spare, as evocative, and as cogent as any writing in journalism today." ■

Camera & Film

BUYING A JOURNALIST'S CAMERA

A news photographer's bag is like a doctor's bag — both contain the essentials for handling any emergency the professional might face.

Each photographer, like each doctor, carries different equipment, depending on personal needs and taste. Some photographers are partial to extra-long lenses, whereas others like motorized cameras. But all news photographers pack enough gear to handle any assignment, whether the event they cover takes place in the brilliant light of day or the pitch black of night. A news photographer must have a sturdy camera, a variety of lenses, a strobe, and, of course, film — lots of film.

■ THE NEED FOR RUGGED EQUIPMENT

The most expensive piece of equipment you will buy will be your camera system. Purchasing cameras and lenses can cost from hundreds to thousands of dollars. In the past, some cameras, because of their ruggedness, gained popularity among news photographers. In previous years,

A camera's automatic exposure meter would see this predominantly white scene as 18 percent neutral gray and under-expose the final picture. For proper exposure in similar situations, increase your exposure about two stops or take a reading off something in the same light that reflects a neutral gray. (Photo by Joel Draut, *Houston Post*.)

photojournalists chose the Graflex and later the 4"x5" Speed Graphic. The twin-lens reflex Rollieflex and the rangefinder Leica became popular after World War II. During the 1960s, the single-lens reflex Nikon and Canon dominated. Today, with miniaturization and automation, no single camera controls the photojournalist's field.

Yet today's photographers face the same problems that the Graflex user did. They want a camera sturdy enough to take the bashes of the business; they need a camera that can be subjected to freezing weather one day and melting temperatures the next. Yet they want that camera to continue to function perfectly, frame after frame.

KEEPING YOUR CAMERA DRY

Marty Forscher, a 45-year veteran of the camera repair business, warns photographers "to keep your camera dry." This is particularly important with newer cameras that have electronic circuitry. The electrical contacts can corrode on exposure to moisture, especially salty moisture at the beach. Forscher notes that when David Douglas Duncan, a well-known war photographer, shot pictures in Korea under the worst rain and mud conditions possible, Duncan used a simple underwater camera and got wonderful results.

Today, there are also various "rain hoods" available commercially that fit over photographer and camera and help keep both reasonably dry. These fold up easily for storage in a camera bag.

Forscher suggests that if you're caught in the rain without a raincoat for your camera and have neither an underwater camera nor waterproof housing, wrap your regular lens and camera body in a plastic bag sealed with a rubber band. Cut one hole in the front of the bag to let the lens stick out, and another in the back of the bag to enable you to see through the viewfinder. Put the lens and eye-piece through the holes and secure them with rubber bands. Now you can operate the camera through the bag, but you can shoot and view through a clear area. Remember to keep the front element of the lens dry because drops of water on this element will distort the image on the film.

WHEN TO OVERRIDE YOUR AUTOMATIC EXPOSURE METER

In a predominantly dark scene like this one, the camera's automatic light meter would be fooled into overexposing the final picture. In a situation like this one, take a meter reading off the subject receiving the light. (Photo by Steve Campbell, *Houston Chronicle*.)

■ BUILT-IN EXPOSURE METERS ARE STANDARD

When manufacturers first brought out cameras with built-in light meters, many photojournalists discounted the new technology. "Who can trust a built-in light meter?" they asked. "It can't possibly be as accurate as a hand-held meter."

Gradually, however, most photographers adapted to the built-in meter.

Next, manufacturers brought out a camera that automatically set the aperture once the photographer had selected the shutter speed. Camera designers called this option 'shutter priority.' They also developed a reverse option called 'aperture priority,' in which the photographer selects the desired aperture setting, and the camera adjusts the shutter speed for the correct exposure.

Again, photojournalists were leery. "How could an automatic camera possibly get the exposure right?" they queried.

Then camera companies developed the "programmed" exposure mode that sets both the aperture and shutter speed. Now seasoned photographers were really suspicious. The camera was setting the exposure with no help from the photographer. In fact, some cameras today are so sophisticated that they recognize whether the photographer has on a wide-angle or telephoto lens and then adjust the shutter speed accordingly — matching longer lenses with faster speeds to prevent problems with camera movement.

"Are all our years of experience and street smarts and seat-of-the-pants guessing going to go down the drain?" some photographers demanded.

Few photojournalists today would leave the newsroom without a light meter built into their camera that can perform a variety of exposure readings. With the advent of extremely sensitive cells and tiny, on-board computers that can evaluate various parts of the scene to determine the ideal exposure, the built-in light meter performs remarkably well. As long as the photographer knows when to override the automatic light meter — sun flaring directly in the lens, for example — photojournalists have found that the in-camera meter works well for shooting both black-and-white and color.

Free-lancer Keith Philpott (see page 213) says the automatic light meter allows him to shoot while moving from one light level to another without worrying about exposure — allowing him to concentrate on his subject's reactions, not on the mechanics of the camera.

BEWARE OF EXTREMES

Automatic light meters are generally accurate except when the majority of the picture is either all-white or all-black. Backlighting also presents a challenge to automatic exposure meters.

Joel Draut of the *Houston Post* switched to manual reading when he shot a funny face carved in snow. With an automatic light meter reading, the snow would have turned gray. Draut opened the aperture about two stops above the light meter's reading to compensate. Steve Campbell, who shoots for the *Houston Chronicle*, switched to manual when photographing after "lights out" in a military academy. The room was completely dark except for the flashlight shining from the door and lighting the sleeping boy's face. On automatic, the light meter

The circle in this picture shows approximately where an automatic camera would have focused. With the camera left on autofocus, background would have been sharp, the leaping player in the foreground soft, and the photographer disappointed. (Photo by Michael Maher, *Lowell* (Mass.) *Sun.*)

would have given a reading for the black room. Campbell took a reading for the boy in the bed and kept that reading when he reframed the camera.

■ AUTOFOCUS CAN HELP

If photojournalists resisted automatic light metering, they were even more skeptical initially about automatic focusing (AF). "How could a mechanical motor replace the eye-hand coordination of a trained shooter with twenty years' experience?" they asked.

At first, autofocus 35mm single-lens reflex (SLR) cameras with interchangeable lenses could focus automatically only in bright light. Then camera designers developed more sensitive light receptors, more sophisticated computer chips and faster motors to turn the lenses. Today's autofocus cameras can follow-focus and even anticipate the location of the subject as it moves toward or away from the lens. The photographer can prefocus on the finish line of a race, and the first runner crossing the finish line will automatically trip the shutter.

With some cameras — even in extremely low light or total darkness — the photographer can use a dedicated strobe that emits infrared light, which allows the camera to focus the lens accurately and automatically. Photojournalists can take pictures at night, in a dark back alley — without ever focusing the camera. Just point, shoot, and get well-exposed, sharp pictures.

Like most automatic features on a camera, autofocus works perfectly for many but not all situations. Knowing when to switch from autofocus to manual remains the key to bringing back consistently sharp negatives and transparencies.

STAYING CENTERED

Mickey Pfleger, who regularly shoots for *Sports Illustrated,* finds the automatic feature suitable if the subject is in the middle of the viewing screen. He finds, however, that most of his sports shots locate the quarterback or the pitcher off-center. When a subject is not in the middle of the frame, the camera will focus on whatever happens to

be in the center, thereby leaving fuzzy the main subject at the edge of the frame. While the autofocus camera allows the photographer to lock in focus and then reframe with the subject off-center, the sports shooter has no time for this extra step when covering a slide at third base or a quarterback option play.

One way some manufacturers are trying to correct this problem of off-center autofocusing is by adding to the viewing frame more than one location from which the photographer can select. Some cameras now have three spots — left, center, and right — that they can select for autofocus. The photographer chooses which area contains the most important subject and then lets the camera do the rest.

TRICKY SUBJECTS

In addition, sports photographers note that when the referee or a tangential player crosses in front of the lens during a play, the camera starts focusing on this new element. Paul Bereswill, who shoots for *Newsday* and *Sports Illustrated,* described this incident in an interview with *Photo District News*: "I was shooting college basketball, and when someone ran in front of the player I was trying to photograph, the camera shifted focus. By the time I could train the AF (autofocus) back on the player, the picture was gone."

HAIL, HAIL MARY

Photojournalists agree that the autofocus feature offers one clear advantage over manual focus. Sometimes a photographer is caught in a situation when, with nothing in the vicinity to provide height, he or she needs to shoot over the heads of a crowd. For instance, at the end of a football game, everyone on the field crowds around the

ONE PRO'S CAMERA BAG

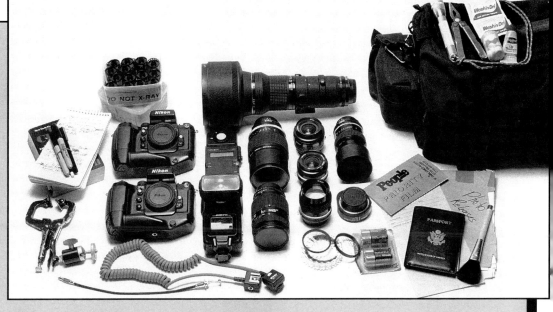

Keith Philpott has been both a newspaper and magazine photographer. Based in Kansas City, Missouri, Philpott has shot assignments for the *National Geographic* and works extensively for *People* magazine. Here he explains the contents of his camera bag and the reasons for his choices.

CAMERA The Nikon F4 is a highly sophisticated electronic camera, yet it handles much like the mechanical cameras of a few years ago. This old-fashioned user-friendliness, coupled with the new camera's extreme durability, is why it's my choice.

I carry two camera bodies because I often need two different lenses in a situation, a wide-angle and a medium telephoto. Also, if one camera body malfunctions, the other will save the day. Finally, I carry twin cameras because sometimes I shoot black-and-white and color on the same assignment.

LENSES My favorite lenses are wide-angles, with the 20mm f/3.5 topping the list. I like the 20mm because I can squeeze a lot of information into the frame. However, this lens can distort severely and should be used carefully.

I covet the 35-70mm AF (autofocus) f/2.8 lens for its speed, sharpness and commonly used focal lengths. The zoom capability is useful when you're confined to one spot and for the occasional "zoom" effect. The 55mm f/2.8 macro is indispensable for close-up work and doubles as a normal lens. My lenses include the 105mm f/2.5, 180mm f/2.8, and 400mm f/3.5. The 105mm and 180mm are used mostly for tight people shots and for details. I use the 400mm for sports and for special effects like compressing a hilly highway into a dramatic scene. When the Nikkor TC-1.6 tele-converter is added, the 400mm becomes autofocus and a powerful 640mm lens. Despite its weight, size, and hefty purchase price, I always take this lens on the road, where I carry it in a nondescript fanny pack.

ELECTRONIC FLASH AND METER I carry Nikon's SB-24 strobe because it's perfectly matched to the Nikon's F4 camera. Some of the strobe's more esoteric functions include an infra-red beam that allows the F4 camera to focus in total darkness.

I use the precise fill-flash capability made possible with through-the-lens (TTL) metering, which measures the actual light coming through the lens and reflected off the film. I sometimes use an extension sync cord so I can aim the flash in different directions and still keep its automatic features functioning.

Although the flash can be used automatically, I still carry a Minolta strobe meter to verify exposures whenever I can when using manual strobes. I also frequently use a LumiQuest diffusing baffle for softening the strobe's light.

FILM I carry lots of film, both black-and-white and color transparency. My film — sixteen rolls to a container — travels in Tupperware food storage boxes. Stripping away boxes and plastic film cans cuts weight and bulk by about 60 percent. (Plus you have the added benefit of attending a Tupperware party to buy the containers.) With the plastic film carriers removed, your camera bag can go quickly through airport X-ray machines. Hand check your film to avoid repeated exposure to X-rays.

FILTERS I carry ultra-violet (UV) filters, which cut down on haze for scenic shots and provide protection for the front element of my lenses. I also carry a neutral density filter (ND), which functions like gray sunglasses for the camera. On a sunny day, when I want to use a wide aperture, I attach this ND lens, which doesn't change the color of the light, just the quantity. Finally, I always carry a fluorescent-daylight (FLD) filter for shooting transparencies under fluorescent lighting.

BATTERIES Carry extras and buy them WHENEVER you shop.

NOTEBOOK & PENS Take notes on a napkin if you must, but I recommend a special notebook for the purpose. The longer I'm in this business, the more notes I take. I use a standard reporter's notebook or a large steno pad. Both fit nicely in the back pocket of my camera bag. I also carry caption sheets and shipping envelopes.

I carry two kinds of pens, fine-point Pilot markers for note-taking and indelible markers for labeling film cassettes. Take plenty of pens because they dry out or are lost frequently.

SPECIAL TOOLS Like many photographers, I fool around with gear a lot — improving and designing my own equipment. One of my own adaptations is a pair of pipe vice-grips connected to a Leitz ballhead. I use this hybrid clamp as a makeshift tripod, light stand, and I even used it once to secure a pair of jumper cables to a frozen rental car in western Nebraska.

Other favorite tools include the Leatherman survival tool, a kind of combination needle-nose pliers and Swiss Army knife. The pliers are the most-used option on this unit.

I even carry a make-up brush for dusting lenses and camera bodies. And I bring along a cable release so that I won't jiggle the camera during long exposures. The mini-mag flashlight in my bag runs on AA batteries and is waterproof to thirty feet. You'd be surprised how often you have to photograph in the dark, and the mini-mag produces enormous amounts of light for its size.

BAG I needed a sturdy bag that could carry everything except my 400mm lens. I've carried this Tamrac from Darwin to Adelaide shooting a solar car race in Australia. The bag has seen the natives of Tahiti, the mysterious statues of Easter Islands, the plains of Kansas, and it's still going.

IS IT MAGIC?

In the photo to the immediate right, Dizzy Gillespie, performing at the Monterey Jazz Festival, appears sharp as a tack with Kodak's "Magic" film rated at 1600. (Photo by Eric Risberg, *Associated Press.*) **At center, the photographer rated Kodak's T-Max 3200P film at its normal 3200 ISO to get this candid photo of an adoptive father holding his new son for the first time. (Photo by Eric Slomanson.) The arrest scene at far right was shot using Kodak's T-Max 3200P film "pushed" two stops — to an effective film speed of 12,800.** (Photo by Hal Wells, *Long Beach Press-Telegram.*)

RATED AT 1600

winning coach. Before autofocus, sports photographers used to prefocus the camera and then hold it high above their heads — pointing at the coach, firing, and hoping the focus was correct. This shot was called a "Hail Mary" — after the prayer many photographers offered when they took a picture in these less-than-ideal circumstances. With autofocus, the photographer can shoot a "Hail Mary" over the top of a crowd and have more assurance of getting a sharply focused picture of the winning coach.

For the photojournalist, selecting and framing the subject and precise timing form the key ingredients of picture taking. Setting exposure and focusing are mechanical necessities to achieve good pictures. Pressing the shutter just as the mayor grimaces or the boxer throws a punch determines the difference between a routine picture and one that tells a story. The more photojournalists can concentrate on what's in front of the camera and the less they have to fiddle with their equipment, the more telling photos they will produce.

ONE B&W FILM FOR MOST OCCASIONS

■ STANDARDIZING WITH ONE FILM

Most photojournalists working in black-and-white use one type of film to shoot the majority of their assignments.

With a versatile ISO 400 film, they can handle everything from an outdoor save-the-animals rally at noon to an indoor press conference. By standardizing on one film, the photojournalist avoids mistakes. More standardization means fewer errors when covering multiple assignments and meeting tight deadlines. Also, one film simplifies a camera bag. The photographer doesn't have to pack different emulsions for every event or change of weather. Also, with a relatively fast film, the photographer can flow from outdoors to indoors, sunlight to shade, without wasting time rewinding and changing to a different film.

Most cameras today have shutter speeds of 1/1000 sec., and many reach 1/8000 sec. Thus, the photographer can even use larger apertures outdoors while continuing to shoot with the same fast film.

■ SHOOTING IN LOW LIGHT
OVERRATING FILM

For low light, many photographers continue to use their standard film but adjust the film speed and the film's development time. This combination of overrating the film and adjusting development is often called "pushing" the film — something photographers do for several reasons.

First, poor light means that the photographer must set his or her lens at its widest aperture. Unfortunately, this narrows the depth of field and reduces the chances for a sharp picture.

Second, the photographer might have to turn his or her shutter dial to a slower speed to compensate for the low-light conditions — but again, this may blur the

RATED AT 3200

RATED AT 12,800

image in the final picture due to either camera or subject movement.

To get sharp pictures under minimal light conditions, such as a gym, you can overrate your film's ISO. This allows you to use a higher shutter speed and/or a smaller aperture.

For instance, Eric Risberg of the Associated Press was assigned to cover a match between the L.A. Lakers and the Golden State Warriors. He used Kodak Tri-X film, which is rated at ISO 400. At that speed, the exposure in the Oakland Coliseum would have been 1/125 sec. at f/2.8. To capture the moves of L.A.'s Magic Johnson, the AP photographer rated his ISO 400 film at 1600. He set his light meter accordingly and got a new metering of 1/500 sec. shutter speed at the same aperture.

"PUSH" PROCESSING

Simply giving the overrated film longer development in a standard developer, such as Kodak's D-76, is not satisfactory if the film was shot under normal or contrasty lighting conditions. The overdevelopment will only produce more contrast without a true gain in sensitivity. Overdevelopment will build up the highlight areas of the negative but will not provide more detail in the film's shadow areas.

True gain in sensitivity depends on an increase in the detail of the picture's darker areas. Overdeveloping the negative in a standard developer only works satisfactorily if the film was taken under flat lighting conditions such as a gray, overcast, or foggy day. It does not work for most other conditions.

To compensate in the darkroom for overrating the film on assignment, you should use high-energy developers. For normal and contrasty lighting conditions, high-energy developers such as Acufine, Diafine, Ethol's UFG, and Edwal's FG-7 with sodium sulfite specifically compensate for shadow detail. When you increase the normal ISO ratings, thereby underexposing the film, these special developers act more on the shadow area of the film than on the highlight, and consequently produce a negative with a fairly complete tonal range.

Every photographer who shoots black-and-white pictures in dingy gyms or poorly lit stadiums has settled on one or another of the high-energy developers. Many have found that an FG-7 and sodium sulfite combination gives excellent results for ISO 400 film rated at 1600. The manufacturer's directions call for increasing development times to 12 minutes at 70 degrees to build up shadow detail. You must also eliminate all agitation except at the halfway point to cut down on highlight blockage. Finally, the sodium sulfite part of the combination helps to keep down the base fog level for the extended development time. (See manufacturer's directions for more detail.)

Many photographers prefer Kodak's T-Max developer, which Kodak says works as both a normal and a "push" developer. With T-Max developer and T-Max film, experiment with different development times to produce the negatives you like best. But be very careful to control the temperature, agitation pattern, and time.

Regardless of which alchemist you listen to, you pay a price when you rate your black-and-white film

DEADLINE DESPERATIONS

Photojournalists on tight deadlines don't always have the perfect facilities for processing film and printing negatives. While at sea, this photographer had to use the ship's bathroom as a darkroom. (Photos by Chip Maury.)

above normal. That price is enlarged grain. Grain tends to become more pronounced and to clump at higher ratings. Although unattractive for display prints, enlarged grain rarely shows up in newspaper halftone reproduction. But because of the higher rating, you do get sharper pictures. These inflated ratings enable you to shoot sports or other action pictures — unencumbered by strobes, cords, batteries, and delayed recycle times — and still get sharp, motion-stopping pictures.

"MAGIC FILM"

For times when you need film speed, Kodak's T-Max P3200 comes to the rescue. Originally dubbed "Magic Film" by the photographers who tested it, the film can be shot at 1600, 3200, or even 6400 and beyond with excellent results. AP's Risberg shot Dizzy Gillespie at the Monterey Jazz Festival using the film rated at 1600. Eric Slomanson rated the film at 3200 to capture the expression of a wheelchair-bound father holding his adopted son for the first time. Other photographers are using the film under even more adverse conditions. (See examples on previous spread.)

Ilford has manufactured a fast black-and-white film with similar capabilities to Kodak's T-Max P3200. With the new films, photographers are shooting basketball games with longer, slower lenses; night football, without strobe, in poorly lit high school stadiums; and drug busts lit by street lamps and police car headlights.

■ DEVELOPING & PRINTING TO MEET A DEADLINE

Once your pictures of the train wreck or car accident are on film, you'll want to develop your negatives and make prints as quickly as possible. A delayed print could mean the photo won't reach the editor's desk on time and might miss the paper altogether.

Newspaper and wire service photographers use short-cuts to reduce the processing time of film and paper

in the darkroom. You can process at higher temperatures for shorter development times. You can fix just long enough for the film to clear, and you can cut wash time to a brief rinse. Use these short-cuts when you are on deadline; then, when you have free time, you can return to the darkroom and re-fix and re-wash the negative without any permanent damage to the film.

Sometimes, deadlines force photojournalists to print negatives while they are still wet — an undesirable procedure because the wet negative's soft emulsion is easy to scratch and readily attracts dust. Also, as the film dries in the enlarger's negative carrier, the emulsion tends to contract and buckle from the heat of the enlarging lamp. As the negative changes shape, it requires constant refocusing in the enlarger. With the glassless negative carrier of the Beseler and Omega enlargers, you can print a wet negative; but with the glass negative carrier of the Leitz enlarger, you must wait for the negative to dry.

When Chip Maury was a staffer for the Boston office of the Associated Press, he was assigned to photograph the start of the 200-mile fishing limit. He needed to transmit pictures while still at sea. Having spent twenty years as a photographer in the U.S. Navy, Maury was the perfect choice for the assignment. Aboard a Coast Guard cutter when it came time to process film, Maury was unfazed by the lack of a darkroom. He processed the film in a junior officer's bathroom, dried it in the shower stall, and washed the prints in the head. Now that's working under minimal conditions and still making the deadline.

When developing is speeded up, whether by machine or by hand, the photographer saves time but loses print quality. Speed processing tends to increase the apparent grain of the negative. In the end, though, a grainy photo that makes the deadline carries more value than a less grainy one that arrives at the editor's desk too late.

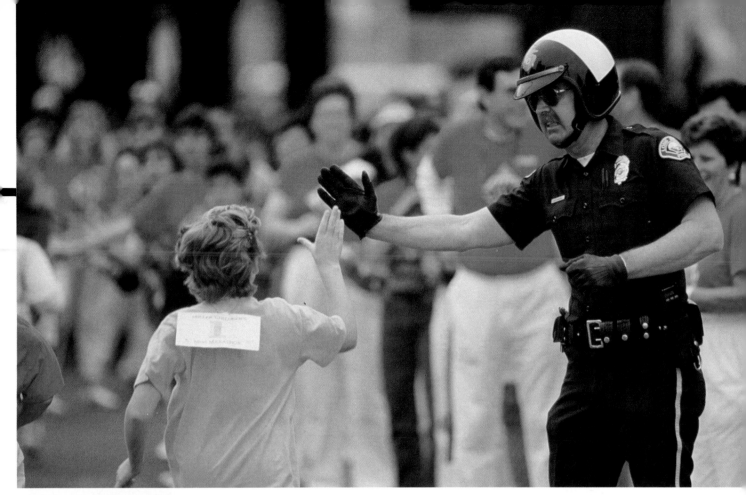

SHOOTING WITH COLOR FILM

■ HOW READERS REACT TO COLOR

Readers prefer color to black-and-white. That's what J. W. Click and G. H. Stempel found in their study of reader reaction to page design. This finding was supported in a follow-up study by the Poynter Institute Color Project, conducted by Drs. Mario Garcia and Robert Bohle.

Readers think color photos are more realistic. That's what an International Newspaper Advertising and Marketing Executives survey concluded. Not surprisingly, the researchers also discovered that readers dislike poor color reproduction.

Readers remember color better. That's what the Newspaper Advertising Bureau discovered in a test of recall as opposed to attention. Color ads were recalled more frequently than black-and-white ads. Readers, however, did remember black-and-white ads in greater detail and for a longer period of time.

■ TRANSPARENCIES VS. NEGATIVE FILM

As American newspapers have converted from black-and-white pictures to color during the '70s and '80s, a raging debate has gone on in darkrooms from Seattle, Washington, to Miami, Florida. The debate centers on two options — shooting with transparency film (also called color reversal, chrome, or slide film) or shooting on color negative film and then making color prints.

Chrome supporters point out that you can edit color transparencies as soon as they have been processed — no need for contact sheets and then enlargements like print film. For instance, when Hal Wells of the *Long Beach Press-Telegram* sped back to the office after shooting a footrace, all he needed to do was process his film, lay out the rolls, and select the most telling moment — a cop giving one of the participants the "high five." Unlike working with color negatives, Wells did not need to make contacts. His editors did not have to try and guess what the color would look like when it was printed. Wells' take on transparency film was easy to edit.

Negative film users respond that once you get used to looking at color negatives, you can read them as easily you can a black-and-white negative.

Chrome defenders note that most magazines today reproduce from transparencies almost exclusively. They argue that you get better reproduction from transparencies than prints. When working with transparencies, the engraver in the backshop is separating the actual film that was in the camera. When working with color prints, the engraver reproduces from a second-generation image. The color negative represents the first generation; the enlargement, the second.

However, photo expert Peter Krause, in a report to a National Geographic Society seminar that was later published as *The White Paper on Newspaper Color*, observed that "while color transparency images show a somewhat better overall color reproduction than color prints, this finding does not hold true with film speeds above 200."

In fact, color negative enthusiasts add that when

Most magazines and many newspapers use transparency film because of its rich quality and ease of editing. (Photo by Hal Wells, *Long Beach Press-Telegraph*.)

With his children, the inventor of an artificial fog machine (seated) now operates a company that sells and installs the machine for commercial purposes. For this portrait, taken in the company's warehouse, two banks of soft boxes lit the family, and two strobes covered with colored gels backlit the fog from the inventor's machine. (Photos by Ken Kobré for Sci-Tech Feature Service.)

separations are adjusted correctly, the engraving department can produce equally outstanding results working from either transparencies or prints. Unfortunately, few newspapers are set up to handle both formats.

Furthermore, many newspapers can now prepare photos for publication without making a color print. With a computer, the photo editor can scan a color negative into a computer, thereby avoiding the intermediate step of making a print. Eliminating this step assures greater sharpness for the final image in the paper, and saves time, as well.

Those who shoot color negatives point out that their film has a wide tolerance for under- and overexposure. Some color negative users claim that they can expose one to two stops under and up to three stops over the meter reading, depending on the film stock, and still produce an acceptable print in the darkroom. Unlike black-and-white or color negative film, if the photographer's exposure is more than a third of a stop off with transparency film, the final image will be washed out or muddy. (See pages 222–223.)

In addition, the different colors of different light sources affect the overall hue of the final pictures. Photos shot on color negative film can be corrected in the darkroom. With transparency film, what you see is what you get. All correcting must be done while shooting. Photographers using transparency film must go to great lengths to match film to light sources, filter out unwanted colors with gels, or shoot aided by strobes to achieve attractive, color-balanced photos. (See page 225 and 227.)

Since the engraver works directly from the transparency, the photographer has little opportunity to correct mistakes after the film has been shot. Color negatives allow for a lot more variation in lighting and exposure. In fast-breaking news situations when photojournalists have trouble producing perfect exposures on every frame, the inherent forgiving latitude of color print film might save the once-in-a-lifetime shot.

Both sides, consequently, agree that transparencies have one distinct disadvantage compared to negative film. This disadvantage, say many photographers, represents its major drawback for news work. Because of transparencies' narrow exposure latitude and problems with color balance, the photojournalist shooting with transparency film can no longer shoot quietly and unobserved from the corner of a room, using only available light and a few rolls of high-speed film. Today, the shooter with chrome in the camera often rolls into a shooting assignment with 100 pounds of lighting gear on a cart. After unpacking the lights, setting up the light stands, plugging in the power pack, putting together the soft box and umbrellas, test-firing the strobe, and exposing a Polaroid, the photographer turns to the subject and says, "Now let's have some candid shots."

Because of the need for correct color balance and adequate lighting, many street shooters prefer color print film. In general, they find they can handle it more or less like traditional black-and-white film without all the lighting and filtration hassle associated with transparencies. With color print film, the photographer can correct color imbalances in the darkroom.

Scott Henry of the *Marin Independent Journal* points out that at Candlestick Park, home of the San Francisco Giants, night baseball shot on transparency film requires filtration, which effectively reduces the film speed. He claims better results shooting with fast color

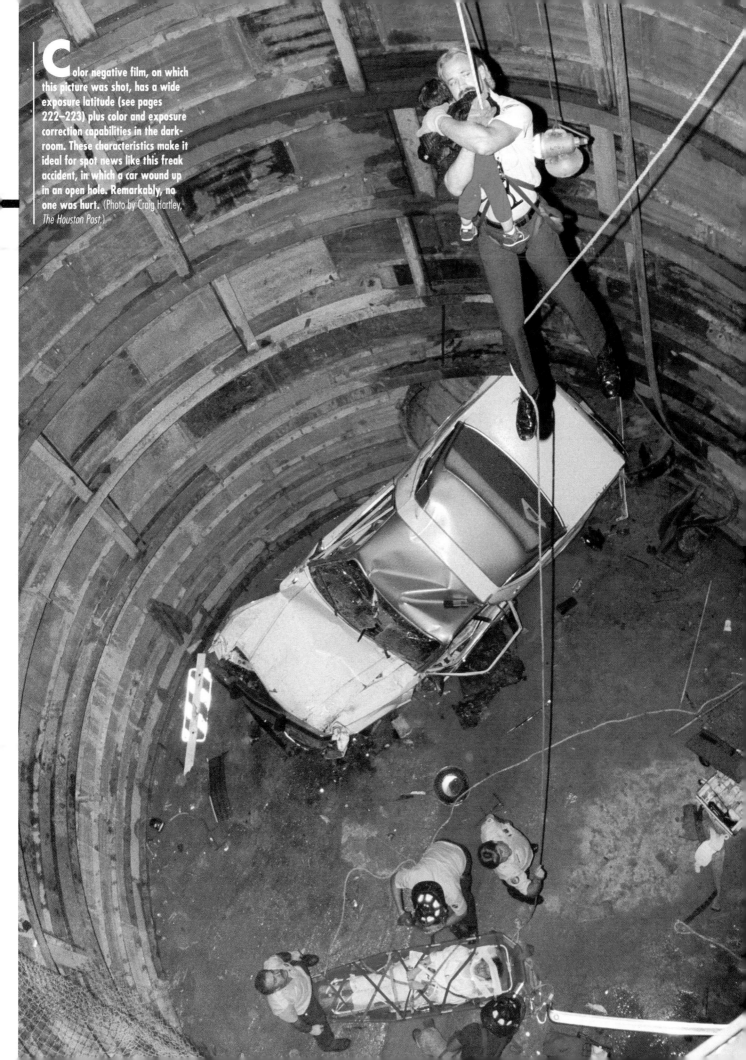

Color negative film, on which this picture was shot, has a wide exposure latitude (see pages 222–223) plus color and exposure correction capabilities in the darkroom. These characteristics make it ideal for spot news like this freak accident, in which a car wound up in an open hole. Remarkably, no one was hurt. (Photo by Craig Hartley, The Houston Post.)

SHOOTING A STORY WITH COLOR NEGATIVE FILM

Says Julie's boyfriend, Al, "I'm against everything, just about. It's all against me. What is there to be for?"

JULIE:
LIFESTYLE OF A PUNK

Donna Terek spent nine months "just hanging out" with punks — getting accepted into the group, looking for an appropriate angle, and convincing someone to reveal his or her lifestyle to the mainstream press.

Although she began the project for her master's thesis, Terek was a part-time staffer for the *Minneapolis Star-Tribune* by the time she started shooting Julie. After six weeks of actual shooting, Terek wrote the story herself for the paper's Sunday magazine because the punks felt they'd get a raw deal from anyone else.

Negative film allowed Terek to shoot candidly under changing light sources and lighting conditions. The only additional lighting she needed was on-camera bounce flash. These pictures are just a few from her extensive project. (Photos by Donna Terek, *Detroit News*.)

Of the tattoo on Julie's skull, her mother says, "The one redeeming feature is that her hair will cover it."

Julie's parents live in a ranch-style house. Both parents work day jobs, while Julie works a graveyard shift. The family eats dinner and watches a few hours of TV together.

Julie says she doesn't care "if I look good or not, just so long as I look cool. Something really off the wall, something nobody else does. That's cool."

COLOR NEGATIVE FILM VS. COLOR TRANSPARENCY: EXPOSURE TOLERANCE COMPARISON

▼ COLOR NEGATIVE CONTACT: exposures varied by one stop for each photograph

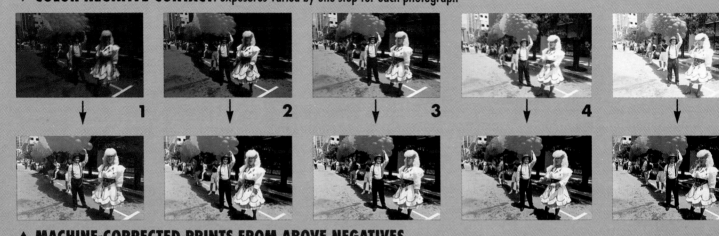

1 2 3 4

▲ MACHINE-CORRECTED PRINTS FROM ABOVE NEGATIVES

 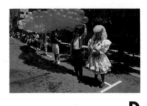 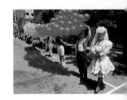

A B C D

▲ COLOR TRANSPARENCY FILM: exposures varied by one stop for each photograph

negative film rather than with transparency film. Toby Massey, assistant bureau chief in Washington for the Associated Press, recommends 400 ISO color negative film under most conditions, "pushing" the film when necessary. He prefers switching to an extremely fast negative film for really low lighting conditions. Photographers can also "push" some color negative film from 1600 to 3200 or even 6400 and still get good results.

Many newspapers that started with transparency film have since converted to color print film. More than a third of the papers in the nation that regularly run color use negative film, according to a survey by the National Press Photographers Association.

The Associated Press shoots all its assignments on color negative film. With the AP Leafax 35, wire service or newspaper photographers on assignment can transmit pictures without even making prints. The "Leaf," as photographers call it, allows photographers to develop film, insert the negative into the machine, and transmit a color photo to any AP receiver in the world.

TRANSPARENCIES: A PRIMER

■ CHOOSING THE RIGHT FILM

For transparency films, many photographers give Kodak's family of Kodachrome films (ISO 25, 64, and 200) the best rating for color and sharpness, but they find that the film is inconvenient to process. While many magazine photographers shoot exclusively with Kodachrome, few newspaper photographers have this luxury. To process Kodachrome, the lab must add color dyes at the time of development. This critical process takes expensive equipment ranging upwards of $1 million for the machinery alone. To maintain the tight tolerances Kodachrome requires, a lab needs a full-time chemist to monitor the operation. While a number of large cities have labs that offer 24-hour turnaround (or less) for Kodachrome pro-

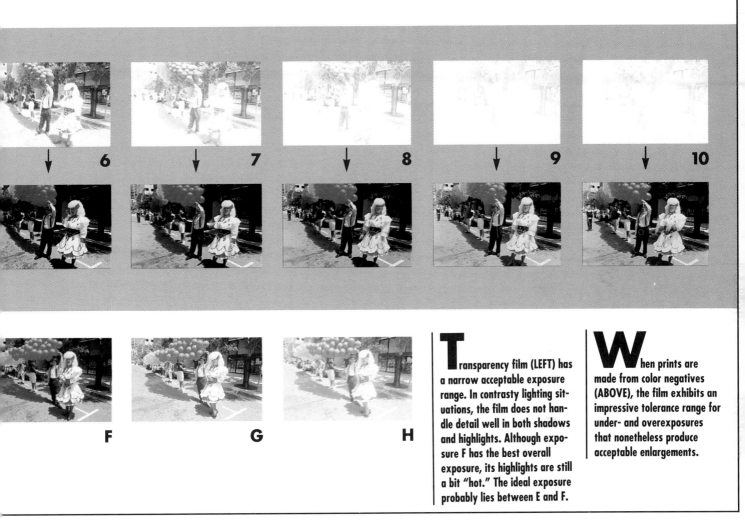

F G H

Transparency film (LEFT) has a narrow acceptable exposure range. In contrasty lighting situations, the film does not handle detail well in both shadows and highlights. Although exposure F has the best overall exposure, its highlights are still a bit "hot." The ideal exposure probably lies between E and F.

When prints are made from color negatives (ABOVE), the film exhibits an impressive tolerance range for under- and overexposures that nonetheless produce acceptable enlargements.

cessing, most newspapers need their film even faster.

Newspaper photographers usually select one of the color transparency films with color couplers built in. These films, which can be processed in less than thirty minutes using the E-6 process, come in a wide range of speeds. When possible, most photographers prefer to shoot with the slower films because the color looks richer, images look sharper, and grain is less noticeable.

Some photographers prefer to use fast film right out of the package for shooting in low-light conditions — like a baseball game in a domed stadium, or night football. Many, however, report better results "pushing" slower films — underexposing the film by one or two stops and then overdeveloping the film during the first step in processing.

Remember the old body builder' motto: "No pain, no gain." The same holds true when you "push" film. While you gain film speed, you'll be pained to see lower quality in your pictures. "Pushing" film increases contrast in highlights and middle tones while the density of the blacks gets thinner. Photo expert Peter Krause

observes that when you "push" color film, grain becomes more noticeable, and color balance shifts, as well.

■ HANDLING EXTREME BRIGHTNESS

Color transparency film has a low tolerance for contrast situations in which important subjects are located both in bright sunlight and in deep shadow.

At a midday parade, for example, a group holds a rainbow of balloons that shadow some of the group's members. One person, however, is backlit by bright sunlight. The trees in the background are in deep shade. Shooting this scene on color transparency film requires precise exposure. A half-stop over or under can wash out or dull down the final slide (see frames E and G, above).

Even when correctly exposed, color transparency film has a low tolerance for contrast situations in which important subjects are located in both bright sun and in deep shadow. When the photographer exposed for the deep shadow area that included the trees in the background, the highlights on the white dress completely

blew out (frames G and H). However, when the photographer exposed for the highlights on the dress, the trees in shadow went dark with no detail (frame E).

Because the scene's brightness is greater than the film range, no exposure in this situation is perfect. On the light table, however, frame F seemed the best compromise for this situation.

EXPOSE FOR THE HIGHLIGHTS

Still, some photographers, particularly those working for magazines, prefer slides a little richer and therefore regularly underexpose their film by a third of a stop. Other photographers stick with the film's ISO rating because they like their slides on the brighter side.

In general, when you have important parts of a scene both in sun and shade and have extreme brightness differences, your transparencies will look better if you expose for the lightest area important to the picture. With transparency film, overexposed highlights look terrible (frames G & H) but underexposed shadows look acceptable (frame F). With transparencies, "expose for the highlights" is the rule of thumb. Exposing for the highlights will produce a transparency in which the content of the shadows will be dark but still recognizable, while the overall transparency will be color-rich.

COMBINE STROBE WITH AVAILABLE LIGHT

During the middle of a sunny day, you might find that exposure alone will not compensate for harsh shadows. When shooting a head-and-shoulders portrait that includes the sky, you might find that the subject's face is partially in shadow. If you expose for the shadow area of the face, the blue sky will be washed out. If you expose for the most important highlights, the shadow area of the face might be too dark.

For subjects standing within fifteen or twenty

feet of the camera, photographers shooting on transparency film often fill in shadow detail with light from a portable strobe.

The technique, called fill flash, can provide enough light to open but not eliminate harsh shadows on the subject's face. It allows you to compress the brightness range of the scene to within the film's tolerance. Your final picture will still look natural.

Generally, for fill flash, you want the light from the strobe to be about one stop dimmer than the brightest important highlight in the picture area. With some camera-and-strobe combinations, you can accomplish this available light/flash ratio automatically.

For other cameras, you need to use a separate flash meter and vary either light output of the strobe or its distance from the subject to achieve this one- to one-and-a-half stop highlight-to-shadow ratio. (See Chapter 11, "Strobe.")

Sometimes, you may want the subject to be brighter than the background. Underexposing the background will cause it to come out with richer, more saturated colors. When I photographed a zookeeper for butterflies, I wanted the sky behind him to be a rich, saturated blue. I accomplished this by exposing the flash normally but slightly underexposing the sky.

■ MATCHING FILM TO LIGHT SOURCE

Ever notice that when you meet a friend for drinks by candlelight, the person seems to radiate a warm glow?

Transparency film has a limited brightness range. Unlike black-and-white film, overexposed transparency film cannot be corrected in the darkroom. Always expose for the highlights. (Photo by Ana Vanegas, *The* (Orange County) *Register.*)

Transparency film without fill flash (ABOVE) has trouble handling the brightness range from intense blue to dark shadows on the subject's face. By underexposing the sky and adding strobe, the richness of the sky's blue as well as the details of the scientist's face were recorded (LEFT). See page 252 for more on fill flash. (Photo by Ken Kobré, for Sci-Tech Feature Service.)

Walk outdoors, and you'll see that your friend loses that radiant, reddish color. The color on your friend's face was caused not by the liquor but by the candlelight's red wavelengths. The candle glowed red, with little green or blue light mixed in.

Almost every light source — whether a candle in a nightclub, a fluorescent tube in an office ceiling, or the sun outdoors casts a light that is not purely white but rather has a hint of color to it. The color cast of most light sources is not as pronounced as that of a candle, so you rarely observe radical color shifts when you move from one light source to another. After all, you know that a white shirt looks white, regardless of the kind of light illuminating it. Transparency film, however, does pick up these color changes.

Scientists measure the color of light emitted by a light source on a Kelvin scale. Color films are balanced either for daylight (5500 Kelvin) or tungsten light (3200 or 3400 Kelvin).

DAYLIGHT FILM
Noontime daylight contains relatively large amounts of blue wavelength light. Daylight-balanced color film is designed to filter out this excessive blue.

MATCHING FILM TO LIGHT SOURCE

	DAYLIGHT FILM	**TUNGSTEN FILM**
OUTSIDE		
	Daylight-balanced film used in daylight produces natural colors.	Tungsten film used in daylight produces a blue cast. Use a #83 amber filter to shoot tungsten film outdoors.
INSIDE		
	Daylight-balanced film used under tungsten light gives an orange cast to the picture. To shoot daylight film under tungsten light, use a #80 blue filter.	Tungsten film used with tungsten lights produces normal-looking color transparencies.

SHOOTING UNDER FLUORESCENT LIGHTS

AVAILABLE LIGHT, NO FILTER

This transparency was shot with existing light on daylight film, with no filtration on camera. Note the green overall hue to the photo.

AVAILABLE LIGHT, LENS FILTERED

Adding a 30 magenta color-correcting (CC) filter to the camera eliminated the green cast in the picture.

STROBE, NO FILTERS

Using a strobe, which emits light color-balanced for daylight film, gives a natural look to the subjects. The background, lit by the fluorescent hall lights, is still left with a greenish tint.

STROBE & LENS, FILTERED

Covering the strobe head with a window-green gel gives its light the same color as the fluorescent light. Now, adding a magenta filter to the camera lens eliminates all the green and leaves a natural overall color. (Photos by Sibylla Herbrich.)

Generally, use daylight film when most of the light comes from the sun.

TUNGSTEN FILM

Light from a common tungsten-filament light bulb (2900 Kelvin) or photo flood (3200 or 3400 Kelvin) contains an over-abundance of wavelengths in the red portion of the spectrum. Tungsten-balanced color film filters out this unwanted red cast and is designed for use with common light bulbs or 3200K photo floods. A few Type A color films are designed for use with 3400K photo lamps. In general, use tungsten film for available-light shots indoors when most of the light comes from light bulbs. These situations include theaters and some sports arenas.

MISMATCHED FILM AND LIGHT SOURCE

Shooting with a daylight-balanced film in a room lit by tungsten bulbs will give an orange hue to everything in the picture. Sometimes this effect looks odd. Other times, though, the orange hue gives a picture a warm glow. Using a tungsten-balanced film outdoors results in a blue cast to the photo. Except when used at night, this effect rarely looks natural or pleasing.

Use daylight film when lighting an indoor scene with electronic flash. Combining the strobe with a long shutter speed allowed the computer screen to become an integral part of this portrait of the first black owner of an IBM dealership. (Photo by Ken Kobré, for *San Francisco Business*.)

ELECTRONIC FLASH

An electronic flash emits a color approximating daylight. When you use electronic flash, shoot with daylight transparency film.

And because your electronic flash has a color balance similar to daylight, you can use your strobe as a fill light when taking pictures outdoors without affecting the final photo's overall color balance.

FLUORESCENT TUBES

Although most office buildings, hallways, classrooms, and other public spaces are lit with fluorescent tubes, no manufacturer makes a color transparency film specifically designed for use under fluorescent lights. When shot under fluorescent lights with daylight-balanced film, pictures come out with a decidedly green cast. Shooting under the same conditions with tungsten film washes the pictures with a strong blue tint.

To further complicate the situation, each type of fluorescent tube, whether it's warm white or cool white deluxe, puts out a slightly different color. The name says white, but the resulting color on your transparency film won't be.

Because most photographers don't want to scale ladders to verify the make of each fluorescent tube before shooting, they use a standard filter or filter pack to subtract unwanted tints. The standard filter or pack adequately subdues the green of fluorescent lights in most locations. Some photographers use an FL-D filter with daylight film. Many, however, have found a 30-magenta color-correcting (CC) filter used with daylight film works well for handling most fluorescent-lit situations. When using tungsten film, an FL-B filter should do the trick.

FLASH PLUS FLUORESCENT

Sometimes photographers shooting with daylight film need to combine strobe and available fluorescent light. (See above.) By placing a window-green gel over the strobe, both the light from the flash and the available light will have the same tint. Thus, the addition of a 30-

The time of day a subject is photographed — particularly a building — affects the mood of the final picture. The mood shifts from stark at noon **(NEAR RIGHT)** to rich in late afternoon **(FAR RIGHT).** (Photos by Ken Kobré.)

magenta CC filter in front of the camera's lens eliminates the green wavelengths from both the fluorescent lights and the green wavelengths from the filtered strobe, leaving correctly balanced light to reach the film. The resulting transparency will look perfectly normal.

COLOR CONSIDERATIONS

■ TIME OF DAY IS CRITICAL

Editors unaccustomed to color sometimes disregard the hour of the assignment when they set up a photographer's schedule. They ignore the angle and the color of the light. For an indoor job, timing might be less crucial, but for an outside assignment, timing is everything.

A painter picks oils from a palette to create mauves and maroons. Likewise, a photographer picks the time of day to capture the delicate pinks of the morning or the bold reds of the late afternoon.

By selecting one time of day over another, you can determine the color of light striking your subject when shooting outdoors.

From 5 A.M. to 5 P.M., color changes, intensity changes, and mood changes. A routine shot of a building taken at noon becomes an *Architectural Digest* photo at 6 P.M. A common mug shot photographed at 10 A.M. becomes a gallery portrait photographed at sunset. The selection of time to photograph is as important as the choice of lens or film.

DAWN

While you can't control when a peace demonstration or a car wreck will occur, you often can select the time of day for shooting an outdoor portrait or a building exterior. For soft shadows and monochrome colors, shoot at dawn.

MIDDAY

Some photographers try to avoid the harshness of the midday sun. Although colors might appear bright in transparencies or prints, people photographed on a sunny afternoon often have shadows running across their faces. These unflattering shadows can turn eye-sockets into billiard pockets.

When you must shoot portraits on a bright, clear afternoon, try 1) moving your subjects into the shade of a building or tree, or 2) turning your subjects so that their backs face the sun. Here is where you can use fill flash (see Chapter 11, "Strobe") to your advantage.

LATE AFTERNOON

Late afternoon light is the choice of many photojournalists working in color. As the sun falls lower in the sky, its rays travel farther through the atmosphere. Molecules of water in the sky tend to scatter the short, blue wavelengths of light. The long, red wavelengths pass freely

The early evening sky, just after sunset, offers a a warm afterglow for a background. To capture both the mime and the view outside her luxury hotel, it was necessary to balance the exposure of the electronic flash with that of the outside available light. See Chapter 11, "Strobe," for more on balancing strobe and available light. (Photo by Ken Kobré, for *San Francisco Business*.)

To show both the landing strip outside and the air controllers inside, the photographer waited until the waning afternoon light matched the exposure of the indoor light. Note also in this series of pictures how the color and quality of light changes as the time of day changes. (Photos by Ken Kobré, for *San Francisco Business*.)

toward earth. This is why, as the sun sets, late afternoon light turns redder and redder. Also, shadows stretch as the sun drops. The long, picturesque shadows lend a sculptured look to a scene. Greens and reds seem more saturated under this waning light.

Although the reddish light of late afternoon usually flatters a subject, you will occasionally need a more technically correct picture at this time of day. To reduce the excessive redness of late afternoon, you can use tungsten rather than daylight film if you are shooting transparencies. (A #81 filter would accomplish the same results but would result in loss of effective film speed.) Tungsten film will filter out many of the long wavelengths of light abundantly present in the late afternoon. The result: a more normal, color-balanced picture. If you are shooting negative film, you can correct with filters in the darkroom.

The conversion of a color transparency to black-and-white requires the extra step of making a black-and-white internegative (LEFT) and then a print. (Photo by Hal Wells, *Long Beach Press-Telegram*.)

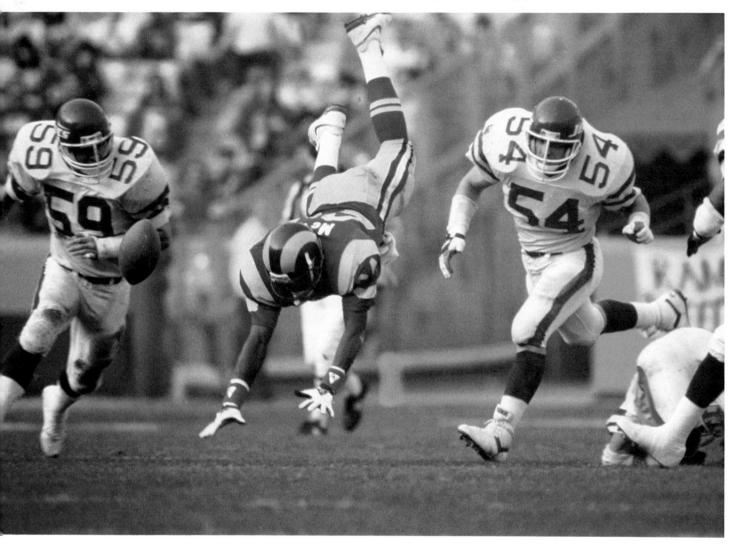

As sunset approaches, the sky takes on its most flamboyant corals and oranges. You can silhouette subjects against this richly colored background. If you want to avoid a silhouette but still use the sky's palette, try balancing your strobe with the early evening sky. In this situation, your strobe would become the dominant light source for the subject. The ratio of strobe light to the sky light would be equal. Many newspaper and magazine photographers shoot portraits and fashion using this balanced-light technique.

EVENING

Evening light is cold and blue. Sometimes streets and buildings that look as bland as white bread during the day look haunting by night. Don't overlook the possibility of flash to illuminate the foreground and a long shutter speed to pick up any ambient light in the back-

ground. Also, tungsten film used at night turns the nighttime sky a rich blue.

CONVERTING COLOR

While many papers today run all their photos in color, others have all assignments shot in color, which they convert to black-and-white if necessary. So photographers face the challenge of shooting pictures that might run in either color or black-and-white. Can you imagine Van Gough painting sunflowers without knowing whether his yellows would be seen as shades of gray? Or Ansel

Color in this picture carries a layer of information unavailable with black-and-white film. Color information is important for some photos, but not all. (Photo by Ken Kobré.)

Adams photographing "Moonrise over Hernandez" both ways — color and black-and-white — just in case? Yet that is what newspapers ask of photographers, who must visualize the scene simultaneously — with and without color. They try to take pictures that work both ways.

Some scenes, however, have strong light but monotone hues. Others are awash with vivid hues, but the light is flat and uninteresting. You can't convert every color photo to black-and-white and expect to get equally good images.

Photographers faced with this unsolvable problem usually choose to shoot for one medium or the other and hope that editors back at the office don't second-guess the decision.

COLOR FOR COLOR'S SAKE?

When the *St. Petersburg* (Fla.) *Times and Independent* began using color in the '60s, editors often would send a photographer to the beach to photograph a pretty woman with a brightly colored beach ball for the Monday morning color project.

Thane McIntosh, shooting for the *San Diego Union and Tribune* since 1960, says he thinks editors are still in the "comic book era" of picking bright colors. In an interview for the National Press Photographers Association's *White Paper on Color*, McIntosh observed, "Sure,

COLOR
VS.
BLACK-AND-WHITE

Over a two-year period, 690 Detroit youngsters were shot, and 74 died violently. Which set of pictures best shows the impact of this violence? Will color photos inform or repel the reader? *(Photos by Manny Crisostomo, Detroit Free Press.)*

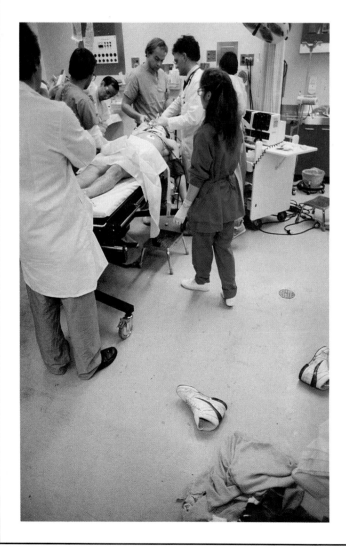

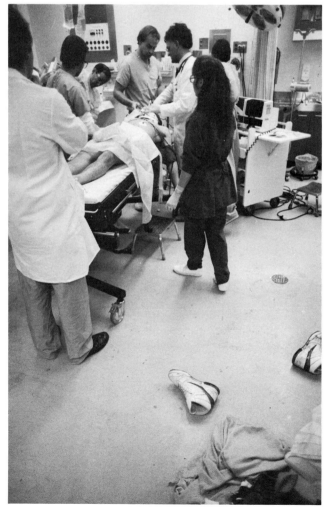

in the old days, you had to go for those bright colors, but I still hear editors picking pictures for color, not for content. And I find myself, when setting up pictures, adding color to make the scene more 'complete.'"

Barry Fitzsimmons, a thirteen-year staffer also with the *San Diego Union and Tribune,* recalls the old days: "For many years, color pictures were picked for bright colors. If it wasn't bright, they wouldn't use it." He remarked that photographers carried on location red sweaters, scarves, and jackets. They included these items of clothing in the pictures so that later the pressmen could match the reds when they adjusted the inks.

Today, Fitzsimmons says, "It's with news that editors and readers have a hard time with color. It shows the reality of the scene, while black-and-white covers it up. In black-and-white, blood can just blend in with the street. In color (the blood) jumps out, and the editors are left to deal with it more than ever before. Same goes for fires. In color they're unbelievable, but in black-and-white they're practically nonexistent."

While editors should not use photos just because they are as multihued as Joseph's coat, neither should they forget that color carries a great deal of information that would be lost on black-and-white film. Journalists are in the information business. Giving readers more information usually adds to their understanding of a story.

PROCESSING & PRINTING COLOR NEGATIVE FILMS

Many newspapers use a Wing-Lynch processor for developing color transparencies as well as color negative films. Once you have loaded the machine in total darkness, you can turn on the lights to develop the film. From first developer to final wash, each step is automatically timed. For "push" processing, you just need to increase the time for the first developing solution. After processing, dunk the film in a final stabilizer and then hang it to dry. For really huge volumes of film, news organizations like the Associated Press in Washington, D.C., have put in daylight-loading "mini labs" that can process film continuously.

With color negatives, the photographer can lighten and darken an area of the picture in the darkroom but not as much as with black-and-white prints. "Color is not as forgiving as black-and-white," says Sal Castanon of the *Houston Post,* who has been printing for fifteen years. "Too much dodging or burning changes the color cast in the area you are correcting."

Many newspaper labs have bought color analyzers to make color printing faster. An analyzer determines the time of the exposure and the filters needed for a natural-looking print. The analyzer helps to reduce the trial and error of the process. Finally, however, the photographer must evaluate the color print by eye to determine the correct color balance. Sandy Shriver, director of photography at the *Portland* (Maine) *Press-Herald,* points out that you must evaluate the color prints under a light source compatible with the newspaper's separator. Viewing the prints under typical fluorescent lights might throw off your color evaluation. ■

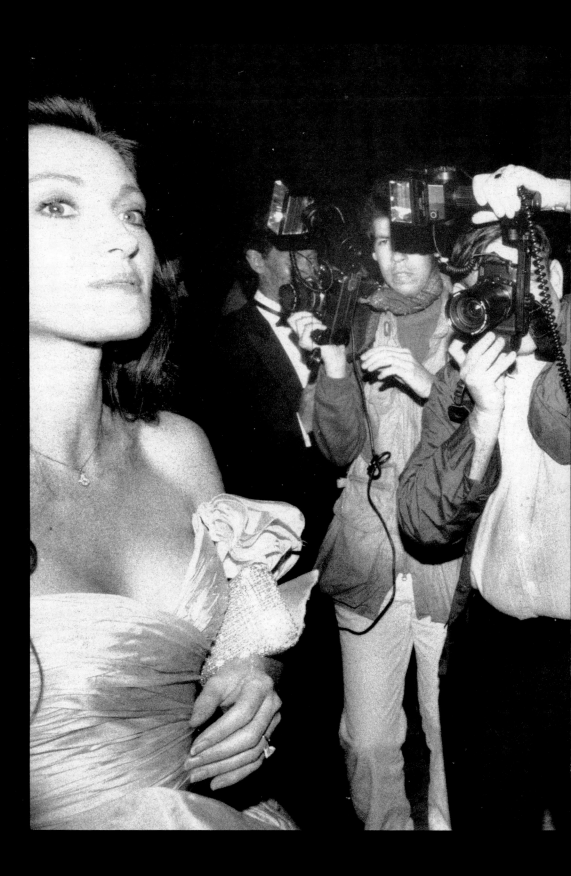

Strobe

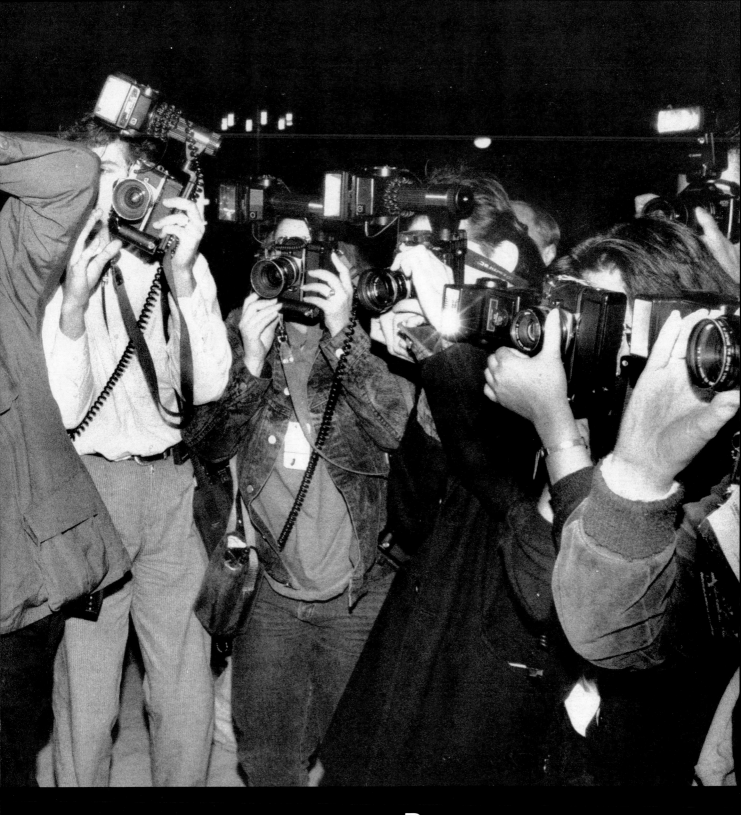

Photographers covering the Oscars use the strobe light's quick duration to catch the celebrities as they enter and leave the pavilion. (Photo by Deanne Fitzmaurice, *San Francisco Chronicle.*)

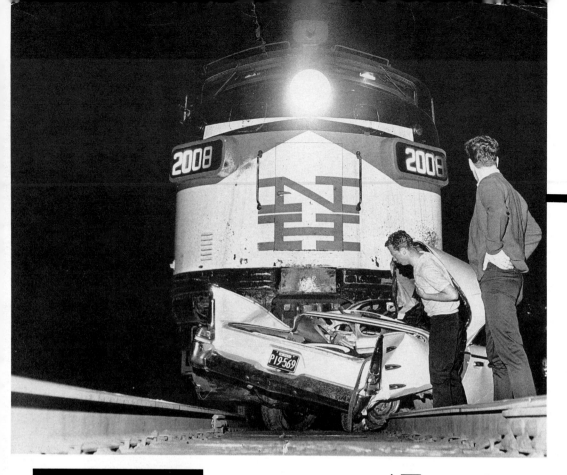

SUNSHINE AT YOUR FINGERTIPS

Originally, photographers were limited to picture-taking only when the sun was out. Not all news, however, happens in the light of day. From flash powder through flash bulbs to electronic flash, photojournalists have searched for a convenient light source that would enable them to take pictures under any circumstances. Today, possessing a compact strobe is similar to having a pocketful of sunshine at your fingertips.

In the '70s, manufacturers brought out miniaturized, lightweight, high-powered strobes. With a thyristor (energy-saving) circuit, the strobes used only the power they needed for a correctly exposed picture. With the advent of strobes with automatic exposure control, the number of over- or underexposed negatives were reduced. The photographer no longer had to estimate the flash-to-subject distance, then calculate the f/stop. The strobe's automatic eye, coupled with the unit's internal computer, released just enough light from the device to produce perfectly exposed pictures most of the time.

The next generation of electronic flashes was called "dedicated." The manufacturers designed each unit to work with — be dedicated to — one particular camera system. The strobe and camera work in tandem, both using the same information about film speed, shutter speed, lens length, and aperture.

With some dedicated flashes, the camera measures both available and strobe light directly through the lens (TTL). With a through-the-lens dedicated flash system, the camera can read the available light of a scene and automatically set the strobe to dominate the available light, equal it, or just provide a fill light, according to how

For spot news photography at night, a flash is almost mandatory equipment. (Photo by John Connolly, Boston Herald.)

the photographer has set the controls.

■ THE ELECTRONIC FLASH CONTROVERSY

Although designers have engineered a compact and convenient strobe, flash critics still point out that the strobe's light looks artificial in photos. These purists note that the strobe throws an unnatural black shadow behind the subject's body — producing pictures with the look of a police line-up. True: flash pictures can look stark. In the old days, photographers, who kept their flash guns mounted to the sides of their Speed Graphics, churned out these unnatural, stylized pictures.

The cause of harshly lit pictures does not lie with the flash but rather with the flash photographer. When the photographer uses techniques like bounce and multiple-flash, almost any lighting effect that occurs naturally can be created with the strobe. The light from a strobe, when used creatively, can give a photo the even feeling of fluorescent light, the dramatic effect of direct sunlight, or the moody flavor of window light. But when the flash photographer leaves the strobe on the camera and aimed straight ahead, the harsh effect is unavoidable.

Flash-haters argue one persuasive point, however. Initially, when a flash goes off, it does tend to draw

attention to the photographer. The burst of light can throw cold water on a hot discussion. However, just as a mayor becomes accustomed to being followed by a photographer clicking off pictures, most subjects will eventually pay little attention to the firing of the strobe.

Strobe supporters point out the advantages of a portable light source for the photojournalist. They note that a strobe can boost the overall quantity of light in a room, thereby enabling the photographer to set a smaller aperture for greater depth of field, which is needed, for instance, when shooting an overall picture of a meeting in progress. Also, the strobe light lasts for only a brief instant, usually 1/1000 of a second or less. The photographer, therefore, takes a picture at an effective speed of 1/1000 of a second, freezing both subject and camera movement.

As a photojournalist, you must weigh the strobe's advantages against its disadvantages. In many cir-cumstances, you would not be able to get any pictures without your strobe. In other situations, you can produce a technically improved or visually more interesting picture when you fire a portable light source. Patrick Downs

With the strobe in his left hand, the photographer reached under the arm of the person pouring the champagne and aimed the strobe so that light came from an unusual direction. (Photo by Tom Duncan, *The (Oakland, Calif.) Tribune.*)

of the *Los Angeles Times* photographed avant-garde musi-cian Zoogsz Rift poolside at the player's apartment build-ing. Using flash at night, combined with a slow shutter speed to pick up the ambient light from the pool, Downs created a picture unique because of the special properties of flash photography. (See page 238.)

Sometimes the strobe, especially in a sensitive situation such as a funeral, can be disruptive. Other times,

Balancing the strobe light with the light from the pool gave this new wave effect to the portrait of musician Zoogsz Rift. (Photo by Patrick Downs, *Los Angeles Times.*)

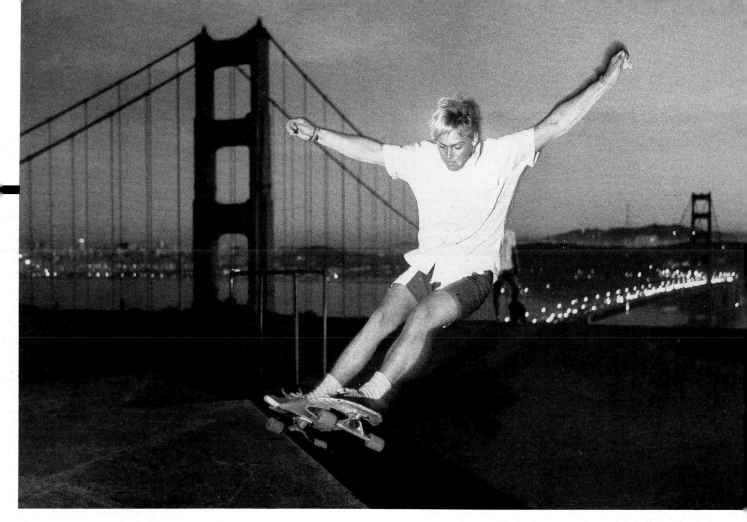

natural light can add more visual variation to pictures. However, few spot news photographers would leave their offices without their electronic flash equipment in their camera bags.

<div style="background:black;color:white">

SELECTING THE SHUTTER SPEED

</div>

■ STOPPING ACTION

The super short flash duration of the strobe appears to freeze a subject's movement, no matter how fast the person is running or jumping. The strobe freezes the gymnast as she leaps in mid-air, the motorcyclist as he bends into a turn, or the skateboarder as he appears to hang suspended in time.

In addition to stopping subject movement, because the light of the flash is almost instantaneous, you avoid blurry pictures caused by camera movement. Even if you are clicking pictures as you chase a city council member up the stairs of city hall, your pictures will come out sharp if you shoot with a strobe.

SYNC SPEED

Note, however, that a flash picture will not come out correctly if you set your shutter speed too fast. On some cameras, the upper limit is only 1/60 sec. Other cameras synchronize with the flash up to 1/250 sec. If you use too fast a shutter speed, only part of the image receives the strobe's light. Some camera/strobe systems prevent the operator from using an incorrect sync speed. Check your

camera instructions. (See demonstrations on page 240.)

■ COMBINING FLASH PLUS AVAILABLE LIGHT

Each camera model does have an upper limit sync shutter speed. However, selecting a slower shutter speed often results in a more natural-looking flash photo. Indoors or outdoors at dusk, many photographers use slower shutter speeds to pick up available light from the environment and combine this with light from the flash. While the electronic flash light captures a moving subject in mid-air, the available light from the longer shutter speed lightens the background. Because the shutter stays open longer than the flash duration, the photographer can adjust the shutter speed to let in more and more available light. Up to a point, the greater the amount of available light the photographer lets in by slowing the shutter speed, the brighter will be the background behind the subject (see demos on page 240).

Beware, however, that some dedicated flash-camera combinations allow for limited or no variance in setting the shutter speed. Again, check your manual.

Many professional photographers also like the effect combining strobe and a slow shutter speed has on moving subjects. Although the strobe freezes the subject's movement for one instant, the long exposure also captures the subject's continuing movement, adding a ghost-like blur. The result is a sharp image combined with the blur of motion (see demo on page 240).

When Tom Duncan photographed a boxer in a dimly lit gym, he stopped the boxer's punch, with a

At dusk, the short duration of the electronic strobe freezes the skateboarder in midflight. (Photo by Tom Duncan, *The* (Oakland, Calif.) *Tribune.*)

CONTROLLING BACKGROUND WITH SHUTTER SPEED

You can use the flash at any shutter speed at or below your camera's flash/sync speed. In these photos, the flash output remained constant. The flash was on manual. For flash pictures, the f/stop is determined by the amount of light emitted by the flash that reaches the subject. In this case, the photographer measured the amount of light with a strobe meter. The f/stop on the camera remained at f/5.6. With the camera on a tripod, the pho-

tographer simply varied the camera's shutter speed from 1/500 sec. to 1 sec. To demonstrate the full range of shutter speeds, the photographer shot at dusk. He also had the subject jump in every frame. Notice how changing the shutter speed influences the picture. The choice of shutter speed controls the amount of available light reaching the film. As the shutter speed slows, the background gets progressively lighter in each picture. (Photos by John Burgess.)

• **1/500 SEC.** You can see that most of the subject is dark. The focal plane shutter on this camera drops from top to bottom like a guillotine. The curtain on the shutter was about half open when the strobe fired.

• **1/250 SEC. (SYNC SPEED)** At this shutter speed, the shutter's curtain was completely open when the flash fired. This camera's sync speed is 1/250 sec. Note: some camera models sync with the strobe no higher than 1/125 sec. or 1/60 sec. The subject is correctly exposed, but the background is dark because at this exposure, the scene behind the subject is completely underexposed. Notice that the flash froze the subject in mid-air.

• **1/125 SEC.** The background lightens as the shutter speed lengthens. The subject remains frozen.

• **1/60 SEC.** The subject remains correctly exposed while the background gets yet lighter. By keeping the exposure on the subject constant and varying the shutter speed, you can control the background's brightness.

• **1/30 SEC.** Here, the subject "pops" out of the background, which is about two stops darker but still readable.

• **1/15 SEC.** The moving subject produces two images, the sharp one frozen by the electronic flash, the other blurring in the available light. The strobe's light lasts only a split second, thereby freezing the subject in mid-air, while the available light remains constant — lighting the subject's motion — throughout the entire exposure. The "ghosted" blur from the available light becomes noticeable only when the subject is moving. When the subject is stationary, the strobe and available light images exactly overlap.

• **1/8 SEC. (STROBE/AVAILABLE LIGHT BALANCE POINT FOR THIS LIGHTING SITUATION)** As the shutter stays open longer, the available light image (the ghost) gets stronger. Here, the flash and ghost images become equal. At the point of equality, the picture is said to be balanced for flash and for available light.

• **1/4 SEC.** As the shutter speed slows further, the available light begins to overpower both the background and the subject. The available light is washing out the flash picture.

• **1/2 SEC.** At this exposure, the available light further overpowers the light from the strobe. The subject's face is starting to disappear.

• **1 SEC.** The flash exposure leaves just the subject's legs and dress. The darker image is the subject's body after the jump.

strobe. So the gym wouldn't go black, he combined the strobe's light with ambient light, which he picked up by using a slow shutter speed. The combination of strobe and ambient light gives a sharp but natural-looking picture. The little bit of "ghosting" around the boxer adds to the feeling of movement and power in the picture.

DETERMINING APERTURE

Strobe manufacturers build their strobes in different ways, hence a brief check of your instruction book will indicate how to operate your particular unit. Some basic principles, however, do apply.

■ MANUAL

To determine the aperture, measure the distance from the flash to your subject, and then check the distance scale on your strobe. Watch out. Some dials are rated in both meters and feet. Also, be careful to set the dial or read the scale for the particular film speed you are using.

■ AUTOMATIC EYE

The automatic sensor works well as long as the subject is neither exceptionally dark nor exceptionally light. The sensor adjusts the strobe's light as if the subject were a neutral gray tone (18 percent gray).

The light meter in the camera and in the strobe function in similar ways. Both the strobe's sensor and the camera's light meter give correct readings most of the time because the average brightness of most subjects is equivalent to approximately 18 percent neutral gray. For the exceptionally light or dark subject, however, the photographer using a strobe with an automatic sensor must adjust the f/stop on the lens to compensate for incorrect

The strobe light stops the boxer's punch. A relatively slow shutter speed (1/15 sec.) lightens the dark gym. The ghosting highlights give the picture its dynamic feel. (Photo by Tom Duncan, *The* (Oakland, Calif.) *Tribune.*)

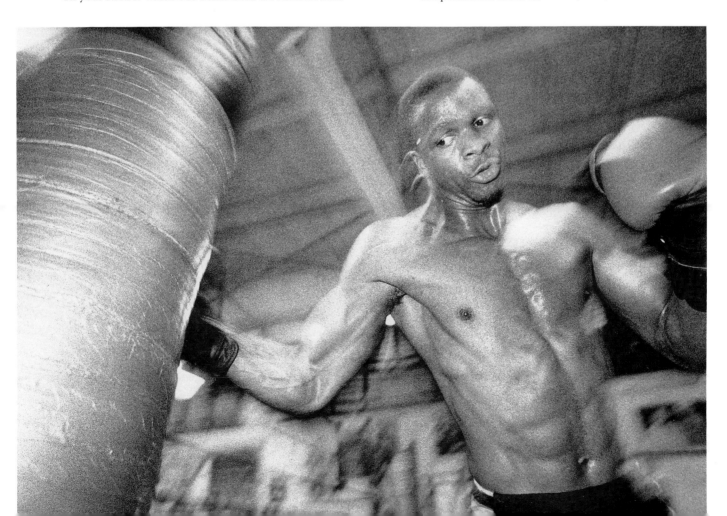

exposure information. The sensor on the strobe considers a small 5–10 percent angle of view in the center of the picture. The sensor eye is geared to read neutral gray correctly. If, for example, a subject is wearing jet black leotards while standing in front of a black brick wall, the sensor eye will be thrown off. To compensate, **close down** the lens' aperture one or two stops to avoid overexposed negatives. For a subject wearing wedding white, perhaps standing in front of a chalk-white chapel, the sensor eye will be misled once again. To compensate in this situation, **open up** one or two stops to avoid underexposed negatives. (See pages 210–211 for examples where the camera's automatic light meter is fooled. Similar situations would fool the strobe sensor.)

■ THROUGH THE LENS (TTL)

With some dedicated strobe/cameras, the flash sensor is located in the body of the camera. With this setup, the flash automatically is informed about the film's ISO. The photographer can select any aperture on the camera. When the flash fires, the light returns through the lens' aperture. When the internal sensor gets enough light, it will shut off the strobe. The photographer can use any f/stop on the camera because the sensor is located behind the lens. Also, because the sensor is in the camera and not in the strobe, the photographer can point the flash in any direction, and the sensor will record the amount of light that returns to the film.

■ HAND-HELD STROBE METER

Unlike standard light meters, strobe meters can measure the fantastically short burst of light emitted by a strobe. Often the meters are accurate to within one-tenth of an f/stop. Most strobe meters measure incident light — the light falling on the subject. Incident light meters have a white sphere that looks like a ping-pong ball cut in half. The photographer or assistant holds the meter about where the subject will be standing, pointing the meter back toward the camera. When the strobe is fired, the meter measures the light falling on the sphere — light that would have struck the subject. The meter indicates the correct f/stop for a particular film. Using a strobe meter works fine if the subject is a celebrity sitting for a portrait, but the measuring device proves more difficult to use if

To check the flash exposure, an assistant holds the incident strobe meter in front of the subject and points it back toward the camera.

the subject is a crook running down the courthouse steps. For fast-moving, slippery subjects, the internal sensor in the strobe or the through-the-lens sensor in the camera works best.

STROBE PROBLEMS TO WATCH OUT FOR

■ SHADOW ON THE WALL WITH DIRECT STROBE

The strobe mounted on the top or side of the camera produces a direct light aimed at the subject. At night, outside, or in a big gymnasium, direct strobe-on-camera works satisfactorily. Direct strobe on camera, however, creates a harsh shadow behind the subject in a normal-sized, white-walled room.

To get around the lurking black shadow problem, move the subject in front of a dark wall if possible. Now the black shadow created by the strobe will blend somewhat with the dark wall and be less prominent.

Or move the subject away from the wall. If you and the subject move away from the wall, keeping the same distance between the two of you, the subject will receive the same amount of light, but the wall behind will get less. Again, the wall will darken and the obtrusive shadow will merge with the darkened wall and disappear.

Direct strobe can result in harsh, dark shadows, particularly if the subject is near a white wall.

■ REFLECTIONS OFF GLASS

If you face someone wearing glasses to take a picture using strobe, often you will get an annoying bright reflection off the subject's lenses. To avoid reflections of polished metal, glass, or eyeglasses, keep the strobe at an angle to the reflective surface you are shooting.

■ UNEVEN LIGHTING

Sometimes you must photograph a group of people with direct strobe. Flash on camera may overexpose group

members nearest the light and underexpose those farthest from the light source. To avoid this problem, arrange the participants so they are approximately equidistant from the strobe light. When all the group's members are the same distance from the strobe, they will get the same amount of light and, therefore, be equally exposed.

■ INCOMPLETE COVERAGE AREA

Some strobes automatically adjust the area the light covers to match the lens on the camera. These units change the light pattern to coincide with the wide-angle or telephoto lens you might have on the camera.

Most strobes, however, are designed to light only the area of a 35mm to 50mm lens. When you use a wider lens on your camera, you need to spread the light out farther. For telephoto lenses, it helps to focus the light on a smaller area. Some strobes have an attachment that will spread the light so the scene will be evenly illuminated or focus the light so that it will be more efficient.

EVENLY LIGHTING YOUR SUBJECTS

With direct strobe, you can avoid bleaching out the nearest child and underexposing the farthest child by bringing all the birthday celebrants together at one table.

AVOIDING REFLECTIONS

To avoid reflections off highly polished metal, glass, or eyeglasses, keep the strobe at an angle to the reflective surface, in this situation, the eyeglasses. You can eliminate reflections by having subjects turn their heads or tip their glasses, or by moving the light source. (Photos by John Burgess, illustrations by Ben Barbante.)

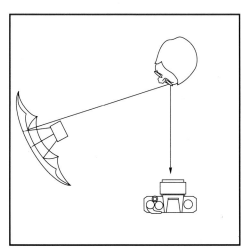

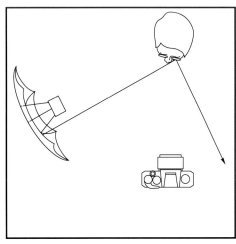

POSITIONING
THE STROBE

FRONT-LIGHTING.

When the main light is placed close to the lens, few shadows are visible. Forms seem flattened and textures are less pronounced.

HIGH 45° LIGHTING

With the main light high and to the side of the camera, about 45°, shadows model the face, creating a more rounded shape. This is often the main light position used in commercial portrait studios.

SIDE-LIGHTING.

A main light that is at about a 90° angle to the camera will light the subject brightly on one side and cast long shadows across the other side.

BACK-LIGHTING.

Here the light is moved almost to the back of the subject. If the light were directly behind the person, her entire face would fall into shadow.

TOP-LIGHTING.

The light directly overhead casting dark shadows into the eye sockets and under the nose and chin. Few portrait purchasers would pick this lighting arrangement.

BOTTOM-LIGHTING.

Lighting that comes from below looks distinctly odd in a portrait. This is because light on people outdoors or indoors almost never comes from below. This type of light casts unnatural shadows that often create a menacing effect.

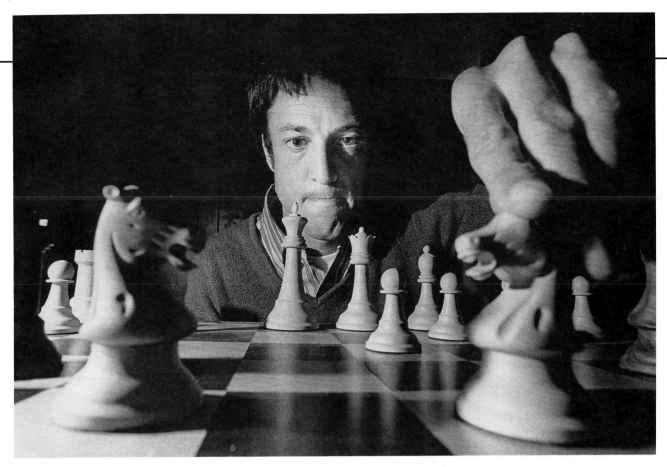

The photographer used sidelighting and a wide-angle lens to achieve a dramatic effect. (Photo by Ken Kobré for *The Boston Phoenix*, illustration by Ben Barbante.)

SIDELIGHT
FOR DRAMA

CREATING DIFFERENT EFFECTS

■ OFF-CAMERA LIGHTING FOR BOLD EFFECT

Sometimes lighting from the side with direct strobe can add drama to a picture. To achieve this effect, remove the flash from the top of the camera. Attach the flash to the camera with a PC extension cord or other remote triggering device (see page 255). Place the flash to the side of the subject. Moving the flash will dramatically change the picture's light.

On an assignment to photograph a young chess master playing in Boston, I found him practicing in a drably decorated, fluorescent-lit chess studio. I wanted the photograph to project the tension of the upcoming match. I decided to photograph the young player by placing a camera with a wide-angle lens on the playing board. With my left hand, I held out the strobe as far to the side as I could reach. The wide-angle lens, low vantage point, and side-lighting added punch to the picture that a straight, available-light portrait might have missed.

■ BOUNCE STROBE FOR SOFTER LIGHT

To avoid the harsh effects of direct strobe, a photographer can bounce the strobe's light off a room's ceiling, walls, or any other light-colored surface.

Bruce Chambers of the *Long Beach Press-Telegram* was covering an undercover police operation when the officers arrested a suspect inside a motel room. The room's curtains were drawn. The light was low. Direct flash would leave tell-tale harsh shadows.

For this picture, taken with bounce flash off the back wall, the photographer was located inside a motel room used for a sting operation. After this older man proposi-tioned the undercover policewoman on the street, she brought the "john" into the room, where police officers made the arrest. (Photo by Bruce Chambers, *Long Beach Press-Telegram*.)

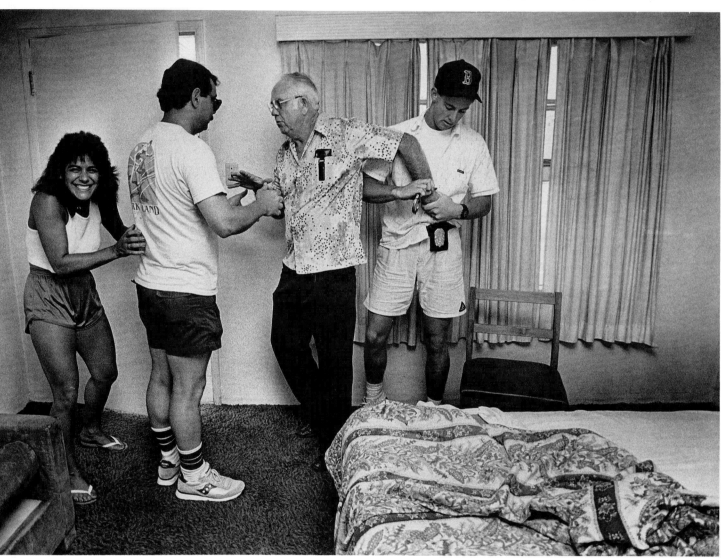

Instead, the photographer bounced the light off the back wall of the room.

When the light leaves the strobe, it comes out in a bundle of rays the size of the strobe face — about three inches in diameter, depending on the size of the flash. The rays spread out as they head toward the ceiling. By the time they reach a typical ceiling, the rays cover an area about ten feet across. Because the surface of the ceiling is rough, the rays bounce off it in all directions, evenly lighting a much larger area below and leaving few shadows.

Bounce light has at least two advantages over direct strobe. Bounce light eliminates unattractive shadows, and it helps light a group of people evenly, removing the danger of burning out those in front or letting those in back go dark.

Not only can you bounce light off the ceiling, but you can also bounce light off a wall, partition, or any other large, opaque object. Light bounced off the ceiling results in a soft, relatively shadowless effect similar to that produced by fluorescent bulbs found in ceilings of most modern buildings. Light bounced off a wall or partition gives a more directional effect, such as the light that comes from a window. The directional effect becomes more prominent the closer the subject and the flash are to the wall.

Many photographers attach a small white card behind and up about an inch from the top of the strobe head. This card picks up a little light when the strobe goes off and reflects this light into the subject's eye sockets. This reflected light from the white card avoids the raccoon look you can get with bounced light if you are standing near the subject.

HOW TO BOUNCE THE STROBE

To bounce most strobes, all you have to do is tilt the strobe head toward the ceiling or wall, then fire. To bounce off a portable photographic umbrella, you must attach a cord between the camera and strobe so that you can remove the flash from the camera. (Illustrations by Ben Barbante.)

THREE WAYS TO BOUNCE

CEILING

WALL

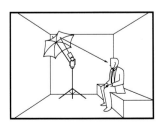
UMBRELLA

AIM ACCURATELY. . .

When you point the strobe, pick a spot on the wall or ceiling midway between yourself and the subject. Light leaving the strobe reflects from a surface such as the ceiling or wall at the same angle — but in the opposite direction — from which it came. In scientific terms, the angle of incidence of the light is equal to the angle of reflection. In less scientific terms, think of the strobe as a cue ball and the light as if it were a pool ball. You are going to bounce the light off a ceiling or wall as if it were a cushion on the pool table. You are going to bounce the light into a pocket, i.e., onto your subject.

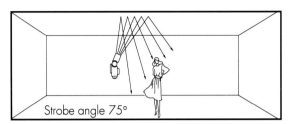
Strobe angle 75°

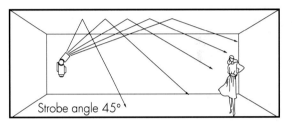
Strobe angle 45°

CORRECT

. . . OR PAY THE PRICE

One difference between a billiard ball and light is that light spreads out as it travels. So be careful not to point the head of the strobe too low, or some unwanted direct light from the strobe will hit the subject.

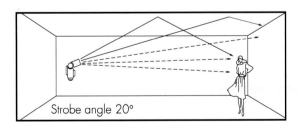
Strobe angle 20°

INCORRECT

While photographing a child lighting candles for Hanukkah, I could have taken the picture by the available light from the candles. I knew, however, that in the final print the candles in relation to the boy's face were so bright that they would wash out. The rest of the picture would fall into deep shadow. I opted, instead, to bounce a strobe's light off a nearby wall. The bounced strobe light looks like it comes from the candles. The effect leaves both the candles and the young boy in sharp relief.

When I photographed Claude Caux, leader of a Houston mime troupe, I wanted to place a highlight on one side of his face. I didn't, however, want the shadow side to loose all detail. Also, I wanted a gradual fall-off between the highlight and shadow of the face. Bouncing the flash off an umbrella satisfied these demands: the bounced light wrapped around the mime's face and allowed the highlights to blend into the shadows. (See more on umbrellas on page 250.)

■ FILL FLASH HANDLES HEAVY SHADOWS

At noon on a sunny day, the sun's harsh light can leave some subjects buried in shadow while others scorch in the sunlight. Shadowed eye sockets on faces turn into raccoon-like masks. Fill flash to the rescue. The light from the strobe opens the shadow areas of subjects within ten or fifteen feet of the strobe.

With fill flash, light from the strobe fills in the shadows without overpowering the highlights.

You will find fill flash particularly useful when

CAUTION
WITH
BOUNCE
FLASH

The light leaving the face of your strobe is spread over a much wider area when it reaches the bounce surface. When it strikes a ceiling, wall, or umbrella, the light is partly absorbed by the bounce surface. Finally, once reflected off that surface toward the subject, the light scatters in many directions. With bounce strobe, therefore, much less light reaches the subject than when you are using direct strobe. With bounce strobe, use caution:

• Save the bounce flash technique for medium to small rooms.
• In an auditorium or gymnasium, the ceilings are usually so far away that not enough light will return from the ceiling to light up your subject adequately.

• Bounce your strobe off a light-toned surface. A dark wall, for example, will absorb the light rather than reflect it back toward your subject.
• Small, cigarette pack-sized strobes don't put out enough power to produce an efficient bounce light in most rooms.
• With color film, don't bounce your strobe light off a pink, blue, or any other colored surface. The tint will color the strobe's light, giving the whole picture a color-cast that you may not like.
• When you bounce a strobe that has a sensor eye, make sure the eye remains pointed toward the subject. Don't try to bounce with a unit that has a sensor that points only at the bounce surface.
• When bouncing, always set the strobe for its widest automatic aperture.

Bounce works perfectly with a medium to large strobe, in a normal room, with eight- to ten-foot high white ceilings and a subject standing within three to twenty feet of the photographer.

With the strobe bounced off a wall outside the picture area, the light appears to come from the candles. Mimicking the available light with strobe increases overall illumination without losing the natural feel. (Photo by Ken Kobré, for *The Boston Phoenix*.)

TWO AND A HALF FEET FROM SUBJECT

SIX AND A HALF FEET FROM SUBJECT

ELEVEN FEET FROM SUBJECT

DISTANCE MAKES A DIFFERENCE

Whether the light is from an umbrella (like these examples) or from a soft box, the shadows it produces will be softer and less distinct when the source is near the subject, and sharper and more defined as the light source is moved away. (Photos by Ron Bingham.)

STROBE ACCESSORIES TO DIFFUSE LIGHT

When a wall or ceiling is not available for bouncing the strobe light, photographers use a number of other techniques and devices to soften the light and reduce shadows. Each device attempts to take the concentrated bundle of light coming from the strobe's face and broadens it before it heads toward the subject. The larger the effective light source, after it has been broadened, the softer will be the light that reaches the subject.

DIFFUSERS ON THE STROBE
Small devices placed over the strobe increase the effective light area some what. The **Omnidome** (TOP) works like a bare tube. It combines the characteristics of direct and bounce light simultaneously. The indirect light bouncing off the ceilings and walls helps to soften the direct light coming straight from the dome. The **Lumiquest Pocket Bouncer** (BOTTOM) enlarges the effective light source by reflecting light off the angled hood. In addition, the angled hood helps to scatter light so that the rays will bounce off nearby surfaces and further soften the light on the subject.

UMBRELLA
Because direct strobe light comes from a small light source, it produces a harsh effect on the subject. Light bounced off the ceiling is soft but produces somewhat featureless pictures. Many photographers use photographic umbrellas as alternatives.

The photographic umbrella is similar to a standard rain umbrella, only the inside is covered with a white or silver material, and the handle can easily be attached to a light stand. When the photographer aims the strobe into the center of the umbrella, out comes a soft white blanket of light that wraps around the subject.

Because the umbrella is on a light stand, the photographer can move it easily from side to side or up and down — allowing for total control of the light's direction. The nearer the photographer brings the light to the subject, the more the rays will encircle the person.

SOFT BOX
With a soft box, the photographer aims the strobe through the back of a lightweight cloth box that is held together with tension rods. The light spreads out through an inner diffuser panel of white fabric and then is further softened as it goes through the front panel, which is also made of translucent white fabric. The result is lighting similar to that of indirect light coming from a big picture window. This window, however, is portable. The soft box has a defined edge. The difference between the light bounced from an umbrella and through a soft box is that the box gives a define, controllable edge to the light source.

COMPARING STROBE ACCESSORIES

The harshest light comes from a camera-mounted strobe aimed at the subject. So photographers use a number of accessories to soften the light and reduce harsh, dark shadows behind the subject.

Generally, the larger the effective light source, the softer the light will be. The light from an 3'x4' *soft box* will produce softer light than the light from a 2"x3" *direct strobe.* When you *bounce* light off a ceiling, the effective light source becomes the wide spot on that ceiling. Photographic *umbrellas,* whether you are shooting through them or reflecting off them, also provide a relatively large light source, depending on their size.

Although smaller devices such as the *Omnidome* and *Lumiquest Pocket Bouncer* are not as effective as the larger light sources, many of the smaller items do work well indoors. In a light-colored room, some light rays bounce off the ceiling, walls, and floor. This extra scattered light helps soften the shadows when the devices are used within a small room.

However, outdoors or in a large ballroom or gymnasium, all the accessories work less well at softening shadows. The scattered light rays coming from the accessories have few surfaces to bounce off. Notice, in the outdoor series, that the shadow behind the model is darker in almost each situation. For these tests, the strobe was located nine feet from the subject. (Photos by John Burgess.)

DIRECT

NO CEILING OUTDOORS

BOUNCE

LUMIQUEST

OMNIDOME

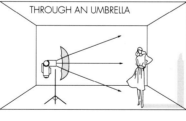

THROUGH AN UMBRELLA

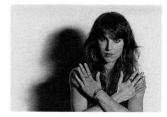

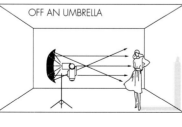

OFF AN UMBRELLA

THROUGH A SOFT BOX

(Illustrations by Ben Barbante)

FILL FLASH

You can use strobe outdoors on a bright day to help fill in deep shadows on a subject if the person is within ten or fifteen feet from the camera. Some of the dedicated/ flash combinations will allow the photographer to select the ratio of fill flash to available light. The camera and strobe do the rest automatically.

you shoot color transparencies, which can record hue and texture in either brightly lit areas or deeply shadowed ones, but not both at the same time. If important shadow areas meter more than one or two stops darker than highlight areas, adding fill light will probably improve your picture. (See above.)

POWERING THE STROBE

SHOE-MOUNT STROBES

Most shoe-mount strobes are powered by AA batteries. Alkaline-type batteries last the longest, but rechargeable Nicad batteries are cheaper over the long haul. Nicads also provide a consistent recycle time before they completely and suddenly lose their charges. Alkaline batteries, on the other hand, run down gradually, resulting in excessively long recycle times as they wear out. Note: always carry backup batteries. Nothing is more frustrating than waiting eons for dying batteries to recycle.

While both Alkaline and Nicad batteries designed for shoe-mounted strobes are convenient, neither provide enough electricity for more than a few rolls of 36-exposure film when the flash is used at full power. As Jon Falk says in his book *Adventures in Location Lighting*, "Throw away all whimpy AA and Nicad battery clusters." Many photojournalists who need power continuously over an extended time turn to external rechargeable batteries. You can recharge these external low- or high-voltage batteries repeatedly.

Some of these batteries fit on your belt, screw onto the bottom of the camera or attach with Velcro onto the strobe back. What they all have in common is their ability to provide 100 to 200 flashes at full power — with less than a four-second delay between complete strobe recharge. These external batteries have become a mandatory part of most working pros' flash kits.

MEDIUM-POWERED PORTABLES

The typical battery-powered strobe most photographers use has a maximum output of 50 watt-seconds of light. For slow transparency films, many photographers have turned to more powerful portable strobes that can generate anywhere from 200 to 1200 watts. While heavier and more costly, these strobes provide the needed light power for using umbrellas or soft boxes with slow films. With some of these medium-powered portable strobes, you can add on batteries for more power.

AC-POWERED STROBES

Using small portable strobes, you can't see the lighting effects until you have developed the film — hours or sometimes days later. With most AC powered strobes, a modeling light is built into the strobe head, allowing the photographer to see where the light will fall.

Manufacturers have built AC-powered strobes with tremendous light output — an important consideration when working with slow color films. Also, for large format-cameras like the 4"x5" or 8"x10" view camera, the photographer needs this quantity of light. Much of the photography taken in studios requires high-output power supplies. You can buy an AC-powered strobe with 500, 1000, 2400, 4800 or more watt-seconds of light. The AC-power units can drive two or more strobe heads at the same time.

Some newspaper and many magazine shooters regularly haul medium-sized AC units on assignment. These strobe units allow photographers to shoot color film at small apertures — and they also provide fast,

dependable recycling. High-wattage strobes with modeling lights allow photographers to light a room and see where all the shadows will fall.

While these strobes usually have more power than a portable strobe, they also require AC power and are consequently less convenient than their portable brethren. For shooting outdoors, for instance, photographers must remember to bring along either a long extension cord or a portable generator. However, the strobes' fast recycle times, practically unlimited number of flashes, and powerful light output make them ideal for multiple-light photography.

For a story about actors in a horror film, the photographer positioned one strobe at the feet of the couple in the foreground. A second strobe, hidden behind the tree and remotely triggered with an infrared slave eye (see page 255) signaled from the camera, lit the third actor for this just-past-dusk haunted house picture. (Photo by Keith Philpott for *People* magazine.)

PHOTOJOURNALISM GOES HOLLYWOOD

With the increasing use of color, photographers often are lighting scenes with several strobes. Fine-grain transparency film requires lots of light. And, as discussed earlier, transparency film cannot handle great brightness differences within a scene. Suppose you are taking pictures that include the corporate president inside his fifty-second floor office and the sun-drenched, spectacular view outside his window. Our eye has no trouble seeing both the wrinkles

on the president's face and the sparkling bay outside. But your film cannot handle this brightness range. You may need to set up several lights to bring the two worlds into brightness balance.

Sometimes, you may simply want more control of a scene than the light from one strobe can produce. You want to produce a special effect. Perhaps you seek to add a highlight to a person's hair, or you want to feature one member of a group more than the rest, or you want to use a light on either side of a dancer to emphasize the person's form.

Keith Philpott was assigned by *People* magazine

For this picture, the photographer positioned a soft box to the left of the subject and a reflector card to the right to fill in shadows. The exposure was chosen to balance the light on the subject with the available light outside. (Photo by Cindy Charles.)

USING MULTIPLE LIGHTS

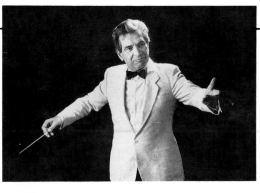

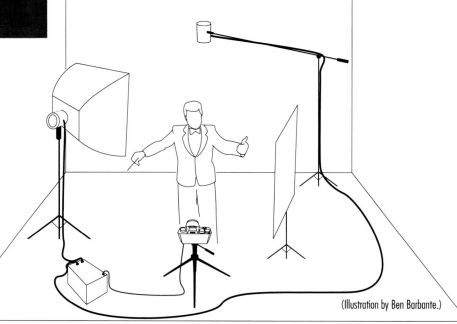

A soft box to the left of the conductor was the main light source in this picture. A fill card to the right bounced light from the main light source back toward the conductor and helped avert harsh shadows. A strobe on the end of a boom flooded the conductor's hair with light that helped separate him from the black background. The strobe heads were powered by a 1000-watt power pack. Each strobe head had a modeling light so the photographer could see where the shadows would fall. All lights fired simultaneously because they were hooked to one power supply. (Photo by Ken Kobré.)

(Illustration by Ben Barbante.)

to photograph the cast of a spooky movie. To get the horror-lighting effect he wanted, he placed one strobe below the actors' faces and a second light, remotely triggered, behind a tree to light up another actor. Taken at dusk to pick up some natural light, the picture had the desired scary look. (See previous page.)

To handle complicated photo situations, you might set up several strobes on light stands and fire all of them simultaneously. The camera's sync cord can be connected to a three-way plug, and cords from strobes can be attached to this plug. Then, when you trip the camera's shutter, all three strobes fire at once. With portable strobes, alternatively, you might use one of the cordless triggering devices. (See opposite page.)

■ WHERE TO PLACE THE LIGHTS
MULTILIGHT SET-UP

While you will find no two lighting situations identical, you often can use a basic lighting combination (see above) for shooting portraits: set up a main light and reflect it into an umbrella or through a soft box. Set the light about 45 degrees to one side of the camera. Bring the light as near as possible to the subject while still evenly lighting the person. You can use a large reflector card to bounce light into the shadow side of the subject's face. Finally, attach a second strobe to a boom, a weighted arm that extends over the subject's head. Locate the strobe above and behind the subject to provide a hair light.

LIGHTING A WHOLE ROOM

To light an entire room, you can set up several strobes around the room and bounce all of them off the ceiling or off umbrellas. Even if the room is not perfectly evenly lit — a common problem in this circumstance — you can

still shoot freely by taking a reading with your hand-held strobe meter at different parts of the room ahead of time. With predetermined exposure readings, you can leave the lights in one place, and as you move from one area to another, adjust the aperture for each section of the room. This technique of lighting and predetermining exposure allows you to shoot, in a relatively candid manner, with slow color film and multiple lights. ■

To light this computer room, the photographer arranged several umbrellas to give a soft, even light across a large area. (Photo by Cindy Charles.)

ELIMINATING PC EXTENSION CORDS

For the picture to the left, when the photographer tripped the shutter, a strobe mounted on top of the camera fired. In addition, a radio signal went out and fired a second strobe hooked to the receiver. The second strobe, which you can see at the edge of the frame, was held by an assistant. A radio slave was used to avoid cords between the two strobes and so that no other flashes in the vicinity would activate the second light.

LIGHT-ACTIVATED SLAVE

PHOTO SLAVES

To eliminate the need for a long cord running from each strobe, connect just one directly to the camera; fire the others remotely with "photo slaves." The photo slaves detect light from the primary strobe, which is attached to the camera, and, in turn, trigger the remote strobes. Because the speed of light is so fast, all the strobes, in effect, fire simultaneously. The photo slave reacts only to the onset of a strobe light and is not affected by room light. To function properly, however, the photo slaves must be close enough to and pointed directly at the main strobe light. Some, more sensitive photo slaves have a longer range and synchronize the remote strobe without being pointed precisely at the main trigger light.

 Watch out, though. The slave-eye can be tricked. If any other strobe or flash in the area goes off, the slave-eye will fire the remote strobes. So if you're shooting at a basketball game or a boxing match with two lights — one main and the other remotely fired — the second light might go off if someone in the audience pops off a Kodak Instamatic flash. Then you need to wait until both your units have recycled and are ready to fire before making your next exposure. Sometimes you can tape a tubular hood in front of the slave-eye to reduce the likelihood of a stray flash causing your remote strobe to fire.

RADIO-ACTIVATED SLAVE INFRARED-ACTIVATED SLAVE

(Illustrations by Ben Barbante.)

RADIO SLAVES & INFRARED SLAVES

You can fire your strobe remotely with a radio slave or an infrared slave. Each device has two parts — a sender box attached to the camera and a receiver box attached to the strobe. When activated, the sender unit emits an electronic signal (either radio or infrared) that sets off the receiver on the strobe. Consequently, the strobe fires at the same instant that the camera's shutter is opened even though strobe and camera are not connected by a cord. The flash can be held by an assistant or located on the other side of a room atop a light stand. When the shutter is released, the flash fires. Unlike photo slaves and infrared slaves, the radio slave is unaffected by other strobes firing in the area as long as no one else is using your radio frequency.

Electronics

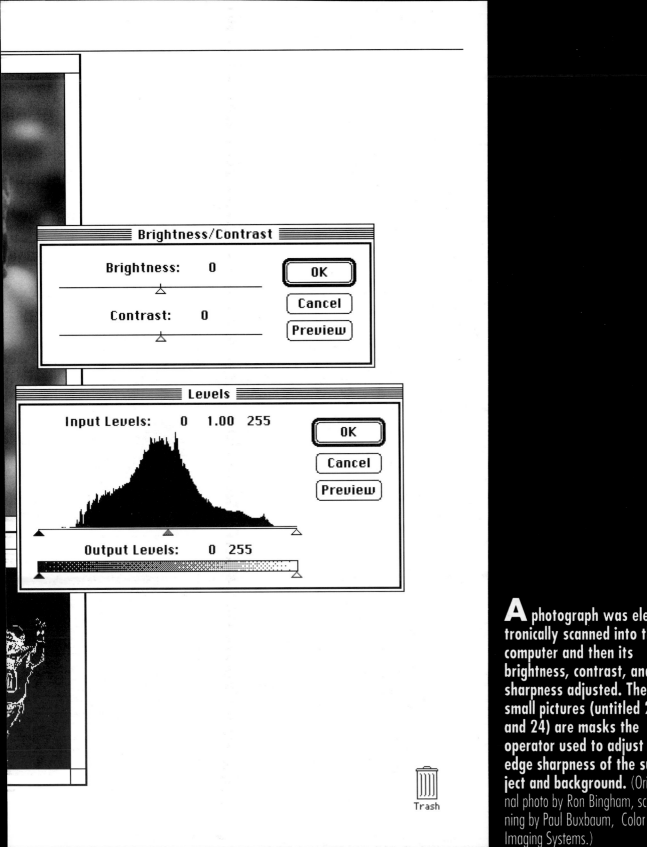

Brightness/Contrast

Brightness: 0

Contrast: 0

OK

Cancel

Preview

Levels

Input Levels: 0 1.00 255

OK

Cancel

Preview

Output Levels: 0 255

Trash

A photograph was electronically scanned into the computer and then its brightness, contrast, and sharpness adjusted. The small pictures (untitled 23 and 24) are masks the operator used to adjust edge sharpness of the subject and background. (Original photo by Ron Bingham, scanning by Paul Buxbaum, Color Imaging Systems.)

THE FUTURE IS NOW

If the black box looks like a camera, feels like a camera, and operates like a camera, it must be a camera.

Not necessarily. At least not a traditional camera.

Electronic still cameras don't use silver-based film. They take the picture on a tiny silicon chip and then store the image on a magnetically sensitized disk.

What does this mean for the photojournalist?

The photographer can shoot a picture, view it, and send it anywhere in the world — within seconds. A newspaper editor can receive the image, enter it into a computer, and then integrate it into a page design. Within a few minutes, from the time the photographer trips the shutter release, the presses can roll, printing a newspaper containing the shooter's four-column picture.

When the electronic still camera is perfected, a photographer will be able to shoot and transmit a picture without ever returning to the office or even making a print in a portable darkroom. No negatives, no prints, no chemicals, no smell. Even more important, no time lost between shooting a picture and making a deadline.

A photojournalist will be able to transmit a picture of a five-car pile-up that happened a block away from the newspaper office, or a riot taking place halfway around the world. All from a black box that looks and acts like a camera.

Manufacturers call this black box an electronic still camera. Basically, the electronic still camera acts like a television camera that takes one picture at a time.

SHOOTING WITH THE ELECTRONIC CAMERA

■ A NEW PRESIDENT IS SWORN IN

At high noon, the new president of the United States was to be sworn in. Associated Press staffers knew that afternoon papers in the Midwest would be going to press at almost the same time as the ceremony. Yet midwestern editors wanted a candid picture of George Bush the moment he raised his hand and recited the oath. Shot with traditional silver-based film and processed in the standard manner, the photograph would never make those papers' deadlines — even with the fastest techniques of film development.

Wire editors turned to the electronic still camera.

Washington-based AP staff photographer Ron Edmonds was assigned to shoot the inauguration with an electronic still camera, and Bob Daugherty was to shoot with standard color negative film. Edmonds shot from a

SHOOTING THE BUSH INAUGURATION

Ron Edmonds takes picture of Bush being sworn in.

Disk containing image is removed from camera.

Edmonds places the disk in the transmitter, reviews the pictures, selects one, and writes a caption for it.

Nikon Still Video Camera QV1000C as shown with the Nikkor 10–40mm f/1.4 lens and the Still Video Transmitter QV1010T. On the right, the Nikkor QV11–120mm lens.

side platform. Daugherty covered the ceremony from the center press riser. As the Chief Justice of the Supreme Court raised his hand and held the Bible for Bush, Edmonds focused the Nikon electronic still camera.

While it didn't have quite the feel of his old F3, he found the shutter speed, aperture, and focus basically the same as those on standard-issue cameras he was accustomed to. Edmonds had to focus on the president, take an exposure reading, and trip the shutter at the critical moment. The basic shooting skills of the trained photojournalist remained the same. The electronic camera had not altered the job of the photographer in the field.

But while shooting had remained the same, everything after the photojournalist pressed the shutter had changed.

THE CEREMONY

The day started out warm and bright, but as the ceremony began, a cold front blew through and brought in overcast skies. Because the electronic camera does not handle contrasty lighting well, the cloud cover was a blessing. The electronic camera tends to produce less-than-adequate pictures when the highlight and shadow areas differ too much or when the subject is backlit.

When Edmonds released the shutter on the electronic still camera and exposed the charge-coupled device, the electronic information from each cell was sent to a reusable "floppy disk" in the camera. The 2 1/4-inch disk, which looks like a square piece of plastic a bit thicker than three credit cards, works like a miniature video

recording tape. The magnetic area inside the disk electronically stores each image.

THE DISK

On the tiny disk, a standard format used by all the electronic still camera manufacturers, the AP wire photographer could record up to fifty pictures in a setting called "field mode." He knew, however, he would get twice the quality by using a setting called "frame mode" that records only twenty-five images per disk.

To assure a photo of the critical moment, the staffer could have used the electronic still camera's built-in motor drive to expose a sequence of one to four images per second. In fact, Edmonds shot about ten to fifteen images of the swearing-in ceremony.

LIGHT METER

The light meter in Edmonds' electronic camera operated like that in a standard camera. The electronic still camera has the approximate sensitivity of ISO 400 film. In low light, although you can't change to a more sensitive film, you can electronically increase the gain. The increased sensitivity, along with the use of fast, long lenses, means that from 100 yards, you can take sharp pictures of a night scene lit by weak street lamps and still be able to read the license plate on a car. At its highest gain, the camera has a sensitivity approximately equivalent to ISO 1600 film.

When Edmonds removed the tiny disk from the camera, he placed it in a portable electronic still transmitter that included a small black-and-white television.

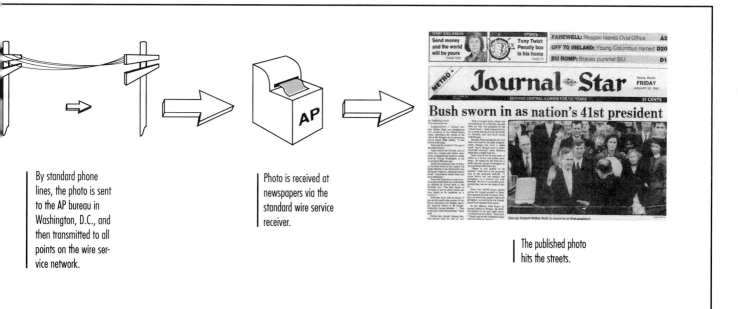

By standard phone lines, the photo is sent to the AP bureau in Washington, D.C., and then transmitted to all points on the wire service network.

Photo is received at newspapers via the standard wire service receiver.

The published photo hits the streets.

CCD

CHARGED-COUPLED DEVICE & DISK REPLACE FILM

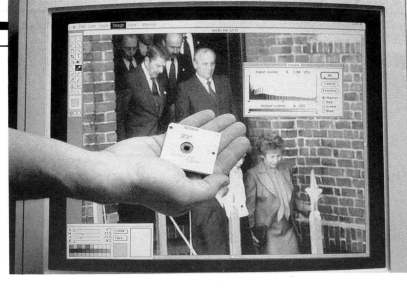

In place of silver-based film, the electronic still camera uses a charge-coupled device (CCD). The CCD is a plate covered with an array of receptor cells, each of which acts like a miniscule light meter measuring the brightness of one tiny part of a scene.

The more receptors available, the more precisely the camera can record the subject's image. Instead of the traditional measure of a film's sharpness by the size of silver grains in the film, the industry measures the electronic still camera's sharpness by the number of receptors in its CCD. Each receptor on the device is called a picture element (pixel or pel for short.)

With traditional film, the higher the ISO, the larger the grains of silver. Kodak's T-Max 3200P, for example, has larger silver grains than T-Max 100. In the electronic world, each cell on the device is the same size. For a crisper image, the device needs more cells. Early electronic cameras used 380,000 cells. More recent high-band models are using 600,000.

Kodak has developed an extremely expensive chip that can capture 4.2 million pixels (extremely small, individual pieces of the image). Because of the chip's prohibitive cost, however, it will be a while before the company puts it into commonly available cameras.

The information from the chip is stored on a small, magnetized disk that will hold twenty-five high-quality (frame mode) images. (Illustration by Ben Barbante.)

Each generation of cameras comes out with more cells compressed onto the receptor. Increased quality of the electronic still camera will depend on the continued improvement of the CCD. Experts estimate that to produce an image with the same resolution as an Ektachrome color transparency would require a CCD with 16 million cells.

Edmonds used the television to view the photos on the disk. After viewing each of the photos he shot, he selected the best image. However, he could not crop or enlarge his image on the screen. To go with his picture selection, he typed in an abbreviated caption of two or three words.

TRANSMITTING

Edmonds plugged his transmitter into a standard telephone, dialed the Washington AP office and sent the picture via normal phone lines back to the AP's office, where it was received by standard wire service equipment. At the office, the signal representing the photo was directed to AP's photo network and relayed to newspapers around the world.

From the time Edmonds took the disk from the camera to the time the picture was received by a paper in central Illinois, only fourteen minutes had elapsed. In Illinois, the *Journal Star's* editor grabbed the picture off the AP receiver, sized it, and included it in the one-star metro afternoon edition. By that afternoon, readers in central

Illinois along with those in Long Island, New York; Houston, Texas; and Seattle, Washington, saw an electronically generated picture of President Bush reciting his oath of office, an event that took place in Washington, D.C., at high noon Eastern Standard Time.

Says Jim Dooley, *Newsday's* director of photography, "We took the photo in on our electronic picture editing system, sharpened it electronically and output it, and it was as good as any wire footage you'd ever want to see."

Bob Daugherty's AP color picture, taken at the same time, was developed in a special trailer equipped with color negative processing equipment. The trailer was located a few hundred yards from the reviewing stand. Daugherty's color print was on the wires within twenty minutes after Edmonds' electronic photo. The first black-and-white image was received at least twenty-eight minutes after the event. However, those few minutes between transmission of the electronic picture and transmission of

Robert Hanashiro uses the Mavica electronic still camera on the West Coast to make East Coast color deadlines for *USA Today*. The paper is headquartered in Virginia.

Tom Levy of the *San Francisco Chronicle* has used the Nikon electronic camera, a battery-operated transmitter, and a cellular telephone to cover stories on deadline — no chemicals, electricity, or telephone lines.

COMPARISON OF TRADITIONAL & ELECTRONIC STILL CAMERA USING SAME LENS

TRADITIONAL CAMERA

ELECTRONIC STILL CAMERA

The design of the electronic still camera requires a smaller image size than that of a traditional 35mm film frame. Therefore:
• A standard 50mm f/1.4 lens from a traditional 35mm camera becomes the functional equivalent of a 200mm f/1.4 lens on an electronic camera.
• A standard 80–200mm f/2.8 zoom lens becomes the equivalent of a 320–800mm f/2.8 zoom.
(Illustration by Ben Barbante.)

the standard photo made the difference between making or missing deadlines for many newspapers.

■ ELECTRONIC CAMERA USE SPREADS
USA TODAY MAKES ITS COLOR DEADLINE

When Robert Hanashiro joined *USA Today* as the paper's West Coast shooter, he knew he would have to use the electronic still camera extensively. *USA Today's* 8:30 p.m. Eastern Standard Time deadline means all pictures from the West Coast must be shot and transmitted by 5:30 P.M.

Assigned to cover a major boxing match in color, Hanashiro was handed a Sony Mavica electronic still camera, ten diskettes, and told, "Shoot anything you like this afternoon. Try out the camera. Be ready by tomorrow."

By the following evening, Hanashiro was covering ring action using an 18-lb., 300mm f/2 lens on the Sony Mavica camera.

He attached the fast lens because the camera's sensitivity was equivalent to only ISO 100. The *USA Today* photographer found he had to shoot at 1/250 sec. under the lighting conditions in the arena.

Because of the camera's small image area, the

300mm f/2 Nikon lens became the equivalent of a 1200mm f/2 — a lot of lens to handle.

At first Hanashiro found the camera a bit cumbersome, but basically he had no trouble adapting to its different feel. He notes that while the camera functions well as long as the light is relatively flat, it does not produce a crisp image in deep shadows. He says the shadows produce a lot of "noise" — like the snow on a poorly receiving TV screen.

The *USA Today* staffer says that the electronic still camera is the right equipment choice "when you have a hard-core deadline and you have no other way to get a picture in the paper. That's when you can't beat the electronic still camera."

CELLULAR TELEPHONES FOR LATE-BREAKING STORIES

The *San Francisco Chronicle* uses a Nikon electronic camera, a transmitter, and a battery-operated cellular portable telephone to send pictures from the field to the office. The photographer needs neither a darkroom, electricity or telephone lines. The newspaper transmitted pictures from Candlestick Park when the '49ers football team beat the Rams to compete in the Super Bowl. The *Chronicle's* Steve Ringman shot the game's fourth quarter using

GLENN DICKEY

Playoff Perfect

| 49ers | 30 |
| Rams | 3 |

49ers Have an Easy Time Getting Back to Super Bowl

FIRST QUARTER: Joe Montana eluded a pass rush by Shawn Miller

FOURTH QUARTER: Tight end Jamie Williams (left) hugged tackle Harris Barton after they realized late in the game that they were headed for the Super Bowl

Chronicle Photos by Steve Ringman, Frederic Larson and Brant Ward

FIRST QUARTER: Roger Craig looked downfield on his way to a long run

the electronic still camera. He captured the crucial jubilation picture late in the game when the team realized they had won. Within minutes of taking the shot, Ringman was at his car in the parking lot — transmitting the picture back to the office for a 5:30 p.m. deadline. Fighting the traffic out of the stadium and on the highway would have delayed the picture by at least another hour.

With an electronic still camera, monitor, transmitter, and cellular telephone, the photojournalist could eventually send a picture from the site of a burning building or from the top of a remote mountain to anyplace in the world where there is a telephone and a receiver as long as the cellular signal can be received.

NEWS JUDGMENT REMAINS CRITICAL

While electronic still cameras may someday eliminate traditional film processing and printing, they will never alter the basic news-gathering skills of the photojournalist. These skills remain constant, whether the photographer uses silver-based film or electronic circuitry. News judgment still remains the key resource of the photojournalist. No camera can determine what makes a great picture. Nor can any camera assess visual values such as light and composition. And, of course, electronic gadgetry has not replaced timing. The electronic still camera is no substitute for the photographer's eye-and-hand coordination. Being at the right place at the right time remains the basic ingredient of the profession for capturing important news pictures, regardless of the type of camera that exposed the image. For the working pro, these skills will not go out of style as electronic still cameras become pervasive in the industry.

ELECTRONIC DARKROOMS ELIMINATE CHEMICALS

■ COMPUTER CHIPS REPLACE DIP AND DUNK

Today's computers can perform many of the functions handled by a traditional darkroom. In fact, the AP calls its computer and software program an electronic darkroom.

Eventually, the silicon computer chip will compete head-on with the traditional liquid-and-silver darkroom. From desktop micro computers like those found in millions of homes and businesses to the mini- and mainframes used by the wire services and large publications, editors are using computers to scan, store, crop, size, and even manipulate photos.

Not only can computers lighten or darken a picture, they can even change its color balance. Computers can change the size of a picture and even sharpen it if it is out of focus. With computers, editors can dodge

or burn a segment of the picture, or clone one part of the picture, reproducing it exactly and placing it in another location.

SCANNING THE PICTURE

Digital imaging technology, developed by NASA in the '60s to enhance images transmitted to earth from satellites such as *Voyager,* has moved into the commercial marketplace. Companies such as Scitex, Crosfield, and Hell produce high-end systems that cost between $750,000 and several million dollars.

While large magazines like *Time* and newspapers like the *Orange County Register* and the *St. Petersburg Times* have purchased the high-end machines, the technology is not limited to large companies any longer. With lower costs for memory chips and the advent of new software programs, desktop computers like Apple's Macintosh® and scanners like the Barneyscan and the Nikon scanner can achieve results similar to those of the high-end equipment. Soon, anyone with a home computer and scanner will be able to manipulate images electronically.

All computers handle photographs in the same basic way. First, an operator scans in the picture. The color and brightness of each tiny section of the picture is transformed into electronic information — hundreds of thousands of tiny dots, known as picture elements or pixels. A typical 8"x10" color photo contains 618,744 pixels, each of which is turned into a number representing properties such as color and brightness. An individual picture might require up to 65 million bits of data to capture the original image precisely. One high-resolution picture can

Steve Ringman of the *San Francisco Chronicle* shot the jubilation picture of the '49ers beating the Rams for their spot in the Super Bowl. He used a Nikon electronic still camera and transmitted the photo by cellular telephone from the hood of his car to make the paper's early deadline. (Courtesy of the *San Francisco Chronicle* ©.)

The *San Francisco Examiner's* Chris Gulcker edits a color picture of Gorbachev. These computers and monitors have replaced the need for color printing at the paper. The equipment can handle a picture taken with the electronic still camera or with conventional color negative film.

require as much digital information as would be contained in a week's worth of text from a daily newspaper, explains Dave Cole, who is a consultant in the field.

The picture can start out as a color transparency, or as a color or black-and-white negative or print. Or the computer can directly receive the image from a video or electronic still camera. If the computer looks at small enough points — if the resolution is fine enough — and the computer has a wide enough brightness range and color wheel to draw from, it can reproduce in its memory an accurate representation of the original picture.

At newspapers such as the *San Francisco Examiner,* photographers are shooting almost all their assignments on color negative film using traditional 35mm cameras. Then, without walking into a darkroom, they feed their film into a processing machine called a daylight mini-lab. Within twelve minutes, the film comes out as dry negatives. Next, the photographers themselves electronically scan the color negatives into their Macintosh® computers.

■ HOW COMPUTERS HANDLE PICTURES

Inside the computer the picture is represented by numbers — digital numbers — something the computer loves.

Here is how it works. Do you remember paint-by-numbers canvases from your childhood? So that you could paint a picture of the Eiffel Tower, the canvas would indicate a specific number for each color of paint. When a segment of the picture needed a blue sky, the canvas would call for a number five (blue). When a sec-

tion of the tower needed to be red, the canvas would call for a number two (red). On the original canvas, the area representing the sky was covered with number fives, and the Eiffel Tower itself was filled with number twos. All you had to do was match the paint color on the little jar with the number printed on the canvas. Even if you didn't know what the canvas was supposed to show, you would eventually produce a painting of the Eiffel Tower if you painted in all the numbers correctly.

Now, imagine a paint-by-numbers canvas in which sections are of equal size but smaller than the head of a pin. Each section is called a pixel. Then imagine if, instead of just a few paints, your canvas called for colors in millions of different shades, levels of brightness, and saturations. Now you can understand what the computer is constructing when it looks at a picture and turns it into numbers. Experts call the process scanning and digitizing a picture.

Once the computer has received the scanned and digitized image, it can show the picture on a video monitor, which the computer treats like a paint-by-number canvas and similarly fills in each place or pixel on the screen with a color and brightness. The viewer then sees the original transparency or print transformed into a high-resolution video image.

MANIPULATING THE NUMBERS

While the picture is still in the computer and projected on the monitor, the operator can perform all kinds of manipulations with the numbers — for instance, changing all the numbers that represent red to numbers that represent green. The operator can tell the computer to find all the number fives (red) and change them to number sevens (green) — transforming an American flag from red, white, and blue to green, white, and blue.

Since everything in the picture is described by a set of numbers, the computer can easily copy those numbers — allowing the computer to precisely replicate a part of the picture and reproduce that part of the image somewhere else. This technique is called cloning.

Because the computer is reproducing a set of numbers, it can copy them with perfect accuracy. For example, in a picture that shows two boys who have just wrestled in the mud (see following page), the computer copied the numbers that represent the body of the boy on the left and copied the numbers that represent the face of the boy on the right.

And because the computer can reproduce those numbers anywhere else in the picture, it was possible to combine elements of the two boys to construct a third child who was never there. The computer-born child could have the muddy torso of one child with the muddy face of the other child. The combinations and permutations of body parts are almost unlimited when the equipment is in the hands of a skilled operator.

PLAYING THE NUMBERS

The original photo was taken by Peter Souza. The manipulated photo (BOTTOM) was specifically produced for this book.

Besides generating the third boy constructed of parts taken from the first two, the computer operator, John F. Brown, was able to increase the background above the subject's heads as well as the area on the right of the photo.

How many other changes from the original can you find? Hint: check arms, hands, feet, and hay.

Would you have realized the right-hand child was constructed using the computer if you had not seen the original?

This image manipulation was performed on the Crosfield 646 IM Laser Scanner and the Crosfield 880 Studio System. As desktop scanners and computers become more powerful, their output should approach the quality of this high-end equipment.

(Original photo by Peter Souza. Image manipulation courtesy of Kedie/Orent, Inc., Sunnyvale, Calif.)

ELIMINATING PC EXTENSION CORDS

For the picture to the left, when the photographer tripped the shutter, a strobe mounted on top of the camera fired. In addition, a radio signal went out and fired a second strobe hooked to the receiver. The second strobe, which you can see at the edge of the frame, was held by an assistant. A radio slave was used to avoid cords between the two strobes and so that no other flashes in the vicinity would activate the second light.

PHOTO SLAVES
To eliminate the need for a long cord running from each strobe, connect just one directly to the camera; fire the others remotely with "photo slaves." The photo slaves detect light from the primary strobe, which is attached to the camera, and, in turn, trigger the remote strobes. Because the speed of light is so fast, all the strobes, in effect, fire simultaneously. The photo slave reacts only to the onset of a strobe light and is not affected by room light. To function properly, however, the photo slaves must be close enough to and pointed directly at the main strobe light. Some, more sensitive photo slaves have a longer range and synchronize the remote strobe without being pointed precisely at the main trigger light.

Watch out, though. The slave-eye can be tricked. If any other strobe or flash in the area goes off, the slave-eye will fire the remote strobes. So if you're shooting at a basketball game or a boxing match with two lights — one main and the other remotely fired — the second light might go off if someone in the audience pops off a Kodak Instamatic flash. Then you need to wait until both your units have recycled and are ready to fire before making your next exposure. Sometimes you can tape a tubular hood in front of the slave-eye to reduce the likelihood of a stray flash causing your remote strobe to fire.

RADIO SLAVES & INFRARED SLAVES
You can fire your strobe remotely with a radio slave or an infrared slave. Each device has two parts — a sender box attached to the camera and a receiver box attached to the strobe. When activated, the sender unit emits an electronic signal (either radio or infrared) that sets off the receiver on the strobe. Consequently, the strobe fires at the same instant that the camera's shutter is opened even though strobe and camera are not connected by a cord. The flash can be held by an assistant or located on the other side of a room atop a light stand. When the shutter is released, the flash fires. Unlike photo slaves and infrared slaves, the radio slave is unaffected by other strobes firing in the area as long as no one else is using your radio frequency.

LIGHT-ACTIVATED SLAVE

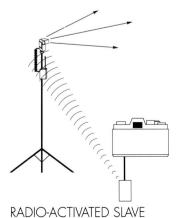

RADIO-ACTIVATED SLAVE

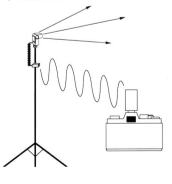

INFRARED-ACTIVATED SLAVE

(Illustrations by Ben Barbante.)

Electronics

VOICES FOR AN AGE

FOUR GRADUATES DISCUSS THEIR FRIENDS, THEIR FEARS AND THEIR FUTURE

Computer-assembled photographic illustration/Mitch Toll

Likewise, when an area of the picture is removed, the computer operator can clone a neighboring section into the missing area. Soon the area is filled in as if nothing had been removed.

Not only can the computer clone a subject from one part of the picture to another, but it also can combine several different pictures into one. The *Sacramento* (Calif.) *Bee*'s Mitch Toll used this technique to create a computer-assembled photographic illustration from individual pictures of four subjects originally photographed in the studio. Using a desktop computer, Toll combined the teen-agers' images and superimposed them on a blue sky with clouds.

NO HARD COPY PRINT NEEDED

After the editor or photographer has manipulated the image, he or she can send the electronic information to a high-resolution output machine. This machine can produce a positive print or a film negative. Printers can, in the traditional manner, reproduce from this image.

Alternatively, of course, once the image has been scanned electronically into the computer, and the photographer or editor has performed manipulations such as enlarging, cropping, burning, and dodging, the image's signal can be piped into a compatible computer in the same room or sent by telephone lines or satellite anywhere in the world. The day is near that photographers, even those not working for a wire service, will be able to send their images from a computer in their home to a magazine in Paris, France, or a newspaper office in Paris, Texas.

Photographers can store their images on magnetic disks or tape. As long as they are not destroyed by an electronic force, such as a strong magnet, the electronic images will last without any degradation.

INTEGRATING WORDS AND PICTURES

Virtually all newspapers and magazines use computers to design and set type for the pages in their publications. Now, pictures from the electronic darkroom can flow

Images of the teen-agers were shot individually in the studio. The photos were scanned and then combined using a desktop computer. (Computer-assembled photographic illustration by Mitch Toll, *Sacramento* (Calif.) *Bee*.)

THE ELECTRONIC DARKROOM

Starting with the image of the football players catching the pass, Paul Buxbaum of Color Imaging Systems scanned the photo into the computer using a Barneyscan, manufactured by his company. First he made a preview scan. He then set the controls on an appropriate tonal range and adjusted the midpoint on the range for the best reproduction.

Once Buxbaum had scanned the image into the computer, he could determine the final size of the image. He adjusted the contrast and brightness, and then constructed an electronic mask that exactly fit over the image. (See pages 256–257.)

This mask allowed Buxbaum to selectively alter either the fans in the background or the football players in the foreground. Using the computer to alter the image in this way is analogous to dodging, burning, and switching contrast filters in the traditional darkroom. Buxbaum could 1) change the contrast and brightness of the background fans; 2) alter the foreground football players in the same manner; or 3) change both.

In addition to varying contrast and brightness, Buxbaum increased the sharpness of the players by having the computer identify edges where the image turns from dark to light. If the original image is blurry, i.e. out of focus, the computer cannot save the day. However, if the image is relatively sharp, the computer can make the subject appear sharper.

Furthermore, Buxbaum was able to take a section of the picture, in this instance, the fans in the background, and decrease edge sharpness. In other words, he blurred the background. This manipulation had the same effect as if the photographer had used a longer lens and wider aperture to alter the depth of field in the **photo.** (Original photo by Ron Bingham; scanning courtesy of Color Imaging Systems from Barneyscan Corp., Alameda (Calif.); Paul Buxbaum, manager customer support.)

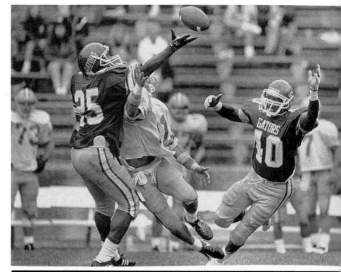

TRADITIONAL HALFTONE

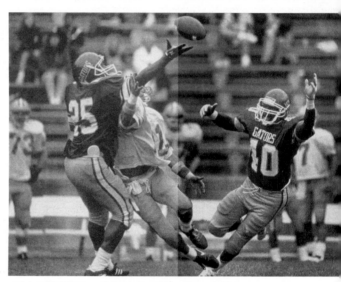

FLATTENED CONTRAST ON LEFT

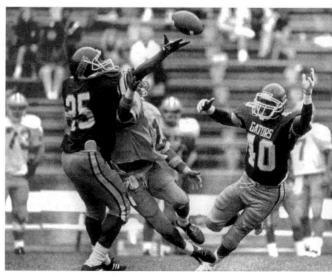

LIGHTENED BACKGROUND

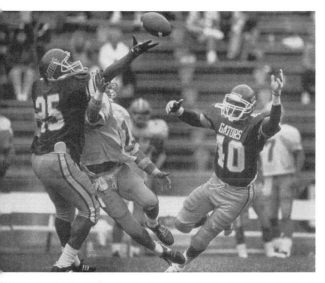

NNED HALFTONE

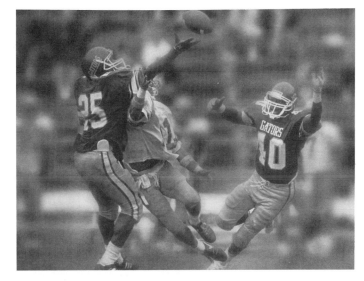

BACKGROUND BLURRED

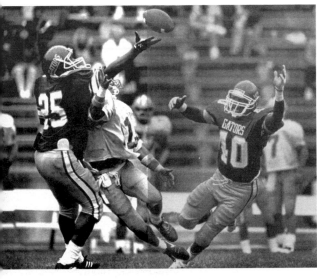

GHTENED CONTRAST ON LEFT

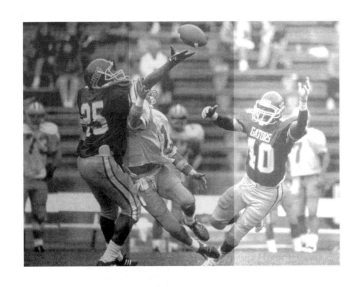

AN ELECTRONIC TEST STRIP

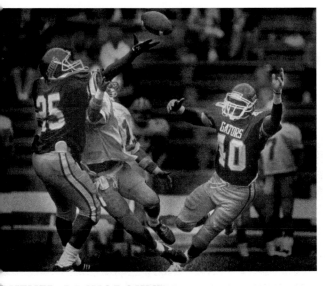

RKENED BACKGROUND

MASK USED TO MANIPULATE BACKGROUNDS

directly into these page layout computers. The computer integrates the picture with the rest of the text for a newspaper or magazine and then can display how the final page will look before it is printed. Finally, the computer can send the picture and type to another machine that can produce an entire page, including the photo, in the form needed by the presses. From the time the picture enters the computer to the time it appears in a newspaper or magazine, it can remain an electronic image. No quality is lost as the image passes from computer to halftone printed on the pages of the *Democrat/Republican Chronicle* or *Time/Newsweek/Life* magazine.

THE ELECTRONIC DARKROOM

■ AP LEAFAX 35: PORTABLE ELECTRONIC DARKROOM

If you are covering an earthquake in San Francisco for your paper in St. Petersburg, Fla., you could shoot the destruction, process the film, make a print, and send the photos by air. Alternatively, you could process the film, whether it's black-and-white, color negative, or transparency, and — without making a print — you could insert your negative or transparency into a Leafax 35. Fitted into a Halliburton suitcase, this portable scanner reads the film and turns it into an electronic image. You can even see the image on a tiny TV screen. Then, by hooking the AP Leafax 35 into the telephone system, you can transmit the image across the United States, where it will be received by a standard wire receiver. At the home newspaper, either a single black-and-white photo or three separations that will provide the basis of a color reproduction will come off the receiving machine.

Using the "Leaf," as photographers call it, eliminates printing and allows the transmission of pictures from a remote location to any standard picture receiver. For the back shop, the photo comes into the newspaper office already separated, ready for halftone reproduction in the paper.

■ PHOTOSTREAM

Via satellite, the AP is now sending pictures electronically at the rate of one per minute for black-and-white photos and one every three minutes for color photos. Using digital data compression techniques, the wire service will be transmitting black-and-white photos in less than twenty seconds and color photos in less than a minute. Imagine the number of pictures possible under this system.

The received photos are of excellent quality because they avoid the traditional problems of interference associated with telephone lines. With "PhotoStream," the name of the electronic photo service, a picture is scanned into a computer as a series of numbers. These numbers are transmitted via satellite to the receiving computer in the next state or across the country. The exact same set of numbers that represents a scanned picture in New York, for example, will be used to print out the picture in San Francisco. What you see in New York is what you will get in San Francisco.

In San Francisco, the newspaper can either print out or store in its computer one of the many images transmitted daily. The editor can call up any of the the day's images to size and crop them and then electronically insert them into the page layout for the next day's paper.

The use of the computer to store pictures has a major benefit as the number of transmitted pictures increases. With several agencies transmitting pictures, a wire service editor could receive, in the near future, more than 700 images a day. The computer can sort the wire service photos by category, time transmitted, wire service name, slug, and caption. The computer can quickly display many small images on the screen, usually called "thumbnails," and provide the operator with the ability to pick a thumbnail and quickly display it full-screen. The picture editor then must decide on the best crop and then transmit the picture to the page layout system and the caption to the text-editing system. Without the computer to handle this massive amount of visual information, editors would be overwhelmed with pictures but have no way to handle them.

PICTURES DON'T LIE...OR DO THEY?

The photographic profession has considered altering pictures through dodging and burning in the darkroom a perfectly acceptable practice. In fact, careful printing that involves dodging and burning is highly praised.

On the other hand, photojournalism professionals try to avoid retouching photos or combining photos.

Newspaper artists used to hand retouch photos to enhance reproduction on poor quality newsprint. Notice the white line around the farmer and the hoe, as well as the painted white streaks that simulate rain. The results of retouching often look obvious. (Photo by Dan Murphy, courtesy of *Boston Herald*.)

Many old photos were retouched because of poor newspaper reproduction, a practice that has basically been eliminated since the '70s. Combining photos into a composograph, a practice at *New York Daily Graphic*, an early tabloid (see Chapter 15, "History"), has been shunned by the "straight" press for many years.

Photographers have found extensive retouching with an airbrush or paints on black-and-white photos difficult, with results that usually look obvious. *National Enquirer* composites still serve as examples of tacky retouching. Photographers report even less success retouching color.

Recently, however, with the application of computer technology to photography, photographers and editors have discovered an easier way to manipulate picture elements so that the changes are undetectable.

■ COMPOSING PHOTOS ON THE ELECTRONIC LAYOUT TABLE

In a now-famous incident at the *National Geographic*, editors puzzled over what could have been a terrific cover shot of the great pyramids of Giza. Unfortunately, the foreground's camels and the background's pyramids were not lined up to fit correctly on the vertical cover. The answer: send the picture to the scanner and computer. Through the magic of computer manipulation, the computer operator actually moved the pyramids in the photos. The final picture left no detectable trails.

Rich Clarkson, who became director of photography at the *Geographic* after the incident, defended the magazine's digital alteration of the picture. "It's exactly the same as if the photographer had moved the camera's position," he is quoted as saying in an article by Sheila Reaves in the National Press Photographers' Association special report, *Ethics of Photojournalism*. Clarkson's argument, however, made no distinction between acceptable and unacceptable methods to obtain a photo. Is fudging a photograph electronically really the same as moving the

photographer — even if both methods result in photos that look the same?

The editor of the *National Geographic*, William Graves, would not release the pyramids cover of the magazine nor the original picture of the pyramids for production in this book. You can see the February 1982 cover of the *National Geographic* at your local library.

As if moving pyramids was not enough, Collins Publishing Co., publishers for the ***Day in the Life*** book series, found moving the moon a necessity. Reviewing their take from a ***Day in the Life*** shoot, the editors decided that an evocative picture of a cowboy, tree, and crescent moon would make a perfect cover photo for ***A Day in the Life of America***. Like the *Geographic*'s uncooperative photo, however, the horizontal shot would not fit on the full-bleed vertical cover — so a computer technician moved the cowboy and moon nearer to the tree trunk and then finished composing the picture by adding branches to the top of the tree and filling in with extra sky.

So, although more than one hundred photographers submitted thousands of frames of film, editors determined that only the picture of a cowboy who was too far away from a tree would succeed as a cover. And instead of redesigning the cover to accommodate the photo, they redesigned the photo.

■ ADDING OR SUBTRACTING ELEMENTS

Editors don't have to stop at moving the moon or just limit themselves to rearranging pyramids. They even can add or subtract elements from the original picture.

At *Rolling Stone*, after "Miami Vice" star Don Johnson had posed for a cover shot wearing a gun in a shoulder holster, he later decided he didn't want to appear with the weapon. Rather than reshoot the picture, editors obliged by using digital imaging technology to remove the pistol.

The photographer's original picture for the "Day in the Life of America" project was a horizontal. With a computer, editors brought the moon, cowboy, and tree closer together so they would all fit the cover's vertical format. (Photo courtesy of Collins Publishing Co.)

The original photograph, taken by Deborah Feingold, showed Don Johnson, star of TV show "Miami Vice," wearing a shoulder holster and gun. After the photograph was taken, editors decided to eliminate the gun using computer retouching. (© *Rolling Stone* magazine.)

ARE THE PHOTOS ON THESE COVERS REAL OR DIGITI

Picture Week, a short-lived photo publication of Time, Inc., ran on its cover a picture of Nancy Reagan and Raisa Gorbachev sitting side by side. The combined montage was a fake. Separate pictures of the individual women had been seamlessly welded together with electronics. The only indication for the reader that this was a composite photo was that two photographers were given credit lines.

Some newspapers have used the computer to remove small distracting items from a picture. The *St. Louis Post Dispatch* removed a Coke® can from a portrait of its Pulitzer prizewinning photographer. *The Orange County Register* increased the saturation of the blue sky in some of their prizewinning Olympics pictures. On a more mundane level, the *San Francisco Examiner* changed the color of a wall behind the mayor's to enhance the appeal of a front-page picture. Did these newspapers cross the ethical boundary between normal picture handling and doctoring photos?

■ GOING TOO FAR?

While few photographers object to dodging and burning a negative in the darkroom, most are outraged at digitally retouching a person in or out of a news picture. How far should electronic retouching go:
• remove a distracting branch behind a person's head?
• tone the sky to a deeper blue?
• smooth out wrinkles from a star's face?
• alter a news picture if the manipulation will produce a more telling picture?
• change a feature photo?
• electronically sharpen an image?

Electronic manipulation has not been around long enough for the photojournalism community to form

95 cents

Picture Week

THE MAGAZINE OF NEWS & HUMAN INTEREST *NOVEMBER 25, 1985*

Sexy
Sam Shepard

NANCY MEETS RAISA
How Will They Hit It Off at the Summit?

For a photo that appears to show Nancy Reagan and Raisa Gorbachev in one room together, the editors of *Picture Week*, a now defunct Time, Inc., experimental magazine, combined the two photos with the aid of the computer. Only a two-photographer credit line played inside the magazine gave the deception away to those who bothered to read the small print. (From *News Photographer* archives.)

agreed-on standards. At bars and coffee shops, national meetings, and local darkrooms, digital manipulation has been hotly debated since *National Geographic* moved the pyramids for its 1982 cover.

Photojournalists who take the absolutist's position argue that editors should not attempt any digital retouching or other manipulations of the image at all. Period. They say that the printed picture should look as near as possible to the original slide or negative. They maintain that the original slide or negative is "truth" and any change from that is categorically wrong. Bob Gilka, who was the director of photography at the *National Geographic* when the pyramids were moved, now argues that limited electronic manipulation is like a limited nuclear war. There isn't any such thing.

A less stringent position holds that editors should restrict manipulation of the photo to the same techniques

practiced in the traditional darkroom — dodging, burning, lightening, darkening, and changing contrast.

Still others hold that editors should only make "global" changes — changes made to the entire photo similar to the way photographers in the field switch filters on the camera. This group says that shooters and editors should not electronically manipulate parts of the photo after it's been taken because photographers cannot do that in the field.

Finally, some photographers argue that if the photographer could have taken the picture with a different lens or from a different angle, then manipulating the electronic image to get the same result passes muster.

WHO BENEFITS?

How should the profession resolve this dilemma? Perhaps photojournalists should consider who benefits by altering photos. The photographer? The editor? The reader?

Consider this. In the situations where *National Geographic* moved the pyramids and Collins Publishing Co. moved the cowboy and the moon, editors and designers sought to fit a horizontal picture onto a vertical cover format. Could another picture have been substituted that would suffice? Could the cover design have been changed to fit the shape of the image? Who benefitted? Editors and designers. Was the reader any better off? Not really.

Again, removing a gun from Don Johnson's holster made the actor feel better and saved the editor from scheduling a reshoot. Similarly, removing a Coke® can from a picture cleaned up the image for the editor. But did the reader gain anything from this move?

In all of these instances, electronic manipulation eased the jobs of either editors, designers, or actors. None were carried out to benefit readers.

Combining the pictures of Nancy Reagan and Raisa Gorbachev begins to go beyond making jobs easy to simply fooling the reader because there's technology available that makes it easy to do so. Two separate pictures of the women run side-by-side would have conveyed the same message. Here, the reader not only fails to benefit but becomes the butt of a joke, as well.

FACILITATE, DON'T FOOL THE READER

On the other hand, when a photographer burns or dodges a print in the darkroom or similarly darkens or lightens the print in the computer, the reader benefits by seeing more clearly items in the picture that might have been missed with an unaltered picture. In the same way, the computer's ability to sharpen pictures or blur backgrounds to make the subject stand out more distinctly and legibly also benefits the reader. (See page 266.)

Perhaps an ethical rule-of-thumb might read: "Electronically alter pictures only when doing so clearly benefits the reader. Avoid altering pictures when doing so fools the reader in any way." ∎

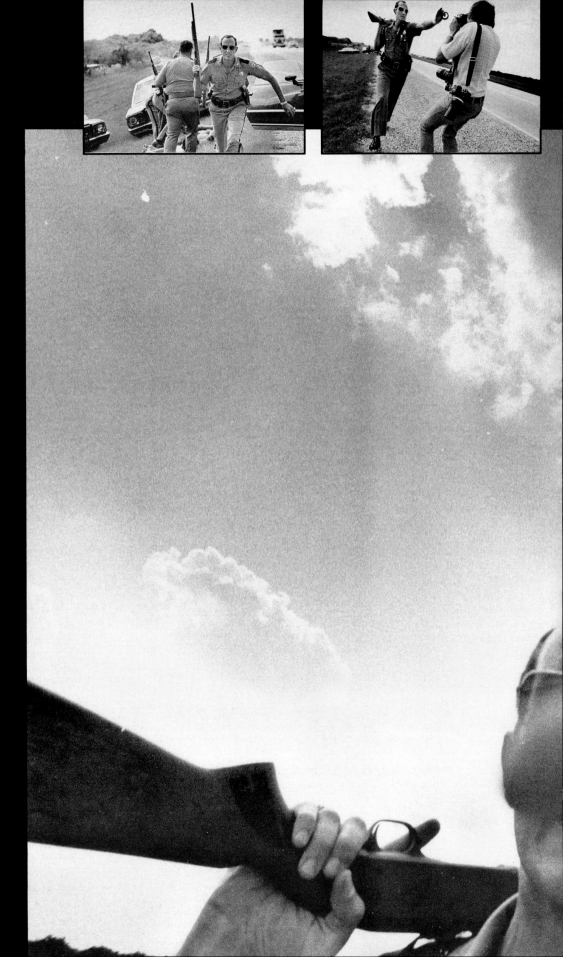

The Law

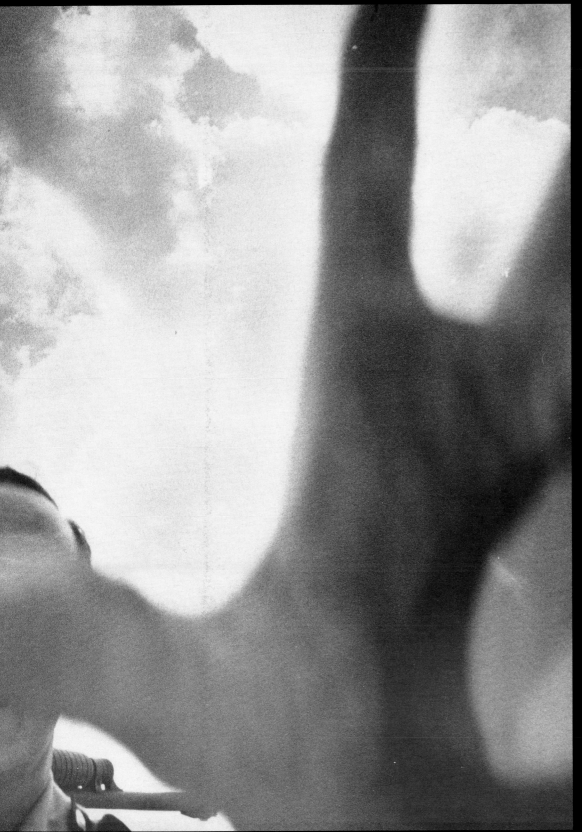

A state trooper illegally tried to block the cameras of two photographers from the *Palm Beach Post* who were covering the arrest of an armed robber. (Top left and bottom photos by Ken Steinhoff, top right photo by C. J. Walker, *The Palm Beach Post*.)

Chapter revised with Dr. Michael Sherer, Department of Communication, University of Nebraska at Omaha.

An Agen Works Undercover To Get the Goods

PRIVACY VS. THE PUBLIC'S RIGHT TO KNOW

When people talk about "privacy," they usually mean the "right to be left alone." But privacy is simply not a broad constitutional right basic to American citizens. The U.S. Constitution does not explicitly grant us this general right to be left alone. In fact, most analysts believe there never will be an explicit, expressed constitutional right of privacy similar to the right outlined in the First Amendment that protects and guarantees free speech and press.

However, over the past ninety years, some commonly recognized principles of privacy have evolved based on federal and state laws and court cases. These principles protect individuals from anyone:

• intruding by taking pictures where privacy could be expected.
• using a picture to sell a product without consent.
• unfairly causing someone to look bad.
• taking truthful but private or embarrassing photos.

At first glance, this list might appear somewhat intimidating. You may ask yourself, "May I ever take a picture of anyone, anywhere?" In practice, though, the courts have severely limited the meaning of each of the four principles of privacy.

■ INTRUDING WHERE PRIVACY COULD BE EXPECTED

SHOOTING SURREPTITIOUSLY INSIDE SOMEONE'S HOME

When do you need an invitation into someone's home to take pictures? Take the case of Antone Dietemann, a West Coast herbal medicinalist who had achieved a considerable amount of public recognition and was newsworthy but declined to be photographed in his home-laboratory garden.

Life photographer Bill Ray posed as the husband of a patient and visited the medicinalist with his wife-for-

a-day, also a *Life* staffer. With a hidden camera, the photographer snapped pictures of the herb man as he became engrossed in his therapy. Dietemann placed his hand on the patient's breast. He claimed that he could cure people by simply laying hands upon them. Bill Ray discreetly and quietly clicked off several frames. *Life* editors published the photos without the medicinalist's permission. Dietemann sued the magazine because he claimed his privacy was invaded. He won on the grounds that the photographer took the pictures surreptitiously. Dietemann had not given his permission for the pictures to be taken. Individuals do have privacy rights in their own homes.

OUTSIDE THE HOUSE

The case of Ron Galella, self-styled paparazzo and pursuer of Jacqueline Kennedy Onassis, exemplifies the problem of intruding into someone's privacy outside the home. Jackie was newsworthy. Almost anything she did appeared in newspaper gossip columns. Any photo of Jackie a photographer could grab soon appeared on the cover of a national magazine.

Ron Galella is a full-fledged, full-time paparazzo who specialized in photos of Jackie. The word paparazzo means an Italian insect similar to a mosquito. In his movie "La Dolce Vita," director Federico Fellini named the free-lance photographers who covered the movie stars and other celebrities "paparazzo because they buzzed like mosquitos."

Paparazzo Galella, who made his living buzzing after the stars, started tracking Jackie Kennedy Onassis in 1967. Galella hung around her New York City apartment and waited for her to step outside the door. When she bicycled in Central Park, he and his camera were tucked into the bushes. As she peddled by, he would shoot her picture. When she shopped at Bonwit Teller's, he ducked behind a counter and snapped away. When she ate at a restaurant in New York's Chinatown, he hid behind a coat rack to get the first photographs of the former First Lady eating with chopsticks. He even dated her maid for a few weeks in an attempt to learn Jackie's schedule.

Onassis sued Galella, charging him with inflicting emotional distress. The court had to balance Onassis' right of privacy against Galella's right to take pictures.

The court found in Onassis' favor. Galella was

Jackie Kennedy Onassis sued Ron Galella (BELOW), self-styled paparazzo photographer, for harassment, and she won. The court eventually restricted Galella from taking pictures within twenty-five feet of Onassis. (Photo by Joy Smith.)

Marlon Brando broke Ron Galella's jaw. The following year, Galella (RIGHT) wore a football helmet to protect himself whenever he snapped pictures of Brando. (Photo by Paul Schmulbach.)

There are no problems publishing this picture of Desi Arnaz in a newspaper or magazine story. But without Arnaz's written permission, the photo could not appear in an ad for a product such as cigars. (Photo by Patrick Downs, *Los Angeles Times*.)

restricted from coming closer than 100 yards of her home and 50 yards from her personally. This ruling was later modified to prohibit him from approaching within 25 feet of her. Note, however, that the court did not stop Galella from taking and selling pictures of the former First Lady, as long as the pictures were used for news coverage and not advertising. Few cases of this kind have arisen since the Galella-Onassis trial.

■ USING SOMEONE'S IMAGE TO SELL A PRODUCT

The law holds that you cannot publish a photo of a person for commercial purposes without obtaining consent from that individual. A company can't sell a product by identifying that product with someone without getting permission first.

Publishing someone's picture on the cover of a magazine or the front page of a newspaper is permissible if it is newsworthy. The court does not consider the newspaper or magazine itself a product. However, printing the same picture as part of an advertisement in a publication, without the subject's prior consent, is a violation of the person's right of privacy.

For instance, let's say that famous movie personality John Starstruck is driving down the street in a new Ford Thunderbird. As a photographer for the *Daily Sun*, you snap a picture of Starstruck, thinking your editor might want to use the photo, for no one knew Starstruck

was in town. You were right. Your editor publishes, on the front page, the picture of Starstruck in his new car. No problem. You've done nothing wrong, nor has your editor done anything illegal.

Ford Motor Company, however, seeing the picture, recognizes its advertising value because the photo shows a famous movie star driving in a Thunderbird. The company, after legally obtaining a copy of the photo's negative from your newspaper, uses the picture in an advertisement. If the viewer can recognize Starstruck in the Ford advertisement, then the movie star's privacy — in the sense of commercial appropriation — is violated. Ford is using Starstruck's image to sell its cars. Starstruck may sue the Ford Motor Company, and unless Ford can produce a consent form in court, the movie star will win. The consent form, signed by the subject, gives the photographer or publication the right to use the photo in an ad.

Reserving the commercial use of a person's image is not limited to just the famous. All individuals have the right to protect themselves from this form of commercial exploitation. When you take a picture for the newspaper, you do not need a consent form from the subject, famous or unknown. But when you take a picture that you want to sell to a company for use in an advertisement, brochure, fundraiser, etc., then you must get a consent form signed, even if the subject is unknown.

■ UNFAIRLY CAUSING SOMEONE TO LOOK BAD

The law holds that people have the right of privacy not to be placed in a "false light." In other words, photos can't make a person look bad without cause. For example, a photographer photographed a child who had been struck by a car, and the picture appeared in a newspaper. No

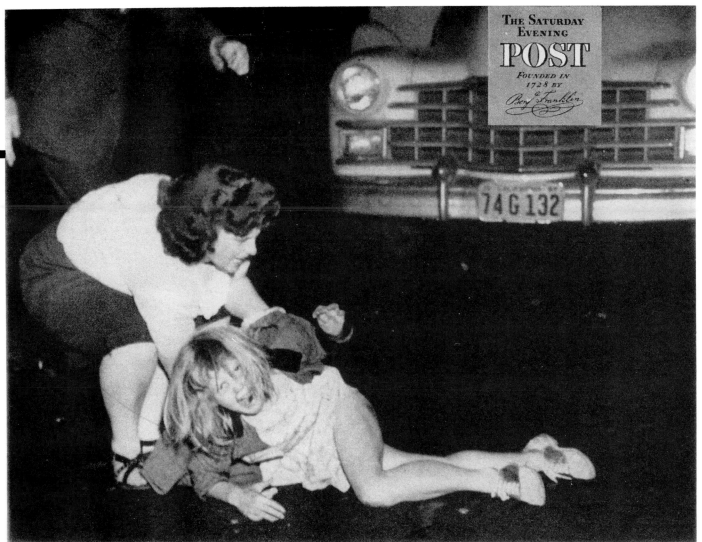

Safety education in schools has reduced child accidents measurably, but unpredictable darting through traffic still takes a sobering toll.

They Ask to Be Killed

By DAVID G. WITTELS

Do you invite massacre by your own carelessness? Here's how thousands have committed suicide by scorning laws that were passed to keep them alive.

problem so far. Two years later, the *Saturday Evening Post* ran the same picture under the title, "They Asked To Be Killed," with a story about child safety. The original use of the picture was a legitimate publication of a newsworthy event. But when the *Saturday Evening Post* used the headline with the picture, and placed the subhead "Do You Invite Massacre with Your Own Carelessness?" next to the photo, the parents claimed that the words and photo implied carelessness on their part. The words and photo gave the impression that the child had willingly run out in front of the car. The court decreed that the photo/headline combination placed the parents in a "false light." The parents won the lawsuit.

Saturday Evening Post editors used a picture from their old photo file to accompany this new story. They used the old picture as an illustration of a general, ongoing problem. Often, this use of file photos provides the grounds for later lawsuits.

In another such incident, John Raible even signed a consent form allowing *Newsweek* magazine to publish his picture with a story about "Middle Americans." The editors, however, chose the headline "Troubled American — A Special Report on the Silent Majority," and printed Raible's picture below the headline. Raible felt that the headline, associated with his picture, implied he was troubled, thus putting him in a "false light." He sued and collected damages.

Both the *Saturday Evening Post* and the *Newsweek* cases show a picture's meaning can be affected drastically by the words associated with it. Although the picture itself might have been legal when it was taken,

The parents of this child claimed that the combination of words and pictures implied that they were careless, thus placing them in a false light. When they sued the *Saturday Evening Post*, the court decided in their favor. (Reprinted from *The Saturday Evening Post*, © 1949 The Curtis Publishing Co.)

THE TROUBLED AMERICAN

A Special Report on the White Majority

Although the skittish 1960s, America has been most obsessed with its alienated minorities—the incendiary black militant and the welfare mother, the hedonistic hippie and the campus revolutionary. But now the pendulum of public attention is in the midst of one of those great swings that profoundly change the way the nation thinks about itself. Suddenly, the focus is on the citizen who outnumbers, outvotes and could, if he chose to, outgun the lesser rebel. After years of feeling himself a besieged minority, the man in the middle—representing America's vast white middle-class majority—is giving vent to his frustration, his disillusionment and his anger.

"You better watch out," barks Eric Hoffer, San Francisco's bare-knuckle philosopher. "The common man is standing up and someday he's going to elect a policeman President of the United States."

Heated up is the little guy, the average white citizen who has been dubbed "the Middle American." Is the country sliding inexorably toward an apocalyptic spasm—perhaps racial or class warfare, or a turn to a grass-roots dictator who would promise to restore domestic tranquillity by suppressing all dissent and unrest? To get a definitive reading on the mood of the American majority, *Newsweek* commissioned The Gallup Organization to survey the white population with special attention to the middle-income group—the blue- and white-collar families who make up three-fifths of U.S. whites.

The survey, bolstered by reports from *Newsweek* correspondents around the country, suggests that the average American is more deeply troubled about his country's future than at any time since the Great Depression. The surface concerns are easy

Himself a prototypical expression of the middle-class majority ("These are my people," he says "We speak the same language"), the President presides over a nation nervously edging rightward in a desperate try to watch its balance after years of upheaval.

The reassertion of traditional values has festooned millions of automobile windows with American-flag decals, generated nationwide crusades to restore prayers to the schoolroom, to ban sex education, to curb pornography. The uneasy new mood has also spawned a coast-to-coast surge to law-and-order politicians—one of them a roly-poly Malaprop named Mario Procaccino who has most America's most outspokenly progressive mayor, John V. Lindsay, in New York City, since the Athens of American liberalism.

For the Negro, the turn in the tide can have the most momentous consequences. More and more American institutions are opening their doors to Negroes—mostly as a result of the social momentum generated in the Kennedy-Johnson years. Still, with the Nixon Administration setting the tone, the country seems to be retreating from active concern with its black minority—as the nation did nearly a century ago with the demise of Reconstruction. Self-reliant or self-delusive, the trend to separation confronts younger blacks only intensifies the withdrawal. Most ominous, even well-educated island of whites have begun once more to speak openly of genetic differences between the races, an intellectual vogue before the turn of the century. One has to consider the very idea that the Negro may be inherently inferior to the white and incapable of competing with him.

'You better watch out— the common man is standing up'

after captioning or headlining, the photo-plus-word combination can be considered illegal. Robert Cavallo and Stuart Kahan, in their book ***Photography: What's the Law?***, say that "Pictures, standing alone, without captions or stories with them, generally pose little danger of defamation. However, an illustration is usually accompanied by text, and it is almost always that combination of pictures and prose which carries the damaging impact."

The *Newsweek* case points up a second legal danger for the photographer to watch for. The consent form signed by Raible did not protect the photographer. The consent form is not a carte blanche; it is a limited authorization given by the subject to the photographer, warning the photographer to use the picture in an understood and agreed-on manner. A consent form does not give photographers or picture editors the right to use a picture in any way they see fit.

Ms. Graham was in a public place and her face wasn't even visible when she was photographed at the Cullman County Fair. She said her children were recognizable, and the courts agreed with her that this picture, though truthful, was embarrassing, and therefore, she could collect damages. (Reprinted from The (Ala.) *Daily Times Democrat*.)

All's Fair in Fair Fun

■ TAKING TRUTHFUL BUT PRIVATE OR EMBARRASSING PHOTOS

The right of privacy does include some restrictions on printing truthful but private or embarrassing information about a subject. Generally, if the information is newsworthy and in the public interest, the press can photograph and publish the facts. The courts have liberally interpreted "public interest" to mean anything interesting to the public — and there are few things that won't interest some people.

PUBLIC BUT EMBARRASSING

The courts, however, have put certain limitations on the right of the public to know and see true but confidential facts about a person. Photographs, even if taken in a public place, should not ridicule or embarrass a private person unless the situation is patently newsworthy. The photos should not be highly offensive to a reasonable person and of legitimate concern to the public.

Ms. Graham went to the Cullman, Ala., County Fair. After several rides, she entered a side-show fun house. In the fun house, she walked across a grate that blew up her dress. At that unlucky moment, a photographer from the *Daily Times Democrat*, Bill McClure, was on his first photo assignment for the paper — looking for "typical" features at the fair. With his Speed Graphic, he snapped Graham's picture just as her skirt blew up around her hips, exposing her underwear. After the picture was published, Graham called and complained. Getting no satisfaction from the photographer with an apology or retraction, Graham hired an out-of-town lawyer and successfully sued the *Democrat* for damages. The picture was truthful, but the jury found that the photo was embarrassing and contained no information of legitimate concern to the public.

SPECIAL CHILDREN

You may take pictures of children; however if the child is in a class for the retarded or handicapped, and you take a picture, his or her parents may consider that photo truthful but embarrassing. They could sue you and your newspaper. Getting the teacher's permission is not sufficient. For you safely to run the picture of the retarded or handicapped child, you must have the consent of the parent or legal guardian.

You can take and publish pictures of children in schools and public parks. You are open to suit only if the photo might be considered embarrassing or derogatory.

HOSPITALS OFF LIMITS

In 1942, an International News Photo photographer entered the hospital room of Dorothy Barber, who was in the hospital for a weight loss problem. Without Barber's consent, the photographer took a picture of her, and *Time* magazine bought the photo and ran it under the headline "Starving Glutton." Barber sued the magazine, and *Time* lost the case. A Missouri court said, "Certainly if there is any right of privacy at all, it should include the right to obtain medical treatment at home or in a hospital without personal publicity."

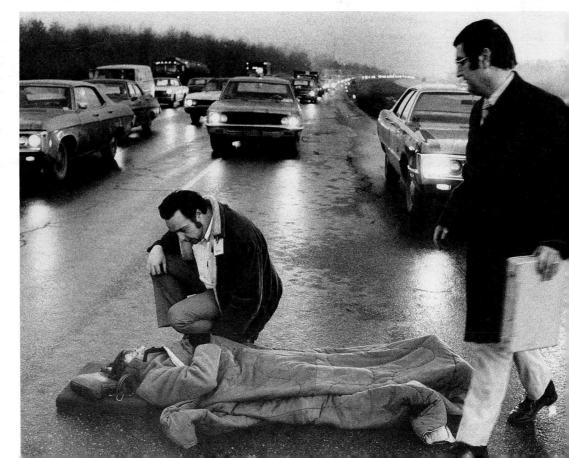

A photographer has the legal right to cover a person who has a "public medical condition." However, coverage stops when the person enters the emergency van or the hospital. (Photo by Richard J. Bielinski, *Boston Herald* File, Print Division, Boston Public Library.)

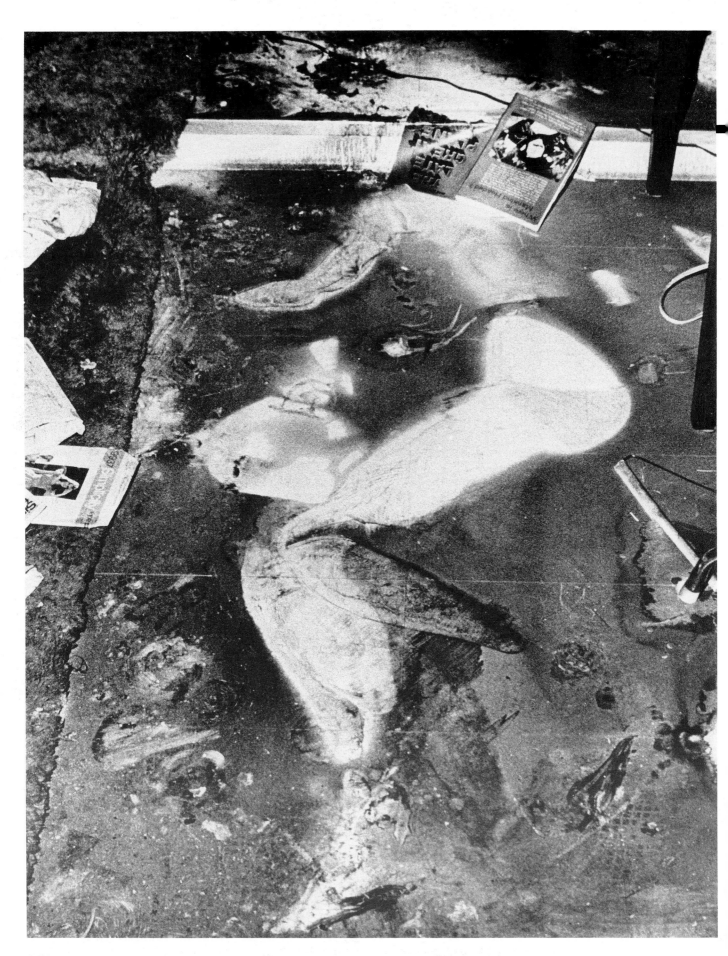

Dorothy Barber had what the court considers a "private medical condition." Therefore, a photographer could not take her picture without her permission.

ACCIDENTS OK

If someone is injured in an automobile accident or plane crash, falls out of a tree, nearly drowns, or is struck by lightning, that person would have a "public medical condition." In addition, if a person is shot by someone who is in the process of committing a crime, that person's condition would be considered "public." People who are victims of a crime, accident, or act of God are considered newsworthy, and they can be photographed outside the hospital.

If an accident happens on First and Broadway, the photographer can begin taking pictures of the victim upon arriving on the scene because the victim has a public medical condition and is not in the hospital. As the rescue team places the victim on the stretcher and slides the body into the ambulance, the photographer is still within legal rights to continue to photograph.

Once the victim enters the emergency van, however, the individual is covered by the right of privacy and is off limits to photographers. The same off-limits rule inhibits photographers once the victim enters the hospital.

If a person's condition is newsworthy, interesting, and historic, but the condition is not caused by crime, accident, or act of God, the person's medical condition is considered "private." Barber's treatment was "private." The first heart and kidney transplants and the first test-tube baby were both "private medical conditions" even though they were newsworthy. Photographers could take pictures inside the hospital only if the patients involved granted permission.

WHERE CAN YOU TAKE PICTURES?

■ THE LAW OF TRESPASS: THE HOME AS CASTLE

Without going onto a person's property, you may, from the street, photograph someone in his yard, on his porch, or even inside his house if you can see the person. You don't need the owner's permission. For instance, the courts consider people sitting on their verandas, mowing their lawns, or standing behind a picture window in their living rooms to be in "public view" and therefore legitimate subjects for photography.

The photographer still should be somewhat cautious when shooting onto private property, however, and should not step onto the grounds to get the picture. Nor should the photographer use an extremely long telephoto lens, which would capture more than the naked eye could see. In fact, the court says you shouldn't go to any extra trouble to get this porch-sitting, lawn-mowing, or window-standing shot. You shouldn't even climb a tree to gain a better view. Although not all photographers follow these guidelines, all are limited essentially to the view of an average passerby, according to the courts.

■ NEWS EVENT: ACCESS

Cindy Fletcher, fourteen years old, died in a house fire in Jacksonville, Florida. Her mother, who was away at the time, learned about the tragedy in the next day's edition of the *Times-Union*. Alongside the story appeared a picture that showed where her daughter's burned body had left a silhouette scorched on the floor. Newspaper photographer Bill Cranford had entered the Fletcher home to take the photo. Mrs. Fletcher sued the Florida Publishing Co., owner of the *Times-Union*, on grounds that the photographer had invaded her home, hence her privacy.

This actual court case serves to illustrate the problem of access for the working photographer. Did the photographer, as a representative of the news media, have the right to enter the house? Which right comes first: the right of Mrs. Fletcher not to have someone trespass in her house or the right of the public to know what happened in that house? Would you have entered Fletcher's home if you were the photographer?

In Florida Publishing Co. (*Times-Union*) v. Fletcher, the court found in favor of the photographer. He had the right to enter the house and take the pictures. Yet in other cases, the courts have recognized the right of private ownership over newsworthiness.

Trespass generally means entering someone's home, apartment, hotel, motel, or car without permission. This right of private ownership prohibits someone from walking in and taking pictures inside a house, without the permission of the resident.

Why, then, did the court find that the *Florida Times-Union* photographer had the right to enter the Fletcher house and take pictures of the silhouette left from Cindy Fletcher's burned body?

Why was this not a case of trespass?

In the Fletcher case, the news photographer had been invited into the home by the police and fire marshal; no one objected to the cameraman's presence. In fact, the authorities had asked the photographer to take pictures because they needed the photos for their investigation, and the fire marshal's camera was out of film. Mrs. Fletcher's suit was dismissed because it was "common custom" for the press to be permitted on private premises for the purposes of covering such newsworthy events. Also, no one had objected to the photographer's presence.

Immediately, one asks, "How could Mrs. Fletcher object when she wasn't there?" That's the "Catch-22," a

WHERE AND WHEN A PHOTOJOURNALIST CAN SHOOT

	ANYTIME	IF NO ONE OBJECTS	WITH RESTRICTIONS	ONLY WITH PERMISSION
PUBLIC AREA				
Street	X			
Sidewalk	X			
Airport	X			
Beach	X			
Park	X			
Zoo	X			
Train Station	X			
Bus Station	X			
IN PUBLIC SCHOOL				
Preschool	X			
Grade School	X			
High School	X			
University Campus	X			
Class in Session				X
IN PUBLIC AREA — WITH RESTRICTIONS				
Police Headquarters			X	
Government Buildings			X	
Courtroom				X
Prison				X
Legislative Chambers				X
IN MEDICAL FACILITIES				
Hospital				X
Rehab Center				X
Emergency Van				X
Mental Health Center				X
Doctor's Office				X
Clinic				X
PRIVATE BUT OPEN TO THE PUBLIC				
Movie Theater Lobby		X		
Business Office		X		
Hotel Lobby		X		
Restaurant		X		
Casino				X
Museum			X	
PRIVATE AREAS VISIBLE TO THE PUBLIC				
Window of Home	X			
Porch	X			
Lawn	X			
IN PRIVATE				
Home		X		
Porch		X		
Lawn		X		
Apartment		X		
Hotel Room		X		
Car		X		

legal dilemma. Had she been there and had said "no," the photographer, despite official invitation, would have been trespassing. But Mrs. Fletcher did not say "no," and the fact that she couldn't say "no" wasn't relevant, according to the courts.

What would have happened if the fire marshal's camera had not run short of film and the *Times-Union* photographer had not been invited into the Fletcher's house to take pictures? Could the photographer have legally entered had no one objected? The answer appears to be yes. In a case involving the coverage of the "Son of Sam" murders in New York, the judge found that reporters and photographers did not commit criminal trespass in entering David Berkowitz's apartment, even though his room was off limits to photographers after the police designated it a crime scene. The judge found that the police had no standing to refuse entry to the room — only the tenant or landlord had that right.

Can you photograph in a person's home if the owners do not object, and the police have not arrived yet? If you were riding down the street and heard a gunshot followed by a scream coming from a house, you could park your car, enter the house, and begin photographing the victim and the assailant.

If the homeowner realized what you were doing and didn't like it, the owner could ask you to leave. You would have to obey or be arrested for trespassing. Even if the police were there, you would have to leave if the homeowner objected to your presence. However, if the resident did not object, the police shouldn't ask you to leave.

The Florida Highway Patrol, after a strong protest from the *Palm Beach Post Times* about the harassment of two staff photographers (see opening spread of this chapter), issued a statement of policy regarding "Journalists' Right of Access to Crime, Arrest or Disaster Scenes." The statement said, in part, "It is the long-standing custom of law-enforcement agencies to invite representatives of the news media to enter upon private property where an event of public interest has occurred...."

"Invite," in this instance, does not mean literally to receive a formal invitation. Invite means to allow the photographer to enter. The common custom exists for photographers to cover news events and not be harassed or otherwise blocked by the police. The photographer should not wait for an engraved invitation from the cop at the scene before beginning to photograph.

The Florida Highway Patrol's policy statement goes on to say that "the presence of a photographer at an accident, crime, or disaster scene and the taking of photographs at the scene does not constitute unlawful interference and should not be restricted."

Unfortunately, this position is a policy statement of the Florida Highway Patrol, not a national or even a state law; therefore, the policy is not followed by police and firefighters in every state. In fact, only California has a law specifically stating that "accident and disaster areas shall not be closed to a duly authorized representative of any news service, newspaper or radio or television station or network." Even this law, however, does not protect the photojournalist if the police claim that the photographers will interfere with emergency operations.

■ PRIVATE PROPERTY OPEN TO THE PUBLIC

Do you have the right to take pictures on private property that is open to the public, such as a restaurant or grocery store? This area of the law is murky. Some authorities hold that you can take pictures unless the management has posted signs prohibiting photography or unless the owners object and ask you to stop. However, CBS was sued when its photographer entered the Le Mistral restaurant in New York with cameras rolling to illustrate a story about the sanitation violations of the establishment. The management objected, but CBS kept filming.

Although no signs prohibiting photography were posted, CBS lost the suit on the ground that the photographer had entered without the intention of purchasing food and was therefore trespassing. Although CBS was covering a legitimate news story in a private establishment open to the public, the network was found guilty of trespassing.

In an earlier case (Lloyd Corp., Ltd. v. Tanner, 1972), the court ruled that "the public's license to enter a private business establishment is limited to engaging in activities directly related to that business and does not normally extend to the pursuit of unrelated business, e.g., news gathering."

Camera journalists have no right to enter the property, even in a spot news situation, if they are prohibited by the owners of the establishment. Photographers must take their pictures from the public street, or they can be sued for trespass.

This means that if a fire is raging inside a business, the management can exclude photographers. If the management asks you to leave, you must comply with the request, or you can be arrested for trespassing. However, you can still publish any pictures you have already taken. The proprietor can stop you from taking more pictures, but he can't restrict you from printing the ones you already have.

California Appeals Court Justice John Racanelli points out that penalties for trespass are usually "nominal" if there is no intent to "do actual harm or injury."

Sometimes a manager will demand the film you have taken inside the store. On this point the law is clear. You do not have to give up your film. The owner or manager can ask you to stop taking pictures but can't take away your film. That film is your personal property, and you have every right to keep it.

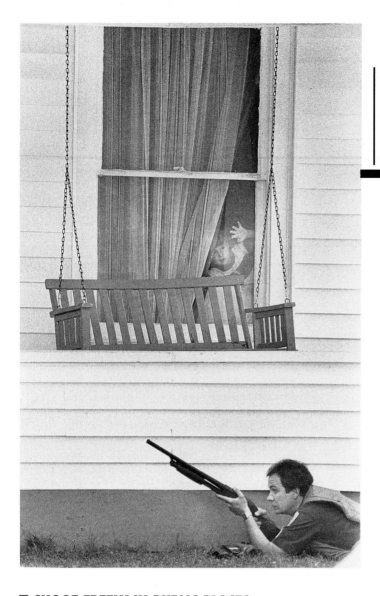

SHOOT FREELY IN PUBLIC PLACES

You may photograph in public places and on public property. You can take pictures on the street, on the sidewalk, in public parks, as well as in the public zoo. You can photograph in a city-owned airport as well as in public areas of schools and universities. However, without the teacher's permission, you can't take pictures of a class in session.

You may take pictures of elected officials or private citizens in public places, such as the street or the park. The person may be the center of interest in your photo, or just part of the crowd. If a news event occurs on public property, then you may cover that event as long as you do not interfere with police or the flow of traffic.

There are times when bystanders or relatives try, by physical assault, to prevent a photographer from taking a picture. In such instances, the courts have generally stepped in to protect photographers when they shoot in public places, according to George Chernoff and Hershel Sarbin in their book, **Photography and the Law.** They note that some years ago New York state even made it unlawful to injure the equipment of news photographers engaged in the pursuit of their occupation in public places.

Difficulties arise when police authorities inhibit photographers shooting on public property. In many situations, an overeager police officer may block a photogra-

pher's lens. In Iowa, photographers were once prevented by highway patrol officers and the National Guard from taking close-ups at the scene of a civilian airline crash. When airline officials arrived, photographers were given a free hand. In Philadelphia, police forcibly prevented photographers from taking pictures as officials bounced a heckler from a political rally. Philadelphia's city solicitor issued a formal opinion in which he told the police commissioner, "Meaningful freedom of the press includes the right to photograph and disseminate pictures of public events occurring in public places."

Police and fire officials have the right to restrict any activity of a photographer that might interfere with the officials' action. But taking pictures and asking questions do not constitute interference. Unfortunately, if a police officer stops a photographer at the scene of a breaking-news event, the photographer might find it hard to argue a fine point of law with an insistent cop. Photographers who disregard police directives can be arrested for disorderly conduct or for interfering with a police officer in the performance of duty, constituting a possible felony.

The National Press Photographers Association (NPPA) and some of its chapters have for years worked with fire and police academies to improve the graduates' understanding of the role of news in society. NPPA members have written police/press guidelines designed to reduce the conflict between working photojournalists and law enforcement officers. The Pennsylvania and the Philadelphia Press Photographers Associations were among the first to undertake such a program beginning in the 1950s. The result has been improved cooperation between photographers and fire and police personnel.

GOVERNMENT BUILDINGS: PUBLIC BUT UNDER SPECIAL RULES

Although facilities may be publicly owned, a photographer does not have unlimited access to government buildings, such as the U.S. Senate and House of Representatives, the state legislature, or the chambers of the city council. The mayor's office and city hospital also fall under the special-rules category. In addition, military bases and jails are strictly controlled.

As mentioned above, hospitals, even if they are publicly owned, publicly supported, and publicly operated, occupy a special place under the law. It's true that the admission list to hospitals is public information, but that's about all. You might be allowed to photograph scenes in a hospital for, say, a feature story. But check your pictures. Are there people in the pictures? Yes. Are some of the people in the pictures patients? Yes. Are they identifiable? Yes. Do you have a release form? No. You say the people in the photo are "incidental"? For instance, a picture taken of a corridor or waiting room shows several people sitting and reading magazines. No matter. You

must (a) get a release form; (b) don't run the picture; or (c) make the subjects unidentifiable in the darkroom.

The halls of the U.S. Congress are certainly public places, as are meeting rooms of state legislatures and city councils. But such places are generally run by their own unique rules. Even though the House of Representatives does allow television cameras limited access to debates, this legislative body will not allow photographers to take still pictures at a regular session of Congress. Politicians are afraid that the uncensored film of the still photographer will catch one of the members of this august body taking a nap, reading the newspaper, or, as is more often the situation, not present. Photographers are usually allowed in the U.S. House or Senate chambers only during ceremonial sessions, such as the opening day of Congress.

Photographers can snap legislators in committee meetings, elected officials in the halls of Congress, or legislators in their offices. Certain buildings — the Capitol and its grounds, all the House and Senate office buildings, the Library of Congress, and the General Accounting Office — are controlled entirely by the rules passed by Congress. The Constitution grants Congress the right to formulate special rules for operating these buildings. These rules are not subject to judicial review.

■ THE COURTROOM: ANOTHER SPECIAL SITUATION

The U.S. Supreme Court does forbid the presence of photographers in federal courtrooms but not in state courts. The effort of photojournalists to obtain access

rights to both federal and state courtrooms has had a turbulent history.

A low watermark in photographing in the courtroom occurred during the trial of Bruno Richard Hauptmann for the kidnapping and murder of Charles Lindbergh's infant child. Lindbergh had captured the imagination and admiration of the entire world for his solo trans-Atlantic crossing. The kidnapping and murder of his child attracted worldwide interest, and an estimated 700 reporters, including 129 photographers, came to the old courthouse in Flemington, N.J., to cover the trial. Photographers were allowed to take pictures in the courtroom only three times each day; before court convened, at noon recess, and after court adjourned. Early in the trial, however, a photographer took unauthorized pictures of Lindbergh on the stand. The photographer claimed that he was "new on the job, having been sent as a relief man, and he did not know the rulings."

Another illegal picture was taken at the end of the trial. Dick Sarno of the *New York Mirror* concealed a 35mm Contax camera when he entered the courtroom on February 13, 1935, the day the verdict and sentence were

During Richard Hauptmann's trial for kidnapping and killing Charles Lindbergh's baby, the judge prohibited photographers from taking pictures while court was in session. On January 3, 1935, Lindbergh himself took the stand. Despite the judge's orders, a photographer snapped the picture during the trial. With only a few exceptions, after this trial cameras were barred from the courtrooms until the 1970s.

announced. At the key moment of the proceedings, Sarno, who had wrapped his Contax in a muffler to conceal the noise, took a one-second exposure of the courtroom. Sarno later related, "As Hauptmann stood up and faced the jury, you could hear a pin drop. I tilted the camera, which I had braced on the balcony rail. The judge was directly in front and below me. If he looked up, I was sure he could see me." As the foreman of the jury stood to recite the verdict, Sarno recorded the instant.

The three-ring circus atmosphere created by the photographers and reporters covering the trial outside the courtroom as they mobbed each witness, as well as the indiscretions of the still and newsreel cameramen inside the courtroom, shocked a committee of the American Bar Association (ABA) that reviewed the legal proceedings in 1936. The ABA Committee recommended banning photography and broadcasting. The 1937 convention of the group adopted this rule as the 35th canon of Professional and Judicial Ethics. Many states, but not all, adopted these canons, effectively slamming the courtroom door shut on photojournalists.

RESTRICTIONS EASING

Florida's judicial system and legal code are viewed as the model by many states. Thus, in the late '70s, when the Florida Supreme Court opened the courtroom to photographers and television equipment on a limited basis for a one-year period, the event was significant. The Florida test allowed nationwide broadcast of the Ronnie Zamora

trial. Zamora, 15, was charged with killing his 82-year-old neighbor. Zamora's attorneys tried to blame commercial television for the murder committed by their client, claiming that the boy was under "involuntary subliminal television intoxication." This defense was unsuccessful. But the experiment allowing photographers to cover the trial worked well. With modern fast films and compact electronic television cameras, photographers did not require excessive lighting, and their behavior did not interfere with the trial's progress. Florida permanently opened its courts to the camera.

In 1980, the Supreme Court upheld the constitutionality of Florida's open courts law. In Chandler v. Florida, two police officers convicted of burglarizing a restaurant claimed that the presence of TV cameras denied them a right to a fair trial because local stations broadcast only highlights of the prosecution's case.

But when the Supreme Court considered the officers' appeal, the Justices ruled unanimously that states are not prohibited from allowing still and television cam-

Accused of bending over to "bare it all" during their show, exotic dancers demonstrated for the judge that their underwear covered up anything "illegal." Pictures are now possible in most courtrooms. The photographer in this instance got a tip that an interesting performance might take place in court. (Photo by Jim Damaske.)

Although truth is an absolute defense for libel, and this picture was "true," Mr. Burton sued when he saw what he looked like in this portion of a Camel cigarette ad. Although Burton had given permission for the ad, the court found publishing the picture was libelous.

WHEN YOU FEEL "ALL IN"

eras in their courts. The decision was a major victory for the First Amendment rights of photojournalists.

By 1990, 46 states had opened their courtrooms to the camera. Note, however, that each state has unique and individual restrictions. Check your state's rules and regulations before you start shooting. The federal court system remains closed.

LIBEL AND THE PHOTOGRAPHER

Libel is a printed, written, or pictorial statement that is defamatory to a person's character and reputation. The image must have been published due to negligence on the part of the photojournalist or due to a willful disregard for the truth.

Since truth is a defense in libel cases, and since photos represent actual scenes and are truthful, it might

seem that a person should not be able to win a libel suit against a photographer. However, a number of successful libel suits have been based on photographs, which can subject someone to ridicule, contempt, or hatred just as effectively as words can. Photographs can lie, or at least appear to lie, and photos in conjunction with print may form the basis for a libel suit.

Usually, a photo alone is not libelous, although such cases have happened. The most famous involved Mr. Burton, who was paid for a cigarette endorsement. For an advertisement, Mr. Burton was photographed holding a saddle in front of him. In the photograph, quite by accident, the saddle's wide girth strap appeared to be attached to the man, giving, in the court's words, a "grotesque, monstrous, and obscene" effect. The photo was libelous.

In some situations, when words have been added to photos either in the form of headlines, cutlines, or stories, the photo/word combination has resulted in libel cases. The photograph itself may be harmless, but the caption or accompanying article may add the damaging element. For example, The *New York American* once printed a photograph of a wrestler, Zbyszko, next to that of a gorilla, with the caption: "Not fundamentally different in physique." The photo-plus-word combination was libelous.

As in cases involving privacy issues, photographers must be particularly careful how their pictures are associated with words.

Many photographic libel suits have involved individuals arrested as robbery suspects, according to Michael Sherer's report, *No pictures please: It's the law*. Sherer notes that individuals allegedly involved in murder, illegal drugs, smuggling, police corruption, financial misdealing, illegal gambling, organized theft rings, and organized crime have sued for libel when their pictures appeared in print. In addition, he notes, people have sued because they felt photos of them implied sexual promiscuity or abnormal or illegal sexual activity.

To prove that a photo is libelous, the defendant must show that the photojournalist acted with willful disregard for the truth or was unprofessional. By relying on proper reporting procedures in gathering and publishing the photos, several media defendants have successfully defended themselves in libel litigation.

Sherer notes that problems arise when courts discover that proper reporting techniques were not used to obtain the photos. For instance, photographers failed to verify that individuals who were photographed during arrests were indeed suspects in the robberies or suspects accused of prostitution.

Finally, Sherer cautions that if you have any doubt that the subjects pictured are not the same people as those mentioned in the accompanying caption or news story, find another way of illustrating the story.

PRESS CREDENTIALS USEFUL BUT LIMITED

Press credentials issued by the newspaper or magazine for which you work are a means of identification and nothing more. Press passes entitle you to nothing. Authorities use press credentials to determine if you are an official media representative and then *may* "invite" you to the scene of a crime or disaster.

Essentially, your press pass gives you no more rights than those held by the public. The press credential does not give you a right to break the law, even if you are in hot pursuit of a big news story.

Credentials issued by the highway patrol or the state police carry no legal weight other than proof you work for a newspaper or magazine. Official credentials can be ignored or recalled at any time by the law enforcement agencies that issued them.

On the other hand, at the scene of a crime or disaster, authorities cannot discriminate against you or your newspaper. All reporters, photographers, and TV camera operators must have an equal opportunity to cover the story. The police cannot select one newspaper photographer and reject another. Nor can police choose to let in television camera crews and keep out still photographers.

If the crime scene is crowded, however, they can ask photographers to cooperate and form a pool. One representative of the pool will photograph in the restricted area, and then share the pictures with the other photographers.

SUBPOENAS FOR NEGATIVES

A reporter for the *Louisville* (Ky.) *Courier-Journal* wrote a story about making hashish from marijuana. The article included a photograph of a pair of hands working over a laboratory table with the caption identifying the substance in the photo as hashish. After the article and photograph were published, the reporter was subpoenaed to appear before a grand jury and ordered to testify about whose hands had appeared in the photograph. The reporter claimed that both the First Amendment of the U.S. Constitution and a state law protected his confiden-

tial source of information. The U.S. Supreme Court said the reporter had witnessed a crime and that the sources did not receive special protection (Branzburg v. Hayes).

While twenty-six states have laws that to some extent shield reporters and photographers from courts subpoenaing negatives and notes, each state's laws are different. Unfortunately, the federal government has no shield statute that protects journalist/source confidentiality. And existing state laws provide only limited protection, especially when the photojournalist witnesses a crime. As the Supreme Court said in the marijuana/hashish case, "The crimes of news sources are no less reprehensible and threatening to the public interest when witnessed by a reporter than when they are not."

A subpoena for negatives and prints, surprisingly, is the No. 1 legal problem faced by news photographers, according to a survey of NPPA members by Michael Sherer of the University of Nebraska at Omaha. He found that 25 percent of the survey respondents had been subpoenaed for photographic materials. Sherer recommends not complying with a subpoena without first consulting with a lawyer and your editor. Finally, he cautions against destroying photographs sought by a subpoena. Doing so, he points out, can result in a citation for contempt of court.

COPYRIGHT: WHO OWNS THE PICTURE?

■ WHEN THE EMPLOYER OWNS THE PHOTOS

When you are an employee of a newspaper or magazine, the copyright for your photos is owned by your publication. The employer holds the rights to the pictures and can reprint or resell the photos. Protecting those rights is the employer's concern. Usually the entire newspaper or magazine is copyrighted, including all material contained in each issue.

You may, however, form other specific contractual arrangements with your employer. For example, when a company hires you for a staff position, you can agree to take the job with the stipulation that you own your negatives and transparencies, along with the rights to sell the photos after the company has published the originals. In fact, you can negotiate any contract you like with your employer as long as you arrange the details before you sign on the dotted line.

The right to sell pictures to other publications that you originally took for your newspaper or magazine differs among publications. Some papers keep the negatives and prints permanently. When newspapers sell a pic-

ture to another organization, they retain the profits but usually give the photographer a credit line. Other papers give the photographer a percentage of the profits from any resales. Some papers give the negatives to the photographer after a fixed period of time; other periodicals let the photographer retain the negatives and prints immediately after the paper publishes the photos the first time.

As a free-lancer, if you accept an assignment and agree to a "work-for-hire" contract, your employer can reuse or resell the photos without your permission.

■ WHEN YOU RETAIN THE COPYRIGHT

However, without a "work-for-hire" agreement, the publication does not own the copyright to those photos. Unless you make a special agreement, you retain the copyright. When you accept an assignment, you are granting a magazine or newspaper one-time rights. The pictures can be published only once. Any other use the publication wants to make of the photos is up to you — and all slides, negatives and prints should be returned to you.

If you take pictures on your own without an assignment, you own the negatives and the copyright. When you sell a picture that you did not take on assignment but shot on your own time with your own film, you can form several arrangements with the publication or agency buying the picture — as long as you form the agreement at the time of the sale. You can sell one-time rights. After the photo appears, you can resell the picture to another outlet. In a second type of arrangement, you can sell the picture along with exclusive rights to the picture for a specified period of time. In a third type of agreement, for even more money, hopefully, you can sell your copyright. This means that only the agency or publication has the right to distribute and sell the photo. You no longer have that right.

Remember, if you formed no specific agreements when you sold the picture, you automatically retain your copyright. The agency or publication has first rights, but you can resell the photo to other outlets later.

■ COPYRIGHTING YOUR OWN PHOTOS

If you don't work for a paper or are not on a magazine assignment, how do you protect yourself from someone reprinting your photos and not giving you credit or paying you? How do you prove the printed photo is yours if it does not carry your credit line?

To protect your rights, put your copyright notice on the back of each print with either of the following notations: ©, or the word "Copyright," with your name and the date. Although not required, it is a fairly common practice to include a statement that reflects the concept of "all rights reserved" or "permission required for use."

After you've put the copyright notice on the back of the print, you can immediately register the print with the U.S. Copyright Office in Washington, D.C., by filling out a form, sending two copies of the print, and paying a fee, or after the photo is published, by sending two sheets from the publication issue and paying a fee. But you do not have to register the print with the Copyright Office immediately, as long as you mark the photo with a copyright notation.

In fact, you never have to register the photo with the Copyright Office unless someone prints your picture without paying you, and you want to sue. Registration of the copyright is not necessary to maintain your rights, only to defend against infringement of them.

If you feel that someone is using your pictures in a manner that constitutes infringement, you must register your work as a prerequisite to filing an infringement suit. The advantage to registering your material as close to the original publication date as possible lies in the fact that the type of damages you can collect is tied to the registration date. For infringement prior to the registration date, the law allows only the award of actual damages and an injunction barring further infringement. However, for proven infringement after registration date, the law allows for the assessment of additional statutory damages and legal fees. Regardless of whether you decide on immediate or delayed registration, remember that registration must occur within five years of original publication and no suit may be filed and no damages collected without registration. ■

LAW REFERENCES

Barber v. *Time*, 1 Med. L. Rep. 1779 or 159 S.W. 2d 291 (Mo. 1942).

Branzburg v. Hayes, 408 U.S. 665 (1972).

Burton v. Crowell Publishing Co., 81 Fed. 154 (2d Cir. 1936).

Daily Times Democrat v. Graham, 276 Ala. 380 162S. 2d 474 (1964).

Dietemann v. *Time*, 449 F. 2d 245.

Estes v. Texas, 381 U.S. 532, 536.

Florida Publishing Co., v. Fletcher 340 So. 2d 914.

Galella v. Onassis, 487 F. 2d 986.

Le Mistral v. Columbia Broadcasting System, N.Y. Sup. Ct., N.Y. L.J. 6/7/76.

Leverton v. Curtis Publishing Co., 192 F. 2d 974 (3d Cir. 1951).

Lloyd Corp. Ltd. v. Tanner, 407 U.S. 551, 92 S. Ct. 2219, 33 L. Ed. 2d 131 (1972).

People v. Berliner, 3 Med. L. Rep. 1942.

People v. Zamora, 361 So. 2d 776.

Raible v. *Newsweek*, Inc. 341 F. Supp. 804 (1972).

Sbyszko v. *New York American*, 1930: 239 NYS, 411.

Photo Ethics

To protest the South Vietnamese government in 1963, a monk set himself afire after notifying the press. Should the photographer have tried to stop the monk from committing suicide? Should American newspapers have run the picture? (Photo by Malcolm Browne, *Wide World Photos.*)

ETHICS: DOING THE RIGHT THING

Photojournalism as a profession imposes a set of responsibilities. Some are fairly routine and fall neatly into the "daily duties" category: get to the scene, frame and focus the shot, collect the caption info, and so forth. Beyond — or perhaps beneath — these functional tasks lie broader ethical considerations. And confronting these issues is often more challenging than the assignment itself.

At times, these ethical issues pit the photographer's professional duties against his or her own conscience, that internal barometer that guides behavior and ultimately maintains social order. Photographers may, in the course of completing their assignments, be forced to choose between how they might act as individual citizens and how they feel they should act as visual journalists.

This dilemma — personal choice vs. professional responsibility — is certainly not unique to photojournalism. Consider, for example, the plight of the public defender charged to represent a rapist who he knows is guilty. Or the doctor who has the resources and training to artificially prolong the life of a suffering patient. In these examples, the Constitution and the Hippocratic oath, respectively, are compelling codes, but what about the individual rights of the attorney? Or the private conscience of the physician?

Now consider the less dire but still clouded situation of a photographer shooting a story about suburban high schools. While scanning a clattering lunchroom scene, the photographer spots a trio of students exchanging $20 bills and bags of white powder. Does the photographer, acting as a genuinely concerned citizen, try to stop or at least to disrupt the deal? Does he or she report the incident to the principal and offer a description of the players? Or does the photographer take the picture and publish it?

Almost every day, photojournalists face decisions of morality — ranging from removing a distracting item from a photograph to taking a gruesome picture at a murder site. But a looming deadline or the logistical challenge of a six-site assignment sheet can pressure the photographer into making snap judgments about even the most morally delicate situations. Thus, thinking about issues ahead of time may allow the photojournalist to avoid crisis on the scene or regret after a picture has been published.

Photojournalists use several arguments to explain their decisions to take or print controversial pictures. One argument, which sometimes fails to distinguish between practices and standards, relies on the familiar "Other Guy" argument: "I did it because that's the way other photojournalists do it."

These photographers are comparing their actions to a perceived industry "standard." Whether the action is inherently right or wrong is irrelevant to their argument: "This is the way everyone does it." While such a decision-making strategy might reflect professional practices, it does not create a standard grounded in the norms of ethical decision-making.

■ FOUNDATIONS OF ETHICAL DECISION-MAKING

Many photographers, whether they realize it or not, turn to an established ethical framework to try to guide their decisions.

UTILITARIAN

That framework includes the "utilitarian" principle defined by ethicists. Here the overriding consideration is "the greatest good for the greatest number of people."

The utilitarian position recognizes that photojournalism provides information critical to a democratic society. Photography might show the horrors of war, the tragedy of an accident, or the hardship of poverty. Therefore, it is right to take and publish pictures. Without information, in general, and pictures, specifically, voters cannot make informed decisions. Seeing accident pictures, for example, might cause voters to pass laws requiring air bags in every car.

ABSOLUTIST

However, the utilitarian principle of "the greatest good..." bumps up against a competing ethical principle that says, "Individuals have certain rights. . .," among them, the right to privacy. These rights are absolute and inviolable regardless of the benefits to society. Taking a picture of the distraught parents of a drowned child and then publishing it might cause others to be more cautious, but invading the privacy of their grief— regardless of the benefits — is not acceptable, according to the absolute rights argument.

"THE GOLDEN RULE"

Another of the ethical cornerstones is the Judeo/Christian rule, "Do unto others as you would have them do unto you." This rule, too, sometimes conflicts both with professional standards and with actions that might benefit a democratic society in need of information.

In the last example, if you put yourself in the place of the grieving parent, you might not want *your* picture taken. On the other hand, if you are trying to save children from drowning in the future and think that running the picture might caution parents or affect funding for extra lifeguards, you might run the photo, anyway.

Without providing a behavioral prescription for the photographer, this chapter will lay out some of the ethical dilemmas faced by the working pro and the picture editor. Rather than deal with cases of obvious fraud,

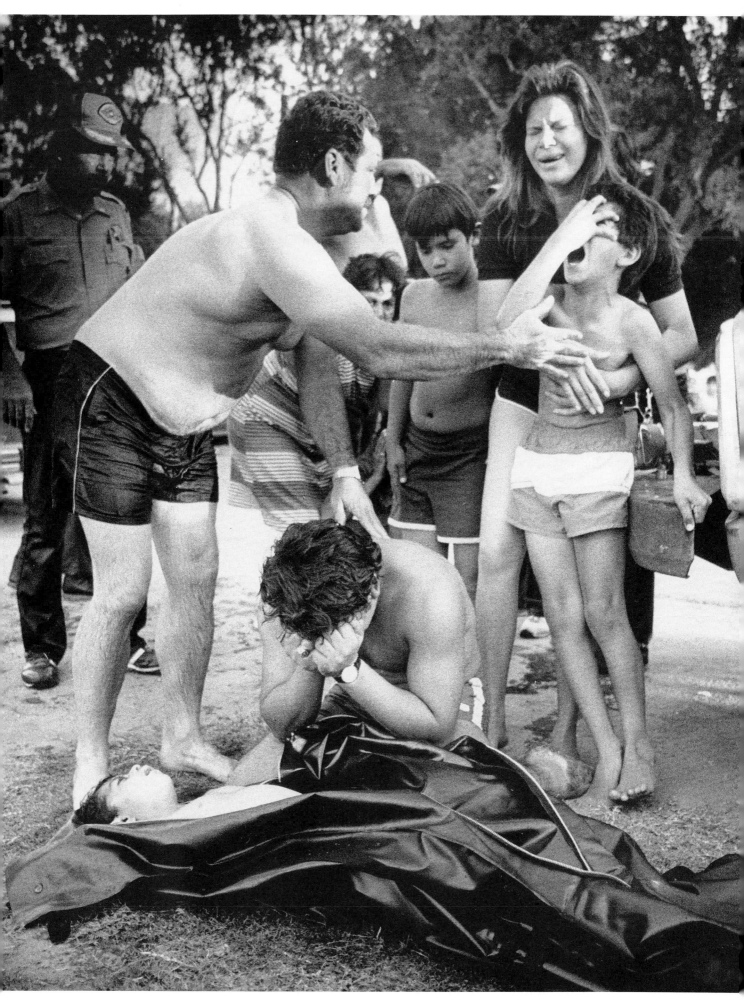

Dignitaries break ground for the John F. Kennedy Memorial Library. Would it be wrong to stage-manage a picture like this? **Do readers care?** (Photo by George Rizer, *The Boston Globe*.)

fakery, and patent sensationalism, the chapter tackles the gray area between right and wrong — the zone that troubles photographers on an almost daily basis.

CLEAN UP OR SET UP?

At a party, I once saw the well-known photo editor of a national magazine — and one of the most respected elders in the business — remove a Coke® bottle to improve the scene before he took a picture. While removing a pop bottle is a fairly trivial act, the incident does illustrate a basic ethical question: when can the photographer alter the scene without altering the message and creating an untruth? And if some set-up is permissible, when does 'some' become too much?

■ DETERMINING A NORM FOR ETHICS

In a precedent-setting study in 1961, Walter Wilcox, at the time chairman of the Department of Journalism at the University of California, Los Angeles, designed a study to determine the attitudes of readers, photographers, and editors toward staging news pictures. He sent questionnaires to three groups of subjects: general readers, working photographers, and managing editors.

On a three-level scale, each group evaluated sample situations a photographer might face as "definitely unethical," "doubtful," or "not unethical." Here are three sample situations from Wilcox's study:

Murder trial: *A photographer attempts to get a shot of a woman defendant, but she consistently evades him by shielding her face or ducking behind her escorting warden. The photographer spots another woman who looks like the defendant and by diffusing the light and adjusting the focus, he gets a striking picture, which no one will challenge as being fake.*

Ground-breakers: *A photographer covers a ground-breaking ceremony for a new church. Local dignitaries have already turned the first bit of earth before the photographer arrives. He asks that the ceremony be repeated. The dignitaries cooperate, and he gets his picture.*

Cricket plague: *A plague of crickets is devastating the hinterland. A photographer goes out to cover the story, but he finds the crickets are too far apart and too small to be recognizable in a photograph. He thinks he could get a better picture if the crickets were shown in a mass, and to that end, he builds a device that brings crickets through*

the narrow neck of a chute. He gets his shot of closely massed crickets on the march.

Wilcox found that the general public, managing editors, and working photographers agreed to a remarkable extent on what was ethical and what was not. In the survey, 92 percent of the public, 93 percent of the photographers, and 99 percent of the editors said the court photographer was wrong to photograph one person and claim it is another, even if the two look similar.

By comparison, 83 percent of the public, 88 percent of the photographers and 94 percent of the managing editors said it was not unethical to restage the ground-breaking ceremony.

Thus it seems that these three groups operate within the same ethical framework that allows "set-up" pictures but rules out clearly faked photos.

The third scenario, however, the photographer who collected and choreographed the crickets, sparked disagreement within each of the three groups. The general readers were almost evenly divided along the three-point ethics scale: 29 percent considered the photographer's actions "definitely unethical," 39 percent considered it "doubtful," and the remaining 32 percent considered it "not unethical." Managing editors were similarly split between definitely unethical (23 percent), doubtful (34 percent), and not unethical (44 percent).

Photographers, however, who probably have faced similar problems, were much more likely to consider amassing the crickets part of a photojournalist's routine job. Only 7 percent of the photographers polled felt the photographer in the example was definitely unethical; 30

A woman covers the head of her child to protect the youngster from radiation after a major accident at the Three Mile Island Nuclear Power Plant. Skeptical of photographers in general, an editor questioned the truthfulness of the incident. (Photo by Martha Cooper, © *New York Post*.)

percent considered his behavior doubtful; but a whopping 63 percent said that the cricket photographer was not wrong.

One could assume that two-thirds of the photographers polled would have rigged the shot if faced with the same situation.

In a 1987 study for the National Press Photographers Association (NPPA), Ben Brink found that re-creating a situation was acceptable to more than a third of the professional photographers he surveyed. However, staging a scene from scratch was acceptable to only 2 percent of the working pros.

Here was the **staging from scratch** vignette:

A photographer is assigned to cover the aftermath of a big storm. She notices a phone booth turned over in about two feet of water. She asks a child riding a bike in the water next to the phone booth to pick up the phone and pretend to be making a call. The photographer hands in the photo without telling the editor it was a set-up photo.

Only 2 percent of the photojournalists responded that this situation was acceptable. On the other hand, 91 percent said they would definitely not stage this picture without telling their editors.

The **re-creation** scenario in the NPPA study produced a different result, however.

A photographer is doing a picture page on a visiting nurse in a rural farming community. The one element she lacks to tell the story is a shot of the nurse walking across the field to the farm house. The photographer has seen her walk across the field before, but she's never been at the right place at the right time to get the shot, so she asks the

nurse to meet her at the house and walk across the field just as she normally would do. She has the nurse repeat the scene a couple of times to make sure she gets just the right shot.

The survey results, based on the responses of 116 professional photographers, indicated that 38 percent would re-create the scene. On the other hand, 28 percent of the respondents were not sure how they would handle the situation. Another 34 percent indicated that they definitely would not have the visiting nurse walk across the field just for the camera.

CHANGING VALUES

In fact, photojournalists' ethics are changing. In 1961, Wilcox found that none of the pros he surveyed were bothered by repeating a ground-breaking ceremony for the camera. Twenty-six years later, Brink, in the NPPA survey quoted above, found that a third of the photographers he sampled would not repeat or re-create a picture. While the two vignettes, the repeated ceremony and the nurse crossing the field for the camera, are not identical, the radical difference in photographers' responses over time does suggest a shift in photojournalistic ethics. Re-creations of picture situations that were acceptable to every pro in the '60s were anathema to a large segment of the photojournalistic community by the '80s.

WHOSE RESPONSIBILITY?

Surprisingly, many photographers felt that telling their editors absolved them of ethical responsibility. In a follow-up question to the staging vignette, the study showed that 33 percent of the photographers no longer found staging the picture unethical if they explained the facts to their editors. Telling a higher authority seemed to eliminate feelings of responsibility on the part of these pros. Can photographers avoid ethical decisions this easily?

DO READERS BELIEVE THEIR EYES?

Below a headline in the *New York Post* that read NUKE LEAK AT INDIAN POINT, a picture ran showing a woman holding a child covered by a blanket. The mother appeared to be trying to protect her child from nuclear rays from the atomic energy plant. The picture was published not only by the *Post* but also by *Time*, the Associated Press and United Press International.

When several newspapers in the Northwest printed the photograph, the editor and publisher of the *Centralia* (WA) *Daily Chronicle*, Jack Britten, attacked the integrity of the picture in an editorial.

"Come on," the editorial demanded. "Who do

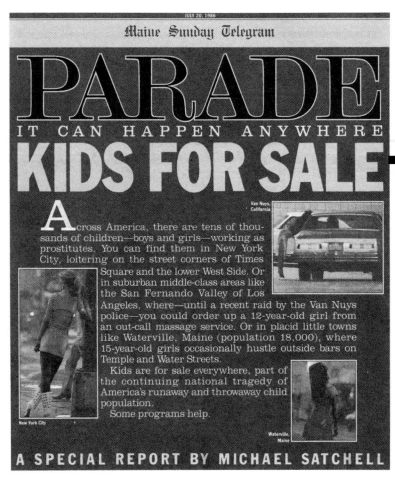

MAINE SUNDAY TELEGRAM

JULY 20, 1986

PARADE

IT CAN HAPPEN ANYWHERE

KIDS FOR SALE

Across America, there are tens of thousands of children—boys and girls—working as prostitutes. You can find them in New York City, loitering on the street corners of Times Square and the lower West Side. Or in suburban middle-class areas like the San Fernando Valley of Los Angeles, where—until a recent raid by the Van Nuys police—you could order up a 12-year-old girl from an out-call massage service. Or in placid little towns like Waterville, Maine (population 18,000), where 15-year-old girls occasionally hustle outside bars on Temple and Water Streets.

Kids are for sale everywhere, part of the continuing national tragedy of America's runaway and throwaway child population.

Some programs help.

Van Nuys, California

New York City

Waterville, Maine

A SPECIAL REPORT BY MICHAEL SATCHELL

they think they're conning? Any discerning reader could quickly see that the photo is very likely staged. . .the photo is an obvious put-on, a misrepresentation of the actual situation, and the editors should have known it. If they didn't know it, they shouldn't be editors."

In fact, the photographer who took the picture, Martha Cooper, and *Post* reporter Deborah Orin, actually found the woman as she was leaving her house, her baby covered with a blanket. Orin interviewed the woman, who had been worried about her year-old daughter's exposure to radiation. She had been ready to climb into her car and leave the area when the *Post* team found her. During the interview, Cooper took the pictures. In a follow-up story in the *Washington Star*, noted columnist Mary McGory confirmed the photo's authenticity.

If a seasoned newspaper editor questioned the photo's truthfulness, how often do readers wonder whether what they see in newspapers and magazines really took place? After all, guests watch professional photographers pose pictures at every class reunion, Bar Mitzvah, and wedding. While such photographers are not photojournalists, how many readers make the distinction?

■ WHEN FACTS CONFLICT WITH PICTURES

Just how widespread is disbelief in photojournalism? No one knows for sure, but the disbelief extends at least to Waterville, Maine.

"Kids for sale," shouted the July 20, 1986, cover of *Parade* magazine. "It can happen anywhere."

Three small color photos of unidentified and unidentifiable, sultry adolescent "girls of the street" dotted the text-dominated black cover, which announced a "special report" on child prostitution.

Anywhere, according to the picture identification, included New York City, Van Nuys, Calif., and "placid little towns like Waterville, Maine."

Fortunately, a local Maine newspaper challenged the story. Local reporters discovered that the Attorney General's office in the Maine jurisdiction had prosecuted only two cases of prostitution in Waterville, none involving teen-agers — and that the young Waterville "prostitute" in the photo was actually a model.

When free-lance photographer Dean Abramson was unable to find an actual street-walking teen in Waterville, his *Parade* magazine editors told him to hire a model. Abramson complied and eventually snapped the posed picture.

Although *Parade* editors initially denied the subterfuge, later they recanted, saying that an explanatory line of type had been omitted. In a follow-up article for *News Photographer* magazine, they further rationalized the situation by telling writer Betsy Brill that they routinely used models for stories involving minors.

However, in interviews with other photographers on the project, Brill discovered that, despite editors' claims, only two of the three pictures had been set up with models for the *Parade* cover. A third captured an actual candid moment.

Camera 5 free-lancer Neal Preston verified that his assignment from *Parade* had been to find and photograph actual teen-age prostitutes (not models). He had done so in Van Nuys, California. "I could have saved a lot of time and film if I had hired a model," he told Brill when he learned the other photos had been set up. "I'm proud that my picture was the one that was real."

Award-winning photojournalist Eddie Adams, who photographed the New York City set-up, told Brill that concern over the staged photos was "a lot of bullshit." He said that the hiring of models for stories involving children is done "all the time " — not just by him, he said, and not just by *Parade*, but by all magazines, especially for cover stories.

"There's a difference," Adams said, "between an illustration and a straight picture." (See Chapter 8, "Illustrations.") Yet, he admitted, the reader has no way of knowing the difference without words.

Adams, however, begged the ethical question and relied on the familiar "everybody does it" argument. The question is not "do photographers hire models regularly when taking pictures of children?" The real question is "should photographers use models — and pose them so that they look as though they're in real situations?"

Whether you're a magazine reader in Waterville, Maine, or a newspaper reader in New York City, your belief in pictures drops when you discover that some of the images you are seeing are figments in the imaginations of photo editors and not records of reality.

A CONTINUUM OF CONTROL

Between moving an obstructing Coke® bottle and hiring a model to impersonate a teenage hooker lies a large, gray ethical chasm. This gray zone, with its myriad shadows and shadings, can challenge even the most clear-sighted photographer. Are all situations the same?

Do the same rules apply to features, portraits, and illustrations as well as to hard news? Far from being a fixed commodity, the photographer's level of control is variable, logistically and ethically. A newspaper photojournalist's weekly assignment sheet is likely to represent a continuum of control — from strictly hands-off to complete manipulation. Photojournalists cover subjects ranging from a war in the Middle East to a fashion shoot in midtown. Like the fashion shoot, some pictures require complete control. Other situations, like disputes in Israel or arrests downtown, require the hands-off, fly-on-the-wall approach.

Any time you take pictures, you are affecting the scene to some degree. According to noted physicist Werner Heisenberg, observation itself alters the object being observed. This principle applies to photography as surely as it does in the sub-atomic world.

For instance, whether a subject consciously thinks about the photographer or not, that person's behavior changes in the presence of a camera. Some subjects exaggerate their behavior; others shy away from the camera. Even thinking a camera might be present can alter some people's behavior.

Even though photographers and their cameras have some influence on the scene they are photographing, the question the working pro must ask is: "*when* should the photojournalist remain an observer, removed as much as possible from the scene? When should the photographer intervene?"

■ HIDDEN CAMERAS

On the extreme end of the continuum, consider the security camera located in the ceiling of the First National Bank. The camera automatically snaps a picture at regular intervals, regardless of who is standing at the teller

window. The bank camera, which exercises no control over the subject, represents the farthest end of the control

continuum — no control at all. Despite its passivity, however, even it alters the scene being observed: most criminals would certainly take different precautions while robbing a bank under constant photographic surveillance.

■ SPORTS PHOTOGRAPHY

Next, consider the sports photographer shooting action along the sidelines of a track event. A hurdler races down the track. Even if she wanted to, the sports photographer could have little influence on the athlete. She would not tell the

(Photo by Michael Meinhardt, UPI.)

runner to run to the right for a better picture. The sports photographer has virtually no control over the subject but does select the moment to release the camera's shutter.

■ HARD NEWS

Elsewhere along the continuum is the news photographer covering a riot. Most photographers would hesitate to direct a demonstrator or tell a policeman to stand aside to improve a photograph's composition. The photographer could initiate control but refrains in a true hard news situation.

(Photo by Charlie Fellenbaum, *The Hemet* (Calif.) *News.*)

■ FEATURES

When shooting the feature picture, the continuum becomes slippery. Here, photographers disagree about when to intervene and when to merely observe. The action is touching, but the light is not great. If you asked the subject to move over a few feet, you could get perfect back-lighting. Would that be acceptable?

Different photographers have determined different points where they will draw

(Photo by Arthur Pollock, *Boston Herald.*)

the control line when faced with a feature assignment. Some photojournalists would not hesitate to ask the subject to move.

Other shooters would never consider disturbing the moment, even if leaving the situation untouched meant that they would not get a superb picture.

■ PORTRAITS

Taking portraits usually requires some direction on the part of the photographer. If the assignment is to take pictures of the president of the local university, the photographer usually must tell her where to sit and what to do with her hands. The photographer might ask the president to look directly at the camera. This way the reader

(Photo by Ken Kobré)

will know that the administrator was cognizant of the photographer and won't think the picture is a candid photo. An unwritten but probably accurate rule holds that if the subject is looking straight at the photographer (i.e., the reader), the subject is aware of the camera.

■ PHOTO ILLUSTRATIONS

Now let's analyze the extreme, full-control end of the continuum: photo illustrations. Photojournalists manufacture every aspect of a photo illustration — including editorial concept photos, food photos, studio and location fashion shoots. The photojournalist arranges the props, perhaps builds the set and hires and even dresses the models. In fact, the only real element in the picture is the film. The viewer has no illusions about the illustration or the photographer's role.

(Photo by Bob Farley, *Birmingham Post Herald.*)

If the photographer has been careful, the created photo cannot be mistaken for real. Through the use of

exaggerated size, seamless backgrounds, and other visual devices, the photojournalist can assure the reader that the picture is constructed and not a slice of real life. (See Chapter 8, "Illustrations.") With photo illustrations, the photographer exercises complete control.

■ CONCLUSION

As they go from assignment to assignment, most working pros find themselves at different points on the continuum of photographic control. Generally, photojournalists find decisions about how to handle the ends of the continuum fairly easy. How the photojournalist approaches a sports event or five-alarm fire is quite different from how that person handles a fashion or portrait assignment. Photojournalists set up some pictures but not others. The question that each photographer must ask is: where should I be on the continuum of control. At any given time, what part of the continuum should I choose? Which spot along the continuum is appropriate for this assignment?

KEEPING UP WITH SHIFTING STANDARDS

That decision regarding control is a choice based more on a photographer's time in history than on any established guidelines. Photojournalism has no Bible, nor does it have a rabbinical college or a Pope to define correct choices. And while surveys like those by Wilcox and Brink help establish current practices in the field, professional values do not remain fixed in time. Not only are professional standards changing, so are readers' expectations. Staying abreast of professional standards and evaluating decisions with an eye to the ethical foundations described at the beginning of this chapter should be helpful when faced with difficult moments.

Keep in mind that setting up feature pictures used to be perfectly acceptable to most newspaper photojournalists. In his book **Spot News Photography**, written in the early '50s, *New York Post* photographer Barney Stein proudly described as a routine photojournalistic activity how he went about setting up feature pictures of a cowboy performing for crippled kids or of a Dalmatian firedog wearing the chief's hat.

John Faber, historian for the National Press Photographers Association (NPPA), recalls traveling around the country as Kodak's professional representative, teaching newspaper photographers how to create imaginative feature pictures.

In his 1961 survey, Wilcox found that no photojournalist objected to restaging a ceremony for a photo.

ONE PHOTOGRAPHER WHO DIDN'T CHANGE WITH THE TIMES

(Photo by Norm Zeisloft, *St. Petersburg Times and Independent.*)

Not long after the Janet Cooke affair (see page 300), one *St. Petersburg* (Fla.) *Times* staff photographer selected a spot on the continuum that proved out of sync with changing times. The results were disastrous for him.

The incident began with a routine assignment for 61-year-old Norman Zeisloft, a veteran photographer and past president of his regional NPPA chapter. He had been shooting for the *St. Petersburg Times and Evening Independent* for more than seventeen years.

HELPING ALONG A FEATURE

Zeisloft had been assigned to cover a baseball game between Eckerd and Florida Southern Colleges. "It was quite a nothing event," he recalled for Jim Gordon, who later wrote a comprehensive story about the incident for *News Photographer* magazine.

Spotting three bare-soled fans with their feet up, Zeisloft approached them and said it would be "cute if you had 'Yea Eckerd' written on the bottom of your feet."

They agreed, and Zeisloft pulled out a felt-tip pen and began writing on the soles of one man's feet. Zeisloft found that his pen was dry and the spectator's feet were too dirty to accept writing. Meanwhile, one fan left the stands, washed his feet and reappeared with "Yea, Eckerd" on his soles. Zeisloft took the photo, and it ran two days later in the *Evening Independent.*

"It was just a whimsical thing, just for a little joke," Zeisloft recounted. "It was just a little picture to make people smile rather than an old accident scene."

But nearby was Phil Sheffield, a *Tampa* (Fla.) *Tribune* photographer since 1974 and a photographer for Miami's Associated Press bureau before that. Almost instinctively, Sheffield said, he snapped one frame as Zeisloft originally applied pen to sole.

Posted as a joke on the bulletin board of *The Tampa Tribune,* the photo eventually found its way to the president and editor of the *St. Petersburg Times* — Norm Zeisloft's boss, a judge on the Pulitzer committee that had been caught in the web of Janet Cooke's dishonesty.

STANDARD PROCEDURE BECOMES GROUNDS FOR DISMISSAL

Zeisloft was fired on his first day back from vacation.

Later, in an administrative appeal hearing over denied unemployment benefits, Zeisloft explained that news photographers often set up pictures about society and club news, recipe contest winners, ribbon-cutting and ground-breaking ceremonies, awards and enterprise features.

He took to the hearing pictures that had won professional contests, some from the old *Life* "Speaking of Pictures" department.

Others, he explained, had gone "nationwide via AP and UPI wire services. The pictures had won awards plus applause from editors.

"These pictures were not intended to bamboozle the public or to 'distort' the news. They were shot with good humor and were merely designed to give the reading public a good chuckle. They were harmless and entertaining. That and nothing more," Zeisloft said.

"To me," Zeisloft said, "it seemed like cruel and unusual punishment to be fired after seventeen and a half years of faithful service on the basis of one photo that was designed merely to bring a chuckle to our readers. There was not one phone call or letter from our reading public in regards to the picture.

"If a cop shot a person he'd get a suspension. Doesn't seventeen and a half years count for anything?" he asked.

A CONTINUUM TEMPERED BY TIME

Unfortunately, Norm Zeisloft had selected a spot on the control continuum that was not professionally acceptable for the time and place he was working. Ten years earlier or at another newspaper or magazine, the set-up feature might have been perfectly accepted by the profession and even by the public. Zeisloft found himself out of register with the current dividing line between acceptable and unacceptable practice on the continuum of control.

Because the place acceptable to fellow professionals and the public on the continuum shifts with time and events, all photojournalists should re-evaluate their own set points. Do theirs coincide with other members of the profession, with editors, and with the public?

Finally, even if a practice is acceptable in the field, the photographer must answer a more difficult question: is the behavior ethically right? Should I do this even if all my peers are doing it? While photographers should be aware of standards in the field, they should also deal with the more basic question of right and wrong.

Yet, today, according to the Brink survey, at least a third of the photographers who are NPPA members would object to restaging a situation.

JANET COOKE

What has caused this change in standards for the profession? Many observers point to one incident as the pivot point for journalists.

In 1981, Janet Cooke, a reporter for the *Washington Post*, won a Pulitzer Prize based on a story she wrote about a 6-year-old drug addict. After the prize was awarded, investigators discovered that the child never existed. The young addict was a figment of Cooke's imagination — a "composite" of characters and incidents she had come upon in her research. The journalism profession threw up its arms in outrage and began a hard, soul-searching re-examination of its ethical practices. Professional groups sponsored seminars, authors wrote books, and universities initiated classes in journalism ethics. And the public's view of the press, its practices and its prizes dropped to a post-Watergate low.

The outgrowth of this examination was an increased sensitivity, even vigilance, to how the profession performs its work. The profession began to question some of its accepted standards. The spotlight on the Cooke case also heightened sensitivity toward ethical standards within the photojournalism community.

MONITORING

For the neophyte photographer or the seasoned pro, the profession does not provide a fixed yardstick, a definitive set of guidelines, or a regular measure of what other photojournalists in the trade are thinking and doing.

In fact, photojournalists disagree among themselves about the correctness of many choices.

Craig Hartley, in a national survey of professionals for his thesis on photojournalistic ethics, found that of nineteen hypothetical problems presented to working pros, almost half the questions resulted in a wide split among respondents. On nine questions, at least a third of the photojournalists did not agree with their other responding colleagues. Clearly, photojournalists do not think as a monolithic block when the topic turns to ethics.

Interested photographers can, however, use the trade media and other resources to monitor the thoughts of their fellow journalists and shape their own ethical touchstones. *News Photographer* magazine, the trade publication of the National Press Photographer's Association, reports on controversial issues. Read, in particular, the magazine's letters-to-the-editor column to check the pulse of the working pro. In addition, magazines such as *Columbia Journalism Review, Washington Journalism Review* and *Photo District News* report on changing professional standards. *Journalism Quarterly* publishes research on this topic.

Besides magazines, workshops such as NPPA's Flying Short Course and the *San Jose Mercury-News'* and the *Pittsburgh Press'* annual graphics conferences provide valid insights into photojournalism's shifting mores.

RULE OF THUMB

What if you're not abreast of current standards, and you find yourself in a touchy situation on assignment? You might use this test of your own honesty, originally suggested by Elisabeth Biondi, photo editor of *GEO* and later *Vanity Fair* magazine. She suggests that photographers test their ethical decisions by considering whether they would feel comfortable writing an imaginary note to the reader explaining how the picture was taken. For example, would the photographer mind explaining, "I brought these clothes for the subject to wear, and then I told him to make that crazy face"? If the photographer is willing for the reader to know how the picture was constructed, what props were added, and what direction was given, then, Biondi says, the photo is probably acceptable ethically. However, if the photographer would feel uncomfortable revealing to the reader his or her methods, then the picture likely falls on the unethical side of the line.

COVERING TRAGEDY AND GRIEF

When injuries occur at a car crash, a hotel fire, or a natural disaster, bystanders and relatives often block a camera reporter from taking pictures. Understandably, these people are upset. John L. Hulteng, in his book ***The Messenger's Motives***, writes, "Photographers have acquired the reputation of being indifferent to the human suffering they frame in their viewfinders."

While the law gives the photographer the right to take a picture, the law is an institution, not a human being who has just lost a son or daughter.

Using the utilitarian principle of ethical decision-making, on the other hand, photographers have a moral responsibility to their readers to picture the world accurately, showing both its triumphs and its tragedies. An open democracy in which citizens must be informed to vote intelligently depends on information. Photos provide information. In the long run, individuals cannot make insightful decisions without a balanced and accurate picture of the world. This argument says that, in general, people will benefit from seeing both the good and bad, the happy and sad, the joyful and tragic elements that comprise our world.

Totalitarian dictators always try to muzzle the press to suppress information. The press also self-censors

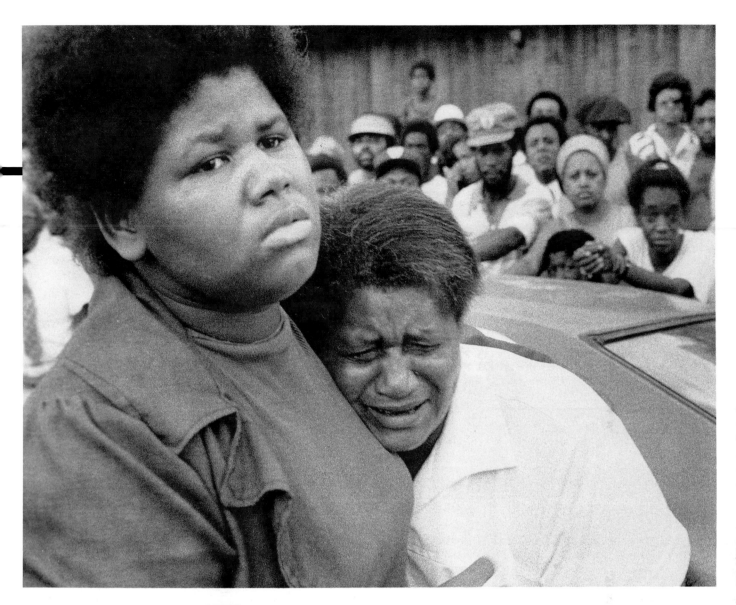

its own publications with written or unwritten guidelines. Newspapers at the beginning of World War II, for example, never showed dead American soldiers because editors wanted to keep morale high on the homefront. Until *Life* magazine ran a photo showing dead American soldiers strewn on a beach, the public was sheltered visually from some of the war's impact. Is it right or even responsible for the press to protect the public in this way? Is it possible that by withholding these scenes, the press actually prevented Americans from developing a healthy outrage about events in Europe, a fury that perhaps could have fueled the war effort?

The corpseless photos were not inaccurate per se. They were merely incomplete. Arbitrarily editing out death — or any other sign of violence or tragedy — gives readers a false sense of their own security and a skewed view of their world.

However, does this case for the "common good" supersede the rights of the grief-stricken individual?

The woman on the right has just seen her grandson accidentally killed by the police. Photographers have the moral responsibility to picture the world accurately, but also the personal responsibility not to increase the individual suffering of victims' friends and relatives.
(Photo by Bela Ugrin, ©*The Houston Post.*)

World War II was a tragedy comprised of millions of individual tragedies. Does the photographer have the right — or the obligation — to record moments of individual loss? These issues are complex, but there is one clear tenet to guide the photographer's behavior in traumatic situations: the photographer has a responsibility not to inflict greater suffering than necessary on survivors of a tragedy. "Than necessary" is obviously a troublesome phrase here, one defining that difficult gray zone. Unfortunately, there is no clear measure of necessity.

In the end, the photographer must balance the harm to the individual subject caught in the jaws of tragedy with the long-range needs of society to see an unvarnished picture of the world.

■ DO ALL TRAGEDIES NEED PHOTO COVERAGE?

If you are familiar with your equipment, you can usually take a few quick, available-light, candid shots nearly unnoticed at an accident scene. Beyond these photos, you must weigh the short-range pain of your presence versus the long-range value of your potential photos — a difficult judgment each photographer must make. Neither photographers at the scene nor editors back at the office are clairvoyant. Neither can look into a crystal ball and predict the effect of a picture.

Photojournalists must maintain a belief in the

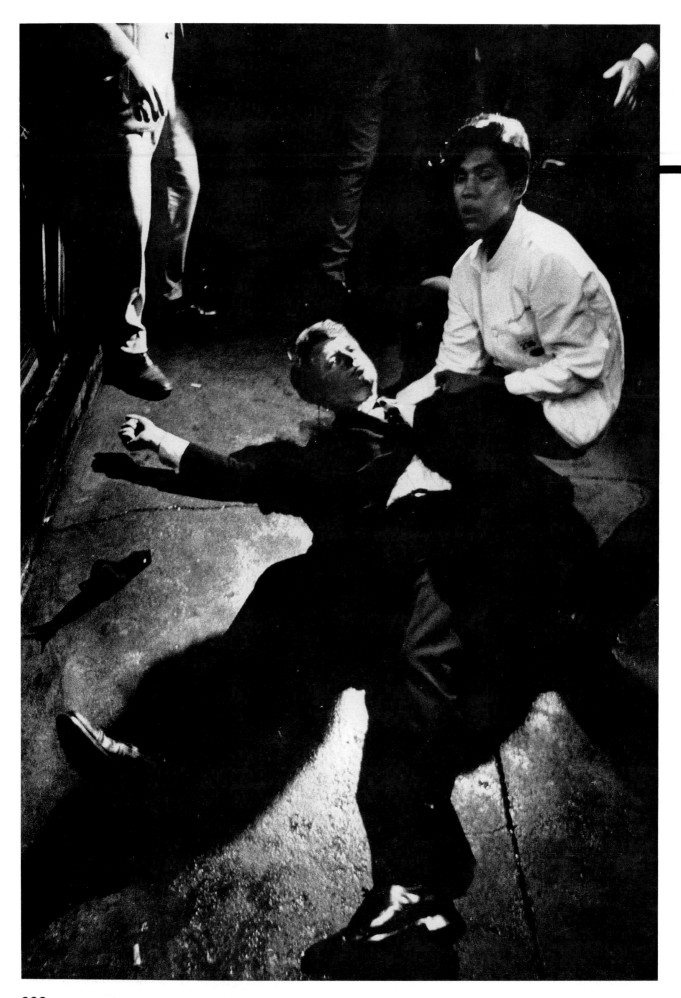

When Robert Kennedy was shot, a woman bystander blocked Boris Yaro's camera. He said to her, "Goddammit, lady, this is history!" and took this unforgettable picture. (Photo by Boris Yaro, © Los Angeles Times.)

overriding long-range importance of photos and the specific contribution of their particular photo. With emotion-laden events, this balancing act proceeds cautiously and continuously.

Eddie Adams, who photographed a Viet Cong suspect being assassinated in the streets of Saigon (see page 312), told me about a photo he didn't take while covering that war:

"On a hilltop in Vietnam, I was pinned down with a Marine company. Machine guns were going off. Dead bodies were lying on either side of me. Rocket fire seemed to be coming from everywhere. I was lying on the ground five feet away from an 18-year-old marine. I saw fear on that kid's face like I had never seen before. I slid my Leica, with its preset 35mm lens, in front of me. I tried to push the shutter, but I couldn't. I tried twice more, but my finger just would not push the button. Later, I realized that I was just as scared to die as that kid was. I knew my face looked exactly like his, and I would not have wanted my picture seen around the world. I think his and my face said WAR, but I still think I did the right thing by not taking that picture."

Adams chose to invoke the "do unto others ..." Golden Rule. However, the photographer might also have considered the possible value to society from seeing the censored image. Adams' Pulitzer prizewinning picture of the Vietnamese colonel executing a suspected Viet Cong did help to change the course of the Vietnam war. In the execution situation, society's greater good was served by photographing the scene.

Adams' hesitation at taking pictures on the hilltop in Vietnam was rare. Most professional photographers don't hesitate to take pictures when faced with a gut-wrenching accident or tragic murder.

In fact, many photographers say that because the critical moment is fleeting, they shoot instinctively. They point out that you can always decide not to use the picture, but you can't revisit the moment. The consequences of taking someone's picture, the momentary disturbance or embarrassment, is relatively minor. Publishing the picture, which will be seen by friends, colleagues, and strangers, has a different and perhaps longer lasting impact on the subject.

Finally, hesitating to take pictures can conflict with the professional role of the photojournalist. In most circumstances professional standards would support the "shoot now—edit later" approach.

Boris Yaro, a *Los Angeles Times* photographer, had no trouble making the decision to take pictures when he photographed Senator Robert Kennedy's assassination at the Ambassador Hotel. Later he told the story to John Faber, author of **Great News Photos**.

"I was trying to focus in the dark when I heard a loud Bang! Bang! I watched in absolute horror. I thought,

'Oh my God it's happening again! To another Kennedy!' I turned towards the Senator. He was slipping to the floor. I aimed my camera, starting to focus, when someone grabbed my suit coat arm. I looked into the dim light, seeing a woman with a camera around her neck screaming at me. 'Don't take pictures! Don't take pictures! I'm a photographer and I'm not taking pictures!' she said."

For a brief instant, Yaro was dumbfounded. Then he told her to let go of him. "I said, 'Goddammit, lady, this is history!'" He took the photographs.

■ SUGGESTIONS FOR PHOTOGRAPHING TRAGIC MOMENTS

In an article for *News Photographer* magazine, Michael D. Sherer collected comments from photographers who had covered tragic events. Here are their guidelines:

On conduct: Be early, stay out of the way, and don't disrupt what's going on. Be sensitive to your subjects and the situation. Be compassionate. Do not badger or chase subjects to the point of annoyance.

"How would I feel if I were the person being photographed?" asked Jim Gehrz, of the *Worthington* (Minn.) *Daily Globe*, invoking the "Golden Rule."

On equipment: In sensitive situations, carry as little gear as possible, leave the motor drive behind, and use the longest lens possible. Don't become a spectacle.

On selectivity: Pick your shots carefully — look for angles and subjects that will not offend subjects' and readers' sensitivities.

On dress: Wear "appropriate" clothing. "Dress is an important part of the way the public perceives us and in their acceptance of us in times of stress," said Mark Hertzberg, of the *Racine* (Wisc.) *Journal-Times*. "I think many of us can dress better day-to-day without having to wear a three-piece suit."

Afterward: Dave Nuss of the *Salem* (Ore.) *Statesman-Journal* suggests, "Consider contacting the subjects sometime after publication to discuss the reason for, and reaction to, publishing the image."

■ RESPECTING PRIVACY AT FUNERALS

Funerals are sad, stressful, and emotionally draining. They provide a context for grief and a forum for sharing sorrow among family and friends — not photographers. Unfortunately, sometimes they are also newsworthy.

The decision to cover a funeral generally rests with an editor, but once that decision is made, it's the photographer's responsibility to complete the assignment. And it's the photographer, not the editor in the office, whom mourners notice, resent, and berate.

Photographers and the public have widely differing views about professional ethical conduct at these ceremonies. Craig Hartley surveyed NPPA members and citizens of Austin, Texas. He wanted to find out how each

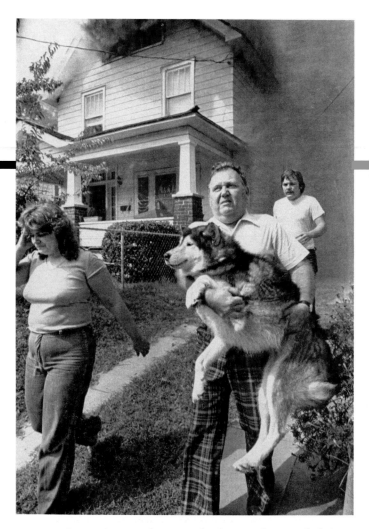
group viewed a number of ethical situations, one of which involved the funeral of a slain police officer, an event that an uninvited photographer attends and photographs even after being asked to leave.

Hartley found that while 63 percent of the news photographers he surveyed found the photojournalist's behavior at the funeral "ethical," 85 percent of the public found the behavior "unethical." Readers, who vehemently hated the actions of the photojournalist at the funeral, did not perceive the picture's value as meriting this intrusion into the private ceremony.

With such reader reactions in mind, Mary Lou Foy of the *Miami Herald* offers suggestions for funerals:

Make arrangements ahead: When you get a funeral assignment, contact the family or close friends to let them know you are coming. Express your sincere sympathy by simply saying you are sorry about their loss. If you are unable to speak with a family member or friend, the funeral director is your next best choice.

Dress soberly: Photographers must dress as if attending the funeral. This means a suit or dress in dark color.

Be early: Then you will be situated and are a part of the scene when everyone else arrives.

Limit the motor drive: Pick your shots and don't unload with your motor drive. Even if the family has said okay, you'll offend those who are also grieving and who don't know you have family permission.

No lights, please: Avoid using strobes. Nothing is more offensive than a strobe flashing in the face of a crying person during a funeral service.

PROFESSIONAL VS. GOOD SAMARITAN

When should the photographer act as a professional photojournalist, and when should the cameraperson act as a responsible citizen? What happens when the roles conflict?

Consider these scenarios:

You are driving along the street and see a man running out of a pawn shop carrying a television set under his arm with the proprietor in hot pursuit. Do you try to stop the thief with the intent of holding him for the police, or do you take a picture of the whole scene as the criminal escapes around the corner?

Later in the day, you see an accident by the side of the road. A child, stuck behind the car's dashboard, cries inconsolably. Do you take the little girl's picture or sit and comfort her?

A terrorist group has agreed to let you photograph their activities. They take you on a secret mission to plant a bomb in a building. Do you take their pictures or try to stop them from activating the explosive? How would you handle the situation if you were photographing a similar raid, only this time the group was a U.S. army unit, not a terrorist gang?

The argument for professionalism often parallels the utilitarian principle of ethics. The photojournalist has a role in society just as a doctor or lawyer has. That role is to inform the public. Information allows this country's citizens to make intelligent decisions. By actually seeing what is going on — including a thief in the act of stealing a television set, terrorists planting a bomb, a person committing suicide, or even the agony of a child caught in a car wreck — citizens can perhaps learn enough — or be moved enough — to prevent such things from happening to others in the future. Information can lead to changes in public policy, laws, funding, or perhaps just improved behavior.

A photographer's job is to record the news, not to prevent it or to change it. Like an anthropologist observing a foreign culture, the photojournalist should look, record, but not disturb what is going on.

The Good Samaritan argument is absolutist: a photojournalist is, first and foremost, a human being. A photojournalist's primary responsibility is to the human being needing immediate help. Journalism comes second. No one can measure the ultimate good a photo will do later, but you can see the immediate needs of the present.

A SUICIDE FOR THE MEDIA

At a press conference called by Bud Dwyer, Pennsylvania's state treasurer, he proclaimed himself innocent of a kickback scandal and then killed himself. No photographer could have stopped him. Should these pictures have been published? (Photos by Gary Miller (LEFT) and Paul Vathis (CENTER and RIGHT), Associated Press.)

Joe Fudge of the Newport News (Va.) *Daily Press/Times Herald* had no problem making the ethical choice between being Good Samaritan and professional photojournalist when he saw smoke pouring from a third-floor roof.

First asking the newspaper office via two-way radio to notify the fire department, Fudge then charged into the burning house and alerted residents that their attic was ablaze. "I went into the house and found three people sitting around eating. They didn't know that a fire was burning off the top of their house. The woman said, 'Oh, my God, my husband is asleep in the the third-floor bedroom.' By this time, the flames were coming through the ceiling of the third floor. We went up and woke him up. Then all of us escaped."

When Fudge jumped out of his car after spotting the fire, he did not take in his cameras. Later, he returned for his equipment for a picture of the dad saving the family dog. Rather than photograph the burning house, Fudge decided to save lives first.

■ SUICIDE: A SPECIAL CASE?

When he shot for the *Oregon Journal*, photographer William T. Murphy, Jr., faced the dilemma of taking pictures or trying to help a woman stop her husband from killing himself. He tried to do both — by taking five shots as he attempted to talk the man out of jumping one hundred feet into the Columbia River and as he yelled at another motorist on the bridge to go for help.

But the man soon struggled free from the desperate grip of his wife and jumped to his death in the swirling river.

Few readers sympathized with Murphy's ethical dilemma. According to "Ethics of Compassion," an article

by Gene Goodwin in *Quill* magazine, many readers complained about Murphy's photo of the suicide, which went out over the UPI wires.

"Don't the ethics of journalism insist that preservation of human life comes first, news second?" asked a reader from Philadelphia. A New York reader wrote, "He let a man die for the sake of good photograph."

Murphy replied to the criticism: "I don't know what I could have done differently. I am a photographer, and I did what I have been trained to do. I did all I could."

SUICIDE AS A FORM OF EXPRESSION

No one attempted to stop a Buddhist monk who set himself on fire protesting the 1963 Diem government in South Vietnam. The shocking pictures showed readers dramatically and convincingly how serious the country's problems were. The monk used his death as the ultimate form of political expression. (See pages 290–291.)

One person's private turmoil resulted in a national issue when Pennsylvania State Treasurer R. Budd Dwyer called a press conference just hours before he was to be sentenced for his conviction in a $300,000 kickback scandal.

Dwyer, 47, was facing up to 55 years in prison. After thirty minutes of proclaiming his innocence to reporters and photographers, Dwyer picked up a large manila envelope and pulled out a long-barrel, blue-black handgun. He placed the gun in his mouth and pulled the trigger.

Could photographers, reporters, or TV camera crews have stopped Dwyer? The consensus was no. Once the gun was out of the envelope, only 15 seconds elapsed before Dwyer shot himself. Also, Dwyer had built a barricade of chairs and tables between himself and the press.

USING PHOTOS TO SHOW MENTAL ILLNESS

A former mental patient shot himself with a 12-guage shotgun. Do the pictures help call attention to the problems of the mentally ill? (Photo by Peter Bradt, *Wichita Falls Record News.*)

Should photographers have stopped Budd Dwyer if they had the opportunity?

Was Dwyer making a political statement? On the other hand, are the pictures so upsetting to the public that they cause the reader to look away from the paper rather than consider the underlying issues?

SUICIDE AS MENTAL ILLNESS

Beyond the political question of suicide as a form of expression, photographing suicide raises the issue of documenting severe mental problems.

In Wichita Falls, Texas, a former mental patient committed suicide with a 12-gauge shotgun. In this situation, the photographer had no chance to stop the man. Don James, the executive editor of the *Record News,* explained the picture to readers by saying, "We felt the story leading up to the suicide illustrated a shocking failure on the part of our system."

In the United States, mental illness remains hidden behind closed doors. Yet half the deaths by gunshot are a result of suicide. Rarely does the problem of mental illness become photographable. The relatively rare pictures of someone in the act of suicide might help to call

attention to the failure of mental health policies in the United States.

MORAL DILEMMAS OF A PICTURE EDITOR

■ THE GRUESOME PICTURE: SEEN OR SUPPRESSED?

Editors who deal with pictures are also on the ethical firing line. A photographer at the scene of an accident or disaster does not have the time to determine if a particular picture is too gruesome or horrible to appear on the paper's front page. Only when the film has been processed can the photographer and the editor study the images with an impartial eye toward deciding if the photos are too indecent, obscene, or repulsive for publication. The reader, with the morning edition of the *Republican-Democrat* neatly folded between his coffee and his

oat bran, might gag on a gory front-page accident shot (ultimately tossing both the paper and his cereal).

Yet newspaper managers must not whitewash the world. Murders, accidents, wars, and suicides happen. Eliminating pictures of violence presents readers with a false view of their community and the world.

Northwestern University's Curtis MacDougall, author of ***News Pictures Fit to Print ... Or Are They?*** recalls that when he was a reporter on the old *St. Louis Star Times*, the managing editor once spent a full hour soliciting the opinions of everyone in the newsroom regarding the propriety of using a picture of a lynching. The photograph showed a corpse slumped at the base of the "hanging tree." MacDougall recalls the photo and the incident: "No facial expression was visible; nevertheless the decision was made to black out the body and substitute an artist's drawn 'X' to mark the spot."

This conservatism was typical of American editors through a century of brutal torture and murder of Blacks. According to MacDougall, plenty of photographs were available to document this inhuman treatment of blacks; however, when those photographs reached the newsroom, they were relegated to the paper's files rather than its news pages.

Of another lynching picture described as "shocking and unnecessary," Ernest Meyer wrote in the *Madison* (Wisc.) *Capital Times*, "So was the crime. The grim butchery deserved a grim record. And those photographs were more eloquent than any word picture of the event."

At the time, newspaper editors argued that lynching pictures were too grisly to print. However, during that same era, editors did play up horrible pictures of blood-soaked, maimed car-accident victims. Editors rationalized that accident pictures served as a warning to careless drivers and thus improved highway safety. (The same logic today prompts driver's ed teachers to screen a bloody crash site film for novice drivers.) Sadly, no one thought to add that lynching pictures might also have a positive benefit by stirring up moral outrage against mob rule.

Today, the number of accident photos has decreased. Because accidents have become so common, they are less newsworthy. Accident photos, too, are often more difficult to get because the police remove bodies promptly. But the underlying moral question remains: does the sight of mutilated victims in a mangled car frighten readers into caution when they drive their cars? And should this type of picture be published?

The *Akron* (Ohio) *Beacon Journal* said in an editorial about accident coverage:

"The suddenness and finality of death, the tremendous force of impact are vividly depicted in crushed, twisted bodies and smashed vehicles. The picture

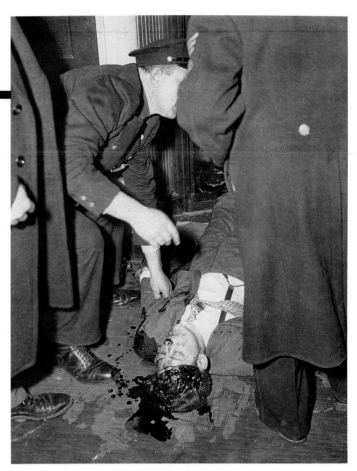

implants in the minds of all who see it a safety lesson that could not be equally well conveyed in words alone. How long the shock value of such a picture persists, varies. But one can be sure that a majority of those who see photographs of traffic accidents are more concerned with their safety than they had been before seeing the picture. 'This can happen to you!' is the unwritten message of every picture of an accident."

The man fired first at police and then took his own life. Will the reader look at or turn away from this picture? (Photo by Warren Patriquin, *Boston Herald* File, Print Division, Boston Public Library.)

■ READER COMPLAINTS

In Craig Hartley's survey comparing photojournalists' and general readers' reactions to ethical situations, he found that the two groups differed widely in their reactions to shooting and transmitting gruesome pictures.

Hartley found that 58 percent of the professionals he surveyed *considered ethical* the actions of a photojournalist who photographed the removal of a famous actress' body from an automobile crash and the editors' subsequent decision to send the pictures over the wires. However, nearly three-fourths (71 percent) of the public *disapproved* of the journalists' actions.

When editors select and publish strong, compelling, but perhaps hard-to-look-at pictures that include mangled bodies, blood, or victims' or bystanders' tearful reactions, readers often complain.

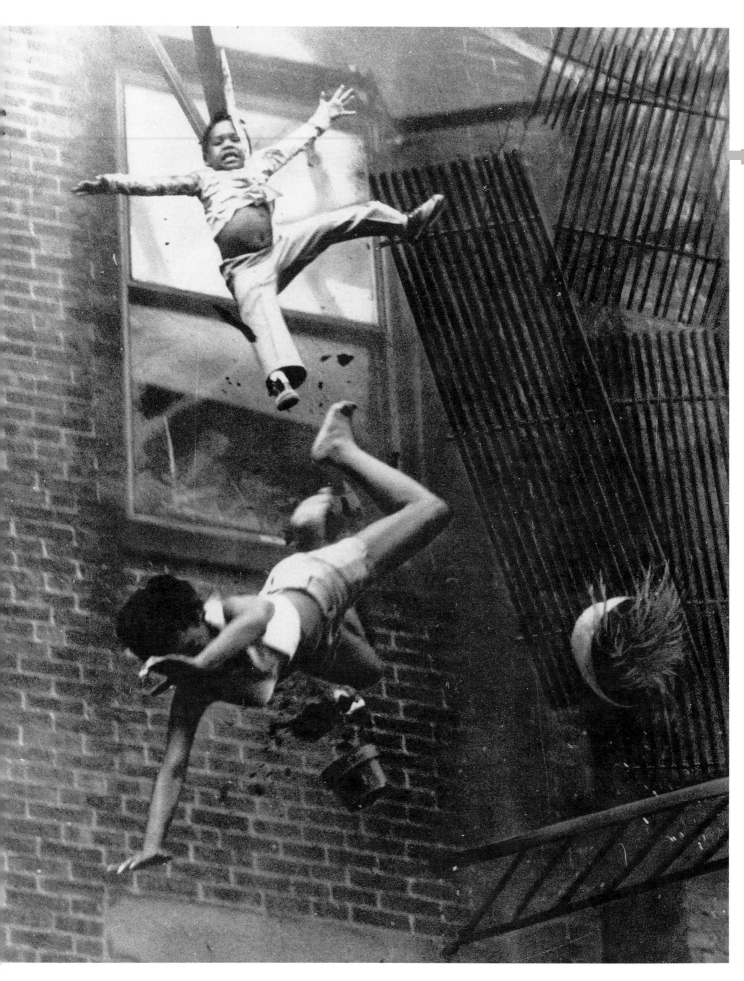

This fire escape collapsed dur-
ing a fire, plunging a woman to
her death; the child miraculouly
survived. After the picture ran on
hundreds of front pages around
the country, telephone calls and
letters deluged newspapers,

charging sensationalism, invasion
of privacy, insensitivity, and
tasteless display of human
tragedy — all to sell newspa-
pers. Would you have printed
this picture? (Photo by Stanley
Forman.)

**MORAL DILEMMAS
OF THE
PICTURE EDITOR**

From an economic point of view, editors cer-
tainly care what readers do and don't want on the front
page of the daily newspaper. From the ethical perspec-
tive, however, should editors make decisions based on
reader preferences? Do editors have a responsibility that
supersedes the likes and dislikes of their audience?

Stanley Forman's photo of a collapsing iron bal-
cony during a fire — a woman plunging to her death
along with a falling child who miraculously survived —
was printed on more than a hundred front pages across
the country. Later, telephone calls and letters to newspa-
pers charged sensationalism, invasion of privacy, insensi-
tivity, and tasteless display of human tragedy to sell
newspapers.

Hal Buell, who was AP's assistant general man-
ager for news photos at the time, said he received more
reaction to the Forman picture than to any other news
photo. Buell wagered that if the woman had survived,
there would have been very little reaction. "The pictures
would not have changed, but the fact of death reached
into the minds and feelings of the readers," he said.

Most of the nation's editors published Forman's
picture on their front pages. Yet in a survey taken by the
Orange County Daily Pilot in Costa Mesa, Calif., 40 per-
cent of its readers did not approve of that paper's pub-
lishing the photo. Wilson Sims, editor of the *Battle Creek*
(Michigan) *Enquirer and News*, defended publishing the
picture: "The essential purpose is not to make the reader
feel pain or to bring the reader happiness. It is to help
the reader understand what is happening in the world.
Therefore, we ran the picture."

Forman's photo of the falling woman and child
won a Pulitzer Prize and contributed to to a change in
fire safety laws in Boston. Forman's editor, Sam Born-
stein, said, "Without the picture, the word-story would
have been 'page 16.' Only pictures of this magnitude
would have resulted in something being done by the
safety agencies."

For stories involving tragedy, journalists some-
times have made conflicting decisions regarding the play
of written stories compared to photos. For written stories,
geographic proximity is one of the determining criteria in
assessing news value — the closer the event, the more
importance and, therefore, more prominent play it is
given. Yet because readers are more likely to complain
about gruesome local pictures than those from far away,
editors often will play down or suppress strong pictures
that involve hometown residents but run revealing pic-
tures of atrocities in other parts of the world. In fact,
some newspapers even have policies mandating this
practice. This attitude toward photos is counter to tradi-
tional news criteria for print stories — top among them,
proximity. Editors, however, don't like fielding calls from
irate readers.

Malcolm F. Mallette, director of the American
Press Institute in Reston, Virginia, discussing ethics in
news pictures at a seminar for picture editors and graph-
ics directors, rhetorically asked the attending members,
"Do we print the gruesome picture of the Buddhist monk
who has set himself afire? Yes, of course. And do we
print the horrifying pictures of the South Vietnamese mili-
tary officer firing his pistol pointblank in the brain of a
captive? Startling. But, yes again, life is often startling and
horrible. But only by knowing can readers seek a better
existence for all."

As Mallette pointed out, however, a fine judg-
ment must be made: "The fact that one shocking picture
is printed does not mean that all should be."

Dieter Steiner, a photo editor for the German
magazine *Stern*, has offered a thoughtful insight into
whether or not to run a gruesome photo: "Don't run the
photo if more people turn away from it than look at it."
When the photo is so upsetting that few people will look
at it, then the editor can have little hope that the picture
will effect change. If people are so disgusted by the
photo, they might not think about its meaning.

■ MATTERS OF TASTE

Nudity in pictures generates more disagreement among
editors than even the most gruesome picture. An editor's
judgment about nudity in pictures generally reflects his or
her understanding of readers attitudes and of morés in
the host community. In most cases, the standards for pic-
torial nudity are more a matter of taste than a question of
ethics. With the advent of *Hustler* and other "skin" maga-
zines, almost no part of the human anatomy is reserved
for the imagination. Yet most American newspapers and
magazines refrain from printing nudity on their pages.
AP's Hal Buell says that the wire service won't carry
frontal views of nude men or women except in extreme
cases. "Such a story has yet to occur," he observes.

Professionals and the public again disagreed in
Hartley's ethics survey when he turned to the question of
nudity. Here is the hypothetical situation: *Two women
athletes collide in a volleyball game, with one falling in
such a way that her shorts are pulled down and her bare
buttocks are exposed.*

While a majority of the professionals surveyed
endorsed sending out a photo of the athlete's derriere, a
whopping 75 percent of the public turned thumbs down
on the bottoms-up picture.

Robert Wahls, who was a photo editor for the
New York Daily News, avoided running nudes except
under unusual circumstances. Despite the *Daily News'*
reputation as a genuine tabloid, Wahls felt that while
nudity is acceptable in film and theater, "it is inappropri-
ate when you can sit and study it." The photo editor
made an exception when there was an overriding news

value to a picture. The photos from Woodstock, a massive outdoor rock concert in 1969, showed members of the audience frolicking in the muddy field without their clothes on. The sheer size of the audience — 300,000 — gave the activities news value.

Also, the prevailing view of the 'Woodstock Nation' as an assembly of free-spirited Flower Children, the standard-bearers of the 'Love Generation,' added a certain social/news relevance to the photos. The hippies' uninhibited nudity was simply another expression of their counter-culture politics.

Wahls, however, pointed out that even if nude pictures help push up the circulation of a newspaper, the gain might be useless if advertisers start to consider the paper pornographic. "A newspaper's job is to inform, not to titillate," said Wahls.

Pictures of Fanne Foxe stripping in a Boston burlesque house might have titillated some readers. However, the photos possessed overriding news value because the "Argentine bombshell" was the consort of Wilbur Mills, at the time a powerful member of Congress. Both clothed and unclothed, Fanne Foxe was well-covered in words and pictures.

On the other hand, no banner headlines were associated with a protesting woman in the seedy, teeming Tenderloin neighborhood of San Francisco. Photographer Frederic Larson, in the course of a long-term project about the area (see pages 8–9), happened upon the woman just after she had thrown off her clothes in frustration with a security guard who refused to let her into a building. For everyone who knows the neighborhood — and perhaps for those who see the picture —

the woman's stark nakedness and the guard's bored reaction sum up the daily insanity of living in an area riddled with poverty, homelessness, and crime. The *San Francisco Chronicle*, however, decided not to run the picture.

Readers also might disapprove of photos showing obscene gestures. However, with the exception of the *New York Times*, few news desk editors refrained from printing the picture of then Vice President Nelson Rockefeller "giving the finger" to a crowd of hecklers at an airport. News value overruled matters of good taste in this situation also.

FAIR
AND BALANCED
REPORTING

The experienced professional reporter continues to dig up the facts of a news story until he or she feels prepared to write an unbiased, balanced report of the event. News reporters might write articles in which several paragraphs explain the position of each conflicting party. Many stories have no clear heroes or villains; hence, the reporter

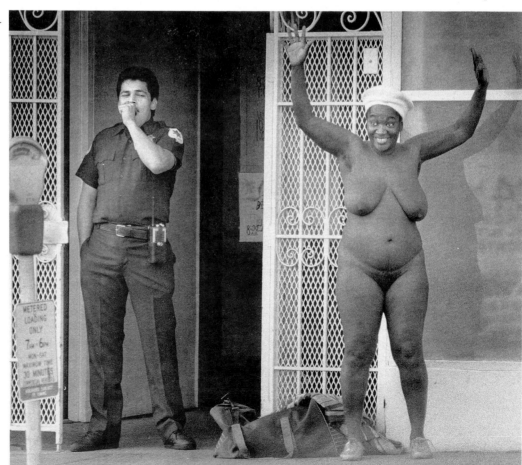

With perhaps little else to protest except the clothes on her back, this woman throws off her garments in frustration at being denied entrance to this building. The *San Francisco Chronicle* declined to run this photo. Would you? (Photo by Fred Larson, *The San Francisco Chronicle*.)

simply extends copy to explain the complexities of the situation. The writer has not only the advantage of several paragraphs, but the subtlety and precision of the English language, with its great store of adjectives and adverbs. These modifiers enable the writer to emphasize an idea or soften a phrase. Listen to the difference between "the suspect stared at me" and "the criminal glared at me."

The photographer has no adjectives or adverbs, no pictorial thesaurus to refine his image. A single picture captures only one moment in time, one set of circumstances, one expression or action. If the newspaper's managing editor has allotted space for just one picture to illustrate a complicated story, then the photo editor is faced with a task as difficult as if the writer had to tell a

multifaceted story in one monosyllabic sentence. Of the two hundred or so exposed frames shot on an assignment, which single picture tells the whole story?

When former President Richard M. Nixon gave a speech to 10,000 listeners, ten hecklers in the back of the hall tried to interrupt him. A single picture could not incorporate both the president, the audience, and the hecklers. AP's Hal Buell remembers the difficult decision whether to run a photo showing the large enthusiastic, supportive crowd or the small but newsworthy band of dissenters. Although the AP photowire could carry both pictures, newspaper editors with space limitations often had to choose between the two photos. Did either the crowd picture or the heckler picture reflect the complete truth about the event?

Brigadier General Nguyen Ngoc Loan, police chief of Saigon, assassinates a Viet Cong suspect. Because the South Vietnamese were U.S. allies, this picture disturbed the American public and helped change sentiment about U.S. involvement in Vietnam. (Photo by Eddie Adams, *Wide World Photos*.)

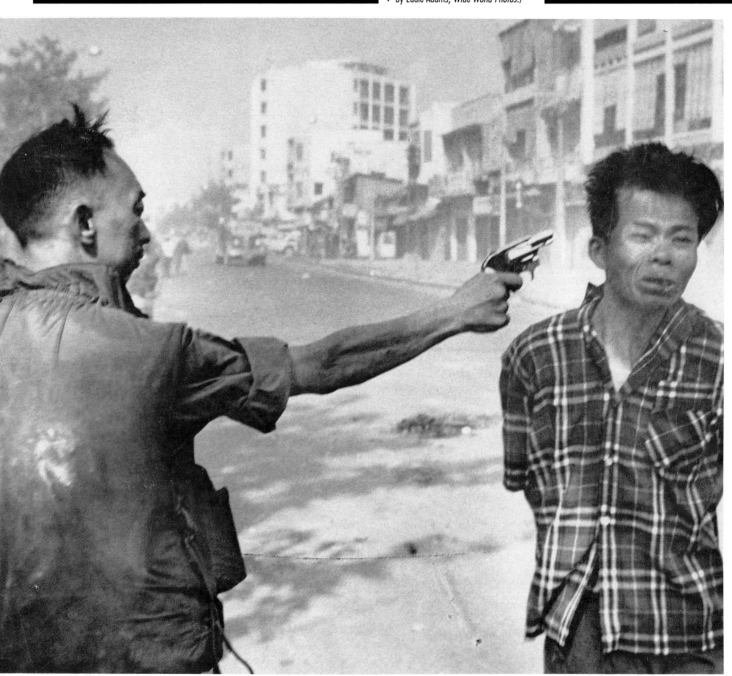

The Vietnam War presented a constant challenge for photo editors. Each day they had to sum up a complicated, tragic event in a few pictures. Eddie Adams won a Pulitzer Prize for a shocking photo of a South Vietnamese colonel executing a suspected Viet Cong on a Saigon street. During this war, the South Vietnamese were our allies. The overwhelming message of the picture, however, spoke of the cruelty of the South Viet-namese officer. To balance this view of the war, many editors chose to run, on the same day, another picture portraying the terrorism of our enemies, the Viet Cong. The photo, although not as dramatic as Adams' picture, showed a soldier leaving a civilian house recently bombed by the Viet Cong. Do the two photos really explain both sides of the conflict? Can any two pictures be balanced?

The body of a dead Viet Cong soldier was dragged by a U.S. tank to a burial site. Liberals said the photo showed the horrors perpetrated by American Armed Forces. Conservatives said the media were biased and that editors, with pictures like this, tried to downgrade the American soldier. Who was right? (Photo by Kyoichi Sawada, *UPI*.)

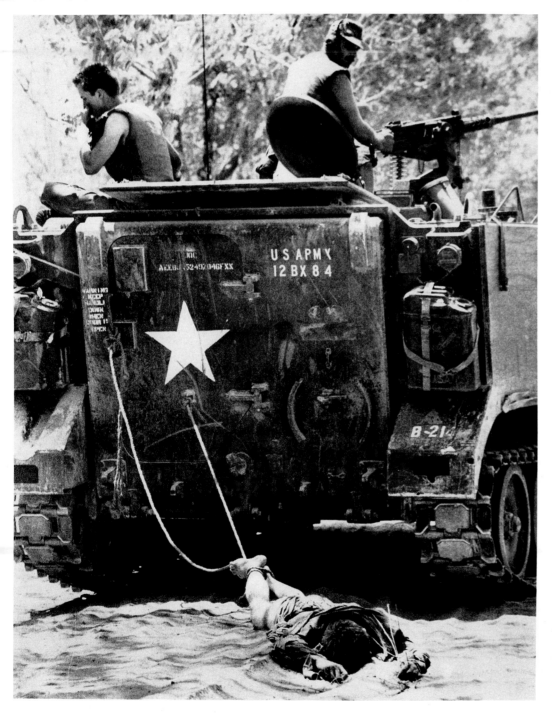

individual image, its size and placement on the page, its accompanying story — and the play the subject has received recently in other media.

■ SELF-CENSORSHIP

Editing often occurs before the shutter is ever released or a print ever made. For a variety of reasons, photographers decide not to take or publish photographs. A photographer might not photograph two men holding hands for fear the community "is not ready to deal with homosexuality" or that "my paper won't run that." A photographer might not want to "embarrass the person."

Besides gays, newspapers traditionally have ignored various groups over the years. Through neglect or perhaps in deference to a predominantly white readership, newspapers have overlooked large segments of the American population — blacks, Hispanics, and other minorities. Through self-censorship on a conscious or subconscious level, photojournalists can create an artificial reality for their readers. Each journalist must look at his or her biases.

Who is being protected by not taking or running a picture?

Are you sure your editor won't publish a picture? Are the regulations about acceptable subjects and topics written down or just unofficially passed on to

When a deadline looms near, whether a photo is apparently innocuous or loaded with emotional impact, the editor must decide which picture to run. Knowing that no picture is immune from interpretation by the reader, the editor must make an attempt at fair and balanced photo reporting. The editor must take into account the

new members of the staff? Are you responding to your own fears and prejudices when you hesitate to release the camera's trigger or turn in a print? Have you challenged your publication's written or unwritten policy?

The message: examine your own motives. Scrutinize your actions for patterns that may reveal your own

or wrong? To borrow an apt phrase from the vernacular of mothers everywhere, "Just because everyone else does it doesn't mean you have to."

Then ask yourself, will taking or running a photo serve the greatest good for the greatest number of people? Although you will find it hard to predict exactly a photo's effect, can you hypothesize a positive outcome from readers seeing the photo? What is the negative impact if readers don't see the picture?

If you decide the photo has some potential social significance, you should next ask, who will be hurt by taking or running the picture? Is this a situation in which an individual's rights super-sede those of society? You might phrase the question, how would I feel if I were the person in the photo?

Finally, while some individual rights are absolute, some are not. Keep in mind that you must weigh an individual's rights against society's need for correct and complete information.

■ LOOKING FOR A YARDSTICK

Curtis MacDougall, in his book **News Pictures Fit to Print Or Are They?**, struggled to find a common rule to help editors decide when to splash a controversial picture on the front page or when to file the picture in the bottom desk drawer. "My yardstick is the public interest," said MacDougall. "I would run any picture calculated to increase the public's understanding of an issue about which the public is able to act."

Curtis MacDougall's yardstick, however, does not take into account competing claims like privacy, which in certain circumstances must also be considered.

While each editor will use his or her own yardstick of public vs. private interest, photographers should not rely on editors to shoulder the ethics burden. Photographers must determine for themselves what they find valuable about taking and then publishing photos. The photographer provides the first line of ethical defense and, finally, the photographer's name runs under the photo. The photographer must take responsibility for the printed image. ■

prejudices. Are elements or groups from your community consistently absent from your shots? Is it coincidence — or choice — that your pictures display these patterns?

Then apply the same vigilance to your editor and your organization. A responsible journalist must remain alert to even the most subtle signs of prejudice, at all levels. If you discover that prejudice is part of the 'corporate culture' at your paper, you have three options: accept it, change it, or quit. Each carries a price.

Sometimes photographers don't take pictures of gays — like this one from a photo story about adoptive gay fathers — and other minority groups because they assume their papers won't run the pictures. Through conscious or unconscious self-censorship on the part of news organizations, groups such as gays, blacks, Hispanics, Asians, Native Americans, disabled people, and others remain invisible to the public eye. (Photo by Kaia Means, San Francisco State *Struggle for Life Project.*)

■ REMEMBER THE READER

Photojournalists don't take pictures for contests, editors, or other members of the profession. They take pictures for readers — pictures that provide information about sad moments as well as happy ones. Without complete and well-rounded reporting, including both written and visual facts, a democratic society cannot function.

Therefore, when faced with a tough ethical question, try phrasing problem in this way:

First, faced with this problem, what do other professionals in the field do? What is the professional standard for this action?

Next, are the actions of other professionals right

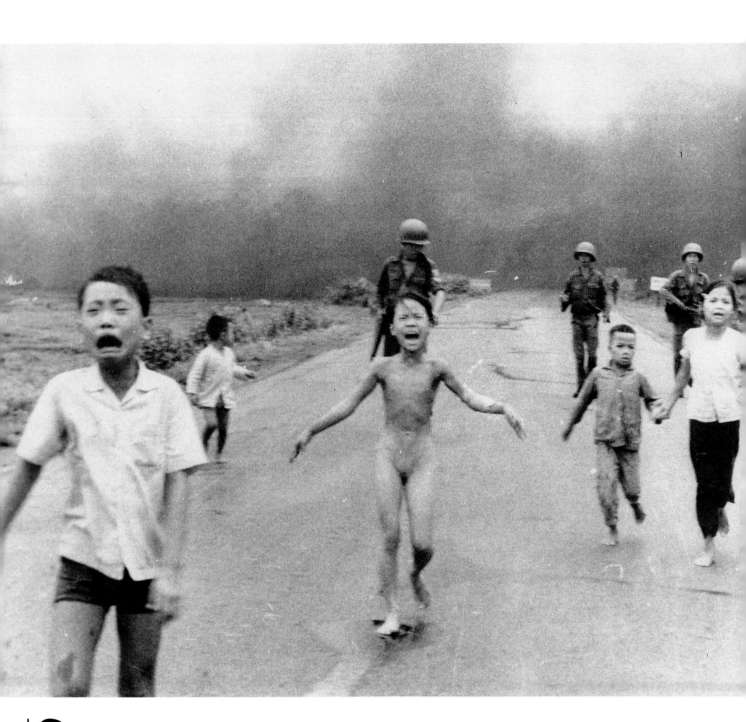

South Vietnamese army forces follow terrified children fleeing after an accidental aerial napalm strike during the Vietnam War. While horrible to look at, this picture and the one of the execution on page 312 are perhaps the two most powerful to come out of that conflict. Meeting Curtis MacDougall's "public-interest" yardstick, both are credited with influencing American opinion against the war and eventually leading to the withdrawal of U.S. forces from Vietnam. (Photo by Huynh Cong "Nick" Ut, *Associated Press.*)

History

The first "portable" strobe for the news photographer was perfected and manufactured by Edward A. Farber for members of the *Milwaukee Journal* photo staff. (*Milwaukee Journal.*)

COVERING A FIRE: THEN AND NOW

■ PHOTOS INTO DRAWINGS

On a balmy April day in 1877 the staff of the *New York Daily Graphic*, the first illustrated daily newspaper in the United States, conducts business as usual.

Reporters labor to complete their copy in time for the morning deadline. Artists put the finishing touches on their drawings, which will comprise three and a half of the tabloid's eight pages.

In a makeshift darkroom, where a janitor stores mops and brooms, a lone photographer places 5"x7" pre-coated, dry glass plates into light-tight holders. The photographer is so engrossed in the delicate operation that he barely hears the sudden commotion in the newsroom. The commotion's cause is a passing fire engine. For the staff of the *Daily Graphic*, whose every sense is attuned to such signals, the fire engine's clanging bell tolls news.

Several reporters drop what they're doing, grab pencil and paper, and dash out to cover the late-breaking story. Someone remembers to inform the photographer about the fire alarm. He, too, puts aside his work and carefully balances his cumbersome view camera and tripod on one arm and a case containing twelve previously prepared glass plates on the other arm. The *Graphic* cameraman sets off with his unwieldy load.

By the time he reaches the site of the blaze, it is raging full force. He sets up his tripod and camera as quickly as possible, points his lens at the action and takes his first exposure. Normally, he would take only one exposure, or perhaps two, of a given event. Because this is such a huge fire, however, he decides to expose several of his glass plates. He has only one lens, so if he is to get different perspectives on the action, he must change his position, pick up his bulky equipment, lug it to the new spot and take the time to set up again. He then covers his head and the back of the camera with a black focusing cloth. Next he opens, focuses, closes, and sets the lens. Following this he loads the plate holder into the rear of the camera body and removes the dark-slide. Finally he takes the picture.

Before he can make the next photo he must replace the dark slide and carefully put the holder back into his case. If he accidentally knocks the holder too hard, the glass plates will shatter. Unfortunately, the crowd continually jostles him as he works.

He attracts much attention because a news photographer is still a curiosity. But the *Graphic* photographer doesn't mind; he is particularly excited about the challenge posed by this event. Usually his assignments

limit him to photographing portraits of famous people or carefully posed tableaux. Because of the technical limitations of his slow film (equivalent to ISO 24 by today's standards), he can photograph only under optimum conditions, with bright light and minimal subject movement. On this day, he is able to get some action shots by carefully panning his camera with the movement of a late arriving horse-drawn fire engine.

After several hours, the *Daily Graphic* photographer finishes making his twelve exposures, and by the time he packs his case, camera, and tripod, the firemen finally have the blaze under control. But as the photographer heads back to the newspaper office, weary from his physical exertion, his own ordeal has just begun. Now he must develop his pictures in chemicals he mixes from a formula he found in a copy of the *Philadelphia Photographer*, one of the first photo magazines.

Enlargers are not used commonly. The 5"x7" negative is of sufficient size for reproduction when it is simply contacted on photographic paper. More than an hour after returning from the fire, the photographer has his first picture.

After all that work, however, the photo can't be printed in the newspaper.

The photographer now hands his pictures over to an artist, who draws replicas of them. Unfortunately, the artist often changes details from the original if he thinks the new variations improve the picture. The artist, in turn, gives his drawings to an engraver, who reproduces them onto a zinc plate. The plate is then printed on a Hoe rotary press.

As may be imagined, a good deal of time elapses between the hour of the fire and the moment when these line-drawn renderings of the photographs appear in the newspaper. Yet the drawings receive front-page play.

■ EVOLUTION OF THE CAMERA REPORTER

How did the photographer of 1877 evolve into the photojournalist — the reporter with a camera — of the 1990s? Two major factors contributed to this development. First, the technical innovations: the invention of roll film, smaller cameras, faster lenses, and the introduction of portable light sources enabled the photographer to shoot pictures more easily and get better results. The invention of the halftone process for reproducing photos and the improvement of printing presses led to better reproduction. Meanwhile, with the expansion of the wire services and the development of picture transmission devices,

In 1877, the *New York Daily Graphic*, the first U.S. illustrated daily newspaper, devoted an entire front page to five fire pictures. The *Daily Graphic's* hand-drawn sketches were often based on photographs taken at the news scene. (New York Public Library.)

THE DAILY GRAPHIC

AN ILLUSTRATED EVENING NEWSPAPER.

39 & 41 PARK PLACE

VOL. XIII All the News. Four Editions Daily. NEW YORK, MONDAY, APRIL 16, 1877. $12 Per Year in Advance Single Copies Five Cents NO. 1273

photos could be sent across the nation and the world almost instantaneously.

This is an enlargement of a halftone dot pattern showing an eye.

The technological leaps made in photography since 1877 enable today's resourceful photographer to reach virtually any action anywhere and bring home a picture to the newspaper- and magazine-reading public. Because of these scientific and engineering discoveries, photographers can capture events previously impossible to shoot on film: night pictures, fast action, and successive motion now can all be recorded with the camera.

But technological strides are only half the answer to this evolutionary question. Photographers broadened the scope of news pictures by introducing feature and sports pictures to the newspaper. Photographers sought candid photos that revealed natural moments rather than the posed, frozen images typical of early photo reportage. Photographers today do more than just record the news. They have become visual interpreters of the scene by using their camera and lenses, sensitivity to light, and keen observational skills to bring readers a feeling of what the event was really like.

The ingenuity and inventiveness of individual photographers in taking photos also laid the foundations of modern photojournalism. From the days of the *Daily Graphic* to the present, photographers first have had to figure out a way to get to the news event no matter where it is located — skyscraper or coal mine. Then they often must work around obstacles, both physical and human. Once photographers have the picture, they face the pressure of the deadline. They must get the picture to the darkroom and develop it in time for the next edition. The daring and cleverness of the early photojournalists represent the kind of personality traits that successful photographers have exhibited throughout the history of photojournalism.

Thus, technical advances and the imagination and resourcefulness of the photographer have gone hand-in-hand. The two have had complementary developments, each contributing to the gradual evolution of reportorial photography.

HALFTONE SCREEN REPRODUCES PHOTOS

■ SCREENS FIRST USED IN 1880

In 1877, our *Daily Graphic* photographer had little way of knowing that he stood on the threshold of a new age in photography. The next twenty years would see several rapid technological advances that would revolutionize the field of pictorial journalism: light, hand-held cameras; faster lenses; improved shutter mechanisms; and roll films. But perhaps the most momentous technological occurrence in the history of photojournalism was the development of the halftone printing process.

Before the introduction of the halftone process, there was no practical way to transfer the photograph directly onto the printed page. An ordinary press could print only blacks and whites — full tones — and was incapable of rendering the intermediate shades of gray, the halftones. As such, newspaper illustrations, based on artist's original sketches or photographs, consisted of black-and-white line drawings, hand-carved on wood blocks or etched on zinc plates.

After years of experimentation, a method was found that could reproduce the full tonal range of photographic images. Still employed today, this process involves the use of a screen with an ordered dot pattern. This screen is held rigidly against a sensitized film in the engraver's camera. The engraver's camera copies the original photo through the screen, which breaks up the photo's continuous tones into a series of tiny dots of varying sizes. The darkest areas of the original photo translate into a series of large dots. As the tones in the picture change from black to gradations of gray and white, the dots get progressively smaller.

The engraver develops the film and contact prints it onto a metal plate. The pattern of dots is chemically transferred onto this printing plate. On the press, the dots transfer the ink onto the paper. Where they are largest and closest together, the image is darkest, and where they are smallest and farthest apart, the image is lightest. Thus, the resulting printed image duplicates the shadings of the original photograph.

How much detail can be reproduced depends upon the fineness of the screen and the quality of the paper. By holding a magnifying glass up to any newspa-

per or magazine picture, you can easily see the tiny dot pattern of the halftone screen.

■ THE FIRST HALFTONE: SHANTYTOWN

The *Daily Graphic* published the first halftone on March 4, 1880: a picture of Shantytown, a squatter's camp in New York City. Stephen H. Horgan, the photographer in charge of the *Daily Graphic*'s engraving equipment, produced the halftone. Although Horgan had been perfecting this process for several years, his successful experiment in 1880 did not immediately affect the look of the daily newspaper. His halftone invention, however, did encourage further experimentation.

■ OPPOSITION TO PHOTOS

In 1893, four years after the demise of the *Daily Graphic*, Horgan was working as art editor for the *New York Herald* when he again recommended the use of halftones to James Gordon Bennett, the paper's owner. After a brief consultation with his pressmen, Bennett pronounced the idea implausible.

Similarly, Joseph Pulitzer, who had been publisher of the *New York World* since 1883, initially expressed reluctance to print halftones. In fact, Pulitzer feared that widespread use of any pictures, including line drawings, would lower the paper's dignity, so he tried to cut down on the extensive use of woodcuts, which had already made his paper famous. When circulation fell as a result, Pulitzer reconsidered his decision and reinstated the drawings.

As Pulitzer realized the paper-selling potential of such illustrations, he began to increase their size from the original one-column to four- and five-column spreads. When the halftone was finally perfected, the *World* was one of the first newspapers to make liberal use of the new process. The daily's circulation rose rapidly. Other publishers and editors soon jumped onto the pictorial bandwagon. One such newsman, Melville Stone, investigated the potential of newspaper illustrations for the *Chicago Daily News*. He ultimately concluded, "Newspaper pictures are just a temporary fad, but we're going to get the benefit of the fad while it lasts."

Today we know that newspaper pictures were neither temporary nor faddish, but in the closing years of the nineteenth century, the halftone continued to struggle for legitimacy. By the late 1890s, the process had yet to achieve daily use, although the *New York Times* did print halftones in its illustrated Sunday supplement begun in 1896. Skeptical publishers still feared that their readers would lament the substitution of mechanically produced photographs for the artistry of hand-drawn pictures; also, artists and engravers were well-established members of the newspaper staff. Thus, long after the halftone was perfected, carefully drawn copies of photos continued to appear in many papers. Gradually, however, papers

The first photograph reproduced on a printing press using the halftone process: on March 4, 1880, this photograph of Shantytown dwellings appeared in a special section of *The New York Daily Graphic*. (Henry J. Newton, *New York Daily Graphic*, courtesy of the New York Historical Society, New York City.)

Jimmy Hare (LEFT), with his two folding cameras carried in their leather cases, covered the globe for *Collier's Weekly*. He photographed everything from the Spanish-American War (ABOVE) to the closing days of World War I in Europe. (Jimmy Hare Collection, Humanities Research Center, The University of Texas at Austin.)

adopted the halftone process. By 1910, hand engraving was becoming obsolete and the halftone, in turn, became a front-page staple.

THE MAINE BLEW UP AND JIMMY HARE BLEW IN

While these technological strides were taking place in the latter part of the nineteenth century, several photographers were setting photojournalistic precedents. Jimmy Hare, one of the most colorful of the pioneer photojournalists, wrote the handbook for future photographer-reporters. During his career, Hare covered nearly every major world event, from the wreckage of the U.S. battleship Maine in Havana harbor during the Spanish American War in 1898 to the closing days of World War I in Europe. His ingenuity and his no-holds-barred attitude when it came to getting the picture set a standard for the new profession of photojournalism.

London-born Hare, whose father crafted hand-made cameras, came to the United States in 1889. One magazine, the *Illustrated American*, committed itself to using halftone photographs. From 1896 to 1898, Hare worked as a free-lancer, supplying the magazine with photos ranging from presidential inaugurations to sporting events. A month after he left the *Illustrated American*, the battleship Maine exploded, thus signaling the start of the Spanish-American conflict. The ever enterprising photographer promptly presented himself to the editors of *Collier's Weekly*, and offered to take pictures of the wreckage. Twenty years after the Maine episode, then-editor Robert J. Collier was to recall, "The Maine blew up and Jimmy blew in! Both were major explosions!" Jimmy continued "blowing in" to important world events for the next several decades.

So successful were his pictures of the Maine and of Cuba, where American soldiers fought the Spanish in the Spanish-American War, that the publisher named Hare special photographer for *Collier's*, thus beginning a long and productive association.

Whether trekking over Cuban countryside, touring battlefields with author Stephen Crane, or following Teddy Roosevelt's Rough Riders, Hare and his camera remained intrepid and resourceful. Hare made use of the new folding cameras (with lenses as fast as f/6.8) and of roll film (with twelve exposures per roll). His lightweight equipment gave him more mobility than his competition, who were shooting with fragile glass plates and awkward 5"x7" Graflexes, the popular news-cameras of the day.

Regardless of the reduced weight of his folding camera, Hare still had to get to the middle of the action to take a picture. In one battle during the Spanish American conflict, a soldier spotted Hare snapping away as wounded bodies dropped all around him. "You must be a congenital damn fool to be up here! I wouldn't be unless I had to!" the soldier shouted. Hare's even-handed

reply: "Neither would I, but you can't get real pictures unless you take some risks."

In addition to the Spanish-American War, Hare's photographic escapades brought him to the combat lines of the Russo-Japanese War, the Mexican Revolution, the First Balkan War, and the First World War. Hare described these experiences as "one-sided adventures in which it was always my privilege to be shot at but never to shoot." But shoot he did — with his camera, that is — and his pictures contributed greatly to *Collier's* rapidly rising circulation and national prominence.

■ HARE COVERS FIRST FLIGHT

Not all of Hare's exploits took place on the battlefield, however. The story of how Hare managed to record on film the experiments of the Wright brothers in 1908 is indicative of his tenacity and his skill. The Wrights' first successful flight had taken place in 1903 but, five years later, the public remained unconvinced that men had actually flown. Rumors abounded but no one had documented proof of any flight. The brothers refused to allow reporters to witness their experiments at Kitty Hawk.

Hare was determined to check out the rumor for *Collier's*, however, and along with four reporters from various newspapers, he secretly went to the Wright brothers' testing area. The five intrepid men spent two days hiking over the sands of Kitty Hawk, North Carolina. Approaching the site of the rumored flights, the newsmen took cover in a clump of bushes and anxiously waited for something to happen. Covered with mosquito bites and tired of lugging his camera, Hare was tempted to dismiss the rumors as false and head back home. But suddenly an engine noise was heard, and, as the reporters watched in disbelief, an odd-looking machine glided across the sand and gradually rose into the air. Hare ran out of the bushes and managed to snap two photographs of the airborne machine. The party of reporters then sneaked back to their base and prepared to reveal their booty to the world.

Because Hare was far away from the plane, the image in his photo was small and indistinct. But *Collier's* was proud to publish the picture in its May 30, 1908, issue. The photo proved, at last, that man could, indeed, fly. Hare had the distinction of taking the first news photograph of a plane in flight.

Hare began chronicling his world during photojournalism's infancy. When *Collier's* first published his photos, editors considered pictures mere embellishments of the text. But through his dogged efforts to capture, with his camera, a sense of immediacy and excitement, Hare served as a catalyst in the growth of the photographer into a full-fledged reporter-with-a-camera.

WOMEN ENTER THE FIELD

Since 1900, female photojournalists have made their mark in the world of the newsroom. Frances Benjamin Johnston, an indomitably spirited woman, managed to transcend the constraints usually imposed on Victorian women. Johnston documented early educational methods in black, white, and Indian schools. She shot a series of photographs on the activities in the White House and on the visits of foreign dignitaries. Then, Johnston sold her pictures to the newly formed Bain News Service, and became its photo representative in Washington. Bain suggested that she photograph Admiral George Dewey aboard his battleship after his successful takeover of the Philippines. With great ingenuity she made her way to Italy, where Dewey's ship first docked, and covered the story. She managed to endear herself to the crew, and when it came time to fill out an enlistment record, she earned five out of five possible points for everything from seamanship to marksmanship, but only a "4.9" for sobriety.

Jessie Tarbox Beals was another photojournalistic pioneer. She started out as a school teacher but soon discovered the lure of photography. In 1902 the *Buffalo Inquirer and Courier* hired her as a press photographer. During her two years with them, and later in St. Louis

and New York, she exhibited an important skill of the photojournalist — the "ability to hustle," as she once put it. Before her career ended, Beals sneaked photographs through a transom at a murder trial, rode the gondola of a balloon above the St. Louis World's Fair for a photo, and photographed Mark Twain.

THE CAMERA AS REFORMIST'S TOOL

Social documentary photographers, notably Jacob Riis and Lewis Hine, demonstrated that the camera could provide not only a record of events but could serve as a potent tool for social change. Hine once summarized his goals as a concerned photographer: "There were two things I wanted to do. I wanted to show the things that had to be corrected. I wanted to show the things that had to be appreciated." As America moved into the new century, crusading photographers chose to concentrate on the former aim, the social objective. Riis and Hine were among the first to press the camera into service as an agent for social awareness.

Their photographic pleas for reform placed them in the ranks of such social muckrakers as Upton Sinclair, Lincoln Steffens, and Ida Tarbell. Together with these writ-

ers/reformers, the camera journalists probed the underside of city life, exposing the unimaginable, and bringing out into the open what had previously been shielded from view. The tradition Riis and Hine helped to establish carried through to the 1930s with the photographers of the Farm Security Administration who used their cameras to record the faces of Depression-ridden America.

With flash powder lighting the way, Jacob Riis exposed New York's slum conditions endured by recent immigrants. This man slept in a cellar for four years. (Jacob Riis Collection, Museum Of The City Of New York.)

■ RIIS EXPOSES SLUM CONDITIONS

Neither Riis nor Hine, in fact, began as a photographer. The Danish-born Riis started in the 1870s as a carpenter and then got a job as a reporter for the *New York Sun*. He wrote first-hand accounts of the indignities and iniquities of immigrant life. When he was accused of exaggerating his written descriptions of life in the city slums, he turned to photographs as a means of documenting the human suffering he saw.

For Riis, the photograph had only one purpose: to aid in the implementation of social reform. Pictures were weapons of persuasion that surpassed the power of words and the absolute veracity of the photographic image made it an indispensable tool. As Riis stated, "The power of fact is the mightiest lever of this or any other day."

But Riis was up against many obstacles as a photographer. The crowded tenements were shrouded in darkness and shadows. To show the perpetual nighttime existence in the slums, Riis pioneered the use of German Blitzlichtpulver — flashlight powder — which although dangerous and uncontrollable, did sufficiently illuminate the scene. Lugging a 4"x5" wooden box camera, tripod, glass plate holders, and a flash pan, Riis ventured into the New York slums with evangelical zeal. With a blinding flash and a torrent of smoke, he got his pictures. The scenes he recorded of immigrant poverty shocked and goaded the public into action for reform.

The Riis pictures are remarkably poignant glimpses of ghetto life. Grim-faced families stare at the camera with empty eyes. Shabbily clothed children sleep amid the garbage of a tenement stoop. A grown man stands in the middle of the street and begs for someone to buy one of his pencils. An immigrant sits on his bed of straw. In a coal bin, a newly arrived American citizen prepares for the Sabbath.

Unfortunately, when Riis was photographing, the halftone had yet to achieve widespread use. Consequently, his actual pictures were not directly reproduced in printed sources and so were seen by only limited numbers of people, such as those attending his lantern-slide shows. At these talks, he used his pictures to buttress his plea for attention and reform.

When his first book, *How the Other Half Lives,* was published in 1890, it consisted of seventeen halftones and nineteen hand drawings modeled on his photographs. The halftones were technically poor — somewhat fuzzy and indistinct — but the pictures exerted a powerful influence that drew attention to slum conditions, and they remain moving documents of human suffering.

▪ HINE'S PHOTOS HELP BRING ABOUT CHILD LABOR LAWS

Lewis Hine began as an educator and, like Riis, turned to photography as a means of exposing "the things that had to be corrected." In turn-of-the-century urban America, a great many conditions begged to be noticed and changed. The influx of immigrants into the cities and the simultaneous growth of industrialism were important characteristics of the new century. With the reformer's commitment, Hine set out to catalogue how people survived in this new way of life.

In 1908, the magazine *Charities and the Commons* published a series of his pictures of immigrant life. The series included some of Hine's most famous pictures: portraits of newly arrived immigrants at Ellis Island. The power and eloquence of these pictures attracted much attention. With the further refinement of the halftone, Hine, unlike Riis before him, published his work in books and magazines and gained a good deal of public exposure for his social issues.

That same year, Hine began to work as an investigator and reporter for the National Child Labor Committee. His work took him everywhere, from St. Louis slums to California canneries. To get past the doors of the offending factories and mines, Hine posed as every type of worker, from a fire inspector to a bible salesman. One time he packed his camera in a lunch pail, filed with

Lewis Hine photographed the soot-blackened faces of children who worked in the coal mines. In part because of Hine's photos, Congress passed protective child labor laws. (Photo by Lewis Hine, Library of Congress.)

the workers into a clothing factory, and surreptitiously snapped pictures of the sweatshop conditions. Hine juxtaposed the diminutive children against the huge machines. The weary stares of young knitting mill operators and seamstresses spoke more eloquently than words. The impact of these photographs, along with others he took, such as the soot-blackened faces of child coal-miners, helped the committee get the new Child Labor Laws restricting exploitation of youth passed by Congress.

PHOTOS FILL MAGAZINES & ROTO SECTIONS

■ PICTURES COME IN HANDY AT *NATIONAL GEOGRAPHIC*

The *National Geographic* did not start out as a picture magazine. In fact its first issue in 1888 contained no photos. In 1903, the *National Geographic* magazine ran its first halftone — a photo of a Philippine woman at work in the rice fields. Not until 1905 did the magazine try a photo spread unbroken by text. As it happened, the photo display was unintended. On the day the magazine was scheduled to go to the printer, the editor, Gilbert Grosvenor, was faced with eleven open pages and no material whatsoever to fill the space. By coincidence, he had received that same day a package of photographs from the Imperial Russian Geographic Society. These pictures of the previously unphotographed Tibetan city of Lhasa had been taken by two Russian explorers and were being offered to the *Geographic* for publication. Grosvenor, fascinated by the photographs, decided to take a risk. He laid them out as an eleven-page spread — all pictures and almost no text — and sent them to the printer. Grosvenor was sure he would be fired for having made this unprecedented and expensive editorial decision. Instead, readers stopped him in the street to congratulate him.

Although Grosvenor had run the Lhasa pictures primarily to fill up empty pages, he repeated the experiment after seeing the stir they created. In April 1905, he ran thirty-two consecutive pages of 138 photographs of the Philippines — a turning point in the magazine's history.

The *National Geographic* contributed many photographic firsts including the first nighttime nature shots ever published, shot by George Shiras III in 1906.

The magazine's first color photos, in 1910, were not color photos at all. In fact, they were hand-painted black-and-white pictures by William C. Chapin showing scenes of Korea and China. Coloring black-and-white pictures continued until 1916, when the Autochromes

Lumieres, real color photos, made their debut in the magazine's pages. The first series had no particular theme other than that they were all natural-color photographs. Since those early Autochromes, the magazine has published color photos from every part of the world as well as from the bottom of the sea and from outer space.

■ ROTOGRAVURE AND THE PICTURE PAGE APPEAR

In 1914, the *New York Times* began publishing the first Sunday rotogravure section, and several other newspapers soon followed. The rotogravure process, which usually used a dark sepia ink, offered a cheap printing process that could print sixteen pages simultaneously and an unlimited number of screened photos.

On deadline at the *National Geographic* and faced with eleven open pages, editor Gilbert Grosvenor used free pictures from Lhasa, Tibet, to fill the space for the magazine's first extensive photo layout.

Readers were so delighted with the magazine's first picture layout that editor Grosvenor ran 32 pages of pictures about the Philippines in the following issue.

A HAPPY ACCIDENT AT *NATIONAL GEOGRAPHIC*

George Shiras III took the first night nature photos for *National Geographic.* (Photos courtesy of *National Geographic.*)

That same year, the *Times* also started the *Mid-Week Pictorial War Extra* to absorb the rash of World War I pictures pouring in from Europe. In spite of severe censorship, picture agencies managed to obtain photos of the trench warfare, poison gas, and wholesale destruction of small towns taking place in Europe.

Photographers were explicitly forbidden to visit the battlefield. In fact, censorship was so severe that the Allied command attached an officer to each correspondent to control what the journalist saw and what scenes were photographed. Photographers covering the war employed their best ingenuity to circumvent the censors. Many of the photographs that finally appeared in print, however, were taken by soldiers at the front who

happened to be amateur photographers. By 1916 the *New York Times* expanded the coverage of the *Mid-Week Pictorial,* sold it for 10 cents and dropped the words War Extra.

PICTURE PAGES

Presses of the period were technically incapable of interspersing pictures with print and still achieving good halftone reproduction throughout the paper. Therefore, almost all the photos were grouped together on one single page. Printers achieved this improved reproduction by putting a specially designed ink blanket on the press cylinder that carried the halftone engravings. Thus a page-one story would have its corresponding picture printed inside on this special "Picture Page."

THE TABLOIDS: THRILLS AT THREE CENTS A COPY

◼ IMMIGRANTS UNDERSTAND PICTURES

The immigrants Hine and Riis photographed couldn't read English very well, but they could understand pictures. At a time when the country was teeming with non-English speaking immigrants, photographs became a universal language and, along with movies, a visual handle on the new world. Also, because of the new industrialism, people had more leisure time to spend reading newspapers and magazines. With the wiring of the city for electricity, families could study published pictures long after dark.

In the late 1910s, another journalistic phenomenon caught the public's fancy: the tabloid, a half-the-standard size newspaper that the commuter could easily read on the trolley or subway. The tabloid was designed for the less-educated masses and newly arrived immigrants.

The first twentieth-century tabloid in the United States was the *New York Illustrated Daily News,* launched in 1919. Circulation of the heavily illustrated *Daily News* soared rapidly, and it became one of the most remarkable success stories in journalism. The name of the paper was changed to *The News, New York's Picture Newspaper,* and survives to this day with one of the largest circulations of any daily newspaper in the country

In its early days the *News'* stock and trade was titillation — with crime and sex scandals — vicarious thrills for only three cents a copy. One of the most famous stories illustrating the lengths the *Daily News* would go to get a provocative picture involved the electrocution of Ruth Snyder in January 1928. In what was dubbed "the crime of the decade," a jury found Snyder, with the aid of her lover, guilty of murdering her wealthy husband. The *Daily News* editor felt the public was entitled to see Snyder's execution, but photographers were barred from the actual scene. The editor devised a plan to sneak a cameraman into the room. Thomas Howard, a news photographer from the *Chicago Tribune*, sister paper of the *Daily News,* was brought in for the occasion. He strapped to his ankle a prefocused miniature glass-plate camera. The camera had a long cable release running up Howard's leg into his pants pocket. Howard aimed his camera simply by pointing his shoe and hiking his trouser leg. To get sufficient light to the film , Howard, when the time came, exposed the plate several times — one for each shock administered to the body of Ruth Snyder. The following day, Friday the 13th, the picture ran full page with a single-word headline: "DEAD!"

The *New York Daily News,* a tabloid, hired Thomas Howard to get a picture of murderess Ruth Snyder's electrocution in 1920. He strapped a miniature glass-plate camera (NEAR RIGHT) to his ankle and released the cable as he hiked his trouser leg. He exposed the plate three times, once for each electric shock administered to Snyder. (NEAR RIGHT: Smithsonian Institution; FAR RIGHT: Photo by Thomas Howard, *New York Daily News.*)

HIDDEN CAMERA

◼ THE COMPOSOGRAPH

If the *News* was "a daily erotica for the masses," it still paled in comparison to its fellow scandal monger, the *Evening Graphic,* commonly known as the "Porno Graphic." In the *Evening Graphic,* the composograph, the first staged and faked news photo, was born. The occasion for its conception was the Kip Rhinelander divorce trial. Alice Jones, a black, was sued for annulment by Rhinelander. The husband maintained he had married her without knowing she was black. The wife's defense attorney had her strip to the waist as proof the husband should have known her race. Barred from the courtroom, photographers brought back no pictures of the sensational display.

Borrowing the techniques of the photomonteurs, The *Graphic's* assistant art director, Harry Grogin, shed no tears. "Hell with photographers," Harry muttered. "What we need 'em for?"

He began tearing pictures. He had pictures of Alice, of the Judge, of opposing counsel, of the stolid, forlorn Rhinelander, of Alice's mother, of Rhinelander's lordly father. The pictures were put through a process by which they would come out in proper proportion. Meanwhile, Harry sent for Agnes McLaughlin, a showgirl, and got her to pose as he imagined Alice Rhinelander had stood before the lawyers and the judge. For the photo, the art director had the actress wear as little as possible.

Grogin tinted Agnes McLaughlin's skin, faintly, to give the effect of being light-colored. He used twenty separate photos to arrive at the one famous shot, but for the *Graphic,* it was well worth the effort.

Average net paid circulation
of THE NEWS, Dec. 1927
Sunday, 1,357,556
Daily, 1,193,297

DAILY ⬛ NEWS

NEW YORK'S ⬩ PICTURE NEWSPAPER

EXTRA
EDITION

Vol. 9. No. 173 66 Pages New York, Friday, January 13, 1928 2 Cents

DEAD!

Story on page 3

(Copyright: 1928; by Pacific and Atlantic photos)

RUTH SNYDER'S DEATH PICTURED!—This is perhaps the most remarkable exclusive picture in the history of criminology. It shows the actual scene in the Sing Sing death house as the lethal current surged through Ruth Snyder's body at 11:06 last night. Her helmeted head is stiffened in death, her face masked and an electrode strapped to her bare right leg. The autopsy table on which her body was removed is beside her. Judd Gray, mumbling a prayer, followed her down the narrow corridor at 11:11. "Father, forgive them, for they don't know what they are doing?" were Ruth's last words. The picture is the first Sing Sing execution picture and the first of a woman's electrocution. *Story p. 3; other pics. p. 28 and back page.*

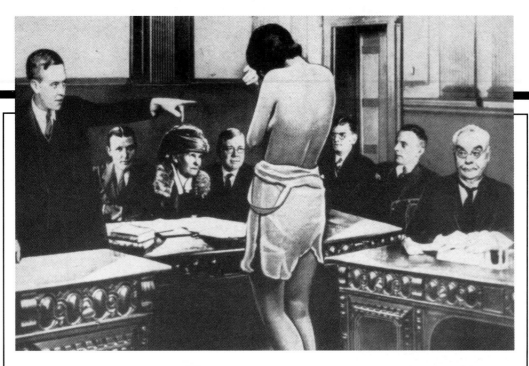

The picture was believable. You feel you are looking in on the judge's chambers. With Alice in the foreground, one of the lawyers points at the husband, as if to say, *He knew it all the time!*

Emile Gauvreau, the managing editor, and the City Desk went wild; what to call it? Headline, maybe: ALICE UN-DRESSES? They settled for ALICE DISROBES IN COURT TO KEEP HER HUSBAND.

And so the *Graphic* Composograph was born. The *Graphic*'s circulation rose from 60,000 to several hundred thousand after that issue.

The composograph was a *Graphic* depiction, posed in the art department, of a sensational real-life scene that for one reason or another could not be photographed. It was officially called a "Composograph" in the paper and identified as having been made in the art department.

As might be

FAKED PHOTOS

Because they couldn't take a picture inside the courtroom during the sensational Rhinelander divorce trial, the *Evening Graphic* staged the courtroom scene at the newspaper office with actors playing the parts of real individuals (ABOVE). Faces of actual participants were pasted on later. The new technique was dubbed a composograph — and repeated many times. The pretend hanging (RIGHT) nearly cost the life of the art department assistant when he accidentally kicked over the stool on which he was posing for the composograph. (Harry Grogin, *New York Evening Graphic*.)

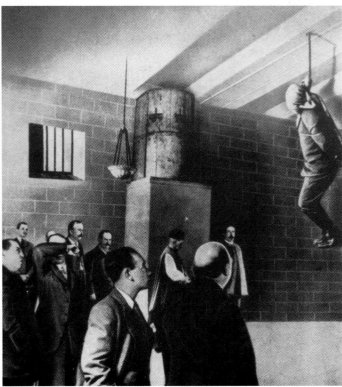

expected, the *Graphic* continued to exploit the popularity of the composite picture while admitting in tiny print at the bottom of the composograph that the pictures were faked. Later, while staging a phony hanging of thief Gerald Chapman, Grogin called upon one of his assistants to pose with a noose around his neck, bound hands and feet, and a mask over his head. The man stood on an empty box that later would be blocked out of the picture. Just as the picture was about to be

snapped, the stand-in victim accidentally kicked the box away. Luckily, Grogin acted with lightning reflexes and caught the suspended man seconds before the would-be hanging became a real one.

Of course, not all of the tabloid pictures were composographs. If a real-life picture was gruesome and lurid enough to satisfy the thrill-hungry public, the *Graphic*, the *Daily News*, and their tabloids were more than happy to run the photo.

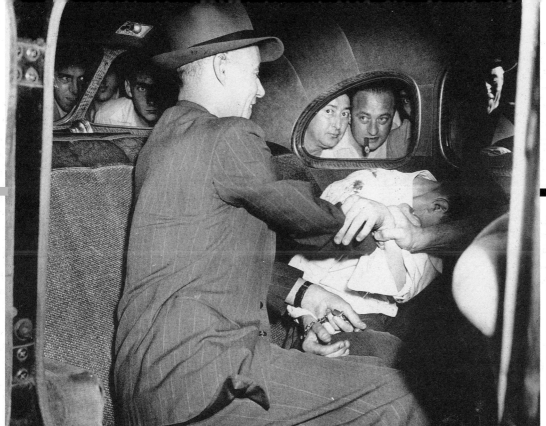

WEEGEE: KING OF CRIME PHOTOGRAPHERS

The most famous photographer to capitalize on the tabloid mentality and concentrate his energies on the seamier side of city life was Arthur Fellig, universally and simply known as "Weegee." Weegee acquired his name because, like the Ouija board, he supposedly had an uncanny ability to predict what would happen when and where, and he would miraculously be there often ahead of the police. However, because he was a poor speller he wrote his new name phonetically "Weegee." His news sense, of course, was a helpful quality for a photojournalist and, with the advantages of his police radio and a strategically located living quarters near the police station, Weegee managed to keep on the scent of the city's assorted crimes, auto crashes, and fires. The city was his working space, the night was his time, and violence was his specialty. Too independent to be tied to any one publication, Weegee remained a free-lancer and a free spirit for most of his career. He cruised the city streets nightly in his car, always ready to cover the happenings of urban nightlife.

Weegee poked his inquisitive camera into every dark corner of the city, photographing life as he saw it — stark and uncensored. His book **Naked City** was later made into a movie and then a television show. Its title is an apt summation of his style and his subject. In his pictures, the city was indeed naked, unadorned, and exposed.

Weegee knew not only how to get a picture but how to sell it as well. He explained his technique, "If I had a picture of two handcuffed criminals being booked, I would cut the picture in half and get five bucks for each." For a photo of a bullet-ridden corpse, he had an entrepreneur's price scale. Weegee's going rate: $5 per

bullet! Never one for modesty, he would stamp the back of his pictures, "Credit Weegee the Famous." The stamp was hardly necessary, though, as his direct, unflinching style of photography identified him as much as his signature or his omnipresent cigar.

Weegee reveled in his role as a special character and he played it to the hilt. With his chewed-up cigar, crushed felt hat, and bulging eyes, he sometimes looked like the popular stereotype of a crime photographer. He gloried in beating the cops to the scene of the action. Rushing from his car he would point his camera at the subject without bothering to focus or adjust the f-stop. Ten feet at f/11 with flash covered most situations.

Besides covering violent scenes, Weegee also shot ordinary life — people relaxing at Coney Island, fans at Frank Sinatra concerts, children sleeping on a fire escape. Later in his career he photographed many Hollywood stars.

In Weegee's work the flashbulb's explosion intruded on the night's protective darkness, violating its cover and exposing the startling scenes that he was a party to. In all of his photos, the flash bulb is a real presence. It is evident in the strong tonal contrasts from the harsh light of a flash used on the camera. Somehow, in Weegee's world, everyone looks like a victim, caught unaware by the insistent light of the camera's flash.

THE SEARCH FOR A CONVENIENT LIGHT SOURCE

■ DANGERS OF FLASH POWDER

Although Weegee had to replace the flash bulb after each exposure, flash bulbs proved infinitely more convenient than the flash powder used in Jacob Riis' day. Horror sto-

Flash powder fired in a pan left the room filled with smoke, unfortunately delaying the possibility of taking a second photo. Here, Harry Rhodes demon-

strates his flash technique. Rhodes, we hope, never breathed in at the wrong time. (Files of the National Press Photographers Association, courtesy of John Faber.)

FLASH POWDER

The Imp powder synchronizer, (RIGHT) used for taking pictures of large groups indoors, was operated with either a cable release or air line. (Files of the National Press Photographers Association, courtesy of John Faber.)

ries about flash powder are legion. Flash photographers in the old days wore special cuffs so the powder wouldn't roll down and burn their arms when the chemical was ignited. Eddie McGill, a *Chicago Tribune* photographer, suffered a skull fracture when a big flash pan bent as it fired. Another Chicago photographer, Nick McDonald of the *Chicago Herald-Examiner*, lost a hand from exploding powder as he poured it from a bottle onto a hot flash pan. When there were several photographers on the scene, it was necessary to decide which of them would set off the flash powder. Once the substance was lit, smoke filled the room, eliminating the possibility of anyone taking a second picture. An additional problem, of course, was the subjects gasping for air, sometimes between curses. Needless to say, photographers and their flash pans were not exactly welcome in most places.

Three kinds of flash lamps were available for the photographer: the Caywood, the Imp, and the Victor. The Caywood flash was used for indoor portraits and group pictures. The Imp lamp, manufactured by the Imperial Brass Co., worked well for large groups indoors. Outdoors, at night, when lots of light was needed, the news photographer used a long Victor flash pan.

A photojournalist could choose between three types of flash powder manufactured by the Excel Fire Works Company. Powder in the red label can burned the fastest (1/25 sec.), so it was selected for sports. Yellow-labeled powder fired slower but brighter. Blue-labeled powder, used for portraits, burned the slowest but gave off the most light.

Photographers always filled the flash pan with four times as much powder as needed to make sure they would have enough light, recalls Frank Scherschel, who was a news photographer in those days. He says that besides packing his camera and plates, he always carried a tube of Unguentine in case he burned his hands. With the lens set at f/16 the news photographer fired the flash lamp and prayed.

■ FLASH BULBS: SAFE BUT INCONVENIENT

Although smokeless flash powders were developed over the years, it was not until 1925 that a superior method of lighting was found. In this year Paul Vierkotter patented the flash bulb — a glass bulb containing an inflammable mixture that was set off by a weak electric current. Four years later, the flash bulb appeared in an improved form, with aluminum foil inside. Although these bulbs were infinitely preferable to the smoky, noisy, and dangerous flash pans, the flash bulbs still were inconvenient for the press pho-

Flash bulbs, which replaced flash powder, were smokeless and safe, but they were cumbersome and awkward. (Files of the National Press Photographers Association, courtesy of John Faber.)

tographer. Some of the biggest bulbs were close in size to a football. Static electricity or electromagnetic energy could cause them to fire. In addition, the bulbs had to be replaced after each shot, a delay that could cause the photographer to miss important pictures.

Marian Fulton in her book *Eyes of Time* points out that the flash bulb gives an artificial quality to the photo. The light coming from the on-camera flash is always bright. The flash tends to flatten the subject in the foreground, separating it from the rest of the scene, which becomes a separate, darker background. She notes that all flash pictures, regardless of content, tend to take on the same "look."

■ EDGERTON DEVELOPS THE ELECTRONIC FLASH

Although it did not change the character of the light, the electronic flash was far more convenient than the flash bulb. The forerunner to the modern electronic flash was designed by Harold Edgerton of the Massachusetts Institute of Technology in the early 1930s. While investigating motors, Edgerton developed an electronic stroboscope that flashed at repeated fixed intervals, synchronizing with the moving parts of the machine. Edgerton later used his stroboscope to take single and multiple image photos not only of moving machine parts but also of tennis players, golfers, and divers, as well as hummingbirds in flight. Basically, his electronic flash worked by discharging a high voltage from a capacitor through a gas-filled tube, producing an extremely brief burst of light. The light was powerful enough for photography despite the relatively insensitive films available at the time. Though an observer would not be aware of it, the light from the electronic flash exceeded the combined output of 40,000 50-watt bulbs.

Edgerton (ABOVE, far right) inventor of the electronic flash, took pictures with local photojournalists at the circus to demonstrate how his equipment could be used to cover events outside the lab. (Courtesy, MIT Museum.)

Ed Faber (LEFT) of the *Milwaukee Journal* developed a practical, portable battery and AC electronic flash for photojournalists. (Files of the National Press Photographers Association, courtesy of John Faber.)

Edgerton designed his electronic flashes for research. George Woodruff, a photographer with the International News Photos (INP), heard about Edgerton's invention and dropped by the scientist's M.I.T. lab. Woodruff asked if the electronic flash had any use in news photography. Edgerton answered by helping Woodruff lug three flash units to the circus playing in town that night.

Each strobe — all are still in use, according to Edgerton — had a large capacitor that put out 4000 volts (9600 watt-seconds). The flash duration lasted less than 1/50,000 of a second. On successive nights, the pair tried their strobe set-up at a variety of sporting events. With Woodruff on camera and Edgerton on strobe, the team of photographer and scientist managed to stop the action of runners, boxers, and swimmers in their natural environments.

While working for the *Milwaukee Journal*, photojournalist Edward Farber designed an electronic flash that could be synchronized with the common shutter found on most press cameras. Farber's first working electronic flash weighed ninety pounds and had oil capacitors and an AC power supply. The *Journal* sent Farber back to the lab to design a more portable model.

By October 1940, Farber had the flash's weight down to twenty-five pounds. Powered by a motorcycle battery, it also had a plug for household current. In the fall of 1941, Farber found a lighter battery, and around it he built a "dream" portable flash weighing only 13 1/2 pounds. In the 1950s, the electronic flash design was sold to Graflex Inc., in Rochester, New York, and remained for many years a standard piece of equipment for the news photographer.

To view through the Graflex camera, the photographer looked down into the hood on top of the box. The bulky camera used glass plates. (Files of the National Press Photographers Association, courtesy of John Faber.)

The Graflex camera (bottom row), nicknamed Big Bertha when fitted with a telephoto lens, was used by many papers to cover sports until the mid-1950s. (Photo courtesy of Dave Wurzel, *UPI.*)

CAMERAS LOSE WEIGHT AND GAIN VERSATILITY

About the time the flash bulb was perfected, another invention was being developed that allowed pictures to be taken in dim indoor light without any artificial illumination at all. The candid camera, as it came to be known, was to change the course of news photography and redefine the role as well as the potential of the photojournalist.

■ GRAFLEX USED UNTIL 1955

At the beginning of the century, the most widely used press camera was the Graflex and its German counterpart, the Ica. These cameras were portable, although still heavy; they used either a 4"x5", 4"x6", or 5"x7" glass plate. Because of the large size of the negative, the resulting print was of high quality and had adequate detail.

The Graflex looked like a large rectangular box with a hood on top. To view through this oversized single-lens reflex camera, the photographer would look down the hood at an angled mirror that would reflect what the lens saw — except that the image was reversed left to right. The photographer could fit on a 40-inch telephoto lens for shooting sports from the press box. When the Graflex carried the telephoto, the 70 lb. combination was affectionately known as Big Bertha. The large negative produced by the Graflex meant that photographers did not have to frame perfectly on every play — they were secure in the knowledge that if they captured the action on at least part of the film they could make a usable blow up. James Frezzolini, a news photographer, modified the Big Bertha with a notched lever for rapid focusing between first, second, and third bases at a baseball game. According to John Faber, historian of the National Press Photographers Association, some photographers continued to shoot with the Graflex at sports events until 1955.

■ SPEED GRAPHIC: A NEWS PHOTOGRAPHER'S BADGE

For general news events, the Speed Graphic, introduced in 1912 by Folmer and Schwing, a division of Eastman Kodak, replaced the Graflex by the 1920s. The front of the Speed Graphic folded down to form a bed with tracks. The lens slid out on these tracks. A bellows connected the lens to the box of the Graphic and expanded or contracted as the photographer focused. The film was carried in holders, two shots to a holder. Whereas a rangefinder came attached to the side of the camera, a seasoned photographer often removed this device and just guess-focused. While the camera could be used with a tripod, it was more conveniently hand-held. The 9½ lb. camera could take intensive pounding, and even after the development of the small 35mm camera, many press photographers continued to shoot with their Speed Graphics.

Robert Gilka, who later became director of photography for the *National Geographic*, was picture editor of the *Milwaukee Journal* in 1955, when he issued a memo that read in part, "This 35mm stuff may be okay for magazines. . . but we might as well face the facts. We are wasting our time shooting the average news assignment on 35mm."

The 4"x5" Speed Graphic was the standard news camera of the business from the 1920s to the 1950s. Experienced photographers didn't focus: they just guessed the distance. Old Speed Graphic users claimed the camera had only three distance settings: here, there, and yonder. The group of photographers above worked for the *Providence Journal-Bulletin*.

Robert Boyd, a past president of the National Press Photographers Association, was once asked what the press camera could do that the 35mm couldn't. Boyd put the big camera on the ground and sat on it.

The days of the Speed Graphic, however, were numbered.

■ LEICA LIGHTENS THE LOAD

The earliest miniaturized camera was the Ermanox, a German-designed small camera that took single glass plates and had an extra-fast lens. The lens, at f/1.8, had an almost incredible light-gathering capability for the period. The manufacturer of the Ermanox

EARLY LEICA CAMERA

lens proudly claimed, "This extremely fast lens opens a new era in photography and makes accessible hitherto unknown fields with instantaneous or brief time exposures without flash-light...."

He was right that the lens opened a new era in photography. But unfortunately, one major drawback aimed the Ermanox for extinction. The camera used only individually loaded 4.5x6 cm glass plates — an obvious inconvenience for news photographers. Still, the Ermanox was important in that it was the forerunner to the camera that would revolutionize photojournalism.

Oskar Barnack, a technician at the E. Leitz factory in Germany, invented the Leica. Like the Ermanox, the

The man pointing had just learned that press photographers were not being allowed in. The politician said he doubted that and wagered that at least one would be there. Slowly, he peered around the room until he discovered Erich Salomon just as the photographer was taking a picture of him. Salomon was the first photographer to use extensively the Ermanox miniature camera to catch candid photos. Salomon specialized in diplomatic gatherings and governmental functions. If Salomon couldn't get in openly, he hid his camera in the crown of his hat, in a temporary sling around his arm, or in a hollowed-out book. (Photo by Erich Salomon, Magnum.)

Leica had an extremely fast lens but, rather than glass plates, the Leica used a strip of 35mm motion picture film with as many as forty frames per roll possible in the original models. Barnack continually worked on his design and, in 1924, the first Leicas were put on the market. By 1932, Leitz mass-produced the camera in fully refined form with extremely fast, removable lenses and a built-in rangefinder.

The implications of this handy, small-format camera were wide-ranging.

Now, with existing light, the photographer could snap pictures without having to bother with flash bulbs. The Leica's lightness, ease of handling, and fast lens allowed the photographer to move freely, unencumbered by heavy camera accessories, flash attachments, clumsy tripods, or glass plates. Because the film could be rapidly advanced, photographers could make exposures one after another, thus enabling them to capture an unfolding event without stopping between pictures.

The Leica gave the news photographer unprecedented mobility and the ability to take a picture unobtrusively. The photographer no longer had to stop life in its tracks to snap a picture; people no longer posed for the camera's lens. Now, subjects could be more relaxed and natural and the photographer in turn, was free to concentrate on atmosphere and composition rather than on technical matters. These new capabilities did nothing less than change the relationship between photographers and the world. Because they could use available light and remain unobtrusive, press photographers could imbue their pictures with a new sense of realism, of life in the making.

ERICH SALOMON: FATHER OF CANDID PHOTOGRAPHY

The man who first exploited this photographic impression of life was Erich Salomon. Often called "the father of candid photography," he was probably the person who coined the term photojournalism to describe what

he was doing. Salomon began his photography career in 1928 with the new Ermanox camera. Salomon's arenas of action were diplomatic gatherings and government functions; his subjects were the foremost statesmen and political personalities of Europe. When he initially tried to penetrate these carefully guarded events, the officials refused to let him in, claiming that flash powder and large cameras would disrupt the orderly proceedings. But when Salomon demonstrated the capabilities of his unobtrusive camera, he was not only given entry into these private quarters but he became a regular habitue of diplomatic circles, causing French Prime Minister Aristide Briand to remark, "There are just three things necessary for a conference: a few Foreign Secretaries, a table, and Salomon."

However, even the ingenious Salomon could not charm his way into all top-level, top-secret meetings. When barred from an important conference, the dapper photographer would don his top hat, white gloves, and tails and set to work concocting some scheme to allow him entry into this private world. The ruses that Salomon used are legendary. He once managed to take pictures in a courtroom, which was off-limits to photographers. He shot his film by cutting a hole in the crown of his hat and hiding his camera there. Following the success of this technique, he used a similar ploy to photograph a roulette game in Monte Carlo. He hollowed out several thick books and hid his camera inside. While Salomon appeared absorbed in the game, he was actually busy clicking away with his concealed camera.

The urbane, multilingual Salomon moved with ease among dignitaries and heads of state, capturing with his camera the personalities of the people who shaped history and the atmosphere of their inner sanctums. With the Ermanox, and later with the Leica, he penetrated the masks of the public personae to reveal those very human characteristics that lay underneath — of dozing diplomats, bored-looking royalty, down-to-earth movie stars.

There is a remarkably intimate quality to Salomon's work. Because his camera enabled him to catch these prominent people off guard, his pictures give the impression that the camera, rather than being an intruder, is simply a watchful observer who happens to be present at the scene. Salomon's candid photography attracted a good deal of attention, and he numbered among his subjects such luminaries as Albert Einstein, President Herbert Hoover, Marlene Dietrich, and William Randolph Hearst.

Salomon later died in one of Hitler's concentration camps. As one of the first to demonstrate the possibility of recording events with the candid camera, Salomon truly deserves the title of "father of candid photography."

THE PHOTO ESSAY

Salomon's candid camera style proved that current events could be captured pictorially. The impact of this discovery was felt strongly in Germany, where in such picture magazines as the *Muncher Illustrierte Press*, *Berliner Illustrierte Zeitung* and in England in the *Illustrated London News*, the photo essay first appeared in embryonic form. Stefan Lorant, editor of the *Muncher Illustrierte Press*, developed the notion that there could be a photographic equivalent of the literary essay. Previously, if several pictures appeared together, they were arranged either arbitrarily or sequentially, with little regard for the conceptual logic of the layout, captions, cropping, or picture size. Lorant and his colleagues began experimenting with a new photographic form in which several pictures appeared, not in isolation but, rather, as a cohesive whole.

Illustrated magazines were not a new phenomenon in the United States. As early as the nineteenth century, *Leslie's Illustrated Newspaper* and *Harper's Weekly* relied on drawings to elucidate their articles. After the invention of the halftone, such publications as *McClure's*, *Cosmopolitan*, and *Collier's* continued the tradition of adding pictures to supplement their stories.

The difference between these early magazines and the great American picture magazines that followed lay not only in the number of pictures used but also in the way they were used. In the new magazines, several pictures were grouped together with an overall theme and design, and picture editors discovered truth in the old adage, "The whole is worth more than the sum of the parts." Accordingly, the role of the picture editor became all-important; along with the photographer, the picture editor shaped the story and, with the aid of shooting scripts, mapped out the photographer's plan of attack.

■ *LIFE* COMES TO LIFE

Life was the brainchild of Henry Luce, the publisher of *Time* and *Fortune* magazines. Spurred by the success of similar European ventures, Luce and his colleagues felt the time was ripe in the United States for a new, large-format picture magazine. Hence, *Life* came to life in the 1930s. In its manifesto, the new magazine stated its credo: *To see life, to see the world; to eyewitness great events; to watch the faces of the poor and the gestures of the proud; to see strange things — machines, armies, multitudes, shadows in the jungle and on the moon; to see man's work — his paintings, towers and discoveries; to see things a thou-*

LIFE SET THE PACE

The first cover of *Life* magazine taken by Margaret Bourke-White (seen at near left) showed a WPA dam in New Deal, Montana. (© 1936 Time Inc., courtesy of Time Incorporated)

NOVEMBER 23, 1936 10 CENTS

sand miles away, things hidden behind walls and within rooms, things dangerous to come to; the women that men love and many children; to see and to take pleasure in seeing; to see and be amazed; to see and be instructed.

For the first issue, November 23, 1936, *Life*'s editors dispatched Margaret Bourke-White to photograph the construction of a WPA dam in New Deal, Montana. In the 1920s Bourke-White had made a name for herself as a free-lancer and later as a top-notch industrial photographer on the staff of *Fortune* magazine. Her pictures celebrated the burgeoning machine aesthetic of the time, and her expertise in capturing on film structural and engineering details made her the perfect candidate for the industrial assignment.

When she returned with her pictures, however, the editors of *Life* were in for a surprise. Not only had she captured the industrial drama of the dam under construction, but she took it upon herself to document the personal drama of the town's inhabitants, as well. Bourke-White turned her camera on the details of frontier life –– the hastily erected shanty settlements, the weather-beaten faces of the townspeople, the Saturday night ritual at the local bar — and enhanced her story by adding the human dimension.

On the cover of the first issue of *Life* is a picture of the huge dam in all its geometrical splendor. And inside is Bourke-White's photo essay: nine pages of carefully laid out, strategically chosen pictures of the New Deal's people. The first issue was a sell-out. The editorial offices of *Life* in New York were besieged by phone calls and telegrams asking for more copies. The presses were restarted to meet the demand. "During the first year you had to hurry to the news stands on publication day to grab up a copy before they were all gobbled up," accord-

ing to Arthur Goldsmith in an article about the magazine.

The photo essay of Peck Dam became the prototype for a form that flourished in the pages of *Life*, a form that expanded the scope of photojournalism and redefined the way we see. The first four photographers who appeared on the magazine's masthead besides Margaret Bourke-White were Peter Stackpole, known for his photographs of the construction of the Golden Gate Bridge; Thomas McAvoy, an expert on the use of the 35mm for political candids; and Alfred Eisenstaedt, a specialist in the new German style of candid photography.

During its first few years, *Life* had the reputation of a magazine that ran sensational pictures. The magazine's first real shocker was titled "How to undress in front of your husband." The story, tame by today's standards, was supposed to be "sophisticated satire," but many readers let it be known they thought it indecent. Several issues later, *Life* ran an article titled "Birth of a Baby." The feature ran four pages and showed in drawings how the unborn child grows in the womb and the progress of the baby from the mother's body. In the actual birth pictures the only things visible in the frame were the baby's head, the doctor, and masses of sterile dressing. After publication, a furor broke out. The magazine was banned in 33 cities and Canada and publisher Roy Larsen was arrested for selling indecent literature.

THE COMPLICATED CAREER OF W. EUGENE SMITH

Perhaps the most influential, controversial, and well-remembered photographer ever to work for *Life* was W. Eugene Smith — who quit the magazine twice. He signed a contract with *Life* magazine in 1939, and subsequently shot many photos and photo essays for the magazine. Smith resigned in 1941 because he felt he was in an assignment rut at *Life*. He referred to his pictures at this time as having "a lot of depth-of-field but

First Communion Dress
[caption partially illegible]

ON THE OUTSKIRTS
[caption partially illegible]

Spanish Village
IT LIVES IN ANCIENT POVERTY AND FAITH

The village of Deleitosa, a place of about 2,300 peasant people, sits on the high, dry, western Spanish tableland called Estremadura, about halfway between Madrid and the border of Portugal. Its name means "delightful," which it no longer is, and its origins are obscure, though they may go back a thousand years to Spain's Moorish period. In any event it is very old and Life Photographer Eugene Smith, wandering off the main road into the village, found that its ways had advanced little since medieval times.

Many Deleitosans have never seen a railroad because the nearest one is 25 miles away. The Madrid-Sevilla highway passes Deleitosa seven miles to the north, so almost the only automobiles it sees are a dilapidated sedan and an old station wagon, for hire at prices few villagers can afford. Mail comes in by burro. The nearest telephone is 12½ miles away in another town. Deleitosa's water system still consists of the sort of aqueducts and open wells from which villagers have drawn their water for centuries. Except for the local doctor's portable tin bathtub there is no trace of any modern sanitation, and the streets

smell strongly of the villagers' donkeys and pigs.

There are a few signs of the encroachment of the 20th Century in Deleitosa. In the city hall, which is run by political subordinates of the provincial governor, one typewriter clatters. A handful of villagers, including the mayor, own their own small radio sets. About half of the 200 homes of the village are dimly lighted after dark by weak electric-light bulbs which dangle from ancient ceilings. And a small movie theater, which shows some American films, sits among the sprinkling of little shops near the main square. But the village scene is dominated now as always by the high, brown structure of the 16th Century church, the center of society in Catholic Deleitosa. And the lives of the villagers are dominated as always by the bare and brutal problems of subsistence. For Deleitosa, barren of history, unfavored by nature, reduced by wars, lives in poverty—a poverty shared by nearly all and relieved only by the seasonal work of the soil, and the faith that sustains most Deleitosans from the hour of First Communion (opposite page) until the simple funeral that marks one's end.

FIRST COMMUNION DRESS
Lorenza Curiel, 7, is a sight for her young neighbors as she waits for her mother to lock door, take her to church.

PHOTOGRAPHED FOR LIFE BY W. EUGENE SMITH

not much depth-of-meaning." He covered World War II at first for Ziff-Davis Publishing Company and then was rehired by *Life*.

Obsessed with the gap between the reality of war and the comfortable headlines of war seen by the people back home, the 24-year-old correspondent hurled himself into the front lines, trying to catch on film the horror of killing. Smith followed thirteen invasions, taking memorable pictures of the war — a tiny, fly-covered, half-dead baby held up by a soldier after being rescued from a cave in Saipan; a wounded soldier, bandaged, stretched out in Leyte Cathedral; a decaying Japanese body on an Iwo Jima beach. Then, while shooting a story on a day in the life of a soldier, Smith was hit by a shell fragment that ripped through his left hand, his face, and his mouth — critically wounding him. Two years of painful convalescence followed.

In 1947, Smith resumed his work for *Life* magazine. During the next seven years, he produced his best-known set of photo essays: the exhausting dedication of a country doctor; the poverty and faith in a Spanish village; the pain of birth, life, and death being eased by a nurse midwife, Smith's own favorite essay (see pages 132–143). "In many ways, shooting these photos was the most rewarding experience photography has allowed me," said Smith of the midwife essay.

W. Eugene Smith's landmark essay "Spanish Village," for *Life* magazine, opens with a young girl preparing for confirmation and closes with a wake for a dead villager. (*Life*, April 9, 1951.)

According to Jim Hughes' extensive biography, ***Shadow and Substance***, Smith himself was not an easy photographer to work with. While most *Life* staffers shot their assignments and shipped the film back to New York, Smith developed his own negatives and then held onto them. With control of his negatives, Smith could threaten to withdraw a story if he felt the editors were not going to play the photos accurately.

In 1954, Smith photographed the essay "Man of Mercy," about Dr. Albert Schweitzer and his leper colony in Africa. After carrying the Schweitzer essay back to America, Smith quarreled with *Life*'s editors about it. In a futile attempt to affect the use of pictures and captions, and to expand the Schweitzer layout, Smith resigned from *Life* for the second time.

Smith, in the latter part of his life, and with the help of his wife Eileen, photographed a moving story about mercury poisoning in Minamata, Japan, that was published first in *Life* and eventually appeared as a book.

■ COMPETITION FOR *LIFE*
LOOK BASED ON SURVEY

The astounding success of *Life* was matched by that of its fellow picture magazine *Look*. *Look* was founded by the Cowles brothers, a Minneapolis newspaper publishing family who commissioned George Gallup to discover what part of the newspaper was most widely read. When Gallup's poll revealed that the picture page was most popular, the brothers founded *Look*, which first appeared in January 1937, a few months after *Life* began. *Look* quickly developed a reputation for sensational stories. One

WHEN PICTURES TOLD STORIES

The success of *Life* and then *Look* spawned many picture magazines in the days before television.

description at the time claimed that *Look* was a combination of "gall and honey." Cowles answered, "*Look* has been criticized as sensationally thrilling. My only reply is that life itself is thrilling..."

Look toned down its sex-and-violence image to concentrate on feature stories. Known for its writer/photographer team approach, *Look* hired many outstanding shooters including Arthur Rothstein, Paul Fusco, and Stanley Tretich.

SEE, PEEK, CLICK, SCOOP

The rapid increase in *Life*'s and *Look*'s circulation persuaded other publishers to start picture magazines. Within two years of *Life*'s first issue, the picture magazine field was crowded with thirteen periodicals sporting one-word, punchy names like *See, Click, Peek, Pix, Picture,* and *Scoop* and boasting a combined circulation of 16 million per issue. The magazines' content ranged from "girlie" pinups to the social ills of drinking. Stories included the "Truth about cremation" and "How you should tell your child about sex." Most stories in these *Life* and *Look* imitators were highly scripted with few candids. Each represented a little melodrama, and sometimes actors even played parts in the photos. The proliferation of picture magazines starting in 1936 and continuing through the '40s and '50s has caused historians to call the period before television's dominance the golden age of photojournalism.

PHOTOGRAPHERS COMPETE

■ RIVAL PHOTOGRAPHERS WERE MANY

The success and style of the picture magazines had some important effects on newspaper photojournalism. The photo essay layout influenced many newspapers to adopt a similarly simple and direct arrangement of pictures about one subject. Likewise, newspapers began running more feature stories and using larger pictures.

Philadelphia boasted 20 daily newspapers during the 1920s and more than 200 press photographers. During the depression, however, many papers died. While newspapers competed for readers, press photographers competed for scoops. Photographers were not above sabotaging one another. Joe Costa, who worked for *The New York Morning World* and later the *New York Daily News,* recalled that photographers never let their camera bags out of their sight. He called it a "dog-eat-dog" business. A competitor might expose the film in a fellow photographer's holders or simply switch holders: the exclusive picture would be in the opposition's newspaper the next day!

Using the basic 4"x5" speed graphic, photographers of this period covered gangland slayings and bootlegged booze all without the aid of an exposure meter. Photographers determined most exposures by "guesstimations." The effective film index at this time was around ISO 25.

Guessing lighting exposures was just one of the shooting techniques photographers learned from one another because few went to school to learn photojournalism. In fact, almost no universities prior to the 1940s offered photojournalism as a major. News photographers often got their start as copy boys on a newspaper. If they expressed a leaning toward pictures, they could start an apprentice program in which they mixed chemicals and loaded film holders in the darkroom — progressing then to developing film and printing. They also carried equipment for photographers in the field. Moving from printing in the lab to covering news in the street was a major hurdle that took some photographers five years or more to leap, according to Sam Psoras, who started with International News Photos before joining the *Philadelphia Daily News.*

One newspaper that maintained a large photographic staff was the *Milwaukee Journal.* Historically, the *Journal* staff worked under a unique setup. They were a part of the engraving department rather than the editorial department. Because they were part of the production team, the engraving department management was not shocked by large capital outlay expenses for equipment. As a result, the photo department instigated many technological advances, including the early use of the 35mm camera. Staff photographer Brownie Rowland brought back a Leica from Germany, and Frank Scherschel was interested enough to borrow the little camera and try it out. History books credit Bob Dumke with inventing a

synchronizing switch for his Speed Graphic that allowed him to shoot flash pictures in daylight. Ed Farber developed the portable electronic strobe for covering news events. The *Journal* continued to experiment with running four-color pictures throughout the paper during the depression.

Another newspaper noted for its outstanding use of pictures was the *Des Moines Register and Tribune*. In 1928, to transport pictures from rural areas of Iowa, the paper bought an airplane and hired a pilot. In the latter half of the '30s, *Quill and Scroll*, a trade journal, ranked this paper first in the number of pictures carried.

■ A PROGRESSIVE VISUAL NEWSPAPER

PM, a short-lived, liberal tabloid, exhibited the most progressive and modern use of pictures by a newspaper. Founded in 1940 by Ralph Ingersoll, who

PM combined a newsmagazine's approach to writing and a picture magazine's approach to photos into a strikingly different daily newspaper. (Collection of Sidney Kobré.)

The 85,000-ton liner Queen Elizabeth is re-fueled and could sail today for Halifax. But Cunard officials, making mysteries, deny she will sail, won't explain re-fueling.

previously had helped edit *Time* and *Life*, the paper combined the word approach of the newsweekly with the visual approach of the picture magazine in a daily, tabloid newspaper. The squarish-format tabloid hired the best photographers of the day, including WeeGee (Arthur Fellig) and Margaret Bourke-White. The paper was beautifully printed with a special ink and stapled so that the pages would not fly apart. Its sections with eight consecutive pages of full-page pictures were an approach unheard of in its day and, in fact, rarely if ever seen since. The crusading paper used photographs to document its exposés, including one series on the unsanitary conditions in the New York poultry market. Depending on newsstand sales and subscriptions alone, the paper eventually died because it contained no advertising.

PHOTOGRAPHERS ORGANIZE

Because the public began to recognize such names as Margaret Bourke-White and Alfred Eisenstaedt, the photographer began to achieve parity with the writer. Originally, the photographer began as a second-class citizen in the newsroom. According to one common story, when a news photographer's job opened up, the editor would find the nearest janitor and hand him a camera, telling him to set the lens at f/8 and shoot. Photographers were thought of as the people who chased fires and took cheese-cake pictures. Taking cheese-cake pictures involved meeting the incoming steamship to take snaps of pretty women with "lots of leg showing."

Along with steamships, cheese-cake pictures slowly went out of vogue. Editors began acknowledging the contribution of pictures as a means of reporting the news. The photographer's status gradually rose.

In 1945, Burt Williams, a photographer with the *Pittsburgh Sun-Telegraph*, started organizing a professional association for photographers, The National Press Photographers Association. According to Claude Cookman in his history of the organization, *A Voice is Born,* Williams obtained financial backing from the Cigar Institute of America for the organization and began the groundwork with a ten-city coast-to-coast telephone conference in which leaders in press photography took part. At a meeting in New York City on February 23 and 24, 1946, the group adopted a constitution and elected officers: Joseph Costa, *New York Daily News*, president; Burt Williams, *Pittsburgh Sun-Telegraph*, secretary; and Charles Mack, Hearst Metrotone News, treasurer. Today the organization holds an annual meeting, runs a traveling education seminar and publishes an attractive, well-written magazine,

News Photographer, which is edited by Jim Gordon. With more than 9,000 members including pros and students, the association also administers a photo contest and sponsors educational programs in photojournalism.

More and more college graduates enter the field of photojournalism each year. The first college grad to work on the picture side of a newspaper was Paul Thompson, who graduated from Yale in 1902. Today many schools offer courses and even degrees in photojournalism. More than ninety colleges offer at least one class in news photography. Some universities even grant a Ph.D. in journalism or communications with an emphasis in photojournalism.

DISTRIBUTING PICTURES ACROSS THE LAND

■ BAIN CREATES A PICTURE SERVICE

In 1898, a newspaper writer and photographer, George Grantham Bain, started the Bain News Photographic Service in New York City. As manager of the Washington, D.C., United Press office in the 1890s, Bain realized that he could accumulate pictures and sell them to subscribers. After Bain left the United Press, he began his own photo service. He catalogued and cross-indexed photographs he had bought from correspondents or newspapers that subscribed to his service. From newspapers throughout the country, he received pictures, copied them, and sent the copies to his list of subscribing newspapers. Bain's business expanded rapidly, and by 1905 he had acquired a million news photographs. Many of his pictures were the first of their kind, including the first federal courtroom pictures, the first photos of the Senate in session, and the first automobile race. Although a massive fire in 1908 completely destroyed Bain's archives, he immediately set about rebuilding his collection.

Other picture services developed, including Underwood and Underwood, who started out making stereoscopic pictures. Newspaper editors would call on the Underwoods for pictures to illustrate stories about remote countries where the Underwoods had operators. The Brown brothers, too, saw the possibilities of selling news pictures from their experience as circulation managers on *Harper's Weekly*. Soon the Underwood, Brown, and Bain photographers were all competing for scoops.

By 1919, the Hearst organization formed International News Photos (INP); Wide World Photos followed. In 1923 Acme News Pictures appeared. The Associated Press News Photo service began in 1927. These services sent their pictures by train, giving a tip to the

EARLY PICTURE AGENCIES

From light features (ABOVE) to photos of the unemployed in New York's Bowery (RIGHT), Bain News Photographic Service provided a steady supply of photos to member papers around the country. (Bain Collection, Library of Congress.)

porter to hand deliver the package of photos for extra-quick service. Today Acme and INP are combined into United Press International (UPI), and Wide World Photos is owned by the Associated Press (AP).

■ PICTURES TRANSMITTED INSTANTANEOUSLY

Ever since newspapers began publishing pictures, the search was on for a way to transport the pictures over long distances. As early as 1907, Professor Alfred Korn of the University of Munich, Germany, had demonstrated an electrical system using a photocell, which would transmit and receive a picture over a telegraph wire. His basic principle remains in use today. In the same year, *L'Illustration of Paris* and the *London Daily Mirror* inaugurated a cross-channel service that later included other capitals of Europe.

Not until 1925 was there a permanent transmission line set up in the United States. In that year the American Telephone and Telegraph Co. (AT&T) opened a commercial wire between New York, Chicago, and San Francisco. It was first-come, first served and cost $60 to send a picture coast-to-coast. AT&T sold the wire to the Associated Press in 1934. The AP bought the Bell Lab equipment, leased AT&T wire, and set up twenty-five stations. On January 1, 1935, the AP serviced an aerial picture of a plane that went dawn in the Adirondack Mountains, and the age of rapid wire transmission began in the

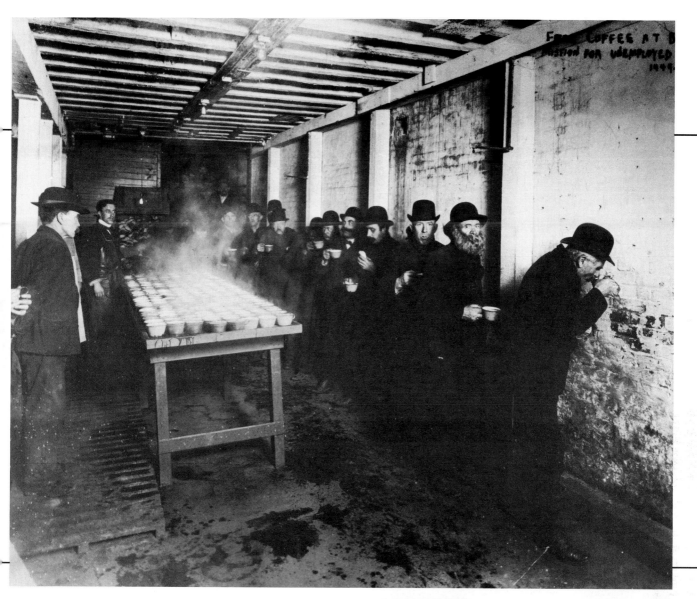

United States. Soon other picture services, including International News Photos and Acme, started their own wire photo transmission networks.

For a long time, such uncontrollable factors as weather conditions would influence the quality of pictures sent on long-distance transmission lines. But today, because of digital-laser techniques, the wire services can send photos instantaneously all over the world, with the quality of the final product looking as good as that of the original.

The development of laser transmission, the improvement in fast lenses, and the introduction of lighter cameras and more sensitive film have freed the photojournalist from many of the earlier technical limitations. The improvement in technology has led to a greater range of photo styles and subjects for the news photographer. Instead of cheese-cake and composograph photos taken with flash-on-camera, the new journalist can produce creative and expressive photos. These in-depth pictures, taken with available light or light from portable strobes, on color film or on electronic disks, can attain a candid look impossible in the days of the *New York Daily Graphic*. ■

Transmitters like this Associated Press machine did for photographers in the 1930s what the telegraph had done for writers prior to the Civil War. The device allowed photographers to send pictures by wire across the country and eventually around the world. (Photo courtesy of the Associated Press.)

SELECTED BIBLIOGRAPHY

In addition to listings from the first edition of *Photojournalism: The Professionals' Approach*, this bibliography includes articles and books derived from searches of a number of different electronic databases. Lucinda Covert-Vail, journalism librarian at San Francisco State University, conducted the searches, which span 1980 through summer 1990.

Adams, R. C., Copeland, Gary A., Fish, Marjorie J., and Hughes, Melissa. "Effect of Framing on Selection of Photographs of Men and Women." *Journalism Quarterly* 57 (1980): 463-67.

Ades, Dawn. *Photomontage.* Rev. & enlgd. ed. London: Thames and Hudson, 1986.

Alexander, S. L. "Curious History: The ABA Code of Judicial Ethics Canon 35." Paper presented at the Annual Meeting of the Association for Education in Journalism and Mass Communication, Portland, OR, 1988. ERIC, ED296422.

Alland, Alexander. *Jacob A. Riis.* Millerton, NY; Aperture, 1974.

Angeli, Daniel, and Dosset, Jean-Paul. *Private Pictures: Photographs.* New York: Viking Press, 1980.

Armor, Terry. "'Enterprise' Art: When Should You Pitch It?" *News Photographer* (March 1988): 20, 22, 25.

Arnold, Edmond C. *Modern Newspaper Design.* New York: Harper & Row, 1969.

"Associated Press." *Camera 58* (July 1979): 52-53.

Associated Press News and Photo Staff, eds. *One Day in Our World.* New York: Avon Books, 1986.

Auer, Michel. *The Illustrated History of the Camera: From 1839 to the Present.* Translated & adapted by D.B. Tubbs. Boston: New York Graphic Society, 1975.

Baker, Robert L. "Portraits of a Public Suicide: Photo Treatment by Selected Pennsylvania Dailies." *Newspaper Research Journal* 9 (Summer 1988): 13-23.

Barnes, Fred. "Where Is It Leading?" *News Photographer* (April 1979): 28-29.

Barney, Ralph D., and Black, Jay. *Journal of Mass Media Ethics* 2 (Spring/Summer 1987).

Baxter, William S., Quarles, Rebecca, and Kosak, Herman. "The Effects of Photographs and Their Size on Reading and Recall of News Stories." Paper presented at the Annual Meeting of the Photojournalism Division, Association for Education in Journalism. Seattle, WA, 1978. ERIC, ED159722.

Baynes, Ken. *Scoop, Scandal and Strife.* New York: Hastings House, 1971.

Benson, Harry. *Harry Benson on Photojournalism.* New York: Harmony Books, 1982.

Bergeman, Rich. "Photo Editing: A Neglected Art." *Community College Journalist* 15 (Winter 1987): 18-20.

Bergin, David P. *Photojournalism Manual: How to Plan, Shoot, Edit and Sell.* New York: Morgan & Morgan, 1967.

Bessie, Simon Michael. *Jazz Journalism: The Story of the Tabloid Newspapers.* New York: E.P. Dutton, 1938.

Best of Photo Journalism. Annual, 1977-1989. Publisher varies.

Bethune, Beverly. "Under the Microscope: A Nationwide Survey Looks at the Professional Concerns and Job Satisfaction of the Daily Newspaper Photographer." *News Photographer* (November 1983): R1-R8.

Bethune, Beverly, ed. *Women in Photojournalism.* Durham, NC: National Press Photographers Association.

Bethune, Beverly M. "Profile of Photojournalists on Two Metropolitan Newspapers." *Journalism Quarterly* 58 (1981): 106-8.

Bethune, Beverly M. "A Sociological Profile of the Daily Newspaper Photographer." *Journalism Quarterly* 61 (1984): 606-14, 743.

Bilker, Harvey L. *Photojournalism: A Freelancer's Guide.* Chicago: Contemporary Books, 1981.

Blackwood, Roy E. "The Content of News Photos: Roles Portrayed by Men and Women." *Journalism Quarterly* 60 (1983): 710-14.

Blackwood, Roy E. "International News Photos in U.S. and Canadian Papers." *Journalism Quarterly* 64 (1987): 195-99.

Blake, Donald P. "Anybody with a Camera Can Be a Newsman." *Popular Photography* (February 1967): 81.

Blumenfeld, Harold. "The Wire Services That Want You." *Popular Photography* (January 1974): 88-89.

Bork, Charles. "On War Photography." *National Review* (12 September 1986): 34-38.

Bossen, Howard. "Zone V: Photojournalism Ethics and the Electronic Age." *Studies in Visual Communication* 11 (Summer 1985): 22-32.

Bourke-White, Margaret. *Portrait of Myself.* New York: Simon & Schuster, 1963.

Bowden, Robert. *Get That Picture.* Garden City, NY: Amphoto, 1978.

Bowditch, Tom, and Gay, Jerry. "Stress." *News Photographer* (February 1979): 11-13.

Bowermaster, J. "Eyes on the Prize (How a Photographer and a Newspaper Turned Iowa's Farm Crisis into a Pulitzer Prize)." *American Photographer* (January 1988): 60-69.

Brauchli, Marcus. "Prize Under Glass...Chance, Ingenuity, Violence Often Cited as Key Factors in Pulitzer Winners." *News Photographer* (June-July 1981): 20-23.

Brill, Betsy. "Town Protests Staged Photo, Hooker Image." *News Photographer* (September 1986): 4-8.

Brill, Betsy. "Pictures Don't Lie. . . or Do They?" Master's Thesis, University of Missouri, 1988.

Brill, Charles. "The Early History of the Associated Press Wire Photo: 1926-1935." Paper presented at the meeting of the Photojournalism Division, Association for Education in Journalism, Madison, WI, 1977.

Brink, Ben. "Question of Ethics: Where Does Honesty in Photojournalism Begin? 'The Foundation Is Basic, Simple Honesty,' an Editor Says." *News Photographer* (June 1988): 21-22, 23-33.

Brown, Cindy M. "How the Use of Color Affects the Content of Newspaper Photographs." Paper presented at the Annual Meeting of the Association for Education in Journalism and Mass Communication, Washington, D.C., 1989. ERIC, ED308525.

Brown, Jennifer E. "News Photographer and the Pornography of Grief." *Journal of Mass Media Ethics* 2 (Spring/Summer 1987): 75-81.

Brown, Susan L. "Shooting Sports: John Iacono Shows Us How He Captures Sizzling Action." *Popular Photography* (October 1983): 72-75, 146, 166.

Brown, Theodore M. *Margaret Bourke-White, Photojournalist.* Ithaca, NY: Andrew Dickson White Museum of Art, Cornell University, 1972.

Bryant, Garry. "10-50 P.I.: Emotion and the Photographer." *Journal of Mass Media Ethics* 2 (Spring/Summer 1987): 32-39.

Bryant, Michael. "The Problem with Illustrations." *News Photographer* (July 1987): 36.

Buell, Hal. "The Associated Press Behind the Scene." *Camera 58* (July 1979): 4-6, 15-16.

Buell, Hal, and Pett, Saul. *The Instant It Happened.* New York: Associated Press, 1975.

Burnett, D. "Seven Voices." *Columbia Journalism Review* (November/December 1986): 57-59.

Byrne, Howard. *Without Assignment: How to Freelance in Photography.* New York: Pellegrini and Cudahy, 1952.

Callahan, Sean, ed. *The Photographs of Margaret Bourke-White.* Boston: New York Graphic Society, 1972.

Callahan, Sean, and Astor, Gerald. *Photographing Sports: John Zimmerman, Mark Kauffman and Neil Leifer.* Los Angeles: Alskog, 1975.

The Camera. Rev. ed. Alexandria, VA: Time-Life Books, 1981.

Campbell, Bryn. *Great Action Photography.* New York: Amphoto, 1983.

Capa, Cornell. *The Concerned Photographer.* New York: Grossman Publishers, 1968.

Cappon, Massimo, and Zannier, Italo. *Photographing Sports.* Translated by Maria Piotrowski. Chicago: Rand McNally, 1981.

Carlebach, Michael Lloyd. "The Origins of Photojournalism in America, 1839-1880." Ph.D. diss., Brown University, 1988.

Carnes, Cecil. *Jimmy Hare News Photographer: Half a Century with a Camera.* New York: Macmillan, 1940.

Cartier-Bresson, Henri. *The Decisive Moment.* New York: Simon & Schuster, 1952.

Cartier-Bresson, Henri. *The World of Henri Cartier-Bresson.* New York: Viking Press, 1968.

Cavallo, Robert M., and Kahan, Stuart. *Photography: What's the Law?* 2nd ed. New York: Crown Publishers, 1979.

Chapnick, Howard. "Markets and Careers: Photographic Captions." *Popular Photography* (February 1979): 42, 64, 127, 143.

Chapnick, Howard. "Looking for Bang Bang: Photojournalists are Flocking to Trouble Spots Like El Salvador, and Too Many Are Not Returning Alive. Are the Results of War Photography Today Really Worth the Risks?" *Popular Photography* (July 1982): 65-67, 99, 101-102.

Chapnick, Howard. "Markets and Careers: Keeping News Pictures Meaningful." *Popular Photography* (March 1983): 18, 130.

Chapnick, Howard. "Markets and Careers: Today's Ethics in Photojournalism." *Popular Photography* (August 1983): 40, 93.

Chapnick, Howard. "Photojournalism Should Work On More Than One Level—and Its Images Should Be Clear, Simple, and Spontaneous." *Popular Photography* (September 1984): 36-37.

Chapnick, Howard. "Markets and Careers: American vs. European Picture Editing." *Popular Photography* (December 1986): 38-39.

Chernoff, George, and Sarbin, Hershel B. *Photography and the Law.* 5th ed. Garden City, NY: Amphoto, 1975.

Cioffi, Ron. "*USA Today:* Its Influence on the Color, Design, Graphics and Photography of Daily U.S. Newspapers." MA thesis, Michigan State University, 1986.

Cohen, Lester. *The New York Graphic. The World's Zaniest Newspaper.* Philadelphia: Chilton, 1964.

Cohen, Stuart. "Focusing on Humanity: The Life of W. Eugene Smith." *Boston Phoenix* (31 October 1978).

Cole, Bernard, and Meltzer, Milton. *The Eye of Conscience: Photographers and Social Change.* Chicago: Follett, 1974.

Coleman, A. D. "Private Lives, Public Places: Street Photography Ethics." *Journal of Mass Media Ethics* 2 (Spring/Summer 1987): 60-66.

Converse, Gordon N. *All Mankind: Photographs.* Boston: Christian Science Pub. Society, 1983.

Converse, Gordon N. *Reflections in Light: The Work of a Photojournalist.* Boston: Christian Science Monitor, 1989.

Cookman, Claude. *A Voice is Born: The Founding and Early Years of the National Press Photographers Association Under the Leadership of Joseph Costa.* Durham, NC: National Press Photographers Association, 1985.

Costa, Joseph. Collected Papers. George Arents Research Library. Syracuse University: Syracuse, NY.

Costa, Joseph. "Cameras in Court: A Position Paper." Muncie, IN: Journalism/Public Relations Research Center, Ball State University, 1980.

Costa, Joseph, ed. *The Complete Book of Press Photography.* New York: National Press Photographers Association, 1950.

Covert, Douglas C. "Color Preference Conflicts in Visual Compositions." *Newspaper Research Journal* 9 (Fall 1987): 49-59.

Craig, R. Stephen. "Cameras in Courtrooms in Florida." *Journalism Quarterly* 56 (1979): 703-10.

Crawley, Shirley. *1988 Scholarship Compendium for Communication and Photojournalism Majors: Scholarships, Essay Contests, Loans, Fellowships, Internships.* Washington, DC: Crawley, 1986.

Daniel, Pete. *Official Images: New Deal Photography.* Washington, DC: Smithsonian Institution Press, 1987.

Daniel, Pete, and Smock, Raymond. *A Talent for Detail: Frances Benjamin Johnston.* New York: Harmony Books, 1974.

Davidson, Bruce. *Subway.* New York: Aperture, 1986.

Denton, Craig L. "Supercharged Color: Its Arresting Place in Visual Communication." Paper presented at the Annual Meeting of the Association for Education in Journalism and Mass Communication, Gainesville, FL, 1984. ERIC, ED244292.

Deschin, Jacob. "W. Eugene Smith Recalls Brutal Beating While Documenting a Poison Scandal." *Popular Photography* (October 1973): 14, 20, 212.

Dick, David B. "'What Did Mr. Dwyer Do, Daddy?' 'Well, As You Could See, He Committed Suicide, Darling.'" *The Quill* (March 1987): 18-20.

Diehl, Michael. "Viewer Response to Contrivance in Journalistic Photography." Paper presented to the Graduate Office of Journalism, University of Texas at Austin, Autumn 1981.

Dobell, Byron. "The Picture Story." *Popular Photography* (June 1959): 49.

Dorfman, Ron. "Journalists Under Fire: This Year's 'Absence of Malice' Will Make Even More Trouble." *The Quill* (October 1983): 12.

Doughtie, Daniel H. "Have the Technical Problems Associated with Color Changed the Shooting Style of News Photographers." MS thesis, Ohio University, Athens, 1988.

Dow, Caroline. "Privacy Law As It Affected Journalism, 1890-1978: Privacy Is a Visual Tort." Paper presented at the Annual Meeting of the Association for Education in Journalism and Mass Communication, Memphis, TN, 1985. ERIC, ED262399.

Dow, Caroline. "The Response of the Law to Visual Journalism, 1839-1978." Ph.D. diss., Michigan State University, 1985.

Dow, Caroline. "Prior Restraint on Photojournalists." *Journalism Quarterly* 64 (1987): 88-93, 118.

Duncan, David Douglas. *Self Portrait: U.S.A.* New York: Abrams, 1969.

Dunn, Philip. *Press Photography.* Sparkford, UK: Oxford Illustrated, 1988.

Durniak, John. "10 Stories Around You." *Popular Photography* (June 1959): 72.

Durniak, John. "Focus on Wilson Hicks." *Popular Photography* (April 1965): 59.

Durniak, John. "The New Wave of Picture Agencies." *Popular Photography* (November 1980): 95-101, 146-47.

Dykhouse, Caroline Dow. "Public Policy's Differential Effects on News Photographers." Paper presented at the meeting of the Photojournalism Division, Association for Education in Journalism, Seattle, WA, 1978.

Dykhouse, Caroline Dow. "Privacy Law and Print Photojournalism." Paper presented at the Annual Meeting of the Association for Education in Journalism, Seattle, WA, 1978. ERIC, ED1655144

Dykhouse, Caroline Dow. "The Detroit Workshop, 1949-1951: Robert Drew and the *Life* Photojournalism Essay Formula." MA thesis, Michigan State University, 1980.

Dykhouse, Caroline Dow. "Shuttered Shutters: The Photographic Statutes and Their Faithful Companion, 18 USC 1382—An Examination of Photographic Access to Military Areas." Paper presented at the Annual Meeting of the Association for Education in Journalism, Athens, OH, 1982. ERIC, ED218678.

Edey, Maitland. *Great Photographic Essays From Life.* Boston: New York Graphic Society, 1978.

Edgerton, Harold E. *Electronic Flash/Strobe.* 3rd ed. Cambridge, MA: M.I.T. Press, 1987.

Edgerton, Harold E., and Killian, James R., Jr. *Moments of Vision: The Stroboscopic Revolution in Photography.* Cambridge, Massachusetts: M.I.T. Press, 1979.

Edom, Clifton Cedric. *Photojournalism: Principles and Practices.* 2nd ed. Dubuque, IA: W. C. Brown Co., 1980.

Edwards, Owen. "A Mover Among the Shakers: Arnold Newman's Photographs Are a Tribute to the Staying Power of a Good Idea." *American Photographer* (November 1985): 68-73.

Einsiedel, E.F., and Murray, A. "Content Analysis of the Use of Front-Page Photographs: *Akron Beacon Journal* 1936-1976." Paper presented at the meeting of the Photojournalism Division, Association for Education in Journalism, Madison, WI, 1977.

Eisenstaedt. Alfred. *Witness to Our Time.* New York: Viking Press, 1966.

Eisenstaedt. Alfred. *The Age of Eisenstaedt.* New York: Viking Press, 1969.

Eisenstaedt. Alfred. *People.* New York: Viking Press, 1973.

Eisenstaedt, Alfred. *Eisenstaedt—Germany.* Edited by Gregory A. Vitiello. New York: Abrams, 1981.

Eisenstaedt, Alfred. *Eisenstaedt on Eisenstaedt: A Self-Portrait.* New York: Abbeville Press, 1985.

Eisenstaedt, Alfred. *Eisenstaedt: Remembrances.* Boston: Little, Brown, 1990.

Evans, Harold. *Eyewitness: 25 Years Through World Press Photos.* London: Quiller Press, 1981.

Evans, Harold. *Eyewitness 2: 3 Decades Through World Press Photos.* Updated ed. London: Quiller Press, 1985.

Evans, Harold, ed. *Pictures on a Page: Photo-Journalism, Graphics and Picture Editing.* New York: Holt, Rinehart and Winston, 1978.

Faber, John. "On the Record: Development of the Halftone." *National Press Photographer* (February 1957).

Faber, John. "On the Record: Wire Transmission of Photos." *National Press Photographer* (April 1958).

Faber, John. "On the Record: Birth of *Life* Magazine." *National Press Photographer* (August 1958).

Faber, John. "On the Record: History of the Photo Syndicates." *National Press Photographer* (December 1958).

Faber, John. "On the Record: Development of the Electronic Flash." *National Press Photographer* (March 1959).

Faber, John. "This is How NPPA Came into Being." *National Press Photographer* (June 1960).

Faber, John. *Great News Photos and the Stories Behind Them.* 2nd ed. New York: Dover Publications, 1978.

Faber, John. "On the Record: The Atomic Bomb, Hiroshima." *News Photographer* (July 1980): 30.

Faber, John. "On the Record: Sacrificial Protest of Quang Duck." *News Photographer* (July 1983): 10.

Faber, John. Telephone Interview with author. September, 1988.

Falk, Jon. *Jon Falk Presents Adventures in Location Lighting.* Rochester, NY: Eastman Kodak, 1988.

Farsai, Gretchen Jeanette. "A Review of Moral Standards Used to Select News Photographs." MA thesis, California State University, Long Beach, 1985.

Fedler, Fred, Counts, Tim, and Hightower, Paul. "Changes in Wording of Cutlines Fail to Reduce Photographs' Offensiveness." *Journalism Quarterly* 59 (1982): 633-37.

Feinberg, Milton. *Techniques of Photojournalism.* New York: John Wiley & Sons, 1970.

Finberg, Howard I., ed. *Through Our Eyes: The 20th Century as Seen by the San Francisco Chronicle.* San Francisco: Chronicle Publishing Co., 1987.

Finberg, Howard I., and Itule, Bruce D. *Visual Editing: A Graphic Guide for Journalists.* Belmont, CA: Wadsworth Publishing Co., 1990.

Fincher, Terry. *Creative Techniques in Photo-journalism.* London: Batsford, 1980.

Fisher, Andrea. *Let Us Now Praise Famous Women: Women Photographers for the U.S. Government, 1935-1944.* New York: Pandora Press, 1987.

Fishman, Mark. *Manufacturing the News.* Austin, TX: University of Texas Press, 1980.

Floren, Leola. "The Camera Comes to Court." Columbia, MO: Freedom of Information Center, 1978. ERIC, ED163559.

Fosdick, James A. "Stylistic Correlates of Prescribed Intent in a Photographic Encoding Task." Ph.D. diss., University of Wisconsin, 1962.

Fosdick, James A., and Tannenbaum, Percy H. "The Encoder's Intent and Use of Stylistic Elements in Photographs." *Journalism Quarterly* 41 (1964): 175-182.

Foss, Kurt, and Kahan, Robert S. "Still-Video Photography: Tomorrow's Electronic Cameras in the Hands of Today's Photojournalists." Paper presented at the Annual Meeting of the Association for Education in Journalism and Mass Communication, Washington, D.C., 1989. ERIC, ED310443.

Foster, D.Z. "Photos of Horror in Cambodia: Fake or Real?" *Columbia Journalism Review* (March 1978): 46-47.

Fox, Rodney, and Kerns, Robert. *Creative News Photography.* Ames, IA: Iowa State University Press, 1961.

Frascella, Larry. "The Searchers: Four of Today's Most Committed Picture Editors Talk About How They Hunt Out the Best Photographs, Where Visual Style is Headed, and Why Photographers Need to Be More Original." *American Photographer* (December 1989): 48-51.

Fulton, Marianne, ed. *Eyes of Time: Photojournalism in America.* Boston: Little, Brown, 1988.

Galella, Ron. *Jacqueline.* New York: Sheed and Ward, 1974.

Gans, Herbert J. *Deciding What's News: A Study of CBS Evening News, NBC Nightly News, Newsweek and Time.* New York: Pantheon, 1979.

Garcia, Mario R., and Fry, Don. *Color in American Newspapers.* St. Petersburg, FL: The Poynter Institute for Media Studies, 1986.

Garrett, Lillian. *Visual Design.* New York: Van Nostrand Reinhold, 1967.

Garrett, W. E., ed. *Photojournalism '76.* Boston: Godine, 1977.

Gatewood, Worth. *Fifty Years in Pictures: The New York Daily News.* Garden City, NY: Doubleday, 1979.

Gentry, James K., and Zang, Barbara. "Visual Editing: Graphics and Photo Editors Are Finding Their Place in the Newsroom." *MGR* (insert in *News Photographer*) (April 1989): 1-3.

Geraci, Philip C. *Photojournalism: Making Pictures for Publication.* Dubuque, IA: Kendall/Hunt, 1976.

Geraci, Phillip C. "Newspaper Illustration and Readership: Is *USA Today* on Target?" *Journalism Quarterly* 61 (1984): 409-13.

Geraci, Phillip C. *Photojournalism: New Images in Visual Communication.* 3rd ed. Dubuque, IA: Kendall/Hunt, 1984.

Germar, Herb. *The Student Journalist and Photojournalism.* New York: Richards Rosen Press, 1967.

Gidal, Tim N. *Modern Photojournalism: Origin and Evolution, 1910-1933.* New York: Macmillan, 1973.

Gilbert, Kathy, and Schleuder, Joan. "Effects of Color Complexity in Still Photographs on Mental Effort and Memory." Paper presented at the Annual Meeting of the Association for Education in Journalism and Mass Communication, Portland, OR, 1988. ERIC, ED298579.

Girvin, Robert E. "Photography as Social Documentation." *Journalism Quarterly* 24 (September 1947): 207-220.

Goldberg, Vicki. *Margaret Bourke-White: A Biography.* Reading, MA: Addison-Wesley, 1987.

Goldberg, Vicki. *Bourke-White.* East Hartford, CT: United Technologies, 1988.

Golden, Anthony R. "The Effect of Quality and Clarity on the Recall of Photographic Illustrations." Paper presented at the Annual Meeting of the Association for Education in Journalism and Mass Communication, San Antonio, TX, 1987. ERIC, ED287162.

"The Golden Age of the Picture Magazine." *Photographic Journal* 126 (March 1986): 104-8.

Goldsmith, Arthur. "A Lesson in Portraiture From a Master: A Look Over Arnold Newman's Shoulder as He Photographs Dr. Francis Crick for His Notable 'Great British Series.'" *Popular Photography* (December 1979): 100-107, 123-25.

Goldsmith, Arthur. "Reinventing the Image: As We Edge Uncertainly Into the Electronic Age, Does Photojournalism Have a Future?" *Popular Photography* (March 1990): 48-53.

Goodwin, Gene. "The Ethics of Compassion: 'Hard-nosed, Macho' Journalism Is Turning Off Readers and Viewers." *The Quill* (November 1983): 38-40.

Gordon, Jim. "Hanging Up the Handcuffs No. 3." *News Photographer* (July 1979): 8-9, 13-14.

Gordon, Jim. "Question of Credibility: A Western Editor Raises Issue." *News Photographer* (October 1979): 20-22.

Gordon, Jim. "Judgement Days for Words and Pictures: To Print or Not to Print." *News Photographer* (July 1980): 25-29.

Gordon, Jim. "Zeisloft Incident: Foot Artwork Ends Career." *News Photographer* (November 1981): 32-36.

Gould, Lewis L.. and Greffe, Richard. *Photojournalist: The Career of Jimmy Hare.* Austin: University of Texas Press, 1977.

Grace, Arthur. *Choose Me: Portraits of a Presidential Race.* Waltham, MA: University Press Of New England/Brandeis, 1989.

Gramling, Oliver. *AP, the Story of News.* New York: Farrar and Rinehart, 1940.

"Great News Photos." *Photographic Journal* 119 (December 1979): 384-85.

Gross, Larry, Katz, John Stuart, and Ruby, Jay, eds. *Image Ethics: The Moral Rights of Subjects in Photographs, Film, and Television.* New York: Oxford, 1988.

Grossfeld, Stan. *The Eyes of the Globe: Twenty-Five Years of Photography from the Boston Globe.* Chester, CT: Globe Pequot Press, 1985.

Grossfeld, Stan. "Photo Opportunities: Local Photographers Go Global." *WJR Washington Journalism Review* (May 1986): 39-41.

Grossfeld, Stan. *The Whisper of Stars: A Siberian Journey.* Chester, CT: Globe Pequot Press, 1988.

"Guidelines: Suggestions for Police/Press Relations Prepared by the National Press Photographers Association, Inc." *News Photographer* (December 1981): 12.

Gutman, Judith Mare. *Lewis W. Hine: Two Perspectives.* New York: Viking Press, 1974.

Halliday-Levy, Tereza. "The Connotation Dimension of News Photographs." Paper presented at the Annual Meeting of the Association for Education in Journalism, Athens, OH, 1982. ERIC, ED217475.

Halsman, Phillipe. *Halsman on the Creation of Photographic Ideas.* New York: Ziff-Davis, 1961.

Hamblin, Dora Jane. *That Was the Life.* New York: W.W. Norton, 1977.

Hanka, Harold. *Positive Images: Photographs.* Willimantic, CT: Chronicle Print, 1982.

Harris, John. *A Century of New England in News Photos.* Chester, CT: Globe Pequot Press, 1979.

Harrison, Randall. *Pictorial Communication Search No. 6.* East Lansing, MI: National Project in Agricultural Communication, 1962.

Harrower, Tim. *The Newspaper Designer's Handbook.* Portland, OR: Oregonian Publishing Co., 1989.

Hartley, Craig. "Photographers, Public View Practices: Ethics and Photojournalism Today." *News Photographer* (January 1982): 23-25.

Hartley, Craig H. "Ethical Newsgathering Values of the Public and Press Photographers." *Journalism Quarterly* 60 (1983): 301-4.

Hartley, Craig, and Hillard, B.J. "The Reactions of Photojournalists and the Public to Hypothetical Ethical Dilemmas Confronting Press Photographers." MA thesis, University of Texas, Austin, 1981.

Haworth-Booth, Mark. *Donald McCullin.* London: Collins, 1983.

Hazard, William R. "Responses to News Pictures: A Study in Perceptual Unity." *Journalism Quarterly* 37 (1960): 515-524.

Heartfield, John. *Photomontages of the Nazi Period.* New York: Universe Books, 1977.

Heller, Steven. "Photojournalism's Golden Age (Through the Great Picture Magazines of the '20s and '30s)." *Print 38* (September/October 1984): 68-79, 116, 118.

Heller, Steven, and Chwast, Seymour, eds. *Sourcebook of Visual Ideas.* New York: Van Nostrand Reinhold, 1989.

Herde, Tom. "Editorial Illustration." *News Photographer* (July 1979): 28-29.

Heyman, Ken, and Durniak, John. *The Right Picture: A Photographer and a Picture Editor Demonstrate How to Choose.* New York: Amphoto, 1986.

Hicks, Wilson. *Words and Pictures: An Introduction to Photo-Journalism.* 1952. Reprint. New York: Arno Press, 1973.

Hightower, Paul Dudley. "The Influence of Training on Taking and Judging Photos." *Journalism Quarterly* 61 (1984): 682-86.

Hine, Lewis. *America and Lewis Hine: Photographs 1904-1940*. Millerton, NY: Aperture, 1977.

Horenstein, Henry. *The Photographer's Source: A Complete Catalogue*. New York: Simon and Schuster, 1989.

Horrell, William C. "A Survey of Motion Picture and Still Photography and Graphic Arts Instruction 1976-1977." Rochester, NY: Eastman Kodak, 1978.

Horton, Brian. *The Picture: An Associated Press Guide to Good News Photography*. New York: Associated Press, 1989.

Horton, Brian. *The Associated Press Photo-Journalism Stylebook*. Reading, MA: Addison-Wesley, 1990.

How to Catch the Action. Alexandria, VA: Time-Life Books in association with Kodak, 1983.

Hoy, Frank P. *Photojournalism: The Visual Approach*. Englewood Cliffs, NJ: Prentice-Hall, 1986.

Hoyt, James L. "Cameras in the Courtroom: From Hauptmann to Wisconsin." Paper presented at the Annual Meeting of the Association for Education in Journalism, Seattle, WA, 1978. ERIC, ED158307.

Hughes, Jim. "The Nine Lives of W. Eugene Smith." *Popular Photography* (April 1979): 116-117, 135-141.

Hughes, Jim. *W. Eugene Smith, Shadow & Substance: The Life and Work of an American Photographer*. New York: McGraw-Hill, 1989.

Hulteng, John L. *The Messenger's Motives: Ethical Problems of the News Media*. 2nd ed. Englewood Cliffs, NJ: Prentice-Hall, 1985.

Hunter, Jefferson. *Image and Word: The Interaction of Twentieth-Century Photographs and Texts*. Cambridge, MA: Harvard University Press, 1987.

Hurlburt, Allen. *Publication Design*. Rev. ed. New York: Van Nostrand Reinhold, 1976.

Hurlburt, Allen. *The Grid: A Modular System for the Design and Production of Newspapers, Magazines and Books*. New York: Van Nostrand Reinhold, 1978.

Hurlburt, Allen. *The Design Concept*. New York: Watson-Guptill Publications, 1981.

Hurlburt, Allen. *Photo/Graphic Design*. New York: Watson-Guptill Publications, 1983.

Hurley, Forrest Jack. *Portrait of a Decade: Roy Stryker and the Development of Documentary Photography in the Thirties*. 1972. Reprint. New York: Da Capo, 1977.

Hurley, Gerald D., and McDougall, Angus. *Visual Impact in Print: How to Make Pictures Communicate; A Guide for the Photographer, the Editor, the Designer*. Chicago: American Publishers Press, 1971.

Hurter, Bill. *Sports Photography: Breaking Into the Field, How to Capture the Action*. Los Angeles: Petersen, 1978.

Huttenstine, Marian L., and Reddin, Debra D. "Let's Keep Photographers Out of Court: A Legal Primer for Photographers." Paper presented at the Annual Meeting of the Association for Education in Journalism, Boston, MA, 1980. ERIC, ED192368.

Huyler, Jean Wiley. "Teach Photojournalism: Not Just Photography." *Communication: Journalism Education Today (C:JET)* 14 (Spring 1981): 4-7.

"Illustrations." *4Sight* (May-June 1985): 10.

Images of Our Times: Sixty Years of Photography from the Los Angeles Times. New York: Abrams, 1987.

Iooss, Walter. *Baseball*. New York: Abrams, 1984.

Iooss, Walter. *Sports People*. New York: Abrams, 1988.

Jacobs, Louis, Jr. *Free-lance Magazine Photography*. New York: Hastings House, 1970.

Jaubert, Alain. *Making People Disappear: An Amazing Chronicle of Photographic Deception*. Washington: Pergamon-Brassey's International Defense Publishers, 1989.

John, Alun. *Newspaper Photography: A Professional View of Photojournalism Today*. Marlborough: Crowood, 1988.

Johns, David. "All about Boo-Boos: Is It Ethical to Photograph Embarrassing Moments? Is Prominence Enough Justification?" *News Photographer* (July 1984): 8.

Jones, Bernard, ed. *Cassell's Cyclopedia of Photography*. 1911. Reprint. New York: Arno Press, 1974.

Juergens, George. *Joseph Pulitzer and the New York World*. Princeton, NJ: Princeton University Press, 1966.

Junas, Lil. "Ethics and Photojournalism: Posed, Set Up, Faked, Controlled or Candid?" *News Photographer* (March 1982): 19-20.

Junas, Lil. "Ethics and Photojournalism: Techniques and 'Bring Back Something'." *News Photographer* (June 1982): 26-27.

Junas, Lil. "Ethics and Photojournalism: Photographer Qualities and Picture Selection." *News Photographer* (June 1984): 24.

Junas, Lil. "Ethics and Photojournalism: Code of Ethics: Yes or No?" *News Photographer* (July 1984): 6-7.

Kalish, Stanley E., and Edom, Clifton C. *Picture Editing*. New York: Rinehart, 1951.

Kaplan, Daile. *Lewis Hine in Europe: The Lost Photographs*. New York: Abbeville Press, 1988.

Karsh, Yousuf. *Portraits of Greatness*. New York: Thomas Nelson & Sons, 1959.

Kendall, Robert. "Photo 1978: Some Provisions of the 1976 Copyright Act for the Photojournalist." Paper presented at the meeting of the Photojournalism Division, Association for Education in Journalism, Madison, WI, 1977.

Kennedy, Thomas. "Content and Style: How Do Limited Expectations Affect the Creative Process?" *MGR* (insert in *News Photographer*) (January 1989): 1-3.

Kenney, Keith. "*Mid-Week Pictorial*: Pioneer American Photojournalism Magazine." Paper presented at the Annual Meeting of the Association for Education in Journalism and Mass Communication, Norman, OK, 1986. ERIC, ED271767.

Kerns, Robert. *Photojournalism: Photography with a Purpose*. Englewood Cliffs, NJ: Prentice-Hall, 1980.

Kerrick, Jean S. "Influence of Captions on Picture Interpretation." *Journalism Quarterly* 32 (1955): 177-184.

Kerrick, Jean S. "News Pictures, Captions and the Point of Resolution." *Journalism Quarterly* 36 (1959): 183-188.

Kessel, Dmitri. *On Assignment: Dmitri Kessel, LIFE Photographer*. New York: Abrams, 1985.

Kielbowiez, Richard B. "The Making of Canon 35: A Blow to Press-Bar Cooperation." Paper presented at the meeting of the Photojournalism Division, Association for Education in Journalism, Houston, TX, 1979.

Kobré, Ken. "Last Interview with W. Eugene Smith on the Photo Essay." Paper presented at the Annual Meeting of the Association for Education in Journalism, Houston, TX, 1979. ERIC, ED178948.

Kobré, Ken. "Something Different for the News Photographer: Illustrations Solve Problems." *News Photographer* (July 1979): 28-30.

Kobre, Sidney. *News Behind the Headlines: Background Reporting of Significant Social Problems*. Tallahassee, FL: Florida State University, 1955.

Kobre, Sidney. *Behind Shocking Crime Headlines*. Tallahassee, FL: Florida State University, 1957.

Kobre, Sidney. *Press and Contemporary Affairs*. Tallahassee, FL: Florida State University, 1957.

Kobre, Sidney. *Modern American Journalism*. Tallahassee, FL: Florida State University, 1959.

Kobre, Sidney. *The Yellow Press and Gilded Age Journalism*. Tallahassee, FL: Florida State University, 1964.

Kobre, Sidney. *Development of American Journalism*. Dubuque, IA: Wm. C. Brown, 1969.

Kochersberger, Robert C. "Survey of Suicide Photos Use in Newspapers in Three States." *Newspaper Research Journal* 9 (Summer 1988): 1-12.

Kodak Datalines: An Exclusive Report from Kodak for the Photojournalist, Rochester, NY: Eastman Kodak Company (Issue No.1 1989).

Kodak Milestones: 1880-1980. Rochester, NY: Eastman Kodak, 1980.

Kunhardt, Phillip B., Jr. *The Joy of Life*. Boston: Little, Brown, 1989.

LaBelle, David. *The Great Picture Hunt*. Bowling Green Kentucky: Western Kentucky University, 1989.

Lain, Laurence B. "How Readers View Mug Shots." *Newspaper Research Journal* 8 (Spring 1987): 43-52.

Lamb, John, and Postle, Bruce. *Images of Our Time: 30 Years of News Photographs*. South Jarra, Victoria: Currey O'Neil, 1985.

Lang, Wendy. "Sequences: Conceptual Relationships." *Peterson's Photographic Magazine* (June 1979): pp. 88-99.

Lange, George. "Feature: Riding Shotgun with Annie (Leibovitz)." *American Photographer* (January 1984): 56, 59.

Lasica, J. D. "Photographs That Lie: The Ethical Dilemma of Digital Retouching." *WJR Washington Journalism Review* (June 1989): 22-25.

Leekley, Sheryle, and Leekley, John. *Moments: The Pulitzer Prize Photographs*. Updated ed. 1942-1982. New York: Crown, 1982.

Leibovitz, Annie. *Annie Leibovitz: Photographs*. New York: Rolling Stones Press, 1983.

Leifer, Neil. *Sports!* Text by George Plimpton. New York: Abrams, 1983.

Leslie, L. Z. "Newspaper Photo Coverage of Censure of McCarthy." *Journalism Quarterly* 63 (1986): 850-53.

Lester, Paul. "Use of Visual Elements on Newspaper Front Pages." *Journalism Quarterly* 65 (1988): 760-63.

Lester, Paul. "Computer Aids Instruction in Photojournalism Ethics." *Journalism Educator* 44 (Summer 1989): 13-17.

Lester, Paul Martin. "Front Page Mug Shots: A Content Analysis of Five U.S. Newspapers in 1986." *Newspaper Research Journal* 9 (Spring 1988): 1-9.

Lester, Paul Martin. "The Ethics of Photojournalism: Toward a Professional Philosophy for Photographers, Editors and Educators." Ph.D. diss., Indiana University, 1989.

Lester, Paul, and Smith, Ron. "African-American Picture Coverage in *Life, Newsweek,* and *Time,* 1937-1988." Paper presented at the Annual Meeting of the Association for Education in Journalism and Mass Communication, Washington, DC, 1989. ERIC, ED310460.

Lewinski, Jorge, comp. *The Camera at War: A History of War Photography from 1848 to the Present Day*. London: W.H. Allen, 1978.

Lewis, Charles W. "*From Brady to Bourke-White: An Examination of the Foundations of American Picture Magazine Photojournalism, 1860-1940.*" MA thesis, Mankato State University, MN, 1986.

Lewis, David M. "*Electronic Cameras and Photojournalism: Impact and Implications.*" MS study, Ohio University, Athens, 1983.

Lewis, Greg. "A Tribute to W. Eugene Smith." *The Rangefinder* (December 1978): 35.

Life 50, 1936-1986: The First Fifty Years. Boston: Little, Brown, 1986.

Life, the First Decade, 1936-1945. London: Thames and Hudson, 1979.

Life, the Second Decade, 1946-1955. Boston: Little, Brown, 1984.

Life, Through the Sixties: An Exhibition and Catalogue. New York: Time, 1989.

Livingston, Jane. *Odyssey: The Art of Photography at National Geographic*. Charlottesville, VA: Thomasson-Grant, 1988.

Loengard, John. *Pictures Under Discussion*. New York: Amphoto, 1987.

Loengard, John. *Life Classic Photographs: A Personal Interpretation*. Boston: New York Graphic Society Books, 1988.

Logan, Richard, III. *Elements of Photo Reporting*. Garden City, NY: Amphoto. 1971.

Loosley, A.E. *The Business of Photojournalism*. New York: Focal Press, 1970.

Lopes, Sal. *The Wall: Images and Offerings from the Vietnam Veterans Memorial*. New York: Collins, 1987.

Lukas, Anthony J. "The White House Press 'Club'." *New York Times Magazine* (15 May 1977): 22, 64-68, 70-72.

Luebke, Barbara F. "Out of Focus: Images of Women and Men in Newspaper Photographs." *Sex Roles* 20 (1989): 121-33.

Lyons, Nathan, ed. *Photographers on Photography*. Englewood Cliffs, NJ: Prentice-Hall, 1966.

MacDougall, Curtis D. *News Pictures Fit to Print ... Or Are They?* Stillwater, OK: Journalistic Services 1971.

MacDougall, Kent A. "*Geographic*: From Upbeat to Realism." *Los Angeles Times* (5 August 1977): 1, 8-10.

MacLean, Malcolm S., Jr. "Communication Strategy, Editing Games and Q." In *Science, Psychology and Communication*. Edited by Steven R. Brown and Donald J. Brenner, 327-44. New York: Teachers College Press, 1972.

MacLean, Malcolm S., Jr., and Hazard, William R. "Women's Interest in Pictures; The Badger Village Study." *Journalism Quarterly* 30 (1953): 139-162.

MacLean, Malcolm S., Jr., and Kao, Anne Li-An. "Picture Selection: An Editorial Game." *Journalism Quarterly* 40 (1963): 230-232.

MacLean, Malcolm S., Jr., and Kao, Anne Li-An. *Editorial Predictions of Magazine Picture Appeals*. Iowa City, IA: School of Journalism, University of Iowa, 1965.

Maddow, Ben. *Let Truth Be the Prejudice: W. Eugene Smith, His Life and Photographs*. Millerton, NY: Aperture, 1985.

Magmer, James, and Falconer, David. *Photograph + Printed Word*. Birmingham, MI: Midwest Publications, 1969.

Mallen, Frank. *Sauce for the Gander. [The New York Evening Graphic]*. White Plains, NY: Baldwin Books, 1954.

Mallette, Malcolm F. "Ethics in News Pictures: Where Judgement Counts." Paper presented at Rochester Photo Conference, George Eastman House, Rochester, NY, 1975.

Mallette, Malcolm F. "Should These News Pictures Have Been Printed? Ethical Decisions Are Often Hard but Seldom Right." *Popular Photography* (March 1976): 73-75, 118-120.

Manchester, William Raymond. *In Our Time: The World as Seen by Magnum Photographers*. New York: American Federation of the Arts with Norton, 1989.

Manion, B. C. "Faking It! Omaha Daily Fabricates Photo." *News Photographer* (June/July 1981): 30-31.

Mann, Maria. "Great Expectations: Trying to Gain an Equal Foot in the Decision Making Process." *MGR* (insert in *News Photographer*) (April 1989): 1, 4.

Marcus, Adrianne. *The Photojournalist: Mary Ellen Mark and Annie Leibovitz*. Los Angeles: Seskog with Crowell, 1974.

Markus, David. "Moving Pictures: How Photographers Brought the Ethiopian Famine to Light in the Shadow of Television." *American Photographer* (May 1985): 50-53.

Martin, Edwin. "Against Photographic Deception." *Journal of Mass Media Ethics* 2 (Spring/Summer 1987): 49-59.

Martin, Peter. "Gene Smith As 'The Kid Who Lived Photography.'" *Popular Photography* (April 1979): 130, 149-150.

Martin, Rupert, ed. *Floods of Light: Flash Photography, 1851-1981*. London: Photographers Gallery, 1982.

Mason, Jerry. *The Family of Children*. New York: Grosset and Dunlap, 1977.

Matthews, Mary L., and Reuss, Carol. "The Minimal Image of Women in *Time* and *Newsweek*, 1940-1980." Paper presented at the Annual Meeting of the Association for Education in Journalism and Mass Communication, Memphis, TN, 1985. ERIC, ED260405.

McCullin, Don. *Hearts of Darkness*. London: Secker & Warburg, 1980.

McDonald, Duncan. "Staff Employment: A Tie That Binds?" *News Photographer* (May 1980): 26-29.

McDonald, Michele. "The Hard Way: Know What You're Doing Before You Sell Your Photos, It's a Tough World Out There." *News Photographer* (April 1987): 13-15.

McDougall, Angus, and Hampton, Vieta Jo. *Picture Editing and Layout: A Guide to Better Visual Communication*. Columbia, MO: Viscom Press, 1990.

McQuilkin, Robert. *How to Photograph Sports and Action*. Tucson, AZ: HP Books, 1982.

McQuilkin, Robert. *Outdoor Sports Photography Book*. Mountain View, CA: Runner's World Books, 1982.

McQuilkin, Robert, and Landers, Clifford. "How to Photograph Sports and Action." *Darkroom Techniques* (September/October 1984): 41.

Meijer, Emile, and Swart, Joop, eds. *The Photographic Memory: Press Photography: Twelve Insights*. London: Quiller Press, 1988.

Meltzer, Milton. *Dorothea Lange: A Photographer's Life*. New York: Farrar, Strauss, Giroux, 1978.

Meredith, Roy. *Mr. Lincoln's Camera Man Mathew B. Brady*. 2nd rev. ed. New York: Dover, 1974.

Mich, Daniel D., and Eberman, Edwin. *The Technique of the Picture Story*. New York: McGraw-Hill, 1945.

Middlebrooks, Donald M., Jones, Clarence, and Shrader, Howard. "Access: Scope of Privilege in Gathering News Is Vague and Narrow, Scope of Liability Is Far More Certain." *News Photographer* (December 1981): 10-11, 13-16, 18-19.

Mili, Gjon. *Gjon Mili: Photographs and Recollections*. Boston: New York Graphic Society, 1980.

Moeller, Susan D. *Shooting War: Photography and the American Experience of Combat*. NY: Basic Books, 1989.

Moments in Time: 50 Years of Associated Press News Photos. Rev. ed. North Ryde, Aust.: Angus & Robertson, 1984.

Morgan, Willard D. *Graphic Graflex Photography for Prize Winning Pictures*. 11th ed. New York: Morgan and Morgan, 1958.

Moriarty, Sandra E., and Garramone, Gina M. "A Study of Newsmagazine Photographs of the 1984 Presidential Campaign." *Journalism Quarterly* 63 (1986): 728-34.

Morris, Desmond. *Manwatching: A Field Guide to Human Behavior*. New York: Abrams, 1977.

Morris, Joe Alex. *Deadline Every Minute: The Story of the United Press*. Garden City, NY: Doubleday, 1957.

Morse, Michael L., ed. *The Electronic Revolution in News Photography*. Durham, NC: National Press Photographers Association, 1987.

Mundt, Whitney R., and Broussard, E. Joseph. "The Prying Eye: Ethics of Photojournalism." Paper presented at the Annual Meeting of the Association for Education in Journalism, Houston, TX, 1979. ERIC, ED173863.

Murphy-Racey, Patrick. "Pictures of the Month-January: A Case of Situation Ethics." *News Photographer* (May 1988): 30-31.

Mydans, Carl. *Carl Mydans, Photojournalist*. New York: Abrams, 1985.

Nachtwey, James. *Deeds of War: Photographs*. New York: Thames and Hudson, 1989.

Nelson, Roy Paul. *Visits With 30 Magazine Art Directors*. New York: Magazine Publishers Association, 1978.

Nelson, Roy Paul. *Publication Design*. 2nd ed. Dubuque, IA: Wm. C. Brown, 1972.

Newcomb, John. *The Book of Graphic Problem Solving: How to Get Visual Ideas When You Need Them*. New York: R.R. Bowker, 1984.

Newhall, Beaumont. *The History of Photography from 1839 to the Present Day*. Rev. & enlgd. ed. New York: Museum of Modern Art, 1964.

Newman, Arnold. *One Mind's Eye*. Boston: New York Graphic Society, 1974.

Newman, Arnold. *The Great British*. London: Weidenfeld and Nicolson, 1979.

Newman, Arnold. *Artists: Portraits from Four Decades*. London: Weidenfeld and Nicolson, 1980.

Newman, Arnold. *Arnold Newman, Five Decades*. San Diego: Harcourt Brace Jovanovich, 1986.

"News Views: Edward Farber, Portable Strobe Inventor, Dead." *News Photographer* (April 1982): 3.

"News Views: Milwaukee Sentinel Photographer Helps Firemen in Rescue." *News Photographer* (March 1988): 4.

"News Views: Texas Tragedy, Suicide Coverage a Jolt in Newspaper, on TV." *News Photographer* (June 1983): 4-5, 8.

Nilson, Lisbet. "Paper Tiger: As an Associate Editor at the *Boston Globe*, Stan Grossfeld Has Advised Something Few Photojournalists Ever Get Their Hands On—Power in the Newsroom." *American Photographer* (October 1988): 46-55.

Noble, Edward R. "Credible Cutlines." *Editor and Publisher* (17 February 1979): 9.

Norback, Craig T., and Gray, Melvin, eds. *The World's Great News Photos, 1840-1980*. New York: Crown Publishers, 1980.

Nottingham, Mary Emily. "From Both Sides of the Lens: Street Photojournalism and Personal Space." Ph.D. diss., Indiana University, 1978.

Ohrn, Karin Becker. "How Photographs Become News: Photojournalists at Work." Paper presented at the Annual Meeting of the Association for Education in Journalism and Mass Communication, Corvallis, OR, 1983. ERIC, ED232191.

Padgett, G. E. "Let Grief Be a Private Affair." *Quill* 76 (February 1988): 13, 27.

Paine, Richard P. *The All American Cameras: A Review of Graflex*. Houston: Alpha Publishing, 1981.

Parker, Douglas. "Ethical Implications of Electronic Still Cameras and Computer Digital Imaging in the Print Media." *Journal of Mass Media Ethics* 3 (Fall 1988): 47-59.

Pasternack, Steve, and Martin, Don R. "Daily Newspaper Photojournalism in the Rocky Mountain West." *Journalism Quarterly* 62 (1985): 132-35, 222.

Peattie, Peggy. "Photojournalism in the '80s: Special Report, Part I: Can Serious Newspaper Documentary Photography Survive the Economic Crash, Quick-Read Presentation and the Photo-Illiterate Paginator?" *News Photographer* (November 1988): 57-60.

Permutt, Cyril. *Collecting Old Cameras*. New York: Da Capo Press, 1976.

Phillips, John. *It Happened in Our Lifetime: A Memoir in Words and Pictures*. Boston: Little, Brown, 1985.

"Photographers of the Vanguard: Front-line Journalism is a Matter of Life and Death." *News Photographer* (September 1981): 13-26.

"Photography in Newspapers Issue." Pullout Section. *Editor and Publisher* (24 February 1990): 1P-52P.

Photojournalism. Rev. ed. Alexandria, VA: Time-Life, 1983.

Pierce, Bill. "W. Eugene Smith Teaches Photographic Responsibility." *Popular Photography* (November 1961): 80-84.

Pierce, Bill. "Photography Down and Dirty: Tips from White House Press Photographers on How to Grab Those Candid, Travel and News Pictures That Everybody Else Misses." *Popular Photography* (November 1975): 88-91, 130-133.

Pollack, Peter. *The Picture History of Photography*. New York: Abrams, 1969.

Poppy, John. *The Persuasive Image: Art Kane*. New York: Crowell, 1975.

Pozner & Pomeyrol. *Leica Story*. Publisher and date of publication unknown.

"The Process of Recording Conflict" (five article anthology). *Aperture* 97 (Winter 1984): 6-77.

Professional Photographic Illustration. Rochester, NY: Eastman Kodak, 1989.

"A Public Suicide: Papers Differ on Editing Graphic Images." *Associated Press Managing Editors (APME) Report: Photo and Graphics*. New York, 1987.

"A Question of Ethics." (multiple article anthology). *News Photographer* (July 1983).

Ratcliff, Carter. "The Image Makers." *Picture* 20 (1982): 12-56.

Rayfield, Stanley. *How Life Gets the Story: Behind the Scenes in Photojournalism*. Garden City, NY: Doubleday, 1955.

Reaves, Shiela. "Digital Retouching: Is There a Place for It in Newspaper Photography?" *Journal of Mass Media Ethics* 2 (Spring/Summer 1987): 40-48.

Reaves, Shiela. "Digital Alteration of Photographs in Magazines: An Examination of the Ethics." Paper presented at the Annual Meeting of the Association for Education in Journalism and Mass Communication, Washington, DC, 1989. ERIC, ED310444.

Reaves, Shiela. "Photography, Pixels and New Technology: Is There a 'Paradigm Shift'?" Paper presented at the Annual Meeting of the Association for Education in Journalism and Mass Communication, Washington, DC, 1989. ERIC, ED310388.

Reed, Pat. "Paparazzo, Meet Ron Galella. Nemesis of Jackie O., Brando, etc." *Houston Chronicle Texas Magazine* (15 April 1979): 20.

Remole, Mary K., and Brown, James W. "Ethical Issues for Photojournalists: A Comparative Study of the Perspectives of Journalism Students and Law Students." Paper presented at the Annual Meeting of the Association for Education in Journalism, Boston, MA, 1980. ERIC, ED191022.

Rhode, Robert B., and McCall, Floyd H. *Press Photography: Reporting with a Camera*. New York: Macmillan, 1961.

Riboud, Marc. *Marc Riboud: Photographs at Home and Abroad*. Translated by I. Mark Paris. New York: Abrams, 1988.

Rich, Kathy. "Contact Sheet: Responses of Leading Picture Editors to a Survey to Determine How They Choose Pictures." *Camera 35* (April 1979): 34.

Richards, Eugene. *50 Hours*. Text by Dorothea Lynch. Long Island City, NY: Many Voices Press, 1983.

Richardson, Jim. *High School: U.S.A.* New York: St. Martin's Press, 1979.

Rigger, Robert. *Man in Sport*. Baltimore, MD: Baltimore Museum of Art, 1967.

Riis, Jacob. *How the Other Half Lives*. New York: Scribner, 1904.

Roche, James M. "Newspaper Subscribers' Response to Accident Photographs: The Acceptance Level Compared to Demographics, Death Anxiety, Fear of Death, and State Anxiety." Paper presented at the Annual Meeting of the Association for Education in Journalism and Mass Communication, Corvallis, OR, 1983. ERIC, ED234386.

Rodger, George. *Magnum Opus: Fifty Years in Photojournalism*. London: Nishen, 1987.

Rolling Stone, the Photographs. NY: Simon & Schuster, 1989.

Rosen, Marvin J. *Introduction to Photography*. 3rd ed. Boston: Houghton Mifflin, 1987.

Rothstein, Arthur. *Arthur Rothstein, Words and Pictures*. New York: Amphoto, 1979.

Rothstein, Arthur. *Photojournalism*. Garden City, NY: Amphoto, 1979.

Rothstein, Arthur. *Documentary Photography*. 3rd ed. Boston: Focal Press, 1987.

Rotkin, Charles E. *Professional Photographer's Survival Guide*. New York: American Photographic Book Publishing, 1982.

Sahadi, Lou, and Palmer, Mickey, eds. *The Complete Book of Sports Photography*. New York: Amphoto, 1982.

Salgado, Sebastiao. *Other Americas*. New York: Pantheon, 1986.

Salomon, Erich. *Erich Salomon, Portrait of an Age*. New York: Macmillan, 1967.

Schiffman, Amy. "Through the Loupe: Schiffman's Ten Rules of Photojournalism." *American Photographer* (August 1984): 14.

Schiffman, Amy. "Keeping Tabs on Photojournalism." *American Photographer* (September 1984): 18.

Schuneman, R. Smith. "The Photograph in Print: An Examination of New York Daily Newspapers, 1890-1937." Ph.D. diss., University of Minnesota, 1966.

Schuneman, R. Smith, ed. *Photographic Communication: Principles, Problems and Challenges of Photojournalism*. New York: Hastings House, 1972.

Self, Charles. *How to Take Action Photographs*. Garden City, NY: Dolphin Books, 1975.

Sentman, Mary Alice. "Black and White: Disparity in Coverage by *Life Magazine* from 1937 to 1972." *Journalism Quarterly* 60 (1983): 501-508.

Shames, Laurence. "Profile: On the Road with Annie Leibovitz, The Queen of Celebrity Photographers Is Quite a Character Herself." *American Photographer* (January 1984): 38-55.

Sherer, Michael D. "The Photojournalist and the Law: The Right to Gather News Through Photography." Ph.D. diss., Southern Illinois University at Carbondale, 1982.

Sherer, Michael D. "Photographic Invasion of Privacy: An Old Concept with New Meaning." Paper presented at the Annual Meeting of the International Communication Association, Dallas, TX, 1983. ERIC, ED236626.

Sherer, Michael D. "Your Photos or Mine: An Examination of the Laws Governing Warranted Searches and Subpoenas for the Photojournalist's Work Product." Paper presented at the Annual Meeting of the Association for Education in Journalism and Mass Communication, Corvallis, OR, 1983. ERIC, ED236610.

Sherer, Michael D. "Invasion of Poland Photos in Four American Newspapers." *Journalism Quarterly* 61 (1984): 422-26.

Sherer, Michael D. "The Problem of Trespass for Photojournalists." *Journalism Quarterly* 62 (1985): 154-56, 222.

Sherer, Michael D. "Photojournalism and the Infliction of Emotional Distress." *Communications and the Law* 8 (April 1986): 27-37.

Sherer, Michael D. "The Problem of Libel for Photojournalists." *Journalism Quarterly* 63 (1986): 618-23.

Sherer, Michael D. *No Pictures Please: It's the Law*. Durham, NC: National Press Photographers Association, 1987.

Sherer, Michael D. "A Survey of Photojournalists and Their Encounters with the Law." *Journalism Quarterly* 64 (1987): 499-502, 575.

Sherer, Michael D. "Comparing Magazine Photos of Vietnam and Korean Wars." *Journalism Quarterly* 65 (1988): 752-56.

Sherer, Michael D. "Photojournalists and the Law: A Survey of NPPA Members." *News Photographer* (January 1988): 16, 18.

Shoemaker, Pamela J., and Fosdick, James A. "How Varying Reproduction Methods Affects Response to Photographs." *Journalism Quarterly* 59 (1982): 13-20, 65.

Sidey, Hugh, and Fox, Rodney. *1,000 Ideas For Better News Pictures*. Ames, IA: Iowa State University Press, 1956.

Singletary, M. W. "Newspaper Photographs: A Content Analysis, 1936-76." *Journalism Quarterly* 55 (1978): 585-89.

Six Decades: The News in Pictures: A Collection of 250 News and Feature Photographs Taken from 1912 to 1975 by the Milwaukee Journal Co. Staff Photographers. MN: Milwaukee Journal Co., 1976.

Smith, C. Zoe. "Great Women in Photojournalism." Parts 1-3. *News Photographer* (January 1985): 20-21; (February 1985): 26, 28-29; (April 1985): 22-24.

Smith, C. Zoe. "Black Star Picture Agency: *Life's* European Connection." *Journalism History* 13 (Spring 1986): 19-25.

Smith, Ron F. "How Design and Color Affect Reader Judgement of Newspapers." *Newspaper Research Journal* 10 (Winter 1989): 75-85.

Smith, W. Eugene. "Saipan." *Life* (28 August 1944): 75-83.

Smith, W. Eugene. "Country Doctor." Life (20 September 1948): 115-126.

Smith, W. Eugene. "Spanish Village." *Life* (9 April 1951): 120-129.

Smith, W. Eugene. "Nurse Midwife." *Life* (3 December 1951): 134-145.

Smith, W. Eugene. "A Man of Mercy." *Life* (15 November 1954): 161-172.

Smith W. Eugene. "W. Eugene Smith Talks About Lighting." *Popular Photography* (November 1956): 48.

Smith, W. Eugene. "Pittsburgh." *1959 Photography Annual* (1958): 96-133.

Smith, W. Eugene. *W. Eugene Smith: His Photographs and Notes*. Millerton, NY: Aperture, 1969.

Smith, W. Eugene. *W. Eugene Smith, Master of the Photographic Essay*. Millerton, NY: Aperture, 1981.

Smith, W. Eugene, and Smith, Aileen M. *Minamata*. New York: Holt, Rinehart and Winston, 1975.

Sobieszek, Robert A. *Arnold Newman*. Englewood Cliffs, NJ: Prentice-Hall, 1982.

Solomon, Deborah. "Newman at Work." *American Photographer* (February 1988): 44-55.

Spaulding, Seth. "Research on Pictorial Illustration." *Audio-Visual Communication Review* 3 (1955): 355.

Spina, Tony. *On Assignment, Projects in Photojournalism*. New York: Amphoto, 1982.

Spina, Tony. *Press Photographer*. Cranbury, NJ: A.S. Barnes, 1968.

Spitzing, Gunter. *The Photoguide to Flash*. Garden City, NY: Amphoto, 1974.

Spremo, Boris. *Twenty Years of Photojournalism*. Toronto: McClelland and Stewart, 1983.

Spruill, Larry Hawthorne. "Southern Exposure: Photography and the Civil Rights Movement, 1955-1968." Ph.D. diss., State University of New York at Stony Brook, 1983.

Squiers, Carol. "Seeing History As It Happened: A Century and a Half in the Life of the World, As Recorded by Its Most Daring Witness." *American Photographer* (October 1988): 33-44.

Steichen, Edward. *The Family of Man*. New York: Simon & Schuster, 1955.

Stein, Barney. *Spot News Photography*. New York: Verlan Books, 1960.

Stensvold, Mike. *Increasing Film Speed*. Los Angeles: Petersen, 1978.

Stern, Bert. *Photo Illustration: Bert Stern*. New York: Crowell, 1974.

Stettner, Louis. *Weegee*. New York: Alfred A. Knopf, 1977.

Stettner, Louis, and Zanutto, James M. "Weegee." *Popular Photography* (April 1961): 101-102.

Stone, Steve. "When Two Worlds Collide: Public Press, Private Lives, Crash Head-On." *News Photographer* (August 1986): 14-18.

Stott, William. *Documentary Expression and Thirties America*. New York: Oxford Press, 1973.

Streitmatter, R. "The Rise and Triumph of the White House Photo Opportunity." *Journalism Quarterly* 65 (1988): 981-85.

"Suicide." (multiple article anthology). *News Photographer* (May 1987): 20-32, 34-43, 62.

Sutton, Albert A. *Design and Makeup of the Newspaper*. Englewood Cliffs, NJ: Prentice-Hall, 1948.

Swanson, Charles. "What They Read in 130 Daily Newspapers." *Journalism Quarterly* 32 (1955): 411-21.

Sweers, George, ed. *A White Paper on Newspaper Color: A Special Report*. Durham, NC: National Press Photographers Association, 1985.

Szarkowski, John. *The Photographer's Eye*. New York: The Museum of Modern Art, 1966.

Szarkowski, John. *Photography Until Now*. New York: Museum of Modern Art, 1989.

Szarkowski, John. *From the Picture Press*. New York: The Museum of Modern Art, 1973.

Tait, Anna. *Assignments I: The Press Photographer's Association Yearbook*. Oxford: Phaodon, 1987.

Tames, George. *Eye on Washington: The Presidents Who've Known Me*. New York: Harper & Row, 1990.

Tannenbaum, Percy H., and Fosdick, James A. "The Effect of Lighting Angle on Judgment on Photographed Subjects." *Audio Visual Communication Review* 8 (1960): 253-262.

Tatiner, Peter. "News Photography Goes Electronic." *Photo District News: Lighting & Equipment Issue* (November 1986): cover.

Tell, Judy. *Making Darkrooms Saferooms. A National Report on Occupational Health and Safety*. Durham, NC: National Press Photographers Association, 1988.

Terry, Danal, and Lasorsa, Dominic L. "Ethical Implications of Digital Imaging in Photojournalism." Paper presented at the Annual Meeting of the Association for Education in Journalism and Mass Communication, Washington, DC, 1989. ERIC, ED310397.

Thayer, Frank. "Legal Liabilities for Pictures." *Journalism Quarterly* 24 (September 1947): 233-237.

Time: 150 Years in Photojournalism. New York: Time, 1989.

Townsend, Jerry. "Photojournalists Need Reporting Skills, Too." *Community College Journalist* 8 (Winter 1980): 8, 29.

Truitt, Rosalind C. "Electronic Photography Coming of Age." *Presstime: The Journal of the American Newspaper Publisher's Association*. (October 1988) 30-37.

Trussell, Robert C. "Press Image 'Under Fire': Recent Movies Fuel Public Debate Over Journalistic Ethics." *The Kansas City Star* (6 November, 1983): 1F, 13F.

Tsang, Kuo-Jen. "News Photos in *Time* and *Newsweek*." *Journalism Quarterly* 61 (1984): 578-84, 723.

Turnley, David C., and Cowell, Alan. *Why Are They Weeping? South Africans Under Apartheid*. New York: Stewart, Tabori and Chang, 1988.

Turner, Richard. *Focus on Sports: Photographing Action*. Garden City, NY: Amphoto, 1975.

20 Years with AP Wirephoto. New York: Associated Press, 1955.

Ungero, Joseph M. "How Readers and Editors Judge Newspaper Photos." *APME Photo Report* (15 October 1977).

Vitray, Laura, Mills, John Jr., and Ellard, Roscoe. *Pictorial Journalism*. New York: McGraw Hill, 1939.

Walter, Paulette H. "*A History of Women in Print Photojournalism*." MS thesis, University of Ohio, Athens, 1987.

Walters, Basil L. "Pictures vs. Type Display in Reporting the News." *Journalism Quarterly* 24 (1947): 193-196.

Wanta, W. "The Effects of Dominant Photographs: An Agenda-Setting Experiment." *Journalism Quarterly* 65 (1988): 107-11.

Wanta, Wayne, and Leggett, Dawn. "Gender Stereotypes in Wire Service Sports Photos." *Newspaper Research Journal* 10 (Spring 1989): 105-14.

Warner, Bob. "Photo Seminar Emphasizes Need for Picture Editors." *Editor and Publisher* (15 September 1962): 9.

Webb, Alex. *Hot Light/Half-Made Worlds: Photographs from the Tropics*. New York: Thames and Hudson, 1986.

Webb, Alex. *Under a Grudging Sun: Photographs from Haiti Libere 1986-1988*. New York: Thames and Hudson, 1989.

Wedding, George. "Illustrative Photojournalism." Paper presented at San Jose Graphics '88 Conference, CA, April 30, 1988.

Weegee. *Naked City*. New York: Essential Books, 1945.

Weegee. *Weegee by Weegee: An Autobiography*. New York: Ziff-Davis, 1961.

Weegee. *Weegee's People*. 1946. Reprint. New York: Da Capo Press, 1975.

Weinberg, Adam D. *On the Line: The New Color Photojournalism*. Minneapolis: Walker Art Center, 1986.

Weintraub, David. "Ektapress Gains Popularity." *Photo District News* (April 1989): cover.

Welling, William. *Photography in America: The Formative Years 1839-1900, a Documentary History*. New York: Crowell, 1978.

Welsch, Ulrike. *The World I Love to See*. Boston: Boston Globe/Houghton Mifflin, 1977.

Welsch, Ulrike. *Faces of New England: Special Moments from Everyday Life*. 2nd ed. Chester, CT: Globe Pequot Press, 1981.

White, Frank William. "Cameras in the Courtroom: A U.S. Survey." *Journalism Monographs* 60 (April 1979).

White, Jan V. *Editing by Design: Word and Picture Communication for Editors and Designers*. New York: R.R. Bowker, 1974.

Whiting, John R. *Photography Is a Language*. New York: Ziff-Davis, 1946.

"Why Do They React? Readers Assail Publication of Funeral, Accident Photos." *News Photographer* (March 1981): 20, 22-23.

Wilcox, Walter. "Staged News Photographs and Professional Ethics." *Journalism Quarterly* 38 (1961): 497-504.

Willem, Jack M. "Reader Interest in News Pictures." In *Graphic Graflex Photography*, edited by Morgan and Lester. New York: Morgan & Lester, 1946.

Williamson, Daniel R. *Feature Writing for Newspapers*. New York: Hastings House, 1977.

Williamson, Lenora. "Page 1 Fire Photos Draw Reader Protests." *Editor and Publisher* (30 August 1975): 14-15.

Williamson, Lenora. "Editor Calls for More Decisive News Display." *Editor and Publisher* (8 November 1975): 13.

Williamson, Lenora. "New Council Raps ABA Courtroom Camera Position." *Editor and Publisher* (24 March 1979): 14.

Wischmann, Lesley. "Dying on the Front Page: Kent State and the Pulitzer Prize." *Journal of Mass Media Ethics* 2 (Spring/Summer 1987): 67-74.

Wolf, Henry. *Visual Thinking: Methods for Making Images Memorable*. New York: American Showcase, 1988.

Wolf, Rita, and Giotta, Gerald L. "Images: A Question of Readership." *Newspaper Research Journal* 6 (Winter 1985): 30-36.

"Women in Photojournalism." *News Photographer* (December 1984): 16-17; (February 1985): 25-29; (April 1985): 22, 24.

Woodburn, Bert W. "Reader Interest in Newspaper Pictures." *Journalism Quarterly* 24 (1947): 197-201.

Wooley, Al E. *Camera Journalism*. South Brunswick, NJ: A. S. Barnes, 1966.

INDEX

NOTE: ITALICIZED PAGES LOCATE ILLUSTRATIONS OR SOURCES OF ILLUSTRATIONS

Photo by Brian Peterson, *St. Paul Pioneer Press Dispatch*

Photo by Tom Levy, *The San Francisco Chronicle.*